GOYA

GOYA

A PORTRAIT OF THE ARTIST

Janis A. Tomlinson

PRINCETON UNIVERSITY PRESS PRINCETON AND OXFORD

ISBN 978-0-691-19204-8
ISBN (ebook) 978-0-691-20984-5

Library of Congress Cataloging-in-
Publication Data
Names: Tomlinson, Janis A., author.
Title: Goya : a portrait of the artist /
Janis A. Tomlinson.
Description: Princeton : Princeton
University Press, [2020] | Includes
bibliographical references and index.
Identifiers: LCCN 2019041721 |
ISBN 9780691192048 (hardback)
Subjects: LCSH: Goya, Francisco, 1746–
1828. | Artists—Spain—Biography.
Classification: LCC N7113.G68 T666 2020 |
DDC 700.92 [B]—dc23
LC record available at
https://lccn.loc.gov/2019041721

British Library Cataloging-in-Publication
Data is available

Design and composition by Julie Allred,
BW&A Books, Inc.
This book has been composed in
Dante MT Pro

Printed on acid-free paper. ∞
Printed in the United States of America
10 9 8 7 6 5 4 3 2 1

For J.G.T.

CONTENTS

MAIN AND SUPPORTING CHARACTERS

A note on naming conventions: In Spanish, individuals have one or more given names, illustrated by that of Goya's friend Juan Agustín Ceán Bermúdez and by Goya himself, baptized as Francisco Joseph Goya. Individuals often use only one first name, in Goya's case, Francisco. Surnames are composed of both the paternal and maternal surnames: thus, Goya (paternal surname) y Lucientes (maternal surname). As in Goya's case, the paternal surname alone is generally used; however, if that name is particularly common, the maternal surname might be used: the most famous example is Pablo Ruíz Picasso, who chose his mother's name. Throughout this book, I have generally used a single last name in the text, although the full name is given in this list. In the index, Spanish conventions are followed in indexing by the first (paternal) last name.

On several occasions, Goya himself introduced the particle "de" before his paternal surname, as had the writers Miguel de Cervantes and Lope de Vega over a century earlier. By the eighteenth century, this served as an identifier of noble lineage, and very possibly indicates Goya's unfulfilled aspirations. In this text, his name follows that of his baptismal certificate, without the particle.

For further information on the royal, political, and governmental figures listed here, see *Diccionario Biográfico electrónico* (www.dbe.rah.es).

Joseph Goya and Gracia Lucientes, his parents, and their children:

> **Rita**
>
> **Tomás**
>
> **Jacinta** (died at the age of seven)
>
> **Francisco Joseph** (identified throughout as "Goya")
>
> **Mariano** (died in infancy)
>
> **Camilo**

Goya's in-laws, the Bayeu y Subías family:

> **Francisco**: originally from Zaragoza; ascended rapidly in the ranks of court painters in 1763; following his parents' death, became the caretaker of his siblings:
>
> **Ramón**: painter, who often assisted his older brother
>
> **Manuel**: painter, who entered the Carthusian order
>
> **María Josefa**: known as Josefa, married Goya in 1773
>
> **María Josefa Matea**: married Marcos del Campo in 1783

Francisco Goya y Lucientes and Josefa Bayeu y Subías family:

> **Javier Francisco (Javier)**: sole survivor of seven documented children

The in-laws of Goya's son, Javier, members of Goicoechea y Galarza family:

> **Gumersinda**: wife of Javier Goya
>
> **Her father**: Martín Miguel de Goicoecha
>
> **Her sister**: Manuela, who with her husband, José Francisco Muguiro, and father accompanied Goya from Paris to Bordeaux in September 1824
>
> **Juan Bautista de Muguiro**: brother-in-law of Manuela, also with Goya in Bordeaux and the subject of his last known portrait

FRIENDS AND PATRONS IN ZARAGOZA

Allué, Matías: chair of the building committee at El Pilar

Goicoechea, Juan Martín de: successful businessman and patron of the arts (no known relation to the family of Goya's daughter-in-law)

Pignatelli y Moncayo, Ramón de: noble and cleric, whose accomplishments included the realization of the Canal de Aragón and the founding of the Economic Society of the Friends of the Country in Zaragoza

Yoldi y Vidania, José: of noble lineage; lived from rental income and in Madrid from 1787 to 1794, when he returned to become a chief administrator of the Canal of Aragón

Zapater y Clavería, Martín: businessman best remembered as Goya's closest friend and correspondent from 1775 to 1799

> **Alduy, Joaquina**: Zapater's aunt

ARTISTS

Adán Morlán, Juan: sculptor and a student of José Ramírez; coincided with Goya in Rome and later in Madrid

Aralí Solanas, Joaquín: sculptor and a student of José Ramírez

Castillo, José del: painter of tapestry cartoons and other works at the court of Carlos III

Eraso, Manuel: painter, who studied with Francisco Bayeu before going to Rome in 1762

Ferro Requijo, Gregorio: painter and Goya's frequent rival in competitions and elections of the Royal Academy of Fine Arts of San Fernando (hereafter, "Royal Academy" or "academy")

Esteve, Agustín: frequently cited as a collaborator of Goya; his success as a portraitist at the court of Carlos IV was second only to Goya's own

Giaquinto, Corrado: Italian painter; first court painter to Fernando VI and subsequently to Carlos III

Gómez Pastor, Jacinto: court painter under Carlos IV

González de Sepúlveda, Pedro: engraver, academician, collector, and diarist; here referred to as Sepúlveda.

González Velázquez, Antonio: student of Giaquinto; named court painter in 1757

López y Portaña, Vicente: student of Maella; replaced him as first court painter in 1815

Luzán Martínez, José: leading painter in mid-eighteenth-century Zaragoza, advocate for artistic education, and Goya's first teacher

Maella, Mariano Salvador: court painter to Carlos III, Carlos IV, and Joseph Bonaparte; shared with Goya the position of first court painter after 1799

Mengs, Anthony Raphael: German-born painter; appointed court painter by Carlos III in 1761 and first court painter in 1776

Merklein, Juan Andrés: Flemish-born painter active in Zaragoza and teacher of Francisco Bayeu, who married Merklein's daughter, Sebastiana

Napoli, Manuel: studied in Rome with Mengs; returned to Madrid in 1800 to become the leading paintings conservator at court

Paret y Alcázar, Luis: Spanish painter; exiled to Puerto Rico from 1775 to 1778 for his role in facilitating the amorous adventures of his patron, the *infante* don Luis

Ramírez de Arellano, José: leading sculptor in eighteenth-century Zaragoza

Rodríguez, Ventura: born Buenaventura Rodríguez Tizón; court architect and designer of the Santa Capilla in El Pilar (Zaragoza)

Salas Vilaseca, Carlos: Catalan sculptor active in Zaragoza and friend of Francisco Bayeu and Goya

Sanz, Agustín: architect active in Zaragoza and student of Ventura Rodríguez

Tiepolo, Giambattista: Italian master of illusionistic ceiling frescoes and court painter to Carlos III from 1762 until his death in 1770

WRITERS AND STATESMEN

Cabarrús y Lalanne, Francisco: financier of French origin

Ceán Bermúdez, Juan Agustín: close friend of Jovellanos, writer, and collector

Fernández de Moratín, Leandro: playwright at court, whose friendship with Goya endured until their final years together in Bordeaux; referred to as "Moratín"

Jovellanos, Gaspar Melchor de: jurist and writer of noble heritage; the major voice identified with the Spanish Enlightenment

Meléndez Valdés, Juan: poet turned jurist; friend of Jovellanos

Melón González, Juan Antonio: enlightened cleric and writer; lifelong friend of Moratín

Ponz Piquer, Antonio: author of *Viaje de España* and secretary of the Royal Academy from 1776 to 1790

Sabatini, Francisco: Italian-born court architect to Carlos III and Carlos IV

Silvela y García Aragón, Manuel: humanist and jurist, who in 1816 settled in Bordeaux to establish a school for the children of Spanish-speaking émigrés

The Royal Family

Carlos III of Spain and his wife, Maria Amalia of Saxony (d. 1760): one child deemed unfit for the throne remained in Naples; those who came to Madrid:

> **Carlos**: heir to the throne (titled in Spain the Príncipe de Asturias, or Prince of Asturias)
>
> **Gabriel Antonio**
>
> **Antonio Pascual**
>
> **Francisco Xavier**
>
> **María Josepha**
>
> **María Luisa**

The brother of Carlos III, the *infante* don Luis de Borbón, and his wife, María Teresa de Vallabriga; their children:

> **Luis María**: future cardinal and supporter of the Spanish Constitution of 1812
>
> **María Teresa**: married Manuel Godoy in 1797 and became the countess of Chinchón in 1803
>
> **María Luisa**: became the duchess of San Fernando de Quiroga in 1817

Appointees and Aristocrats at the Court of Carlos III

Aranda, count of (Pedro Pablo Abarca de Bolea): president of the council of Castile, subsequently ambassador to France under Carlos III, and briefly secretary of state under Carlos IV

Floridablanca, count of (José Moñino y Redondo): secretary of state under Carlos III, and into the early years of the reign of Carlos IV

López de Lerena, Pedro: protégé of Floridablanca; minister of finance during the final years of the reign of Carlos III and the early years of the reign Carlos IV; referred to as "Lerena"

Osuna, duke and duchess of (Pedro de Alcántara Téllez-Girón and María Josefa Pimentel y Téllez-Girón, countess-duchess of Benavente): grandees of Spain and patrons of Goya from 1785 until 1816

Vandergoten Canyuwell, Cornelius: director of the Royal Tapestry Factory of Santa Bárbara until his death in 1786

The Royal Family (as presented in The Family of Carlos IV *[pl. 19])*

Children of Carlos IV and Queen María Luisa (front row):

Carlos María Isidro

Fernando, prince of Asturias

María Isabel (under the queen's arm)

Queen María Luisa

Francisco de Paula

King Carlos IV

Don Luis of Borbón-Parma and María Luisa, the king's son-in-law and his wife, holding the infant **Carlos Luis**

Siblings of Carlos IV (second row):

Doña María Josepha and don Antonio Pascual, positioned next to a woman with head turned, representing his deceased wife (and niece), **María Amalia**

Appointees and Aristocrats at the Court of Carlos IV

Alba, duchess of (Cayetana de Silva-Álvarez de Toledo y Silva, María del Pilar Teresa): member of one of the most important aristocratic families; fell out of favor at court after 1796

Caballero y Campo Herrera, José Antonio: minister of grace and justice from August 1798 to 1808

Ceballos y Guerra de la Vega, Pedro Félix de: appointed secretary of state in 1800 and continued in service to the wartime Spanish government in exile, to Fernando VII, and, briefly, to Joseph Bonaparte

Cayetano: see below, Soler Ravasa

Godoy y Álvarez de Faria, Manuel: member of the royal guard, who from 1791 ascended rapidly through the ranks of the court to become the most trusted confidant of Carlos IV and María Luisa

His wife, **María Teresa de Borbón y Vallabriga**: oldest daughter of the *infante* don Luis and, from 1803, the countess of Chinchón

Iriarte de la Nieves Rabelo, Bernardo de: noble long in service at court; appointed vice-protector of the Royal Academy in March 1792

Saavedra y Sangronis, Juan Francisco de: following a military career, held government positions under Carlos III and Carlos IV; appointed minister of finance in 1797 and secretary of state from 1798 to 1799

Soler Ravasa, Miguel Cayetano de: appointed minister of finance in 1798; killed in 1809 in a public uprising in Malagón for having imposed a tax on wine

Valdecarzana, marquis of (Fernández de Miranda y Vallacis, Judas Tadeo): *sumiller de corps*, or the highest senior officer of the royal household, under Carlos III and Carlos IV

THE WAR YEARS (1808–1814)

Bonaparte, Joseph: older brother of Napoleon; appointed king of Spain in 1808; his reign, interrupted in 1808 and again in 1812, would end in March 1813

Palafox y Melci, José de: appointed Captain General of Aragón in May 1808 and Commander in Zaragoza during the first and second French sieges

Borbón y Vallabriga, Luis María de: son of the *infante* don Luis; led the regency government during the interim between the expulsion of Joseph Bonaparte and the return of Fernando VII

THE COURT OF FERNANDO VII

San Carlos, duke of (José Miguel de Carvajal-Vargas y Manrique de Lara): long a confidant of Fernando as both prince and king; appointed secretary of state in 1814

THE BORDEAUX YEARS

Brugada Vila, Antonio de: student at the Royal Academy from 1818 to 1821; left Spain in 1823 and settled in Bordeaux, where he befriended Leocadia Weiss and Goya

Galos, Jacques: French businessman and prominent citizen of Bordeaux, who served as Goya's financial adviser from 1824 to 1828

Pio de Molina, José: Goya's neighbor in his final residence in Bordeaux and witness of his death certificate

Weiss, Leocadia: wife of Isidoro Weiss; lived with Goya in Bordeaux from 1824 to 1828

Weiss, Rosario: daughter of Leocadia and Isidoro and student of Goya after 1821 in Madrid and Bordeaux

ACKNOWLEDGMENTS

To thank all who have contributed to my knowledge of Goya and to this book is a difficult task. I could begin with my parents, who, when leading a student trip through Spain, fell ill. The students continued on, we remained in Zaragoza, and I, then a high school student, explored as my suffering parents and younger brother tried to convince the hotel staff to boil rice without garlic. I delighted in discovery of the city, even if I was unaware that this was Goya's hometown, and, upon entering the basilica of El Pilar, did not know that many of its frescoes were done by Goya and his brothers-in-law, Francisco and Ramón Bayeu.

A decade later, Priscilla Muller, then curator of The Hispanic Society of America, provided a letter of introduction to Rocío Arnaez in the Museo del Prado, whose assistance was crucial as I embarked on research for my dissertation on Goya's tapestry cartoons. Nor can I overlook Eleanor Sayre, at the Museum of Fine Arts, Boston, who welcomed me on my regular holiday vacation returns to the print room and generously shared her knowledge about the magnificent collection of prints by Goya at the museum, and John Mc-Coubrey, who encouraged my early interest in the intersections of art and history.

Best to jump ahead, since this book is, after all, a biography of Goya and not of its author.

Following a lecture I gave at the Frick Collection in 2006, in which I tried to imagine Goya looking back on his life from his late years in Bordeaux, a curator expressed envy at the breadth of documentation we have about Goya. As a Goya specialist, I of course tended to focus on what we did not know, rather than what we did, and this comment led me to undertake a chronological survey of all known documentation, which in turn led me to think about writing this book.

Other projects distracted me, until Manuela Mena Marqués, then curator of eighteenth-century painting and Goya at the Museo del Prado, invited me to present a seminar to a group of young professionals, in conjunction with her lectures as the Cátedra del Prado on Goya. I chose biography as my topic, and in preparation followed the evolution of the genre in relation to Goya, from the 1830s to the present day. What became clear is that over the past two centuries, writers presenting his life and work have transformed Goya into many characters, from a revolutionary in a dark and superstitious land, to a Catholic family man and Spanish patriot, to an intimate friend of the enlightened writers, or *ilustrados*, of his day. The persistence of some of these characterizations might be attributed to the fact that they make an extremely multifaceted and complex artist accessible to the thousands who discover him in museums and exhibitions, in books, in film, and on the Internet.

I am indebted to Manuela Mena Marqués for her generous assistance and encouragement from the earliest glimmering of this project and to many others at the Museo del Prado, including José Manuel Matilla Rodríguez, Gudrun Maurer, Almudena Sánchez, and Gloria Solache Vilela. I am also grateful to the institution itself, for supporting the development of what is perhaps the greatest website dedicated to a single artist: *Goya en el Prado*. This model resource makes available digital images and full entries on each of the artist's works in the collection, a digital library of early writings on the artist, and documents—most importantly 119 letters from Goya to Martín Zapater, reproduced and transcribed. My thanks to Isabel García Toraño of the Biblioteca Nacional de España for facilitating access to drawings and assisting in all matters related to that institution. That institution's *Hemeroteca digital*, or digitized library of Spanish newspapers, was critical to recreating the historical and social context of Goya's long life. My gratitude to the staffs at both the archive of the Real Academia de Bellas Artes de San Fernando and the Archivo General del Palacio in Madrid. To José Ignacio Calvo Ruata and Juan Carlos Lozano López in Zaragoza, thank you for being always ready to join me on my returns to the city and for sharing your knowledge of its history, of its art, of Goya, and of his contemporaries. Finally, gratitude is due to the Fundación Goya en Aragón, which has supported seminal research on the artist.

On this side of the Atlantic, I am indebted to Stephanie Stepanek and colleagues of the Museum of Fine Arts, Boston; to the staff of the Metropolitan Museum of Art, who over the years have welcomed my many visits to examine Goya's prints and drawings; to Susan Galassi, Fronia W. Simpson, and Marcia Welles for their comments on a first draft of this book in great need of revision; to Luis Martín-Estudillo, for his help with the finer points

of Spanish and his thorough review of this manuscript; to Andrew Schulz, for sharing and understanding my fascination with the artist; and to Gillian Malpass, for her support of this project in its early stages. My research over the past five years has been facilitated and enriched by the dedicated and expert staff of the Interlibrary Loan Department in the Library, Museums and Press of the University of Delaware, who patiently sought arcane articles, mid-eighteenth-century travelers' maps of Italy, and even the 1823 *Album Bordelaise*, published by the man who two years later published Goya's *Bulls of Bordeaux*. I am grateful to Trevor A. Dawes, for support that was essential to the completion of this book, and to Monica McCormick, for advice that only someone who had an earlier career as an editor for a university press can give. I am deeply grateful to the reviewers of this manuscript and to Michelle Komie, Terri O'Prey, and the team at Princeton University Press who guided it into publication.

The audiences who have attended my lectures in museums and universities have helped me enormously; their questions often inspired me to think more broadly or to explore a new thesis as I thought about Goya and his work, and their enthusiasm for the artist reminded me why I do what I do. To Barbara Duval for her insights on Goya's prints and printing techniques; to Annette Giesecke for her translation of Latin and near Latin; to Bella Mascota, who constantly reminded me to "lighten up"; to Pilar Vico, who has taught me so much about Spain; and to the friends who over the years have both tolerated and encouraged my obsession: what can I say but, once again, thank you.

Introduction

OVER the past twenty years, as thousands have visited exhibitions and museums, read books and seen movies based on the life and work of Francisco Goya y Lucientes (1746–1828), the outline of his life has become familiar. He pursued his early studies in his hometown of Zaragoza, before going to Madrid in 1775, where he lived for almost five decades. During those years he witnessed the downfall of the Bourbon monarchy, the occupation of the Spanish throne by Napoleon's brother, and the restoration of the Spanish king, whose reign was interrupted by a three-year period of constitutional government. Through it all, Goya remained in service to successive monarchs, as he simultaneously explored subject matter never before seen in drawings, prints, and paintings, ranging from the etched satires of *Los Caprichos* to the enigmatic scenes painted on the walls of his country house over two decades later. In 1824 he requested leave from his position as first court painter and, supported by his full salary, traveled to France, where he spent the last four years of his life in Bordeaux among a colony of Spanish exiles. He made two return trips to Madrid before his death in Bordeaux in the early morning hours of April 16, 1828. This chronological overview of his career, however, does little justice to the complexities and transitions of the era that informed Goya's art and defined his life; his story personalizes the political and cultural transformation of Spain, from the mid-eighteenth to the early nineteenth century. His patrons and acquaintances were often victims of ever-shifting politics, and their stories, briefly told here, offer foils to Goya's own.

Goya's youth in Zaragoza coincided with changes in the education of young artists, as the private academies of Goya's first teacher, José Luzán Martínez, and of the sculptor José Ramírez de Arellano, both advocates for the establishment of a royal academy in Zaragoza, challenged the power of guilds over artistic production. This transition toward academic control

impacted Goya's family directly, as the neoclassical style sanctioned by the recently founded Royal Academy, which gave preference to marble over gilded wood for altarpieces, threatened the profession of Goya's father, Joseph, and older brother, Tomás, both gilders. Unable to retain the property that had been in the family for a century, the family relocated frequently and was at times separated. When his father died in 1781, intestate because there were no possessions to leave, Goya became the main financial support of his mother, sister, and two brothers, as well as of his wife and growing family, which by then included as many as six children. Both his lifelong attention to income and investments and his concern for the financial security of his heirs betray a determination to never again experience or impose on his family the poverty of his youth.

Occasional visits to Madrid and Goya's relocation to the city at the age of twenty-nine introduced him to the world of the Bourbon and cosmopolitan court of Carlos III. Central to his reign was the modernization of his capital, as many of Madrid's iconic buildings and public spaces were created: the royal palace; the promenade of the Paseo del Prado, with its shaded walks, fountains, and sculptures; the adjacent botanical garden; and a museum of natural history—today, the Museo del Prado. As in the larger capitals of Paris and London, and in contrast to Goya's native Zaragoza, new public spaces made the city a stage, not only for royal celebrations but also for individuals from widely diverse groups, now brought into daily contact.[1] Types emerged, identified by dress and manners, including most famously the *majos* and their female counterparts, or *majas*, representatives of the popular classes who in dress and manners resisted the reforms of a foreign king; their antitheses were the *petimetres* (from the French, *petit maître*) and *petimetras*, blindly devoted to French manners and fashions. Born on the streets, such characters appeared in prints and plays, to be immortalized by Goya in his designs for tapestries.

Goya's public life encompassed roles at court and within the society of Madrid, governed by etiquette and demanding conformity if not restraint; a counterbalance to that public life was the world defined by family and personal relationships, including, until 1803, his friendship with an enlightened businessman in Zaragoza, Martín Zapater. Although Goya lived in the capital, he never completely left Zaragoza and Aragón, which he defined as his *patria*, or homeland; in signing an altarpiece for the Cathedral of Seville forty-two years after he settled in Madrid, he identified himself as both first court painter and *Cesaraugustano*, or from Zaragoza. Even after Goya lost the support of powerful patrons in Zaragoza, it remained close to his heart, very possibly because of Zapater, the recipient of over 140 known or documented letters from the artist.

The collection of the Museo del Prado houses 119 of those letters; images of them on the *Goya en el Prado* website intimate the artist's moods, expressed through a variety of scripts and styles, from the formal script of an amanuensis to informal letters in which Goya scrawls only a few words across the page or adds drawings.[2] Written from 1775 to 1799, the letters reveal a growing intimacy, as well as a mutual admiration, between the two men and represent what we today call a private world—a term that in the eighteenth century had not yet coalesced to describe an individual reality that stood beyond the conventions and codes of public life.[3]

The letters bear witness to a deepening friendship and trust between the friends, to their interests, and to what could be expressed. In the years immediately following his arrival in Madrid, Goya referred frequently to common acquaintances in Zaragoza, but after a dispute with his brother-in-law, a senior court painter, and patrons of a major commission in Zaragoza, his subject matter shifted, as the very thought of Zaragoza infuriated the artist. His tone became increasingly confidential as he confessed his hopes and his tribulations in seeking patronage and making his way at the court of Madrid. Coming to claim Madrid as his home, he urged Zapater to join him there to escape the petty jealousies of Zaragoza. As both men enjoyed increasing success and suffered the stresses that accompanied it, Goya's letters became an outlet, as he reported in verse the tragic death from smallpox of a favored prince and his consort, or responded to Zapater's joke about the mourning dress at court following the death of Carlos III. The men shared blatantly ribald humor, with drawings to accompany. Of course, with only one side of the correspondence, we can only infer Zapater's words.

Following a visit to Zapater in November 1790, Goya returned to Madrid to discover that his sole surviving son had contracted smallpox; Goya, too, fell ill during his own requisite quarantine. In letters dated to that period, Goya feelings for Zapater approached obsession: one man's fevered honesty may have been the other's transgression, for Zapater apparently stopped answering. When a letter was lost in the mail, Goya realized he had gone too far, writing that he would regret it if others saw it. His tone became more measured, and the friendship endured until Zapater's death in 1803.

———

Given his unwavering confidence in his genius (*genio*) and creative intellect, or *invención*, Goya possibly considered himself entitled to such transgressions. The word *invención* enters his story shortly after his arrival in Madrid, as he worked as an unsalaried painter for the royal tapestry factory. Painters of tapestry designs, or cartoons, were paid on a scale: cartoons of the artist's

own *invención* earned more than those based on another artist's concept: when granted permission to develop his own sketches, Goya immediately identified his cartoons as "de invención mía" (of my invention). For Goya, invention was far more than a scale for payment: it was the central tenet of his art. Aware that his genius might cause trouble following his appointment as court painter in 1789, he wrote to Zapater: "There is also the circumstance of my being a man so well-known that from the king and queen down everyone knows me, and I cannot underplay my genius as others might."

Recuperating from the illness of early 1793 that left him deaf for life, Goya experimented with subject matter, drawing and painting for the first time with no commission to guide his hand: he drew vignettes inspired by contemporary life and in paintings gave free rein to what he called his "caprice and invention." From this point forward, this experimentation continued in tandem with his commissioned works: as he painted portraits of the royal family, ministers, and Madrid society, frescoed the interior of a church in Madrid, and fulfilled religious commissions from Cádiz, Madrid, Toledo, and eventually Seville, he represented in small paintings natural disasters, cannibals, madhouses, and murder. These works of fantasy, referred to in a contemporary inventory as *caprichos*, apparently found buyers, for they are recorded in inventories of private collections. The now-deaf artist began to add captions to his drawings, giving them a voice that implies that they, too, were shared.

Goya's sociability surely contributed to his success with influential individuals and even the king. People enjoyed his company. He was an avid and excellent hunter, who, when he killed eighteen pieces of small game with nineteen shots on one outing, felt it necessary to justify his one miss. As a game of golf might today foster relations with clients, Goya hunted with at least two patrons, the *infante* don Luis (brother of the king Carlos III) and the future duchess of Osuna, whose patronage of Goya over three decades was second only to that of the royal family. Years later, following his appointment as first court painter, he requested and received special permission to fish on the hunting grounds adjacent to the royal palace in Madrid. Even the king liked Goya, who reported to Zapater how Carlos IV joked with him about the Aragonese and Zaragoza and took him by the shoulders, almost embracing him; in a visit months later, the king inquired about the artist's son, recently recuperated from smallpox, and then began to play the violin. Contrary to the romantic image of Goya, deaf and isolated, he enjoyed family and friendships throughout his life.

As a courtier, Goya served kings and earned the favor of ministers and aristocrats, even when his genius tempted conflict. Within a year of be-

coming court painter, he refused to undertake a series of tapestry cartoons ordered by the king—even though he was a salaried painter whose main responsibility was to paint cartoons. A yearlong standoff ensued, but well-placed friends apparently tolerated his insubordination and, even though Goya had painted nothing to earn his salary, granted him a leave of absence to travel to Valencia. Years later, during the Napoleonic occupation of Madrid, he painted numerous portraits of the supporters of Joseph Bonaparte, and probably even painted the "intruder king" himself, but was nevertheless cleared in 1814 of any collusion with the Napoleonic court and allowed to resume his court position with full salary under the restored Fernando VII.

Prior to his deafness, Goya had a keen interest in music; sent popular songs to Zapater, to whom he also recommended a singer; and wrote of a concert in the palace with more than one hundred musicians. He also learned French, writing one letter to Zapater in the language, before he conceded the difficulty he had in writing, though he could understand it when spoken. We do not know the contents of Goya's personal library, given a lump-sum value by an unqualified appraiser in 1812, but parallels between *Los Caprichos* and the subjects of essays and satires in the daily *Diario de Madrid* attest to his knowledge of issues of the day, which a deaf man could best glean through reading. His name was included on a subscription list for the Spanish translation of Samuel Richardson's novel *Clarissa*, and a reference to the fables of the Italian author Giambattista Casti in an etching of about 1813 signals his familiarity with Casti's satire, *Gli animali parlanti* (*The Talking Animals*), translated into Spanish and advertised that summer. During the politically tumultuous summer of 1823, as royalists took revenge on liberals in Madrid, Goya received the recently published posthumous works of Nicolás Fernández de Moratín and responded with praise that delighted the writer's son (and publisher) Leandro Fernández de Moratín, who within a year welcomed Goya to Bordeaux. A lifelong learner, Goya pushed the potential of aquatint etching to its limits and, three years before his death, experimented with his new technique for painting miniatures and revolutionized lithography with the publication of the *Bulls of Bordeaux*.

Goya's illness of 1793 has long been considered a major life crisis. Granted that such turning points are inventions of hindsight by those who remember a life rather than live it, I suggest that if such a point existed, it occurred about a decade later. Zapater died in early 1803, court patronage waned, and Goya turned his attention to his family, securing the financial well-being of his son, who married in 1805; a grandson was born the following year. Numerous commissions confirm his status as the leading portraitist of Madrid society, and his sitters included his son's in-laws, who appeared in portraits

painted from about 1805 to 1810. When the invasion of Napoleonic forces brought the downfall of the royal patrons Goya had served for thirty-three years, his career as first court painter came to an apparent end, eventually recognized only as a hiatus. Beyond the commissions fulfilled for the French occupiers, his art became increasingly intimate and experimental, including still lifes for the family house, and allegories of time and youth. When he returned to etching, it was no longer to create a series intended for public edification as he had done eleven years earlier with *Los Caprichos*: in wartime Madrid he created an extended meditation on the devastation of war, imagining the atrocity of conflicts raging beyond Madrid. He etched on whatever copper he could find, and as the war brought famine to Madrid, he recorded the suffering of which he was a witness. If he undertook these etchings originally with an eye toward publishing them, his intention shifted as his subject matter became relentlessly tragic. He etched for posterity and left the plates with his son; they were published thirty-five years after Goya's death.

In portraying Goya as a liberal thinker, some writers downplay his service to Fernando VII, the conservative monarch restored to power in 1814; others overlook his service to the French court in favor of representing him as a patriot. In fact, he served both rulers. To assume that Goya considered his personal perspective more important than his public identity as a court artist is to impose values that are not of his time: these were two separate spheres. After a six-year war, Goya, like many of his countrymen, possibly welcomed the return of order, no matter the cost. Judged innocent of any wrongdoing during the Napoleonic occupation, he collected his salary but was for the most part invisible at court, since Fernando VII preferred a younger artist, Vicente López. Corporations and municipal governments commissioned the requisite royal portraits from Goya, who responded with images that today often appear half-hearted and formulaic.

Beyond commissions, he drew incessantly and also etched *disparates*—or irrationalities—that gave form to a world where ignorance and cruelty have displaced all virtue. He spent time with friends and possibly met or renewed an acquaintance with Leocadia Weiss, documented as his companion in Bordeaux in 1824. When in 1820 liberal forces triumphed, leaving Fernando VII with no option but to accept the constitution promulgated eight years earlier, Goya created drawings that perhaps celebrate the event, but few saw them. Increasingly he absented himself, making improvements to a country retreat across the Manzanares River from Madrid. On the walls he painted scenes that would become known in the twentieth century as the "black" paintings, *disparates* writ large.

With the help of an international alliance, Fernando VII was restored to power in 1823 and within eight months of the king's return, Goya requested a leave from court, ostensibly to take the waters in France for his health. He never followed that recommendation but in Paris joined the in-laws of his son before returning with them to settle in Bordeaux with Leocadia Weiss and her children. There he enjoyed a salaried leave of absence, which he conscientiously renewed several times before soliciting his retirement with his full salary, also granted to him. He returned twice to Madrid, visiting friends and a son who rarely wrote to his father, and sitting for a portrait by Vicente López to be installed in the recently founded royal museum on the Paseo del Prado. Goya chose not to remain in Spain and returned to a quiet life with Leocadia, whose daughter Rosario became his only known artistic heir.

There is, to be sure, an extensive bibliography on Goya, dating back to articles of the 1830s. The first book-length monograph, published in French by Laurent Matheron, drew on conversations with those who purportedly knew Goya in Bordeaux (or knew people who had known the artist), leaving Matheron to fill in gaps. Many books followed on Goya's life as constructed through his works, but these do not address the central challenge of biography: "Is biography essentially the chronicle of an individual's life journey (and thus a branch of history, employing similar processes of research and scholarship), or is it an art of human portraiture that must, for social and psychologically constructive reasons, capture the essence and distinctiveness of a real individual to be useful both in its time and for posterity?"[4] Having written the first draft of this book as a history, dependent solely on extensive documentation, I realized that without going further, the book did no more justice to Goya than a curriculum vitae does for any individual. In thinking about biography, I became increasingly tolerant of Matheron, whose inventions I once dismissed as romantic fabrications. He wrote at a time when a good story was valued as highly as fact, and he attempted to situate Goya within his epoch, which, for Matheron and his French audience, was defined by the French revolution. In the most recent biography, published in French in 1992 and translated into Spanish three years later, Jeannine Baticle embraced facts while telling a good story. Interpretation is intrinsic to a biography, although I hope here that I have successfully distinguished fact from inference.

The many discoveries since the publication of Baticle's biography justify a new consideration of Goya's life. The publication of a sketchbook used by the artist during his final months of an early trip to Italy and in years following his return to Spain in 1771 illuminated his artistic pursuits, his contacts in

Italy, his children, and his investments. The re-edition in 2003 of Goya's letters to Martín Zapater presented significant research published since the first edition of 1982; this was expanded with the publication of the letters today in the Museo del Prado on the *Goya en el Prado* website. Documents filed before his marriage in 1773 and a book-length study of his youth and family in Zaragoza provide new knowledge of his formative years; the chronology of his illness in 1793 has been clarified; a will, written by his wife in 1801, offers a glimpse into Goya's family life and friends; a letter reveals Goya's concern for Leocadia Weiss following his death. With Goya, there will always be more to learn. *Aun aprendo.*

Part I

An Artist from Zaragoza

Early Years

1746–1759

THE birth of Francisco Joseph Goya y Lucientes on March 30, 1746, in the hilltop village of Fuendetodos was to become the stuff of legend. Laurent Matheron recounted how one day as the fifteen-year-old Goya was carrying a sack of wheat to the nearby mill, he stopped to rest and hummed softly as he drew on a wall with charcoal the figure of a pig. Fate intervened as an aged monk was passing by; astounded by the young man's talent, he soon arranged to take Goya to the capital of the province of Aragón, Zaragoza, where he placed the youth in the studio of the town's leading painter, José Luzán Martínez.[1]

The circumstances of Goya's birth and entry into the studio of Luzán are in fact far more prosaic. By 1746 the family of Goya's father, Braulio José Benito Goya (who signed himself as Joseph Goya) had resided in Zaragoza for almost a century. Joseph was one of eight children born between 1702 and 1717 to the royal notary Pedro Goya and Gertrudis Franqué y Zúñiga, and one of three children still living when Gertrudis died in 1727. Following his father's death, Joseph, his two sisters, and his aunt Manuela inherited the family's three adjoining houses in the poor to lower working-class parish of San Gil on the Morería Cerrada (a name that reflected its Moorish heritage).[2] By 1739 two of the three houses had been sold to the convent of Santa Fe; the third, between a monastery of discalced Augustinians and the Chapter of San Lorenzo, remained for the time being in the family.[3]

The sale of the property provided welcome income for Joseph, who had married Gracia Lucientes in 1736 in the church of San Miguel de los Navarros, still standing today with a *mudéjar* tower and later baroque portal adorned by the figure of Saint Michael vanquishing the devil. The marriage certificate identified Joseph as "a young man who is a gilder by profession" (mancebo de Oficio Dorador) and the bride as a native of Fuendetodos, a village about

thirty-five kilometers southeast of Zaragoza; her parents were described as "new residents of this city and members of this Parish."[4] Although new to Zaragoza, the Lucientes family was well established in Fuendetodos, where about three hundred inhabitants earned their livelihood from the cultivation of wheat and barley and the herding of sheep; Gracia's grandfather Miguel de Lucientes y Navarro became mayor in 1747.[5] Joseph and Gracia's first child, Rita, was baptized in the parish church of San Gil on May 24, 1737, and their second, Tomás, was baptized in San Miguel de los Navarros on December 30, 1739.[6] A daughter, Jacinta, was born in 1743; three years later, Francisco Joseph was born in Fuendetodos on March 30, 1746. The birth certificate, dated the following day, describes his parents as "inhabitants of this parish and denizens of Zaragoza."[7]

The books of the San Gil parish church in Zaragoza offer a probable explanation for the family's relocation to Fuendetodos in March 1746. On March 8 and on April 12, the chapter made two loans to Joseph Goya, "to complete the renovation and construction" of Joseph's house, which served as collateral.[8] With renovation ongoing, the house may not have been an ideal setting for bringing a child into the world, even though the family returned to Zaragoza within a month of Goya's birth.[9] The spring census of 1747 records the family in the house, where they remained through the birth in 1750 of Mariano (who would die in infancy) and the death of the seven-year-old Jacinta later that same year; the following year the five-year-old Goya took communion with his twelve-year-old brother, Tomás, in the church of San Gil on July 26, 1751; the next year brought the birth of their last documented sibling, Camilo, who three decades later would owe his position in the church to his well-connected older brother.[10]

Goya's youth was spent within the society of the many artists in Zaragoza, which by the mid-eighteenth century was a medium-sized Spanish city of about thirty-five thousand inhabitants.[11] His daily life revolved around the trade of his father and older brother Tomás, both gilders, and he grew accustomed to the apprentices who came and went: Joseph Ornos (or Hornos) in 1749, Miguel San Juan in 1750, Manuel Peralta in 1751 and again in 1754, Thomas Martínez in 1751, and Vicente Onzín in 1754 (to be identified as Vicente Uncín in 1755 and as Onzí in 1756 and 1757).[12] Miguel San Juan belonged to a family of gilders first documented in Zaragoza during the late seventeenth century; in 1756 both Onzín/Uncín/Onzí and Tomás Goya were working in the village of Puebla de Albortón, a little over thirty kilometers from the city. Apprentices undoubtedly assisted Joseph in gilding the altar of Saint Michael in the Zaragoza church of Santa Engracia (destroyed during the Napoleonic invasion), as well as the organ and choir screen in the church

of San Pablo, which earned him 45 *libras* in 1754, a sum that might be measured against the 150 *libras* borrowed eight years earlier.[13]

After 1757 the family no longer lived in the house on the Morería Cerrada, and other residents are recorded there from 1758 to 1762, prior to its sale by the parish to a certain Andrés Garcés; a probable reason for the sale is that the loans made in 1746 had not been repaid. By 1759 Joseph Goya was living with Agustín Campas in the parish of San Gil; "Santa Fee"—a reference to the convent which purchased two of the three Goya family houses twenty years earlier—is penned next to Joseph's and Agustín's names. No mention is made of other family members, and the family's frequent moves in years to follow suggest their financial situation was precarious. This had a lasting effect on Goya, who as an adult took great care of his money, worried about any loans he had to take until he was able to repay them, and sought wise investments as his fortune grew.

According to Goya's son, his father was thirteen years old when he began his studies with Zaragoza's leading painter, José Luzán Martínez, where Goya himself remembered studying for four years and learning "the principles of drawing, being made to copy the best prints [Luzán] had."[14] As a youth in Zaragoza, Luzán benefited from the patronage of the noble Pignatelli family, which enabled him to travel in 1730 to Naples, where he studied with Giuseppe Mastroleo. Following his return to Zaragoza, he became an advocate for art education as well as the city's leading painter of religious imagery and Inquisitional censor. When in 1744 news arrived that in Madrid plans were under way to establish a royal academy of fine arts, Luzán was among the artists who envisioned the creation of a royal academy in Zaragoza. The petition failed, and almost five decades passed before Zaragoza won royal endorsement, with the help of Goya's friend Martín Zapater. Joseph's professional connections may have facilitated his son's admission into the studio of Luzán, whose brothers, Pedro and Juan, were both gilders: Pedro, a master gilder, had traveled with Joseph Goya in 1756 to Calahorra (La Rioja) to paint and gild the case of the organ in the cathedral; following Pedro's death in 1759, Joseph remained close to his family and was named one of the executors of José Luzán's will in 1772.[15] We might however ask whether special connections were essential to Goya's entry into Luzán's studio, known as a "school open to every young man who wanted to take advantage of his learning; [Luzán] teaching them with patience and friendship, with no other objective than their advancement."[16]

What inspired Goya to be an artist may never be known, but a project undertaken in 1753 in Zaragoza's massive basilica of El Pilar introduced him to the power of court patronage at an early age. The basilica, to play a major

role in his early career, commemorates the site of the miraculous appearance of the Virgin to the Apostle James, to whom she gave a statue of herself as well as a column (*pilar*) of jasper to serve as its pedestal, still venerated today. When the court architect Ventura Rodríguez arrived in 1753, he envisioned the Santa Capilla (Holy Chapel), oval in plan and surmounted by a balda-chin, to house the sacred column. What took form over the next twelve years is one of the greatest late baroque ensembles in Spain, its main sculptural groups illustrating the appearance of the Virgin to Saint James and his seven disciples, a theme carried into reliefs and medallions in marble, stucco, and bronze adorning the chapel.

The project brought new life to art in Zaragoza, as well as opportunities for her native sons. Zaragoza's leading sculptor, José Ramírez, created the central groups of the apparition of the Virgin on a cloud surrounded by an-gels above the main altar, and Saint James with seven converts who witness the miracle from the altar to the left. Arriving from Barcelona in 1760, Car-los Salas contributed marble reliefs depicting the life of the Virgin and, on the chapel's exterior wall, a relief of the Ascension of the Virgin; Goya's rela-tionship with Salas dates to this time.[17] A student of the Italian painter Cor-rado Giaquinto, who had recently arrived in Madrid to serve as first court painter to Fernando VI, Antonio González Velázquez painted the chapel's dome, assisted by Francisco Bayeu, a student of Luzán, and Goya's future brother-in-law.

Bayeu was the Zaragoza painter who most benefited from the Santa Ca-pilla project. In 1757 he entered a competition at the Royal Academy and won a two-year daily stipend of 4½ *reales* to study in Madrid and to work again as assistant to González Velázquez, now a court painter. He arrived in the capital in April 1758, accompanied by the four siblings in his charge follow-ing the deaths of their parents: two sisters, María Josefa (Goya's future wife) and María Josefa Matea, and two brothers, Manuel and Ramón, who enrolled in the Royal Academy in October. Their academic careers would be short-lived. To González Velázquez's great displeasure, Bayeu continued work on paintings commissioned by institutions in Zaragoza and, when confronted by González, responded with "improprieties...and other bold and indeco-rous expressions," leading to the immediate termination of his pension. Per-haps following the advice of artists in the academy (who were not involved in the aristocratic councillors' decision to deny his support), Bayeu appealed, ex-plaining that his stipend was insufficient to support his family. In response, the councillors granted a more face-saving strategy by accepting his resignation.[18]

By early 1759 Bayeu found himself again in Zaragoza and later that year married Sebastiana, the daughter of the painter Juan Andrés Merklein. He

returned to Madrid four years later, but in the interim probably met Goya, who in 1783 testified that "it has been twenty years more or less that I have known and have been friendly with Doña María Bayeu...having studied in the house of her brother Don Francisco."[19] Goya's relationship with Bayeu, eventually solidified by his marriage to Bayeu's sister, played a significant role in his early career.

Both Goya and Bayeu were thus in Zaragoza in October 1759 to witness a rare and splendid occasion: the arrival of Spain's new royal family. Upon the death of Fernando VI in August 1759 his half brother, Carlos VII of Naples, was proclaimed Carlos III of Spain. The royal family sailed from Naples to Barcelona and made their way to Madrid, stopping in Zaragoza for a brief stay. On October 28, 1759, the royal guard led the procession into the town, followed by Carlos III and Maria Amalia of Saxony in one carriage and the royal children, or *infantes*, in three others: the first with Carlos, the crown prince (titled in Spain the Príncipe de Asturias; hereafter, the Prince of Asturias), and his brother Gabriel Antonio; the second with Antonio Pascual and Francisco Xavier; and finally the carriage with the *infantas*, María Josepha and María Luisa.[20] Many of their faces are familiar thanks to Goya's brush, for beyond his portraits of Carlos III and his son Carlos IV, he immortalized the aged María Josepha (1744–1801) and her younger brother Antonio Pascual (1755–1817) forty-one years later in portrait sketches and in the background of *The Family of Carlos IV* (pl. 19). With their progeny on display, Carlos III and Maria Amalia guaranteed the vigor of the Spanish monarchy, in sharp contrast to the late Fernando VI, who had died widowed, insane, and without heir.

Writing to Bernardo Tanucci, her trusted minister in Naples, the queen described the Aragonese countryside as an improvement over that of Catalunya, but sparsely populated and uncultivated. "In a few words, it looks like a desert. The people are miserable, but their misery does not make them more industrious. Thank God, up to now, we have had a good trip. Carlos's measles obliges us to remain here a few days. He came down with a mild case and no longer has a fever, so I hope that within a few days we can continue our journey."[21] On November 8 the queen wrote again: "Here, it is a veritable hospital";[22] contrary to her wishes, the royal visit to Zaragoza lasted another three weeks. Carlos III took the delay as an opportunity to hunt in the afternoons, an exercise that may have saved him from the illnesses that struck every other member of his family who, once recuperated, visited the town's shrines and sites, many of which were destroyed by Napoleon's forces five decades later. On November 30 the royal departure was announced, and alms were given to churches, convents, monasteries, and the poor. On the first of

December, the royal procession left Zaragoza in the same order in which it had arrived. A chronicler reported that the emotions of the day were most evident among the lower classes, who, unable to hide their feelings, sobbed as their new king departed.[23]

The monthlong presence of the royal family offered the thirteen-year-old Goya a glimpse of a new world. As a student and son of a gilder, he may even have contributed to the celebration by painting decorations or assisting his father in gilding frames for the new royal portraits that adorned public spaces and building façades. Perhaps, too, he began to dream of a future at the court of Carlos III. But could he even imagine that within twenty years he would personally present his work to the king, and to the particular acclaim of the prince of Asturias and of his young and vibrant wife, María Luisa of Parma?

2

First Trials

1760–1769

THE royal family entered Madrid on December 11, 1759, ending their jour-
ney at the seventeenth-century palace of the Buen Retiro, their tem-
porary home until the royal palace under construction across town was
habitable.[1] One of the many challenges for the new king was to find artists to
extol the virtues of his reign in allegorical ceiling frescoes in the new palace,
immortalize the royal family in portraiture, decorate the many royal resi-
dences beyond Madrid, and inspire faith by giving visual form to the myster-
ies and miracles of the Catholic faith. To lead the effort, Carlos III summoned
Anthony Raphael Mengs from Italy, who arrived in Madrid in September
1761 and soon replaced Corrado Giaquinto as first court painter. The pre-
ferred artist of Carlos III, Mengs fulfilled commissions for portraits and reli-
gious subjects, including a magnificent series of the Passion of Christ for the
royal bedroom,[2] oversaw and contributed to the ongoing creation of ceil-
ing frescoes in the palace, and supervised the painters at court. The king
also brought to Madrid the Venetian master of illusionistic ceiling frescoes,
Giovanni Battista (or Giambattista) Tiepolo, who arrived with his two sons
in April 1762. That same month, the sixty-year-old Giaquinto took a tempo-
rary leave from the court to recuperate his health; after suffering a stroke the
following year, he never returned.

Given the breadth of their assignments, both Mengs and Tiepolo needed
capable assistants. Tiepolo could rely on his sons Giandomenico and Lo-
renzo, but Mengs sought permission to bring a painter to assist him; in a let-
ter to the minister of finance, the marquis of Esquilache, dated January 17,
1763, he named his choice: "Don Fran.co Bayeu."[3] Bayeu soon arrived at court
to prove his knowledge of fresco technique and settled there after a brief re-
turn to Zaragoza, where his family remained that spring, absent the head of
the household.[4] So quickly did Bayeu compensate for his earlier missteps that

the biographer Ceán Bermúdez (hereafter, Ceán) considered it "incredible how Bayeu progressed under the wise direction of Mengs."[5] He was granted an annual salary of 12,000 *reales de vellón* (hereafter, *reales*) at the end of his first year; two years later he was elected to the Royal Academy and his salary was doubled to match that earned by the senior court painter Andrés de la Calleja. Following his appointment as court painter in 1767, his salary was increased to 30,000 *reales* in 1769.[6] A decade after his transgressions at court, Bayeu had triumphed: the young Goya, twelve years his junior, could not find a better role model.

Following the mention of Joseph Goya at "Santa fee" in 1759, we lose track of the family in Zaragoza from 1757 to 1761, when the fifteen-year-old Goya, now of age to be named in the parish census, reappears in the household of his sister Rita and her husband, Francisco Frayle, in the small, central parish of San Juan el Viejo. There is no mention of Goya's parents or brothers. Although the parish census was taken during Lent, it was customary for housing rentals to begin around the feast of Saint John (June 24), so residents listed in 1761 may have lived at the given address for almost a year.[7] Thus, Goya possibly lived in the central parish in October 1760, when he witnessed the auto-da-fé of the heretic Orosia Morena, a thirty-three-year-old woman, who had spent three years in the Inquisitional cells of Zaragoza before being brought to trial, charged with practicing Molinism, and boasting about her sorcery in pact with the devil.[8]

Public autos-da-fé were infrequent by the eighteenth century, replaced by private trials of individuals in the local Inquisition chambers. The rarity of this event might explain why the image remained with Goya, whose memories inspired him to draw Orosia decades later, with the inscription: "They put a gag on her because she spoke / and they hit her in the face / I saw her in Zaragoza Orosia Morena because she knew how to make mice" (pl. 1).[9] His memory of this spectacle, which he witnessed as a fourteen-year-old, was neither photographic nor documentary: according to the Inquisitional order, Orosia was to be dressed in a tunic, or *sanbenito*, decorated with an "X" shaped cross, a detail omitted in the drawing.[10] As a prisoner, she was beaten for her vocal and violent resistance, and very possibly she was again beaten and gagged during her public appearance; her ability to make mice is not documented.

The Goya family was reunited by spring 1762, and shared a house with the family of Domingo Saras, a member of the guild of carpenters, joiners, carvers, and sculptors. Joseph was not eager to see any of his sons leave, and when in March all guild members were requested to respond to a royal order to identify men in their households between eighteen and forty years

of age (a preliminary to conscription made necessary by hostilities with England and Portugal), he answered that his oldest son Tomás was seventeen years of age; Francisco, twelve; and his youngest, Camilo, eight. In fact, their ages were twenty-two, sixteen, and ten.[11] The "twelve-year-old," Goya, was judged to be "healthy with no indisposition" and able to serve.[12] In 1763, the family no longer shared a household, and would remain in "the house of Joseph Goya" in the parish of San Miguel de los Navarros for three years. The documented presence of *criados* (servants or apprentices) and one "student" who became a *maestro* (master) the following year suggests that Joseph had work; it is also possible that Goya brought in some income from commissions no longer known to us. His brother Tomás married in 1763, and the following year he and his wife were counted among the family; by 1766 Rita reappeared without Francisco Frayle, of whom no further mention has come to light.[13] But of most interest is the absence of Francisco Goya from the parish record in spring 1764: in all probability he was in Madrid.

The previous November, the Royal Academy had announced to the "poor young men of these kingdoms" a competition for five stipends: one to study painting and two each for sculpture and architecture (the competition is not to be confused with the 1763 triennial competition that had been judged the previous summer).[14] The maximum age for entrants was twenty-one, to be proven by the presentation of a certificate of baptism: Goya obtained a copy of his on November 20, 1763.[15] The entrants were announced in Madrid on December 4, among them "Francisco Joseph Goya, a native of Fuendetodos, seventeen years of age";[16] another undated manuscript identified him as "from Zaragoza, his father a gilder, and he is without support in this Court."[17] The assignment was to draw the statue of Silenus in the academy, and rules were strict. Competitors began on Monday, December 5, and worked on their drawings at the academy from nine in the morning until noon and again for two and a half hours in the afternoon. They could not bring anything into the room, nor could they remove their drawings, created on sheets of paper signed and distributed by the secretary and stored under lock every night. The results were announced on January 15: the prize had gone to Gregorio Ferro, who had participated previously in the 1760 and 1763 competitions.[18] Goya's drawing does not survive.

The absence of Goya's name from the census of parish households in spring 1764 suggests that he remained in Madrid following the competition and possibly worked in Bayeu's studio. As Goya was preoccupied with his competition drawing in December, the senior painter had fallen from the scaffolding and broken his left arm, so probably welcomed assistance on his current project, a ceiling fresco in the royal palace representing the

Surrender of Granada.[19] Such an apprenticeship would explain how Goya became sufficiently familiar with the fresco technique to win a commission for El Pilar in Zaragoza in October 1771. It would also have introduced him to the wider world of artistic activity within the royal palace, where by September 1764 Mengs was painting frescoes for the king's dining room, a conversation room, and the bedroom of the queen mother, as Tiepolo focused on the room adjoining the throne room. Junior artists were assigned less public spaces: González Velázquez worked on the reception room of the queen mother and was about to begin an antechamber for the king's brother, the *infante* don Luis; Bayeu's next assignment was the Fall of the Giants for the antechamber of the prince and princess of Asturias, the future Carlos IV and María Luisa.

Goya returned to Zaragoza in time to attend the baptism in San Miguel de los Navarros of his nephew, Manuel, born to Tomás and his wife on December 23, 1764, and is documented in the family household in 1765 and 1766. If Goya's son is correct in saying the artist began studies with Luzán at the age of thirteen, Goya's own statement that he studied with Luzán for four years suggests that he did not continue in the master's studio following his first disappointment at the Royal Academy.[20] He was in Zaragoza to witness another rare celebration in October 1765, when the annual festival of the Virgin of El Pilar coincided with the consecration of the recently completed Santa Capilla, "a sumptuous tabernacle, constructed in the same place in which it was built by the Apostle Saint James Major."[21] Its celebration was to be equally splendid, leading the author Antonio Ponz to rue its cost even twenty-three years later, opining that funds would have been better spent on the decoration of the basilica, which remained unfinished.[22]

A contemporary description of the celebration offers a rare glimpse of Goya's hometown, to become a source of memories and inspiration for his works in years to come. A bullfight on Wednesday, October 9, was held in the town's new bullring, completed the previous year and funded by Ramón Pignatelli to support the royal hospital and "so perfect, and beautiful, that it leaves nothing to envy in those [i.e., the rings] of Madrid and Aranjuez." Although the *torero* José Candido proved a disappointment, Goya would long remember the ring of Zaragoza, the site of three feats recorded in etchings of the *Tauromaquia*, published over fifty years later.[23] On Friday city bells tolled at noon to announce the eve of the festival. That afternoon, statues of saints from churches throughout the city were carried in procession to El Pilar, followed by four *gigantones* (big giants) representing two women dressed in the latest fashion, a Spanish gentleman, and a Moor; they were followed in turn by *gigantillas* (smaller giants), accompanied by boys riding cardboard

horses. As night fell, torches and chandeliers illuminated the city, and crowds pressed into the square adjacent to the basilica of El Pilar to enjoy the fireworks. Decades later, after a monarchy ever more wary of overly exuberant commoners regulated such popular celebrations, Goya remembered in paintings, drawings, and prints boisterous processions with statues of saints and masqueraders, as well as confrontations with benign giants. The coincidence of sacred and profane, reality and fantasy, seen in the Zaragoza celebration also came naturally to the artist.

Giants, little giants, and cardboard horses dancing to the accompaniment of pipers returned on Saturday to open the parade, followed by participants unique to Zaragoza, "dressed in green, and brown, those who many call lunatics, in this city Brothers of the Hospital, and in all places madmen: they carried their small pennants with the arms of their Saintly House, and making noise with some flutes, and drum. . . . They made it clear that to be a little crazy today was sane insanity."[24] These were the patients of the Hospital of Our Lady of Grace, built in the fifteenth century under the patronage of Alfonso V of Aragon. Beyond a hospital, it was renowned as a home for the impoverished insane from throughout Spain: a notice of the charitable acts of the Royal Fraternity of Refuge in Madrid regularly reported the money spent to accompany *pobres dementes* (the impoverished demented) from the court to Zaragoza.[25] In 1765 admissions included seventeen men and sixteen women from Aragón and thirty-seven men and seventeen women from other parts of Spain.[26] Regulations for admission were published two years later: a medical reference and certification of the patient's poverty, property, and family were required; for patients from outside Aragón, the documentation had to be notarized.[27] The wards for the insane had undergone a complete renovation and by 1765 had capacity for 100 to 127 men and for 120 to 140 women in well-ventilated dormitories; the renovated facility also featured open-air yards (*corrales*), a warming room, latrines, and rooms for solitary confinement for the raging mad (*furiosos*). Other rooms were reserved for clerics or more well-to-do patients. By 1766 the hospital was unique within Spain for having a doctor dedicated to the treatment of the insane.[28]

Goya's early familiarity with these patients, who aroused both compassion and mirth, might explain his deeply sympathetic representations of the insane in drawings executed many years later; the "madhouse of Zaragoza" would also be invoked in a painting of 1794. Anyone living in Zaragoza recognized its inmates, uniformed in green and brown; those who were deemed safe solicited alms as they accompanied the dead in funeral processions and were also accompanied to Mass on feast days.[29] For the celebration in October 1765, the hospital decorated its façade and placed on an exterior balcony

mannequins of a man and woman in patchwork uniforms who danced to the music of flutes played within to create "a spectacle of great artifice, that fooled and entertained many of the unsophisticated and less aware."[30]

In describing the decoration of the houses and streets, the chronicler praised an image of the Virgin of the Pilar created by the Aragonese sculptor Gregorio de Messa Martínez (1651–1710); to illustrate the continued excellence of Aragonese art, he cited the works of the sculptor José Ramírez (artist of the main figural groups in the Santa Capilla) and Francisco Bayeu, "court painter of his Majesty, and Lieutenant Director of the Royal Academy of San Fernando, born in this city, who is currently painting in the new Royal Palace."[31] Bayeu presumably could not attend the celebrations in Zaragoza, given his responsibilities as both court painter and academician, but was among the members of the Royal Academy who met the following January to select subjects for the first-, second-, and third-class competitions in 1766. Announced by royal edict on January 6, details of the competition were posted publicly in Madrid, in the royal residences, and in "the capitals and major villages of this realm." Goya did not miss the opportunity. In his undated application for the contest, he introduced himself as a native and resident of Zaragoza, who "having seen the posters displayed in public about prizes for paintings, and being a student, and stating said posters that those who live outside of the court can apply in writing, I am writing to ask your honors for admission to the contest of the first category of painting." His statement that admission to the competition would add to the list of favors he received "during the time that I was at court, for which I confess I am in your debt" suggests that he was treated well during his stay three years earlier.[32]

Goya was one of eight competitors for the highest (first-class) prize; among them was Francisco Bayeu's younger brother Ramón. The subject assigned, from the history of Spain by Padre Mariana, was "Martha, Empress of Constantinople, presents herself in Burgos to the King Alfonso the Wise to ask for one-third of the ransom requested by the Sultan of Egypt for the return of the Emperor."[33] The spring parish census shows Goya in Zaragoza, for there was no need to travel to Madrid until he delivered his work (of which no trace survives) in time for the July 15 deadline. Although Francisco Bayeu recused himself, Ramón Bayeu triumphed with five votes;[34] Goya received none. Study of prints in Luzán's studio had not prepared Goya for the tests posed by the academy: drawing after classical casts or painting secular, historical subjects. A single painting is attributed to these early years, and perhaps that attribution has not been questioned because the work, destroyed in the Spanish Civil War, is known only through black-and-white photographs. It is a painted reliquary cabinet with doors which, when closed, showed the apparition of the

Virgin to Saint James and, when opened, revealed the figures of the Virgin del Carmen and Saint Francis of Paula. The Virgin upon clouds, surrounded by cherubs delivering the column to the astounded saint, illustrates a late baroque vision not easily adapted to the subjects of kings and captains preferred by the academy.[35]

Goya remained with his family during the next three years, living the first two with his parents, younger brother Camilo, and sister Rita, in a house shared with Ramón Gabarra and his wife, before the family again relocated prior to the 1769 census. He possibly spent time in Madrid with Bayeu, for following the completion of the Santa Capilla, work was increasingly scarce in Zaragoza and competition undoubtedly intense: in 1767 municipal records of professions within Zaragoza documented seventeen painters in the city, the highest figure for the entire century; three years later, the number had decreased to seven.[36] Having twice failed in academic competitions, Goya considered alternative paths for his artistic education: when the Royal Academy announced the 1769 competition, he paid no heed, and by the June deadline was preparing for his journey, or perhaps was already en route, to Italy.[37]

3

Italy

1769–1771

D ISCOVERY in the 1980s of a sketchbook measuring a little under seven and one-half by five and one-quarter inches, with parchment covers and pages of paper made in Fabriano, marked a turning point in our knowledge of Goya's trip to Italy. Its varied subjects include pencil studies of draped figures and classical sculptures, red chalk drawings of Old Testament subjects, and sketches after works of art seen in Rome. More freely drawn figures, including naked men, a mother and child, and a monster's head, interspersed among its pages reveal the artist "doodling" at leisure. Sketches related to his 1771 entry in the competition at the academy of Parma, notes related to his return trip, and many blank pages confirm that Goya used this book during his final months in Italy and returned to Spain with it, making it in all probability the last of many sketchbooks used during his two-year sojourn. Christened the *Cuaderno italiano* (Italian sketchbook), its title is misleading, for Goya continued to use it following his return to Spain in 1771, drawing small devotional images and subjects related to a 1773 commission for a Carthusian monastery outside Zaragoza. He took advantage of its blank pages to keep notes of payments and of investments (one dated 1785) and to record the birth dates of six children. The first child listed is known only through this sketchbook, bringing the number of Goya's children to seven: only one of them— born in 1784 and not included on the list—survived.[1] Endearingly, he also allowed one or more of his children to draw in the book.

On a single page Goya composed three lists, divided into two columns (fig. 1). The uniform script in pen and ink shows that he wrote the list from memory at a single sitting, although he subsequently added the names of five towns—Recanati, Milan, Tolon (Toulon), Abila (yet to be identified), and Marsea (Marseilles)—in red chalk. The list on the left side of the page includes Italian cities and towns presumably visited; on the right, he opened a

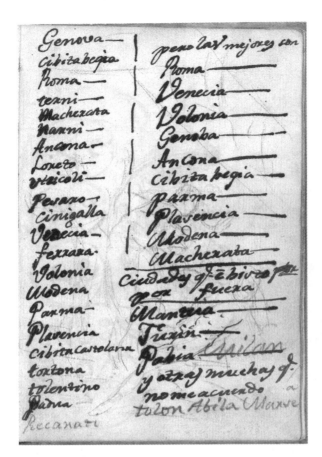

1. Lists of cities visited or seen, *Italian Sketchbook*, p. 39, ca. 1770–1771. Ink over red chalk drawing of the miracle of Saint Anthony of Padua, 7 ⅜ × 5 ⅛ in. (18.7 × 13 cm). Museo del Prado, Madrid.

more selective list with the words "but the best are …," and about two-thirds down the column offered another subtitle: "Cities that I have only seen from the outside." Plotting the Italian cities on a map reveals possible itineraries but does not help us trace the dates or direction of Goya's travel. One hypothesis would have him arriving by boat (possibly from Genoa) to the port of Civitavecchia near Rome. The order of towns on his first list follows a route from Rome to Bologna described in a contemporary guidebook, traveling northeast to cross the peninsula, passing through Città Castellana, Otricoli, Narni, Terni, Tolentino, Macerata, and Recanati before reaching Loreto. Continuing northward along the Adriatic coast, he could reach Ancona, Senigallia, and Pesaro.[2] The list of cities visited or seen from a distance through the window of a coach suggests that he followed other recommended routes from Venice to Bologna (through Padua and Ferrara, with a possible detour to Mantua and Modena). From Modena he might have taken a route northwest toward Genoa through Parma and Piacenza; other towns in northern

Italy seen only from afar are more difficult to plot: Mantua, Pavia, Turin. Although a definitive reconstruction of Goya's travels in Italy is elusive and the possible combinations are many, there is no doubt that he covered significant territory in two years, in addition to his studies in Rome.

Goya's list of ten "best" places in Italy betrays his enthusiasm for new sights. It opens with Rome and Venice, although he also admired the cities of Bologna, Modena, and Parma, set in the rich and fertile landscape of Emilia-Romagna, so different from his native Aragón. He took note of the historic, fortified ports of Civitavecchia and Ancona, as well as the squares and fountains of Piacenza and Macerata, then the "most beautiful, and most populous city of Marca d'Ancona," situated on a hillside overlooking the Chiento River and offering a "bellissima" view.[3] The itinerary of a young artist hungry to see all that he could, it reflects a certain improvisation, perhaps dictated by funds or available coaches, since Florence—essential to the grand tour—is absent from the list. Some scholars have suggested that Goya traveled in the company of Anthony Raphael Mengs, who took a leave of absence from Madrid from 1769 to 1774.[4] But no documentation suggests that Mengs knew Goya at this time, nor would Mengs have needed Goya's services, since he had been granted royal permission and a per diem of 10 *reales* to hire his assistant from the royal palace, Alejandro Cittadini, to "prepare canvases, paints, and brushes, and other things necessitated by his profession" during his trip.[5] The itineraries of Mengs and Goya also diverged, since the senior painter arrived in Genoa in spring 1770 and traveled to Florence, where he painted the magnificent portrait of the ambassador's wife, the marquise of Llano,[6] and arrived in Rome only in February 1771, a few months prior to Goya's departure. In his lists of cities, Goya made no mention of Florence.

In Rome, Goya encountered two young artists from Zaragoza: Manuel Eraso, a student of Francisco Bayeu two years older than Goya; and Juan Adán, a student of José Ramírez and Goya's senior by five years, both of whom had found new opportunities in Rome. Eraso arrived in 1762 and the following year won first prize in the first-class drawing competition at the Roman academy of fine arts, the Accademia di San Luca (Academy of Saint Luke); a stipend from the Royal Academy in Madrid followed in 1766. Juan Adán arrived in 1765 and soon triumphed in drawing competitions in the Accademia del Nudo (Academy of the Nude) in 1766, 1767, and 1769. He also won second prize in the first-class sculpture competition of the Academy of Saint Luke in 1768.[7] Shortly before Goya's return to Spain in late spring 1771, both Eraso and Adán testified to his unmarried status: "In all the time that said Don Francisco has remained in this City of Rome where he has studied

the Art of Painting until the present day he has not contracted any Marriage nor has he obligated himself to any contract."[8]

Goya made his way to the church of San Nicola dei Lorenesi near the Piazza Navona, where he drew sketches of the allegorical figures of Prudence and Fortitude by Corrado Giaquinto, the former first court painter to the Spanish court; coincidentally, this French church was obliged to house all French-speaking visitors, with French artists possibly among them.[9] At Saint John Lateran he made a pencil drawing, reinforced with bistre ink, of the sculpture of Saint Bartholomew, one of a series of colossal apostle figures decorating the church's nave, executed between 1705 and 1712 by Pierre Le Gros II. Only one name recorded in the sketchbook can be firmly associated with Rome: "Timoteo Martínez," an "official of the post of his Catholic Majesty in Rome," who lived with his uncle, the postmaster, above the post office located near the Piazza di Spagna, where Goya could mail letters and receive correspondence that arrived every Tuesday from Spain.[10]

Beyond these sparse traces, we know little of Goya's stay in Rome. He possibly found lodging at the Aragonese church of Santa María di Montserrato or at other Spanish churches in the city,[11] and also might have joined other Spanish artists who met at the house of Francisco Preciado de la Vega on the fourth floor of the Casa di Pellegrini on the Piazza Barberini and the corner of the Strada Salaria. Born in Seville, Preciado had lived in Rome since 1732 and hosted a private academy in his house, where Juan Adán rented rooms from 1768 to 1773. Although in 1758 the Royal Academy in Madrid appointed Preciado to oversee students in Rome and acquaint them with masterworks in the city and with workshops where they might study, five years later he was reprimanded by the academicians, who reminded him that his duties were to support the academy's curriculum, not offer his own. He nevertheless continued to teach students in his home.[12] In 1769 the Academy of Saint Luke appointed Preciado, with Carlo Marchioni, to oversee foreign students,[13] so he may have been predisposed to meet a young artist recently arrived from Zaragoza, a friend of his lodger.

Shortly before Goya's marriage in 1773, the sculptor Carlos Salas was among those who testified on his behalf, stating that Goya went to Rome in 1769 with the intent of studying in the "Academy of Drawing."[14] Did he accomplish his goal? The Italian sketchbook suggests that he found opportunities to draw after models and sculptures, or more probably the casts preferred by Preciado, who thought it "easier to study ancient works by their plaster casts, which are always available and can be rotated at any time to see them in the best light."[15] Although the French Academy on the Via del Corso

offered artists of all nationalities the opportunity to draw from casts of ancient sculptures, as well as from male models, the Royal Academy in Madrid directed its students to draw at the Academy of the Nude, founded in 1754 by Pope Benedict XIV. This academy occupied an oval space beneath the picture galleries of the Capitoline Museum, designed by the painter Giovanni Paolo Panini (today, the library of the Avvocatura del Commune), and was connected by a staircase to the picture gallery above, where students could study paintings by Titian, Tintoretto, Veronese, Annibale Carracci, Guido Reni, and Carlo Maratta.

The Academy of the Nude was open ten months per year; in winter students drew the nude model in the early afternoon; to avoid the midday heat, summer hours were in early morning, and the model was draped against the morning chill. A new pose was set on a weekly basis, and ten members of the Academy of Saint Luke oversaw the students, each taking a monthlong turn. The English artist Matthew William Peters drew at the Academy of the Nude during his stay in 1762 and recorded the schedule: "The human figure is every day in the week, holidays excepted, free for any person to draw after without any expenses—in the summer at half an hour after five in the morning and in winter after nightfall, two hours each time."[16] Students from all nations attended: between 1755 and 1800, records include 24 French, 2 Corsicans, 20 Germans, 20 Spaniards, 16 Flemish, 8 Swiss, 8 Portuguese, 5 English, 4 Polish, and 2 Russian students. Goya's name does not appear, but these figures—totaling only 109 students over a period of forty-five years—surely do not account for all who attended.[17]

It was probably in Rome that Goya was sufficiently settled to record in pencil an artist's studio (presumably, his own) on the final page of his sketchbook, facing the inside back cover (fig. 2). It is a working space, with easel, stretched canvases leaning against the wall, containers and paint stick on a table, a palette, and under the table a face suggesting a sculpted bust; over the palette, he wrote in script his initial "G," playing off the palette's curve, and repeated in ink to the right. He apparently did not think the sketch worth saving, for over it he wrote in ink the names of artists whose works he had seen in Genoa, Venice, and Parma; the uniformity of the script again suggests a list written from memory in one sitting. No subjects are mentioned, but the names and places indicate that in Genoa he saw the *Assumption of the Virgin* by Guido Reni, as well as the *Circumcision* and the *Sermon of Saint Ignatius* by Rubens in the church of Santi Ambrogio e Andrea, and admired the *Stigmatization of Saint Francis* by Guercino and *Martyrdom of Saint Blas and Saint Sebastian* by Carlos Maratta in Santa Maria de Carignagno. In Venice, he saw a large painting by Veronese, possibly *The Wedding at Cana* then in San

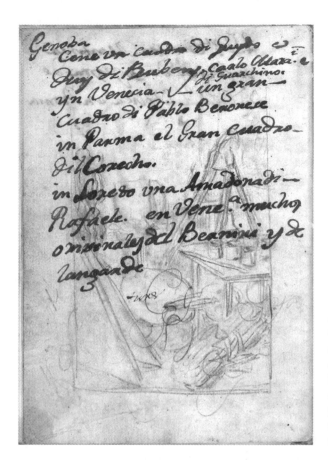

2. List of artists and works of art seen, *Italian Sketchbook*, p. 172, ca. 1770–1771. Ink over black pencil drawing of an artist's studio, 7 ⅜ × 5 ⅛ in. (18.6 × 13 cm). Museo del Prado, Madrid.

Giorgio Maggiore; in Parma, "the large painting by Correggio" was possibly the *Virgin with Child and Saint Jerome*; and the *Madonna of Loreto* in that town was in fact a copy after Raphael.[18] A separate mention is made of "originals" by Bernini and Langarde (Algardi) in Venice, suggesting that he gained entrance to the sculpture collection of Filippo Vincenzo Farsetti (1703–1774), which included several models by both masters.[19]

On May 26, 1770, the *Diario Ordinario* of Rome carried news of the coming year's competition at the Royal Academy of Fine Arts in Parma. The subject assigned to painters was "Hannibal victorious, seeing from the Italian Alps the landscape of Italy before him" and, more specifically: "Hannibal, lifting the visor of his helmet, turning toward a figure of Genius who takes his hand and shows him the distant beautiful countryside of subjugated Italy. Hannibal's eyes and face are to convey the joy he felt as well as his confidence in the imminent victory."[20] The unusually generous prize was a five-ounce medal of gold. Applicants to the competition were to write to the secretary

of the academy, Count Rezzonico, and deliver finished works to him by April 1771, to be judged in May. To maintain anonymity, each entrant was to identify his work with a "brief sentence to serve as a device" that would be included in a signed letter to the count.

Goya's letter to Rezzonico, dated April 20, 1771, and written by another hand in fluent Italian, is the first document of his entry in the competition. In it he reported that he had sent his painting, adding, "I hope it arrives in time for the competition." He also supplied the verse required to identify his work, excerpted from Virgil's *Aeneid*: "Jam tandem Italia fugientis predimus oras" (Now at last we take the shores of fleeing Italy).[21] He was apparently planning to return to Spain by the time he posted his letter, for a week later Juan Adán and Manuel Eraso signed the testimony mentioned above of his bachelorhood: "We know this by having had continued company and friendship with the above-mentioned D. Francisco Goya and for it also being well-known to many dedicated to study."[22]

On June 27, Paolo Borroni, a student of Benigno Bossi, professor at the Parma Academy, was awarded the gold medal. The jurors praised his work for its "ingenious composition that responded fully to the project, and a delicate harmony in its colors"; nudes, soldiers, and mountains were "expressed with an easy and frank touch." But their praise seems lukewarm in comparison to their reaction to Goya's entry, which came in second with six votes, as the jurors praised "the easy handling of the brush, the warm expression in the face and attitude of Hannibal, a grand character," and noted that, had the artist's "colors been closer to the truth and the composition to the subject, it would have put in doubt the first place award. Its author is Sig. Francesco Goja [sic], Roman, student of Sig. Francesco Vajeu [sic], Court painter of His Catholic Majesty."[23] There was no official second prize, but the extended mention of Goya's work attests to strong support, in spite of the fact that, even at this early point in his career, he did not necessarily follow the academic script. The *Diario Ordinario* published the record of the competition on August 3, 1771, by which time Mengs was in Rome. He may have taken notice, for even if the name of Goya was unfamiliar to him, he recognized that of Bayeu, whom he had called to Madrid eight years earlier. The identification of Goya as a student of Bayeu also supports conjecture that Goya worked in his Madrid studio during the previous decade; it might also suggest that the testimony of Goya's unmarried status given by Adán and Eraso was taken with a specific goal in mind: marriage to Bayeu's sister, María Josefa.

Entrants to the Parma competition submitted their works at their own expense, but the academy covered the cost of their return. Goya's painting was addressed to Valencia, presumably at the artist's request; mail sent to

the port of Valencia was forwarded to Madrid. But orders changed before the painting left Genoa, and it was sent instead to Barcelona, the relay point for mail to be forwarded to Zaragoza. Apparently, Goya had a change of heart and rather than go to Madrid, returned to his native town.[24] On the inside back cover of the Italian sketchbook, penciled in a large, irregular script that might reflect the bumpy road his coach was traveling, Goya recorded a sequence of towns—Broni, Casteggio, Voghera, Tortona—tracing a route from Piacenza to Genoa, his point of embarkation. Nine pages from the end of the book, he noted in pencil: "Genoa, patrón Bartolomeo Puigvert at the fish store of the black eagle. Don Luis Beltrán, treasurer of Spain." Don Luis Martínez Beltrán oversaw the Giro Real in Genoa, a banking office established in 1745 to facilitate financial transactions with the royal household in Spain; its services were also available to individuals.[25] Beltrán was also responsible for payment to Puigvert, who in 1771 was under contract from the Spanish minister to the duchy of Parma to transport Spanish soldiers from Genoa to Barcelona.[26] The Parma connection suggests that Goya's participation in the academy competition may have provided contacts in Genoa who helped him arrange his own return trip to Zaragoza, where a new opportunity awaited.

Triumphs of a Native Son

1771–1774

A ccording to Goya's son, it was a "blind love" that the artist "always had for his parents that made him return to Spain."[1] But in fact Goya had little to show for his two years in Italy, with the exception of his unofficial success in the Parma competition: he had no regular sponsor, no stipend from the Royal Academy in Madrid, and no known commissions. An upcoming opportunity at El Pilar put the lessons learned during two years in Italy to the test. Documented in Rome in late April 1771, Goya had probably not yet returned to Zaragoza by June 9, when Juan Andrés Merklein submitted to the archiepiscopal council (*cabildo metropolitano*) his petition to be considered for a commission to paint a vault over the *coreto*, or small choir, in El Pilar.[2] His request was premature given that funding for the project had not yet been made available in Madrid, and he waited for three months only to meet with disappointment.[3] On October 21 the building committee convened and invited Goya to demonstrate his ability to paint in fresco. If Goya's experience was limited, his confidence was not.

The minutes of a committee meeting on November 11 detail the young artist's coup. Experts had approved his trial piece demonstrating his command of fresco technique, and the next step toward a contract was taken. Merklein was not mentioned, but Goya's advantage over another contender was clear:

> Asked about terms for painting the vault of the small choir, he [Goya] responded that he would do it for 15,000 reales vellón with the assistant and equipment at his expense. Having heard this proposal, and seeing its advantage in light of that of Don Antonio [González] Velázquez (whose letter was also read) who requests for said work…25,000 reales vellón, they decided upon Goya's proposal; but, to proceed with pru-

dence and assurance, he must create sketches that will represent the Glory and send them to the court for the approval of the Academy; and, having it, the agreement will be firm and the contract signed.[4]

The committee had nothing to lose: Goya's low bid was far more attractive than that of González Velázquez, who had painted the dome of the Santa Capilla almost two decades earlier, and members of the Royal Academy in Madrid would vet his sketch. By the time of the next meeting on January 27, 1772, some committee members had already seen the sketch and deemed it a demonstration of the artist's "ability and particular taste"; so enthusiastic was their response that further review by the academicians in Madrid was deemed unnecessary. Three days later Goya was paid 5,000 *reales*, one-third of his first documented professional fee.

Goya's fresco on the vault, spanning approximately fifteen meters over the small choir, depicts the Adoration of the Holy Name: supported upon banks of very solid clouds, angels, cherubs, and other figures praise the Holy Name, emblazoned on a golden triangle at center that illuminates the heavenly celebration, a corollary to the praises sung in the choir beneath.[5] X-rays of Goya's sketch show that he deleted figures in the foreground to open up the view into the heavens, applying lessons learned from frescoes in Italy, such as Correggio's dome in the Parma Cathedral.[6] Unseen today by viewers looking up at the vault are the subtleties of two preparatory drawings for the idealized heads of two angels standing on the left of the composition: informed by Goya's study of antique sculptures, they are enlivened by the slight turn of a head, wisps of windblown hair, and volumes shaded by the red chalk (fig. 3).

The *Adoration of the Holy Name* provided income for the artist through the first half of 1772, with payments made in late January, late April, and late July. That same year, Zaragoza initiated a tax on professional work, valued by an assessor: Goya's worth was listed at 300 silver *reales* (600 *reales vellón*) and taxed at 7 percent; the 21 silver *reales* could be paid over three installments.[7] Sums aside, the assessment recognized Goya for the first time as a professional painter; that same year the parish census listed him with the honorific "Don" preceding his name. His two years in Italy and success at El Pilar had served him well.

During Goya's years in Italy, his parents, sister Rita, and brother Camilo relocated annually. Manuela Frayle, identified as Rita's daughter, appears for the first time in the census of 1769 and again in 1770, but then disappears until 1777 (when she is identified as Manuela "Frayre"); Mariano Frayle is listed annually from 1771 to 1773.[8] By spring 1772 the household also included a "student," Lucas Puycontor (possibly Goya's assistant in painting the small

3. *Head of an Angel*, 1772. Red
chalk with highlighting,
17 ¾ × 13 ¾ in. (45 × 35 cm).
Museo de Zaragoza.

choir vault), Benita Uriola (perhaps a maid), and Goya's nephew Manuel; the
following year Lucas and Benita were no longer present.[9] Joseph Goya re-
appeared at El Pilar on May 28, 1773, when he reported with Miguel de San
Juan (who in 1750 had lived in the family household and was now a master
gilder) on Bernardo Zidraque's preparation of a dome; he returned on June 4
with another master gilder, Francisco Ponzano, to approve Zidraque's prog-
ress with its gilding.[10]

 Not all welcomed Goya's emergence on the competitive Zaragoza art
scene. As he was finishing his fresco for the small choir, the committee's cost-
saving decision to leave the scaffolding in place signaled that more work was
to come. Braulio González, godfather to Francisco Bayeu's younger brother
Manuel and a longtime acquaintance of the Bayeu family, penned two pro-
posals, one dated only to the month, the other more specifically to the
twenty-third of October.[11] The more generally dated of the two suggests an
artist desperate for the commission, overly anxious in detailing his process
and guaranteeing against any risk of hiring him: if the work be found lack-
ing and cannot be corrected to the council's satisfaction, he wrote, "it will
be Braulio's obligation to demolish everything he painted, and to leave the
space as it was given to him, ready for another brush, with no payment due
to him: for in this way Your Illustrious Honor can never be fooled, which is
very just."[12] His second, more concise and tempered, proposal of October 23

included the participation of his son Blas, a student in the Royal Academy in Madrid and possibly also of Francisco Bayeu.[13] To illustrate his talent, Braulio included his son's copy of an unnamed sketch by Bayeu, adding that the court painter had seen and approved it. When Goya delivered his proposal on November 22, he promised to finish the work in four months, with drawings reviewed by "Don Francisco Bayeu," and invited experts of the committee's choosing to judge the completed work. Having invoked the name of Zaragoza's famous native son, both González and Goya were soon disappointed.

In Madrid, Francisco Bayeu was granted two months' leave on August 5, 1772, to return to Zaragoza for reasons of health,[14] providing him the opportunity to inspect Goya's choir fresco and to discuss his marriage to Bayeu's sister María Josefa (hereafter, Josefa): testimony taken prior to their marriage the following July confirms that both Josefa and Goya promised themselves to one another "a year ago,"[15] suggesting that Josefa accompanied her older brother to Zaragoza in late summer 1772. Bayeu also took advantage of his stay to renew acquaintances in Zaragoza and more specifically at El Pilar. Writing the following December to Mathías Allué, the chair of the building committee, Bayeu set his own price for painting not one, but two vaults in El Pilar, the first between Goya's small choir and the Santa Capilla, and the second on the far side of the Santa Capilla. By late December 1772, Allué and Bayeu had compromised to agree on a price of 4,000 *escudos* or 40,000 *reales*, with El Pilar providing scaffolding, plaster, and sand for the two frescoes.[16]

Although Allué was eager for work to begin, Bayeu was hesitant to request leave from the court after his recent visit, and explained that "one license is easy to get, but two wouldn't be; even if it were, I wouldn't do it, because I don't want to bother His Majesty and it doesn't work to my benefit to be away from his service."[17] Bayeu enlisted the sculptor Carlos Salas to represent him, reminding him of the need for a "Professor," or practicing artist, "who presents the obstacles and difficulties of the profession, because sometimes he who is full of erudition is not worth much when it comes to painting it."[18] Together, they agreed that narrative subjects were inappropriate for domes seen from below (a convention that Goya would overturn in the Madrid church of San Antonio de la Florida in 1798, three years after Bayeu's death) and by March 1773 decided on the Virgin as Queen of Saints and the Virgin as Queen of Angels. This was the easy part: the council would have to wait for more than two years for Bayeu to return to Zaragoza and begin work.

In response to Bayeu's request for a dowry for his sister Josefa, Carlos III granted him 50 *doblones sencillos* (or 3,750 *reales*) for the marriage of a sister that "has already been agreed upon," in recognition of "how well he [Bayeu] carries out works in the royal service."[19] Although the document of Goya's

unmarried status signed in Rome by Manuel Eraso and Juan Adán is among those collected in preparation for the marriage,[20] more recent testimony was required as the wedding approached. The architect Agustín Sanz, a native of Zaragoza and student of Ventura Rodríguez, and Carlos Salas served as Goya's personal witnesses: the forty-four-year-old Sanz declared he had known Goya since he was a child; Salas, of the same age as Sanz, but who arrived in Zaragoza in 1760, gave the length of their acquaintance as eleven years; only during the two years that Goya resided in Rome were these artists out of contact with the groom-to-be.[21] Upon arriving in Madrid on July 14 Goya stayed at the Bayeu home,[22] and on July 25 married Josefa in the parish church of San Martín (destroyed some thirty years later by urban renovation under Joseph Bonaparte).

By the following spring, "Doña Josepha Bayeu" and Goya, as well as a maid "Lucía N," were living in the Goya household in Zaragoza. The new family address was in the house of a government official, José Asensio, on Zaragoza's main street, El Coso, described in 1788 as "the best street that there is in Zaragoza, because of its length, width and the buildings found there."[23] Even though they shared the house with a widower, his son, and other occupants, the Goya clan may have enjoyed a street-level apartment (given six years later to the owner's son) for themselves, with rooms for studios for both Goya and his father,[24] a step-up presumably made possible by Goya's income. The maid Lucía was perhaps enlisted for Josefa, accustomed to a comfortable life in Madrid and soon pregnant: on August 29 she gave birth to the couple's first child, Antonio Juan Ramón y Carlos, baptized in San Miguel de los Navarros under the watchful eye of his godfather, Carlos Salas.

———

A commission for a series of mural paintings to decorate the church of the Charterhouse (*cartuja*) of Aula Dei, about twenty kilometers northeast of Zaragoza, explains the return to the city of Goya and his new bride.[25] By 1773 the beautification of its church had been under way for almost two decades, initiated by the sculptor Manuel Ramírez, probably assisted by the shop of his brother José in creating the portal sculpture commemorating the death of the Virgin. Within the church he executed an exuberant rococo altarpiece dedicated to the Assumption, with a total of twenty-six sculpted figures, in addition to twenty-one cherubic heads, six saints in attendance, and narrative reliefs.[26] Before Mengs summoned him to Madrid in 1763, Francisco Bayeu also contributed two lunettes to the altarpiece with attendant angels. Following his profession as an oblate in the order, Manuel Ramírez oversaw the ongoing project and, by the early 1770s, sought an artist to paint a series of

murals high on the nave and presbytery walls illustrating the life of the Virgin. Who better than Goya, who had not only painted the choir at El Pilar, but whose promise was confirmed by his marriage into the Bayeu clan?

For almost two centuries, the sole confirmation of Goya's authorship of these murals was a note by the naval officer, historian, and eventual director of the Royal Academy of History, José Vargas Ponce, who visited the charterhouse in June 1800 and recorded "eleven horizontal paintings that represent the mysteries of Our Lady, painted by Don Francisco Goya," as well as sketches for them in the chapter room (today lost).[27] The institutional records from Goya's day are few: an account book of communal expenses from 1739 to 1777 records the expenses in 1774 of "Brother Ramírez," including payments for finishing and gilding the main altarpiece and for equipment for scaffolding, and in December 1774 payments were made for the gilding of brackets (presumably for the statues of saints that decorate the nave) and for eleven frames—the number of scenes painted by Goya. The tumultuous history of the monastery explains the paucity of documents: used as barracks by Napolcon's troops from 1809 to 1813, it was returned to the order after the war, only to be privatized by the secularization of church property two decades later. The Carthusians returned and in 1901 commissioned the French artists Paul and Amadée Buffet to repaint four of Goya's deteriorating paintings on the north wall, the exterior of which was exposed to Zaragoza's harsh summer heat and winter winds. The Buffet brothers also restored the remaining seven murals by Goya. A century later, the monks of Aula Dei left the monastery, subsequently transferred to the Order of the Chemin Neuf in 2011. For the first time, women could see Goya's paintings.

Evidence brought to light by the Italian sketchbook confirmed the attribution of these frescoes to Goya. On a blank page preceding the drawing made in Rome of Saint Bartholomew by Pierre Le Gros II, Goya listed in pencil four subjects from the life of the Virgin: the Circumcision, the Adoration of the Kings, the Purification of Christ (or the Presentation of Jesus in the Temple), and the Flight into Egypt.[28] These are the subjects of the murals in the presbytery at Aula Dei, considered by some to be the first paintings completed. Two rapidly executed drawings, each spanning two pages, record early ideas for the nave: one of the sketches relates either to the Circumcision or to the Presentation in the Temple, and the second shows an early conception of the Adoration of the Kings.[29] The following page has notes for materials and a payment to "Tomás"; five pages later we find a payment to "Tomás" for "the frames" and payments to a certain Mateo Alemán for "gilding the pedestals," as well as the date August 16, 1774, repeated on the following page, where Goya noted that he had taken 200 *escudos* thus far.[30] Goya's use of a

Christian name, "Tomás," supports identification of the man working on the frames as his older brother, hired to gild them.[31]

The larger-than-life scenes required at Aula Dei forced Goya to create historical narratives on a grand scale. The seven surviving scenes by Goya depict the Annunciation to Saint Joachim, the Birth of the Virgin, the Marriage of the Virgin, the Visitation, the Circumcision, the Adoration of the Kings, and the Presentation of Jesus in the Temple. Color calls out the main protagonists, in distinction from secondary groupings of figures defined by posture and gesture. Together the figures command pictorial fields measuring ten feet high and from seventeen to thirty-three feet long, staged before invented structures ranging from lowly wooden houses to monumental buildings of stone, which in *The Visitation* (pl. 2) measure the distance back to open skies. Possible sources for Goya's paintings range from prints after the French classical baroque painter Nicolas Poussin, to the fresco known as the Aldobrandini Wedding, the works of Francisco Bayeu, and a sculpture of the Marriage of the Virgin by José Ramírez in the church of Saint Charles Borromeo in Zaragoza.[32] No matter what his sources, Goya's monumental figures and architectural settings firmly rejected the late baroque exuberance of the main altarpiece sculpted about fifteen years earlier, and mark a clear departure from the heavenly angels he had painted only two years earlier in El Pilar, offering a bridge to the worldly interactions he would soon portray in his tapestry cartoons.

While Goya worked at the Aula Dei, Francisco Bayeu remained at court, painting an allegorical ceiling fresco of the Arts Paying Homage of the Spanish Monarchy at the royal residence of El Pardo, about fifteen kilometers from Madrid. He corresponded with Allué, who repeatedly encouraged him to request leave. In October 1774 Bayeu reported that leave had been granted, and in December, having finished work at El Pardo, he wrote that he was beginning the sketches. Soon after, Goya recorded in his Italian sketchbook: "The third of January 1775, we leave Zaragoza for Madrid." On the page facing, with the journey complete, Goya wrote in ink: "We left Zaragoza for Madrid on 3 January 1775. And we arrived the 10."[33] Upon arrival, Goya, Josefa, and their infant son joined the Bayeu household near the royal palace behind the Convent of Doña María de Aragón, at 7, Calle del Reloj (Street of the Clock).

———

Goya's formative years in Zaragoza, often overlooked or dismissed as prologue to his career in Madrid, introduced him to an active circle of painters, sculptors, gilders, and architects, including those who testified on his behalf

in advance of his wedding. Many of these relationships endured long into his years at the court of Madrid, a city where immigrants from throughout Spain, who shared a common background and *patria*, remained close.[34] The network among artists in Zaragoza was self-perpetuating, as illustrated by Mariano Ponzano y Segura—the son of the gilder Juan Ponzano—who in 1777 went to study painting at the Royal Academy under Goya's eye and returned to Zaragoza with Goya to again paint at El Pilar in 1780.[35]

We do not know how or when Goya came to know Martín Zapater y Clavería prior to his departure for Madrid in 1775. The hypothesis that they met as students in the school of the Escolapian fathers, based on a passing remark in a 1787 letter from Goya to Zapater, has been justifiably called into question; living around the corner from each other in Zaragoza as early as 1761 to 1762, they may also have met.[36] But only after Goya's arrival in Madrid is their friendship documented by correspondence that opens with a letter, often quoted but today lost, dated to September 1775.

Zapater's origins, like Goya's, were humble. Baptized in the Zaragoza parish of La Magdalena in 1747, he lived with his parents and siblings in shared housing in working-class neighborhoods of the town. His sister, María Manuela, died in 1781; his brother Luis died unexpectedly in 1799, leaving his two sons in Martín's care.[37] The ten-year-old Zapater joined the household of his great-aunt Juana Faguas, widowed three years earlier, whose daughter Joaquina Alduy was at this point absent; he was very possibly brought in as a page, only to become indispensable. As Goya began his career in Madrid, Zapater grew his business, first renting properties and then investing his income in rural properties—including those that become available in 1798 after the government appropriations of properties owned by monastic institutions; he also traded in grains and fabric in Catalunya, Valencia, and in France. A dedicated public servant, Zapater was among the founders of the Royal Economic Society of Aragón of Friends of the Country in 1776, its first treasurer, and supporter of the society's patronage of a drawing academy.[38] In 1788 he was appointed deputy in charge of wells, municipal provisions, and granaries, and the following year he resolved a critical shortage with a loan to the city, for which he was awarded the title of Noble of Aragón in 1789, months after Goya became court painter. Both men owed their recognition to the new king, Carlos IV, who came to the throne following his father's death on December 14, 1788. But in January 1775, as Goya arrived in Madrid with his wife and first child, these rewards were only castles in the air, fourteen years in the future.

Settings for the Court
of Carlos III

U PON his arrival in December 1759, Carlos III faced challenges far greater
than finding artists to decorate the royal palace. Madrid was a capi-
tal distinguished in travelers' accounts for its filth and cries of "¡Agua va!"
(Water's coming!) as inhabitants threw wastewater and worse from their
balconies. Arriving in early October 1760, the critic and writer Joseph Ba-
retti described the result. His approach to the city left little to be desired,
as he crossed the Manzanares River on a "magnificent stone bridge built by
Philip II," made necessary by the river's width when the snows of neighbor-
ing hills melted. He continued along a "wide avenue of fine trees, which ren-
ders the entrances on that side [of the city] very noble" and arrived at the city
gate. But then:

> It is impossible to tell how I was shock'd at the horrible stink that
> seized me the instant I trusted myself within that gate! So offensive
> a sensation is not to be described. I felt a heat all about me which
> was caused by the fetid vapours exhaling from heaps of filth lying all
> about. My head was presently disordered by it, and the head-ake con-
> tinued very painful from that moment.[1]

Upon entering the capital ten months earlier, the royal family could not
have been spared a similar welcome, and Baretti reported that Carlos III had
vowed to "cleanse" the city, "which will prove a truly Herculean labour."
But when he published his letter a decade later, he noted: "The King has car-
ried his scheme into execution four or five years after the date of this letter,
and Madrid is now one of the cleanest towns in Europe."[2] The man respon-
sible for this transformation was the Italian architect Francesco (in Spanish,
Francisco) Sabatini, who arrived in July 1762 to become lead architect of royal

projects. During the next three decades, as court painters departed or died, Sabatini remained a central figure in the art of the court; following Mengs's second and final departure from Madrid in early 1777, he oversaw the Real Fábrica de Tapices de Santa Bárbara (Royal Tapestry Factory of Santa Bárbara), where Goya found his first employment at court.[3] But Sabatini's main priority was that of his king: the modernization of Madrid. His first architectural project was a new customs house on the Calle de Alcalá, the classical simplicity of which augured the architecture of Carlos's reign. He then turned to the city's infrastructure, paving central Madrid's sidewalks and streets, installing glass lanterns to illuminate the streets at night for six winter months beginning in October (except on nights when there was a full moon), requiring the owners of all buildings to modernize plumbing, and numbering Madrid's city blocks and buildings with porcelain tiles.[4]

Not everyone embraced these improvements. On Palm Sunday, March 23, 1766, inhabitants rebelled in the *motín de Esquilache* (Esquilache uprising), shattered the street lanterns (a symbol of foreign intervention that was also perceived as a frivolous expense in difficult times), and attacked Sabatini's house as, inside, the architect and his pregnant wife, the daughter of the architect Luigi Vanvitelli, awaited the outcome. The uprising was christened for an Italian minister who had accompanied Carlos III from Italy, the marquis of Esquilache (a Spanish adaptation of his Italian Squillace), and is popularly credited to his prohibition of men's broad-brimmed hats and all-concealing capes; however, edicts outlawing such garments, which offered a ready disguise for unsavory characters, had been promulgated seven times previously without serious repercussions (and, clearly, without lasting effect).[5] In fact, the rising price of bread, resulting from bad harvests throughout Spain, coupled with a distrust of the king's Italian ministers were the probable inspiration for public outrage.

Having witnessed the Palm Sunday uprising from his palace, Carlos III met with the people's representative the following day and acquiesced to the demand to dismiss Squillace. That same night, the king and the royal family left the palace through subterranean passages to the Saint Vincent gate, where waiting coaches transported them to the palace at Aranjuez; they did not return to Madrid until the following December.[6] Carlos III wisely appointed Spaniards to his ministry: Miguel de Múzquiz y Goyaneche, the count of Gausa, to oversee finances (*hacienda*), and Pedro Pablo Abarca de Bolea y Jiménez de Urrea, the count of Aranda, to preside over the Council of Castile. Aranda pardoned the participants in the riots but also took precautions to eliminate future risks, transforming a site originally developed as a royal factory of fine cloth in the village of San Fernando into a correctional

institution.[7] Previously abandoned because of frequent epidemics, San Fernando would confine vagrants, beggars, and others who could not prove a source of regular income.[8] According to the account of Giovanni Battista Malaspina, the mission was accomplished: visiting Madrid two decades later in the company of the minister plenipotentiary of the Portuguese court, he noted the absence of beggars, a result of the government policy to put all able-bodied people to work or to send them out of the city.[9]

Nine years after the Esquilache riots, Goya arrived to find urban projects under way that today remain central to Madrid's identity. Across town from the new royal palace, running water and fountains as well as the royal botanical garden designed by Sabatini soon enhanced the popular promenade, the Paseo del Prado.[10] Five years later, marble from Toledo and stone from Redueña arrived, and work began on the monumental sculpture of Cibeles (Ceres) at the Paseo's northern end, designed by Ventura Rodríguez and still an iconic landmark. The 1787 census gave the population of the city at just under 157,000 inhabitants—over 5,000 of them on royal salary.

The king, however, spent barely two months of the year in his refurbished capital. His royal passion for the hunt contributed to his preference for country palaces, as did the memory of the Esquilache riot, according to the English traveler Henry Swinburne: "The king still retains so much spleen against Madrid, as to dislike to sojourn in it; and indeed, he escapes from it as often as decency will allow him.... Every blackguard now loiters about with this hat pinned up triangularly; but the moment he gets out of town and beyond the bounds of the proclamation, he indulges himself in flapping it down on all sides."[11]

The court's annual itinerary remained unchanged throughout the reign of Carlos III, with exceptions permitted on occasions such as the imminent birth of a royal child. Arriving in Madrid in early December, the court remained through the Epiphany (January 6), traveling the following day fifteen kilometers north to El Pardo, with its extensive hunting grounds rich in boar, deer, and rabbits. (Four series of tapestries woven after Goya's designs would decorate rooms in this palace, expanded by Sabatini in the early 1770s.) Returning to Madrid on the Saturday before Palm Sunday, the royal family remained for ten days before traveling fifty kilometers south to Aranjuez, where they stayed until June. Travelers' accounts are unanimous in their praise of this elysian retreat, among them, Swinburne's of May 3, 1776:

> The situation of this place renders it one of the most agreeable residences I know belonging to a sovereign.... The walks and rides along the banks, through the venerable groves, and under the majestic elms

that overhang the roads, are luxuries unknown to the rest of Spain. The beauties of the scenery are enhanced by the flocks of many-coloured birds that flutter and sing on the boughs, by the herds of deer, which amount to no less than seven thousand head, and by the droves of buffaloes, sheep, cows, and brood mares, that wander un-controlled through all these woods. The wild boars are frequently seen in the evenings in the streets of the town.

The gardens, fountains, sculptures, and a small island garden on the Tagus River offered respite as summer approached and made Aranjuez a "heavenly place," even though the palace, built two centuries earlier, and its recent expansion elicited a less enthusiastic response. Turning to the town, built at the order of Carlos III to accommodate the hundreds of officials and servants of the household who accompanied the court, Swinburne continued:

> Half a million sterling has been laid out since the year 1763; and it must be acknowledged, that wonders have been performed; several fine streets drawn in straight lines with broad pavements, a double row of trees before the houses, and a very noble road in the middle; commodious hotels for ministers and ambassadors; great squares, markets, churches, a theater and an amphitheatre for bull feasts, have been raised from the ground. Neatness and convenience have been more studied and sought for than shew in architecture, but altogether the place has something truly magnificent in the coup d'oeil.[12]

Leaving Aranjuez before the heat of summer, the royal family returned to Madrid in late June, staying a few weeks before traveling northwest to La Granja de San Ildefonso (hereafter, La Granja), where they enjoyed the air of the Guadarrama mountains, as well as the magnificent formal gardens designed by the French architect René Carlier for the father of Carlos III, Philip V. An Englishman little impressed by French design, Swinburne nevertheless admired the fountains, which he considered far superior to those of Versailles, which spurted out Seine water of a "muddy-colour" in contrast to the "*jet-d'eaus* of Saint Ildephonso [that] send forth a stream as clear as crystal, whereon the sun-beams play in the most beautiful prismatic tints."[13] Departing from La Granja in early October, the court returned to the palace of San Lorenzo at El Escorial, a massive monastery complex built two centuries earlier by Juan de Herrera as a dynastic mausoleum and retreat for Philip II. Nothing could be further from the springtime delights of Aranjuez. Visiting dignitaries marveled at the building, its library, its paintings, and its

sculptures; given the royal passion for the sport, it goes without saying that the hunting was excellent. But in Swinburne's opinion, "the Escurial [*sic*] will always remain a most uncomfortable habitation for winter residence."[14] Returning to Madrid in early December, the royal family recommenced the cycle one month later.

Like all other courtiers, Goya came to know the royal itinerary well, as over his career he traveled to residences on official business, including documented trips to El Escorial, La Granja, and Aranjuez to present sketches to his patrons, and to Aranjuez, where he was appointed court painter in 1789 and eleven years later painted ten portrait sketches as preliminaries for *The Family of Carlos IV*. Even before he visited these royal residences, they were central to his career, for were it not for the ambitious campaign to expand, renovate, and decorate these palaces, he may never have found work at the court of Madrid, painting cartoons, or designs, for tapestries to be woven for private rooms in the fall and winter palaces of El Pardo and El Escorial. Granted, painting tapestry cartoons was not prestigious: writing over a decade after Goya's arrival in Madrid, Francisco Bayeu admitted that the best painters could earn more with private commissions, and little was to be gained from painting cartoons, which, once delivered to the tapestry factory and translated into tapestry, were rolled, stored, and never seen by the public.[15] Treated as ephemera, Goya's cartoons disappeared in the early nineteenth century until 1868, when they were discovered, rolled up with cartoons by other artists, in the basement of the royal palace in Madrid; with the exception of seven cartoons, they were transferred to the Museo del Prado, where they can be seen today. For the twenty-nine-year-old Goya, however, painting cartoons provided a crucial entry into the court, of which he would take full advantage.

6

"Of my invention"

1775–1777

Of Goya's wife, Josefa Bayeu, or "Pepa," we know little. In letters to Zapater, Goya made only passing mentions of her: when she gave birth or suffered a miscarriage; recuperated from one or the other; or worked as a seamstress for Zapater's aunt, Joaquina Alduy. The only surviving image of her, a small profile drawing by her husband, shows her at about fifty-eight years of age (fig. 23). One of ten children born to Raimundo Bayeu Fanlo, a master *lancetero* (maker of small knives and surgical equipment), and María Subías Domínguez, Josefa was lucky: five children who preceded her apparently died in infancy, a misfortune that she was to experience as a mother. When the deaths of her parents left Josefa and her siblings under the care of their oldest brother Francisco, the clan became close-knit as they traveled to Madrid for Bayeu's first unsuccessful stay at court in 1758, returned to Zaragoza, and in 1763 returned to Madrid. Following a year spent in Zaragoza with her new in-laws as Goya worked at Aula Dei, Josefa probably rejoiced to return to her family in Madrid, where she lived until her death in 1812.

The Bayeu household was a lively one as Goya, Josefa, and their firstborn arrived to join Bayeu, his siblings Ramón and María, his wife Sebastiana, and their infant daughter, Feliciana, born the previous May; servants would have also lived in the residence on the Calle del Reloj. Near the palace, the street was prime real estate in an area transformed from the 1770s onward with the construction and expansion of a palatial residence for the secretary of state (today, the Centro de Estudios Constitucionales).[1] Only the middle Bayeu brother, Manuel, was absent: having briefly studied painting at the Royal Academy seventeen years earlier, he returned to Zaragoza, entered the Carthusian monastery of Las Fuentes in Huesca in 1760, and in 1772 made his solemn profession.[2] He remained a painter throughout his life, and his letters to Martín Zapater reveal a sociable individual, sincerely concerned for his

family and his brother-in-law and interested in news of the country, of artists, and of mutual acquaintances.[3] A month after Goya's arrival in Madrid, Manuel sent Zapater his own sketches of the cardinal virtues, intended for frescoes in the monastery church at Las Fuentes, envisioning them in Zapater's home between the "large paintings by my Goya," today unidentified.[4] Zapater is thus the first documented collector of Goya's works.

In addition to living quarters, the house on the Calle del Reloj probably provided studio space, as Goya arrived to find Ramón painting a series of hunting scenes for tapestries to decorate the dining room of the prince and princess of Asturias at El Escorial. Having already completed a cartoon of a hunters' luncheon (seventeen feet in length), as well as two smaller still lifes for overdoors (*sobrepuertas*), Ramón now worked on a second narrow corner piece (*rinconera)* and another large scene of the end of the hunt, fourteen and one-half feet in length, to be delivered in March, before Goya completed the series.[5] Goya's response to a query from Matías Allué in Zaragoza confirmed that Francisco Bayeu was working on his sketches for the vaults at El Pilar: since Bayeu's return from El Pardo, Goya wrote, he had done nothing "but work to such an extent that even on holidays and nights until ten; you can believe that he wants more than anyone, but he cannot work more. He told me that he will go after Lent at the latest."[6] Bayeu requested assistance in finding housing in Zaragoza, as well as an advance to purchase paints in Madrid equal in quality to those used in projects for the king. The building committee undoubtedly breathed a communal sigh of relief when he finally arrived in Zaragoza on May 10.

The subject of the hunt ordered for the series of cartoons first assigned to Ramón could not have been better suited to Goya's taste, given his own enthusiasm for the sport. He delivered five paintings to the royal tapestry factory in late May, with the required invoice providing measurements and descriptions of each of the subjects, including "a wild boar attacked by four dogs, three biting it, and another defeated on the ground, and four hunters who with bayonets are going to finish it, with the appropriate landscape."[7] The king and prince of Asturias, who hunted daily, surely appreciated his attention to details, including ammunition pouches, game bags, decoys, and nets. Beyond hunters, dogs play a central role, enlivening the scenes as they attack their prey, track a scent, follow their master on leash, or rest after their exertions; Goya owned hunting dogs, and his knack for capturing canine postures and expressions becomes evident in comparing these details with those painted by Ramón. The total value of Goya's five tapestry cartoons delivered in May was 10,500 *reales*, from which he paid for his materials.[8] The work had taken him four months, and another four would pass before he received payment.

This transaction introduced Goya to the ways of the court, where patience was a necessary virtue. Cornelius Vandergoten, director of the tapestry factory, responded the day of the delivery that he had received from "Francisco Bayeu painter of the court of His Majesty five works painted under his direction by Don Francisco Goya." (Although Bayeu was not in Madrid at this time and surely did not deliver the paintings, Vandergoten called attention to a detail that Goya omitted: that the cartoons were, ostensibly, painted under Bayeu's supervision.) The approval process ultimately worked to Goya's benefit, for within two months both Mengs and Sabatini had seen his work and given final approval to his invoice, paid in mid-August.[9] In August, approval was also given to pay 4,000 *reales* for a cartoon (today unidentified) for the bedroom of the prince of Asturias at El Escorial, part of a series of hunting scenes otherwise executed by José del Castillo.[10] In October he delivered the final four hunting scenes for the prince's dining room, for which payment was approved in December.[11] Not until the following October did Goya deliver another tapestry cartoon, but it is unlikely that he sat idle. Zapater collected Goya's work and, if the proposed attributions of many early works are correct, was not Goya's only patron.[12] At some point he also tried his hand at etching, as did other painters at court, including his brothers-in-law; among Goya's early undated etchings are the *Flight into Egypt* and *Saint Isidore*, the patron saint of Madrid, which survive in rare impressions.[13] As Goya's first year in Madrid drew to a close, Josefa gave birth to a second son, Eusebio Ramón, on December 15, 1775; the child's name suggests a warm relationship between Goya and the child's godfather, Ramón Bayeu.

The senior Bayeu remained in Zaragoza until March 1776, and before returning to Madrid proposed that both Ramón and Goya participate in the work at El Pilar as it progressed under his direction; four years passed before their return together to El Pilar.[14] His absence had provided his family a respite from his irascible nature, which soon became apparent. Prior to Bayeu's departure from Madrid, the archbishop of Toledo, Francisco Antonio Lorenzana, commissioned Bayeu and the younger Mariano Maella to paint scenes from the life of Saint Leocadia in the lower cloister of the city's cathedral. Upon returning to Madrid to find that Maella had begun the project without him, Bayeu was furious. When the archbishop, aware of Bayeu's return, questioned why he had not resumed work in Toledo, the architect in charge of the project, Ventura Rodríguez, explained the delay by writing that Bayeu "thought that Your Excellency considers his ability on the same level as that of Don Mariano Maella."[15] Whether Lorenzana deigned to respond to Bayeu's petulance is not known, but by July the senior painter was in Toledo at work on the cloister.

After a year and a half at court, Goya thought it was time to improve his position and requested a promotion. That document, today lost, was circulated among court officials and in June was forwarded for an opinion from Mengs, who responded promptly, deeming Goya "a man of talent, and spirit, who could make significant progress in the Art, with the support of Royal munificence, being already useful to the Royal Service."[16] Goya was not the only contender, and Mengs also assessed Ramón Bayeu and José del Castillo, writing of Ramón Bayeu that he has painted "with my guidance, and completed several commissions in the royal service, as he also completed under the direction of his brother several cartoons for tapestries," and describing Castillo as a "good man, of ability, prompt in completing commissions in various genres, whether paintings of his invention, or copies for the Royal tapestry factory."[17] In retrospect, we are tempted to give Goya the laurel, for surely "talent and spirit" trump Castillo's ability and promptness and Ramón's completion of tasks under the guidance of senior painters?

Palace administration then asked Mengs to rank the artists. He recommended that Castillo continue with an annual salary of 9,000 *reales*, to be supplemented by one-half the assessed value of his works; that Ramón receive 8,000 *reales* and continue to paint after his brother's sketches; and that Goya earn 8,000 *reales* "for now" (with no stipulation that he paint after another's sketches).[18] To put these salaries in context, Francisco Bayeu earned 30,000 *reales* as did Andrés de la Calleja; Maella and Antonio González Velázquez earned 18,000; and Antonio González Ruíz, 12,000. Mengs admitted that the salaries of Ramón, Castillo, and Goya were not enough to live on but were intended to encourage them to complete cartoons for tapestries, for which they were paid one-third the assessed value for cartoons after another artist's sketch and one-half for cartoons of the artist's own "invention."

Mengs also responded to a petition from Joseph Napoli, a servant in the royal household since 1762, who requested a stipend for his son Manuel to travel to Rome with Mengs and continue his studies; anticipating Mengs's official request for retirement by almost a month, Napoli's request suggests that the senior painter's imminent departure from court was known. His son was granted seven *reales* per diem to study in Rome and was one of five students who accompanied Mengs upon his departure the following January.[19] Napoli's success might have inspired Goya to address a petition to Mengs, known only from a lightly penciled draft on the recto and verso of the penultimate page of the Italian sketchbook:

My Dear Sir whom I hold in the greatest esteem: I come to bother you because I have convinced my wife to go to Rome and to be able to do

so I ask You by the grace of God your favor and that you speak on my behalf to His Majesty so that he provide enough to support me there with my family so that I can study with you. When you go to ask him, I ask that you do so with complete determination, for God well knows that if you go things will go badly for me pardon me and tell me if you find any difficulty that I will try to overcome and do whatever you order your humble admirer Franco Goya.[20]

The draft identifies no recipient, but Mengs was the only person from court going to Rome and with the authority to advocate for Goya. It also offers a rare glimpse into his domestic life since he consulted with Josefa, and illustrates his concern for his position at court, leaving us to guess who will cause things to go "badly" were he left behind. Certainly, Goya was aware of the double-edged sword of having married into the family of a senior court painter: three years earlier Francisco Bayeu had eclipsed his own bid for work at El Pilar and Bayeu's response to Maella's perceived affront on the Toledo commission shows a man who insisted on recognition and guarded his own senior status closely. With such an ally, how could Goya hope to advance his own career?

Goya did not go to Rome, but continued to paint tapestry cartoons for the dining room at El Pardo of the prince and princess of Asturias, and in late October delivered *The Picnic,* accompanied by the requisite "Invoice for a painting that I, Francisco Goya, have executed of my invention" [pl. 3].[21] Following the clarification that the painting was of *his* invention, he described the composition, introducing the men, identified by their doffed capes, broad-brimmed hats, and colorful dress as the swaggering stalwarts of Madrid streets known as *majos*. Having left the city, they lounge on the banks of the Manzanares River surrounded by bottles and the remains of their meal, smoking and drinking as a cheeky orange seller, alone beyond city limits (clearly, no place for a lady), arrives to flirt and offer her fruit. A nearby dog sniffs in the grass. By rejecting the anodyne hunters and peasants that populated the cartoons of other painters, Goya brought a new immediacy and contemporaneity to his scene, a declaration of his invention, defined by the *Oxford English Dictionary* as "the devising of a subject, idea, or method of treatment, by exercise of the intellect or imagination." For Goya, without invention, there was no art. Three months later he responded to a request to provide sketches for Manuel Bayeu: "Too many obligations don't allow me to do more and it is odious to invent for another, besides, Fray Manuel doesn't need anyone to invent for him."[22]

Goya continued to paint cartoons for the prince's dining room and in early March 1777 delivered *The Dance on the Banks of the Manzanares River,* equal in size to *The Picnic.* Following standard procedure, he had presented

a small oil sketch for approval by his patrons before painting the cartoon, equal in size to the tapestry woven after it. The process had apparently not gone smoothly, for months later, when he offered Zapater the sketch for *The Dance*, he wrote, "If you want it you can put it in a little corner, given how useless it was,"[23] words that suggest he was forced to change his original design. To be sure, there is a striking difference between the inebriated *majos* of *The Picnic* and the prim dancers of its pendant; with Mengs now gone, had Francisco Bayeu or Mariano Maella, who now assessed Goya's work, censored the artist's invention?

Why did Mengs not choose Goya to go to Rome? Very possibly, Goya's success at court worked against him. In contrast to the artists who accompanied Mengs, Goya fulfilled a role that Mengs considered vital, providing paintings to keep the tapestry weavers occupied and the decoration of the royal residences moving forward.[24] Sabatini, in charge of those projects, and in charge of painters for the tapestry factory after Mengs's departure, undoubtedly agreed. Another possible obstacle was probably not apparent in summer 1776: Goya's third son, Vicente Anastasio, was born on January 21, 1777. In a postscript to his letter to Zapater the following day, Goya exclaimed, "Ya parió la Pepa un guapo muchacho adios" (Josi gave birth! A good-looking boy bye).[25] Six days later, Mengs took his final leave from Madrid. Goya remained, and contrary to his predictions, things did not go badly. Upon receiving news of the birth of Vicente Anastasio, Manuel Bayeu wrote to Zapater: "Keeping this up, Carlos III doesn't have to worry," words that suggest that all three of Goya's children were alive and well. Manuel delighted in Goya's success and mentioned his eagerness to see a painting Goya had given to Zapater, before turning to family affairs: "I didn't know that they had given Mengs's house to Francisco, although for some time I know he wanted the salary.... God be with him, and I'm more than a little happy for Francisco and for Ramón and Goya, because it will suit them better."[26]

The house to which Bayeu now moved came with a pedigree, since before Mengs it had been occupied by his predecessor as first court painter, Corrado Giaquinto; Bayeu, however, never attained the title to which he aspired. When Manuel did not hear from his "brothers" (Goya and Ramón) after three weeks, he attributed their silence to the move to new quarters, blaming Francisco's demanding personality in writing, "All are few when it comes to arranging things to please Francho."[27] Goya, Josefa, and their three young children found new lodgings in the house of a certain Joseph Bargas at 1, Calle del Espejo, given as the parents' residence in the birth certificate for Vicente Anastasio. Perhaps included in the household was the assistant who informed Zapater of Goya's recent illness and is mentioned in a letter

of April: "Mariano," identified as Mariano Ponzano y Segura, the son of the master gilder in Zaragoza, had come to Madrid with Zapater's recommendation to study at the Royal Academy.[28] Recuperated, Goya returned eagerly to the studio, where he painted "to greater approbation than when you saw,"[29] as exemplified by cartoons delivered on August 12, *The Fight at the New Inn* and *The Walk in Andalucía*.[30]

The minidramas that Goya creates in these and tapestry cartoons to follow share the spirit with, and possibly betray the influence of, the popular, comic theatrical interludes, or *sainetes* of Ramón de la Cruz, as well as the regional costumes of their characters, illustrated in *Colección de trajes de España tanto antiguos como modernos* (*Collection of the Costumes of Spain Both Olden and Modern*) by Ramón's brother, Juan.[31] Narrative drives Goya's compositions, as illustrated by the plot of *The Walk in Andalucía*, detailed in his invoice: a gypsy couple strolls beneath Andalusian pines as a wise guy (*chusco*) "seated with his cape and round hat his scarlet breeches with gold braid and buckle" pays a compliment to the gypsy girl, whose partner readies for a fight.[32] In *The Fight at the New Inn*, passions erupt as men from various regions of Spain, who have met at a country inn, brawl over a game of cards, a distraction that allows the innkeeper to pocket the money on the table. Measuring over thirteen feet in length, the tapestry after *The Fight at the New Inn* dominated the dining room in the palace at El Pardo, where the slapstick of its regional ruffians, like the passions of the Andalusian gypsies on their walk, introduced popular comedy into the controlled and courtly routine of the heirs to the Spanish throne. They were apparently a receptive audience, for within two months of the delivery of these cartoons, measurements for tapestries for their bedroom had already been taken, and by the time Goya delivered the final four smaller cartoons for the first series "of his own invention" in January 1778, he had his next assignment for these same patrons.

The significance of Goya's work as a painter of tapestry cartoons transcends even the important patronage it won for him. Each group of cartoons he invented for a single room included large scenes (*paños*), smaller counterpoint cartoons intended as overdoors (*sobrepuertas*), others for spaces above balconies (*sobrebalcones*), and narrow pieces to fit between a doorway and a corner (*rinconeras*). Their potential interplay inspired Goya to conceive each cartoon as part of a larger whole, resulting in meanings far more complex and engaging than any single work might convey. The creation of meaning through interrelated images distinguishes Goya's invention, as illustrated by series of decorative paintings and cabinet paintings, by the etchings of *Los Caprichos* and three series of etchings to follow, and ultimately by the paintings he created on the walls of his country house between 1820 and 1823.

Goya Meets Velázquez

1778–May 1780

D URING the final decades of the eighteenth century, a period often iden-
tified as the Spanish Enlightenment, or *ilustración*, intellectuals and
aesthetes voiced a growing desire to document the rich and varied culture
of their country. While the engravings of regional costumes by Juan de la
Cruz were one manifestation of this, another was the detailed exploration
of the art and architecture of Spain by Antonio Ponz, *Viaje de España* (*Trav-
els in Spain*). Following the publication of the first volume in 1772, seventeen
more followed, the last published in 1794, two years after Ponz's death; the
fifth and sixth volumes, dedicated to Madrid, were announced for sale in
May 1776. Word undoubtedly reached Goya of Ponz's commendation of him,
José del Castillo, and Ramón Bayeu, for their representations of "the diver-
sions and costumes of the present day." If Goya continued reading, he dis-
covered Ponz's lament of the general ignorance of the masterpieces in the
Spanish royal collection: "Few have any idea of what they are because they
have barely seen one miserable print of some of them." In Ponz's opinion,
there was once an excuse but no longer, since there were now many compe-
tent artists capable of this task.[1]

Goya counted himself among them. But which of the masterpieces of the
royal collection might he reproduce? The unequaled compositions of Titian,
commissioned in the sixteenth century by the Holy Roman Emperor and
Spain's first Hapsburg king, Carlos I? The unique inventions of Hieronymus
Bosch, acquired by his son, Philip II? The luxuriant compositions of Rubens,
acquired by Philip IV? Goya found his answer in a letter about the royal
collections by the revered Mengs, written at the request of Carlos III and
published in the sixth volume of *Viaje de España*. Mengs opened his discus-
sion with an overview of artistic styles, including the beautiful and the gra-
cious, best illustrated by classical sculptures, and the expressive, illustrated

by the works of Raphael. The "natural" style was seen in the paintings by seventeenth-century Dutch masters, but its ultimate manifestation was "the works of don Diego Velázquez; and if Titian was superior to him in color, Velázquez was [superior to Titian] in his knowledge of light, and of shade, and of aerial perspective, which are the most essential components of said style, because by them is given the idea of the truth."[2] With their emphasis on light and shade, what works were better suited for translation into the monochromatic medium of etching? If Goya needed any further encouragement, he had only to consider Mengs's discussion of the evolution of Velázquez's style, illustrated by four paintings in the king's dressing room: the *Waterseller of Seville*, the *Triumph of Bacchus*, the *Forge*, and the *Spinners*. "And what a study for any artist who considers in the paintings of this room (executed in three distinct periods) the manner by which they teach the path that he [Velázquez] followed to come to imitate Nature with such excellence!"[3]

On July 28, 1778, "nine prints drawn and etched by Don Francisco Goya, Painter; whose life-size originals by Don Diego Velázquez are in the collection of the Royal Palace of this court" were advertised in the *Gaceta de Madrid*. Their subjects were five equestrian portraits (each priced at 6 *reales*), the ancient philosophers Menippus and Aesop, and two seated dwarfs (each priced at three *reales*). These could be purchased in the bookshop of Antonio Sancha in the old customs house or in the bookshop of Manuel Barzo on the Calle de San Jerónimo; Barzo's bookshop would be particularly convenient given that two months later Goya asked Zapater to send his letters to his apartment on the second floor in the house of the "Marquise of Campollano" on the same street.[4] The following December two more prints were advertised: the equestrian portrait of Prince Baltasar Carlos and "a false Bacchus crowning some drunkards," after the painting known today as the *Triumph of Bacchus* (fig. 4).[5] Goya's etchings after Velázquez were probably first printed in response to demand, although by the 1790s, after the Real Calcografía acquired Goya's plates, two separate groups were identified as the "Horses of Velázquez" and a second group of smaller etchings.[6] Surviving rare impressions of etchings never advertised, among them Velázquez's portrait of the young princess surrounded by her servants known as *Las Meninas*, as well as preparatory drawings for etchings never made, including one after the *Waterseller of Seville*, suggest that more etchings were planned. He may also have continued working on the project for several years, if we are to believe the date of 1784 assigned to a rare proof of Goya's etching after *Las Meninas* by the artist's friend who owned it, the collector and art historian Ceán.[7]

In a world where high-quality digital reproductions of masterpieces are only a click away, it is hard to imagine Goya's encounter with the paintings of

4. Un Baco fingido coronando algunas borrachos (*A False Bacchus Crowning Some Drunkards;* or *The Drunkards*), 1778. Etching, 12 ½ × 16 ¹⁵⁄₁₆ in. (31.7 × 43.1 cm). The Metropolitan Museum of Art, New York, Harris Brisbane Dick Fund, Rogers Fund, 1924.

Velázquez, dispersed in the royal palace among the king's dining room, conversation room, and dressing room; the queen's salon; and the salon of the prince and princess of Asturias.[8] What did he see by available daylight, perhaps supplemented by oil lamps or candlelight, as he scrutinized the subtlety of Velázquez's naturalism of light and shadow?[9] It was here that he drew, before going to a studio with a printing press, where he dampened the preparatory drawing, placed it facedown on the etching plate, and put it through a press to transfer the design (in reverse) to a copper plate covered with an acid-resistant ground. The transferred image served as a guide for his etching needle, which scratched through the ground to expose the metal plate beneath. Acid was applied to the surface, to etch, or "bite," the exposed lines, the acid-resistant ground removed, and the plate inked, its surface wiped clean so that ink remained only in the bitten lines. After printing a preliminary impression (or working proof), Goya perhaps decided to add other touches to the plate, sometimes using drypoint to scratch directly into the surface rather than repeat the etching process. Each step offered an opportunity for variations to enter: the result, as many have noted, is that Goya's etchings after Velázquez are less copies than they are translations. Did Goya even believe it was possible to reproduce the brushwork and subtle tones of Velázquez in

the linear medium of etching? Perhaps not. What he did convey was character, gestures, expressions, the play of light and shadow, and, in the landscape backgrounds, aerial perspective: together, the essential components of Velázquez's "natural style," which from this point forward he claimed as his own.

His initiative found its rewards. In opening the eighth volume of the *Viaje*, published in 1778 and dedicated to Extremadura, Ponz provided an update on his discussion of masterpieces in the royal palace: "Another laudable enterprise that must be mentioned...is that undertaken by don Francisco Goya, professor of painting: he has proposed etching the important works of don Diego Velázquez found in the collection of the Royal Palace, and certainly has made us see his ability, intelligence, and zeal in serving the nation, for which lovers of Velázquez and of painting must be indebted."[10] Lovers of painting and of Velázquez indebted to him! The praise undoubtedly resounded in Goya's mind. How might he have reacted had he been aware of his first international mention, included in an undated memorandum sent by P. P. Giusti, the Viennese envoy to Madrid, to the Austrian grand chancellor? With it, Giusti enclosed eight of Goya's etchings after Velázquez and auspiciously noted, "If their author, who is not an engraver but a painter, and who began by attempting the manner of printing [i.e., etching] continues to improve and is inspired to continue this work, it will be a considerable achievement in the Domain of the Arts."[11]

Goya's project after Velázquez might also have introduced him to José Moñino y Redondo, who would play a significant role in his career over the next five years. Appointed to the court judiciary at the age of thirty-five, Moñino championed regalist positions, often in confrontation with the Catholic Church. In 1772 Carlos III appointed him interim plenipotentiary to the Vatican, where he negotiated with Pope Clement XIV the suppression of the Jesuit order, achieved in July 1773; this earned Moñino the title of Count of Floridablanca. In 1776 he returned from Rome to assume his role as secretary of state, and his many responsibilities encompassed the oversight of royal academies, including the Royal Academy of Fine Arts of San Fernando, where Antonio Ponz now served as secretary.[12] According to one early account, one of Floridablanca's earliest initiatives was to commission prints after the paintings in the royal collection, but the project had to be suspended for financial reasons.[13] Whether or not Goya's prints were officially commissioned, Floridablanca's benediction would justify both his undertaking and that of José del Castillo, who advertised two etchings after paintings by Luca Giordano in the king's oratory of the palace of the Buen Retiro in the *Gaceta de Madrid* on January 19, 1779. The secretary's support might also explain

how Goya, without rank as a court painter, entered the rooms in the royal palace to select and study the paintings of the master.

If Goya's veneration of Velázquez, noted by his son in an early biography of the artist, began with the close study essential to translating painting into etching, other works soon betrayed the master's influence.[14] Velázquez lurks behind *The Blind Guitarist*, a large tapestry cartoon delivered to the factory three months before the first etchings were offered for sale. Intended as an introduction to the diverse characters at the annual fair of Madrid, it presents them gathered to listen to a blind man singing a ballad of recent news. Young women, a stylishly dressed foreigner with hand in waistcoat, two women in working-class dress, and two boys stand out in front of a crowd of men wrapped in their brown capes; behind them, a man on horseback has stopped to listen. Subtle highlights distinguish the faces of the men in the crowd, but the contours of their capes fall into shadow, as Goya had emulated the somber tones within shadow of Velázquez's *Triumph of Bacchus*. Behind the crowd and silhouetted against the sky, the rider's broadly painted face, with one side illuminated and the other in shadow, pays tribute to the figure standing in the background doorway of *Las Meninas*.

Not everyone appreciated Goya's newfound subtlety, and weavers at the tapestry factory soon demanded that the artist clarify his forms to facilitate their translation into weave. By Sabatini's order, Goya requested the return of *The Blind Guitarist* in October 1778, as explained in a memo by the factory's director, Cornelius Vandergoten: "This painting, by order of Sr. Don Francisco Savatini [*sic*], was delivered to Don Francisco Goya, who had painted it, to correct and finish that which was indicated and made it impossible to copy in tapestry, for which reason it should not be missed."[15] Goya did as told, and even today traces of white lines defining the borders of dark capes are visible in the cartoon. Perhaps because of this delay, the tapestry after *The Blind Guitarist* was installed in a room other than that for which it was conceived, placed among unrelated scenes of country pastimes. But Goya now knew that prints could document original invention and, working on the largest plate he would ever etch, recorded what is presumably the original composition of *The Blind Guitarist* in an etching that survives only in rare impressions (fig. 5).

Sabatini's intervention in the matter of *The Blind Guitarist* did not dampen his enthusiasm for Goya's works, and when he visited Goya's studio in December, he "pounced on some good sketches" that Goya had set aside for Zapater.[16] With his stock of tapestry sketches depleted, Goya could offer his friend only the "old one of the dance" to be put in a corner, as previously mentioned. He also sent Zapater prints after Velázquez, promising others as

5. *The Blind Guitarist*, 1778. Etching, working proof with touches of graphite, 14 × 21 ⅝ in. (35.5 × 55 cm). The Metropolitan Museum of Art, New York, Purchase, Jacob H. Schiff Bequest, 1922.

they were published, and mentioned in passing the "troubles" he had with them, offering no further details. Grumpily, he signed off: "Go to hell for your making me talk more than if it was about something that mattered."[17] He undoubtedly had much on his mind: two more etchings after Velázquez were announced for sale later that month; *The Blind Guitarist* was possibly still in his studio awaiting correction; and he had yet to finish the remaining cartoons for the El Pardo bedchamber. Making things worse, Josefa had just recovered from the miscarriage of a boy almost brought to term, leading Manuel to write to Zapater that Goya could take comfort that the "others" were well.[18]

Fulfilling the adage that darkness precedes the dawn, a month later, Goya breathlessly reported to Zapater his sudden change in fortune:

> If I were more calm I would tell you how the king the prince and the princess honored me, for by the grace of God I had the opportunity to show them four paintings, and I kissed their hands I have never had such good fortune, and I tell you that I couldn't ask for more so far as their liking my works, judging from the pleasure they took in seeing them and the compliments I received from the king and even more from their Highnesses. And what is more with all dignity thanks to God, that neither I nor my works deserved what I received.[19]

Goya had delivered six scenes of the fair of Madrid to the tapestry factory four days earlier. In them, he expands the diverse cast introduced in *The Blind Guitarist*, as members of classes high and low buy, sell, and bargain in and around the Plaza de la Cebada (Barley Square), with the dome of the church of San Francisco el Grande, recently renovated by Sabatini, prominent in the background. But despite the praise received from his royal patrons, Goya remained wary, and ended his letter: "No one can convince me otherwise that now I begin to have more important enemies, with greater resentment,"[20] words reminiscent of the prediction he made three years earlier in his petition to Mengs, that were he to remain in Madrid, things would go badly. Goya's circumspection and sensitivity to the intrigues and competition among artists at court is a recurrent theme in letters to Zapater, his sole confidant.

Mengs's death in Rome on June 29, 1779, raised the hopes of several painters at court, including Goya, who on July 24 requested for a second time a position as a court painter:

> Having practiced his art in Zaragoza his Patria, and in Rome, where he went and lived at his expense, he was called by Don Antonio Raphael de Mengs to continue painting in the Royal Works of Your Majesty with the approbation of the first Majordomo, having carried them out to the satisfaction of all the professors and even of Your Majesty in the last six works he presented: Humbly requests that Your Majesty deign to grant him a position of Court painter to Your Majesty with whatever salary is to your Royal pleasure.[21]

In his petition three years earlier, Goya had not mentioned any relation with Mengs, nor had Mengs mentioned any relation with Goya, in contrast to his statement that Ramón Bayeu had painted under his supervision;[22] this petition is the only evidence that Mengs called Goya to Madrid, a statement subsequently repeated by Goya and his biographers. To this author, it seems far more likely that Francisco Bayeu recommended his brother-in-law to Mengs. Did Goya exaggerate his relationship with the recently deceased and highly respected master? If so, his strategy failed. Following review, Mengs's words on Goya written three years earlier were recalled, and it was noted that there was no urgency to fill the position, nor was there a dearth of painters to meet demands at court. On October 8, 1779, Goya's second request for a position as court painter was denied, as was Francisco Bayeu's petition to fill Mengs's position as first court painter.[23]

Even without an official court appointment, Goya and his family prospered. The baptismal certificate for Goya's fourth child, a daughter christened

María del Pilar Dionisio, born in October, lists the family's address as 1, Calle del Desengaño (Street of Disillusion). The building was in a newer part of town that had seen recent construction; a permit for Desengaño 1 had been issued in 1772.[24] From an announcement Goya placed in the *Diario de Madrid* in 1793 about a lost snuffbox, we learn more about his home, to be entered from the main thoroughfare of the Calle de Fuencarral, "to the left hand, number 1, quarto Segundo" or an apartment on a third floor above the ground floor (*quartos bajos*) and second floor (*quartos principales*).[25] Many years later, a rental advertisement in the *Diario de Madrid* dated November 20, 1811, might offer an idea of the family lodging: "Calle del Desengaño, corner of Fuencarral, number 1 . . . a quarto segundo with nine rooms beautifully painted, with blinds and views onto both streets." We cannot know if this is Goya's same apartment or only another on the same floor, but with nine rooms it suggests the comfort afforded by the new Goya family residence (demolished for the construction of the Telefónica in 1926–1929). By 1799 the ground floor of the building housed a shop of perfumes and liquors, where Goya offered his *Caprichos* for sale; its occupant in 1811 was the diamond and silver merchant to be contacted for information on the apartment advertised.

Since the delivery in October 1776 of *The Picnic*, the first cartoon of his "own invention," Goya had completed thirty paintings for the royal tapestry factory, with a total value of 115,000 *reales*. Assuming he was paid one-half of the appraised value of his cartoons, as Mengs had recommended, he had earned 57,500 *reales*, as well as an annual salary of 8,000 *reales*, for a total income by March 1780 of 86,500 *reales*, to which any income from private commissions and the etchings after Velázquez would be added. Goya lived comfortably (one estimate of the cost of living in Madrid at this time states that 1,400 *reales* covered basic expenses of food, housing, and clothing), and his income allowed him to move his growing family to a new and spacious house. In February 1780 he entrusted Zapater with 5,000 *pesos*, or 80,000 *reales*, to invest.[26] But international politics soon cast a shadow over Goya's fortunes, as Spain's war with Great Britain took its toll. On March 17, 1780, the king's majordomo wrote to Francisco Sabatini approving payment of 52,190 *reales* for cartoons by several artists, Goya among them. The official then relayed the royal order to suspend commissions for paintings of this type "unless absolutely necessary" due to "the present emergency."[27] This was an unexpected blow for Goya, who had enjoyed the benefits of a steady income for the past four years.

The Family Pact, signed between Spain and France in 1763, united the Bourbon powers against England. The strategies of the monarchs, however, differed: Louis XVI supported the American colonists and recognized the

new nation; Carlos III did not, concerned that Spain's own New World territories would follow the colonists' lead. The Spanish monarch also had a more pressing issue to address with Great Britain: the reestablishment of Spanish rule in Gibraltar, under British rule since 1704. In June 1779 the *Mercurio histórico* published the royal order outlawing all communication between subjects of Carlos III and those of Great Britain, and expelling British citizens from Spanish territories. The siege of Gibraltar ensued, followed by the victory of a British squadron over the Spanish in January 1780. By the time Carlos III suspended the work of tapestry painters, he realized this war would be costly and prolonged: three years passed before peace was restored. Spain would never recuperate financially from the costs of the war, nor would she regain Gibraltar, although in 1783 rule of the island of Menorca and the New World territory of Florida were returned to her.

The work stoppage at the tapestry factory also meant fewer demands for Francisco Bayeu, who received permission in late March to return to Zaragoza, where he had last painted four years earlier. He began assembling a team to continue work at El Pilar and recommended to Matías Allué two sculptors who had expressed interest in replacing the recently deceased Carlos Salas: Joaquín Aralí, by then working in Madrid, and Salas's brother-in-law Pascual Ypas.[28] Bayeu left this decision to Allué but advocated on Goya's behalf, writing:

> And now, because work for the tapestry factory has ceased until further orders due to the excessive expenses of the Monarchy, Goya came to me and told me to write to Your Grace [*Vuestra Merced*][29] to see if he could undertake the work with the provision that, if there were not funds to pay for his labor, he could wait for the time that is of your Grace's will, and that he would cover the cost of the pigments. It seems like a reasonable proposition to me, and I will wait to hear what your Grace determines.[30]

The response was favorable, but funding was needed. To this end, Bayeu lowered his quote for the remaining domes and invited the committee to set the schedule for payment over "two, four or six years," adding that neither Ramón nor Goya "need anything for now, unless it is Goya, who because of his large family needs some help in time."[31] In responding with a counterproposal on price, Allué added, "It will not be a problem to give to Goya what he needs to buy pigments, and if necessary, something to support his family during their stay here."[32] Again, we find confirmation of several children in the Goya household.

On May 10, 1780, Goya hurriedly wrote to Zapater that he had been attending to Ramón Bayeu, who had been in bed for eight days with stomach pains and fever and was in such pain the previous day that he took confession; tepid baths helped with the fever but otherwise brought little relief. He also expressed his hope for work at El Pilar.[33] Good news arrived in Zaragoza with the following week's mail, as Ramón was recovering and the project at El Pilar was moving ahead. The committee's approval for four domes with their pendentives, two to be painted by Ramón, two by Goya, soon followed.[34] There was more good news. On May 5, 1780, Goya solicited admission to the Royal Academy, at the "level deemed appropriate by the members," and submitted a painting of the crucified Christ in support of his application.[35] Two days later, and with the recommendation of the vice-protector, the marquis of la Florida Pimentel, his request was heard, and Goya was unanimously accepted as a member, or *académico de mérito*.[36] He did not mention this in any of the three letters he sent to Zapater that May, focusing instead on El Pilar and on his forthcoming reunion with Zapater: "Dear Martín, I cannot explain the joy I feel that God is letting us see one another."[37]

8

The Zaragoza Affair

June 1780–June 1781

Through the summer, Zapater helped his friends with arrangements for their upcoming stay in Zaragoza, some more complicated than others. Bayeu's requests offer a rare glimpse of his concerns beyond work and family, as he asked for a particular hay for his horse. An explanation of the hay, unknown to Zapater, arrived in the next mail with two women's hair caps (*escofietas*) of the latest fashion made of gauze rather than lace (which, Bayeu explained, was no longer used), so that Zapater could make a "fabulous gift and leave a brilliant impression, jaa, jaa, jaa, ja, ja, ja." (Was the bachelor Zapater courting? Or were these for his aunt, Joaquina Alduy?) When Bayeu's horse became ill, he despaired of having to bleed it to put it down, so that no one could buy it (presumably for slaughter): "I regret it with all my soul because [the horse] was without equal." By September 23 the horse had recuperated, the request for his special hay was reinstated, and plans were made to travel to Zaragoza as early as Monday, September 25, even though this meant missing a Monday bullfight.[1]

Goya's demands were more basic. He asked both Zapater and the businessman Juan Martín de Goicoechea for assistance in finding lodging, and listed the furnishings he needed: a print of Our Lady of El Pilar, a table, five chairs, a frying pan, a wineskin, a tiple, or small guitar (the earliest indication of Goya's interest in music), a spit, and a candle. Goya planned to bring mattresses, bed linens, and, if space allowed, curtains. The house had to accommodate Goya and Josefa, a maid, a male servant or apprentice (*criado*), and as many as five children, including the infant, Francisco de Paula, whose birth in August made it possible for Goya to finalize his travel plans. The first house considered was that near El Pilar where Bayeu had lodged five years earlier, but Josefa resisted, asking Goya to tell Zapater "since the house is the wives' grave, the place seems sad to her." In light of five childbirths and at

least one miscarriage late in pregnancy over the past six years, her resignation is understandable; her husband, in contrast, eagerly anticipated hunting with his friend.[2] If he did not heed his wife's misgivings, the ever-considerate Zapater did, and the family settled at 11, El Coso with Calixta Pérez (a maid) and Goya's assistant Mariano Ponzano.[3] Goya must have been delighted to have Zapater as his neighbor at 13, El Coso.

On October 5 Goya and Ramón presented to the building committee their sketches, as well as those by Francisco, and all were "viewed by the men on the committee with great respect and delight." Ramón and Goya were told to return to their lodgings with the intention of beginning the project; and by the end of November Goya received his first payment of 15,015 *reales*.[4] Having never before painted a dome, Goya embarked on a curved surface of 210 square meters, and covered about four or five square meters in each daily session (*jornada*). He worked on the side of the basilica facing the Ebro River, while his brothers-in-law painted adjacent domes on the opposite side, facing the town. Two days before Christmas, Manuel Bayeu wrote from his monastery to remind Zapater of their correspondence "that seems to have gone by the wayside since Your Grace is having good times with Goya, Francho, and Ramón."[5] But things were not going as merrily as he imagined. On December 14 the building committee learned that Bayeu had gone to Allué's house to tell him that Goya paid no attention to his suggestions and asked to be excused from supervising his brother-in-law. Recognizing that Goya owed his participation in the project to Bayeu, the committee recommended that Allué oversee Goya, check his work regularly, advise him of defects, and remind him of all that he owed to his brother-in-law.[6]

Bayeu finished his dome by February 11, and an unveiling was planned a few days later so that the archbishop could see it; Goya was also finishing his and the Virtues to be represented in the supporting pendentives now had to be chosen.[7] A month later Goya presented sketches for these figures, eliciting the response that they did not "merit the approval as had been hoped . . . especially that representing Charity, the figure being less decent than is appropriate; the backgrounds of the others, besides being poor, are darker than is desirable."[8] Matías Allué was charged with relaying the response to the artist, and did not mince words in writing to Goya the following day: "My dear sir: The sketches that your Grace presented yesterday afternoon did not please the members of the Committee, and, having commissioned me to see your brother-in-law D. Francisco, so that he would make the effort to examine and fix them, you will excuse me, despite earlier agreements."[9] Goya's ire at the thought of Bayeu retouching his sketches began to fester.

The following day Allué confessed to Bayeu that when the committee learned of Goya's resistance the previous December, they considered dismissing him but refrained to avoid offending Goya and, more important, because Bayeu assured them that Goya could produce the work. But since the unveiling of Goya's dome, "so many criticisms of it have rained down that the Committee was put in the position of having to justify having given the commission" to Goya. To address the issue and

to quiet the voices of the public, the Committee has thought of putting the scaffolding back in place, with the pretext of the pendentives, and hav[ing] the work retouched in the best manner. It has put the matter in the hands of Your Grace because of the confidence you deserve, not doubting that, if Your Grace apply his hand, even if it is only to direct Goya, we can tone down much of the said dissonance with the other executed works, that everyone notices, although we suppose them to be ignorant in the Art.[10]

Goya vented his outrage in a long letter written five days later. He maintained that he had agreed initially with Bayeu to paint his part by himself, in recognition of the esteem his works had gained him at court and his standing as a member of the Royal Academy (although Bayeu was the senior academician). He argued that when, as a courtesy, he presented his sketch for the dome to Bayeu, it was approved without reservation. Only after the work was well under way did he learn that the agreement permitted Bayeu to "intervene, and inform the writer what he thought of his work, [and Goya was to] obey him like an assistant in the execution, placement of figures, taste, color, and everything else; in a word, treat him like a mere executor and dependent mercenary."[11] In a second version of the letter dated ten days later, Goya responded to the proposal that Bayeu retouch his fresco: "To consent to such a shameful indignity would be to erase all the merit achieved by his [Goya's] works at court." Again perceiving other artists as jealous adversaries working to undermine him, he accused Bayeu of manipulating the situation, "to strike a blow at court and to persuade it of what he most wants: that the writer has been his mere executor, his dependent, and subject, never to appear in the world without his help and protection."[12]

The events in Zaragoza from December to March brought to a head an estrangement between Goya and Bayeu, implied even three years earlier when Goya confidentially revealed to Zapater that Goicoechea and Salas had approached him to prepare sketches for the canons at El Pilar. He closed the letter with the remark: "I believe Francisco is well and is in Madrid, you will

understand me," proof that the brothers-in-law were not in regular contact.[13] That Francisco Bayeu could be difficult was admitted even by his brother Manuel, but was he guilty of undermining Goya at El Pilar? Documents suggest not. In the eyes of the building committee, Bayeu was both a respected court painter as well as the director of the project at El Pilar, chosen over Goya to paint the vaults almost a decade earlier and trusted to choose his assistants and complete the project. He had advocated for Goya's participation, and had attempted to maintain the peace by recusing himself from supervising Goya the previous December. When members of the committee appealed to him, however, he had no option other than to intervene: the brother-in-law he had recommended had created a work that proved an embarrassment to the committee. If Bayeu had any misgivings about following the committee's orders, Goya's subsequent accusations and behavior surely put them to rest.

Today it is impossible for visitors to El Pilar to compare the works of these painters, with Goya's dome, *Mary, Queen of Martyrs*, conserved and illuminated, as other paintings linger in shadow. But comparison of reproductions and sketches justifies the committee's reaction. Bayeu had completed the vault of *Mary, Queen of Angels* immediately behind the Santa Capilla five years earlier, and the dome of *Mary, Queen of Apostles* during Goya's stay. Considered as models by the committee, both betray a style honed in painting ceilings in the royal palace: stepped progressions of clouds and figures open to the heavens, with the central figures, whether saintly or allegorical, set against a radiant sky; postures and gestures are developed in preliminary drawings, and the color of their garments distinguish individual prophets and angels. In Goya's dome, by comparison, Mary is elevated only slightly above myriad saints in attendance, who are supported on tiers of clouds that obstruct any view into the heavens. If the viewer below can discern individual figures and attributes of the saints closest to Mary, the figures on the opposite side of the dome form a confusing crowd. Goya may have foregone preliminary figure studies and perhaps even improvised on the dome's curved surface. No wonder that those who prized Bayeu's style found Goya's contribution lacking.

Goya's letter of complaint was read in the committee meeting of March 28, and three days later the committee met to review and approve a response written by the secretary and archivist of El Pilar, José Ipas.[14] After stating that Goya's hostility toward Bayeu caused the members of the committee great anguish, Ipas reminded Goya of the authority of "Don Francisco Bayeu, Court Painter of His Majesty," thus invoking the royal will in absentia. Not only those concerned with the commission but also "outsiders" had recognized that Goya's dome "is not as finished as the others that adorn the square around the Santa Capilla; and in truth, the committee understands that a

work of this scale demands more time than that which Your Grace has given it to achieve the necessary perfection."[15] In the meantime, Goya received a letter dated March 30, written presumably at the request of the committee, from Félix Salcedo, the prior at the Charterhouse of Aula Dei. Serving as mediator, Salcedo did not judge, but wrote to "My friend Don Francisco Goya" to remind him of the humility of Christ that is a model for all, concluding his letter with practical advice:

> My opinion, as one of your greatest admirers, is that Your Grace submit to what the committee requests, and see that your sketches are taken to the house of your brother, and tell him with the best manner, "This is requested by the committee, here you have them, examine them to your satisfaction, and put in writing your opinion to present it," conducting yourself in the matter according to God and your conscience dictates, etc. And wait for the result. Your Grace, consider it carefully, ask the Virgin of El Pilar to give you the ability to achieve this, and do what you think would most please His Majesty and His Divine Son, for I ask the same; because I am your dear friend who kisses your hand.[16]

Salcedo's appeal hit its mark, and on April 6 Goya wrote to Allué that he would paint new sketches in consultation with Bayeu; the committee approved these eleven days later. By May 28, pendentives painted, Goya asked to return to Madrid since in Zaragoza he "does nothing but lose esteem." He left his commission for a second dome to Ramón and received his final payment of 4,500 *reales*; in turn, the committee stipulated that Goya have no further role in any of the paintings for El Pilar, and that no gift of religious medals be made to his wife.[17] On June 6 Goicoechea reported to Zapater: "our Goya, after certain episodes too long to recount, was called to the archive of El Pilar where he was given 2,000 pesos as the final payment for his painting, and Wednesday, the 30th of last month, left for Madrid with his wife and a maid."[18]

The events that took place in Zaragoza from 1780 to 1781 have been variously interpreted as evidence of Francisco Bayeu's tyranny, or of Goya's superiority by opening "the way to a completely new kind of painting in which the spontaneity of the sketch, with its rapid impasto and its irregular brushwork, replaces the impeccable but lifeless execution of Mengs."[19] In fact, Goya's fresco at El Pilar did not anticipate other works: it is a single essay and a failed one in the eyes of patrons and of the community. Beyond a disagreement between artist and patrons, beyond the five-year feud that ensued between Goya and his in-laws, his ill-fated participation at El Pilar signaled a break with his

hometown and with its all-powerful church, his first significant patron. Allies remained in Zaragoza: Martín Zapater, Juan Martín de Goicoechea, and Joaquina Alduy. Goicoechea's letter to Zapater reporting the denouement of Goya's stay suggests that Zapater himself was out of town, which explains why Goya's first surviving letter to Zaragoza following his return to Madrid was addressed to his aunt, Joaquina Alduy. He wrote that his return was embittered by "memories of the loss of my diversions and all my happiness in Zaragoza," but he found solace in "that of which we spoke that I believe Your Grace will carry out"—plans that remain a mystery. Of his own situation he commented only: "Here all the details of my matters are well known but I am not in a bad place."[20]

Goya was still fuming a week later as he promised to finish a painting for Zapater, writing that "only your friendship would make me do it because in remembering Zaragoza and painting, I burn up alive."[21] Absent the support of his influential brother-in-law and any regular income from that tapestry factory, Goya's reputation at court was based on his etchings after Velázquez, cartoons now rolled and stored in the tapestry factory, the painting *Christ on the Cross* in the Royal Academy, and his title as Academician. Another opportunity soon came his way, opening a new phase of his career at the court of Madrid.

Part II

The Path of a Court Painter

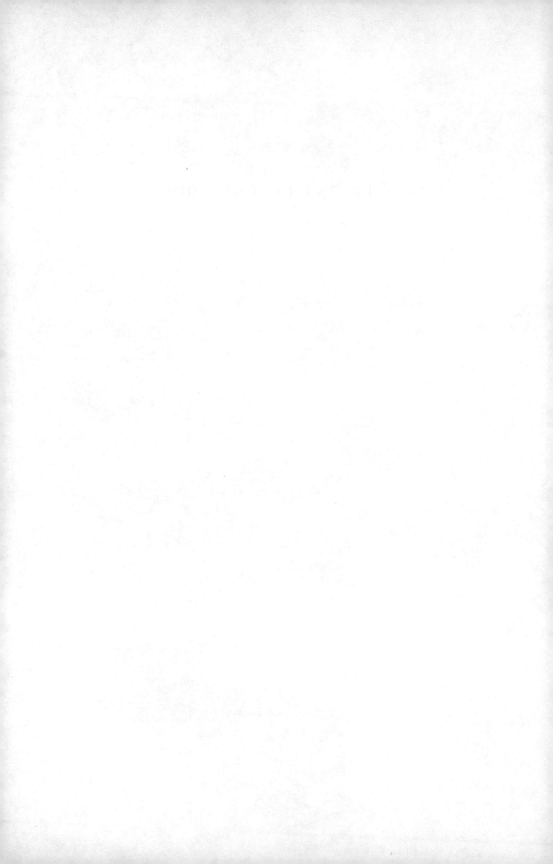

Floridablanca

1781–1783

E VEN after his father's doctor and sister Rita wrote to inform him of his father's failing health in November, Goya did not return to Zaragoza. Beyond his recent disgrace, he may have also avoided confronting the situation, for his father's decline affected him deeply; in response to news received from Rita in early December, he wrote to Zapater: "I assure you, I don't know how I am."[1] At the end of a difficult year, Joseph Goya died on December 17, 1781; for lack of possessions, there was no will.[2] Goya was forced into the role of head of household and took responsibility for the well-being of his mother and siblings; over the next two decades, his support of family is documented in letters to Zapater, who often served as the financial intermediary.[3] By the following spring, Rita, listed for the first time as a widow, had moved with her mother from El Coso to the more modest house they occupied three years earlier, now shared with a married couple and their three children. The following year, Rita remained at the address with her younger brother Camilo; their mother is not mentioned, for by this time she was in Madrid with Goya.[4] The eldest brother, Tomás, moved nineteen kilometers from Zaragoza to Sobradiel, the village of his in-laws.[5]

Within two months of his return to Madrid, Goya received a commission to paint an altarpiece for the convent church of San Francisco el Grande, which he embraced as a potentially career-changing opportunity. A short walk from the royal palace, the massive circular-plan church and adjoining Franciscan convent had long been under renovation, but work had faltered; Sabatini's intervention salvaged the project,[6] to which Goya paid due tribute by including the new dome of the church in the background of his 1778 tapestry cartoon, the *Fair of Madrid*. Three years later, the commission was a lifeline:

Friend, the time has arrived for the most important undertaking in painting that has been offered in Madrid, and it is that His Majesty determined that the paintings for the church of San Francisco el Grande [in] this court will be made in competition, and he has seen fit to choose me, whose order the Minister is sending today to Goicoechea so that he show it to those vile men who so undermined my merit, and you will carry it where you know it will light a fire for there's a reason, the great Bayeu will also paint a work, Maella also does his, as do the other court painters: all said, it is a formal competition, and it seems that God has remembered me. . . . Given your interest in my welfare, you will know the use you must make of this news.[7]

Both Goya's reference to the project as a competition and his statement that the "Minister" (the count of Floridablanca) sent the order to Goicoechea to vindicate him raised the suspicions of Manuel Bayeu, whose perspective, as biased toward his brothers as Goya's was self-serving, is revealed in three letters to Zapater. Having seen the document that Goya sent to Goicoechea, Manuel wrote in early August:

You wouldn't believe how it made me laugh. . . . There is hardly an expression in it that doesn't highlight the ignorance and concerns of its author; and that is to look at it in the most benign manner possible. . . . Because the truth is, it is laughable that that señor presumes that Goya's countrymen have more faith in his words than in what they see with their eyes and touch with their hands. . . .

Another issue is that the writer wants to persuade us that, because of what happened to Goya in Zaragoza, the king was moved to order artists to paint their own works for San Francisco so that the whole world could see the injustice done to Goya in Zaragoza, and everyone learn the way in which he is to be treated. To tell the truth, I confess that, if he [presumably Goya] thinks that, he is an idiot; and if he wants his countrymen to believe it, he underestimates them.

Friend, don't be surprised that I speak in these terms, because the little paper from Madrid shocked me. Beyond that, do not forget that I have a sister married to Goya, and I love her as much as my other siblings.[8]

In a letter of August 11, Manuel mentioned that "Pepa" (that is, Josefa), loyal to her husband, confirmed that the royal order had been sent through the minister for Goya to paint a work for San Francisco el Grande.[9]

Two weeks later, after beginning his letter with the admission that he had previously written with more frankness than appropriate, Manuel could not resist presenting evidence that undermined Goya's view of the commission as a competition. Over a year earlier and before the disagreements at El Pilar, the royal confessor Joaquín Eleta asked the king to order altarpieces for the church; Floridablanca was to select the artists. He chose three court painters whose work he knew from the royal palace—Mariano Maella, Antonio González Velázquez, and Andrés de la Calleja—and then decided to assign three works to more junior artists from the Royal Academy. He sought recommendations, and Antonio Ponz supported José del Castillo; the vice-protector of the academy recommended Gregorio Ferro; and Goya was recommended by Floridablanca's assistant, Vicente "Belmúdez" (Bermúdez), to whom, according to Manuel, Goya had given drawings from Zaragoza. Upon learning that Francisco Bayeu had returned to Madrid, Floridablanca assigned him the main altarpiece, "three times the size of the others," and had Ramón not been engaged at El Pilar he, too, would have painted one of the other altarpieces. (Given that the six altarpieces for six chapels were already assigned, it seems that the possible involvement of Ramón was an embellishment.) Manuel continued, "This is really the truth of it, and it's no surprise that I write it in these terms, knowing that it wasn't possible that the King, made aware of what happened in Zaragoza would be moved to form a palestra among the painters in order to justify one artist in particular," and closed the letter with an avowal: "Believe also that I love Goya from my heart, but I don't love him against reason, against truth, and against my brothers."[10] Two years intervened before Manuel's next surviving letter to Zapater, suggesting a break in their correspondence.

Returned to his easel, Goya was able to put Zaragoza behind him, and in late August he wrote that "it now seems as if I were born in a different world."[11] That different world was the court of Madrid, a hierarchy in which Goya had to make his mark. Eager to please, he wrote to Floridablanca to clarify details about the delivery of his sketch and took the opportunity to explain his choice of a subject from the life of Saint Bernardine of Siena (fig. 6), the miracle that occurred as the saint was preaching to a large audience that included Renato (to be changed subsequently to Alfonso), the Aragonese king of Sicily, and his courtiers, all witnesses to a star that descended from the heavens to bathe the saint in "divine resplendence." Obsequious before his patron, Goya "bowed" before Floridablanca's "enlightened" perspicacity, writing that the secretary surely understood the theoretical underpinnings of his work and the reason for which Goya could only imply the background landscape in order to maintain the pyramidal composition, unified by the essential serpentine line.[12] His

6. *Saint Bernardine of Siena Preaching before Alfonso of Aragón*, 1781–1783. Oil on canvas, 189 × 118 ½ in. (480 × 300 cm). San Francisco el Grande, Madrid.

image of a divine and worldly hierarchy confirms the preoccupation of an aspiring courtier, as a heavenly star illuminates the saint, who preaches to the kneeling king surrounded by his courtiers, with crowds of commoners relegated to the middle and far distance. A detail in the final work is not seen in the sketches, for on the far right Goya included his self-portrait as one of the courtiers in attendance.

His sketch delivered, Goya awaited the return of the court from El Escorial, when the sketches would be judged;[13] although no reports of the court's reaction have come to light, Goya's sketch was approved, for his altarpiece was placed in the church with the others by January 11, 1783.[14] As he awaited his father's imminent death through the fall of 1781, he found some diversion in a single hunting excursion to the mountains about forty kilometers from Madrid, where in the company of two of the court's best hunters, he proved himself by killing eighteen animals with nineteen shots: two hares, a rabbit, five partridges, and ten quail. Had he not missed one, it would have been a perfect day.[15] He considered forgoing such excursions given his finances (even though he had invested 30,000 *reales* in an annuity upon his return from Zaragoza).[16] He also probably still owed Zapater 300 *reales*, lent to his brother Tomás two months earlier,[17] and found himself unable to repay Goicoechea money spent on his parents "until seeing the result and the payment for that big painting"—that is, the altarpiece for San Francisco el Grande, which in Goya's estimate was worth 30,000 *reales*.[18]

No letters to Zapater from late December 1781 to November 1782 have come to light. Perhaps they were lost, but it is also possible that a crisis intervened. References to Goya's large family during preparations for his 1780 trip to Zaragoza confirm that perhaps all five of his children were alive. A daughter, Hermenegilda Francisca de Paula, was baptized in the Madrid church of San Luis in April 1782, the last of six children recorded in the pages of his Italian sketchbook.[19] By fall 1784, with Josefa again expecting, Hermenegilda Francisca may have been the sole surviving child: writing the following spring or early summer, Goya reprimanded Zapater: "Go to hell with your silence,

for I don't follow etiquette with you, if I have not written, I have motives, the girl that I had in the village having died." Four years later Goya mentioned "the woman who had little Paulita, who God now enjoys."[20] These passing references identify the "girl I had in the village" as Hermenegilda Francisca de Paula (Paulita), who had been sent away, possibly because of her ill health or possibly because of the situation in Madrid. Her death is the only one mentioned in surviving documents, but her siblings had apparently died by December 1784, possible victims of a crisis of infant mortality in Madrid from about 1780 to 1782, attributed to an epidemic of smallpox across the peninsula.[21]

———

When Goya again wrote to Zapater in early November 1782, it was to discuss two dresses that Josefa would soon make at the request of Joaquina Alduy and to thank his friend for favors to him and his family; he remarked in closing that he still lived on the Calle del Desengaño, suggesting that the friends had been out of touch. Life was bleak. Three weeks later Goya worried about the rent due in December, saying that "if they don't pay me for the painting," he would be forced to cut his household costs and let go of his servant in order to cover family debts that, as Zapater knew, had burdened him since he was last in Zaragoza.[22] Some relief came in December, when Floridablanca approved a payment of 6,000 *reales* for the altarpieces by the three unsalaried painters involved in the San Francisco el Grande project: Goya, José del Castillo, and Gregorio Ferro.[23] Although only one-fifth of the value Goya had hoped for, it was better than nothing. Certainly, it was better than the reception that awaited Bayeu a few weeks later:

> What happened to Bayeu was the following: Having presented his painting in the palace and the King having said, "fine, fine, fine" as he does; then the Prince and the Infantes saw it and what they said has nothing in Bayeu's favor, but rather all against, for it is public knowledge that they did not like it. Don Juan de Villanueva, the Prince's architect, arrived at the palace, and the Prince asked him, "What do you think about that painting?" He answered: "Fine, Sir." "You're an ignoramus [*bestia*], the Prince told him, for this painting has neither chiaroscuro nor any effects, is very trite, and without merit. Tell Bayeu he is a *bestia*.[24]

"Six or seven" artists and two friends of Villanueva's had recounted this to Goya, who in turn reported it to Zapater on January 11, 1783, with the request that he not tell anyone "for even though he [Bayeu] is my enemy, I'm

sorry to hear it." He added, "It is his fault, for no one else even thought to take their paintings to the Palace and because he was the only one, and even against the desires of some at court, he did it."[25] The dimensions of Bayeu's altarpiece, measuring over twenty-four feet in height, underscored his hubris, for transporting it to the palace was a production sure to be noticed, as the altarpieces by the six other artists stood in the darkness in San Francisco el Grande with no date set for the unveiling. Goya's ultimate vindication would come a century later, when in 1882 renovations of the church led to the removal of Bayeu's main altar; the altarpieces of the six other artists remain on view, gathered in two side chapels to either side of the entrance.

Beyond the palace, Goya's membership in the Royal Academy brought new acquaintances and opportunities. On June 4, 1780, the writer and statesman Gaspar Melchor de Jovellanos was elected honorary academician shortly after his appointment in April to the Consejo de Órdenes (Council of Orders), which since the sixteenth century had overseen the military orders of Santiago, Calatrava, Montesa, and Alcántara. As a member of the council, he chose the order he wished to join, and on May 20 became a knight of the Order of Alcántara. His salary was 44,000 *reales*, but as a result of a petition that he made, "with determination and decorum," Floridablanca raised the amount to 50,000 *reales*.[26] Jovellanos was, according to his obituary, friendly with many of the academicians, but particularly with the engraver Pedro González de Sepúlveda and with "Don Francisco Goya."[27] A member also of the royal academies of history and language, ambitious and well connected, Jovellanos was a good person to know.

The two men may have met when Goya attended a session of the academy on July 14, 1781, at which, following a concert at five thirty, Jovellanos offered "an eloquent oration that he had written and merited the general applause of all present."[28] Ever diplomatic before an audience of aristocrats, artists, and collectors, he proposed to discuss the arts not as an artist or a philosopher but as an aficionado: "Drawn by their enchantments, I will seek them out within history, and after having found them in the most distant eras, I will cautiously follow their footsteps, without losing sight of them, until arriving at the present day."[29] Jovellanos shared Goya's interest in Velázquez, who illustrated the model patronage of Philip IV, and eventually acquired a "sketch" (today identified as a smaller replica) of *Las Meninas*. Jovellanos's protégé, Ceán, who had studied art in Seville and apprenticed briefly with Mengs from August to November 1776, may have advised his mentor on artistic matters. Jovellanos in turn recommended Ceán to Francisco Cabarrús, the founder of the National Bank of San Carlos, who offered him a position in the bank with an annual salary of 6,000 *reales* as well as a

room in February 1783.[30] Two years later Ceán facilitated payment to Goya for the first of several portraits of the bank's directors, the possible beginning of their lifelong friendship.

As 1783 began Goya's hopes brightened. Replying to a remark made by Zapater concerning Allué, he urged his friend to "shit" on the whole affair as he had. To Zapater's lament that a new municipal appointment left him little time to hunt, Goya responded that he too was busy and thought that in time he would be even busier. A secret confided at the end of the letter explained his good mood: that afternoon he had spent two hours with Floridablanca, who asked him to paint his portrait and to keep this request confidential (which for Goya meant telling only Josefa and Zapater). Goya emphasized that he had not solicited the commission and closed with the words: "Say nothing."[31] The mood at court was also lightening and Goya soon reported that an end to the war with England was in sight, even though Floridablanca, with whom he had just spent some time, was now busier than before.[32] The Treaty of Versailles, signed the following September and deemed by one historian "the most advantageous peace agreement made by Spain this century," returned the territory of Florida to Spain and maintained Spanish control over the Gulf of Mexico; Menorca was also returned to Spain, although Gibraltar remained under British rule.[33]

A more personal truce occurred when on February 21, 1783, Goya testified to the unmarried status of Josefa's sister, María, writing that he had known her for twenty years, more or less, "because of having been studying his art in the house of her brother, Don Francisco." On the first day of March, Goya stood with Francisco Bayeu, Sebastiana, and Ramón in the chapel of the royal palace in Madrid (which since 1753 also served as a parish church) to witness the marriage of María Bayeu to Marcos del Campo.[34] He took pride in having encouraged his friend Marcos, who showed promise with a steady job and salary as well as an older brother in the service of the king's brother, the *infante* don Luis;[35] two years earlier, the *infante* had even commissioned Marcos to travel to Rome to retrieve a recently purchased painting on panel by Raphael.[36] Goya's financial situation improved, with a payment of 3,000 *reales* for an altarpiece of the Virgin appearing to Saint James, destroyed during the Spanish Civil War and today known only through a photograph and preliminary sketch.[37] Commissioned by the duke of Híjar for the main altar of the parish church in Urrea de Gaen in Teruel, it was part of a project involving several artists from Zaragoza: the architect Agustín Sanz, the sculptor Joaquín Aralí, and the gilder José Cidraque; Ramón Bayeu and José del Castillo also painted altarpieces.[38] A more significant commission, presumably due to the advocacy of Jovellanos, came from the Council of Orders,

7. *The Count of Florida-
blanca*, 1783. Oil on
canvas, 103 ⅛ × 65 ⅜ in.
(262 × 166 cm). Colec-
ción Banco de España,
Madrid.

which three years earlier had undertaken the renovation of the college of the
Order of Calatrava in Salamanca. In April 1783 the architect and academician
Pedro Arnal presented designs to the Royal Academy for four altars; Goya
was to paint the Virgin of the Immaculate Conception for the main altar-
piece and saints for the three lateral altarpieces. A small sketch for the main
altarpiece, identified in 1977, is all that survives of the project, completed in
October 1784.[39]

Floridablanca finally sat for Goya in late April, allowing him to complete
the "head for the portrait that came out well and pleased the Minister," the
starting point for a composition whose forced complexity suggests an artist
overly anxious to please (fig. 7).[40] It is difficult to imagine the work as it once
appeared, given that the green of the curtain and Goya's brown suit have
darkened, and the underground now shows through (most obviously in the

minister's once white stockings), giving unintended emphasis to the minister's bright red coat, its tonal subtleties lost to ambitious cleaning. Goya's forced narrative nevertheless remains: Floridablanca is a man with little time to spare, who turns from his work-laden table to examine the canvas proffered by a diminutive Goya, standing in the left foreground. Interrupting the examination, the intrusive viewer is met with the intimidating gaze of Floridablanca's steel-blue eyes, a motif used by Pompeo Batoni in an earlier portrait of Floridablanca, looking up from his papers with his monocle in his hand, which was possibly recommended to Goya.[41] Floridablanca's wideranging interests and duties are represented by a volume with a marked page on the floor in the foreground—a treatise by the art theorist Antonio Palomino—and nearby plans for the recently completed Canal of Aragón, propped against the leg of the table. A man with compass in hand behind the table, possibly the military engineer Julián Sánchez Bort, looks up from his work.[42] Carlos III surveys the scene from a painting hanging on the darkened wall behind, as a clock on the table ticks, marking the passage of time and reminding the viewer not to dally and distract the secretary from returning to his many pressing issues in service to the monarchy.

With the portrait completed, Goya waited. Although he spent as many as two hours in the minister's company and Floridablanca assured him of his support, by July nothing had happened, and he contented himself with a commission from a royal librarian to paint a dancer, a throwback to the lowly subject matter of his tapestry cartoons.[43] Waiting to inform Zapater of accolades or advancement, Goya fell silent. But the support of Floridablanca appears to have taken a more subtle form.

Don Luis

September 1783–1784

JUST as Elizabeth Farnese had destined her first son for a future as king of Spain, so did she choose the church as the career path for his younger brother, don Luis de Borbón. Appointed archbishop of Toledo at the age of eight, he became cardinal two years later, and archbishop of Seville four years after that. At the age of twenty-seven, however, don Luis brought his clerical career to a close by petitioning the pope to excuse him from all of his offices so that he might have "greater tranquility of spirit and sureness of conscience."[1] With his brother's accession to the Spanish throne five years later, don Luis was again integrated into courtly life.

The *infante's* interests included music, and beginning in 1770 he employed the composer and cellist Luigi Boccherini at a salary of 14,000 *reales* a year. He also collected art and was a patron of Mengs and of the painter Luis Paret y Alcázar. By the early 1770s, his apartments in the royal palace housed his collections of books and medals, including rarities from the Spanish colonies, as well as five rooms dedicated to his natural-history cabinet: two for birds, one for insects, and another for quadrupeds (cabinets for plants and minerals were then being built.)[2] Visiting Madrid in 1774, William Dalrymple reported that the first visit at court was always made to the apartments of don Luis, who was the "lowest in rank." He observed, "He is the strangest looking mortal that ever appears, and his dress is not more peculiar than his person; ever since he was a cardinal, he has detested any thing that comes near to his neck, so his taylor has been particularly careful, to bring that part, which should be the collar of his coat, no higher that half way up his breast; this prince is of a most humane disposition, and is universally esteemed."[3]

The trait that most famously distinguished don Luis from his older brother, who remained celibate after the death of Queen Maria Amalia in 1760, was his interest in women. In one case he fell in love with a commoner

and came to her defense when charges were brought against her, arguing that he was the one who should be punished. His objections were futile, and the young woman was exiled to Palencia, where a marriage was arranged for her.[4] When in 1775 Luis Paret was accused of helping find young women for the *infante*, the artist was exiled for three years to Puerto Rico; upon his return to Spain, he lived in Bilbao and eventually returned to Madrid, where he was active in the Royal Academy until his death in 1799.

The problem posed by the *infante*'s interest in women went beyond propriety and court etiquette. According to the Salic law introduced to Spain by the Bourbons, the Spanish king had to be male and born in Spain; thus, were don Luis to marry, his children might challenge the claim to the throne of the Neapolitan-born offspring of Carlos III.[5] Following the incident involving Paret, a wife for the *infante* was sought, and when no appropriate princess could be persuaded to marry the aging don Luis, Carlos III granted his brother permission to marry the seventeen-year-old María Teresa de Vallabriga y Rozas, daughter of lower Aragonese nobility. Before the king agreed, he ensured his son's succession to the throne by issuing a pragmatic sanction, stipulating that all morganatic marriages (valid unions contracted between a nobleman and a woman of lower rank) would preclude the children of that marriage from inheriting the father's station. That sanction determined the final decade of don Luis's life, as well as the fates of his wife and children. Don Luis and María Teresa were married in the province of Toledo and resided outside of the court, eventually building a palace in the town of Arenas de San Pedro in Ávila. The official press made no mention of their marriage or of the births of their four children, and their three surviving children could use only their mother's name of Vallabriga until 1799, when Carlos IV permitted them again to use "de Borbón." When granted permission, don Luis could visit the court, but his wife and children could not; his letters to the king went unanswered; in the fall of 1781, he asked Floridablanca to prepare his will.[6]

By early 1783, when Floridablanca assured Goya he was working on the artist's behalf, it seems likely that he had in mind a position with don Luis; equally possible is that Goya's portrait of the minister, commissioned in confidence, was a trial run.[7] Goya's involvement with don Luis's household in 1783 and his return the following summer mark the beginning of a lifelong relationship with the family. Years later, around 1800, Goya painted portraits of the three children, recently reintegrated into the royal family; in 1814 don Luis's son Luis María was regent of the interim government that preceded the return to power of Fernando VII, which offered Goya a stipend to paint scenes of the recent Spanish resistance to Napoleon. In Paris in 1824, Goya

visited don Luis's youngest daughter (the duchess of San Fernando de Quiroga since her marriage in 1817), to whom the artist wrote two months later, sending her three drawings inspired by the fair of Bordeaux. The duchess's patronage extended after Goya's death to his protégée, Rosario Weiss.

Don Luis provided Goya with a coach for his return to Madrid in early September 1783, when the jubilant artist reported to Zapater:

> I just returned from Arenas and am very tired. His Highness offered me a thousand honors I have done his portrait, and that of his wife and boy and girl with a warm reception that was unexpected given that other painters have gone and not succeeded in this: I went hunting twice with his Highness and he shoots very well and the last afternoon he said to me about shooting a rabbit, this dauber is even more of an aficionado than I am. I have been a month continually in the company of this couple and they are angels, they gave me 1,000 *duros* [20,000 *reales*] and a robe [*bata*] for my wife all in silver and gold that is worth 30,000 *reales* from what the wardrobe staff tells me. And they so regretted my departure that they couldn't say goodbye and insisted that I was to return at least every year.[8]

Goya confided a secret: don Luis had arranged a chaplaincy for his younger brother Camilo in the town of Chinchón, about fifty-seven kilometers southeast of Madrid.[9]

Although Goya had portrayed children playing in his tapestry cartoons, at Arenas he painted his first known portraits of children: don Luis's son, Luis María, and daughter, María Teresa, whose age of two years and nine months is recorded on the work (fig. 8). More a miniature adult than a child, she stands before the parapet of a garden opening onto a view of the Gredos mountains, fashionably dressed for a walk outdoors in a black overskirt, or *basquiña*, blue shoes with a silver buckle, a lace bonnet, and a white mantilla. Her faithful lapdog looks out from under his frothy mane, guarding her with clenched jaw. Rejecting precedents that portrayed Bourbon children comfortably ensconced in interiors of gilded rococo furniture (the setting used in the pendant portrait of her six-year-old brother), Goya looked back to the landscapes that had served Velázquez as backgrounds for his portraits of kings, queens, and the ill-fated young prince, Baltasar Carlos. At some point in 1783, Goya also painted a full-length portrait of Jovellanos standing before a coast, presumably that of his native Gijón. As he often did, Goya took advantage of a previously used canvas, painting over a full-length portrait of a woman who has been identified as don Luis's young wife, María Teresa de

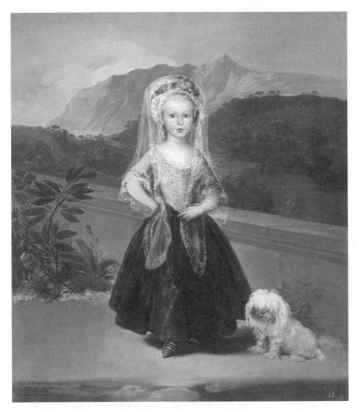

8. *María Teresa de Vallabriga, Later Condesa de Chinchón*, 1783. Oil on canvas, 52 ¹⁵/₁₆ × 46 ¼ in. (134.5 × 117.5 cm). National Gallery of Art, Washington, DC, Alisa Mellon Bruce Collection.

Vallabriga. If that identification is correct, it documents an otherwise unknown portrait and confirms that Goya painted Jovellanos after he returned from Arenas de San Pedro in September, and before the end of 1783, the date of a miniature after the portrait.[10]

In Madrid, family intrigues and petty jealousies soon crushed Goya's high spirits. Writing to Zapater from his brother's house in October, Camilo offered an account reflecting the heartfelt distress of a younger brother accustomed neither to the jealousies common among court artists nor to the lingering animosity between Goya and his in-laws. Goya was "so persecuted with such fervor that they can no longer hide it (for this town is not Zaragoza) they try his patience saying if he said, if he didn't say, and twisting everything they can with lies." Even worse was that they were succeeding in making him hate painting, because "they cannot stand that he gets recognition and honors [that elude] all the others." Addressing Zapater as "Your

Grace," Camilo admitted that he didn't know what to write, that he thought to write Juan Martín [Goicoechea] and cannot, but he will. "At this moment the new brother-in-law [Marcos del Campo] is fighting in favor of Bayeu and against Francho [i.e., Goya] and raising his voice because they have given me the chaplaincy." He added a postscript. "[Goya] isn't at home now; if he had been, he would have suffered because of the argument."[11] Goya's role as the sole support for his family was also taking a toll. His mother, absent from the previous spring's parish census in Zaragoza, was living with him in October and still the following January, when Goya asked Zapater to keep up the rental payments on her lodgings in Zaragoza, adding that "they have me absolutely exhausted, with everything on my shoulders, I assure you I don't know how I do it."[12] Two months later, when a daughter of his brother Tomás wrote to ask for a favor, Goya sent a response through Zapater: "They are holding me hostage so that I cannot tolerate any more, nor can I do any more, for up until now I have had very little luck."[13]

Even if Goya did not tell his estranged brothers-in-law of his triumph at Arenas de San Pedro, Marcos del Campo would have informed them, since his brother Francisco remained in the household (until the year after don Luis's death, when he was summarily told to return to Madrid following a report of the widow's "waxing and notorious affection" for her servant).[14] Bayeu very possibly saw himself as entitled to the patronage of don Luis, even though he had still not delivered a painting of the Virgin and Child commissioned by the *infante* thirteen years earlier.[15] Goya had trumped him, and the position given to Camilo was further evidence of don Luis's favor. Bayeu reciprocated: as Goya enjoyed his stay at Arenas de San Pedro, the minister of finance issued a directive to resume production of tapestry cartoons "of comic and agreeable subjects" for fifteen rooms in El Pardo palace, to be overseen by Bayeu and Maella; Goya was not invited to participate.[16]

Goya continued to fret about his standing with Floridablanca, who now paid less attention to him than before his portrait was painted, telling him: "All in good time"; "prudent men" advised him that it was best not to bother the count and that silence was a good sign.[17] Floridablanca in turn may have felt that he had done enough for the artist by introducing him to don Luis; besides, other artistic concerns distracted him. Fifty crates of art objects, books, and prints from the British ship the *Westmoreland* had been stored in the southern port city of Málaga since shortly after her capture en route from Italy by French warships in January 1779.[18] The secretary informed the king, who ordered on July 8, 1783, that the contents be inspected by a "man of taste." Four days later, the vice-protector of the Royal Academy responded that there was no one in Málaga qualified to assess the prize and

recommended transfer of the objects to Madrid: seventeen crates arrived in October and thirty-three more in November 1783. Floridablanca expedited their passage through customs and paid the bill, charging Antonio Ponz with recording and caring for the objects and with keeping him informed of the project; he also chose works for the king, and some for himself, including an unattributed painting of an apostle and "two boys, half length, in oil, one in the style of Rubens," today unidentified.[19] He also selected two portraits by Pompeo Batoni: one full length, of Francis Basset, Baron of Dunstanville, standing among architectural fragments with a map in his hand, Saint Peter's Basilica and the Castel Sant'Angelo in the distance; the other three-quarters in length, of George Legge, Viscount of Lewisham, seated and studying a map of Italy.[20] Soon installed in the antechamber to Floridablanca's bedroom in his official residence, these portraits surely overshadowed Goya's effort in the eyes of the secretary of state, who had sat for Batoni during his tenure as ambassador in Rome.[21]

Zapater's impression that his friend "will have money to burn with so many works and payments" signals an improvement in Goya's situation that the ever-wary artist refused to admit.[22] As 1784 opened, the four altar-pieces for the chapel of the college of Calatrava and an equestrian portrait of María Teresa de Vallabriga (today lost, but known through a sketch in the Uffizi, Florence) were under way, but Goya found no joy in his work and in July confessed to Zapater: "I am worn out and I do not work much."[23] Only in late summer did a second invitation from don Luis offer him the respite of a working vacation; once in Arenas, he could shoot the partridges that abounded, and even Josefa, seven months pregnant in October when she returned to Madrid, was given a tour of the palace by the *infante* and his wife.[24] Goya completed the equestrian portrait of María Teresa and undertook a group portrait of the family and servants at home (pl. 4).

Measuring about eight by eleven feet, Goya's portrait of the family gathered at home is far larger than the British "conversation pieces" with which it has been compared. María Teresa de Vallabriga sits at center behind a gaming table attended by her hairdresser, García Santos; her husband sits stiffly in profile to her right; and a single candle on the table provides the scene's sole source of light. The seven-year-old Luis María stands behind his father, his juvenile profile underscoring his father's age; his inquisitive little sister María Teresa, now taller and with less baby fat than in the portrait painted a year earlier, is too impatient to pose and looks toward Goya in the left foreground. The artist crouches before a canvas placed vertically on the easel before him to which he has applied an earth-toned ground and now paints the outlines of a full-length figure of a woman (a subject unrelated to the scene at

hand). Candlelight casts Goya's silhouette onto his canvas, to recall the myth of the origin of painting in which a Corinthian maiden traced by candlelight the silhouette of her lover. This myth was the subject of two paintings by the Scottish artist David Allan, included in the *Westmoreland* trove; one version of Allan's painting remained at the Royal Academy and was possibly among the works from the *Westmoreland* exhibited in spring 1784. The image possibly inspired Goya's shadow cast on the canvas, for there is no doubt that the Spanish title of Allan's work, *Invención de la pintura* (*Invention of Painting*), would have piqued his interest.

In addition to don Luis, his wife, and offspring, Goya portrays seven other adults: two women bring in a lace cap or *escofieta*; an older woman holds the one-year-old María Luisa; two gentlemen look either toward don Luis or the painter's canvas; and on the far right, two male servants acknowledge the viewer. The central table floats in space, unconvincingly supported on a single leg, hinting that the composition may have remained unfinished following the *infante*'s death the following year. Or, perhaps, nothing more was to be painted, since the ellipses in the painting would have been far less distracting to the viewer of 1784 who saw the work—perhaps placed across from an entrance—illuminated by candles or oil lamps so different from the modern lighting of today's museum galleries. Clearly visible nonetheless were the faces, expressions, and postures of those portrayed, players in a scene of familial comfort and of social hierarchy. In a manner reminiscent of Velázquez's *Las Meninas*, in which the figures in the painting one by one become aware of the king and queen entering the room (reflected in the mirror on the rear wall), Goya re-created the momentary experience of a visitor who quickly surveys the scene upon arrival. The gathering is yet to be interrupted, for only María Teresa de Vallabriga and the servants have noticed their guest, the viewer.

A necessary return to Madrid in October curtailed Goya's pleasure at Arenas. Carlos III ordered that the project at San Francisco el Grande be brought to a long-awaited close, and Goya joined five other artists putting final touches to their works in San Francisco el Grande. (Bayeu alone was absent and sent word from Toledo that his painting needed no retouching and that he would return to Madrid at the end of the month.[25]) Goya's home life was also improving, for his mother soon returned to Zaragoza accompanied by Camilo. Although he had to refuse don Luis's invitation to return to hunt at Arenas,[26] Goya apparently continued to work for these patrons, painting a portrait of their architect, Ventura Rodríguez, at the order of María Teresa de Vallabriga.[27] From Madrid the artist wrote to Jovellanos to inform him that the four paintings for the church of the College of Calatrava, "all with figures larger than life," were completed, and asked how delivery was to be

arranged. He added that the canvases could be removed from their stretchers and rolled, a detail that confirms that they were thoroughly dry and possibly had been finished before Goya's departure for Arenas. Jovellanos reported to the Council of Orders the next day that the paintings "and particularly the Conception and the Saint Bernard are the best that have come from his hand. So confirm many people of taste who have evaluated and admired them."[28] Once again, Goya's gratification was delayed: the altars were yet to be completed, and six years passed before the church was consecrated on July 25, 1790. The artist also outlived these paintings, destroyed during the Peninsular War.

Having received 30,000 *reales* from don Luis, supplemented by the payment of 4,000 *reales* for the Calatrava altarpieces (signed by Jovellanos, "your most affectionate servant and friend"[29]), Goya again decided to invest, and following the advice of "some friends that I have here" purchased fifteen shares, each valued at 2,000 *reales*, in the National Bank of San Carlos.[30] The investment was political as well as financial, since the bank was a central government initiative, founded two years earlier to support an economy depleted by war with England;[31] the "friends" who advised Goya might have included Jovellanos, who had represented the Council of Orders on the bank's founding committee. Goya noted in the *Italian Sketchbook* the consecutive numbers of his shares; on the facing page, he later added a list of royal bonds purchased between 1785 and 1788.[32]

With the altarpieces for San Francisco el Grande awaiting the church's consecration, Goya wrote to Zapater in early November that people were starting to talk, although nothing mattered until the king saw the works.[33] The *Memorial literario* of December 1784 reported the ten-day celebration of the consecration of the church, which opened on December 6, with the benediction of the monastic community, and continued the following day with the placement of the Holy Sacrament. On Wednesday, December 8, the day of the Immaculate Conception (to which Carlos III was particularly devoted), the king and the prince of Asturias attended the inaugural Mass. The portrait of the king was removed from the presbytery, and a prie-dieu and cushion placed for him; a cushion was also provided for the prince. A guard of 160 men formed two columns flanking a pathway beneath the monumental dome from the entrance of the church to the presbytery. Carlos III descended from his coach and walked to his place. At the end of the Mass, he and the prince departed as they had arrived.[34] There is no mention that they paused to admire the altarpieces installed in each of the six chapels along the circumference of the circular-plan church, and, with the royal guard flanking his procession, it is unlikely that the king could even see them from the

central aisle. Nor has any evidence come to light of any reaction from the members of the royal family, who attended masses daily during the following week.

Three days after the king's visit, Goya wrote: "It is certain that I've been fortunate in the eyes of the connoisseurs and of all the public with the painting at San Francisco, all are on my side, without a doubt, but up to now I know nothing of what might come of it from higher up, we'll see when the king returns from his trip, and I'll give you all the details."[35] A month passed before he reported, "Of my things there is nothing from above, nor do I think there will be."[36] The *Memorial literario* included in April 1785 an account of the architecture and altarpieces of San Francisco el Grande, providing the names of the artists and description of their subjects with no further commentary.[37] That same month Antonio Ponz wrote to Floridablanca requesting compensation for the unsalaried artists, Ferro, Castillo, and Goya; two months later, Floridablanca noted that "although the paintings were not great, it is certain that those by these [painters] were the least bad" and ordered that each be paid 4,000 *reales*, bringing the "competition" of San Francisco el Grande to a close.[38] In addition to the 6,000 *reales* paid in December 1783, Goya's total payment for his altarpiece was 10,000 *reales*, one-third of that for which he once had hoped.

December 1784: As the inaugural masses were celebrated in San Francisco el Grande, Camilo arrived in Madrid. Josefa was in bed with high fever following the birth of a son, and Goya was anxiously seeking a nurse for the child, when a "good-for-nothing" nephew arrived; Goya sent him packing to Zaragoza and asked Zapater to pay the coachman. He had had enough; his family only caused him trouble, and he was considering leaving letters from Zaragoza unopened, unless the handwriting was that of Zapater or Goicoechea. Since his mother did not know how to write, he depended on Zapater to keep him informed of her health.[39] Of his seventh known child, born on December 2 and baptized the following day as Francisco Javier Pedro, in the church of San Ginés, Goya wrote only, "a very handsome and robust boy...God willing this one will survive."[40] At long last, his hopes were not disappointed.

"The happiest man"
1785–July 1786

WITH San Francisco el Grande in the past, new commissions, and a healthy, newborn son, Goya began to enjoy success. Rather than dwell on every perceived slight from his superiors, he now reported to Zapater recent news of the court from the perspective of an insider. No longer a recent arrival from the provinces, he delighted in life in Madrid, proclaiming, "Here one lives, and not in any other place in Spain." Comparing Madrid to Zaragoza, he conjured an image of a modern-day torment of Saint Anthony, clearly inspired by the debacle of El Pilar four years earlier:

> Your little room was fine with chocolate with *roscones* [doughnut-shaped pastries], but without liberty and not free from various insects with instruments of torture of hooks and knives, that time and again lift one's flesh with studied negligence and put your hair on end, and not only do they spin and fight, but they bite and spit, sting and pierce; fatter ones feed on these, and they are worse, because no defense has been discovered but the grave, not because they excuse the dead. And not even buried can they be inoffensive because their cruelty reaches even the nearby corpses; the only way is to know how to keep a distance where their cruelty can't reach.

He urged his friend and Goicoechea to join him in Madrid, continuing: "This contagion is common in all villages where one was born if it is small and there is not much money, but here we do not know such aggravation, something you only realize when you enjoy this happiness. I would like to see you and Goicoechea here, for you are the ones I worry about."[1] Professional demands kept the friends apart, and when they tried to meet in Valencia during an upcoming trip that Zapater had scheduled, Goya had to demur: "Friend, I

am infinitely sorry that your trip to Valencia will be so short, because I can't go at that time."[2]

Madrid in fact offered spectacles unmatched anywhere else in Spain, including the celebration of the marriage of Carlota Joaquina, the daughter of the prince and princess of Asturias, to the Portuguese *infante* Juan of Braganza in March 1785. Regretful that Zapater was not with him to see the procession from the palace through the streets of Madrid to the church of the Virgin of Atocha, Goya described "the entire royal train that made a very pretty sight (and I thought of you, which usually happens with all my best diversions.) there was a fine illumination in the Plaza Mayor, better than other times for my taste and that of others."[3] The Portuguese ambassador hosted two nights of celebrations in a ballroom designed for the occasion in the Corinthian order by the architect and academician Pedro Arnal, and musicians played on an exterior balcony for the pleasure of the Madrid public. Although Carlos III rejected proposals requiring funds from the royal treasury, Spain's major mercantile corporation, the Five Major Guilds (Cinco Gremios Mayores), subsidized the illumination of the seventeenth-century Plaza Mayor,[4] and buildings along the procession's route were decorated by their residents. The king delighted in it all: "The adornment, illuminations, cheers, and continuous applause of an immense crowd filled his Majesty with satisfaction, but that which most satisfied his paternal love was the joy and contentment he saw everywhere. The government had taken precautions to ensure public order; but it should not go unstated that the urban culture, not at all common, of the people of Madrid gave the police no reason to exercise their authority."[5]

The royal wedding brought don Luis to Madrid, offering Goya the opportunity to pay his respects: "The poor infante don Luis could not go out, for he is in very bad condition, today I kissed his hand to say farewell for he departed for his home one-half hour before the King left for Aranjuez. And from what I saw these days, it seems that he was pleased to see me often and I observed that this time he will not survive, and others think so as well."[6] Even in death, don Luis did not return to court. His funeral took place in the church of the Virgin Mary at San Ildefonso on September 5, 1785.[7] Goya now rarely mentioned Floridablanca, in whom he had once placed so many hopes, having perhaps realized that the secretary had ambitions far beyond the welfare of artists. His well-known proclivity for favoring family and friends was proven by the rise of his younger brother, Francisco Moñino, from lawyer in the royal councils in 1770 to governor of the Council of the Indies in 1787, justifying the rumor reported by Goya that "his brother" was in line for the position of minister or secretary of grace and justice.[8] The

secretary's brother-in-law rose to superintendent of the canal of Murcia, and an old friend was appointed to the Council of Castile in 1783. The deaths of ministers appointed years earlier by Carlos III offered opportunities for Floridablanca to consolidate his power further.[9] When Manuel de Roda, minister of grace and justice since 1765, died in 1783, Floridablanca assumed the position on an interim basis. In January 1785, Miguel de Múzquiz died, having served since 1766 as minister of finance and since 1780 as interim minister of war, an appointment that, coupled with the death of his son, was said to have taken a toll on his health. Goya captured the aged and earnest minister, his face tired and careworn, in a pencil portrait probably drawn shortly before his death and later engraved by Fernando Selma as the frontispiece to his eulogy.[10]

To replace Múzquiz as both minister of finance and interim minister of war, Floridablanca appointed his protégé, Pedro López de Lerena. According to one contemporary account, Lerena had neither good breeding nor talent, and his contempt for the founder of the National Bank of San Carlos, Francisco Cabarrús, led him to squander 6,000,000 *reales* of the bank's money in an ill-conceived deal in Paris.[11] Following Lerena's death, Jovellanos wrote that he was "not only illiterate, but lacking any kind of education or knowledge,"[12] and confirmed that his long relationship with Floridablanca explained his ascent to power. The count's maneuvers brought him to the zenith of his power in 1787, when he created the Junta Suprema del Estado (Supreme Committee of State), composed of all the ministers under Floridablanca, who hosted their weekly meetings.[13]

Requisite to Goya's enduring success at court was to maintain a public face: personal views or private concerns expressed in his correspondence with Zapater remained confidential, and he was ever respectful of the patrons he recorded in portraits, in which naturalism and flattery are held in perfect balance. In May 1785 he was painting a portrait "for" (and presumably of) the new minister Lerena, today lost, as beyond the royal palace, he painted the Chilean José de Toro Zambrano, the first in a series of portraits of the directors of the National Bank of San Carlos, for which Ceán administered payment in April 1785.[14] He solicited the position of deputy director of painting in the Royal Academy, left vacant by the promotion of Antonio González Velázquez to the post of the recently deceased court painter Andrés de la Calleja;[15] on the first day of May, in a secret ballot, twenty-one academicians cast four votes for Ginés de Aguirre, eight for Gregorio Ferro, and nine for Goya (given his relation, Francisco Bayeu recused himself). Antonio Ponz wrote to Floridablanca proposing both Goya and Ferro for royal consideration; on May 11 the response came that the king had selected Goya.[16]

With the announcement at the meeting on June 5, Goya was invited to enter the room to be congratulated by all in attendance; he in turn "thanked the committee for having honored him."[17] He also wrote to Ponz thanking him for the honor, which brought with it a stipend and quarterly teaching assignments.[18]

Beyond the court officials who had to date been Goya's main clientele, new patrons sought him out. In July 1785 María Josefa Pimentel y Téllez-Girón, the countess-duchess of Benavente, and her husband, Pedro de Alcántara Téllez-Girón, the marquis of Peñafiel (the future duke and duchess of Osuna), ordered a payment to Goya of 4,800 *reales* for their portraits. Painting a learned and powerful woman from one of Spain's oldest aristocratic families, Goya portrayed her gazing warmly and steadily at the viewer, as she turns slightly to her right, presumably to face the portrait of her husband (pl. 5). With elegantly gloved hands and forearms gracefully extended, she holds a closed fan in her right hand, her left poised on a walking stick, both subtle gestures that bring her grace and elegance to life.

Fascinating to all who see this portrait are the details of the countess's impeccably rendered dress, hat, and accessories: Goya knew his fashion, and his letters to Zapater reveal his keen interest in clothing both masculine and feminine. He assured his friend that two dresses being sent to Joaquina Alduy could not be improved upon; and in responding to Zapater's request for a greatcoat wrote, "I believe that one of such taste has not been seen, for even here it took a lot of walking to find this material, that I had only seen once, and there are very few greatcoats made of it. Pirán made himself one of the same [material] but the color is awful." Writing of a dress he had just sent, he closed his letter, "I will be very happy if you like the adornment [*guarnición*] it is excellent"; such *guarnición* included lace and ribbons (which Goya also sent to Zaragoza), borders, and flowers, all elements masterfully handled in the portrait of the future duchess of Osuna. In no way superficial, Goya's knowledge of women's fashion extended to a corset (*cotilla*), also sent to Zaragoza.[19]

The sitter gave birth to a second daughter on September 21, two months after the order for payment to Goya for the portraits, leaving no doubt that she was pregnant when he painted her. Given that she had lost four children before the birth of her first daughter in 1783, her pregnancy was a joyous event, possibly commemorated by the portrait. Her ample blue skirt, ornamented with lace, ribbons, and flowers, minimizes her condition, and the trompe l'oeil touch of brilliant pink bow distracts the viewer's eye. Ribbons, feathers, and flowers adorn her straw hat, providing a frame of French fashion that sets off her curled hair, soft gaze, and slight smile; other women painted by Goya

during the next few years seem like mannequins in comparison, staring vacantly, among them Floridablanca's new sister-in-law, the marquesa de Pontejos.[20] The countess apparently liked the artist as well as the portrait, for the following summer Goya accompanied "la de Peñafiel" on a hunting excursion,[21] and commissions for more family portraits and seven paintings to decorate her house outside of Madrid followed two years later. Her patronage of Goya continued into the second decade of the next century.[22]

Goya informed Zapater of his daughter "Paulita's" death in the letter previously mentioned, which can be dated to late spring or early summer; he also referred to a painting he was now finishing, and believed "that with what they pay me I can pay you."[23] The plural "they" suggests the countess-duchess and her husband, whose July payment allowed Goya to repay Zapater in August for loans made to his family: "I think that this leaves us free of debts." Another family issue was resolved when Camilo, now settled in Chinchón, took Gracia Lucientes to live with him; passing through Madrid in August, they stopped to see Goya, who accompanied them to Chinchón, where he planned to spend fifteen days hunting.[24] Upon his return to Madrid, Goya completed a large *Annunciation* for another grandee, the duke of Medinaceli, to be placed at the summit of a new altarpiece in the Capuchin convent church of San Antonio del Prado, consecrated on December 8, 1785. The renovation of the church involved Sabatini, as well as carpenters, sculptors, and gilders, among them "Don Antonio Peral," a possible misidentification of Andrés del Peral, master gilder and collector, whose portrait Goya exhibited thirteen years later at the Royal Academy (fig. 17).[25]

Goya threw himself fully into his new role at the Royal Academy. His attendance at the monthly meetings (*juntas ordinarias*) in 1786 was almost perfect: his presence at eleven of thirteen meetings surpassed that of Bayeu. The involvement offered him the opportunity to maintain acquaintances with Ponz, who attended all the meetings, and with Jovellanos, who found time to attend five of the *juntas ordinarias* that year; he could also keep up with old friends from his days in Rome, the sculptors Juan Adán, elected deputy director of sculpture in February, and Joaquín Aralí, who had been elected an academician a month after Goya.[26] Assigned to teach a monthlong shift four times each year, he tried to write to Zapater in March from the drawing class, only to admit: "There are so many who are calling me to correct that I don't know how I write to you." Student interruptions did not keep him from expressing his contentment with his new financial security: "I do not have what you have, for all my work I don't have more with shares, the bank and the Academy than 12,000 or 13,000 reales annually and with all, I am as content as the happiest man."[27] Without the distraction of students, he continued

two weeks later in the same vein, looking beyond finances to express his satisfaction with his way of life: "Of my affairs there is nothing new to tell you except that I always work with the same integrity, which pleases me, without having to deal with any enemies or being subject to anyone, I don't want to do the antechambers I have enough and I don't kill myself for anyone."[28]

New commissions and responsibilities caused the artist to lapse in his correspondence, for which he offered a heartfelt apology in June: "I regret nothing more than if you think that I don't remember you, you have to understand that there are not two days of the year that I don't think of you and how fortune has made me lose so much with your absence."[29] This hiatus in his correspondence from March 25 to June 20, 1786, coincided with a period of transition in the tapestry factory, which marked a turning point in Goya's career. The death on March 25 of Cornelius Vandergoten set in motion petitions for reform and bids for the directorship. The first came from Livinio Stuyck and Vandergoten, who identified himself as the deceased director's nephew and requested that prior agreements be honored and that he be appointed director under the same terms as his uncle. Senior weavers in the factory lost no time in presenting a counterproposal to Lerena, stating that Stuyck had no knowledge of tapestry and reminding the minister that the original objective of Philip V in founding the factory was to educate Spaniards in the art of tapestry. Three weavers—Manuel Sánchez, Antonio Moreno, and Tomás del Castillo—had been assistants to the director and now asked that they be named to fill that position on behalf of the many dedicated and mistreated Spanish workers who, they wrote, had long been underpaid as the Vandergoten family prospered. They also raised the issue of assigning one or two painters to the factory to oversee the quality of the tapestries produced, as was done in "Rome, Paris, and other courts."[30] Tomás del Castillo may have had an ulterior motive in suggesting the involvement of painters, for four days later his brother, José del Castillo, wrote to Floridablanca asking to be considered for the position of artistic director.

Floridablanca forwarded Castillo's petition to Lerena, who in turn delegated the issue to Francisco Bayeu. On April 16 Tomás del Castillo responded to Bayeu's request with a report "giving you the information about the tapestry factory that you requested on order from a superior." He again advocated on behalf of the Spanish workers, reiterated the need for a painter to supervise quality, and questioned Stuyck's relation to Vandergoten, stating that Stuyck had appeared ten years earlier, and "at the beginning was not a relative [of Vandergoten] and after he [Vandergoten] declared him his nephew, even giving him the same last name." The following day Bayeu wrote to

Lerena confirming that one painter would be enough for the position and still would have time left over to paint for the factory or for other commissions. He recommended José del Castillo.[31]

We can only imagine how Bayeu's recommendation was received at home and ask if his ethics had prevented him from considering how such a position might benefit his family. Four days later he wrote again to Lerena with a new proposal, still recommending Castillo, but adding, "in case Your Excellency imposes another new procedure to supply that factory with paintings; this is to salary two, or three, good painters, for this would be enough, without paying them any more than a salary, and thus the king would spend less, and this plan was already made by Don Antonio Rafael Mengs, who did not have time to implement it because of his absence and early death." He then recommended "my brother in first place, in second, my brother-in-law don Francisco Goya, and in third, don Joseph Castillo." In case Lerena questioned Bayeu's ranking, Bayeu dedicated the remaining half of the petition to a justification of his brother, Ramón.[32]

On June 18 Bayeu and Maella proposed to Lerena two painters to supply tapestry cartoons, each with an annual salary of 15,000 *reales*: Ramón Bayeu and Francisco Goya.[33] José del Castillo had gained nothing. Francisco Bayeu allowed him to continue a series of cartoons already begun for the bedroom of the prince of Asturias in El Pardo palace, for which Castillo delivered six cartoons in 1787, after which he turned to a commission given by Floridablanca to paint the ceilings of his residence. After Castillo completed these in May 1792, he found himself unemployed, and his request for more work was denied.[34] We might recall that in 1776 Mengs had judged Castillo a "good man, punctual in carrying out commissions in a variety of genres"; and although he probably would never have proved serious competition for Goya, Castillo may well have eclipsed Ramón Bayeu had he found a protector, or a powerful brother, at court.

Goya owed his official position at court to his perceived nemesis, Francisco Bayeu:

> I am finally painter to the king [*pintor del rey*] with 15,000 reales, although I do not have time I'll just say that the king sent an order to Bayeu and Maella to look for the best painters around to paint cartoons for tapestries and whatever else was needed in the palace, in fresco or oil.
>
> Bayeu proposed his brother and Maella proposed me, it went up to the King and was approved and I without knowing anything it

caught me by surprise and I didn't know what was happening. I have thanked the king, the prince, and those other directors and Bayeu, who says he was behind Maella suggesting me, and Maella for having proposed me and good-bye I will write soon.[35]

The five-year feud between Goya and Francisco Bayeu came to an end, and no one was more pleased than Manuel Bayeu, who reported that Bayeu had to convince Maella to recommend Goya over his own brother-in-law, Antonio González Velázquez. Once the order was approved: "Francho went to the royal residence [La Granja] with the two brothers and presented them to the king and their highnesses, whose hands they kissed, and all comported themselves well. This work of Francho, since it had been some time since they dealt with one another, has been for me of the most satisfaction that I have had. God willing they live in peace and as God commands."[36]

———

Goya began shopping for a carriage, a very public attribute of social status in late eighteenth-century Madrid.[37] His first idea was to buy a light, two-seated, two-wheeled open carriage, or *silla volante*, but he soon upgraded to a more luxurious model, a *birlocho*, a four-seated, four-wheeled open carriage. Possibly after reading an advertisement for a "birlocho in the English style, in good taste and new,"[38] he went out for a test ride on July 25, and when the seller asked if he wanted to learn a new turn, Goya handed him the reins (the horse was included in the purchase): the road proved too narrow for the maneuver, and carriage, seller, and Goya went flying. A week later, as he waited for the royal surgeon to look at his leg and give him permission to walk, he wrote a long letter to Zapater, in which he described his *birlocho* in the English style as "so light that another like it is not to be found, with beautiful shining gilded iron work, whoa: even here people stop to look," recounted the details of his accident and of his new position, and expressed his satisfaction with his current situation, with an income of "a little more" than 28,000 *reales*.[39]

Soon on his feet, and despite his swollen ankle, Goya proved himself the best shot on two hunting excursions, one the previously mentioned outing with the countess-duchess of Benavente, or "la de Peñafiel."[40] But even as his fortunes with aristocratic patrons continued to improve, his skill as a driver of his fashionable *birlocho* did not. He decided against keeping the carriage the following April, having "turned over and almost killed a man who was walking on the street," and bloodying himself in the process. He asked his brother Tomás to find him a good pair of mules and asked Zapater to make

sure "that others don't find out because it is embarrassing." Goya calculated that with his earnings from private commissions, he could maintain a more modest closed carriage (or *berlina*), "very decent, but nothing more," which he made available to Zapater and Goicoechea.[41] When he suspected that the Bayeu clan knew of his decision, he consoled himself with the thought that "other people will only be happy because many had advised it."[42] He had yet to be convinced that the brother-in law, who a year earlier had attained for him a salaried position at court, had his best interests at heart.

"God has distinguished us"

July 1786–April 1789

B Y September, Goya was painting sketches for tapestries for the "dining room" of the prince and princess of Asturias in the palace at El Pardo and traveled that fall to El Escorial to present them to the king and, presumably, to the prince and princess.[1] In keeping with his new station as painter to the king, he turned from the popular subjects of earlier cartoons to portray the seasons, a subject with a long artistic pedigree, as subtle harmonies of pastels and shades of gray replaced the bright, saturated hues of earlier cartoons.[2] Aristocrats enjoy nature during the temperate seasons: in spring, a woman accepts a flower from a young girl in a compositional quotation from Velázquez's *Las Meninas*; in fall, a woman accepts grapes proffered by her husband. The lower classes endure the harsher seasons, as hunters trudge through the snow with their bounty, or peasants reap summer's wheat in Goya's most technically superb cartoon, measuring over twenty-one feet in length. Recent cleaning has revealed that, despite the cartoon's impressive scale, Goya lavished close attention on even the smallest detail: grains of wheat, the spoon that feeds the crying infant, the tattered fallen stocking of a drunken fool enjoying the wine poured for him.

Tapestry cartoons now represented only a fraction of Goya's commissions and income. The National Bank of San Carlos paid him 10,000 *reales* on January 29, 1787, for two full-length portraits of the count of Altamira and Carlos III and a half-length portrait of the marquis de Tolosa. In October he was paid 2,000 *reales* for the portrait of Javier Larrumbe, an honorary director of the bank, and in April 1788 received 4,500 *reales* for the full-length portrait of Francisco Cabarrús, the last of the series.[3] The count of Altamira also commissioned portraits of his wife and children, including the well-known portrait of his son, Manuel Osorio, better known as "The Boy in Red."[4] In April 1787 paintings were transported from Goya's home studio to the Alameda

(Poplar Grove), the country house of the countess-duchess of Benavente, who became the duchess of Osuna following the death of her father-in-law that same month.[5] Goya invoiced his patrons 22,000 *reales* for a small portrait of their three children (today lost) and seven rural scenes, sized to fit within the decorative moldings of a small room.[6] Although the concept for decorative narrative series set within nature came from Paris (where the duchess of Osuna traveled in 1787 to contract an architect for the Alameda[7]), Goya's peasant children climbing a greased pole, bandits, gypsies, and villagers participating in a religious procession were uniquely Spanish.[8] By June three altarpieces, requested by Lerena and ordered by Sabatini for the church of Saint Anne in Valladolid, were foremost on Goya's mind: with life-size figures of Saint Anne, Saint Bernard, and Christ with Mary at Joseph's deathbed, they were to be completed and installed by the feast day of Saint Anne on July 26.[9] Contrary to the popular image of Goya painting directly from nature, the inclusion in his receipts of twenty-two *varas* (units of length slightly less than a yard) of blue and carmine Holland cloth for a "tunic and a mantle" suggests a more traditional preliminary: a drapery study for the clothing of Mary and Joseph.[10] On March 23, 1787, both he and Ramón were granted the service of a *moledor* (literally, a grinder) or studio assistant, to be shared between them and relieving them of manual labor; they would also be reimbursed for supplies; Goya also soon had an amanuensis.[11]

In keeping with his new status and aristocratic clientele, Goya decided to study French, and was not alone in his aspiration: from 1786 to 1789 five French language schools opened in Madrid.[12] He tested his ability by writing a letter in the language to Zapater, but did not try again, admitting that he found writing French too difficult but could, with effort, understand it when spoken.[13] Within the Royal Academy, he served on a committee tasked with assessing a collection of paintings offered to the king by its owner, Juan Esteban de la Hoz; the academicians advised against the purchase, judging the collection rich in small works of the Flemish and Dutch schools appropriate for the decoration of cabinets but lacking in history paintings.[14]

A new series of tapestry cartoons soon occupied the artist, who in early February 1788 paid for five "stretchers with their canvases for tapestries for the bedroom of the Infantas [at El Pardo]"; priced at 12 *reales* each, these were clearly small canvases for preliminary sketches. On April 10 he paid 1,040 *reales* for stretchers for the full-scale cartoons, for which 100 *varas* (about 84 meters) of canvas and tacks had already been ordered.[15] By May 31 Goya had received orders to finish all the "diseños" by the time the court returned from Aranjuez on June 30.[16] It was a gargantuan task: the largest cartoon of the Meadow of Saint Isidore was to measure about twenty-eight feet in

length. He applied himself, according to his account to Zapater, with "great determination and bad humor, for the time is short and it is something to be seen by the King, Prince and Princess, etc.; in addition to this, the subjects are very difficult, with a lot to do, such as the meadow of Saint Isidore on the saint's day, with all the hustle and bustle that usually happens at court."[17] Goya apparently missed his deadline. Only one cartoon from the series, *Blind Man's Bluff*, survives; with fewer details, and more quickly painted than previous tapestry cartoons, it suggests that the artist was in a hurry.[18] Within months there was no longer a demand for the cartoons, since following the death of Carlos III in December 1788, his successors no longer stayed at El Pardo. All that remains of the commission, in addition to *Blind Man's Bluff* and its sketch, are two sketches depicting the Meadow of Saint Isidore and the Hermitage of Saint Isidore.[19]

Goya was ever conscious of the quickened and stressful pace of his life, writing to Zapater: "Time passes without knowing it" (August 23, 1786); "I am behind on works for the King" (January 10, 1787); "I'm working a lot, and I have almost no fun" (February 26, 1787); "How I would like to come to Zaragoza for a couple of months" (June 13, 1787); and, with the demands to finish the cartoons for the bedroom of the *infantas*, wrote, "I neither sleep nor relax until this is finished, and don't call this living, this life of mine" (May 31, 1788).[20] Even under pressure and unable to see his friend, he had not lost his sense of humor: "I would like to know, if you are good looking, serious, noble, or unhappy, if you have grown a beard and if you have all your teeth, if your nose has grown, if you wear glasses, if you walk erect, if you have any gray hairs and if time has passed for you as it has for me." The self-portrait he then offered reflects the toll taken by time and work: "I've grown old with many wrinkles so that you wouldn't know me were it not for my snub nose and sunken eyes."[21]

With new wealth and a healthy son, Goya took family matters in stride. He mentioned Josefa and three-year-old Francisco Javier (hereafter, Javier) in his letters only when both had high fevers; he sent money regularly to Zapater for his sister Rita; his brother Tomás and his family arrived in Madrid in May 1787.[22] Goya's inclusion of a fee for gilding the frames for two portraits delivered to the National Bank of San Carlos following his brother's arrival in Madrid suggests that he employed Tomás in the project, as he had thirteen years earlier at Aula Dei.[23] He rejoiced in the good fortune he shared with Zapater: "Boy, you and I are so much alike and God has distinguished us among others for which we give thanks to He who can do all."[24] If He could do it all, Goya could not, and confessed to Zapater that he had to put aside his friend's request for a painting of the Virgen del Carmen.[25] Forced to admit

to Zapater that he could not meet the obligation, Goya wanted his friend to know that the archbishop of Toledo was treated no better, a comment interpreted as a reference to a commission for an altarpiece for the cathedral in Toledo, completed over a decade later.[26]

Unable to fulfill commissions for his friends, Goya did what he could. He responded to queries from Goicoechea related to the proposal to found a royal academy in Zaragoza and to current styles in painting, which Goya identified as the "architectural style," before referring Goicoechea to his friend the sculptor Aralí.[27] Goya even invited a commission from Goicoechea, asking Zapater to relay the message: "If he wants drawings to be made for him by the best that there is who lives from this and who is appreciated in the Palace because of it," he should send measurements of the walls of all the rooms, identifying windows and doors and their height; if Goya ever completed these drawings, no trace survives.[28] He also sent Zapater quinine from the royal pharmacy to remedy his tertian fevers.[29] This was no small favor, given that the spread of these fevers by mosquitoes had reached epidemic proportions in southern Spain two years earlier and by 1786–1787 had spread to Aragón, while the realization in 1783 that quinine was an effective treatment resulted in trafficking and shortages.[30] Zapater in turn served as financial intermediary for Goya's payments to his family; in a letter of March 1788, Goya also asked his friend to find opportunities in Zaragoza for the guitarist and singer Paco Trigo, famous in Madrid and a recent success in the southern port city of Cádiz.[31]

The rapid evolution of Goya's style during these years astounds. Returning to paint the duke and duchess of Osuna in 1788, now surrounded by four children (pl. 6), he abandoned the bright blues and pinks, abundant ribbons, and feathers seen in the portrait of the duchess painted three years earlier. Grays, greens, and pinks dominate, as Goya defines the duchess's muslin gown by working from darker grays to lighter and adding almost evanescent horizontal lines to subtly define volumes. Paint becomes form, of ruffles and buttons, bodices and bows, worn by the mother and her daughters; the green tones of the one-piece "skeleton" suits worn by her two young sons harmonize with the upholstery of the duchess's chair and the green-gray tones of the background. The duke looms behind; dressed because of his father's death in obligatory mourning, he appears as an intrusion on this quiet pastel homage to enlightened motherhood even as he shelters his wife and children.[32] In October 1788 Goya invoiced the duke and duchess 12,000 *reales* for this portrait and also 30,000 *reales* for two altarpieces, painted for the family chapel in the cathedral of Valencia illustrating scenes from the life of the duchess's ancestor, Saint Francisco Borja. This brought the total income

from paintings commissioned in 1787 and 1788 by the duke and duchess to 64,000 *reales*, over four times Goya's annual salary; the sum was paid over a period of years up to January 1793. The days of worrying about the expense of a hunting excursion were long gone.

The smallpox that possibly claimed the lives of Goya's children continued to threaten infants and adults, the poor and the rich, and even the royal family.[33] On November 2, 1788, Mariana Victoria of Portugal, the daughter-in-law of Carlos III and wife of the well-loved *infante* don Gabriel, succumbed. Her infant son died a week later at El Escorial, and on November 14 the healthy children of Carlos III returned to Madrid, leaving the king and don Gabriel, who had cared for his wife during her fatal illness. Don Gabriel died on November 23. (A decade passed before the royal family was inoculated.[34]) Goya's letter to Zapater on November 19 was an update in a verse that opened with a typical apology to Zapater:

> You are certainly right
> I am a Devil Painter
> And I should not have been
> So silent with you. . . .
> Of recent events
> I want to tell you something
> And it is that that Infante
> Known as don Gabriel
> May by now
> Have already left
> To seek in heaven
> His beloved consort.
>
> With the emotions
> Of so many men and women
> That it is impossible
> To be able to explain it.[35]

The king returned unwell to Madrid on December 1, and consultations with three doctors and various attempts to find a remedy were to no avail. The seventy-two-year-old monarch died in the early hours of December 14. Later that morning the former prince of Asturias began his reign as Carlos IV. His first act was to take the royal seal from Lerena and place it in the hands of the marquis de Valdecarzana, the *sumiller de corps*, or senior officer of the royal household, who had previously served Carlos III. This did

not bode well for Lerena, whose protector, Floridablanca, purportedly prepared a resignation that was not accepted; both would remain in service to the new king for two more years. For the time being, there was continuity between the households of father and son, for in addition to Valdecarzana and Floridablanca, Carlos IV retained his father's majordomo and his master of the king's horse, as well as gentlemen who had served his father, among them the duke of Osuna and the duke of Alba. From the first day of his reign, it was clear that power was shared between the king and his queen, María Luisa of Parma.[36]

Writing to Zapater in early January, Goya dared to jest about the appearance of the court, where everyone dressed in observance of six months of mourning: "Apart from the mourning hatbands everyone has become a crow from their shoe buckles to their pates."[37] Although the *exaltación*, or celebration, of the new king was delayed until mourning was lifted in September, a three-day respite in January permitted the proclamation of Carlos IV and María Luisa to be recognized. The court dressed "de gala," with members in uniform, and the city was illuminated for three nights—a welcome diversion from the long, dark January nights of Madrid. On January 17, 1789, the count of Altamira led the procession of the royal standard to the palace, where the king, queen, members of the royal family, ministers, and ambassadors watched from the balcony as silence was imposed on the crowd. The count then pronounced the words "Castilla, Castilla, Castilla, por el Señor Rey Don Carlos Quarto; que dios guarde" (Castile, Castile, Castile for our Sire and King Don Carlos IV; may God protect), eliciting the crowd's response, "¡Viva! ¡Viva!," rewarded with coins of gold and silver. The procession continued and the proclamation was repeated in the Plaza Mayor, in the plaza of the Monastery of the Descalzas, and finally in front of the town hall on the Plaza de la Villa, where for the following eight days the standard was hung with portraits of the monarchs.[38] At night, torches illuminated the portraits and passing coachmen were ordered to remove their hats and bow their heads before the effigies of the new rulers.[39]

Mentioned in descriptions of proclamation ceremonies throughout Spain and the New World, portraits of the new monarchs by artists unnamed proliferated with no quality control,[40] forcing the city of Madrid to seek an opinion on the many effigies displayed or offered for sale. All such portraits were to be delivered to the Royal Academy, where the academicians, Goya among them, examined them on March 1: the paintings were considered "indecent and monstrous" and "could not be worse, and all of them created with neither knowledge nor skill."[41] The situation was brought to the attention of Floridablanca and soon to that of Carlos IV, who ordered in early April that their

images be "erased" (presumably, painted over) and the stretched canvases returned to the artists for another use.[42] Goya was thus aware of the need to define an image of the new king as he painted two half-length portraits and ordered a custom-made crate to transport them to the royal palace, prior to the departure of Carlos IV and María Luisa for Aranjuez on April 20.[43] Once approved, the portraits were returned to Goya's house, where gilded frames were delivered by July 4.[44]

On April 25, the count of Floridablanca informed the marquis of Valdecarzana that the king had named Goya *pintor de cámara* (court painter). Four days later, a coach drawn by six mules carried Goya and Vicente Gómez to Aranjuez; both were granted the honors of the position, with no change in salary.[45] Having crossed the Manzanares River on the San Vicente bridge, the coach followed a narrow and even road (one of the best in Spain) through an arid landscape dotted with olive trees. The world changed as it entered the verdant and enchanted world of Aranjuez, a fitting metaphor for the charmed life that Goya now lived.

A Coronation under Darkening Skies

April 29, 1789–March 1790

W AITING to take their oaths the following day, Goya and Gómez joined the thousands of courtiers lodged in the village of Aranjuez, built during the reign of Carlos III to house up to twenty thousand people, "almost as comfortably as in Madrid."[1] No site better captured the taste of the new king and queen, who soon eliminated El Pardo from their annual itinerary and after 1792 spent the first half of the year at Aranjuez. As prince, Carlos IV had developed parterres and shrubbery to produce a "vast garden… infinitely varied in its form as well as production."[2] As king, he continued to improve Aranjuez, renovating the palace, continuing the beautification of the grounds, and eventually building and decorating the Casa del Labrador (House of the Farmer). Within three months of his accession, he took the unprecedented step of transferring paintings from one royal residence to another, bringing to Aranjuez almost four hundred works previously installed by his grandfather Philip V in the palace of San Ildefonso at La Granja.[3]

In contrast to his father, Carlos IV was an avid collector and patron of the arts. As early as 1771, a visitor commented on the range of his library that included "very excellent English, French, German, Latin, and Spanish books,"[4] and the following decade, travelers noted his interest in paintings, as the prince looked beyond the riches of the Spanish royal collection to build his own.[5] The exquisite *casitas* he built as prince near the palaces at El Escorial and El Pardo, jewel box–like retreats without overnight accommodations, attest to his passion for architecture and interior decoration. While visiting El Escorial in about 1788, the French traveler Jean-François Bourgoing admired the decoration of the prince's retreat, remarking on the "richest and most highly finished sculpture, gilding, joinery and locksmiths work,"[6] a stark contrast to the sixteenth-century monastery palace looming above. Its

decoration once included a series of cabinet of paintings commissioned by the prince from the French landscape painter Claude-Joseph Vernet, as well as a series of still lifes by Luis Meléndez illustrating the natural bounty and seasons of Spain, which Carlos later transferred to Aranjuez. Improvements continued as Carlos assumed the throne, and Maella completed a series of paintings of Spanish military triumphs, including the taking of Menorca a decade earlier.[7]

Although El Pardo was dropped from the annual itinerary, and its tapestries (among them, four series by Goya) transferred and refit to rooms at El Escorial,[8] work nevertheless continued on its *casita*, which provided a venue for salon-like gatherings with musical entertainment, or *academias*, in which Carlos IV played the violin and participated in chamber concerts.[9] Craftsmen created antique grotesques to adorn its ceilings, as well as frescoes, gilded cornices, and custom-designed neoclassical furniture and rugs, woven by the royal tapestry factory. Silk wall coverings from Lyon complemented the furnishings. The king's interests then turned to the Casa del Labrador at Aranjuez.

Carlos's patronage of the decorative arts explains his prompt appointment of Vicente Gómez and Goya as court painters. His acquaintance with Goya as a painter of tapestry cartoons dated at least as early as January 1778, when he expressed his enthusiasm to the artist; for over a decade he and his consort had lived surrounded by the peasants and *majos*, aristocrats and flirts, who populated Goya's scenes. Goya's recent presentation to the king of a viable royal image may have played some part in the king's decision to appoint him court painter, but within a year the monarch turned to other artists to paint portraits and to Goya to create cartoons for tapestries to decorate his office at El Escorial. Gómez, who described his forte as creating "designs imitating the grotesque style of Raphael of Urbino," had painted ceilings in the prince's bedroom in the palace of El Escorial and in the nearby *casita* before assuming a major role in the decoration of the *casita* at El Pardo.[10]

With his oath taken, Goya attended the *besamanos general* (a ceremonial kissing of the hands of king and queen) celebrated on April 30 at Aranjuez with a "splendid and numerous concourse of grandees, representatives of the kingdoms, foreign ministers, and other distinguished persons who paid respect to Their Majesties."[11] Writing to Zapater after returning to Madrid, he noted that "I also kissed the hand of the king and queen and I was received with a certain special attention."[12] A letter of May 8 to the marquis of Valdecarzana from the miniaturist Eugenio Ximénez de Cisneros confirmed that the queen had in fact made a particular request of Goya:

Having come from that royal residence where he was sworn in as Court Painter before Your Excellency, Don Francisco Goya has informed me that Our Lady, the queen, wants the portraits he has painted in oils of Their Majesties to be copied as miniatures by me for Their Majesties, which I am ready to obey with as much exactitude as possible, as is my obligation: but I will delay beginning until Your Excellency has been so informed, so that, as my supervisor, you might send me the order, which I await in order to begin those portraits.[13]

Shortly before his trip to Aranjuez, Goya had sent Zapater 23,000 *reales* to support his brother Tomás, who soon settled with his wife and two daughters in Gracia Lucientes's native village: documented as a painter in 1796, Tomás remained in Fuendetodos until his death in 1823 or 1824.[14] Returned to a more tranquil household, Goya was both proud and vigilant of his sole surviving child: "I have a boy of four years who is the child who all in Madrid consider as beautiful and he has been sick and I have not lived during the entire time. Now, thanks to God, he is better." With Javier recuperated, Goya asked Zapater for advice on investing 100,000 *reales*.[15] A month later, following the return of the court from Aranjuez, he attended a concert in the royal palace and beamed to Zapater that it was "magnificent, with more than one hundred instruments."[16]

At some time before the court's return to Madrid on June 18, Goya returned to Aranjuez equipped with canvases to begin full-length portraits of the monarchs, later completed in Madrid.[17] He presented Carlos IV as an eminently approachable monarch, who receives us with a benevolent gaze and slight smile, his regal crown and ermine robe relegated to a table in the background (fig. 9). Pointillist decoration of blue and silver enlivens his salmon-rose coat and breeches, its blue and silver coalescing in the silver and gray of his waistcoat, and in the painstakingly rendered silver trim of his coat. His crowning adornment is the Order of the Golden Fleece that hangs from a diamond-encrusted pendant on his chest. There is no context for assessing the dress of a late eighteenth-century Spanish queen, for the country had been without one ever since the death of Maria Amalia in 1760, leaving María Luisa of Parma to create the role she was to play (fig. 10). The costume chosen for her debut borrows from both Spanish tradition and French fashion, with a *tontillo*, or panniers, reminiscent of the *guardainfantas* worn by queens painted by Velázquez, and an intricate headdress of diamonds, lace, silks, and plumage inspired by French fashion. As he had done in portraying the king, Goya lavished paint on the gold, silver, pearls, and gems adorning the queen's

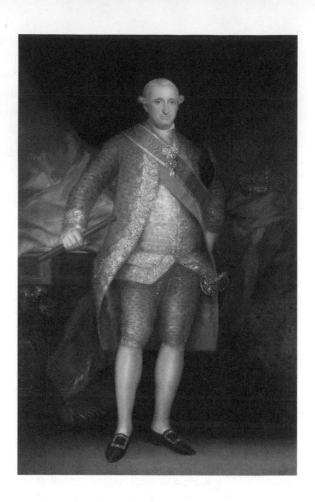

9. *Carlos IV*, 1789. Oil
on canvas, 79 ⅞ × 54 in.
(203 × 137 cm). Museo
del Prado, Madrid.

bodice and headdress, giving them a three-dimensional, physical presence.
Even for the charming, affable, and assertive princess she reportedly was,
María Luisa lost ground to decoration, seeming more a mannequin than a
royal presence, perhaps because Goya possibly painted her garments from
dressed models or mannequins, as she awaited a child, born in early July.

Commissions for replicas or variations of his half-length royal portraits
occupied Goya through the summer, including versions for the tobacco fac-
tory of Seville, for the Royal Academy of History (a commission overseen by
Jovellanos), for the mint in Madrid, and for Lerena; Ceán reported that he
was assisted by Valencian painter Agustín Esteve.[18] An account of a visit to
the king by Mr. Poggetti, the director of *pietra dura* in the royal porcelain fac-
tory, proves that Goya's efforts were not in vain. Poggetti sought the king's
approval of a portrait for a piece of jewelry, only to be told that it was both
"ugly and dirty," and if he needed a portrait, he should go to Goya or to (the

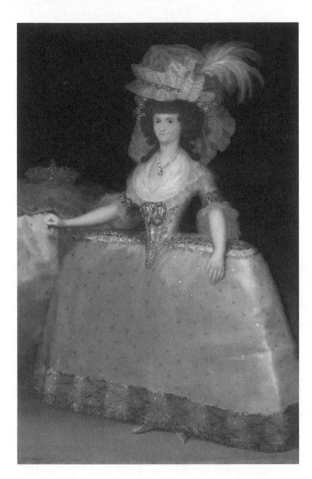

10. *María Luisa with a
"Tontillo,"* 1789. Oil on
canvas, 80 ¾ × 51 ⅞ in.
(205 × 132 cm). Museo
del Prado, Madrid.

sculptor) Celedonio de Arce. The story is recorded by the engraver and ac-
ademician González de Sepúlveda (hereafter, Sepúlveda), who was not one
to recount a story that served only Goya: Poggetti responded by suggest-
ing he contact Sepúlveda, and the king responded with high praise for the
engraver.[19]

As court painter, Goya soon received orders to participate with other
court artists in the inventory of the royal collection, an enormous task tra-
ditionally undertaken following the death of a monarch. Teams of artists
visited all of the royal palaces and residences, recording tapestries and other
textiles, silver, furnishings, watches, porcelain, marble, bronze, carpentry,
mosaics, and, of course, paintings.[20] Goya, Francisco Bayeu, and the painter
Jacinto Gómez together assessed over two thousand paintings in the royal
palaces of Madrid, Aranjuez, La Granja, a country house at El Pardo, and
the Zarzuela palace, on the outskirts of Madrid; a team working with Maella

inventoried paintings in other residences. The inventories were completed with the signatures of all three authors on February 25, 1794. Recording the subject, artist, medium, measurements, and value of each painting offered Goya an opportunity to re-view masterpieces by Velázquez, Titian, Rubens, and Van Dyck as well as genre scenes by David Teniers and other Flemish masters, landscapes on copper by Brueghel, and even the pastels of popular types by Lorenzo Tiepolo (listed separately among the paintings under glass).[21] The values assigned reflect the taste of enlightened connoisseurs: Velázquez's *Surrender at Breda*, in the late king's dressing room, was the most highly valued painting (120,000 *reales*); a *Nativity* and *Annunciation* by Mengs, in the same room, came in second (at 100,000 *reales* each). Velázquez's equestrian portraits of Hapsburg monarchs, as well as *The Forge of Vulcan* followed at 80,000, the same value assigned for both of Titian's seminal works, *The Bacchanal of the Andrians* and *The Worship of Venus*. *Las Meninas*, today considered one of the most fascinating paintings of all time, was valued on a par with Ribera's *Martyrdom of Saint Bartholomew* at 60,000 *reales*.[22]

When in late July Carlos IV bestowed on Martín Zapater the title of Noble of Aragón, in gratitude for loans made to the town of Zaragoza and for his help in securing wheat during recent crises, Goya's response was jubilant: "Congratulations a thousand times over, again and again, and still I fall short, and I would want, and hoped, and hope for much more than what they say, that the King has made you a Noble of the Realm."[23] Their friendship widely known, Goya and Zapater were sought out. When Jorge del Río, a canon of the church of Saint Isidore in Madrid, was appointed precentor at El Pilar, he asked Goya to introduce him to Zapater and Goicoechea; Goya in turn received Joaquín Asensio Martínez, a student of the drawing academy sponsored by the Economic Society of Aragón, who arrived in Madrid to be examined for "master of [architectural] works."[24] Goya's cousin, Félix Mozota, asked him to sign a recommendation for a position at the university in Zaragoza, to be presented to Zapater.[25] Their public status did not impact the private banter of their letters, as Goya told his friend to "Go to hell" for not coming to Madrid for the *exaltación* of the new king and queen, celebrated in September following the mandatory nine months of mourning for Carlos III.

The three-day celebration began on September 21 at five thirty in the afternoon, as the royal family left the palace of Madrid in a suitably splendid procession, which opened with municipal officials followed by halberdiers and musicians; three squadrons of the royal guard; the majordomos of the king's household (riding in four coaches pulled by four mules); musicians playing drums and clarinets; gentlemen of the chamber in ten coaches (each

with four mules and four attendants); and aristocrats in windowed coaches drawn by six mules or as many as eight horses, accompanied by as many as sixteen servants. Only at this point did the populace see the "precious and sumptuous carriage of the Monarchs," drawn by eight horses with two coachmen and ten assistants on foot, preceded by cadets of the royal guard, and accompanied by servants. Four coaches carried members of the royal family, eight coaches followed with members of the royal household, and three companies of the royal guard concluded the parade.

Following a route from the Plaza Mayor to the Puerta del Sol and then along the Calle de Alcalá to the Paseo del Prado, the procession arrived at the botanical garden to be greeted by 208 children, ten to twelve years in age, selected from schools run by municipal charities, each carrying a torch as they formed two semicircles to the right and left of the procession. "Thus did they receive their royal majesties, and with their tender and simple and grateful voices gave to the Monarchs thanks and implored the Heavens for the prosperity and happiness of their long reign." The sight, as reported, warmed the hearts of the monarchs, and the stomachs of the children, who were invited into the greenhouses to enjoy a light supper (*merienda*) attended by many of high rank, including Floridablanca. The garden was illuminated, and three choruses performed.[26] The next day the monarchs, the royal family, aristocrats, and members of the royal household assumed their places on their balconies at the Plaza Mayor to watch a bullfight commemorating the occasion. That evening the royal family crossed central Madrid without ceremony to the palace of the Buen Retiro to spend the night; the following morning in the nearby church of Los Jerónimos nobles swore allegiance to the new prince of Asturias, Fernando, as the legitimate heir to the Spanish throne. The procession crossed the city by a different route to return to the royal palace as the sun set. Passing through their capital, the monarchs viewed the decorations of institutions such as the *casa de correos* (post office) on the Puerta del Sol, illuminated each of the three nights by twenty-eight crystal chandeliers, and 287 torches: at the center of its façade hung two half-length portraits of Carlos IV and María Luisa by Goya, whose royal portraits also decorated the houses of the count of Campomanes on the Plaza de la Villa and of the duke of Híjar on the Calle de San Jerónimo. Although the royal printing house exhibited portraits by José López de Enguídanos on its façade, inside the presses were printing engravings after Goya's portraits.[27]

By the time of the *exaltación*, concern of the Spanish court for the worsening predicament of Louis XVI of France, the cousin of Carlos IV, was growing. Having convened the Estates General earlier that year in a bid for support for desperately needed financial reforms, Louis could not have foreseen that

these meetings would lead to the founding of the National Assembly, composed solely of the third estate, or commoners. Hoping to reassert his control, he dismissed the popular financial director Jacques Necker on July 12; two days later a group of workers from Paris stormed the fortress of the Bastille. With the fortress scheduled for demolition, and only seven prisoners to protect, its governor surrendered, only to have his head paraded on a pike through the streets of Paris. Floridablanca took action on September 18 and again on October 1 by ordering the confiscation of "all prints, papers, printed matter, manuscripts, boxes, fans and any other objects alluding to the events in France." As royal festivities began on September 21, he enlisted the help of the Inquisition with the censorship of materials deemed subversive.[28] That fall the Spanish press remained silent concerning events in France as the National Assembly drafted the *Declaration of the Rights of Man*, and as seven thousand women marched on Versailles in early October to force the return of the royal family to the Tuileries palace in Paris.

For the government press, France served as a foil to the well-being of Spain. The anonymous author of a review of the events of 1789 published in the *Mercurio de España* confessed: "We would well like to veil the situation in which France has found herself since the month of July of the past year; but we cannot avoid treating the political state of a Power that so influences the balance of the States of Europe." Moved by his "noble character and love of his people [*vasallos*]," Louis XVI summoned the Estates General, but those commoners (*pueblo*) mistook "the voice of civil liberty for one of absolute liberty" and "since then, the entire Kingdom has been exposed to the calamity of anarchy, all links of order and subordination progressively broken."[29] The difference between the fortunes of the French people and those of the subjects of Carlos IV could not be more evident:

> While France lamented the combustion of which we have offered a brief sketch, our Spain celebrated the joyous days of the *exaltación* of our sovereigns, and of the oath taking of our Most Serene Prince of Asturias. The capital of this monarchy filled with people from all classes, drawn from the most distant Provinces by the ardent desire to know and pay homage to their august and beloved masters, more than from a desire to attend such stately spectacles; the squares, the streets and the balconies could hardly contain the immense crowds who came with such a worthy goal; and in the middle of the confusion of the crowd, the love and tenderness in their hearts were the best and only manner of maintaining order and the most perfect tranquility.

The author concluded: "Spain, in the end, is on a path to the zenith of splendor, and Carlos IV (we have no doubt) will consummate the great work of public felicity, if the heavens favor his beneficent intentions. We proclaim it: time will verify our notice."[30] In fact, the heavens did not favor the beneficent intentions of Carlos IV, and during the next quarter of a century, politics in France—from revolution, to empire, to war, to restoration—largely determined the fortunes of Spain.

———

Routines resumed. The court traveled to El Escorial on October 5 and returned to Madrid in early December. Goya delivered to the king a portrait he had commissioned for his brother Fernando IV, king of Naples, and reported to Zapater in February that "I had the joy of giving him great pleasure so that he not only praised me with words, but also by putting his hands on my shoulders, half-embracing me, and saying bad things about the Aragonese and Zaragoza; you can imagine my interest." But good fortune did not ease Goya's innate wariness, and he confessed to his friend: "I cannot do more than what I'm doing, my situation is very different from what many will think, because I spend a lot, and because I got myself here, and because I want to. . . . There's also the fact of my being a man so well known from the King and Queen on down, everyone knows me, and I can't subdue my genius as might others, recently I had the desire to ask for more of a salary, but because things are bad and I'm waiting for a better occasion, I don't."[31] His new appointment had brought a title but no raise in salary, yet his status made a carriage, a stylish wardrobe, and a home with a well-furnished studio where he could receive patrons essential.[32]

In fact, times were not auspicious to request a raise, for by now Carlos IV realized the extent of the problems he had inherited, most pressingly a growing national debt that had quadrupled over the past two decades, due in large part to the introduction of royal bonds (*vales reales*) by the National Bank of San Carlos.[33] Making matters worse, the first years of his reign also coincided with three consecutive years of bad harvests throughout Spain, a tragedy last experienced in 1656.[34] To compare the reign of Carlos IV "systematically with the reign of Carlos III would be unjust" according to one historian, for times had changed.[35] Carlos IV was forced throughout his reign to respond to the changing politics of France, and shifted tactics often in an attempt to maintain peace and stanch Spain's hemorrhaging economy. Royal appointees came and went, as royal sentiments veered from short-lived optimism to desperation, from progressive reform to conservative intransigence.[36]

As the king confronted the state of his monarchy, Goya considered his own public face, guarding his status and reputation, and ever deferential to his royal patrons. We wonder if he saw himself in the commentary, "On the Court," published on December 5, 1789, in the *Correo de Madrid*: "At court, at the sight of the Sovereign power disappears, the proud and intrepid tremble, the gravitas of the circumspect is transformed into play and laughter, and pride of the stern sweetens and softens. The politics that originate with envy and the desire to distinguish oneself become familiar and second nature to the character of those who live there." Since his return from Zaragoza eight years earlier, Goya had mastered the ways of the court and the role of the courtier:

> who criticizes nothing in general, but neither does he approve of anything in particular; who never says what he thinks, nor thinks what he says; who speaks freely to the Minister in public, but who trembles when he finds him face to face.... One look from the King at a courtier confuses him or fills him with pride; one word diminishes him or raises him up; his fall raises another and makes him happy; thus the Court is a theater where war is waged between one and another, and in which the scenes are repeated daily.[37]

Even as Goya took pride in any special attention he received from the king or queen, his new prominence at court heightened his circumspection. His admission to Zapater of his difficulty in subduing his genius also reveals an awareness that he, more than his adversaries at court, could bring about his own downfall: having earned the rank he had sought for so long, could he meet its demands?

14

Changing Times

1790–1791

Goya's unbridled *genio* played out during the next year and a half, as he tested limits both professional and personal. Demand for portraits of the new monarchs waned and court artists returned to more routine assignments, which for Goya meant painting tapestry cartoons. Once the king had determined that the subjects of the cartoons for his office in the palace at El Escorial were to be "campestres y jocosas" (rural and comic), the marquis of Santa Cruz (the majordomo who oversaw the finances of the royal household) delegated the matter to Sabatini, who in turn sent the measurements for the tapestries to Francisco Bayeu. Bayeu promptly reminded Sabatini that by royal order he supervised Ramón and Maella supervised Goya, and thus it was Maella who reported that Goya "desired that the orders be given to him by the Most Excellent Sir Marquis of Valdecaranza, his Supervisor." Maella added, "that has never been done since this pertains to tapestries, the responsibility of the head majordomo." Following court protocol, Maella asked Sabatini to inform the marquis of Santa Cruz, which Sabatini did on April 30, adding that he was unable to solve the problem.[1] A year would pass before Goya undertook the assignment.

Upon his appointment as court painter a year earlier, Goya remarked, "Unfortunately, my road is difficult, because times are changing,"[2] and he did not make his own path any easier. His insistence that he receive orders from the highest official within the royal household and his resistance to the commission for tapestry cartoons imply that he sought to be recognized as a courtier and as a painter worthy of commissions more prestigious than cartoons. But painters vying for status and commissions at court were many: upon receiving permission to commission a portrait of Carlos IV for their assembly room, the academicians chose Francisco Bayeu as the artist.[3] Carlos IV

esteemed Bayeu, to whom he granted a pension for his daughter Feliciana in September 1789 and, the following July, a salary of 50,000 *reales*, equivalent to that of a first court painter (a rank that still eluded Bayeu).[4] Another rival was Maella, who made a sketch for a portrait of the royal family never realized.[5] On June 1, 1790, Francisco Folch de Cardona, a protégé of Floridablanca, was appointed court portraitist, possibly displacing Maella; within two years Folch undertook a monumental portrait of the royal family, soon outdated following the deaths of two *infantas*.[6] Eight years passed before Goya created the enduring image, *The Family of Carlos IV.*

Goya's superiors did not respond immediately to his insubordination, perhaps because issues far more pressing demanded their attention. Events in France were a constant reminder of the potential fury of a discontented populace, brought home when, on June 18, 1790, a man with a sharp instrument, crying "Death to this rascal!," assaulted Floridablanca as he entered a passageway to the main patio of the palace at Aranjuez. The secretary's ribbon of the Order of Carlos III reportedly prevented the knife from penetrating, and the injury was minor; the assailant's attempt to kill himself was futile. The official report identified the man as a foreigner (without offering a specific origin), allowing the premise of the love of all Spaniards for the monarchy and its representatives to remain intact. The king informed the public that Floridablanca's wounds were not life threatening and that he was recuperating well. An investigation was ordered, and the assailant was identified as Paul Peret, a Frenchman long resident in Madrid.[7] Although a complete inquiry in both Madrid and Paris revealed no evidence of conspiracy or political motivation, Floridablanca's requests for leniency went unheeded. Peret was publicly executed on the Plaza de la Cebada (the Plaza Mayor having recently been damaged by fire). His corpse was displayed prior to its burial, and his hand cut off and hung for all to see on the road to Aranjuez, removed only before the court made its next journey along the route.[8]

Lerena meanwhile consolidated his power and plotted revenge on longtime adversaries. Francisco Cabarrús, granted the title of Count by Carlos IV in 1789, was placed under house arrest in June 1790 and soon imprisoned in the northwestern town of A Coruña. Upon receiving the news, Jovellanos returned from Salamanca to come to his friend's aid, only to be ordered on a mission to inspect coal mines in his native Asturias before returning to his native Gijón, where he remained for the next seven years.[9] Political maneuvering did not keep Lerena from commissioning Francisco and Ramón Bayeu and Goya to paint altarpieces for the church of Saint Mary of the Assumption in his hometown of Valdemoro, along the route from Madrid to

Aranjuez, where still today the *Death of Saint Peter Martyr* by Ramón and the *Appearance of the Virgin to Saint Julian* by Goya flank Bayeu's central painting of the Assumption.[10] Goya might also have been at work on a portrait of the count of Campomanes, of which no trace remains; the count, we recall, had previously commissioned Goya to paint royal portraits to decorate his palace in Madrid. The sole documentation for his portrait is a letter now lost, published in 1886 by the writer Ildefonso Antonio Bermejo, in which the count responded to Goya's petition on behalf of a certain Facundo de la Cruz Mengívar, accused of assaulting a priest. Having brought this to the king's attention, Campomanes regretted that nothing was to be done: the sentence was lashing and six years in prison. He added in a postscript: "From tomorrow on, we can return to the interrupted sessions for my portrait, because my work has lightened. So that the visit is less of a bother, you may disregard etiquette, and come in normal dress, for my wife will not be at home."[11] Did this letter in fact exist, or was it an invention of Bermejo, a fictional springboard for the short historical vignette to follow?[12] If it was authentic, Goya's solicitation on behalf of Mengívar as well as the count's salutation of "Señor Don Francisco Goya y Lucientes: De mi particular distinción," suggest that it followed Goya's appointment as court painter, while any portrait commission surely preceded Campomanes's removal from his position as governor of the Council of Castile in spring 1791.

Even as Goya shirked his responsibility to paint tapestry cartoons, in July the marquis of Valdecarzana granted him a two-month leave to travel to Valencia,[13] a trip that possibly allowed the artist to renew his acquaintance with Mariano Ferrer, now secretary of the Royal Academy of San Carlos,[14] or to visit the cathedral to see the altarpieces he had completed two years earlier for the duke and duchess of Osuna, depicting scenes from the life of Saint Francis Borja. But the beauty of Valencia's seaside location and the freshness of its maritime air seemed only to annoy him; he could not tolerate any more talk of the Albufera, Valencia's famous lagoon known for falconry and as a gathering point for fashionable types, and complained to Zapater that had his license not specified his destination as Valencia, he would be in Zaragoza with his friend.[15] The ever-vigilant Zapater wrote in turn to another friend in Valencia, Ángel Plaudo de Las Casas, asking him to please visit Goya, "my very dear friend," in his name, and offer him any financial assistance he might need, which Zapater would repay.[16]

Returned to Madrid, Goya paid a visit in early October to José Yoldi, an acquaintance from Zaragoza, and found him writing to Zapater. Yoldi's comfortable life in Madrid was supported by his brother, a government treasurer

in Buenos Aires, who sent money to Zapater to disperse to his brother; to Zapater's displeasure, José nevertheless requested supplemental loans.[17] Goya and Yoldi began to joke about delivering the letter in person, and things became serious: they left Madrid at four in the afternoon on October 9 and arrived by post carriage to deliver the letter on October 12, the day of the Virgin of El Pilar. Possibly during these celebrations Goya attended two performances at the bullring by an "Yndio negro" (Indian of color), who first mounted the bull and then, with shackles on his ankles, jumped from a table onto the bull; both stunts are recorded in his etchings of the *Tauromaquia* (1816).[18] Zapater's account to Yoldi's brother provides details of the visit, during which Goya remained as a guest in Zapater's house, while José joined them to eat almost every day, "having been always together and in an admirable humor," until November 4, when his friends returned to Madrid, leaving Zapater "full of emotion."[19] No record of any request for leave from court has come to light, although Goya's appointment to the Royal Economic Society of Aragón of Friends of the Country on October 22 might have provided some excuse to linger. On October 29 Goya thanked the secretary of the society, writing: "Among the many factors that contribute to my appreciation of this honor, is the principal distinction that it comes from an accredited and respected organization, that does honor to my Patria that I so love, and exult in being its son."[20]

Goya's abrupt departure from Madrid in early October had left his family in the middle of a smallpox epidemic reported in a front-page advertisement for a treatise on the subject in the *Diario de Madrid* on October 11: "The current situation of this Court, infested by the great epidemic of smallpox, gives me the opportunity to remind the public of the advantages of putting into practice the wise methods proposed by D. Francisco Gil, Surgeon of His Majesty's family and the royal residence of San Lorenzo."[21] Upon his return, Goya was surprised that no one came out to greet him and entered his house to find his son "transformed into a monster swollen by smallpox. They say that it's taking its course, and hope he'll survive." Goya was not to go to the royal palace for forty days. A drawing of an anatomically correct heart heads the letter, its radiance suggested by short lines to recall imagery of the Sacred Heart of Jesus.[22] In mid-November Goya offered an update: "My dear, only to give you news of my son, I take up the pen, and he's doing well and will possibly get up tomorrow; I'm going to bed, with some tremors that I can't do more, probably some cold. I cried a lot with your letter to see how much I owe you, goodbye, yours. Paco." After his signature, he added, "I already have the portraits,"[23] a reference to paintings undertaken in Zaragoza and shipped to Madrid to be finished. One of them was the portrait of Zapater,

who, seated at his desk, looks up calmly from his papers to address Goya, author of the portrait's inscription: "My Friend Martín Zapater. With great labor I have made your portrait. Goya 1790" (pl. 7).[24]

From mid-November to December, an increasingly obsessive tone emerges in Goya's letters. In mid-November he wrote rapidly on a single page: "Mine of my soul, I'm standing, but so bad off that I don't know if my head is on my shoulders, with no appetite for food or anything else, only, only your letters please me and only you, I don't know what is happening to me, what of me, who has lost and lost you, he who idolizes you, ends with the hope that you will look at these sketches and is consoled."[25] (The sketches mentioned were not part of the letter, but enclosed as a gift from its feverish and weakened author.) His emotional intensity is undiminished in another undated letter, written in a more measured script on three of the four sides of a folded piece of paper: "The greatest good of all that fill [my] heart, I've just received your inestimable letter; yes, yes, you bring my senses to life with your discreet words of friendship, with your portrait before me, it seems I enjoy the sweetness of being with you oh my soulmate I didn't believe that friendship could arrive to the stage that I am now feeling." With the completed portrait of Zapater at his side, Goya reported that visitors considered it the best he had done. He also had readied a room where he and Zapater could "live together and sleep (a remedy to which I resort when my sadness overwhelms me)." Cognizant of his negligence of official duties he added, "I still haven't begun to work, nor, with my ills, have I been in the mood, next week I'll begin, God willing," but he thought only of Zapater. Aware also that his friend might find his intensity disconcerting, he closed with a comment to temper it: "Written with confidence that my silliness won't bother you, but that maybe you'll laugh a bit." He added a postscript, "Take what I can't give you," illustrated with two drawings of female and male genitalia.[26]

Although authors have succumbed to the temptation to read the love expressed by Goya for Zapater in these letters as homoerotic, historical context, and, more important, what we know about these men, argue against this interpretation.[27] Would Goya, who had thus far dedicated his life to professional success at the court of Spain, ignore everything he had gained to consider such options? Or would such thoughts even enter his consciousness as options? The same questions must be asked of Martín Zapater, a devout Catholic who had long worked to achieve his own economic position and social standing as a businessman, benefactor to his friends in Zaragoza, active member of the city's Economic Society, and, since 1789, a noble of Aragón. If Goya's words and doodles were as incriminating as some have proposed, would Zapater have filed the letters, to be inherited by his nephew and passed

on to his great-nephew? And would that great-nephew, so invested in protecting the artist's name, have kept them?

Without Zapater's letters to Goya, we can only infer his reaction. He apparently did not reciprocate the obsessive affection expressed by Goya and responded with silence that led Goya to write (at some point after Christmas but before the royal departure for Aranjuez in early January): "So you leave me without a Christmas greeting? And you won't respond to this? Nor to the sixty others that I'll write to you?" Goya attributed the silence to the fact that a letter written with "the greatest care and most expressive feelings" had been lost, but he was not to blame, for Yoldi mistakenly mailed it with his own; but with his private conversation with Zapater now in the hands of an unknown recipient, Goya regretted that he had "rambled on." With his quarantine over, Goya had gone to see the king, "fearfully, since there had been someone in my profession who had said, in that very room, that I did not want to serve him, and other things that vile men do, and me without knowing why most of the servants at court like me as well as those around me I don't know who they are who made a case of it and made matters ugly." To his great relief, the king received him warmly, inquired about Javier's smallpox, and took Goya's hand before beginning to play the violin. Goya closed by sending regards to Zapater's brother Luis and his sons and signed the letter: "Your brother is watching, Paco."[28]

As Goya tested the limits of what he could express in writing to Zapater, so, too, did he test limits at the court. After a six-month absence, the prodigal artist continued to resist his awaiting commission, even as "vile men" spread word of his insubordination. By March 1791 Francisco and Ramón Bayeu were painting the king's oratory in Aranjuez; by June 30 Ramón was also painting portraits of members of the royal family, as well as the main altarpiece for a Piarist school in Madrid, which he brought to Aranjuez to show to the king and queen.[29] In contrast, the only known work that might be assigned to Goya during the first five months of 1791 is a privately commissioned portrait of Luis María de Cistué, whose father, Joseph de Cistué, was a jurist in the Supreme Royal Council of the Indies.[30] A year had passed since Goya's refusal of the tapestry commission, and the patience of the director of the tapestry factory had worn thin. He wrote to the king of the imminent consequences of Goya's resistance: without new tapestry cartoons, longtime workers would be left with neither employment nor resources to maintain their families. He added that Ramón Bayeu's other responsibilities at court justified his absence, but "the response of Don Francisco Goya is in the eyes of this writer as strange as it is irregular, for being entirely free, he says he neither paints nor wishes to paint, for he has been given the title of Painter to

the Court—an honor that should stimulate him, and inspire him to employ and busy himself in whatever is necessary in the Service of Your Majesty."[31]

The king intervened. Sabatini was ordered to tell Goya "that he begin the sketches immediately for which he is paid, and the same for Ramón Bayeu, when he finishes the other commissions for his Majesty."[32] On May 9 Goya acquiesced and wrote to Sabatini for the measurements for the cartoons.[33] On May 13 Sabatini wrote to the count of Lerena (granted that title on March 10) for permission to give the measurements directly to Goya to avoid further delay, rather than pass them through Maella as normal operating procedure demanded.[34] A month later, on June 10, Lerena responded to the letter of May 13, which he had brought to the king's attention, saying that if Goya did not begin this work immediately (and Ramón Bayeu begin as soon as he had completed other commissions for the king), their salaries would be suspended.[35] By the date of Lerena's letter, a chastened Goya had returned to work and apologized to Bayeu on June 3:

> Dear brother Francisco: In response to the goodwill that you show me, I send the response that I gave to Don Francisco Sabatini, in reference to the same order that went to Ramón by order of the Count of Lerena, and as a result, I have almost finished the sketch for the largest painting for the office of the King in the royal residence of San Lorenzo, . . . and I ask God with the greatest fervency that he relieve me of the temperament that abounds in me on these occasions, so as not to approach anything that would appear as pride, and that He moderate me always in what remains of my life so that with tranquility, accomplishing the best I can, my works might not be so bad.[36]

Two years after his appointment as court painter, Goya's main achievement was to have earned a reputation as a difficult employee. Francisco Bayeu remained his senior within the court hierarchy, a fact underscored by Bayeu's recently increased salary of 50,000 *reales*. Ramón Bayeu was promoted to court painter in July 1791 and granted a salary of 20,000 *reales*, 5,000 *reales* more than Goya.[37]

The tapestry cartoons that Goya now painted betray a newly satiric tone in scenes of wily women, of men who tempt fate, and, in the small overdoor cartoons, of children who illustrate the haves and have-nots of society. Women toss in a blanket a doll of an effeminate dandy, or *petimetre*, with powdered face and rouged cheeks; in another, young women stand by a village fountain, balancing terracotta jugs (common symbols of virginity in eighteenth-century painting), as an older woman standing behind them sizes

up the viewer. Men strut proudly on stilts, dangerously near the top of the village's ramparts; well-dressed children ride on the backs of those less fortunate or hold them in midair on a seesaw. The largest cartoon, its preliminary sketch mentioned in Goya's letter to Bayeu, depicts a village wedding procession, frozen parallel to the picture plane (pl. 8). A corpulent groom in an outdated, brilliant red velvet coat stands at the center with his pretty bride in blue velvet; in attendance are the bride's girlfriends and other villagers, including a priest, and another well-dressed man. The disparity between bride and groom suggests that only money could induce this young woman to marry, a skepticism shared by the smirking young women in attendance. As in most comedies, the buffoon is oblivious to any future troubles, believing that his bride marries him for love.[38] Antithetical in tone to rococo games, these scenes fulfill the request for "rural and comic" subjects, but introduce subtexts of vanity, greed, and deceit that would come to the fore in the etchings of *Los Caprichos*, published eight years later.

As Goya absented himself from court in 1790, traveling to and from Valencia and Zaragoza and returning only to be isolated in quarantine, Carlos IV, encouraged by Floridablanca, increasingly feared for the security of his own regime. On February 24, 1791, a royal order suspended the publication of all private newspapers including the *Espíritu de los mejores diarios de Europa*, which offered summaries and articles translated from newspapers throughout the continent, and the more literary *Correo de Madrid*. Only the government-sponsored *Mercurio de España*, the *Gaceta*, and the *Diario de Madrid* remained. After two years on the throne, Carlos IV also began to rethink his monarchy. Among the promotions announced in the *Mercurio de España* in January 1791 was that of don Manuel de Godoy y Álvarez (hereafter, Godoy), whose name was to become inextricable from the reign of Carlos IV and María Luisa. A member of the royal guard, Godoy was promoted to general aide (*ayudante general*) as well as brigadier in the Royal Army; in March he was given the key of a gentleman of the king's chamber; in August he became lieutenant general of the Royal Army, and in December he was among the nobles in an entourage accompanying the king at the commemoration of the Order of Carlos III.[39] It was a good year for the twenty-four-year-old officer.

By the time Carlos IV and María Luisa returned from Aranjuez that summer, they had learned of the increasingly dire situation of their cousin on the French throne. On June 20, 1791, Louis XVI had attempted to escape from Paris to Montmédy, a town near the border with the Austrian Netherlands, where he hoped to rally support for the royal cause. At Varennes, about fifty kilometers from his goal, the king was recognized, his family's two carriages

captured, and the royal family forced to return under guard to Paris. Louis XVI accepted the constitution on July 17, as the royal family became virtual prisoners in the Tuileries. Carlos IV responded by ordering all foreigners in Spain, whether resident or transient, to register with local governments and issued instructions to ensure compliance. To demonstrate their own mobility and the loyalty of their subjects, the king and queen traveled for the first time to La Granja on August 26; seeking solace from an increasingly turbulent world, Carlos IV retreated to the charterhouse of El Paular during the first three days of September and upon his return to La Granja issued a new order. In light of the "well-based evidence of attempts to introduce and disseminate in the Kingdom, from France, seditious papers that contradict the loyalty owed to my Rule, the public tranquility, and the welfare and happiness of my vassals," all "seditious papers contrary to the loyalty and public tranquility" were to be immediately surrendered to the proper authority.[40] Five days later Carlos IV and María Luisa traveled to El Escorial to be reunited with the royal family.

In August Goya reported that his inventory of the paintings in the royal palace was complete but that he planned to walk through the rooms to review his work and view any new additions. Obedience paid off, and in early October he was again given leave to return to Zaragoza for personal matters; his request to the Royal Academy is more specific, stating that Goya found it necessary to visit a brother in Zaragoza, and that he would not stay more than fifteen days; Francisco Ramos would substitute in teaching the beginners class.[41] No reports of his visit have come to light, but one very rich letter to Zapater, previously dated to December 1790, deserves consideration for redating to after this 1791 visit.[42]

The salutation of this letter is unique: the "qdo" for *querido* (dear), precedes a drawing of a penis, apparently sent in response to a drawing of the same by Zapater, praised by Goya in his first sentence: "Jesus! Jesus! What a testimony! Is it impossible that you didn't trace with the pen the contours of your own, thinking of la Pía, if you have made it from invention I say you are a natural draughtsman." Was Zapater perhaps continuing a ribald banter of recent late-night conversations? We cannot know. But the tone of Goya's letter is altogether different from the feverish voice of the letters written a year earlier, when Javier's smallpox, his own illness, and obsession guided his pen. His feelings were undiminished but restrained, as he recalled his recent visit: "You will sleep well without conversations disturbing you, I miss them." The letter betrays a growing self-awareness and concern with public appearance, inspired by Zapater's advice and expressed in a train of thought punctuated by a single comma and period: "You've made me want so much to return to

live with you that if it were not for fear of the boss I would have left to bring you this and the *seguidillas* [popular songs] that I enclose for you with what pleasure you will hear them I have not listened to them and maybe I will not because I no longer go where I could hear them for no other reason than that it has gotten into my head to commit to a certain caprice and maintain a certain dignity as I heard you say, that a man must have with which you can believe I am not very happy." He also asked Zapater's help in researching his genealogy and ended the letter asking for an update; the project continued into 1792, without proving the nobility of Goya's lineage.[43] Both concerns, with his social status and his public persona, characterize a chastened courtier, now returned to the fold.

15
———

The Best of Times,
the Worst of Times

1792–June 1793

EW mourned the death of the count of Lerena on January 2, 1792. In late
February, Floridablanca, whose intransigence before revolutionary France
was perceived as a threat to the French royal family, was relieved of the post
he had occupied for fifteen years. Appointed in his stead was his longtime ad-
versary, the count of Aranda, recommended by his years of service to Car-
los III, but, more important, by his experience as ambassador to France from
1773 to 1787 and potential to improve relations with Paris. A decade earlier
Aranda had presented Carlos IV (then prince of Asturias) with a proposal
countering Floridablanca's efforts to increase the power of the appointed
officials at court (many of them professionals rather than nobles), arguing
that power should be held by the aristocratic Consejo de Estado (Council
of State).[1] Carlos IV now heeded that advice, dissolved the Supreme Assem-
bly of State created by Floridablanca five years earlier, and reestablished that
council, to be overseen by Aranda and include all councillors, ministers, and
secretaries.[2] Besieged in Paris, the aristocracy returned to power in Madrid.

Zapater, Goicoechea, and Goya were among the members of the Eco-
nomic Society of Aragón who welcomed Aranda as an ally. Since his appoint-
ment as director of the society's academy of drawing the previous October,
Goicoechea had worked to develop statutes for its transition to a royal acad-
emy of fine arts in Zaragoza. Early on, he had counted on the assistance of ju-
rist and poet Juan Meléndez Valdés, who since 1789 had been in Zaragoza as a
district attorney, until Meléndez—to be identified by Goya as a "friend" in a
portrait of 1797 (fig. 15)—departed for a new assignment in Valladolid after at-
tending only one meeting of the committee.[3] Approved in Zaragoza on Jan-
uary 20, 1792, the statutes were submitted to Floridablanca, who, eleven days
before his dismissal, informed the director of the Economic Society that the

king had never approved the project and the designation of "Royal Academy" would not be granted.[4]

Advocates for the Zaragoza academy realized the opportunity offered by Aranda's appointment and approached him, with the support of Francisco Bayeu and Jorge del Río (who, we recall, had asked Goya for an introduction to Zapater and Goicoechea some two years earlier). Zapater arrived in Madrid in mid-March and remained until August,[5] and although Goya's reference to his friend's upcoming visit predates Floridablanca's dismissal,[6] Zapater's correspondence from Madrid with Goicoechea in Zaragoza leaves no doubt that he used his stay to advance the cause of the Zaragoza academy.[7] As Zapater was planning to go to Aranjuez on April 7, Goicoechea wrote asking him not to do anything without consulting Bayeu, who had written that he was going to speak to the king and give him an extract of the petition. Two weeks later, in response to the unexpected royal order elevating the drawing school of the Economic Society to the Royal Academy of Fine Arts of San Luis (in honor of Queen María Luisa), Goicoechea expressed his elation to Zapater: "I do not find the words with which I can express my happiness, my personal joy, and even madness caused by the news of the triumph that has been achieved in favor of all the Kingdom with the elevation of this School to a Royal Academy with the name, or title of San Luis, in truth it surprised me." Since the academicians in Madrid had still to approve the proposed statutes, on April 24 a calmer Goicoechea wrote that it was essential for Zapater "to continue his efforts to achieve this"; on May 3 Bayeu wrote to Zapater from Aranjuez that, given his absence from Madrid, Goya could introduce him to the new vice-protector of the Royal Academy, Bernardo de Iriarte.[8] Goicoechea fretted over the academicians' procrastination, concerned that the statutes would not be in place by the beginning of the term, and eventually resigned himself to the fact that the matter would be addressed "when those Men feel like it" (quando les dè la gana a esos Señores). Approval was granted on October 19, 1792, as in Zaragoza classes began with 119 students.[9]

Another visitor to Madrid that spring was Sebastián Martínez y Pérez, an art collector and businessman from Cádiz. Having signed over power of attorney in Cádiz on April 20, Martínez apparently planned an extended stay;[10] a possible motive was his desire to make himself known to the new powers, for his election to the Royal Academy four years later and appointment as treasurer-general of the court in 1799 suggest his interest in gaining a standing at court.[11] Years prior to his 1792 visit, he had corresponded with Antonio Ponz and Floridablanca in regard to an overly zealous Inquisitional official, who had threatened confiscation of "indecent" paintings in his collection.[12]

Ponz subsequently visited Martínez in Cádiz and in volume seventeen of the *Viaje de España*, which was advertised for sale in March 1792, shortly before Martínez's visit, praised the collection "of my good friend Don Sebastián Martínez," which "should especially call the attention of connoisseurs." Ponz took special notice of three *bodegones* (still lifes with or without figures) by Velázquez, and other paintings by Leonardo da Vinci, Titian, Murillo, Alonso Cano, and Guido Reni; in his opinion, the print collection also merited an extended discussion.[13] He observed that two figures in a *bodegón* by Velázquez had the same physiognomies as those in "the comic *Triumph of Bacchus* that don Francisco de Goya etched" (fig. 4); upon Martínez's arrival in Madrid, Ponz possibly provided a personal introduction to the artist. The coincidence of Zapater and Martínez in Madrid from May to August may have offered Goya the opportunity to introduce the two businessmen, who within a year exchanged letters between Cádiz and Zaragoza about the artist.

Self-made and learned, Martínez was a new kind of aesthete to whom Goya responded with a groundbreaking portrait (pl. 9). Poised and confident, Martínez acknowledges the viewer as he looks up from the print in his hand, its verso inscribed, "D. Sebastián Martínez, by his friend Goya 1792." Painting to impress a connoisseur, Goya exploited both color and handling in a manner that anticipates his greatest portraits of the coming decade, using a highly diluted blue pigment for Martínez's fashionable coat, allowing the ground to show through to create a painterly equivalent for the shimmer of the material, and then adding narrow green stripes that further define form. Seeing the portrait following its 1906 acquisition by the Metropolitan Museum of Art, the American artist Kenyon Cox praised the technique: "The head is soundly and quietly executed but the most remarkable thing in the picture is the painting of the steel-blue coat. . . . Go up close and look at that coat and you will find that over a warm ground it has been painted with almost infinitesimal draggings of fluid semiopaque color, so thin as to be almost transparent. These little cool blue upper paintings are laid on with the utmost delicacy, and the whole coat is one shimmer of light."[14]

Once Goya learned that Zapater and the friends with whom he arrived would not stay at his house, he wrote that whatever they wished was fine, "even if you do not come to my house except to shit, or to eat dance and drink scratch cry yawn pray shave bark jump argue and swear."[15] Beyond this list, Madrid provided many amusements to be enjoyed between Zapater's visits to the court at Aranjuez. The capital had been transformed during the reign of Carlos III, as described in a letter of January 1792 by a certain (possibly fictional) "Mister Warton," whose experience stands in marked contrast to that of Joseph Baretti three decades earlier:

It has more than five hundred streets, many of them spacious, with very few that coaches cannot travel; they are paved with small and uncomfortable stones, but the sidewalks paved for the comfort of pedestrians. The cleanliness of Madrid is such, and the police so attentive, that this city becomes a most tranquil mansion, where peace, relaxation and cleanliness reign. There are more than seven thousand houses, of good taste, with iron balconies, crystals, or windows. There are many small squares, but only two large ones, which are those of the new palace and that of the Plaza Mayor.... There are also many fountains, with delicate and absolutely pure water.[16]

Arriving during Lent, Zapater found the theater on its annual hiatus, the new season to begin following Easter. Concerts, acrobats, and other entertainments continued: don Joseph Tassinari, having presented his automata and magic tricks to the king and queen, now offered to the public a re-creation of the hot-air balloon of Montgolfier and Blanchard; a chest that opened on demand to reveal the figure of a dancing giant; and a female automaton that answered questions from the audience, whose knowledge of physics delighted science aficionados.[17] The Monday after Easter, the comic opera reopened with *La Pastora reconocida* (*The Shepherdess Recognized*) by Domenico Cimarosa, and the two leading theaters of the Cruz and the Principe offered comedies titled *Love Today* and *My Lady before All*, accompanied by songs (*tonadillas*) and *sainetes*. That same Monday also brought the announcement of bullfighters scheduled to perform during the coming season, including Pedro Romero and his brothers. When the season opened a week later eighteen bulls were fought, sixteen of them by the Romero brothers. This was an all-day affair, with entry at ten in the morning and four in the afternoon; the bulls were on view the evening before, when the gate to the bullring would also be open. No wonder reformers complained of the absence of workers on Mondays when bullfights were held.

Prior to Zapater's arrival, Goya joked that it would be an inconvenience if he had "to work [during] the time you are here and you will bother me a lot but I will beat you and I will make you be quiet."[18] He worked through the summer on the cartoons for the king's office in El Escorial: stretchers and canvases delivered to his house were included in his accounts of late June. On July 28 and September 2 he received canvases for the overdoor cartoons, in which scenes children's play complement the adult pastimes in the larger tapestries.[19] He was also developing his thoughts on the education of artists.

A councilor to the Royal Academy since 1757, the count of Aranda took his responsibility as protector of the academies in Madrid seriously and

recommended Bernardo de Iriarte to serve as the vice-protector. Iriarte, an art collector and member of both the Spanish Royal Academy (of language) and the Royal Academy of Fine Arts, was well versed in the customs of the court, having worked for eighteen years in the office of the secretary of state prior to his appointment as director of the Council of the Indies in 1780.[20] He became an important ally to Goya, who thanked him in 1797 with a portrait inscribed, "painted by Goya in testimony of mutual esteem and affection."[21] Iriarte initiated a review of the academic curriculum and convened meetings, attended by Goya and others on July 30 and on August 19, when he requested all professors to contribute a proposal on curricular reform. Suggested topics for consideration included the collection of drawings available to students, the arbitration of disputes, requirements for the promotion of students, recommendations on how to deal with students who disturbed the silence in class, and, finally, pedagogy. In addition to overseeing the class drawing after plaster casts in October, Goya attended the meeting on October 14 at which the professors' proposals were to be presented, but Iriarte deviated from the agenda and the meeting was spent in discussion of monthly prizes. The presentation of all but three proposals took place on October 28.[22]

Does it surprise us that Goya's recommendations had little to do with Iriarte's proposed topics? Indeed, his may well be the most antiacademic proposal ever presented within the institution. Of the encouragements offered to students, he wrote that the academy should not serve any purpose beyond "offering help to those who freely wish to study in them, doing away with all servility of a grammar school, mechanical precepts, monthly prizes, stipends, and other trivialities that vilify and effeminate an Art as liberal and noble as that of Painting." He questioned whether any curriculum should be set, insisting that he could prove that "there are no rules in Painting and that the oppression, or servile obligation of making all study or follow the same path is a great impediment for the Young who practice this very difficult art that approaches the Divine more than any other." And of the professors? We might ask if he had Francisco Bayeu in mind when he wrote: "Of the Painters that we have known as the most able, and who refined teaching the path of their tired styles (according to what they have told us), how many students have resulted? Where is the progress? These rules? This method? From what they have written, has any more been accomplished than to interest those who are not, nor cannot be, Artists?"

After decrying those who placed Greek statues above nature, Goya pleaded that the Arts not be "dragged down by the power or knowledge of other sciences, but rather governed by their own merit... then the despotic enthusiasts cease and prudent lovers are born, who appreciate, venerate, and

encourage those who excel, providing them with work that can further advance their ingenuity, helping them with the greatest energy to produce all that their inclination promises: this is the true protection of the Arts." We almost sense his tone changing, his pulse slowing, as he concluded, "I see no better means of advancing the Arts, nor do I believe there is one, than to reward and protect the one who excels in them; to hold in great esteem the true Artist; and to allow full freedom to the genius of the students who wish to learn them, without oppression, nor imposition of methods that twist the inclination they show for this or that style of painting."[23]

Although Goya's address was summarized in the minutes of the October 28 meeting, the only known response to it is a diary entry of Sepúlveda, who considered it similar to that of the painter Luis Paret: "Goya, the same, and does not speak of Geometry, saying that there have been great men without such lessons."[24] A letter to Manuel de Cubas, treasurer of the Osuna household, dated January 17, 1793, explains Goya's absence from subsequent meetings: "I have to thank you for the favor of making it known to her Excellency [the duchess of Osuna] that I have been in bed for two months with colic, and that I am going to Seville and Cádiz with license, and I ask her Excellency if she would like to grant that by her recommendation or that of her representative, I might have some money in Seville, I would be deeply grateful."[25] The following day, 10,000 *reales* due to Goya for works painted in the 1780s were made available to him through a member of the city council in Seville.[26]

Goya's illness was known at court, and a document of January 1793 confirmed royal permission for "a two-month leave so that he can go to Andalucía, to regain his health."[27] No record of a substitute for his class in January has come to light, suggesting that Goya fulfilled his responsibility before leaving Madrid.[28] What was the nature of his "colic"? Scholars have suggested a diagnosis of lead poisoning, an infliction well known at the time, as attested by a lead article of the *Diario de Madrid* in April 1792, discussing the use of ceramic vessels to store or serve food as a common cause.[29] Colic caused by lead poisoning was also identified as an occupational hazard among painters. Ramón Bayeu suffered many bouts of incapacitating stomach illnesses accompanied by fever and extreme pain; a letter from Bayeu to Zapater dated February 1, 1792, documents these symptoms, offering the last-known report prior to Ramón's death on March 1, 1793.[30] Goya's orders for supplies include significant quantities of lead white: on June 1, 1792, he purchased twenty pounds of fine and six pounds of superfine lead white, with another 194 pounds purchased from July 1792 to June 1793.[31]

By March 1793 Goya was ill at the home of Sebastián Martínez in Cádiz. With his guest's two-month leave about to expire, Martínez wrote on March

19 to Pedro Arascot, the secretary of the *sumiller de corps*, to request an extension. A draft or copy of the letter, today with Zapater's correspondence in the Museo del Prado, provides the sole surviving account of Goya's arrival in Cádiz:

> My Dear Sir and Master: My friend don Francisco de Goya left that court, as you know, with a desire to see this city and those en route during two months he had on leave, but fortune had it that he would fall ill in Seville, and believing that here he would have more help, he decided to come with a friend who accompanied him, and he entered my door in a very bad state, in which he still finds himself without having been able to leave the house.[32]

Martínez offered to send documentation of Goya's illness from the doctor Josef Labarera and the surgeon Francisco Canibel, who had just left his house, but if documentation was provided, it has not come to light. The "friend" who accompanied Goya from Seville is thought to be Ceán, who had been assigned a position in the archive of the Indies in Seville following the departure of Jovellanos from court in 1790.

As Martínez penned his letter to Arascot, Zapater responded that same day to two letters from Martínez (today lost), thanking him and his family for their care of Goya and offering to help in whatever way he could. He sent his warmest regards to Goya, noting that "the nature of his illness is one of the most feared, it forces me to think with melancholy about his recuperation."[33] He also wrote to Bayeu, opening his letter with references to the Zaragoza academy and to the success of Bayeu's royal oratory in Aranjuez, before turning to Goya: "As for Goya, as I told you, his lack of reflection has caught up with him, but it is now necessary to regard him with the compassion that his misfortunes demand and as a sick man, for whom it is necessary to procure all help, as you have done, obtaining for him the leave to enable him to recover his health, and nothing less would I expect from your good heart and Christianity."[34] Zapater's comment on Goya's lack of reflection (possibly a reference to his decision to travel in mid-winter from Madrid to Seville following a two-month illness) acknowledged his friend's rash behavior. But it is also possible that he was responding to a lack of sympathy voiced by Bayeu, whose own brother, Ramón, despite all precautions, had died earlier that month. In late March, Martínez reported improvements: "Goya continues slowly although somewhat better. I am confident that the season and the baths at Trillo that he will take in time will restore him. The noises in his head and his deafness have not subsided, but his sight is much

improved and he doesn't have the vertigo that made him lose his balance. He goes up and down stairs very well and finally does things that he couldn't."[35] Martínez also expressed concern for Josefa, having heard that she was ill on the day of Saint Joseph (March 19), in part because of her worries about her husband, "even though she knows he is with me."[36]

A treatise on lead poisoning published in 1796 by the royal press documents the current knowledge of the disease; among the symptoms listed are those mentioned by Martínez in reference to Goya: noises in the head, vertigo, and deafness.[37] The identification of Goya's illness with one familiar to his contemporaries raises the question as to whether the doctors who visited Goya in Cádiz came to this same conclusion; if so, perhaps they recommended the baths at Trillo mentioned by Martínez, one of the cures prescribed in the 1796 treatise.[38] In light of the knowledge available by 1793, a diagnosis might have read: "a paralysis of the auditory nerves, from an undefined cause—plethoric, syphilitic or toxic—causing the deafness that, in its turn, stimulated the auditory nerves,—thus producing noises—and justifying his vertigo."[39] In 2019 a clinician reviewed the explanations of Goya's illness offered to date, pointing out their inconsistencies with Goya's case, and concluded that "with only a few notes and letters by Goya and his friends and no detailed clinical information, much less laboratory results, related to the 1793 illness, we can never know for certain what caused Goya to lose his hearing." Today, the deafness that resulted from Goya's still mysterious illness could be at least partially restored with a cochlear implant.[40] We are left to ponder how such a medical intervention might have impacted Goya's art and legacy.

Although Alfonso Bergaz substituted for Goya in his April class at the academy, at some point Goya signed the ledger of April 30 for his quarterly stipend. Exactly when he signed or returned to Madrid is not known: in writing to Manuel Bayeu on June 4, Zapater assumed that Goya had arrived in Madrid only a few days earlier; on July 11 Goya attended the general assembly of the Royal Academy.[41] Bedridden with colic in November 1792 and ill in Cádiz the following spring, Goya had possibly remained unaware of changes at court. The ascent of Manuel Godoy continued with his new title, duke of Alcudia, and status as a grandee of Spain of the highest class added to his honors in March 1792. The following month the king moved Godoy closer to the royal palace by ordering the exchange of Godoy's residence for the "three houses adjacent to the Convent of Doña María de Aragón that the count of Floridablanca, his brother and his wife occupied."[42] The move to Floridablanca's former residence presaged Godoy's appointment as secretary of state (and concomitantly, protector of the Royal Academy) on November 15, ending Aranda's brief tenure.

Perhaps Goya was already en route to Andalucía on January 30, 1793, when news reached Madrid of the execution by guillotine of Louis XVI nine days earlier. The official silence on matters in France ended, and three months of mourning were declared; censorship of all materials relating to revolutionary politics continued. Despite efforts by both Aranda and Godoy to avoid conflict, France declared war on Spain on March 7, and Carlos IV reciprocated three weeks later. The War of the Pyrenees had begun, as the French sought to regain the territories of Spanish Sardinia and the Vall d'Aran that France considered wrongly assigned to Spain in the 1659 Treaty of the Pyrenees. The Captain General of Catalunya, Antonio Ricardos, portrayed by Goya the following year, led Spanish troops in a war that went beyond the political: it was fought to preserve the Catholic faith of the Spanish nation against the godless forces of the French revolution.[43] Over the next two decades, this would become a rallying cry for Spanish patriots.

By June 5, 1793, Goya was out and about in Madrid when he lost a snuffbox, for which he placed an advertisement twelve days later in the *Diario de Madrid*:

> In the afternoon of the fifth of this month, a rectangular box, in gold, engraved, with six exquisite paintings: their author, David Teniers, which was noticed missing at some point between the Convent of the Encarnación and the Prado; whoever has found it will deliver it to the house of D. Francisco de Goya, Court painter to his Majesty, who lives on the calle del Desengaño, on the left side coming from Fuencarral, number 1, number four, second floor, where a good reward will be given.[44]

We recall Goya's description of his lifestyle in an earlier letter to Zapater: "My situation is very different from what many might think, because I spend a lot, because I decided to and because I like it"; his pleasures apparently included decorated gold snuffboxes. His advertisement contradicts notions of the artist, returned to Madrid, weakened and suffering, for he was apparently walking the approximate three kilometers from the Monastery of the Encarnación near the royal palace to the Paseo del Prado. A new world was opening, as he accustomed himself to the spectacle of people, now silent, on the city streets: no footsteps alerted him to their approach, their open mouths emitted no sounds. Perhaps a thief took advantage. If not, Goya heard nothing as his gold box clinked on the stone pavement.

Part III
———
Witness of a Silent World

16

"There are no rules in painting"

1794–1795

AFTER his return, Goya attended a session of the Royal Academy on July 11, 1793, but then absented himself from meetings and discussions he could no longer hear.[1] He was also frequently excused from teaching after April 1794, when he wrote to the secretary of the academy that, having attended the beginning class the night before, he "lost hope for now of being of service, hearing nothing of what they were saying to me, and being the object of the boys' entertainment: I truly regret imposing this inconvenience on my colleagues but it is imperative to do what is necessary."[2] Substitutes taught his classes in April and October 1794, and one-half of his allotted quarterly teaching assignments in January and May 1795.[3] Following the death of Francisco Bayeu in August 1795, Goya solicited and accepted the position of director of painting, but the following spring traveled again to Andalucía, where he remained for almost a year. Following his return to Madrid, he resigned from the directorship on April 1, 1797, citing his continuing ills as justification.[4]

Some academicians very possibly welcomed Goya's absence as discussions about curricular reform continued, for conversations were surely easier without a colleague who proclaimed that there were no rules in painting. But Goya found an alternative method to challenge the status quo. In a meeting of October 13, 1793, Francisco Bayeu offered to oversee the creation of new drawings for use as classroom models and suggested that they be executed by Joseph Camarón and Agustín Esteve. Their fifty drawings were presented at the meeting of January 5, 1794, supplemented by Bayeu's donation of twelve life-size drawings of heads, studies for his paintings in the cloister of the Toledo cathedral.[5] At that same meeting, the academicians viewed eleven works of a very different ilk, recorded in the meeting minutes: "Señor Francisco de Goya submitted so that they could be seen in the Academy, eleven

paintings that he had painted of various subjects of national pastimes and the Assembly was very grateful to see them, celebrating their merit and that of Señor Francisco de Goya."[6] Had Goya intended to upstage Francisco Bayeu—and the academic method represented by his drawings—when he delivered these paintings to the academy the day before the meeting?

A letter to Iriarte accompanied the paintings, in which Goya explained their genesis and also sought the vice-protector's endorsement.

Most Illustrious Sir:

To occupy my imagination, mortified in consideration of my ills, and to compensate in part for the great expenses they have caused me, I dedicated myself to painting a set of cabinet pictures in which I have been able to make observations for which there is usually no place in commissioned works, in which whimsy [*capricho*] and invention have no room to grow. I thought to send them to the Academy for all the ends that Your Most Illustrious Honor knows that I can hope for in exhibiting this work to the judgment of the professors, but to assure myself of these ends, I thought it fitting to send the pictures first to Your Most Illustrious Honor so that you see them and, because of the respect with which they will be regarded given Your Honor's author-ity and singular intelligence, there will be no place for bad feelings. Protect them, Your Most Illustrious Honor, and protect me in a situ-ation in which I most need the favor that you have always shown me. God protect Your Most Illustrious Honor for many years.[7]

Goya was apparently confident that Iriarte, as connoisseur and collector, would endorse these works of invention now liberated, proof of what might be accomplished if his recommendations for curricular reform of October 1792 were put into practice and talented students allowed to learn, uncon-strained by tired precepts and academic traditions. Presentation of the works at the January 5 meeting, alongside the academic drawings by Bayeu and oth-ers, underscored his message. In years to come, Goya proclaimed his ideas through works presented to the academicians, among them the altarpiece for the Toledo cathedral, the *Arrest of Christ*, unanimously praised in a meeting in January 1799; from 1795 to 1819, he also participated in the academy's annual exhibitions, inaugurated by Iriarte.

Goya's eagerness to present his paintings on January 5 explains his sub-mission of an incomplete series. Two days later, he again wrote to Iriarte

thanking him for his help and expressing gratitude to his colleagues, "as much for their concern about my health as for the goodwill with which they have considered my works." He took great satisfaction in finishing what he had begun by painting a twelfth painting of "a yard with lunatics [*corral de locos*] and two that are naked with the one who takes care of them beating them, and others in sacks: (it is a subject that I witnessed in Zaragoza),"[8] which he would send as soon as it was finished. The only firmly documented work of the group, *Yard with Lunatics* (pl. 10), is painted on tinplate, a support that enabled Goya to render delicately detailed figures with small brushes without the interruption of a woven, textured surface; the same support was presumably used for the other eleven paintings. It is unknown if *Yard with Lunatics* ever arrived, for although on January 7 Goya told Iriarte to keep the paintings for as long as he wished, two days later he wrote to request their release to the marquis of Villaverde, where the young lady (*señorita*) who was "very good at drawing would take pleasure in seeing them."[9] Goya may also have sensed a possible sale.

Although during the eighteenth century madhouses throughout Europe were visited as entertainment, the only account of the practice in Zaragoza found by this author is a mention in an epistolary novel set in late eighteenth-century Zaragoza, *La Serafina* by José Mor de Fuentes. In it the young male protagonist visits the insane at the city's well-known hospital to satisfy a whim of his beloved.[10] In contrast to the scene depicted by Goya, the couple viewed individuals in their cells, in keeping with a 1791 description of insane patients who were lodged either in modern and well-kept individual cells (each with a bed) or in wards with many beds, depending on their malady. (The third floor had better accommodations, reserved for the well-to-do patients who brought their servants.) Although the extreme insane (*furiosos*) were naked because they ripped off their clothing, others might wear the type of sacks seen in Goya's painting, while those who tolerated clothing wore uniforms of patchwork, ate in the refectory, did chores within the hospital, and tended its gardens.[11] Within this progressive regime, there was no place for the free interaction portrayed by Goya, among the naked *furiosos,* the men in sacks, and the man in the patchwork uniform (seen in the shadows on the right). Nor would there be any opportunity for the thrashing administered by Goya's warden.

Given the discrepancy between Goya's invention and the model practices at the Zaragoza institution, the parenthetical statement that he had seen the subject of the *Yard with Lunatics* must be interpreted as tongue-in-cheek. By the mid-eighteenth century, the phrase "casa de locos de Zaragoza," like the

English word "Bedlam," had gained a broader meaning, connoting not only insanity but more generally the irrational nature of human behavior: short comic plays satirizing society's foibles were presented in Madrid and Zaragoza with the titles *Los Locos de Zaragoza* (*The Insane of Zaragoza*) or *La Casa de Locos de Zaragoza* (*The Madhouse of Zaragoza*).[12] Interpretation of Goya's painting as an imagined theatrical scene would also explain its relevance to the subjects identified in the minutes of the January 5 meeting as "national pastimes," a description that calls into question the proposed inclusion in the series of scenes of a fire, a shipwreck, an assault on a coach, and a prison.[13]

Given the absence of more specific documentation, we may never firmly identify the eleven paintings that Goya sent the academicians in early January, given that their small format, and probable private ownership, argues against their survival as a group or even individually. Their scale was not new to Goya: almost twenty years earlier, Sabatini had "pounced on" his sketches for tapestry cartoons, probably to be identified with the "rural subjects" listed in a 1797 inventory of Sabatini's collection, which also included six paintings of scenes of children by Goya, today unidentified. What is new in Goya's small paintings after 1793 is their autonomy as finished works, in contrast to earlier preliminary sketches, and their subject matter, for which Goya found no outlet in commissioned works. To judge from early inventories of private collections, Goya's new inventions found patrons: "Fourteen works on panel representing scenes from the bullfight, shipwrecks, attacks by robbers, fires, fire at night" were in the collection of a court jeweler and moneylender, Léonard Chopinot, by 1805,[14] and twelve small paintings, described in 1811 as *caprichos* and ranging in subject matter from scenes of sexual assault to an attack on a military encampment, were listed in the 1811 inventory of the collection of the late marquis de la Romana, the only group of small paintings that has survived intact.[15] By 1798 Goya's reputation for giving form to caprice inspired the duchess of Osuna to commission six cabinet paintings of witchcraft subjects (see pl. 15).[16]

Surely to the artist's relief, his career as a painter of tapestry cartoons soon came to an end. Whether he returned to painting tapestry cartoons following his illness remains an open question: according to Livinio Stuyck y Vandergoten's statement of March 31, 1794, Goya had not delivered any cartoons since Ramón's death a year earlier, but Goya's invoice for materials purchased from January to July 1794 states that these were used for "paintings of tapestries."[17] Carlos IV, still interested in interior decoration, changed his mind about his office in El Escorial, for which Goya previously created the series including *The Wedding*, and instead commissioned small hangings and ornamental rugs. Goya's final series of tapestry cartoons was never finished, and all but one of

its woven tapestries were distributed among other rooms in the palace. The tapestry of *The Wedding*, completed in March 1794, was the last of his cartoons woven by the tapestry factory during the reign of Carlos IV.[18]

Goya returned to painting portraits, supporting the assertion made by Bayeu and Maella in early April 1794 that the artist had "somewhat recuperated and paints, although not with the same tenacity and perseverance as before."[19] His sitters included the actress María del Rosario Fernández ("La Tirana"), who retired from the stage in 1794, and Félix Colón de Larriátegui, captain of the royal guard:[20] the sitters' close relationship explains the coincidence of their portraits, for a year earlier "La Tirana" had named Larriátegui as her heir. (In 1799 Goya again painted "La Tirana" in an exquisite full-length portrait.[21]) Another sitter that year was General Antonio Ricardos, hero of the War of the Pyrenees, portrayed in his campaign uniform, decorated with the Order of Santiago, the ribbon and Great Cross of the Order of Carlos III, and gold braid on his cuffs, awarded following his victory over French forces at Truilles (Rosellón) in September 1793.[22] Ironically, Ricardos died not on the field of battle but during an official visit to Madrid in March 1794 to request reinforcements. His support for the count of Aranda may have been crucial to the former secretary's safety in Madrid, for the day after Ricardos's death, Godoy banished Aranda to the Andalusian town of Jaén, never to return to Madrid.[23] Ricardos's widow nevertheless presented to Godoy Goya's portrait of her late husband, possibly in gratitude for the title of Countess of Truilles granted to her by royal order on March 30.[24] If Godoy had not previously paid attention to Goya, the countess's gift and her accompanying words may have piqued his interest: "Goya knew how to translate not only his features, but the expression of his Soul," to which Godoy responded on April 25: "The soul has neither face nor semblance, and memory alone immortalizes its virtues. There is no one who could have better employed his brush than Goya on the portrait of my friend."[25]

No letters from Goya to Zapater dated to 1793 are known, but their correspondence continued. In a short letter of February 15, 1794, Goya relayed to Zapater a message from Isidoro Bosarte, secretary of the Royal Academy, and closed the letter with the words: "I was doing better over the past days but I am now a little indisposed, for which reason I won't bother you further." A few weeks after excusing himself from his teaching assignment in April, Goya confided to Zapater: "I am the same, as far as my health goes, at times raving in a mood that I myself cannot stand, and others more calm, as this in which I've picked up the pen to write to you, and I tire myself." He was recuperating financially and on May 21 asked Zapater to send him an account of what he owed; five days later, he invested 84,000 *reales* in an annuity.[26]

The dominant subject of the friends' correspondence from February to June 1794 was Zapater's purchase of a new bed, possibly inspired by Goya himself, who joked in a letter of April 23: "What a laugh it would be if it [Zapater's bed] were better than mine; damn, they come from foreign countries to see it, and will explain it in different languages, and maybe even make a print." He also asked Zapater's opinion of a miniature portrait of the recently deceased Aragonese aristocrat Ramón de Pignatelli, by "Estebe," or Agustín Esteve, who had assisted Goya in fulfilling demands for portraits of the king and queen in 1789. Goya boasted that he had encouraged Esteve to paint in this small format, "because I saw it in his body, and he didn't know that he had the ability, boy, if I had [your portrait] here I would make him paint me one to carry you in a box." If all went well, Goya wrote, he planned to attend the first bullfight of the season the following Monday, with twelve bulls fought in morning and afternoon sessions, seven of them by Pedro Romero.[27] The tone of the letters from 1794 is controlled, and in carrying out the order for the bed and explaining its installation, almost businesslike. But the friends' mutual affection endured. When time came to install the bed drapery, Goya began his letter:

If it weren't because I am deaf, I would already be on the road right now (it's nine at night) by post, to hang the curtains on your bed, and return the following day, wouldn't that be grand? There wouldn't be anything better for me, because I would be able to see you; how sweet is the memory when it is so well used that it entertains me with four senses and even seems to me that with you I have all five in good order.[28]

In addition to acquiring a new bed, Zapater was apparently redecorating and asked his friend for help: "I have to know if the ceiling is plain (that I don't remember), the diameter [sic] of the walls or surfaces that Agustín Sanz or another can measure in a minute. And then I will make the drawing only to serve Martín."[29]

Why Goya dated a letter of 1794 "London, August 2, 1800" remains a mystery, apparently one of many ongoing jokes between the friends to which Goya alluded in the first paragraph before recommending a better use of their time:

Better for you to come to help me paint she of Alba, who yesterday came in to my studio so that I could paint her face and she left with it; to be sure, I like it more than painting on canvas, and I also am to paint a full-length portrait, and she will come as soon as I finish a

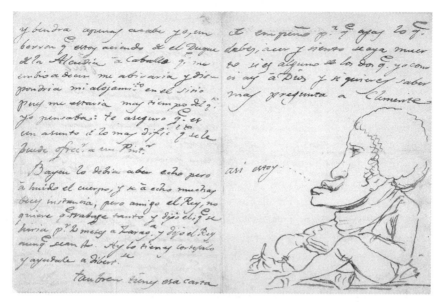

11. *Letter of August 2, 1794, from Goya to Zapater with Self-Portrait*, 1794. Ink on paper, 8 × 6 in. (20.8 × 15.3 cm, folded sheet). Museo del Prado, Madrid.

sketch that I am doing of the duke of Alcudia on horseback who sent to tell me he would let me know and arrange my lodging at the residence because I would be longer than I thought: I assure you it is one of the most difficult subjects that a painter can take on.

Bayeu was supposed to do it but his body is shot, and he insisted several times; but friend, the King does not want him to work so much and he [Bayeu] said, that he would go for two months to Zaragoza and the king said even four. There you have him, pay attention to him and help him to enjoy himself.[30]

Rather than sign the letter, Goya closed with a unique self-portrait (fig. 11), in which he sits idle and cross-legged with a cigarette in his right hand, a posture hardly appropriate for a court painter and reminiscent of the *majos* lounging on the banks of the Manzanares River (see pl. 3). Dotted lines imply his comment, "así estoy," which might be roughly translated as "so you find me." References in the letter support the date of August 1794, as Bayeu's health continued to decline and Goya assumed the commission for an equestrian portrait of Godoy, duke of Alcudia, of which only a sketch survives. It also documents Goya's acquaintance with another leading aristocratic family, the house of Alba, whose beautiful duchess trusted Goya to improve upon her beauty, proclaimed by poets of the day.[31] The coincidence

of the commissions is possible evidence of a dalliance between the duchess and Godoy, implied six years later in words written by the queen to Godoy after she saw the duchess, recently returned following a three-and-a-half-year absence: "She has become a skeleton, and I well believe that what happened to you before wouldn't happen now, and also that you are very sorry for it."[32] Whether the implied infatuation ever occurred, or if María Luisa's words were only those of a jealous older woman whose beauty had never inspired poets, Godoy and Alba knew each other well: by 1800 Velázquez's *"Rokeby" Venus* had entered Godoy's gallery from the Alba collection, a possible futile bid from the duchess to regain lost favor.

The next known letter from Goya to Zapater dates to December 1797; single letters from 1798 and 1799 show that their friendship continued, as does a second portrait of Zapater painted by Goya in 1797.[33] Reasonable conclusions are that letters were either lost or destroyed; the usual suspect for the latter is Zapater's great-nephew, Francisco Zapater y Gómez, who in publishing the first book-length Spanish-language biography of Goya in 1868 drew heavily on the correspondence he had inherited. His stated objective in writing the book was to defend Goya as a Catholic, a family man, and a patriot, to counter the fabrications of two French-language biographies by Laurent Matheron (1858) and Charles Yriarte (1867). Zapater y Gómez also mentioned in passing that after 1789 the "correspondence shows that the change in Madrid society had awakened in the Aragonese artist other desires, and greater aspirations," raising two questions: Did Zapater y Gómez destroy correspondence that didn't serve his intent? And what were the "other desires, and greater aspirations" awakened in Goya?[34]

———

Goya traveled to La Granja to present sketches to Godoy and possibly to begin work on the full-size equestrian portrait, lodging at the house of a certain Ramón Calleja,[35] and returning to Madrid by September 2, when he joined Bayeu in his balcony at the bullfight, and even enjoyed a smoking break. Pedro Romero performed, according to Bayeu, like a modern-day Saint George.[36] At some point—whether before or after his trip to La Granja is not known—Goya found his way to the Royal Laboratory of Chemistry in Madrid in the hope of a cure for his deafness. A letter written by an unidentified court official on September 18, 1794, described the outcome:

Don Francisco de Goya, Court Painter of his Majesty has presented the enclosed petition describing the deafness that he suffers and that to alleviate it the medical physicians told him that electrical therapy

was necessary: to this end you made available to him the Electrical Machine: but he had the misfortune that in using it, the disk broke; he speaks of the difficulties he has had in getting the current, and given this asks Your Majesty to order that the machine be fixed, the supplicant being responsible for the costs incurred. Having presented this to the king, His Majesty has determined to resolve it and orders that, from the account of the royal household, and with all possible speed, you restore the current to the electric machine for use in that Royal Laboratory.[37]

The intended recipient was Pierre François Chavaneau, a French scientist resident in Spain, who by 1794 was director of the Royal Cabinet of Geography and Cabinet of Natural History, as well as director and professor of the Royal Chemistry Laboratory and member of the Academy of Medicine. Electrical machines were used throughout eighteenth-century Europe for the treatment of depression, paralysis, and deafness, but whether Goya made a second attempt once the machine was repaired is not known.

With the failure of electrical therapy, Goya resigned himself to deafness, realizing that he would never again enjoy the music once mentioned in his letters, from popular songs to palace concerts to the king's violin; nor could he easily participate in the social gatherings for refreshment and conversation, or *tertulias*, which some authors have imagined he attended. In his newly silent world, he may have turned to more reading, responding to the prospectus in the *Diario de Madrid* for the "English Novel entitled History of Clarissa or Clara Harlowe, translated into Castillian by Don Joseph Marcos Gutierrez, Lawyer of the Royal Councils"; Goya's name appears among the list of subscribers that also included the duchess of Alba and the duchess of Osuna.[38] The artist also drew a portrait of the duchess of Osuna, engraved by Fernando Selma and included as the frontispiece to the first of four volumes titled *Galeria de mujeres fuertes* (*Gallery of Strong Women*), a translation of the 1747 book by the French Jesuit Pierre Le Moyne. The sale announcement of the book in the *Diario de Madrid* of January 7, 1795, stated that distribution, intended for September, had been delayed so that the portrait of the duchess, to whom the work was dedicated, could be included.[39]

Goya possibly lingered over the essays, notices, and advertisements in the *Diario de Madrid*, the daily newspaper in which he advertised his lost snuffbox and would subsequently advertise the etchings of *Los Caprichos* and *La Tauromaquia*. A decade earlier, commentary celebrated the urban improvements under Carlos III, the elegance of new buildings, the fountains on the Paseo del Prado, and the wide and clean sidewalks. In the 1790s the subject

turned to those who populated these spaces: fashionable ladies or *petimetras* and *madamitas* and their dandyish male counterparts, *petimetres* and *currutacos*, their servants, and others less fortunate. A common sight were the young gallants identified by "fine stockings and slippers, well-dressed powdered hair, two watches, a large button, and on the white neck, a tied cravat. A coat of quality cloth, with stripes of the same color, an undergarment of the finest quality that determines a good cut, pants with a wide waist and thin walking stick."[40] Lingering on the Paseo del Prado, they flirted with ladies for whom fashion demanded great expenditure and sacrifice, according to a certain Pedro Fiel de León.[41] Essentials included lace *basquiñas* (overskirts worn out of doors) and mantillas made of fine wool or cotton, as well as two lapdogs, one in front, the other in back, which they handed to their husband to care for once they returned home: "How stiffly they go! Making little skips, forward and back, coughing, winking, and even sneezing: Tell me … where will it stop?" Beyond ribbons, mantillas, and *basquiñas*, accessories for both sexes included buckles, broaches, buttons, pearls as large as apples, and diamonds the size of hazelnuts.[42]

The theater of the Madrid streets featured disreputable characters as well, according to "The Good Patrician," who in a front-page letter in the *Diario de Madrid* of August 24, 1795, looked beyond the intolerable young men whose cigar smoke polluted the air and who bathed in the fountains well before dusk, to complain about another problem: the swarm of beggars of both sexes who persistently solicited those seated on the Paseo del Prado. "This would be small inconvenience, if it didn't have other repercussions. The age, health, and good disposition of those who beg there serve as the greatest evidence that they are not in fact poor, because almost all are fit for work; thus the alms thoughtlessly given to them are a fraud against the truly needy."[43] The disparity between rich and poor grew ever more apparent during the reign of Carlos IV, as peasants sought refuge in the capital following repeated poor harvests, and charitable support for the poor, particularly in the popular districts of the city such as Maravillas and Barquillo, diminished.[44] Advertisements in the *Diario* for lost articles proliferated, including boxes, broaches, and watches; even Francisco Sabatini offered a reward for a French repeating watch, encased in gold and blue enamel, on a gold chain, with a small crystal bottle, a stamp, and a key on a black ribbon, lost on the city streets on December 3, 1795.[45] Although not admitted by the official press, it could be asked if such items, Goya's golden snuffbox among them, were stolen rather than lost.

The characters of modern Madrid were one of the many subjects recorded in prints advertised for sale in the *Diario*. One might subscribe to a

series introducing the latest styles created outside of Spain, not only in dress but also in furniture, interior decoration, coaches, and even silverwork; each print featured either a figure modeling the latest fashion for both men and women, or a specific object, "well drawn and masterfully illuminated."[46] (Goya's mention to Zapater that a print might be made of his bed suggests he was familiar with the genre.) Another series of four hand-colored prints advertised around the time of Goya's 1793 return to Madrid reiterated subjects seen in his tapestry cartoons: a dance, a game of blindman's bluff, a picnic on the field of Saint Isidore, and a fight—all "enacted by twenty figures of *majos* and *majas*."[47] Regional types popularized almost two decades earlier in the prints of Juan de la Cruz reappeared in four etchings of a good-humored Andalusian, a *petimetra* on the Prado, a woman of Madrid selling chestnuts, and a Murcian orange seller.[48] More fanciful characters made their debut in 1796: don Simplicio (don Simpleton), premier *currutaco* (dandy), soon to be accompanied his female counterpart, or *currutaca*, doña Fanfarria (doña Show-off); the currutaco don Bausan (don Scarecrow); the "little madame," or *madamita*, doña Ojarasca (doña Useless); and the modern *currutaco*, don Valentín *Rompe Esquinas*, or don "Corner Breaker," a reference to one who stands on corners with the pretense of waiting for someone. Advertised individually, these characters were joined by the new *madamita*, doña Cristalina, on July 4, 1796. Immediately preceding was an advertisement for an *Anti-Currutatico* (*Anti-Dandyism*) treatise for new "little ladies."[49] Animals joined the fashion parade, with male and female monkeys dressed in the latest fashion and a child on horseback accompanied by an ass in the costume of a *petimetre* taking his picnic to the country, a possible precedent for the asses to appear in *Los Caprichos* at the end of the decade. Other subjects included the famous actress Rita Luna, dance positions, bullfights, and even an engraving of Charlotte Corday taking the life of the revolutionary Marat.[50]

As commentaries and characters proliferated in the daily press, they also appeared in Goya's drawings of the 1790s. In Luzán's studio, Goya had drawn after engravings; he traveled to Rome to study drawing; in his Italian sketchbook, he drew after classical sculptures and works by other artists and sketched landscapes and early concepts for his murals at the Charterhouse of Aula Dei. He drew preliminaries for angels and altars, and for hunters in his earliest tapestry cartoons. But by the mid-1790s he began to make autonomous drawings, not intended as preliminaries for other works, illustrating vignettes of contemporary life. Fashionable women appear alone or with other figures, engaged in some interaction on the Prado, or within a well-to-do home, singing duets or enacting plays; the less fortunate sit spinning at the detention center for women at San Fernando. Goya began to add

captions, turning his drawings into overt commentary. A group of drawings with captions, known as the "Dreams," or *Sueños*, dated to 1796–1797, mark the point of departure for the etchings of *Los Caprichos*, published at the end of the decade.[51]

From this point forward, Goya drew throughout his life, using pencil, chalk, pen and ink, brush and ink, and crayon. He valued these works, ordered them in numbered sequences, and left them to his son; missing numbers imply drawings lost, reminding us of their vulnerability. Writing in 1860, the collector Valentín Carderera identified a group of small drawings, once part of a notebook, as the Sanlúcar album, identifying many of its figures as the duchess of Alba and assuming they were drawn during a visit to the Alba estate in 1796–1797.[52] But the simple compositions of these drawings suggest an earlier date. New to his deafness in 1793, Goya needed paper to hand: "As a deaf man who could 'hear' strangers only through letters, he could never be without ink and a pad. This constantly invited his graphic stream of consciousness to flow onto paper in drawing that became as natural as writing."[53] Although the Sanlúcar drawings might have originally been intermixed with written messages, the book was unbound, the written notes possibly discarded, and the drawings kept, prior to Carderera's ownership. Executed in brush and wash, or pen and ink, the drawings focus on single female figures, sometimes with a second figure added. Many are graphic reveries: petite, dark-haired, naked women rise from a shared bed; in another a woman turns her head to smirk as she lifts her skirts to show her very round derrière.[54]

A small sketchbook did not suffice. Goya's lists of supplies, for which he was reimbursed from 1787 onward, record purchases of "quality paper," "fine, cut paper for writing," large sheets of "fine Dutch paper," "Dutch paper," and "Genoese paper."[55] A purchase of supplies made on September 29, 1794, specified 10 *reales* of "quality Dutch paper for *drawing*" (emphasis added),[56] making his intended use clear for the first time. He now worked on larger sheets (probably tacked to a drawing board), sometimes taking advantage of the paper's verso; drawing not only in pencil and pen but also in brush and ink wash, he blurred the boundaries between the linear qualities often associated with drawing and painting.

Goya and the Duchess

1795–March 1797

A GROWING roster of influential patrons sought Goya out, among them the duke of la Roca and marquis of Sofraga, the widowed marquise of Villafranca, and her son, the duke of Alba. Around this time he might also have painted a full-length portrait of Godoy on a canvas subsequently reused in 1800 to paint Godoy's wife (pl. 18).[1] One commission stands out for the legends to which it would give rise: the first of two full-length portraits of the duchess of Alba, Goya's fulfillment of the requests first mentioned in his August 1794 letter to Zapater (pl. 11). Wearing a white dress with red sash, the duchess stands before an arid landscape, possibly the grounds of the family palace in Moncloa on the outskirts of Madrid.[2] Small dots of paint and subtle vertical strokes give weight to her abundant white gauze skirt, as does the gold brocade decoration that anchors its hemline. Counterbalancing the skirt's expanse of white are the accents of the red sash and bows, double-stranded coral necklace, gold earrings, bracelet, armlet, and the duchess's crowning glory, the abundant black curls credited by contemporaries with awakening the desire of all men who saw her. Freely painted over a minimal underdrawing, her lapdog stands at her feet, a red ribbon anchoring its left hind leg to echo the adornments of its mistress. The painting bears a double signature as, with a gesture that represents the letter G in the signed alphabet for deaf-mutes published that same year by the royal press,[3] the duchess points to words in the sand: "To the Duchess of Alba / Fr.co de Goya 1795." Well received, the portrait was copied by Augustín Esteve and possibly led to the commissions for portraits of the duke of Alba and of his mother, the marquise of Villafranca.[4]

Contrary to her posthumous reputation, there is nothing of the flirt or temptress in Goya's unsmiling duchess: while other women painted by Goya before a landscape turn their bodies or at least their faces at an angle to the plane of the canvas, the duchess's pose is frontal; while in other full-length

portraits by Goya and, to cite a near contemporary, by Gainsborough, women's shoes are always visible, even if the skirt allows only a fashionably pointed toe to peek out; the duchess's skirt hides her undoubtedly stylish shoes. What led Goya to omit them? One possibility is that the duchess's frontal pose demanded that her feet be either awkwardly foreshortened or turned out in a forced balletic pose, disrupting the quiet elegance of her figure. Another hypothesis is that by hiding her shoes, evidence both of current fashion and of her grounding, Goya distanced her from the mundane.[5] But given that those struck with deafness in mid-life must grow accustomed to people who enter their range of vision without warning, since no footsteps are heard, Goya's experience might also be considered. Even as the duchess stood before him, there was no sound of shifting feet: she floated.

This portrait is one of many images of the duchess created by Goya around this time: she has been identified as the fashionably dressed woman in a wash drawing where, once again, she is posed frontally with her feet hidden by her skirt, and in another drawing as the woman holding Alba's adopted black daughter Mari Luz.[6] Life in the Alba household also inspired two small paintings, both signed and dated to 1795. In one, the duchess playfully brandishes an amulet of coral—traditionally used to protect against the evil eye—before a servant nicknamed "La Beata" (a term describing a devout woman), who responds by brandishing a crucifix; in the second, Mari Luz and a second child identified in the inscription as "Luis Berganza" (the son of Alba's majordomo) tug La Beata's skirt.[7] Interpreted as scenes witnessed, these works have led to the suggestion that Goya had a studio in the Alba residence in Madrid, the palace of Buenavista on the Calle de Barquillo (today, the Cuartel General del Ejército). One author's suggestion becomes another's probability: "He probably had a studio in the Duke and Duchess's Madrid residence."[8] The underlying implication is that Goya had to spend extensive time in the household to "record" the figures and scenes he painted; in fact, these probably reflect inventions based on memory. What is more, Goya's own house and studio on the Calle del Desengaño was a short walk from the Alba palace, and a second studio would hardly be necessary.

"Being sick in bed with the pain that God our Savior has determined to give me," Francisco Bayeu wrote his will on March 22, 1795, and named Goya as one of six executors. He lingered, with good days and bad, until his death in early August and spent lucid periods putting his affairs in order. In February he sent 500 *reales* to Zapater to be given to his father-in-law, the painter Juan Andrés Merklein; wishing to settle matters in April, he asked Zapater for an accounting of everything he had spent in support of Manuel Bayeu, "because I do not want to be in purgatory because you are keeping me in

debt." In June he requested the king's approval of the marriage of his daughter Feliciana to an employee of the postal service. He proudly reported his remedy of lemon juice poultices on his stomach and spoonfuls of lemon juice and sugar to replace the broths and opium prescribed by his doctors, who, ashamed, had not returned to bother him.[9] Memories of the trials with his equally proud brother-in-law weighed heavily, as revealed by Bayeu's words to Zapater in a letter written on the first of April: "My friend, I have always truly loved you and never wanted to offend you, but if by chance I failed you, or Goicoechea, in those disagreements with Goya, I ask you both to pardon me. Friend, this isn't sadness, but once God gives me the illness of a calm mind and strength, in case he disposes of me it seems very right to sweep clean the corners of my conscience."[10] Following Bayeu's death on August 4, his widow Sebastiana returned to Zapater a pair of slippers he had sent, writing, "It is enough that you were friends, I am in shock and deep sadness." Her grief would not last, for she died ten months after her husband on June 3, 1796; nine days later, her aged father wrote to ask that the pension granted to her by the king be transferred to support him and his remaining daughter.[11]

Given the king's awareness of Bayeu's poor health a year earlier, he presumably realized that Bayeu would not live to fulfill the three-year term as general director of the Royal Academy, to which he was appointed on June 17. Maella assumed the position upon his death. Goya, despite his absences from academic meetings and classes during the previous two years, was one of three assistant directors who solicited Maella's place as director of painting, claiming that he was able to fulfill his monthlong turns in the studio and correct drawings. Meeting in September, the academicians gave Goya seventeen votes, far surpassing the eight votes cast for Gregorio Ferro or the single vote for Francisco Ramos; the king approved their recommendation on September 13.[12] Goya meanwhile undertook a portrait of Bayeu based on the artist's self-portrait and exhibited it, unfinished, at the academy in August. It was apparently painted at Feliciana's request and completed the following year, according to her account of her possessions made on the occasion of her marriage, which included "a gold box, oval in shape, with a crystal with a monogram at the center" that "was given to Uncle Goya for painting the portrait of our father Francisco Bayeu in 1796."[13]

Goya sought more than an improved position at the academy following Bayeu's death, as revealed by a document which, by its content and reference to Godoy as the duke of Alcudia, can be dated to sometime after Bayeu's death in early August and before late September, when a new title for Godoy was made public. Iriarte, who as vice-protector of the academy reported to its protector Godoy, served as intermediary:

The request of don Francisco Goya pertaining to salary was not considered possible, nor has the death of Bayeu given the opportunity for an increase, since the king is not inclined to assign the position of first court painter with the title and salary for such, and, as a consequence, it is not vacant, His Majesty made clear that the salary enjoyed by Bayeu himself was greater than he thought.

Yriarte was ordered to speak with S.or Llaguno [the minister of grace and justice] who indicated this to him and invited him to see all the royal resolutions taken after the death of Bayeu relative to some employed painters, who had low salaries and for whom these have been somewhat increased, without any exceeding the 15,000 reales received by Goya and Ramos.

The Señor Duke of Alcudia was who presented the request of Goya to the King, wanting to favor him; but he found the will of His Majesty determined not to make greater increases in pay, with some surprise that Bayeu had been paid so much.

Concerning the request that Goya apparently also made that he be commissioned those works that had been assigned to Bayeu, Yriarte could not, during his stay at the residence, ask in the office of the first secretary of state via the officials, if anything had been determined concerning this matter. But having not obtained the primary objective that included a pecuniary benefit for Goya, it would not surprise if without it they did not want to impose upon him an obligation and work that would be the execution of said works.[14]

Despite the support of Godoy and Iriarte, Goya remained with the salary of 15,000 *reales* granted almost a decade earlier, supplemented by income from his growing number of private commissions.[15]

Following the fall of Robespierre and the end of the Reign of Terror, France established treaties with Prussia (April 5, 1795), the United Provinces (April 16), and Spain (July 22), following the death on June 8 of the imprisoned dauphin, the eldest son and heir to the French throne, who had been a major obstacle to the negotiations. The National Convention established the Directoire in August (inaugurated two months later), approved a new constitution (the third since the fall of the Bastille), and ratified the peace agreement with Spain. Carlos IV ordered a Te Deum Mass, as well as three days of full dress at the court, beginning on Saturday, September 5. The *Mercurio de España* of September 1795 listed four full pages of honors bestowed by the king, saving the most sensational for last: "To the Most Excellent Señor Duke of Alcudia,

first secretary of state, for his outstanding services, and for the distinguished and important one just completed to the general benefit of all the kingdom, the title of Prince of Peace."[16] Although the Hapsburg king Philip IV had bestowed the same title on the count of Haro following the Peace of the Pyrenees (1659),[17] these were different times. Within three years of the execution of the French king, Carlos IV saw fit to invent a noble station and bestow it on a twenty-nine-year-old officer. Perhaps it was intended in defiance of politically motivated gossip casting Godoy as the queen's lover or of popular opposition to Godoy's rapid ascent at court, which eight months earlier inspired a plot to overthrow the government on the day of San Blas (February 2) 1795.[18] But if Carlos thought that ennobling Godoy would put such rumors and plots to rest, events of the coming months soon proved him wrong.

———

Alejandro Malaspina, captain of the Spanish Royal Armada, was arrested on November 22, 1795, less than a year after he had been presented to the king and queen following his triumphant return to Madrid from a government-sponsored, five-year-long voyage to the Pacific.[19] Malaspina's interests went beyond kissing the royal hand, however, and he tried in vain to get a hearing for his thoughts on government and on peace with France. He wrote that same month: "I was, in short, sure of my heart and its complete dedication to the general welfare, without selfishness or prejudice; but it is so difficult to be received by the *Sultán*";[20] the "Sultan" was Manuel Godoy. Contrary to appearances, Godoy was in fact very attentive to Malaspina: in January 1795 he reviewed papers Malaspina had given to the secretary of the navy, Antonio Valdés, and ordered that the author be admonished and all drafts destroyed; in February he received directly from Malaspina a proposal for peace with France. A deluded Malaspina wrote that same month: "I am destined for matters of the greatest moment relative to the prosperity of the entire realm, or I will return to my former naval duties." Neither prediction came true.[21]

Malaspina wrote in November to Carlos IV and María Luisa to recommend a slate of ministers for his new government: the duke of Alba to replace Godoy; Antonio Valdés (who had retired earlier that month) as secretary of the navy; the former viceroy of New Spain, Revilla Gigedo, as secretary of the treasury; and Jovellanos as president of the Council of Castile. Soon arrested, Malaspina apparently still had sympathizers within the Council of State who voted on his case, making it necessary for the council's secretary to remind the members that the king had ordered a unanimous vote on three resolutions, the last of which read: "That His Excellency [Godoy] had been

and was most worthy of the sovereign confidence of Their Majesties, and the selection of his person to take charge of the duties of the first secretary of state fully justified."[22] No dissenting voices were recorded.

Did the individuals named by Malaspina to positions in his government have any knowledge of their involvement? Jovellanos's diary entry of December 3, 1795, suggests not: "Mail: they announce the imprisonment of Don Alejandro Malaspina, who commanded the voyage around the world, and of father Manuel Gil, a minor cleric from Seville who had been named to write his memoirs; they are treated as prisoners of the state and locked up in the barracks of the royal guard. This is important and incomprehensible news. Might they have reached an agreement with the English? Could it be a shot at his former protector, Antonio Valdés? Time will tell."[23] The endorsement of Malaspina's plan by the duke of Alba seems unlikely, and could easily be dismissed, were it not for Alba's unexplained departure from court early the following year; he signed over legal powers for his possessions and estates to his wife on January 29, 1796, and sometime after February 23 traveled to Andalucía.[24]

Following Malaspina's arrest, the monarchs and Godoy traveled south, ostensibly to fulfill a vow to visit the relics of Saint Ferdinand in Seville. The royal family departed from El Escorial on January 4, 1796, and after visits to Talavera de la Reina, Trujillo, and Mérida, arrived at Godoy's hometown, Badajoz, where they stayed for almost a month. They resumed their trip to Seville on February 15 and arrived three days later, stayed until the end of February, and continued to Cádiz before returning to Aranjuez, where they arrived on March 22. Hardly surprising is the official report of the royal tour as an unmitigated success: "In all the villages there has been an innumerable crowd of people who have come out to receive and pay tribute to Their Majesties with justly owed acclamations, being beyond explanation the jubilation and joy that abounds in the hearts of all within the friendly presence of their august Sovereigns."[25] Godoy made a very different impression on clerics in Seville, who in March requested the Inquisitor general and cardinal of Toledo to issue a secret order to Carlos IV against Godoy, suspected of atheism, of not attending Mass, and of scandalous conduct. The plan failed, and its instigators were assigned a mission in Rome.

Following the monarchs' return to Madrid, Goya departed from Madrid. No request for leave is known, although a remark made by the marquis of Santa Cruz in a report of June 17, that Goya appeared to be unable to paint due to his "usual ills" (males habituales),[26] suggests that a leave would have been granted; at some point Josefa Bayeu signed for Goya's first quarterly payment from the academy with the words "due to the absence of my husband."[27] In

early May Goya received a request from Jovellanos for a portrait of the prince of Asturias for the Royal Asturian Institute in Gijón; the portrait was assigned to Antonio Carnicero, who had been named court painter on April 25.[28] Ceán wrote to Goya, asking him to relay a request to his longtime acquaintance, the sculptor Joaquín Aralí, whose response to Ceán in late July provides some clues to Goya's plans: "My dear Sir and Master: I will satisfy the commission that my friend Goya made to me on May 25 telling you about my life, although it would be better to keep quiet for it is of no benefit to anyone." Having offered his biographical details, Aralí signed the letter and added in a postscript: "Please give my regards to Goya, if by chance he is in Seville on his return from Sanlúcar." In a postscript to a second letter written in September, Aralí added, "From news we have received it seems that Goya is not doing at all well, which all of his friends and all who know him regret."[29]

Assuming Goya relayed Ceán's request to Aralí in person, mentioning his forthcoming visit to Sanlúcar, he left Madrid after May 25; by September rumors that he was again ill had reached Madrid. There was little reason to travel to Sanlúcar beyond business at the Alba estate, but if Goya had such plans on May 25, they were disrupted by the duke's sudden illness and death in Seville on June 9, which left an "incomparable Widow, who after the testimony of the deepest love during the time of his illness, was known to sacrifice the most pure and innocent pleasures to the memory of her late husband."[30] Plans to visit Sanlúcar were postponed, for the duchess was in no state to receive the artist. On June 15 the late duke's cousin, Carlos Pignatelli, wrote to the duke of Granada in Madrid relaying the duchess's request for a locket to hold hair of her late husband. Her commission was specific: the lid would be a miniature after the portrait of the late duke by Goya, then in Esteve's studio to be copied; the duchess requested changes in the costume, hair, and decorations. The postscript, in the duchess's hand, attests to her distress: "Dear Cousin and friend the pain that tears apart my heart does not allow me to write but to say that I hope you will place in me the confidence and friendship that you had with my never too highly praised Pepe. Have sympathy for me, and order what you will of the unhappiest woman of all who have been born."[31]

Goya probably lingered in Seville. When Ceán asserted that the terracotta sculpture of Saint Jerome by Pietro Torregiano in Seville was "not only the best piece of modern sculpture that there is in Spain, but we also doubt that there is better in Italy or France" in his dictionary of artists published four years later, he added that he would not offer this judgment had he not heard this opinion from don Francisco Goya, who "in our presence examined it, climbing to the niche in which it is placed on two separate occasions,

staying there each time for more than five quarters of an hour."[32] Goya might have first examined the sculpture in February 1793, prior to his illness, or perhaps on two separate occasions during his Andalusian sojourn of 1796–1797.

The diary of the playwright Leandro Fernández de Moratín, whose acquaintance with the artist would span the next three decades, confirms that Goya was in Cádiz by later December, once again ill. Having served as secretary to Cabarrús in the National Bank of San Carlos, Moratín met Manuel Godoy, whose sponsorship enabled him to travel to Paris, where the political situation soon curtailed his stay, and then to London and eventually to Italy. In Italy he received word from Godoy in August 1796 of his appointment as "secretary of the interpretation of languages." An eventful passage from Italy brought him to Cádiz, where on Christmas day he dined with Sebastián Martínez (as he did frequently during his stay), went to the theater, and visited the ill Goya. He noted other visits, sometimes made in the company of Martínez, simply as "chez Goya," on December 29, 1796, and January 1, 2, 3, and 8, 1797. Five days later, Moratín traveled to Seville, where he enjoyed daily visits and art excursions with Ceán, dined with the duchess of Alba on January 19, and wrote to Jovellanos from Ceán's house on January 21: "The honorable Ceán is the same as always: I write this from his house and at his side."[33]

Goya's stay in Cádiz inspired at least two drawings. One, executed in brush and ink wash, shows a man identified by his short, wide pants and headscarf as of the working class, ogling the abundant cleavage displayed by a woman whose low neckline, short skirt, and brash manner argue for an identification of her as a prostitute. The man sits on a block inscribed "Caricaturas de las Carracas" (Caricatures of the Carracas), a reference to a naval shipyard in Cádiz known as the Arsenal de la Carraca, just the place where such unsavory types might be found.[34] The drawing is one of four whose subjects are simply titled "caricatures," a point of departure for the increasingly witty captions that Goya added to his drawings, for as an observer of scenes without sound, the deaf artist no longer took meaning for granted. His captions function like the note that a friend with hearing might scribble to explain a scene to a deaf person; only now, it is the deaf man who elucidates for us the world of his invention. A second drawing inspired by Cádiz introduces a fashionable dandy, bowing to a woman wearing a mantilla and *basquiña;* she averts her face only to expose her décolleté; a pair of lapdogs in the right foreground mimics the interchange (fig. 12). The pencil caption explains: "A miniature painter: it took him seven minutes to cross the Plaza of San Antonio in Cádiz"; one of two towers on the façade of the church that gave the square its name stands in the background. Over that caption, Goya penned a

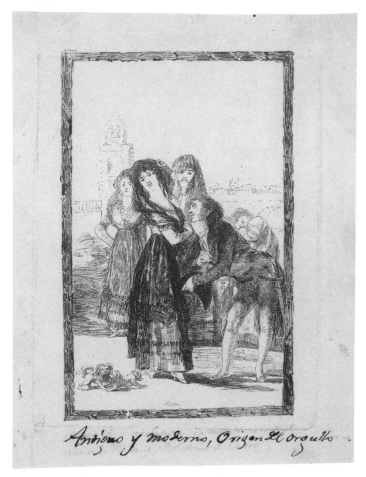

12. *Sueño 18: Antiguo y moderno: Origen del orgullo* (*Dream 18: Ancient and modern: The origin of pride*), 1796–1797. Pen and ink, 9 ⅝ × 7 ⅜ in. (24.5 × 18.6 cm). Museo del Prado, Madrid.

pithier title: "Ancient and modern: The origin of pride." The sheet bears the impression of the metal plate, showing that the drawing was transferred to the plate to guide the artist's hand in etching *Which of them is the more overcome?*, plate twenty-seven of *Los Caprichos* (fig. 13).

We know little of Goya's stay in Sanlúcar, which surely followed his recuperation in early 1797. In discussing the attribution of a painting in the town's parish church over a decade later, the count of Maule noted that "un hábil artista conocedor" assured him that it was by Poussin and in a note identified the "able and knowledgeable artist" as Sr. Goya, who was in Sanlúcar "to see the Duchess of Alba."[35] On February 16, 1797, the duchess wrote her last will and testament, including at the end of a long list of beneficiaries: "To the

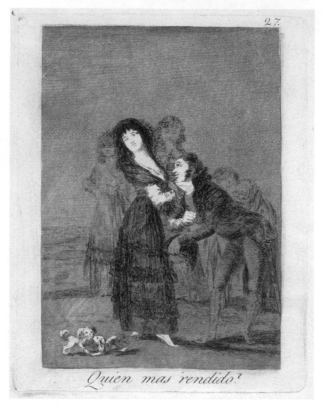

13. *Quien mas rendido?* (*Which of them is the more overcome?*),
Los Caprichos, pl. 27, published 1799. Etching, aquatint, and
drypoint, 7 ½ × 5 ¹³⁄₁₆ in. (19.1 × 14.8 cm). The Metropolitan
Museum of Art, Gift of M. Knoedler and Co., 1918.

son of Don Francisco Goya ten reales a day for life," an addition that suggests
the painter's presence at Sanlúcar around that time. That stay inspired a sec-
ond full-length portrait of the duchess signed and dated 1797 (pl. 12). Noth-
ing could be further from her almost evanescent portrayal two years earlier:
the duchess wears a black mantilla and *basquiña*, her feet fully visible and
grounded, and dominates the large canvas as she points imperiously to the
inscription "Solo Goya" (which might be translated as either "Only Goya" or
"Goya Alone"). Her black lace mantilla sets off her blank expression, perhaps
deadened by grief; she originally wore no jewelry, for the two rings on her
hand inscribed "Alba" and "Goya," which have fed the myth of the romantic
relationship between the two, were added at a later date by another hand.[36]
Arguments against a liaison between the duchess and the artist go beyond
the dating of the rings. The first is the social distance between the duchess, a

widow representing one of the most important aristocratic families in Spain, and the artist, listed in the duchess's will only at the end of a long list of household servants; the second is the duchess's heartfelt grief following the sudden death of her husband the previous year. The inscription "Solo Goya" is not a statement of love but a reflection of artistic pride, that only he could paint this extraordinary, and unconventional, portrait.

Circumstances suggest that the duchess neither saw the portrait nor read Goya's boastful inscription. The painting is included in an 1812 inventory of Goya's studio, implying that Goya either returned to Madrid with the full-size canvas or painted it entirely in Madrid from sketches or memory. The possibility that the duchess rejected the work, so stark and so contrary to Goya's portrayal of her two years earlier, might be considered in light of the fact that she remained in Sanlúcar until her return to Madrid in December 1799. By then, she had fallen from favor at court; Goya, on the other hand, had reached his zenith with his appointment two months earlier as first court painter. Would the artist, once again the chosen portraitist of the monarchs, attempt to deliver the portrait to the outcast duchess? The time may have passed, for her effigy lingered among other canvases in Goya's studio, eventually catching the eye of Baron Taylor on a mission to collect Spanish paintings for the French king, Louis Philippe, who purchased it from Javier Goya with seven other works. The duchess reemerged into public view in Paris in January 1838, installed in the king's gallery of Spanish painting at the Musée du Louvre. A critic noted her idiosyncrasies: "The face of the duchess of Alba does not have an air of reality; the cheeks are too lightened, the eyes and black brows drawn on the skin without intermediary tones, the absence of shading, give her the appearance of a wax figure, but the attitude and costume deserve only praise."[37]

18

Dreaming, Enlightened

April–December 1797

Following his return to Madrid, Goya resigned from his position as director of painting in the Royal Academy on April 1, 1797, explaining that when he assumed the position almost two years earlier, he had hoped for relief from his ills, "but now sees that instead of subsiding, his maladies have been exacerbated, and consequently there is no way that his plans can be achieved." Three days later his assembled colleagues judged that his reasons were "just, sincere, and truthful," and lamented "seeing in such a deplorable state of health a professor of distinguished merit and that one of his maladies be a deafness so profound that he hears absolutely nothing, not even the loudest noises, a misfortune that deprives the students of being able to ask him questions." Goya's appointment as honorary director won unanimous approval.[1]

Various essays titled "Sueño" (Dream) in the *Diario de Madrid* during the 1790s continued a long literary tradition of dreaming as vehicle for social commentary. One anonymous author penned a *sueño* in which he was "strolling on the Prado, on one of the many days when the infinite confluence of people of both sexes offers the most beautiful panorama that one can imagine; I observed with unspeakable pleasure the variety of rich dresses, costly basquiñas." An old man approached and offered the writer a looking glass, at first rejected but accepted once the owner of the glass identified himself as "Human Understanding." Looking through it, the author spied a "terrible marten" that caught birds through flattery only to then deplume them; lowering the glass, he discovered his subject to be a *petimetra*, surrounded by several solicitous young men. The glass enabled him to see young women with their heads filled with nonsense; young men with their bodies corrupted by wine and women; and two people, their hearts devoured by jealousy, embracing. Soon the writer could tolerate no more. The old man invited him to turn

the glass on himself, which he did, only to find himself awakened by a servant, who heard his screams.[2]

Goya came to realize that his invention, like the looking glass, could reveal truths underlying appearances. But how? Four undated drawings of single figures looking into full-length mirrors might have been his first essay in the genre: a *petimetra* is reflected as a snake encircling a crutch; a *currutaco* as a monkey; a constable as a cat; and a student as a frog. Although sometimes related to *Los Caprichos*, these pen-and-ink drawings lack the technical sophistication and complexity seen in the preliminary drawings for those etchings, and the obscurity of their symbolism suggests them to be an earlier exercise, as Goya began to explore visual equivalents for the looking glass of Human Understanding.[3]

Another *sueño* from the *Diario de Madrid* re-created the experience of a more famous dreamer:

> Newton falls asleep. At that moment that active and penetrating faculty, that gave form to the most abstract sciences; that elucidated the system of the universe with so much precision and clarity, falls into confusion and darkness. Now only a mix of erroneous images takes form. Instead of solid and fertile principles come vague phantoms, and he is abandoned to the most ridiculous perceptions.... The brain of one of the most ingenious men, who interrogated the truth with his admirable knowledge, is given over to the most disordered irregularity. Grotesque figures replace the lines of the most brilliant geometry.

Newton awoke and clarity was restored, leaving the author of the essay to ponder, "By what power does the most luminous order of ideas follow the craziest of visions?[4] Did Goya ask himself a similar question as he lay in darkness at night?

> If you wake up in the middle of the night, surrounded by utter darkness and absolute silence, you may perhaps sense a certain difference between them. The two null experiences are not the same: darkness is dense, thick, full, one might say, whereas silence is sheer expectant emptiness. Darkness signifies a temporary invisibility of things you otherwise would be able to see: it is impenetrable, because it prevents you from seeing them. Silence, however, does not impede your hearing, or muffle sounds that would otherwise be audible. It signifies a positive absence of sound: it is not opaque, but deadly.[5]

Prior to the onset of deafness, sounds from the street, of movement within the household, of windows creaking in the wind, mitigated the darkness of Goya's nights. Now, an unearthly silence reigned. Did this make his dreams more vivid, with no sounds ever to interrupt and wake him? And did waking hours seem more like a dream, as people soundlessly entered and left his field of vision, perhaps stopping to gesture or write a message, or perhaps, tired of making the effort, just moving on? As silence became insistent, the interactions that grounded Goya in daily routine became less so, inviting visions of night to seep into day. Two brush-and-ink drawings from the mid-1790s, both captioned "Brujas" (Witches), give form to such irrational visions: in one, a student is indoctrinated in the devil's ways; in the other, a witch uses a child as a bellows, as air blown from his anus brightens the torch that attracts ghouls, a flying witch, and an owl.[6]

The word "Sueño" is penciled above or beneath the images of several pen-and-ink drawings (some with traces of pencil), their paper impressed with plate marks that confirm their use as preliminaries for etchings;[7] included among them is the drawing previously discussed of the miniature painter crossing the square of San Antonio in Cádiz. Far more famous is the *Sueño 1*, intended as a frontispiece, in which a man seated in a chair has dozed, resting his head on a block that serves as a table; above him, a quarter-circle of untoned paper suggests light (or a place for title), as bats and owls emerge from shadows behind; a lynx seated on the floor, alert and wide-eyed, alone suggests clarity of vision (fig. 14). A penciled caption identifies the figure: "The author dreaming. His only objective is to banish prejudicial vulgarities and perpetuate with this work of caprichos the solid testimony of truth." Inscribed on the front of the dreamer's desk are the words: "Universal Language Drawn and Engraved by F^{co} de Goya the year 1797." Thus, by 1797 Goya had conceived the project for a series of etchings, ultimately to become known as *Los Caprichos*; his reference to "this work of caprichos" in the caption to the first *Sueño* suggests that he had already finished many, if not all, of the *Sueños* drawings. We do not know when, where, or by whom the etchings after these and subsequent drawings, in ink, red chalk, and wash, were printed. An undated draft prospectus (today unlocated) offered editions of seventy-two etchings by subscription and noted that "the work is now done and the plates only have to be printed";[8] no other mentions of the series prior to the purchase of four sets by the duchess of Osuna in January 1799 have come to light. Advertised in the *Diario de Madrid* on February 6, 1799, as a set of eighty etchings (rather than the prospectus's seventy-two), the series was priced at 320 *reales*, the equivalent of one ounce of gold.

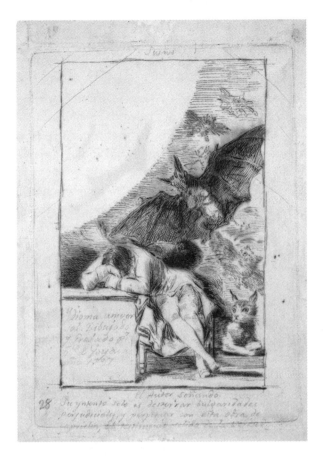

14. *Sueño 1: Ydioma universal. El Autor soñando* (*Dream 1: Universal language. The author dreaming*), 1797. Pen and ink over traces of pencil, 9 ¾ × 6 ¾ in. (24.8 × 17.2 cm). Museo del Prado, Madrid.

Goya's objective, to "banish prejudicial vulgarities and perpetuate with this work of caprichos the solid testimony of truth," echoes the intention of reform-minded writers of his day. Godoy, now Prince of Peace, worked in earnest to find solutions for social and economic problems and in the final months of 1797 appointed Meléndez, Jovellanos, and others to leading positions at court. Their ascendance at court from November 1797 until summer 1798 may also have encouraged Goya to bring the project of *Los Caprichos* to fruition. His brush was in demand among the court's cultured elite, who may have been aware of the evolving project of *Los Caprichos* or possibly admired the innovation illustrated by the "two small paintings of his own invention," included by Goya in the summer 1797 exhibition at the Royal Academy. Goya also showed a portrait, today lost, of Simón Viegas, a jurist, author, member of the Spanish Royal Academy of Law, and friend of Moratín, who often mentioned Viegas in his diary. A writer coming to the defense of Viegas in a

literary quarrel in the pages of the *Diario de Madrid* in 1801 recalled the portrait by Goya (to whom he referred as the "Apelles of Spain"), exhibited to a discreet public only to be defaced by malicious boys. Whether the vandalism of the portrait happened in fact, or was only a metaphor for the literary attacks against Viegas, is unclear, but the mention of Goya's portrait four years after its public exhibition attests to the fame of both the sitter and the artist.[9] That in 1806 Moratín and Viegas, by then an attorney for the Consejo Real (Royal Council), together visited Goya suggests a continued mutual esteem.[10]

The poet and jurist Juan Meléndez Valdés also sat for Goya that year. From Madrid, Meléndez corresponded regularly with his longtime friend and mentor Jovellanos, who provided a recommendation for Meléndez on April 23. As Meléndez persisted, Jovellanos advised him in a letter of July 27 to "run from the Court to enjoy your good reputation in Valladolid" (advice Jovellanos himself would soon ignore).[11] In April and again in July 1797, Meléndez visited Moratín, perhaps to discuss literature but also to seek Moratín's assistance in gaining the goodwill of the Prince of Peace, to whom Meléndez dedicated the first edition of his poems published that April. An appointment to the court judiciary on October 3 was the reward for his perseverance. He soon made a personal trip to Valladolid, where he fell ill, and assumed his position only in February of the following year. Goya's portrait, inscribed "To Meléndez Valdés his friend Goya 1797," is a subtle study of the character of the forty-three-year-old jurist, executed in a harmony of cool grays, white, and the warm red-brown of his coat that contrasts with the dark green tones of the background (fig. 15). Apart from the richness of applied paint, there is nothing in his simple attire or lightly powdered hair to distract from Goya's rendering of his careworn, perhaps jaded, gaze. Probably painted before his early October appointment, given Meléndez's departure from Madrid soon after, this is not an official portrait: as implied by its inscription, it is a friendship portrait, offering a stunning likeness of a dedicated and tired man, painted with little embellishment.

What might have brought these men together? Goya's attendance sixteen years earlier at a general session of the Royal Academy, where Meléndez read his "Ode to the Fine Arts," hardly justifies such a sympathetic portrayal. Moratín offers one connection, since he maintained his relation with Goya through ten visits between June and December of that year.[12] But another mutual association with Meléndez might have been through Zapater, who was again in Madrid by early April 1797, when Goicoechea wrote to say he was happy for his safe arrival to that "emporium"; during his stay, Goya again painted his friend, now fifty years old.[13] Like Meléndez, Zapater is seated behind a parapet inscribed "Goya to his friend Martín Zapater 1797"; the

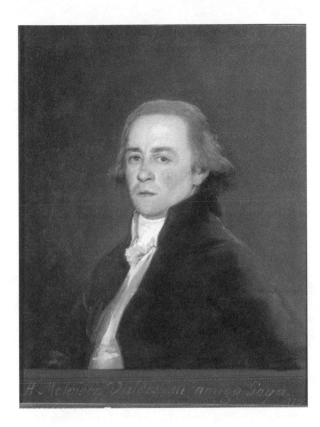

15. *Juan Meléndez Valdés*, 1797. Oil on canvas, 28 ⅞ × 22 ½ in. (73.3 × 57.1 cm). The Bowes Museum, Barnard Castle.

similarity of the portraits would have been more pronounced before that of Zapater was cut down in the early twentieth century to an oval shape.[14] We recall that Meléndez served as justice in the criminal courts of Zaragoza from 1789 to 1791, where he joined the Economic Society of which Zapater was a member, and contributed to developing statutes for the future Royal Academy of San Luis, championed by Zapater in Madrid in 1792.[15] Five years later the men coincided at court with similar objectives, for Goicoechea's words to Zapater suggest that he, like Meléndez, sought a favor from the powerful: "I have already written you, and I tell you now again, do not bother yourself with those people who find themselves with an abundance of vanity, pride, presumption, and that you treat them with this knowledge."[16]

Goya paid a more formal tribute to his advocate, the senior statesman Iriarte, in a portrait inscribed "D. Bernardo de Iriarte Vice Protector of the Royal Academy of the three noble Arts, portrayed by Goya in testimony of mutual esteem and affection. Year of 1797."[17] Perhaps the artist vied with the portraits in Iriarte's collection of "the most classic authors and that of Murillo and of Don Antonio Raphael Mengs, painted by themselves"[18] as he

envisioned his own work hanging among them. The elder statesman sits erect, a characteristic posture satirized by one writer who referred to Iriarte as "the lanceman, because of his stiff and haughty comportment."[19] The lace of his collar and cuffs contrasts with the more fashionable cravat worn by the younger Meléndez, and Iriarte's cutaway coat reveals a waistcoat upon which Goya lavished a free play of strokes and dashes, bringing together the gray, blue, gold, and red tones seen elsewhere in the portrait. So pleased was Iriarte with the portrait that he ordered it brought to the academy on November 1, where it was praised not only for the resemblance but for the mastery with which it was painted.[20]

Contradicting his own advice to Meléndez to run from court, Jovellanos also sought Godoy's favor and to this end wrote to him on April 19; the response is known only from Jovellanos's reaction, noted in a diary entry of May 4: "I am content, because it shows a good opinion of me, and this is enough." In an entry of July 31, he referred to another letter from Godoy concerning "the reasons for the backwardness of useful arts and improvements in education." The following day Jovellanos noted that he responded to Godoy, would prepare for his task (left unspecified), and expressed his pleasure in Godoy's sincere concern for the good of the nation. Godoy soon asked Jovellanos to serve as ambassador to Russia, eliciting the response on October 18 that his poverty, habits, age, and obscurity would make it impossible for him to live in a foreign court. In replying, Godoy emphasized the importance of the position but also opened the door for Jovellanos to suggest another appointment more to his liking. A week later Jovellanos accepted the ambassadorship; the following week Manuel Godoy wrote, "My Friend. You are now in the group of five: the Ministry of Grace and Justice awaits you, and the nation will receive the good your talents will produce for it."[21] Ending a seven-year absence, Jovellanos began his journey to Madrid and met Cabarrús at the Puerta de Guadarrama en route to El Escorial, where they arrived on November 22. Jovellanos also renewed his acquaintance with Francisco de Saavedra, the newly appointed minister of finance, whom he had first met in Seville in 1770.[22] His diary entry of November 22, the last known from his term in Madrid, describes his discomfort in being improperly dressed and his revulsion at seeing Godoy at dinner with his wife, María Teresa de Vallabriga, seated to his right and his mistress, Pepita Tudó, to his left. Jovellanos wrote: "This spectacle culminated my unease; my soul couldn't stand it; I didn't eat, I didn't speak, nor could I put my spirit at rest; I ran from there."[23]

A month earlier, Godoy had married the eldest daughter of the *infante* don Luis, María Teresa de Vallabriga, portrayed as a child by Goya fifteen years earlier (fig. 8). Although the arranged marriage brought Godoy closer

to the royal family, it did not diminish his desire for the eighteen-year-old Pepita Tudó, who bore him two children and in 1808 followed him into exile, as his wife remained in Spain. Following María Teresa's death in 1828, Godoy married Pepita on January 27, 1829. But thirty-two years earlier, his exhibition of his lover at an official dinner was at best offensive; to Jovellanos, returning from a more conservative province to Madrid, where mores had changed significantly during the past eight years, it was indeed shocking.

In that same entry, Jovellanos mentioned his conversation with Francisco Saavedra and Cabarrús and continued: "Everything threatens imminent ruin that envelops us all; my confusion and the affliction of my heart grows." He was not wrong. Having entered into an alliance with France in August 1796, Spain declared war on Great Britain on October 7, 1796, a step described by one historian as "the most momentous decision of the reign." To be sure, Spain had few options, since England, suspicious of her support of France, had already attacked Spanish shipping; the Spanish navy alone did not have the capacity to protect its neutrality.[24] The economic impact of a war that would last a decade, interrupted only by the two-year Peace of Amiens, was catastrophic. Spain lost its maritime security and, with New World trade disrupted, a major part of its income: due to the English blockade, the most significant contributor to the central treasury, Cádiz, lost 90 percent of export trade and 95 percent of its American commerce during the years to come.[25] As 1797 drew to a close, the crown's income was 487,000,000 *reales*; expenses reached an unprecedented 1,423,000,000, and measures to address the ballooning deficit became increasingly desperate: in July 1797 bonds were issued to raise 100,000,000 *reales*; on November 29, another issue of bonds worth 60,000,000 was offered.[26] The November offering closed with many bonds unsold. If anyone was less comfortable than Jovellanos at Godoy's welcoming dinner, it was Saavedra, the third minister of finance brought in since the beginning of hostilities with England.

———

When Goya and his friends gathered for a Christmas feast in December, these issues were far from their minds; instead, they celebrated their benefactor, Zapater, who had won 7,500 *reales* in the lottery and sponsored the party. Goya addressed a letter to the absent host, "Most Powerful, most generous, and most splendid Sir Don Martín Zapater," and continued:

> Who would have thought, even imagined, that a cheapskate, that a misanthrope, such as Your Honor would have, with such great gallantry, taken by surprise our spirits, inclined (and also interested)

to celebrate, and applaud your fortunes; no one; and so our exalta-
tion has reached a point that the joy has almost become immoderate!
What toasts! What bottles one after the next! What coffee and more
than coffee! What glasses in the air! There is nothing more to say ex-
cept that the crystal in the house has been renewed; and with all this
everyone only hears the happy shouts of viva Zapater! What an excel-
lent man! What a good friend: viva and viva again.[27]

Hearing with his eyes, Goya brought to life the boisterous cheers and scene
in a description that was neatly transcribed by a professional on the front
and second page of a folded sheet of letter paper, concluding with the words
"Friends and Servants that Kiss your Hand." Signatures and salutations of
the nine men and two women gathered during the festivities fill the third
and fourth pages; one of them was that of Josefa Bayeu, who signed on the
last page and complimented the rich holiday pastry wound in the form of
an eel. A figure of trumpeting fame, sketched by Goya, proclaims Zapater's
greatness. The party over, the letter transcribed, Goya undoes the letter's
formality by pasting a small piece of paper with an irreverent final word: an
image of a man kneeling, with breeches lowered and shirt raised to expose
his buttocks—an international posture of mockery. Recently interpreted as
a reference to an intimate relationship between the two men,[28] the drawing
would surely have been torn off if that were its implication, rather than filed
by Zapater and passed by his nephew to his great-nephew, the self-appointed
guardian of Goya's reputation, Francisco Zapater y Gómez.

Subir y bajar

1798

GIVEN that Goya sold four prepublication sets of *Los Caprichos* to the duke and duchess of Osuna in January 1799 and advertised the series in early February, he probably etched and oversaw the printing of his plates through much of the previous year. The series evolved as he worked, from the social satire and witchcraft subjects of the *Sueños* drawings, to scenes of creatures made human by their emulation of our foibles, to emblematic images such as *Subir y bajar* (*To rise and to fall*), in which Pan lifts a uniformed man with his hair ablaze as others tumble into the surrounding void (fig. 16). Although contemporary manuscripts interpret this as a reference to Godoy elevated by lust, the rise and fall of government officials between November 1797 and October 1798 justifies a more general reading, as a commentary on the ephemeral nature of political power.[1]

Meléndez Valdés returned to Madrid by February 1798 to assume his position as criminal judge and join his friend Jovellanos, now minister of grace and justice; Meléndez's wife recalled their visits twice daily.[2] Socializing did not hinder his productivity, attested by the eloquent arguments he wrote for the prosecution that provide insight into long-forgotten events of Goya's world. The best known of these, presented in court on March 28, 1798, dealt with the murder the previous December of Francisco Castillo by his wife, María Vicenta Mendieta, and her lover, Santiago de San Juan, a case that fascinated Madrid and probably inspired Goya's *Capricho* of an imprisoned young woman *Porque fue sensible* (*Because she was susceptible*).[3] Between March and July, Meléndez wrote arguments pertaining to a husband's murder of his wife, a father and daughter accused of incest, a man accused of stealing jewels from the image of Our Lady of the Almudena, a theft of livestock, and a ruling in response to women who audaciously wore *basquiñas* in colors other than black during Holy Week.[4]

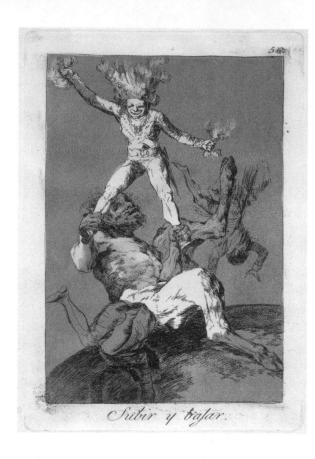

16. Subir y bajar (To rise and to fall), Los Caprichos, pl. 56, published 1799. Etching and burnished aquatint, 8 7/16 × 5 7/8 in. (21.4 × 14.9 cm). The Metropolitan Museum of Art, Gift of M. Knoedler, 1918.

During his years in Gijón, Jovellanos wrote to Goya at least three times in the hope of commissioning portraits for the Royal Asturian Institute, yet the absence of a more personal correspondence calls into question the close friendship often assumed between the two men.[5] In fact, Goya's account of his meeting with Jovellanos in late March 1798 notes with some surprise the warm reception he received:

> I arrived from Aranjuez the day before yesterday for which reason I haven't responded. The Minister went beyond himself in the attention he gave me, taking me with him in his coach, making the greatest gestures of friendship that one can make, he allowed me to eat with my cape on because it was very cold, he learned to sign and stopped eating to speak with me, he wanted me to stay until Easter, and to paint the portrait of Saavedra (who is his friend) and I would have been happy to do so but I had neither canvas nor a shirt to change, and I left him discontent and came home: here is a letter

that proves it, I don't know if you will be able to read his writing that is worse than mine: Do not show it or say anything and return it to me in the mail.[6]

Justification for Jovellanos's commission came the following day with Saavedra's appointment as interim secretary of state. As publicly reported on March 30, Carlos IV gave in to the "repeated pleas" of the Prince of Peace to be relieved of his duties,[7] but if such pleas were made, they were not the sole reason for Godoy's dismissal. A month earlier, five directors of the French government, working outside the usual channels, asked the secretary of the embassy in Madrid (rather than the ambassador) to deliver a note to María Luisa (rather than to her husband), stating the Godoy was "English to the core" and that it was imperative to dismiss him.[8] (Ironically, given the hatred of the Spanish clergy toward Godoy, a major contributing factor to the French government's dissatisfaction with him was his refusal to expel French émigrés, many of them clerics.) Godoy's fall had a soft landing, for he retained his honors, income, and residence.[9]

Two days after his meal with the artist, Jovellanos forwarded to the controller of the royal household Goya's petition for reimbursement of payments made to his color grinder and assistant Pedro Gómez and for materials purchased during the two previous years. Goya's own earlier request had been denied, justifiably, on the basis that the only expenses to be covered were those incurred in painting in service to the king, which Goya could not claim in light of his absence from court, mistakenly dated in the official response to "the full year of 1796." Jovellanos requested information, arguments were repeated, and by mid-April, the case was resolved in Goya's favor "at the order of the king."[10] In light of efforts to pare expenses at court, the indulgence is surprising: the king himself soon ceded half of his private purse to the treasury in June, sacrificed silver from the palace and royal chapel that was not essential to worship or service, and asked all palace officials to economize in any way possible.[11]

By the time Goya dined with Jovellanos in Aranjuez, his portrait of the minister was nearing completion or possibly finished, allowing him to turn his attention to Saavedra (pls. 13 and 14). The image of Jovellanos intrigues as a presentation antithetic to what we expect in an official portrait. The minister sits at a carved and gilded desk, his elbow on one stack of papers, next to another bundle yet to be opened; a statue of Minerva behind serves as a surrogate, and apparently ineffective, muse, her shield bearing the emblem of the Royal Asturian Institute of Nautical Sciences and Mineralogy founded by Jovellanos during his years in Gijón.[12] The opulence implied by

the furniture is at odds with the sobriety of the sitter—dressed in a gray coat; white waistcoat, cravat, and stockings; and black breeches and shoes—as he sits idle with chin in hand, a posture traditionally associated with melancholy. Although the composition invites comparison with the image of the author in *Sueño 1* (fig. 14), its message is altogether different: the figure of *Sueño 1* experiences the opening of an infinite world of dream and inspiration, whereas Jovellanos appears bored, if not overwhelmed, by the demands of court bureaucracy. In painting Saavedra, Goya presented a character diametrically opposed. Saavedra came to his court appointment after years of service in the military, where he participated in the Spanish campaigns in Algiers and in others against the British in North America and the Caribbean. Having served as intendant of Caracas under Carlos III, he returned to Madrid and served on the Supreme Council of War. Goya captured Saavedra's no-nonsense demeanor as he looks up from his work momentarily, his hand poised to flip a page in the papers he is reading. In fact, Saavedra seems only to have sat long enough for Goya to paint his head, after which the artist completed the rest of the freely brushed portrait over a different ground of pinkish orange.[13] Saavedra's posture is attentive and erect, in clear contrast to Jovellanos, seated as if unable to move. At his unornamented desk, with only a few papers awaiting his attention, Saavedra exudes vitality, conveyed visually in Goya's handling of his coat, painted with broad strokes of electric blue brushed over a ground still visible, in contrast to the subdued colors and handling of Jovellanos's clothing. Were it not for the accessories of statue, drapery, and dress, Jovellanos would be dwarfed by the space around him; Saavedra owns it.

Ceán also returned in December 1797 to a position within the ministry of grace and justice. Admitted to the Royal Academy, he continued writing his magnum opus, *Diccionario histórico de los más ilustres profesores de las Bellas Artes en España* (Historical Dictionary of the Most Illustrious Professors of the Fine Arts in Spain). Goya undertook a series of small-format portraits of artists for the *Diccionario,* working in red chalk to facilitate transfer of the design to the etching plate, and drew a portrait of Ceán to serve as a frontispiece; ultimately, no portraits were included in the published tomes, and seven drawings are all that survives of the project.[14] Ceán returned the favor: having acquired several etchings by Rembrandt in Seville, he "gave some of them to my friend Goya as he was etching his *Caprichos.*" A note on the verso of a print from Ceán's collection (today unlocated) specified: "Goya took eight prints by Rembrandt on May 21."[15]

Since his illness five years earlier, Goya had remained in touch with the duke and duchess of Osuna, drawing the portrait of the duchess for the

frontispiece engraving published in early 1795 and later that year recommending a former servant of don Luis for a position in her household, which the duchess had already filled.[16] In 1798 the duke and duchess commissioned a portrait of Captain General José de Urrutia, a military leader involved in every major campaign since 1764, when he served in Mexico and North America as a military engineer in the American Regiment financed by the duke.[17] Having recently explored witchcraft in the *Sueños* drawings, Goya possibly shared these inventions with the duchess to inspire her, for on June 27, 1798, Goya wrote an invoice not only for the portrait but also for six compositions of "asuntos de brujas" (subjects of witches), already delivered to La Alameda, for which he was paid two days later.[18]

The dispersal of the six witchcraft paintings following the auction of the Osuna collection in 1898 marked a great loss, for we may never see the series in its entirety, and are left to imagine it as it was intended, installed in a small room in the duchess's Alameda.[19] Two paintings are today unlocated: a witches' kitchen, reminiscent of a scene observed by the two canine narrators of Cervantes's "Novel of the Colloquy of the Dogs," and a scene from *Don Juan and the Knight Commander*, inspired by Antonio Zamora's play *El Convidado de piedra* (*The Guest of Stone*). Another play by Zamora, *El Hechizado por fuerza* (*Bewitched by Force*) was the source for a painting of don Claudio surrounded by imagined visions as he fearfully lights an oil lamp, wrongly believing he will die if the flame goes out. Goya, or the duchess, drew inspiration not only from literature but also from his *Sueños* drawings, showing a gathering of devil worshippers on a desolate mountain, their revels about to end as day breaks (pl. 15). Most have settled in, and sit surrounding the devil in the form of a smiling he-goat, crowned with a wreath of leaves as bats fly around his horns; a wizened witch proffers an emaciated child, another carries a pole from which fetal or newborn corpses hang. A latecomer runs in from the right, offering a plump baby. The witchcraft theme continues in two other paintings: in one, flying sorcerers perform an unholy exorcism on a screaming victim, as on the ground below, two peasants hide their eyes and cover their ears against the man's cries; in the second, a man in a nightshirt confronts (or dreams of) a chorus of ghouls singing at his side. For the amusement of his patrons, Goya depicted Enlightenment's antithesis, the "prejudicial vulgarities" of superstition and the fears of ignorant people.

On August 17, "El Zeloso del honor nacional" (The Vigilante of National Honor) reported on the 1798 Royal Academy exhibition in a front-page article in the *Diario de Madrid* and praised Goya as the defender of painting in Spain: "First and foremost, it is not true that nothing has been presented to the public, for there was a portrait by Goya.... I still say that the portrait of

Don Andrés del Peral alone, executed by the incomparable Goya, would suffice to give credit to the entire Academy, and to an entire Nation, and to all of our age, when seen in posterity; such is the precision of the drawing, the taste in the coloring, the frankness in the chiaroscuro, in a word, such is the knowledge with which this Professor created his work."[20] Not all were in agreement, and one respondent recommended as testimony of the national glory in the fine arts the works of the late Francisco Bayeu—among them, his frescoes in the royal palace and at El Pardo and his paintings in the cloister of the cathedral of Toledo and in his native Zaragoza.[21] Adept at self-promotion, Goya singled himself out as a senior artist at court who participated regularly in the summer exhibitions at the academy, a showcase for selected recent works, often privately commissioned portraits.

———

Andrés del Peral (fig. 17) was both a highly regarded gilder in the royal service and an astute art collector, praised in 1808 for assembling one of the greatest collections in the country, unique in its inclusion of all major schools and esteemed for the quality of individual works.[22] Goya captured the personality of a model connoisseur, who scrutinizes us with raised eyebrows and overt haughtiness. No reference is made to the gilder's manual labor: indeed, Peral's hands are hidden as he assumes the noble gesture of right hand in waistcoat (which might have been influenced by money saved, since artists charged for painting hands). Exceptionally, Goya painted on poplar panel rather than his usual canvas, a support possibly suggested by Peral, who would have appreciated its durability given that he owned several works on panel, including two landscapes by Rembrandt. Peral's well-timed sale in 1807 of 156 paintings from his collection to the king (at an appraised value of 209,620 *reales*) confirmed the shrewd intelligence conveyed by Goya; he was paid 80,000 *reales* in 1807 and 129,600 *reales* on March 18, 1808. Was Peral wily or merely lucky? The following day saw the uprising that would force Carlos IV to abdicate; had Peral not sold his collection, he may have found it soon picked over by French occupiers.[23]

Goya visited Moratín on April 21 and again ten days later when they went together to look at paintings in the Benedictine monastery of San Plácido, an easy walk from Goya's house,[24] where they could admire the monumental altarpiece the *Annunciation with a Heavenly Host* by the seventeenth-century painter Claudio Coello, the frescoes on the dome and walls of the adjoining Chapel of the Holy Sepulchre by Francisco Ricci and Juan Martín Cabezalero (destroyed in 1906), and Velázquez's *Crucified Christ*, soon transferred to Godoy's residence and today in the Museo del Prado. En route from

17. *Andrés del Peral*, by
1798. Oil on poplar,
37 ⅜ × 25 ⅞ in. (95 ×
65.7 cm). National
Gallery, London.

Goya's house to San Plácido, they might also have stopped to admire another
fresco cycle dedicated to Saint Anthony, in the church of San Antonio de
los Alemanes (Saint Anthony of the Germans). Their visit to one if not both
monuments adorned by frescoes was not casual, for in mid-June Goya placed
the first of seven orders for supplies "for the work of the chapel of San Anto-
nio de la Florida" painted at the order of His Majesty.[25] In addition to large
sheets of paper for sketches and clay containers to hold paint, Goya requested
ten different pigments, proving that he was already familiar with the site,
had his subject in mind, and presumably had presented and received approval
for preliminary sketches.[26]

The *ermita* (hermitage) of San Antonio de la Florida—since 1919, Goya's
pantheon—stands on lands acquired by Carlos IV to extend the royal domain
along the eastern bank of the Manzanares River, paralleling the hunting
grounds of the Casa del Campo on the opposite bank. Moratín certified the
copy of the papal bull necessary to transfer the hermitage from the abbey of

Saint Martín to the Royal Chapel, considered a parish church since 1753. The small central-plan hermitage built by Filippo Fontana between 1792 and 1798 is crowned by a dome, measuring roughly six meters across and supported by four arches, each opening onto a short arm of a Greek cross covered with a barrel vault; the north and south arms have lunettes with windows. Goya frescoed the dome, vaults, lunettes, and pendentives, as well as a half dome behind the altar (pl. 16). Photography cannot convey the experience of standing within the church, surrounded by Goya's invention.

Entering the hermitage through the main door (today closed to visitors), the devout faced the altar opposite (about twenty-three steps in front of us) upon which a polychrome statue of Saint Anthony of Padua by José Ginés, lost during the Spanish Civil War, once stood. On the wall behind, Ginés created in stucco the Holy Name adored by two angels, a theme continued in Goya's rendering of adoring angels above the altar. The theme of adoration continues in the vaults and lunettes, where angels open white drapery with gold brocade, as if to reveal the altar, while others fold their hands in prayer. In the barrel vaults, cherubs lift drapery bearing the royal crest, embroidered in gold. The play of cherubs, angels, and fabric emulates the illusionism seen in the frescoes of San Antonio de los Alemanes, where angels draw back drapery of white and gold to reveal windows and balconies and, assisted by cherubs, support illusionistic tapestries illustrating the life of Saint Anthony; in San Antonio, Goya's angels and cherubs adore and unveil, to inspire the worshippers in the space below. Returning to the front door and lifting our eyes from the statue of Saint Anthony to the dome, we see Saint Anthony of Padua resurrecting the victim of a murder, of which his father was accused. Once brought to life, the victim identified the perpetrator, exonerating the saint's father. Witnesses, mainly female and arrayed in colorful costumes, stand behind the balustrade that follows the dome's circumference; opposite Saint Anthony and above our heads, a single worshipper stands with gaze turned heavenward and hands extended in prayer. Goya turned on its head the cardinal "rule," stated twenty-five years earlier by Bayeu in a letter to Carlos Salas regarding the decoration of El Pilar, that the only appropriate subjects for a dome were the heavens, angels, and saints, while historical narratives should be reserved for the areas closer to the earthly and to the viewer. Goya's historical and miraculous event takes place in the dome, witnessed by onlookers in contemporary dress who blur the boundary between past and present. Angels have fallen, relegated to the supporting walls and vaults.

Beginning on the first day of August, a carriage brought Goya from his house to the church until he completed the work about four months later. He painted in fresco, and interruptions in the plaster surface, denoting the

application of fresh wet plaster for a single day's work (*giornata* in Italian, *jornada* in Spanish), suggest that the entire cycle was painted in thirty-six days.[27] When Moratín visited on October 24, the cycle was nearing completion, perhaps lacking only the details in tempera that Goya would add to its surface. As he painted his fresco and sent his portrait of Peral to the academy, and as the *Diario de Madrid* published letters about the glory of the nation, the *Mercurio de España* reported that Mariano Luis de Urquijo would assume many of the responsibilities of the secretary of state, due to Saavedra's current illness; Miguel Cayetano Soler, who formerly reported to Saavedra, assumed those of minister of finance.[28] The same issue also included the king's decision to "exonerate" Jovellanos from his duties as minister of grace and justice, although he retained his position on the Council of State. His replacement was José Antonio Caballero, a rival of Godoy and of his reforms, credited by historians with the downfall not only of Jovellanos but also of Meléndez, who on August 27 received a royal order to leave Madrid within twenty-four hours and go directly to Medina del Campo, to await further instructions from the king.[29] Caballero soon ordered Jovellanos to Asturias and Meléndez eventually to Zamora. Of Jovellanos, Moratín noted in his diary on August 18, "Jovino cecidit," and visited him two days later; on August 28 he wrote of Meléndez, "Batilo exilé."[30]

Writers have long used Goya's portraits of individuals associated with the *ilustración* as evidence of his politics and commitment to reform, but a reconsideration is overdue. Goya was an artist above all else and, like Moratín, served kings and their courts rather than ideologies. Granted that he knew these men, and may have liked them, social status and the artist's deafness were clear barriers to communication and friendship. Indeed, the dismissals of Jovellanos, Saavedra, and Meléndez had no discernible impact on him: to the contrary, their demise coincided with the beginning of his ultimate ascent at the court of Carlos IV.

20

"The king and queen are crazy about your friend"

1799

O N the day of the Epiphany, January 6, 1799, the academicians viewed Goya's most recently completed canvas, *The Arrest of Christ* (pl. 17), and praised its "good taste in color, line, and the mastery so well credited to Señor Goya."[1] Days later, Cardinal Lorenzana finally saw the work he had probably commissioned over a decade earlier installed in the sacristy of Toledo cathedral, where it remains today in dialogue with El Greco's stunning *Expolio*, painted 220 years earlier.[2] El Greco represented the disrobing of Christ before a raked perspective that compresses the surrounding tormentors toward the picture plane, heightening the sense of pressure and jostling and barring any path of physical escape. Set apart by his lustrous red robe, Christ gestures with hand on heart and lifts his eyes to heaven. Goya, in contrast, stresses the humanity of Christ, who despairs as Judas is about to betray Him with a kiss, and as figures, half-seen emerging from the shadows behind, taunt him; the brilliant red robe painted by El Greco is drained to the pale pink by the light that illuminates Goya's Christ against the darkness. The artist's study of human expressions in developing *Los Caprichos* and years of work in the monochromatic media of pen and ink, brush and ink wash, etching and aquatint, inform his altarpiece. Like the woman accused by the Inquisition and surrounded by a jeering crowd as she is paraded through the streets on an ass in *No hubo remedio* (*Nothing could be done*, fig. 18), Christ is judged and tormented by crowds that reveal human behavior at its most base. It is a theme to which Goya would return.

The artistic journey that originated in drawings of the early to mid-1790s, evolved in the pen-and-ink *Sueños,* and led ultimately to fantastic subjects roughly sketched in chalk, and—with increasing frequency—largely invented directly on the etching plate, came to fruition with an advertisement

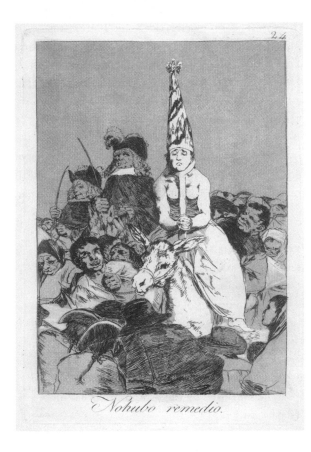

18. *No hubo remedio* (*Nothing could be done*), *Los Caprichos*, pl. 24, published 1799. Etching and burnished aquatint, 8 ⅜ × 5 ¹³⁄₁₆ in. (21.3 × 14.8 cm). The Metropolitan Museum of Art, Gift of M. Knoedler and Co., 1918.

on February 6 in the *Diario de Madrid*. The eighty etchings to become known as *Los Caprichos* proclaimed Goya's invention to a public far wider than the academicians who had seen his cabinet paintings five years earlier or the wealthy who could buy or commission them; their subject matter and exploitation of etching and aquatint to create dramatic effects were unprecedented, and very possibly baffling to many. Goya himself had learned much in the process: in the earliest plates, he used the etching needle to delineate highly detailed figures of witches and goblins on a field of light aquatint. But in the course of etching the series, he discovered the potential of aquatint to create tonal fields of velvety richness, offering the perfect visual metaphor for the underside of enlightenment—darkened other worlds, night skies, shadowy prisons, and monastic cellars.[3] In announcing his "collection of prints of fantasy subjects" in the *Diario*, Goya decided against the simple advertisement usually used for prints, published on pages two or three of the four-page newspaper, which identified artist, printmaker, and title, and sometimes included a brief description of the subject. His front-page announcement took the place

conventionally reserved for essays, commentary, odes, and literary *sueños*, to imply the parity between image and word confirmed by his text: "Painting (like poetry) chooses from the universal that which it deems most appropriate to its ends; it unites in one fantastic character circumstances and traits that nature presents shared among many, and from this combination, ingeniously arranged, results that fortunate imitation, by which a good artist attains the title of inventor, and not servile copyist."

In his report to the academy on curricular reform six years earlier, Goya insisted that the study of nature superseded all academic rules in the education of artists. In this announcement, he justified the visual artist who *transcended* nature:

> Since most of the objects represented in this work belong to the realm of ideas, it is not unreasonable to believe that their defects will perhaps find indulgence among connoisseurs, considering that the author has neither followed the examples of another, nor has been able to copy Nature. And if it is as difficult to imitate it [nature], as it is admirable when imitation is achieved; he who departs from it entirely will not be left without deserving some esteem for having had to expose to the eye forms and attitudes that until now only existed in the human mind, obscured and confused by the lack of enlightenment, or heated by unbridled passion.[4]

That Goya offered *Los Caprichos* for sale in a store of liquors and perfumes at 1, Calle de Desengaño was once cited as evidence that he sought to avoid Inquisitional censorship, but surely if this were the case, he would not have taken a front-page announcement. More likely, he wanted to keep an eye on sales and so chose a shop on the street level of the building where he lived. Equally ungrounded is speculation that another, possibly Moratín, wrote the announcement or the captions for these prints: the similarities between this announcement and Goya's 1792 report to the Royal Academy, and between the pithy captions of the etchings and those that Goya added to his drawings, leave no doubt that he was their author. During his frequent visits with Moratín in 1798, Goya may have invited the playwright's comments, but the ideas and words so integral to the *invención* that was central to Goya's art were his own.

When four years later Goya offered the copper plates for *Los Caprichos* to the royal printing establishment, or Calcografía, he stated that the first edition was not "sold to the public for more than two days, for one ounce of gold

[320 *reales*] for each book, twenty-seven books were sold; five or six thousand books can be printed from the plates." Yet the appearance of an abbreviated version of the *Diario* announcement in the *Gaceta de Madrid* almost two weeks after the first announcement on February 6 calls into question his statement that the prints were available for only two days.[5] There is no evidence that censorship induced Goya to remove the plates from the market; in fact, when in 1803 the government acquired the plates as well as 240 sets already printed, it was so that "impressions can be pulled and sold to the public."[6]

When the duchess of Osuna visited Goya in his studio on January 17, 1799, she left with "some prints" for which she paid 1,500 *reales*; Goya's receipt is slightly more specific, stating that the sum was for "four books of *Caprichos* and etchings by my hand."[7] The announced price for the eighty etchings was 320 *reales*, leaving 220 *reales* paid by the duchess that might have covered other prints or possibly bindings for the four sets. A possible motive for the duchess's purchase of multiple sets was their potential use as diplomatic gifts, for the duke had been appointed ambassador to the imperial court of Vienna, and when the duchess visited Goya's studio, preparations were under way for their January 26 departure. Upon arriving in Paris on March 5, the duke and duchess learned that Spain's alliance with France had caused diplomatic relations between Austria and Spain to be severed; the family remained in Paris until the following December, returning to Madrid on January 7, 1800.[8]

Beyond Spain's increasingly fraught relations with France, her royal bonds continued to lose value, trading by the first half of 1799 at 30 to 45 percent below par.[9] In February 1799 the *Mercurio de España* carried news of Saavedra's retirement for reasons of health; Urquijo, who had been signing papers for Saavedra since the previous August, was appointed to the post. Best known as the translator into Spanish of Voltaire's *Death of Caesar* (1791), Urquijo had been recommended in 1792 by the count of Aranda and was posted to the Spanish embassy in London until hostilities broke out in 1796. In spite of his interest in Voltaire, Urquijo was no friend of the Directoire, whose leaders requested in February 1799 that he be replaced by José Nicolás de Azara, then the Spanish ambassador to Paris. Carlos IV did not look kindly upon this perceived foreign interference into matters of state, maintained Urquijo, and six months later replaced Azara, briefly, with Urquijo's friend the naval commander José Domingo de Mazarredo.[10] Godoy, Prince of Peace, whose dismissal the previous year was possibly influenced by the Directoire, returned to favor as the French government increasingly alienated the Spanish monarchy. The fortunes of his wife and in-laws—the children of don Luis—also improved. In February 1799 Luis de Vallabriga was named archbishop of Seville; in August Carlos IV

overturned the decision of his father and allowed the children of Don Luis and María Teresa de Vallabriga to use the coat of arms and the name of their royal father, "de Borbón." Given his title of Prince of Peace and his marriage to the now fully acknowledged cousin of the king, Godoy came ever closer to royalty.

In early March an ode celebrating Goya was published in the *Semanario de Zaragoza* by the author José Mor de Fuentes, whose enthusiasm may have been inspired by Zapater.[11] By July Goya was again in the public eye as painter of portraits and fantasy, when he exhibited at the academy "six unusual Caprichos," as well as portraits of Don Pedro Bermúdez (today unknown) and of the French ambassador to Madrid, Ferdinand Guillemardet.[12] According to the Danish ambassador, Guillemardet was all powerful in Madrid, "an excellent man, frank, and loyal, handsome, and determined in his manner," who counterbalanced the arrogant, young Urquijo, who dared not contradict the country doctor turned regicide turned diplomat, who earlier that year had delivered the French government's unsuccessful request for Urquijo's replacement.[13]

Following their first visit to the palace chapel of San Antonio de la Florida, with frescoes completed by Goya several months earlier, the king and queen departed from Madrid on July 31 for their annual late summer stay at La Granja. Goya soon followed, and correspondence between María Luisa and Godoy documents his return to favor as royal portraitist.[14] From her summer retreat the queen wrote on September 24 that Goya was painting a full-length portrait of her wearing a mantilla, and "they say it is coming out very well." Although her costume, in which she also wears a lace *basquiña*, has been identified as that of a *maja*, it is in fact not a costume of the lower classes; mantillas and *basquiñas* were, according to the Danish ambassador, a national costume "of a shocking price, given the magnificent lace necessary for them." Another theme of the queen's letters in August and September was her progress in mastering Marcial, a horse given to her by Godoy; she reported that Goya was to accompany the court to El Escorial to paint her on horseback, "because I want him to paint a portrait of Marcial."[15] On October 5 she posed for two-and-a-half hours "with my hat, tie, and velvet dress" upon a raised platform with "five or six steps up to it" in the king's chambers of the palace at El Escorial. Goya finished sittings after three sessions, and the queen reported that the portrait looked more like her than that with the mantilla, writing, "Now the serious work begins." If this comment refers to painting the final equestrian portrait (fig. 19), Goya advanced quickly, for six days later María Luisa wrote from El Escorial: "I am very happy that you like

19. Queen María Luisa on Horseback, 1799. Oil on canvas, 133 × 111 in.
(338 × 282 cm). Museo del Prado, Madrid.

the portraits, and I want Goya himself to make copies for you, I also want to
have another copy made by Esteve of the portrait with the mantilla and of
the horse so that you have Marcial always alive and present." More than an
equestrian portrait, this was a double portrait of rider and horse, with Mar-
cial adorned in his best gold bridle and chest ornament, his braided mane
ending in tassels, and braided ribbons at his head and flanks ending in gold
beads that pick up the gold of his saddlecloth. In her riding habit and hat, the
proud María Luisa is, by comparison, quite plain.

The first ten months of 1799 confirmed Goya's wide-ranging mastery,
from the *Arrest of Christ* to *Los Caprichos* to the pageantry of the angels in San
Antonio de la Florida unveiled in July; from the swagger of the French am-
bassador to the dignity of the queen as equestrienne. The recognition Goya
so long sought came by way of a letter from Urquijo dated October 31:

His Majesty, wishing to reward Your distinguished merit, and give personally testimony that serves as inspiration to all professors of how much he values Your talent and knowledge in the noble art of painting, has decided to name you his first court painter, with a salary of 50,000 reales vellón, that you will receive from this date, free of tax, and also 500 ducados annually for a carriage.[16]

Goya wrote immediately to Zapater and enclosed a copy of the order, asking Zapater to share it with all his friends, naming especially Goicoechea and Yoldi: eighteen years after the embarrassment at El Pilar, Goya still wanted all in his hometown to hear of his crowning achievement. The hour was late, and he was tired but promised to send more details. In closing he added, "Los Reyes están locos con tu amigo—Goya" (The King and Queen are crazy about your friend—Goya).[17] Francisco Zapater recorded these words in his biography of Goya, but the letter, the last documented from Goya to Zapater, is today lost.[18]

Goya shared the position of first court painter with Maella, but there is no doubt that the king and queen recognized Goya as the leading portraitist at court. A carpenter's invoice submitted at the end of the year documents his efforts: in addition to the stairs built for the platform upon which María Luisa posed for her equestrian portrait, it lists the dismantling and reassembly of that portrait, a stretcher for another portrait of the queen, and a platform for the king. The mention of this second platform suggests that Goya began his equestrian portrait of Carlos that fall; it was completed the following year. The carpenter's charges for crates and transport ("All of the portraits were packaged in two crates, which were nailed shut, price 26 reales") document their transfer from El Escorial to Madrid, presumably either to Goya's studio to be finished or to the royal palace, where they remained through the reign of Carlos IV.[19] Of particular interest is the carpenter's itemization of "the painter's brushes, ten curious handles were each made half a vara long, worth forty reales in all," revealing that Goya used custom-made brush handles about sixteen and one-half inches long, to maintain a certain distance as he worked on these almost life-size portraits.[20]

Granted special permission to fish in the Casa de Campo, the restricted hunting grounds across the Manzanares River from the royal palace, Goya wrote on November 29 to Urquijo asking him to give the necessary order.[21] The artist thanked him three days later, before turning to the more important task of identifying a miniaturist capable of doing justice to his royal portraits:

Most Excellent Sir. I thank you infinitely for the permission to fish in the casa de campo. The diamond jeweler Soto came and left me a medallion in which the portraits of Their Majesties are to be inserted. I cannot think who could copy them in miniature, except for Ducker, who is currently in prison, because it happened with a portrait of mine of the duke of Aba [sic; Alba] that no one knew how to copy but for said Ducker, nor do I believe that for this task someone could be found in Italy or France: Your Excellency could permit him to leave prison, even if he returns at night, and you will have excellent portraits of the Monarchs.

Two days later, Urquijo noted in the margin of the letter that the miniaturist Guillermo Ducker was to be released to work for Their Majesties, with the caveat that "he will be expelled from this kingdom unless he uses the necessary moderation in his language and manners." Goya was to relay the order to Ducker to paint the royal portraits for the medallions, as well as a miniature of the queen in *basquiña* and mantilla.[22]

The list of the expenses Goya incurred in painting Carlos IV and María Luisa has not come to light, but approval was given in late January for an unusually high reimbursement of 13,400 *reales*, which presumably included an allowance for extended stays at La Granja in late summer and El Escorial in fall 1799.[23] By July 1800, Agustín Esteve submitted expenses for his copies of six full-length portraits after originals by "D.ⁿ Fran.ᶜᵒ Goya, primer pintor de Cámara," as well as half-length portraits of the monarchs' daughter and son-in-law, the prince and princess of Parma. But "Solo Goya" painted the king and his queen.

———

Within two weeks of Goya's appointment, the coup of 18 Brumaire Year VIII (November 10, 1799) brought Napoleon Bonaparte to power. The *Mercurio de España* devoted seventeen pages to the events of that day, the dissolution of the Directoire, and the appointment of Sieyès, Ducos, and Napoleon as provisional consuls (the first two, former directors). Translated into Spanish, Napoleon's words to the Council of Five Hundred announced the arrival of a new moral hero:

All the factions invoke the constitution, and all violate it, all neglect it; nor can we find in it our well-being, because it is respected by no one. Representatives of my people, I am not a miserable, ambitious

man who disguises himself with that mask of a hypocrite; I have given countless proofs of my love for the Republic, and it would be useless to dissemble. If I explain myself in these terms, it is because I wish that so many sacrifices not be in vain.... All the factions have come to call at my door, and I have not listened, because I do not have more than one party and that is the French people.[24]

The ambassador Guillemardet wrote to Paris that the Spanish court welcomed the events of 18 Brumaire, in the hope that they augured peace in Europe,[25] but expressions of his own allegiance did little good, and he was recalled on November 30. (Guillemardet died insane in 1808 and would be long forgotten had he not returned to France with his portrait by Goya, donated by his son Louis to the Musée du Louvre in 1865. He may also have returned to Paris with a copy of *Los Caprichos*, which his son possibly shared some years later with his friend the young Eugène Delacroix.[26]) Having tolerated French ambassadors who hesitated before using the term "majesty" and avoided the word "sire," Carlos IV and his court welcomed Guillemardet's successor, Charles Alquier, a man whose elegant and easy manner allowed them to overlook his past as revolutionary and regicide.[27] The thaw in relations with Paris was exemplified by the visit of Citizen Arnaud, a French geometer, who traveled to El Escorial in late November to show Carlos IV and María Luisa a model measuring over forty-one feet in circumference of the city of Paris before 1789. They encouraged him to exhibit the fruits of his nine years of labor in Madrid, where it opened on December 15, to the acclaim of the elite.[28] Beyond enjoying models of Paris, the king and queen soon celebrated the birth of a grandson in the royal palace of Madrid, the *infante* Carlos Luis, born to the princess and prince of Parma.

Few at court seemed to notice the return of the duchess of Alba in early December. As her fortunes had declined, Goya's had risen, as proclaimed in an epigram about him published on December 12 in the *Diario de Madrid*:

> You transcend nature
> And your fame will be eternal,
> If from envy it is not killed
> By nature itself.[29]

But most in Madrid did not read the accolade, did not see the map of Paris, knew nothing of the duchess, and certainly never viewed the portraits of the king and queen. In December 1799 the Women's Committee of the Economic Society of Madrid, charged by the king to oversee the city orphanage, placed

an announcement to counter the rumor that children were accepted on the conditions that money was offered and that the names of the parents were given. To avoid the harm that came to so many "inocentes miserables," abandoned at night in need of food and aid, the committee ensured that no such demands were made and all children were welcome, no questions asked. Published in the *Mercurio de España*, this clarification was never seen by its intended public, the growing number of the destitute who were increasingly visible on the streets of Madrid.[30]

The French Connection

1800

D EPARTING from a format established sixteen years earlier, in January 1800 the *Mercurio de España* opened with a summary of politics in France since the revolution and an update on Napoleon's military campaigns, in place of its traditional review of European courts. France remained the newspaper's focus through the year, with reports of the belligerence of the English parliament, resistant to France's overtures for peace (February); of treaties between France and Austria, Russia, Portugal, and Sweden (April); and of Napoleon's triumph at the battle of Marengo and conquests in northern Italy (June and July). New laws and royal proclamations replaced the reports of the comings and goings of the Spanish court: among them a quarantine in October of southern Andalucía, ravaged by an epidemic of yellow fever; the punishment for those who attempted escape from an affected village was two hundred lashes and ten years in prison.[1]

Carlos IV personally selected sixteen Andalusian horses from his stables as a gift to Napoleon. The convoy departed Madrid on August 11 under the command of Nicolás Cheli, accompanied by a servant, a veterinarian, a smithy, and twenty grooms dressed in the royal uniforms of blue with silver buttons (contrary to Urquijo's advice against using livery identical to that of the French Bourbons); anyone who mounted one of the horses along the route, no matter how briefly, would be hanged upon his return. The convoy arrived three months later in Paris, where Napoleon included the horses in a public review of his troops on November 16 and examined each individually. He in turn commissioned six long rifles and four short arms for the Spanish king from the renowned factory at Versailles. Although these did not arrive in Madrid until May 1802, they were worth the wait, according to José Nicolás de Azara, once again the Spanish ambassador to France, who described them as "of the greatest magnificence and of the best taste that I believe I have ever

1. *Le pusieron mordaza porque hablabla...(They put a gag on her because she spoke...)*, Album C, 87, ca. 1810–1816. Pencil, ink wash, and ink, 8 ⅛ × 5 ⅝ in. (20.5 × 14.4 cm). Museo del Prado, Madrid.

2. *The Visitation*, 1774. Fresco. The Cartuja of Aula Dei, Zaragoza.

3. The Picnic, 1776. Oil on canvas,
106 ⅝ × 116 ⅛ in. (271 × 295 cm).
Museo del Prado, Madrid.

4. The Family of the Infante don Luis de Borbón, 1784. Oil on canvas, 97 ⅝ × 129 ⅛ in. (248 × 328 cm). Fondazione Magnani Rocca, Parma.

5. The Countess-Duchess of Benavente,
1785. Oil on canvas, 41 ⅜ × 30 ¾ in.
(105 × 78 cm). Private collection, Spain;
reproduced courtesy of the owner.

6. The Duke and Duchess of Osuna and Their Children, 1788. Oil on canvas, 88 ⅝ × 68 ½ in. (225 × 174 cm). Museo del Prado, Madrid.

7. *Martín Zapater*, 1790. Oil on canvas, 32¾ × 25⅝ in. (83.2 × 65.1 cm). Purchase supported by the Fonalledas Foundation and the Ángel Ramos Foundation. Museo de Arte de Ponce. The Luis A. Ferré Foundation, Inc.

8. The Wedding, 1792. Oil on canvas, 106 × 156 in. (269 × 396 cm). Museo del Prado, Madrid.

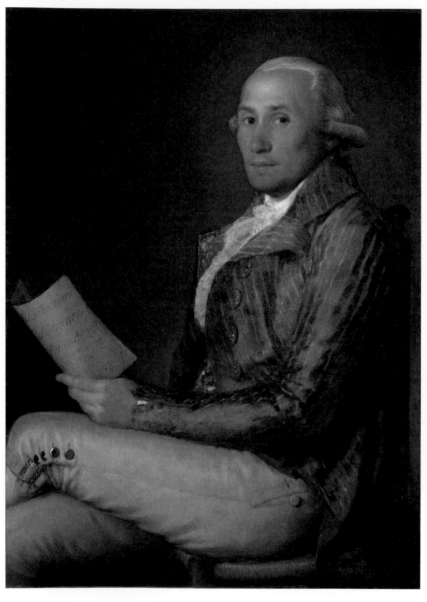

9. *Sebastián Martínez y Pérez*, 1792.
Oil on canvas, 36 ⅝ × 26 ⅝ in.
(93 × 67.6 cm). The Metropolitan
Museum of Art, New York,
Rogers Fund, 1906.

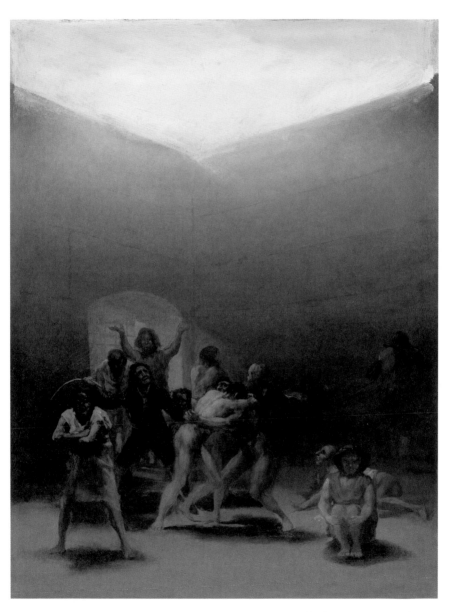

10. *Yard with Lunatics*, 1794. Oil
on tin-plated iron, 16 ⅞ × 12 ⅜ in.
(42.9 × 31.4 cm). Meadows Museum,
SMU, Dallas. Algur H. Meadows
Collection.

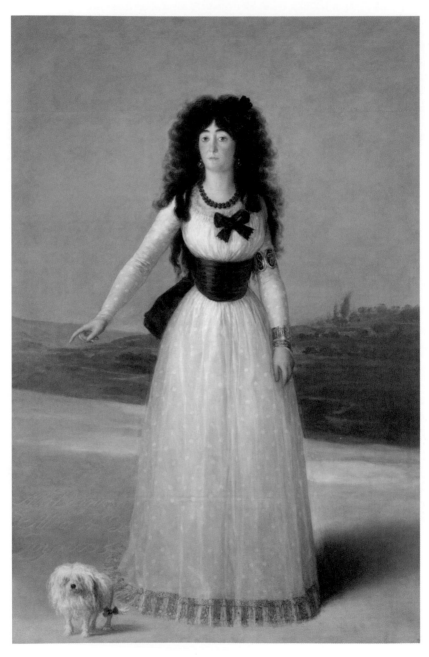

11. *The Duchess of Alba*, 1795. Oil on canvas,
76 ⅜ × 51 ⅛ in. (194 × 130 cm). Fundación
Casa de Alba, Palacio de Liria, Madrid.

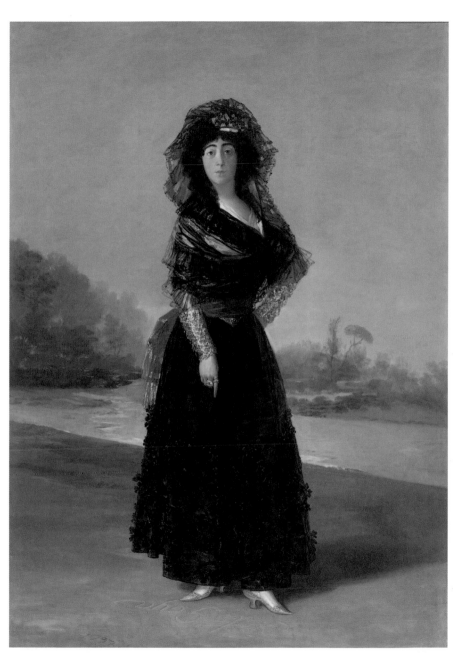

12. *The Duchess of Alba*, 1797. Oil on canvas, 82 ⅝ × 58 ⅝ in. (210 × 149 cm). The Hispanic Society of America, New York.

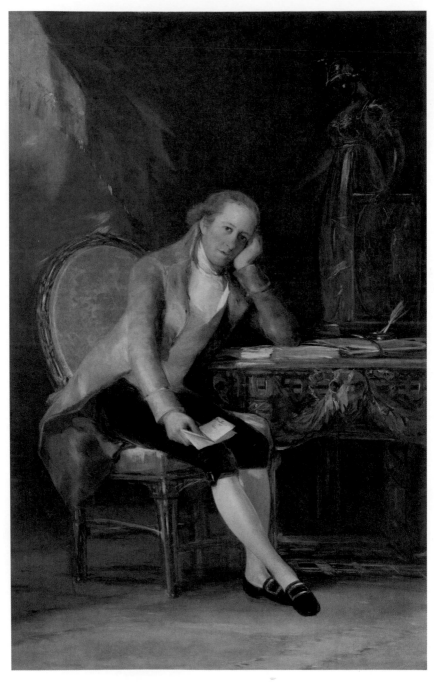

13. Gaspar Melchor de Jovellanos,
1798. Oil on canvas, 80 ¾ × 52 ⅜ in.
(205 × 133 cm). Museo del Prado,
Madrid.

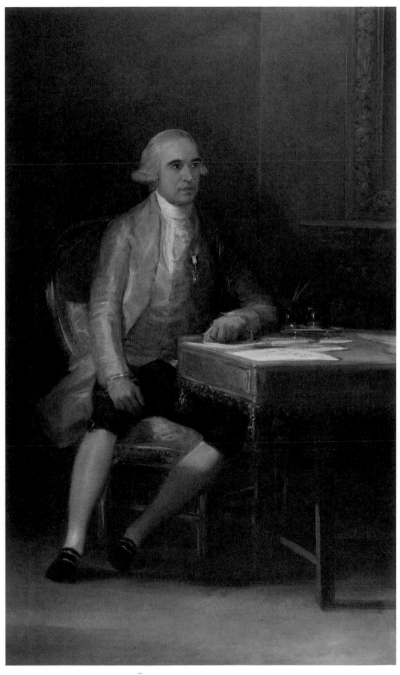

14. *Francisco de Saavedra*, 1798. Oil on canvas, 77 ⅛ × 46 ½ in. (196 × 118 cm). The Samuel Courtauld Trust, The Courtauld Gallery, London.

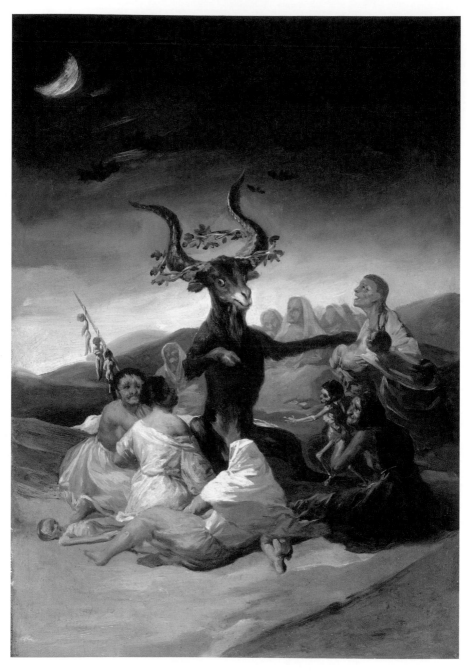

15. The Witches' Sabbath, 1798. Oil on canvas, 17 × 12 in. (43.3 × 30.5 cm). Museo Lázaro Galdiano, Madrid.

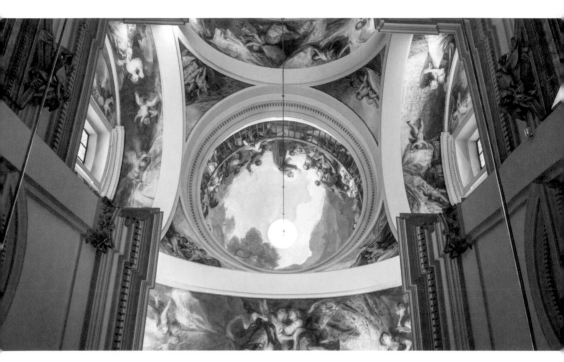

16. Interior, San Antonio de la
Florida, Madrid, 1798. Fresco.

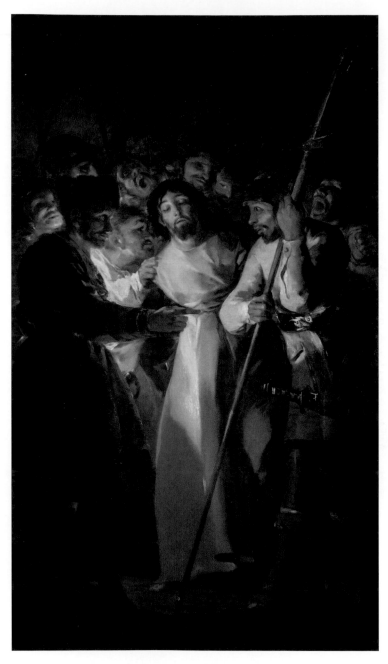

17. The Arrest of Christ, by 1799. Oil on canvas, 118 ⅛ × 78 ¾ in. (300 × 200 cm). Cathedral, Toledo, Spain.

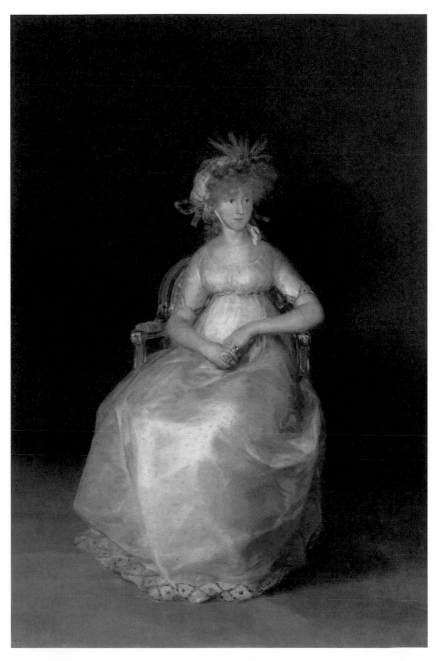

18. *María Teresa de Borbón y Vallabriga*, 1800. Oil on canvas, 85 × 56¾ in. (216 × 144 cm). Museo del Prado, Madrid.

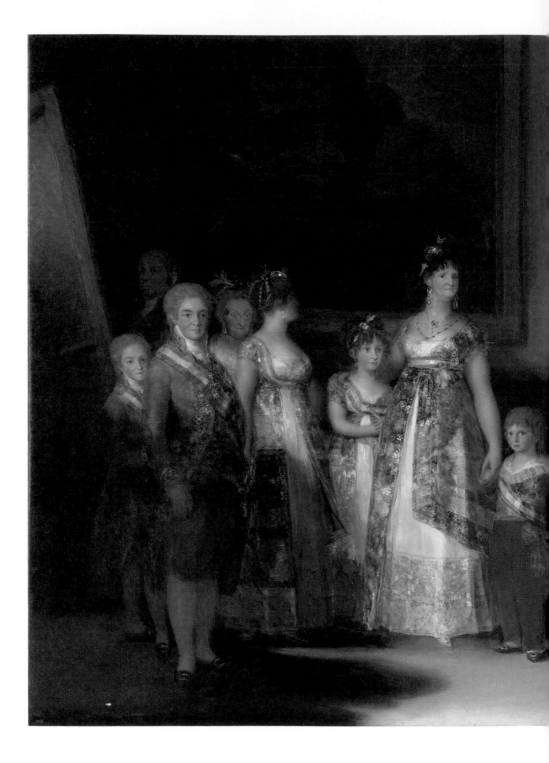

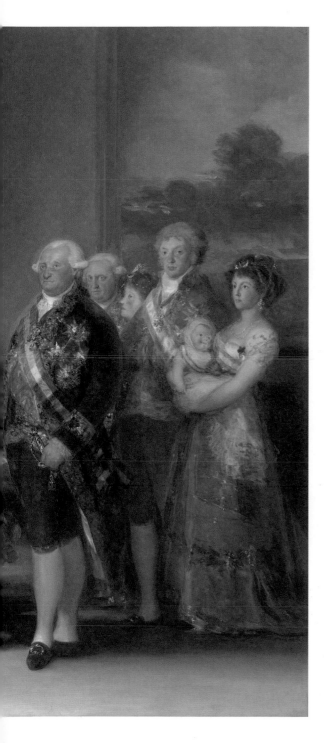

19. The Family of Carlos IV,
1800. Oil on canvas, 110 ¼ ×
132 ¼ in. (280 × 336 cm).
Museo del Prado, Madrid.

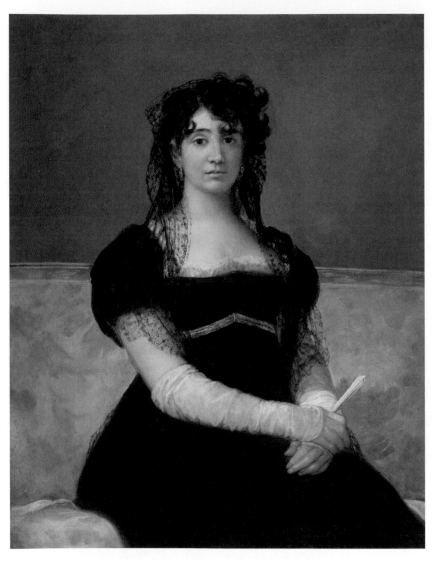

20. Doña Antonia Zárate, ca. 1804(?). Oil on canvas, 40 ¾ × 32 ¼ in. (103.5 × 82 cm). National Gallery of Ireland, Dublin.

21. *Javier Goya y Bayeu*, ca. 1805. Oil on copper, diameter: 3 ⅛ in. (8 cm). Museo de Zaragoza, Zaragoza.

22. *Gumersinda Goicoechea y Galarza*, ca. 1805. Oil on copper, diameter: 3 ⅛ in. (8 cm). Museo de Zaragoza, Zaragoza.

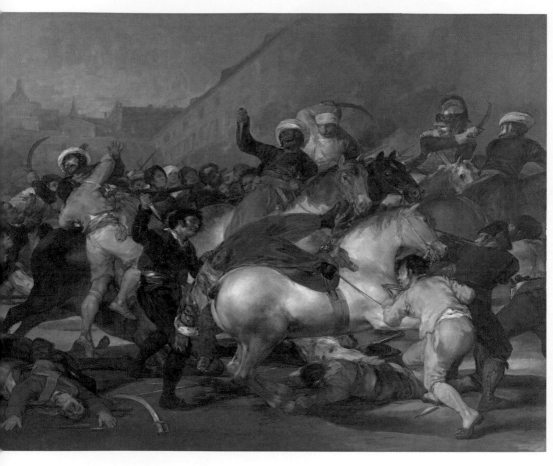

23. The Second of May 1808, 1814. Oil on canvas, 105 ¾ × 136 ¾ in. (268.5 × 347.5 cm). Museo del Prado, Madrid.

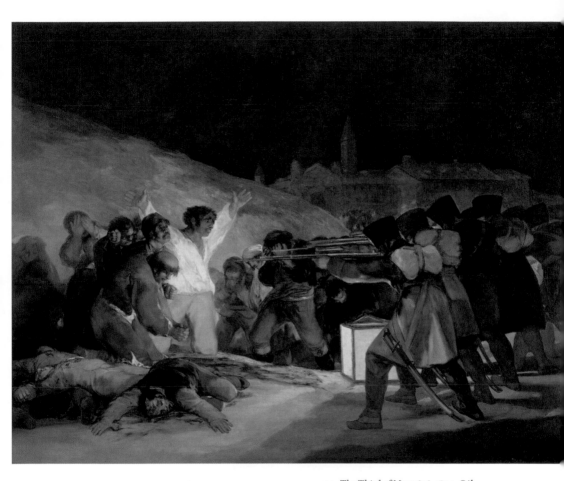

24. *The Third of May 1808*, 1814. Oil on canvas, 105 ½ × 136 ⅝ in. (268 × 347 cm). Museo del Prado, Madrid.

25. *Making Gunpowder in the Tardienta Mountains*, 1814. Oil on panel, 13 × 20 ½ in. (32.9 × 52.2 cm). Patrimonio Nacional, Palacio de la Zarzuela, Madrid.

26. *The Duke of San Carlos*, 1815. Oil on canvas, 93 ¼ × 60 ¼ in. (237 × 153 cm). Confederación Hidrográfica del Ebro, on loan to the Museo de Zaragoza.

27. Self-Portrait, 1815. Oil on canvas,
18 × 14 in. (45.8 × 35.6 cm). Museo del
Prado, Madrid.

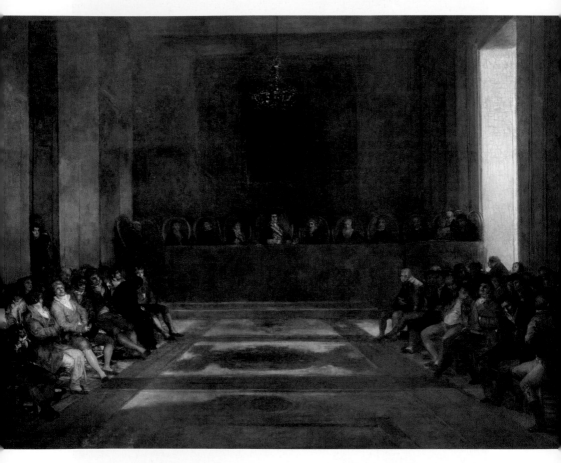

*28. The Meeting of the Company of
the Philippines*, 1815. Oil on canvas,
128 ¾ × 176 in. (327 × 447 cm).
Musée Goya, Castres.

29. *Self-Portrait with Dr. Arrieta*, 1820. Oil
on canvas, 45 ⅛ × 30 ⅛ in. (114.6 × 76.5 cm).
Minneapolis Institute of Art, The Ethel
Morrison Van Derlip Fund, 52.14.

30. Witches' Sabbath, ca. 1820–1823. Oil mural
painting transferred to canvas, 55 ⅜ × 171 ½ in.
(140.5 × 435.7 cm). Museo del Prado, Madrid.

31 (facing). A Young Woman/Leocadia Zorrilla,
1820–1823. Oil mural painting transferred
to canvas, 57 ⅜ × 51 in. (145.7 × 129.4 cm).
Museo del Prado, Madrid.

32. Ramón Satué, 1823. Oil on canvas, 42 ⅛ × 32 ⅞ in. (107 × 83.5 cm). Rijksmuseum, Amsterdam.

33. Portrait of a Lady, 1824. Oil on canvas, 31 ½ × 23 in. (80 × 58.4 cm). Frick Collection, New York, Henry Clay Frick Bequest. 1914.1.63.

34. Maja and Celestina, 1824–1825. Carbon black and watercolor on ivory, 2 ⅛ × 2 ⅛ in. (5.4 × 5.4 cm). Private collection.

35. Jacques Galos, 1826. Oil on canvas, 21 ¾ × 18 ¼ in. (55.2 × 46.4 cm). The Barnes Foundation, Philadelphia.

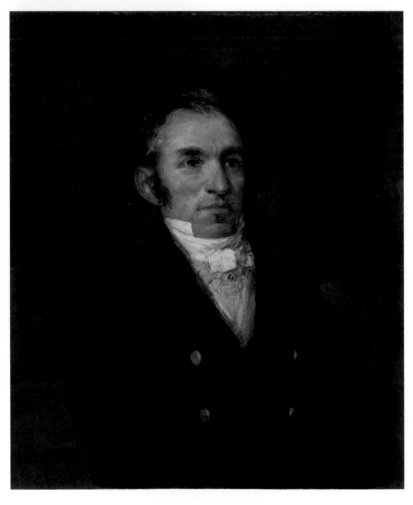

seen in the world." To Godoy, Napoleon sent a suit of armor.[2] In Paris, Azara relayed a commission to Jacques-Louis David for a portrait of Napoleon to be sent to Spain; the result was the first of four versions of *Napoleon Crossing the Alps*, which arrived in Madrid two years later.[3] Far less impressed with the portrait than he had been with the firearms, Azara enumerated its many faults in a letter to Bernardo de Iriarte, including its lack of resemblance to the sitter; Napoleon's posture, kneeling rather than sitting on his horse; the scale and the fantastic gallop of a horse with nothing to support it; and the unnatural palette, particularly the ashen tone of Napoleon's flesh. His conclusion: "Compare it with the equestrian portraits of Velázquez, and there's nothing more to say, or to think."[4]

Carlos IV began his days at five in the morning, heard two masses, read, and then visited the arms and woodworking shops, often rolling up his sleeves to work or offer well-informed advice. A skilled shot, the king, like his father, hunted every day of the year with the exception of Easter week, accompanied by six carriages and a dozen guards. Upon returning to the palace, he took a walk with the queen before enjoying cards or concerts and retired at eleven after a late supper. Decorative arts, music, and collecting paintings remained among his favorite pastimes.[5] By 1800 his attention had turned to a new project at Aranjuez, the expansion of the Casa del Labrador, then a modest building of brick and stone at the eastern end of the gardens that Carlos had developed as prince, built in 1794 by Juan de Villanueva. Arriving in January, he found granite arches to support the terrace of a new eastern wing and, in February, saw the doors of the original building opened onto the new terrace. Visitors to the Casa today discover enduring testimony of the cultural rapprochement of Spain and France at the beginning of the nineteenth century in the *gabinete de platino* (platinum cabinet), designed by the French architect Charles Percier. The commission originated in January 1800 with the visit to Aranjuez of Michel-Léonard Sitel, a *plaqueur*, or specialist in the application of bronze ornaments to wood surfaces. Although Sitel's purpose was to present a Parisian-made carriage to Carlos IV and María Luisa, he took advantage of his stay to propose the adornment of a *gabinete* in the newly constructed wing. The commission was given by royal order on February 26, and Percier's drawings arrived later that spring; by late November the scope of the project had been expanded to include furniture, the design for the floor, and the ceiling.[6] The use and emphasis of platinum was not fortuitous: although indigenous American cultures had used the metal for centuries, it was rediscovered in the eighteenth century by Spanish colonizers (hence the name, "platino," or "little silver"). Mahogany, amaranth, and lemonwood decorated in gilt bronze enhanced by gold plate complemented

the platinum to contribute to cabinet's jewel-box appearance; its decoration included paintings of the four seasons and roundels with children's games by Anne-Louis Girodet, views of European cities by Jean-Thomas Thibault, and landscapes by Jean-Joseph Bidauld. Following a journey of fifty-nine days, four wagons with forty-two crates containing the ornamentation for the cabinet arrived at Aranjuez on June 10, 1804. Installation took another five months. And even as relations between Napoleon and the Spanish monarchy deteriorated, Carlos continued to seek out the work of contemporary French artists to decorate his beloved retreat; his last purchase of thirty-nine paintings arrived in Aranjuez on March 8, 1808, eleven days before the events that would lead to his downfall.[7]

The king's penchant for the latest fashion in decoration and his preference for modern paintings left the weavers at the tapestry factory idle. Livinio Stuyck y Vandergoten informed the king of the situation in a letter of January 18 and suggested possible new projects, including tapestries for the palace at El Escorial to replace those that were moved there from other locations and folded to fit the walls; decorative pieces to complement the carpets in the royal palace; or tapestries to replace those removed following the death of the *infante* Gabriel to be woven "after the paintings in possession of this writer painted by don Francisco Goya and don Ramón Bayeu, and others." In response, the king ordered Goya and Maella to paint ornamental cartoons for tapestries or carpets; both artists balked at such a lowly assignment, insisting that they were painters not of decoration but of "histories and figures." The king acquiesced, requiring Goya and Maella only to supervise those artists who furnished the ornamental designs.[8]

As a result of the government's 1798 confiscation of church properties (in an attempt to decrease the national debt), Goya's dwelling on the Calle del Desengaño was put up for auction; the buyer was Antonio Noriega (whose portrait Goya would paint the following year), acting on behalf of Godoy, who would transfer the residence to Pepita Tudó.[9] In the meantime, Goya apparently noticed in the *Diario de Madrid* on Sunday, May 18, an announcement of the upcoming auction of another church property on the second floor of a nearby building at 15, Calle del Valverde, at the corner of that street and the Calle del Desengaño, assessed at 234,260 *reales* with 8,250 *reales* in rental income.[10] His brother-in-law Marcos del Campo served as intermediary for Goya's bid, and on July 23 the artist paid 126,000 *reales*, with some 71,000 *reales* for other charges remaining. He also became the landlord of tenants in six apartments, including the queen's coachman and a lawyer of the royal councils, and of a shoe store and perfume shop.[11] Mid-nineteenth-century sources suggest that Goya occupied the second (in US terminology,

the third) floor of the building, with seven balconies, four of which faced a public square, providing light for his studio.[12] A mark of his improved status and salary, Goya's real estate with rental income was also a better investment than royal bonds, which by 1800 were circulating at a discount ranging from 62 to 72 percent.[13]

Writing to Godoy from Aranjuez on April 22, María Luisa expressed her pleasure that Goya was painting the portrait of his wife, the twenty-one-year-old María Teresa, now about three months pregnant following two miscarriages (pl. 18). Her isolation as she sits against a tonal background implies her confinement; her averted gaze and distracted expression convey the modesty of a young woman raised in a convent. Goya compensated for her reticence by ensuring that her face remains the focus of the painting, even though with her frizz of hair and her bonnet, ribbons, and decorative sprigs, her head takes up only a fraction of the large canvas. Her carefully defined features and expression are clearly distinguishable from across a room, but as our eyes move from her face to her bodice and abundant skirt, we notice that Goya's focus softens, his handling becomes looser, until he defines her skirt only with broad strokes of grays and white; we even have to guess that the miniature portrait on her ring is that of her husband. Often referred to as the countess of Chinchón, María Teresa was granted that title, transferred to her by her brother, only three years later; in 1800, she was the Princess of Peace or the duchess of Alcudia, her identity inextricable from that of her husband.

In closing her April 22 letter, the queen added, "The King says that in finishing the portrait of your wife, Goya should come to do the portrait of us all together here," words that document the origin of The Family of Carlos IV (pl. 19). Eager to please, Godoy apparently told Goya to depart immediately for Aranjuez, to which María Luisa's responded, "What you say about Goya seems very good to me but let him finish the portrait of your wife." Goya purchased materials in Madrid on April 29 and May 7 and presumably developed a concept drawing or oil sketch approved by his patrons, a preliminary that dictated the poses of sitters seen in the five portrait studies known today of the ten originally painted.[14] In Aranjuez, Goya painted the studies of eight of the ten principal figures by June 9 and the following day began that of the queen. It was completed by June 15, when the queen expressed her satisfaction to Godoy: "They say it is the best of all of them; he is painting the king in the casa del Labrador; I think it will be equally good."[15] Goya in all likelihood painted the king in his retreat, where he kept an eye on the work in progress and sometimes stayed to work on affairs of state, enjoy concerts or other pastimes, and take his midday meal. The artist's per diem expense of 3,200 reales suggests a stay of about six weeks; expenses for four carriage trips

(presumably two round trips) imply that he traveled to Madrid once during his stay. With his sketches crated and transported, Goya returned to Madrid to paint the portrait.[16]

Creating portrait studies for the ten principal figures in the *Family* brought Goya into intimate proximity with the Spanish Bourbons past, present, and future. In the finished work (pl. 19), the past is represented by the king's siblings, relegated to the second row: the aged María Josepha (1744–1801) and her younger brother Antonio Pascual (1755–1817), who in 1795 married the daughter of Carlos IV and María Luisa, María Amalia (1779–1798); having predeceased her husband, she is represented posthumously in profile at his side. The positioning of the background figures could be determined only after Goya had placed the main protagonists, representatives of the Spanish monarchy present and future. María Luisa, her presence emphasized by her shimmering overskirt, stands at center slightly behind the king, surrounded by her children. From left to right they are Carlos María Isidro (1788–1855) and his older brother, the prince of Asturias, Fernando (1784–1833); María Isabel (1789–1848), protected under the queen's right arm, and Francisco de Paula (1794–1865), his hand held by his mother. On the far right, her daughter María Luisa (1782–1824) holds the infant Carlos Luis, born the previous December (1799–1883), as she stands before her husband, Luis de Borbón (1773–1803), prince of Parma.

By the time Moratín visited Goya in Madrid in July, the artist had probably already begun work on the large canvas, fabricated by workers who sewed together horizontally three pieces of canvas, to be mounted on a custom-made stretcher measuring about nine by eleven feet.[17] An assistant presumably primed the canvas and possibly applied the light-toned ground with orange hues, still visible beneath passages such as the king's freely brushed sash. Goya sketched in the central trio of the queen with her youngest children, the king, and the prince of Asturias, before adding the other children and background figures, including himself at his easel.[18] The central trio and king are the only figures in full light; only the faces and upper bodies of others are illuminated by light entering from the left, their legs and feet left in shadow. Goya thus solved one of the awkward results of a group portrait of standing figures: the inevitable proliferation of men's buckled shoes and the pointed toes of women's slippers. To enhance the harmony among the figures, Goya softened the expressions and gazes seen in the five surviving sketches of Carlos María Isidro, María Josepha, Antonio Pascual, Francisco de Paula, and Luis de Borbón (all in the Museo del Prado). Equally subtle is the establishment of hierarchy, for although all the males, including the infant Carlos Luis, wear the blue and white ribbon of the Order of

Carlos III, a more saturated blue, highlighted with strokes of white, makes the ribbon of the king shimmer on the surface. Working with brushes of various sizes, Goya captured light reflected by the brocade trim of women's skirts, the silver and gold of their overskirts, the medals on the king's chest, the diamonds of the queen's pendant earrings, and the hair ornaments worn by the women, all details that would sparkle when the portrait was originally seen by the light of oil lamps or candles. In a virtuoso display, he created upon the king's chest an analog in paint to the medals of the Order of Carlos III, San Gennaro, the Holy Spirit and the four Spanish military orders. The array of strokes, traces of the artist's hand, forces our eyes to see either the substance of the paint or the forms represented, but we can never quite see both simultaneously.

The Family of Carlos IV immortalizes a rare moment of optimism, solidarity, and promise. To Carlos IV and María Luisa, Napoleon was an ally who ensured a mutually beneficial relationship between Spain and France, a return to an earlier era of political stability between the two countries, and possibly even to peace. By mid-summer Napoleon's victory at Marengo brought new hope for an expanded kingdom for the prince and princess of Parma; not coincidentally, in painting the consul's portrait for the Spanish king, Jacques-Louis David posed a mannequin in the uniform worn by Napoleon at that decisive battle.[19] Las Meninas is often cited as Goya's inspiration, the telltale sign being the artist's inclusion of himself working on a large canvas in the left middle-ground, seen also in Velázquez's masterpiece. But Goya also looked back to his own Family of the Infante don Luis de Borbón, behind which Velázquez also lurked, to show how far he had come as a painter during the intervening sixteen years. Now in addressing Velázquez, Goya challenged him, just as he had challenged El Greco in envisioning the Arrest of Christ. He rejected the perspectival setting integral to Las Meninas by imagining the family of Carlos IV on a stage, its shallow depth reinforced by the geometry of large framed paintings on the wall behind. Goya's clearly visible tracks of the paint-laden brush defy Velázquez's subtlety: even today the artist remains insistently present in the marks of his brushes, in the physical substance of golds and silvers, blues and reds, signs of a sumptuous and regal world that was soon to disappear.

———

Carlota Joaquina, the daughter of Godoy and María Teresa, was a little over one month old when in November Ceán, the architect Pedro Arnal, and the engraver Sepúlveda, accompanied by Godoy's secretary Fernando de la Serna Santander, visited the palace and collection of the Prince of Peace; the visit

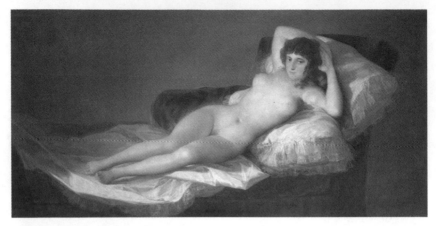

20. *The Naked Maja* (*La Maja desnuda*), ca. 1795–1800. Oil on canvas, 38 ⅝ × 75 ¼ in. (98 × 191 cm). Museo del Prado, Madrid.

had been granted thanks to Sepúlveda's friendship with Godoy's chaplain.[20] In his diary Sepúlveda noted some of the works: Antonio de Pereda's masterful *Life Is a Dream*; portraits by Goya of both Godoy (unidentified) and of his wife (presumably that painted six months earlier); and busts of the king, queen, and Godoy by Juan Adán, Goya's old acquaintance from his early days in Zaragoza. Ornate mirrors gilt with bronze and a bed with similar decoration, described as "the best ever made in Spain, especially in bronze gilt with very well-made decorations," also impressed Sepúlveda. But of most interest here are two paintings, briefly mentioned, in an "interior cabinet" among many representations of Venus, or, more plainly, female nudes. One was the "famous [Venus] by Velázquez that the Duchess of Alba gave him"—that is, the *"Rokeby" Venus*, today in the National Gallery, London. The other was "a nude by Goya without good drawing or pleasant color," known today as *The Naked Maja* (*La Maja desnuda*, fig. 20).[21] Sepúlveda's mention of only *The Naked Maja* confirms suspicions, raised by the stylistic differences, that her clothed counterpart, *The Clothed Maja* (*La Maja vestida*, fig. 21), had yet to be painted, for not until 1808 were both documented in Godoy's collection.

The awkward position of Goya's naked woman on her divan, camouflaged in part by the addition of pillows upon which her form makes no impression, and the elision of her neck that makes her face seem pasted upon her body, confirm that Goya did not paint this figure from life. Indeed, painting a naked female model was not an option for artists in late eighteenth-century Spain. Her breasts are splayed outwards, their curves silhouettes rather than volumes and reinforce the impression of a body imagined rather than seen. This emphasis on her breasts and pubis (notably, with hair) might invite com-

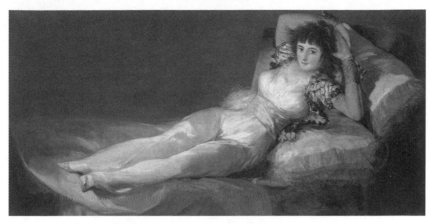

21. *The Clothed Maja* (*La Maja vestida*), ca. 1800–1807. Oil on canvas, 37 ⅜ × 74 ¾ in. (95 × 190 cm). Museo del Prado, Madrid.

parison with a bawdy drawing rather than with a great work of art, were it not for Goya's masterful rendering of the woman's flesh. Still, he probably knew better than to see *The Naked Maja* as a masterwork in competition with Velázquez; his was a titillating image of a woman unclothed, who in contrast with the timeless *"Rokeby" Venus*, unabashedly confronts the viewer with the brazenness of a "modern" woman of Goya's time, a trait described by contemporaries as *marcialidad*. The completion of her clothed counterpart confirmed her modernity and enhanced her eroticism.[22] That Goya painted this subject can only be explained by the protection of a powerful patron; in fact, he was well on his way to becoming Godoy's preferred contemporary artist, who eight years later was represented by twenty-six works in the royal favorite's collection, a number surpassed only by the seventeenth-century painters José de Ribera and Murillo.[23]

22

Absences

1801–1802

Iɴ December 1800 Pedro Félix Ceballos y Guerra de la Vega replaced Urquijo as secretary of state, an appointment often credited to Ceballos's marriage to the cousin of Manuel Godoy. But Ceballos soon distanced himself from Godoy's policies, and his career, like that of Goya, attests that individuals of proven value outlasted the monarchs (and favorites) they served. Ceballos remained as secretary of state until the abdication of Carlos IV in March 1808 and continued in the post during the brief reign of Fernando VII, whom he accompanied to meet Napoleon in Bayonne in May 1808. He returned to Madrid to serve briefly as minister of foreign affairs under Joseph Bonaparte before joining the Spanish government in exile, which appointed him ambassador to England. Fernando VII reinstated Ceballos as secretary of state upon his return to the throne in 1814 and two years later bestowed on him the Order of the Golden Fleece.[1]

Within weeks of his appointment, Ceballos requested Goya's opinion of the work of Ángel Gómez Marañón, appointed the previous June as the official conservator (*restaurador oficial*) of paintings in the palace of the Buen Retiro.[2] Within three days Goya reported on his visit to Gómez's studio:

Most Excellent Sir:

In fulfillment of the Royal Order that Your Excellency so graciously communicated to me dated last December 30 asking me to report on the paintings that are in the care of Angel Gómez Marañón, examining those that he has transferred to new canvases and those that he has cleaned and refreshed, and stating the advantages or detriment that the paintings might suffer, examining the method and quality

of the ingredients he uses for their glazing, I must inform Your Excellency that, having presented myself immediately in the [palace of the] Buen Retiro, I saw and considered with the greatest courtesy the works of that artist and the state of the paintings, of which he showed me first that of Seneca that he was in the process of cleaning and had already done half of the glazing.

I cannot overstate to Your Excellency the dissonance revealed to me by the comparison of retouched areas with those that were not treated, for in the former the brio and virtuosity of the brushwork, the mastery of delicate and knowledgeable touches of the original seen in the untouched areas was lost and destroyed, and with my normal frankness, inspired by my passion, I did not hide what I felt. In continuing, he showed me others, all equally deteriorated and corrupted in the eyes of professors and true experts, because beyond being true that the more a painting is retouched with the pretext of its conservation, the more it is destroyed, and that even the very artists returning alive to us now could not retouch them perfectly because of the aging of tones that happens over time, it is also [true] that [even for] one who paints according to principles and the study of knowledgeable painters, it is not easy to retain the instantaneous and momentary intention of fantasy and the harmony and design that informed the original execution, so that retouches do no harm because of the difference. And if this is considered inevitable for a consummate artist, what will happen when it is undertaken by one who lacks solid principles?

As far as the nature of the ingredients he uses for glazing the paintings, although I asked him of what they were made, he claimed that it was egg white, without further explanation; so I realized that this was a mystery and he was interested in hiding the truth; but I understand that the subject does not merit further consideration and, like all that appears to be a secret, is not worth much.

This is my opinion, briefly and simply stated, always open to those with greater insight and knowledge I offer it for the consideration of Your Excellency, taking advantage of this opportunity to offer my respects.

Our Lord protect Your Excellency for many years.

Madrid, January 2, 1801.

Francisco de Goya.[3]

The passion for art that Goya voiced eight years earlier in his report to the Royal Academy remained undiminished, as did his veneration for the masters who preceded him. We can only imagine the scene in the restorer's studio, with the deaf artist surrounded by Old Master paintings as he attempted to control his outrage at the inept "restoration" of works of art.

Ceballos again asked Goya for his opinion in late July, this time in regard to the repair work of another conservator, Marcos Escudero. Goya's response was brief: "I am not saying that [damages] should not be repaired and lined, but no further than the tear, without extending the brush further, and by someone who has the merit to know and respect them." Goya's words were sufficient for Ceballos, the probable author of a comment in the margin: "Order Escudero to suspend his work and the same for all who do the same."[4] Goya's words may have contributed to Gómez's replacement by Manuel Napoli, who twenty-five years earlier had traveled to Rome to study with Mengs. Having worked as the principal conservator in the palace of Capodimonte in Naples for over a decade, in 1800 he returned with royal permission to Madrid,[5] was appointed conservator of paintings in the royal palace and in the Buen Retiro on July 15, 1802, and later that summer was given lodgings in the Buen Retiro. Years later he confirmed that Goya's aversion to the conservation of paintings was well known, by asserting that his work was praised not only by the royal academicians but also by don Francisco Goya, who "in spite of being a sworn enemy of Professors of this field, upon seeing what the supplicant was doing took back the words he had many times spoken and written."[6]

Goya was also asked by the city of Toledo to assess paintings completed in February for an arch to stand before the Puerta del Perdón (Door of Pardon) of the cathedral for the processional arrival of Luis María de Borbón, elevated to cardinal-archbishop, primate of Spain the previous October. Goya's assessment of 45,000 *reales* was half of the value assigned to the ensemble by its artists, Fernando Brambila and Gregorio Borghini, who unsuccessfully challenged the appraisal.[7] Around this time, the cardinal-archbishop (also Godoy's brother-in-law) posed for a full-length portrait by Goya, known in two versions; his youngest sister, María Luisa, admitted in October to the Order of Noble Women of Queen María Luisa, also sat for a full-length portrait by the artist.[8]

By May, Josefa Bayeu was "sick in bed, but with my judgement, memory and understanding intact"; on May 3 she wrote her will.[9] She professed her Catholic faith, requested to be buried in the habit of Saint Francis in the parish in which she lived at the time of her death, asked that two hundred masses be said for her soul, and left 30 *reales* to charities of the church. She willed her possessions to her son; if he predeceased her without heir, they would pass to

her husband. As executors, Josefa named Goya and her two surviving male relatives in Madrid: her brother-in-law Marcos del Campo (who also signed the will as witness) and Pedro Ibáñez Machín, the husband of Feliciana Bayeu. Other witnesses were Martín de San Miguel, a priest in the nearby monastery of San Basilio who presumably attended Josefa in her illness, and Goya's cousin Félix Mozota, who years earlier has requested a recommendation to Zapater for a position at the university in Zaragoza and was subsequently appointed as administrator of the Bernardine convent in Madrid. Two other witnesses illustrate the intersection of Goya's professional and personal lives: the painter Agustín Esteve, who had collaborated with Goya and copied his portraits since 1789, and Goya's assistant, or *moledor*, Pedro Gómez. The nature of the relationship of Goya or Josefa to a final witness, Josef Oliden, a clerk in the chambers of the royal court, is not known. Josefa recuperated, and her death came eleven years later, on June 20, 1812.

———

Appointed by his brother Napoleon, Lucien Bonaparte arrived on December 6, 1800, to replace Alquier as the French ambassador to Spain, and charged with using the Spanish alliance to occupy Portugal and cut off its ports to England. War on Portugal was agreed to by the Convenio de Madrid, signed by Lucien and Ceballos on January 29; the declaration of war followed on February 27. Godoy assumed command of sixty thousand Spanish troops and established his headquarters near the Portuguese border in his native Badajoz, where he lodged in the episcopal palace of his uncle, Bishop Gabriel Álvarez de Faria. The war was brief: hostilities began on May 19, when Spanish forces occupied the border town of Olivenza, and Portugal surrendered the following day, in a battle to become known as the War of the Oranges for the fruits that Godoy sent to the queen from Portugal. The treaty of Badajoz, signed in June, forced Portugal to close its ports to the British, surrender Olivenza to Spain, and pay an indemnity to France. Carlos IV was content, since the outcome maintained the kingdom of his daughter and son-in-law; Napoleon was not, having sought to conquer all of Portugal as a bargaining chip for the English-held territories of Menorca, Malta, and Trinidad.[10] An exultant Godoy hosted a celebratory visit from the king and queen in Badajoz before returning triumphant to Madrid on July 20; on October 4 he added the title of Generalísimo del Ejército de Tierra y Mar (Commander-in-Chief of the Army and Navy) to those he already owned.

Summoned to commemorate Godoy's career as commander in the field, Goya turned the traditional vertical format of the official portrait on its side, to represent Godoy as the contemplative commander, semireclining on rocks

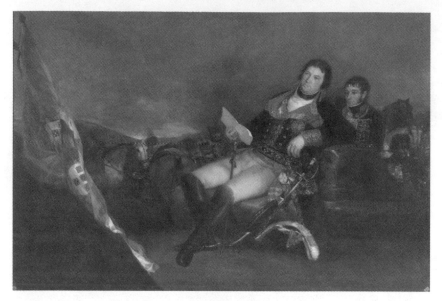

22. *Manuel Godoy as Commander in the War of the Oranges*, 1801. Oil on canvas, 70 ⅞ × 105 ⅛ in. (180 × 267 cm). Museo de la Real Academia de Bellas Artes, Madrid.

that form a natural armchair and holding a letter, as uniformed officers and horses bustle in the background, preparing as dawn breaks. Godoy is lost in thought, his gaze unfocused as he ponders the letter, presumably a missive from Carlos IV (fig. 22). The saber at Godoy's side, a gift from the king, also invokes the monarch. Two standards surrendered by the Portuguese army lean in the left foreground: by a royal decree of July 1, their insignia enhanced Godoy's coat of arms.

Prior to his departure for Portugal, Godoy signed the Treaty of Aranjuez, according to which the prince and princess of Parma (standing on the far right of *The Family of Carlos IV*) were to rule the newly created kingdom of Etruria, encompassing Tuscany and neighboring territories. Spain in turn ceded the New World territory of Louisiana to France, with the stipulation that if France decided to divest itself of the territory, it would be returned to Spain. The kingdom of Etruria was almost as short-lived as Napoleon's promise concerning the Louisiana territory; following Luis's death in 1803, his widow ruled as regent until 1807, when Napoleon reclaimed Etruria for France. But all of this lay in the future in the spring of 1801, when Napoleon invited the new king and queen of Etruria to visit Paris en route to Tuscany. Having departed from Aranjuez in late April, they arrived on June 3 and were guests of Napoleon and Josephine at a dinner at Malmaison on June 14 (the first anniversary of the battle of Marengo) before continuing their journey to Florence.

If some members of the royal family presented themselves in person in Paris, others planned to be present in effigy. An invoice of expenses incurred by Goya for works painted in the royal service from July 1800 to June 1801 includes the equestrian portrait of the king, *The Family of Carlos IV*, and "two full-length, life-size portraits of Their Majesties to send to Paris."[11] These portraits were in fact copies of earlier portraits, documented in a letter of August 10 from Goya to Ceballos, in which the artist reported that the "copies of the portraits of Their Majesties" were finished, and asked for further instructions. Ceballos jotted his response on Goya's letter, ordering the artist to "bring them tomorrow between ten and eleven so that Their Majesties see them." Perhaps due to tensions with France that summer, the portraits were not delivered until early October, when Ceballos ordered Goya to take them without delay to the French ambassador.[12] Recalled on October 24, Lucien Bonaparte may have had little interest in the royal portraits prior to his departure from Madrid on November 11, 1801, for a year later, María Luisa forwarded to Godoy a letter from "that Frenchman" (presumably Lucien) writing, "I return to you the letter from that Frenchman, and the answer, that only the portrait of the King was sent."[13] The fate of the copies destined for Paris remains a mystery.

Lucien's departure marked the end of a heady ten months of diplomacy, and demands for new portraits of the royal family, as well as any optimism following Napoleon's early overtures, gradually waned. Goya continued to fulfill commissions for Godoy, among them four allegorical tondos of Commerce, Agriculture, Industry, and Science, painted in tempera on linen, their subjects of prosperity appropriate to their placement at the center of four lunettes in the first room entered in the public area of Godoy's palace.[14] An 1808 inventory of the palace also includes four other large allegories by Goya, yet to be firmly identified, as well as the first mention of *The Clothed Maja* (identified as a gypsy rather than a *maja*) as a counterpart to *The Naked Maja* already in Godoy's private gallery. How the paired images were displayed remains a matter of speculation: one early account suggests that the unclothed woman occupied the verso of her clothed partner; another specifies that an ingenious mechanism allowed the clothed figure to be raised to reveal her clothes-less counterpart beneath.[15]

Goya's work at court now included these and other projects for Godoy, including portraits for the government of Murcia and from the town councillors of Bilbao. Godoy rejected that for Bilbao, insisting that his legs were badly painted, only to reject it again after Goya repainted the offending passages and insist that Goya begin afresh. Unable to reason with Godoy, Goya appealed to the patrons in Bilbao, stating that he wanted to meet all their

demands, "but to paint another? For all the wealth in the world I could not, nor improve on that which I have done."[16] Whether the commission was completed and ever reached its destination is not known.

—

By 1802 the fifty-six-year-old Goya had witnessed departures from court of patrons and friends, and the deaths of others. After recuperating from the illness that forced his retirement, Francisco Saavedra left Madrid in 1799 and returned to his native Andalucía. Settled in the Puerto de Santa María on the coast north of Cádiz, this very accomplished public servant penned a memoir in which he recounted his final months at court. Before he left Madrid, the king asked him to return to work, but Saavedra soon heard rumors that the king had changed his mind. His fellow courtiers would have been well advised to adopt his attitude: "Undoubtedly, if I had been attached to the ministry I would have gone through some very rough times, but I followed everything with indifference, remaining still in the position determined by destiny. I was very convinced that in that situation, no other behavior would serve me well. . . . I thus assumed the only option that seemed to be available to me was to step neither forward nor back, and to surrender myself completely to the arms of Fortune, as I have done in facing all the vicissitudes of my novelesque life."[17] In 1799 Sebastián Martínez, who had seen Goya through his illness in spring 1793, was appointed treasurer general, but his term was short-lived: on March 7, 1800, the king appointed an assistant to sign for him during his "illnesses or legitimate absences,"[18] and Martínez died in Murcia, where he also owned a house, on November 23, 1800.[19]

Ceballos took further measures to secure the court against the reform-minded ministers who had served briefly from late 1797 to 1798, most famously Jovellanos, arrested at his home in Gijón on March 13, 1801. He would spend the next seven years in Mallorca, detained for a year in the charterhouse of Valldemossa before his transfer to the Castillo de Bellver, about three kilometers from Palma de Mallorca. Jovellanos's situation did not keep him from recording the sights along his journey from Gijón, which brought him to the church at Monte Torrero on the outskirts of Zaragoza, commissioned by the company of the Canal of Aragón. His diary entry of April 7, 1801, is the sole surviving description of its three recently finished altarpieces by Goya:

> Inside is a rotunda with a superb dome, worthy for its grandeur of the greatest temple. Two lunettes on the sides serve as chapels, and another, deeper, in front of the presbytery. In it, there are three altars, with three beautiful original paintings by Don Francisco Goya. The

largest represents Saint——[left blank by Jovellanos], suspended in the air in his pontifical robes, as if protecting the king Don Jaime before the conquest of Valencia. The monarch looks at him in wonder, while a boy offers him a crown, around him are soldiers who greatly enrich the composition. On the evangelist side, Saint Isabel curing the wounds of a poor sick woman; on the side of the epistle, the imprisoned Saint Hermengild receiving his chains. Admirable works, not so much for their composition as for the power of their chiaroscuro, the inimitable beauty of their color, and a certain magic of lights and tints that seemingly cannot be achieved by any other brush.[20]

The church was consecrated in 1802, but not before Goya was ordered to paint over the exposed breast of the woman attended to by Saint Isabel: over two decades after his trials painting the figures of Charity in a pendentive for El Pilar, Goya continued to paint women considered indecent by patrons in his hometown. The three altarpieces were destroyed during the Peninsular War, and only sketches, once in the collection of Francisco Zapater and undoubtedly inherited from his great-uncle Martín, survive.[21]

Following Jovellanos's dismissal from court in 1798, Ceán remained in the ministry of grace and justice and saw through the publication of his *Diccionario histórico* by the Royal Academy in 1800. But with Jovellanos's banishment to Mallorca, Ceán was discharged, and returned to the archive of the Indies in Seville. Bernardo de Iriarte joined the ranks of officials relieved of their duties in August 1802; the reason given at court was his health, although Iriarte confided to Azara that their friendship was the probable cause of his forced retirement. To justify Iriarte's exile from court, the monarchy cited the scarcity of housing in Madrid and the benefits of living away from the city's bustle for someone who should now only "think of resting and enjoying the reward that the king has given to him"; he was allowed to choose his residence "wherever he would like outside of this city."[22] Moratín continued under Godoy's protection; in his diary he noted visits with Goya up to September 2, 1802, the last mentioned until 1806.[23]

The same month that Jovellanos was detained, Meléndez was sent further from Madrid, moving from Medina del Campo, where he had remained since his dismissal from court over two years earlier, to Zamora. Learning that enemies in Madrid were fabricating charges to discredit him, Meléndez wrote a brief in his own defense; on June 27, 1802, the charges were dropped and his salary was reinstated. Friends nevertheless advised him against returning to court, and a letter from the countess of Montijo dated June 30, 1802, intimates the increasingly toxic atmosphere: "I assume that it won't occur to you to

come to Madrid for now, nor for a very long time under any pretext, it would be the greatest possible folly, and even [going to] Salamanca. You must think about it and try to keep a low profile, and forget is what you must do, because relapses in politics, as in the physical and the moral, are mortal. All who love you are of the same opinion, and so I think you better follow it."[24]

The countess also mentioned "the poor Duchess of Alba," who, though close to death, could not receive the sacraments because of the loss of her senses and recognition. A week later Montijo reported that although baths calmed her agitation, the duchess had not recovered her reasoning; in early August, Montijo mourned the duchess's death on July 23, 1802.[25] A drawing attributed to Goya shows the duchess being wrapped in a shroud by three draped figures, possibly a final tribute to a once powerful and beautiful patroness.[26] Within a week of the duchess's death, Carlos IV ordered Godoy to review her personal archive, a request justified by reports that servants had removed papers; Maella was ordered to select paintings for the royal collection. Listed in an undated memorandum, they included the *Virgin, Christ Child, and Saint John* by Raphael, from the oratory of the duchess's palace (the *Alba Madonna*, National Gallery of Art, Washington, DC); *The School of Love* by Correggio, taken from the *gabinete reservado*, or private cabinet (*Venus, Mercury and Cupid*, National Gallery, London); and an *Adoration of the Shepherds* by Ribera and a self-portrait by David Teniers on copper (both, location unknown). For Godoy, Maella selected a portrait of Martin Luther identified as a work by Titian, an unattributed portrait of Anne Boleyn, a painting of a worker with a fox at his feet attributed to Velázquez, a portrait by Juan de Pareja, and fourteen landscapes of various sizes painted on oil and copper.[27] The duchess's palace at Moncloa was claimed by the king and remained a *sitio real* until its destruction in the Spanish Civil War.

Of these many absences, that of Martín Zapater undoubtedly left the greatest void. Goya's last recorded letter to his friend, with the news of his appointment as first court painter, is dated October 1799, but the presence of the sketches for the church of San Fernando at Monte Torrero (1800–1801) in the collection of Zapater's great-nephew suggests Goya gave these to Zapater, and confirms their continued friendship. Zapater continued in public service, was elected first councillor of the Royal Academy of San Luis in Zaragoza on April 7, 1802, and at the end of the year joined eleven others to come once more to the aid of Zaragoza during a crisis of subsistence. The parish of San Gil recorded his death after a long illness on January 24, 1803; three days earlier he had written his will, leaving all his possessions to two nephews, Matheo and Francisco, then in France, whose education he had overseen. He entrusted the older Matheo as executor of his estate.[28]

Although Goya's illness of 1793 and the onset of deafness are often viewed as critical turning points of his life, his invention blossomed in experimental works during the years to follow, patrons sought him out, he became the monarchs' portraitist of choice, and first court painter. If we are to identify a turning point, a juncture at which the artist reconsidered his life and work, it possibly occurred around 1803, a decade after his illness, with royal commissions and accolades in the past. Having witnessed the exile of patrons once powerful and political alliances come and gone, and without his dearest, trusted friend and confidant, Goya now looked to his family and to patrons beyond the court, working to ensure his personal and professional legacy in an increasingly unstable world.

Society High and Low

1803–1804

IN spring 1803 Goya purchased a second house at 7, Calle de los Reyes in Madrid, presumably on the Calle de los Reyes alta, in the newer section of Madrid, leading into the square of the Salesian convent of the Visitation, or Salesas Reales, founded by the queen of Fernando VI in 1748; estimating from the irregular layout of streets at the time recorded in Tomás López's 1785 plan of the city, the property was also a convenient walk of about ten blocks from Goya's house on the Calle Valverde.[1] On June 5 the *Diario de Madrid* listed the price as 99,684 *reales*, and noted that the house was "almost new" and that the seller also had some paintings for sale by "the famous Conrrado"—that is, the former first court painter Corrado Giaquinto. Carlos Chornet, overseer of the royal palace, handled the sale, agreeing with Goya on a significantly discounted price of 80,000 *reales* in cash, with another 3,200 *reales* to be paid to cover the night illumination and patrol.[2] Given the number of properties still on the market five years after the government's appropriation of religious properties, the sellers realized their good fortune in finding a buyer ready to pay in cash. When a judge questioned the sale price, citing the assessment of the property at 99,654 *reales*, Chornet offered to pay the difference and observed, "I am sure that Goya will retract his offer if it is not immediately executed."[3] Thus, on June 21 Goya, accompanied by a notary and constable who "opened and closed the doors, walked through the rooms, and did other proprietary things without any question," inspected the brick house, with three floors and an attic, a portal with granite lintel and door jambs, an entry hall, and a patio with a well. Goya also met the tenants, one on the ground floor who paid 105 *reales* per month, and a second on the second floor, who paid sixty-eight, and took possession of the property,[4] its rental income to be added to that earned from his house on the Calle de Valverde.

Probably awaiting Goya's response as he inspected his new property was a letter from the court painter Jacinto Gómez written the previous day, requesting Goya's assistance in making the case for a pension for his son to work with him and study painting. As justification, Gómez referred to the annual stipend paid by the treasury of 400 *ducados* (6,800 *reales*) to Luis Gil Ranz, "so that he be instructed in drawing and painting with, and under the direction of, Francisco de Goya," and to two assistants who worked with Maella, each paid 200 *ducados*.[5] The nature of Gil's assistance, and whether or not he had a hand in any paintings today attributed to Goya, is unknown; he resurfaces briefly in Goya's story in 1808. Goya's response to Gómez is likewise unknown, but it may not be coincidental that within three weeks of Gómez's letter, Goya petitioned the minister of finance, Miguel Cayetano de Soler, for an allowance for his own son in an exchange:

The work of my caprichos consists of eighty plates engraved in etching by my hand: they were not offered to the public more than two days at one ounce of gold for each book, twenty-seven books were sold: five or six thousand books can be printed from these plates. Foreigners are those who most desire them and for fear that they fall in their hands after my death I want to give them to the King my Lord for his Calcografía. I do not ask of His Majesty more than some compensation for my son Francisco Javier de Goya so that he can travel: he has the desire and disposition to take advantage of it. If Your Excellency would see fit to make this known to His Majesty, I would be extremely grateful. God Keep Your Excellency for many years. Madrid, July 7, 1803.[6]

On October 6, Cayetano wrote to the royal treasurer:

The King has seen fit to accept from the court painter don Francisco Goya the offer that he made of the work of his Caprichos comprising eight [sic] plates of bronze [sic] engraved by his hand in etching, which His Majesty has ordered be sent to the Real Calcografía so that editions be printed and sold to the Public; in compensation for this gift he has granted to don Francisco Javier, son of said don Francisco de Goya, the annual pension of 12,000 reales vellón, so that traveling in foreign countries and teaching himself about painting he can distinguish himself as has his maternal grandfather [actually in all likelihood his uncle, Francisco Bayeu] and his father, who will take care to guide him toward his goal.[7]

The proposal that the plates could be printed and sold, as previously noted, counters any argument that censorial or Inquisitional pressures had forced Goya's decision; in fact, these plates joined the fifteen others etched by Goya after Velázquez, purchased by the Calcografía in 1792; the plates for the *Desastres de la Guerra*, the *Tauromaquia*, and the *Disparates* were added to the collection decades after Goya's death.[8] In responding to Cayetano, Goya promised also to deliver the 240 unsold sets of the series, "not to defraud His Majesty in any way and for my own satisfaction in my way of proceeding." Changing the subject, he informed Cayetano of the completion of portraits and of a copy by Esteve (all unidentified) and offered to frame and install the works in locations of the minister's choosing.[9]

Why did Goya decide to give the plates and printed sets of *Los Caprichos* to the government? The artist's fear that they not fall into the hands of foreigners after his death may be ungrounded, but appealed to the concerns of the king, who in 1801 had ordered that all auctions of paintings be brought to his attention with the objective of preventing the exportation of artworks.[10] Another factor was Goya's desire to secure the future of his son: a pension of 12,000 *reales*, in addition to the 3,650 *reales* left by the duchess of Alba, guaranteed Javier a base income of almost 16,000 *reales*. (Although Cayetano's letter provides the first of two contemporary references to Javier's artistic calling, this was never mentioned by Goya, and there is no record that Javier ever studied painting.) Most important, the changing atmosphere at court may have persuaded Goya to distance himself from *Los Caprichos*. When in 1802 the countess of Montijo advised Meléndez not to return to Madrid because political triumphs were short-lived and careers unpredictable, she based her words on the experience of friends and acquaintances, perhaps even sensing their prescience given her own exile from court three years later. The revenge taken on many who once saw their ideas expressed in Goya's etchings did not bode well for any revival of interest in them, and the misfortunes of his patrons and friends may have made the naturally circumspect Goya aware that he, too, might one day be forced into the role of protagonist of his own *Capricho*, *To Rise and to Fall* (fig. 16). Best to distance himself from his potentially incriminating commentary.

If the final decade of the eighteenth century was one of reform and experimentation at court, the early years of the next century brought a quest for stability, as Ceballos and Cayetano focused on an economy drifting ever downward. The hopes with which the Spanish monarchy had greeted Napoleon were dying; the first consul and soon-to-be emperor had no interest in shoring up the Spanish treasury. The worsening plight of the lower classes in Madrid was apparent to all, leading one correspondent to the *Diario de*

Madrid to propose adoption of the model of Barcelona by establishing a regular lottery for the benefit of children and widows, the infirm, and other unfortunates in the city.[11] Increasingly fearful of popular unrest, the government heightened its vigilance. During the first six months of 1803, royal orders intended to control the behavior of commoners and crowds appeared almost monthly on the front page of the *Diario*. In the days leading up to Carnival, possible transgressions were enumerated, which included throwing "eggs with water, flour, mud, or any other thing that would disturb people and stain their dresses and clothing"; dumping waste water from the balconies from a jar, in a bladder, or with a syringe; and the mistreatment of dogs. Penalties were fifteen days in the city jail and a fine of 20 *ducats*, and if the perpetrators were employed in a household, their masters would be held accountable. Another order in late March dealt with crowds at the theater, where anyone who made gestures or spoke or shouted anything to offend decency or disturb others would be punished with two months' labor with one shackle on their foot for the first offense and four shackles for the second. Military service was the punishment for a third offense.[12]

In advance of Holy Week, the sale of flowers and food along the route of the processions to the royal palace was prohibited "to avoid the disorder that often occurs," and offensive language and behavior were punishable by fifteen days in jail; coaches were prohibited on streets from Thursday to Saturday. Anyone who appeared in the processions dressed as a penitent, flagellating themselves or bearing a cross, would face ten years in prison and a fine of 500 *ducats* if noble, and two hundred lashes and ten years in prison if a commoner.[13] The eve of the feast of Saint John in June brought the prohibition of tambourines, bells, trumpets, whistles, bagpipes, and other "ridiculous instruments." This royal order also named a specific target: Asturian workers in the city who gathered in a field on its outskirts with poles or large stakes to dance their traditional dance, which often gave rise to brawls and injuries. The resulting prohibition went far beyond Asturians, outlawing the gathering of groups at any time, with or without sticks, in the field of the Corregidor, as well as in other locations on the outskirts of Madrid. Also outlawed was the instigation of fights and brawls, to be charged as disturbing the peace and punished with six years in an African prison. The transgressive behaviors cited in these orders would serve Goya in years to come, as subject matter for drawings and paintings ranging from the *Burial of the Sardine* and the *Procession with Flagellants*, probably painted around 1816–1818, to the image of men dueling with long sticks in the "black" paintings, painted sometime between 1820 and 1823.[14]

After another failed harvest and a spring drought that augured yet

another, refugees from the countryside continued to flee to towns and cities. Economic societies throughout the country organized relief efforts to feed the poor, in part compensating for the demise of the charitable religious foundations (*obras pías*), but the rural destitute, without the charity available in cities, bore the brunt of the famine. Weakened by hunger, they were the most susceptible to a resurgent epidemic of tertian fevers in 1803 and 1804, which rivaled the epidemic of the 1780s. In Segovia, civilian mortality in 1804–1805 reached a level far exceeding that suffered during the Napoleonic invasion four years later,[15] a fact rarely acknowledged, perhaps because Goya was not there to record it.

———

Documenting the plight of the unfortunate would not have occurred to Goya at this point in his career, as he responded to a growing demand for portraits, from those who could afford them. His sitters knew that the results could be uneven: the recently appointed director of the Royal Academy of History, José Vargas Ponce, realized that neither his status as a naval commander nor his writings and standing in three royal academies would guarantee Goya's favor, and on January 8, 1805, he appealed to Ceán: "I have to have my portrait painted. I want Goya to do it. He's been approached and has graciously consented. But I also want and ask you to drop him a little note, telling him who I am and of our mutual connections, so that, once this barrel is filled in the Academy, it won't be with a big face done badly, but as he can do when he really wants to."[16] The many sitters recorded in portraits firmly dated from 1802 to 1805 (a partial list, given those lost or undocumented) attest to a steadily growing business. Goya painted the distinguished military doctor and professor in the Royal College of Medicine José Queraltó in 1802 and, the following year, two full-length portraits of the count and countess of Fernán Núñez.[17] In 1804 he painted the almost life-size image of the marquise of Villafranca, daughter of the countess of Montijo and member of the Royal Academy, seated before an easel painting the portrait of her husband, brother of the late duke of Alba. Also dated to that year is the masterful full-length portrait of the jaunty marquis of San Adrián in riding costume, leaning with a grace that recalls that of the duke of Alba painted almost a decade earlier. The marquis's debonair nature provides a foil to the almost comic representation of his wife, the much-talked-about marquise of Santiago, who compensated with makeup for what nature had not given her, a trait brutally captured by Goya.[18] Possibly at Godoy's request, Goya also painted the military officer Alberto Foraster, as well as an officer in the corps of engineers, Ignacio

Garcini and his wife, Josefa Castilla Portugal de Garcini, in 1804.[19] In 1805 he painted the full-length portrait of Félix de Azara (brother of José Nicolás de Azara, who had died the previous year), a military engineer who during his twenty years in the Rio de Plata became expert in the natural history of the region, an interest commemorated by Goya with shelves laden with bird and mammal specimens and a table with his tomes on the mammals and birds of the region.[20] Other sitters included Vargas Ponce; the mother and daughter of the Baruso Valdés family and Francisco Vicenta Chollet y Caballero;[21] the marquise of Santa Cruz, daughter of the duke and duchess of Osuna, dressed in a white empire gown and crowned with a wreath of leaves as she reclines on a divan holding a lyre;[22] the royal architect and academician Juan de Villa-nueva; and the engineer Tomás Pérez de Estala.[23] Although the portrait of the lawyer Tadeo Bravo de Rivera, recently arrived from Lima, has been damaged and extensively repainted, it nevertheless introduces a patron to reappear in Goya's story in 1808 and 1810.[24]

Actors numbered among Goya's clients. He had twice painted La Tirana during the previous decade, and by 1808 his sitters included Isidoro Máiquez, who dominated the Madrid stage following his 1802 return from Paris, where he had studied with Talma, and a far more beautiful but far lesser presence on the Madrid stage, doña Antonia Zárate y Aguirre (pl. 20). Zárate's frontal pose and direct gaze betray a woman accustomed to performance; her raven hair, black empire dress, and exquisitely rendered black lace mantilla set off the beauty of her face. Who was she? And when was this portrait, which has been dated from 1804 to 1810, painted? A singer and actress, Zárate was wife of the actor and tenor Bernardo Gil and mother of the playwright Antonio Gil y Zárate (1793–1861). In 1790 and 1791, she and Gil were in the company of Pedro Zárate Vallés, licensed to perform in Zaragoza and in Aragón and Rioja, and by 1793 had joined the "Company of the Royal Residences [reales sitios] formed by Don Christobal Andreozzi"; by 1797 both were with the Madrid company of Luis Navarro, performing at the Coliseo de la Cruz, one of the city's two theaters where musical theater and operas were performed. Zárate made her debut singing a tonadilla—a short, lighthearted song—on May 19, 1797, but remained low on the list of women in the company, as one "who will sing when she is so ordered." Her husband's career meanwhile flourished. The return and rise of Máiquez following his studies in Paris may have inspired Gil to leave Madrid in 1804, traveling to Paris and other places where he remained for several years; given that the couple's son, Antonio, attended school in France, Antonia presumably accompanied her husband abroad. By 1811 Antonia was again in Madrid, where she died in

March; her son was a classmate of the young Victor Hugo, whose father Joseph Leopold was a field marshal in the occupying French army, in the *real colegio* (royal school) of San Antonio Abad.[25]

Zárate's biography suggests she sat for Goya prior to the family's departure from Madrid in 1804. Goya clearly took delight in having this dark-eyed beauty enter his studio and take her place on the settee also used for his portrait of Tomás Pérez. Since conversation was not easy with the deaf artist, Antonia sat, simultaneously regal and demure, as an expression of slight melancholy revealed itself. That was all Goya captured during the sitting, maybe sketching in the outlines of her black gown, but certainly not taking the time to detail the fine and costly lace of her mantilla, exceptional among those painted by his hand. All of these he could finish later, alone in his studio.

24

A Monarchy at Twilight

1804–1807

DESPITE several years' absence from the Royal Academy, in September 1804 Goya nominated himself for the three-year term of general director; his opponent was again Gregorio Ferro, whose competition with Goya dated to academic contests of the 1760s. Requested to give an account of his works and merits, Goya presented a list of commissions completed for San Francisco el Grande, the cathedral of Valencia, El Pilar, the church of Saint Anne in Valladolid, and San Antonio de la Florida, and noted that he had painted the king and queen successfully several times. He made no mention of privately commissioned portraits, drawings, or etchings, reminding us that many of the works considered by Goya's contemporaries to be his most important are today rarely discussed. He received eight of thirty-seven votes at the meeting of September 30, with the count of Fernán Núñez and the marquis of Santa Cruz among his supporters, but given Goya's absolute deafness and long absence from the institution, Ferro's triumph surprised no one.[1] Having not exhibited at the academy since 1799, Goya submitted privately commissioned portraits to be shown in 1805, 1806, 1808, and as late as 1819.[2] In 1805 these included the marquise of Villafranca painting her husband and the wife of Antonio Porcel, a secretary of the council and chamber for affairs of New Spain; the following year (in which his assistant Gil Ranz exhibited a copy of "Susana"), Goya exhibited portraits of Antonio Porcel and Manuel Sixto Espinosa, a former director of the National Bank of San Carlos, who after 1798 oversaw the funds derived from the government appropriation of church properties. Absent from the exhibition of 1807, in 1808 he exhibited portraits of the wife of the academician and sculptor José Antonio Folch Costa, the actor Isidoro Máiquez, and Fernando "Mauguiro" and his wife.[3]

On July 8, 1805, Javier Goya married Gumersinda Goicoechea y Galarza, the daughter of the businessman Martín Miguel Goicoechea and Juana Galarza, both from Navarra and of noble descent. A day earlier Goya had agreed before the notary of the royal household to support his son and daughter-in-law, their children, and their servants for as long as they wished to remain in his household. If they desired their own house, he promised an annual stipend of 13,055 *reales* (interest earned on a life annuity, or *fondo vitalicio*, purchased in 1794), as well as the house on the Calle de los Reyes acquired two years earlier.[4] The certificate for the wedding celebrated in the church of San Ginés noted Javier's profession as "painter," although it was around this time that the pension awarded him in exchange for the plates of *Los Caprichos* was suspended, since he was neither traveling nor studying painting. (It was reinstated after his father's intervention on March 28, 1806.[5]) The newlyweds moved out of the Goya household by the following January; Goya's transfer to them of the house on the Calle de los Reyes on July 24, 1806, was perhaps motivated by the birth of his only direct descendant, a grandson baptized on July 11, 1806, and named for his godfather Mariano Goicoechea.[6]

Successful merchants of fabrics and fashionable items, Javier's new in-laws provided their daughter with a significant dowry of 249,186 *reales*, almost five times Goya's annual salary as a court painter. Goya reciprocated by painting miniature portraits on copper of Javier and Gumersinda (pls. 21 and 22), her mother, brother, and three sisters; he may also have painted others that have not come to light. Goya's only known miniature portraits on copper, these again illustrate his scrutiny of fashionable details: bonnets of fabric or straw, ribbons, trims, and empire dresses. Working on metal rounds about three inches in diameter, he applied a red-toned ground similar to that of his oil portraits, then with fluid strokes defined the weave of Gumersinda's straw or Manuela's stiffened gauze bonnet, the shimmer of ribbons, the transparency of the pleated edging of their dresses.[7] When we compare their fashionable clothing with the plain dress of the fifty-eight-year-old Josefa, captured in a small pencil drawing possibly intended as a preliminary for a miniature portrait lost or never painted (fig. 23), we can only imagine what Josefa thought of the frippery of her daughter-in-law and her sisters. She would have nothing of it: three ribbons, functional rather than fashionable, secure her cap and an unadorned shawl covers her from the neck down; relentless with his pencil, Goya captured every line of her face and sag of her jaw with a precision that the painter's brush might have softened. This is the only image we have of Goya's wife, one that seems to reflect a life lived in the shadows of her famous husband by a woman who fulfilled her duties patiently, even now, as she sits, staring ahead, enduring with a quiet grace.

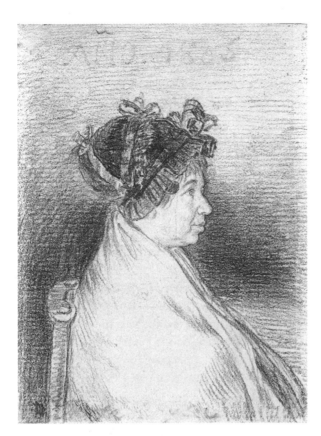

23. *Josefa Bayeu*, 1805. Pencil on paper, 4 ⅝ × 3 ¼ in. (11.8 × 8.1 cm). Abelló Collection, Madrid.

Beyond these miniatures, and full-length portraits of the bride and groom, his son's new family posed for the artist at least five times over the next five years: the *Bookseller's Wife* is a probable portrait of the bride's sister Manuela; the *Woman with a Fan*, in all likelihood a portrait of Gumersinda. He also painted Mariano Goya at about four years of age; and the portraits of Javier's mother and father-in-law, signed and dated 1810. Years later, the presence in Paris of the family patriarch, Martín Miguel de Goicoechea, widowed and accompanied by his daughter Manuela and her husband, helps to explain Goya's journey to that capital in 1824; in September of that year, the trio returned with the artist to Bordeaux. Goya's last known portrait was of Manuela's brother-in-law, Juan Bautista de Muguiro.[8]

Although some scholars have suggested that no drawings date between the publication of *Los Caprichos* in early 1799 and 1808, it is unlikely that an artist as inventive as Goya abandoned drawing for almost a decade.[9] He also continued to paint diverse subjects, such as the "bullfights, shipwrecks, assaults by robbers, fires and a fire by night" listed in an inventory of a private

collection around 1805–1806.[10] Another series, dated circumstantially to 1806, comprises six paintings on panel recording the heroic capture of the bandit Pedro Piñero, alias El Maragato, by Friar Pedro de Zaldivia on June 10, 1806.[11] Arriving at a house in which the bandit had taken prisoners, the humble Franciscan tricked Maragato into lowering his gun, took it, and then shot the bandit in the leg as he attempted to flee. The event was widely celebrated, and in July the *Diario de Madrid* advertised prints of the capture, portraits of the friar, and engravings of the bandit brought to Madrid.[12] An engraving that recorded the bandit's execution by hanging in Madrid on August 18 elicited a lament from an anonymous critic concerning the proliferation of "indecent productions of miserable apprentices who only occupy themselves in giving to the public the death of [the bullfighter] Pepe Hillo, the capture of Maragato, the woman who kills hens and other such insipid subjects."[13] Goya's patrons agreed, for in 1812 his paintings of Maragato remained in his studio.

Yet to be discovered is the meaning of María Luisa's words to Godoy on November 21, 1805: "That resistance from Goya is all the fault of the nuncio that we have here, for the one before agreed to everything instantly."[14] We may never know how the papal ambassador might have encouraged the painter to challenge Godoy, or whether a commission was involved. Months later, another reference by the queen, "that concerning Goya is approved, there being no inconvenience with it,"[15] suggests that Godoy sought the monarchs' permission before commissioning a work from the first court painter. Around this time, Goya painted a portrait known only from Godoy's memoirs, with an inscription of the defiant words he had spoken to the French ambassador: "For love of what is good I love peace, but I will not approve a law that offends my king."[16] The following year Goya created two works for an institute established by Godoy based on the educational principles of the Swiss reformer Heinrich Pestalozzi: a portrait, of which only a fragment survives, showing Godoy standing before the institute and an audience of students, and an emblem for the school, both were unveiled at the opening ceremony on January 1, 1807.[17]

Given Spain's state of crisis, ever more widespread poverty, and growing distrust of foreign influences and innovations, Godoy's decision to introduce to Madrid a progressive educational institution betrays either his oblivion or defiance of opposition to his reforms. Even more offensive to many, however, was the monarchy's continued alliance with Napoleon. To be sure, there were few other options.[18] When the failure of the Treaty of Amiens in spring 1803 reignited hostilities between France and England, Godoy sought alternatives to collaboration with France, which included neutrality, or diplomatic relations with Berlin and Saint Petersburg. His overtures enraged

Napoleon, who in September threatened Spain with war and demanded that Carlos IV dismiss Godoy. Godoy remained and Spain purchased its neutrality at a cost of 6,000,000 pounds per month (financed by a loan on the Paris market) and with the condition that her ports remain open to French ships. Beyond directing Spain's diplomacy, Napoleon, who became emperor in 1804, summoned the Spanish admiral Gravina to Paris as Spain's ambassador, and assumed full control of the Spanish navy. Gravina returned to Spain with Napoleon's approval in February 1805 and fought at Trafalgar the following October, where he received a wound that would prove fatal.[19]

Cracks became ever more visible in the unified front portrayed in *The Family of Carlos IV*. Instigated by Fernando's tutor and a small circle of aristocrats, an anti-Godoy faction formed around the prince and, after 1802, around his new bride, Princess of Asturias María Antonia of Naples. Napoleon's conquest of Naples in February and March 1806 forced Fernando VI, the princess's father, to flee to Sicily, and galvanized pro-Neapolitan, pro-British, and anti-Godoy feelings in Madrid. Rumors were rife, and when the princess of Asturias died suddenly in May 1806, poison was suspected; when Carlos IV fell seriously ill in October, word spread that Godoy would inherit the throne. Godoy's enemies took action, disseminating satires of him in late 1806 and plotting to reveal his treachery to the king.[20] Carlos IV, however, named Godoy Admiral General of Spain and the Indies and Protector of Maritime Commerce in January 1807; four months later he bestowed upon him the title of Count of Castillofiel. Later that month the city of Madrid purchased, as a gift for Godoy, the Buenavista palace, which had remained vacant since the death of the duchess of Alba.[21]

At the urging of the French minister of foreign affairs, Fernando wrote to Napoleon on October 11, 1807, to request the emperor's protection and an alliance by marriage with his family. Still the honorable son, he cast no aspersions upon his father, stating only that his good nature allowed untrustworthy persons to take advantage of him.[22] On October 27, in an episode to become known as the Escorial affair, the plot was discovered, its main supporters imprisoned, and Fernando arrested for treason. His sister's plight was not much better: we remember her holding her infant son on the far right of Goya's portrait, next to her husband, soon to be proclaimed king of Etruria. He died in 1803, leaving his wife to rule until August 1807, when Napoleon's forces occupied the territory. Two days after Fernando's detention, the emperor ratified the treaty of Fontainebleau, committing Spain to the invasion of Portugal.[23] Secret clauses stipulated a tripartite division: northern Portugal would compensate the former queen of Etruria; central Portugal would be under Franco-Spanish military occupation; and Manuel Godoy, newly

named Prince of the Algarve, would control the southern part of the country. The treaty guaranteed Carlos IV's domains and his title as Emperor of the Two Americas. Napoleonic forces under the command of General Junot crossed the Bidasoa River into Spain on October 18 and met with no resistance upon arriving in Lisbon on November 29. As their subjects booed from the docks, the Portuguese royal family boarded English warships: the queen, Carlota Joaquina, a third royal sibling absent from Goya's portrait, was en route to Rio de Janeiro.[24]

Writing to the emperor on December 20, his emissary Philippe de Tournon reported that the Escorial affair had galvanized support for the crown prince, hatred for Godoy, and the opinion that the emperor alone could save the nation, by "deigning to take the Prince of Asturias under his protection, find him a wife, and deliver Spain from the tyranny that oppresses her."[25] In January 1808 Napoleon met his estranged brother Lucien in Mantua and temporarily persuaded him to send his daughter Charlotte to Paris as a bride for Fernando.[26]

War and Restoration

The Old Order Falls

1808

NAPOLEON'S divisions entered the northern regions of Navarra and Catalunya in early February, occupied Pamplona and Barcelona, and seized control of their citadels even as Fernando and his parents vied unsuccessfully for the emperor's favor.[1] On February 24 Napoleon accused the Spanish government of bad faith, which, he claimed, excused him from the terms of the treaty of Fontainebleau: Spain was still entitled to all of Portugal, but only in exchange for an unlimited alliance with France and surrender of all territories from the Pyrenees to the Ebro River, flowing from the north-central province of Cantabria to the Mediterranean at Tarragona. About midway on its course, it flows by the monumental church of El Pilar in Zaragoza, a town to become an early casualty of Napoleon's ambitions in Spain.

Having established his headquarters about 350 kilometers north of Madrid in the Basque city of Vitoria, Napoleon's brother-in-law and commander of the French troops in Spain, Joachim Murat, ordered troops to march on the capital, with a plan to dispatch Carlos IV, María Luisa, Godoy, and Fernando to meet with Napoleon once it was occupied. Aware of the growing apprehension of the Madrid populace at the approach of Napoleon's forces, on March 16 Carlos IV issued from Aranjuez a proclamation intended to allay their fears: "The army of my dear Ally the Emperor of the French crosses my kingdom with peaceful and friendly intentions." In response to the rumors of Godoy's plan to move the king and queen to Seville as a possible point of embarkation for America, the king asserted that he had no such intentions, for, "surrounded by the pure loyalty of my beloved subjects, of which I have so much indisputable proof, what can I fear?"[2] He soon had his answer. On March 19 the *Diario* carried a report by Ceballos of a skirmish during the early morning hours of March 18 between the royal guard (long resentful of Godoy's ascent) and the Hussar members of Godoy's bodyguard. Fighting

between soldiers and civilians "made uneasy by the false rumors that the monarchs and the royal family were leaving" followed, but peace was restored. By the time the article appeared, Godoy's residence at Aranjuez had been ransacked and Godoy, discovered hiding in the attic of his palace, had been beaten and imprisoned. To save the royal favorite, Carlos IV abdicated in favor of his son.

As word of Godoy's downfall spread, mobs in cities throughout Spain took revenge on effigies of the hated royal favorite: such was the probable fate of lost portraits by Goya.[3] When crowds in Madrid demanded a portrait from the church of Saint John of God, it was surrendered without hesitation on the morning of March 19. Later that day, the mob paraded on the main Calle de Alcalá shouting, "Death to Godoy, as a traitor and thief, and bring him to Madrid so that his head can be brought and put on a stick." Beating drums and flying colors the following day, they broke into the Royal Academy, smashing the bust by Juan Adán of the institution's former protector. The confiscation by Fernando VII of Godoy's property saved his primary residence from damage by the commoners, respectful of the new royal ownership. Godoy's relatives, however, were not as fortunate: the houses of his brother, mother, and brother-in-law, as well as those of his supporters, were ransacked, their furnishings burned.[4] Although inventories of two of Godoy's Madrid residences were completed, that of his main residence was delayed by the arrival on March 23 of a new occupant, Joachim Murat; among the paintings missing by the time an inventory was taken in August were Correggio's *Venus and Cupid* (also known as *The School of Love*) taken by Murat when he departed on June 17.[5] Godoy remained imprisoned until Murat ordered him freed on April 21; four days later he was in Bayonne. His wife, María Teresa, remained in Spain, while Pepita Tudó and her two children followed him into exile in France and Italy. Godoy never returned to Spain, died in Paris in 1851, and was buried in the cemetery of Père Lachaise.[6]

Even the new king Fernando VII was wary of the populace, and in an address to the "Public of Madrid," published on March 21 as a supplement to the *Diario de Madrid*, reminded readers of the need for "public tranquility in the joyous time of the exaltation of KING FERNANDO SEPTIMO to the throne of Spain." All were to "return to their houses and maintain the most perfect tranquility" and thus "give to His Majesty in the first moments of his happy reign proof of the sincerity of their feelings." The following day Fernando's royal order recognized the "friendship and close alliance" shared by Spain and France and called for the restoration of public order, which included welcoming the French troops as they entered the capital and providing them all necessary assistance. The king entered Madrid two days later.[7]

What of Goya during these tumultuous days? The sexagenarian in all likelihood remained in his home on the Calle Valverde, disquieted by the knowledge that works documenting his service to Godoy and portraits attesting his association with such reviled figures as Antonio Noriega (who met his end later that year at the hands of a crowd in Badajoz) might incriminate him. He had other reasons to fear, for although Napoleon's soldiers and French-born inhabitants of Spain were the primary targets of popular outrage, Spaniards of property, power, and authority were also at risk. "Tarred by the brush of treason, the Bourbon authorities were easy targets for *fernandino* agitators, mutinous soldiers, or simply angry crowds out to exact revenge on the *antiguo regimen*."[8] Like many of his contemporaries, Goya probably viewed the recent unrest within a tradition of social protest familiar to the ancien régime and reminiscent of the 1766 Esquilache riots; his wealth became a liability. The long-repressed voices of commoners, who felt newly empowered following the downfall of Godoy, were now heard; an anonymous writer to the provisional Spanish government established later that year lamented, "Very soon, the poor will be sovereign, and eliminate rich and French alike."[9]

An inventory of Goya's household taken four years later suggests his property was intact, for even after years of war and nationwide suffering, he lived comfortably. His house was well appointed and sufficiently capacious to accommodate "eight stools covered in yellow damask, a sofa (or chaise), eighteen ladder back chairs, twenty-eight painted chairs, twelve mattresses, three bedsteads, two ordinary tables, another table of fine wood, a large armoire, a large mirror. . . ." Bed and table linens totaled almost 4,000 *reales* in value, and diamond jewelry was valued at over 31,000 *reales*. Following the return of Fernando VII in 1814, Goya stated that during the war he resisted commissions from the intruder regime, preferring to "malvender sus alaxas" (sell his most prized possessions at a discount).[10] If this is true, the 31,000 *reales* worth of diamonds inventoried in 1812 represented only a fraction of what he once owned.

With Fernando VII enthroned in Madrid, members of the Royal Academy agreed in a closed session on March 28 to commission Goya to paint a new royal portrait for the assembly chamber. The secretary informed Goya the following day and requested that the portrait be in place by July. The artist responded with his own demands: "It is not possible for me to paint an accurate portrait if His Majesty does not allow me to do it from life, which the Academy itself could request from His Majesty, as it did in the same circumstance with his august Father, so that Don Francisco Bayeu could carry out a similar commission."[11] On April 5 Ceballos, now Fernando's secretary

of state, responded that the king would be available for a sitting on the following day, Wednesday, at two thirty in the afternoon. Upon delivering the portrait to the academy the following October, Goya noted that the king had granted him only forty-five minutes in two separate sessions before leaving for Burgos on April 10.[12] From Burgos, Fernando continued to Bayonne, to return to Madrid six years later.

Godoy arrived in Bayonne on April 25 and was reunited with Carlos IV and María Luisa, who had not seen him since the uprising at Aranjuez; Fernando was also present. Installed at the Château de Marracq, Napoleon welcomed his guests, whose situation inspired his plan: "The old king and queen ... had become the object of the hatred and scorn of their subjects. The prince of Asturias was conspiring against them ... and had become the hope of the nation. At the same time [Spain] was ready for great changes ... whilst I myself was very popular there. With matters in this state ... I resolved to make use of this unique opportunity to rid myself of a brand of the Bourbons, continue the family system of Louis XIV in my own dynasty, and chain Spain to the destinies of France."[13] Napoleon convinced Fernando to abdicate in favor of his father, who in turn abdicated in favor of the emperor. On June 6 Napoleon decreed his brother Joseph, king of Naples since 1806, as the new king of Spain. With the support of members of the Council of Castile who had accompanied Fernando to Bayonne, Napoleon convened an assembly, including sixty-five Spanish delegates, to write a new constitution for Spain, referred to as the Constitution of Bayonne. Joseph Bonaparte signed it on July 6 and three days later crossed the Pyrenees en route to Madrid.[14]

Following Fernando's departure from Madrid, skirmishes between French troops and the populace continued; during the second half of April, forty-two wounded Frenchmen arrived in the city's hospitals; some died. On alert, Madrid's city council noted on the first of May an unusual number of people congregating in Madrid's central square, the Puerta del Sol, and recommended that the many new arrivals entering Madrid be questioned as to their motivations.[15] On the morning of May 2, crowds long distrustful of French interference and increasingly wary following the departure of Fernando VII reacted at the sight of carriages outside the royal palace, prepared to evacuate the remaining members of the royal family: the former queen of Etruria, Francisco de Paula—the boy in red in The Family of Carlos IV and now the sole heir to the throne who remained in Spain—and his uncle, Antonio Pascual. The crowd fought to prevent their departure, and as news spread, so did the rebellion. French troops, camped on the outskirts of Madrid, entered the city to quell the insurgency, doing so in collaboration with the Spanish police. Among the fatalities was the son of Goya's niece Feliciana Bayeu; León Ortega y Villa,

identified as Goya's student, was wounded. The niece, maid, and son of the painter Antonio Carnicero approached the window of their house to watch the French patrol pass; the niece was shot and killed, the maid wounded, and the frock coat of Carnicero's son was scorched.[16]

More than six years passed before Goya painted two large canvases based on these events, *The Second of May 1808* and *The Third of May 1808* (pls. 23 and 24). Proof of the legendary stature these events had attained by 1814 as the origin of Spain's patriotic resistance to Napoleon, Goya's paintings are propaganda intended for a Spanish, Catholic viewer rather than historical document;[17] to witnesses of the uprising on May 2, 1808, its meaning was far less clear. In *The Second of May 1808* Goya reimagined the uprising against a generalized background that resists identification with any specific site in Madrid. Surging crowds press toward the mêlée, as men on foot, identified by their clothes as commoners, attack mounted adversaries, one in a military uniform, and three others in Moorish dress that identifies them as the Mamluk mercenaries who fought for Napoleon. The focus on Moorish adversaries reinforced Goya's theme of a heinous affront to the nation, by inverting an image familiar to all Spaniards: the miraculous appearance of Saint James, or Santiago, upon his steed, trouncing Moors at the mythic battle of Clavijo in 844 during the Spanish Reconquest. Returned to Spain centuries later, the Mamluks were fitting personifications of the evil threat presented by Napoleon to the rightful Catholic order of the nation. *The Third of May 1808* envisions the executions of those involved in the uprising, although again its setting eludes identification with any of the locations where the killings took place: the Prado, the Buen Retiro, or the hill of Príncipe Pío, not far from San Antonio de la Florida. Goya crystalized atrocity in an iconic image of good versus evil, juxtaposing the fear and disorder of the prisoners, illuminated by a lantern and trapped by the hillside behind, with the merciless precision of guns raised by anonymous figures in greatcoats and shakos. Religious references again play a role, as the modern-day martyr in a white shirt raises his arms in futile surrender, to reveal the stigmata that mark his hands.

The front page of the *Diario de Madrid* on May 4, 1808, proclaimed Murat's *Order of the Day* in both Spanish and French. It opened with a conciliatory appeal to the many "good Spaniards," appalled by the recent disorder. However, given that French had been killed, all armed participants in the uprising would be executed and all inhabitants in Madrid were to surrender all weapons, ranging from guns to barbers' razors; those found armed without special permission would be executed; any group of more than eight individuals would be considered seditious and dispersed by gunfire; and any place where a French citizen was killed would be burned. Employers were responsible for

their employees, and parents for their children. Finally, any authors, sellers, or distributors of oppositional literature would be treated as British agents and executed.[18] "Good Spaniards" who supported the French government had nothing to fear. Like many of his peers, Goya acquiesced. For although the insurgents would eventually be seen as martyrs for a patriotic cause, in May 1808 that unifying national cause was yet to be defined. With other members of the privileged classes, Goya probably viewed the events of May 2 as another manifestation of the xenophobia long inherent among the *populacho*, the rabble. A new order began. On May 19 the *Diario* carried news of the recent departures from Bayonne of Carlos IV, María Luisa, Godoy, and Fernando: the monarchs and Godoy were destined for Fontainebleau, and Fernando, accompanied by his uncle and younger brother, for Valençay, where they would lodge at the estate of Talleyrand (who was not pleased to receive an order on May 8 to expect the arrival of about fifty people, including masters and servants). The same *Diario* presented justifications from both Carlos IV and Fernando of their decisions, and declarations of their support for Spain's new regime.[19] Within two months Spain had lost not one but two kings, and for the first time in twenty-two years, Goya found himself without a royal patron.

As news of the Madrid uprising and its consequences spread throughout Spain, a visceral hatred of the French inspired Spaniards to enlist in the army, organize militias, or ally themselves with small troops of *guerrillas*. Napoleon's response was to order the armies encamped around Madrid, Burgos, and Barcelona to move to secure Seville and Cádiz in the south, Valencia in the east, and Zaragoza and Santander. In Zaragoza, inhabitants defended their city against the French advance on June 15, after which they continued to improve defenses within the city walls as French troops awaited reinforcements. When the French returned on July 2, they met with unexpected resistance, strengthened by the arrival from Catalunya of infantry under the command of José de Palafox. In late July the French bombarded the city and entered in early August, only to be held at El Coso, the formerly elegant avenue where Goya's family and Zapater had once lived. Zaragoza might have fallen had other factors not intervened.

Only the French greeted Joseph Bonaparte upon his arrival in Madrid on July 20, as Spaniards remained inside behind closed doors and windows; ordered to hang draperies, they instead displayed dirty rags.[20] Following his royal farewell from Bayonne, Joseph's arrival in Madrid, as reported to his brother, was unexpectedly deflating:

> All classes of the populace are leaving the city; it is just as it was in '89. Even the servants of the Duke del Parque have left him, writing

to him that they have gone to join the Spanish army.... We must have fifty thousand more men and fifty million francs within three months. Respectable people here have no more use for me than the rabble has. You are making a mistake, Sire; your glory will not avail you in Spain. I shall fail and the limits of your power will be exposed.[21]

The situation was more dire than Joseph realized, for when he wrote these words he had not yet received news of the victory of General Castaños over Dupont at the Andalusian town of Bailén the previous day. He was soon forced to retreat from the capital, as the besieging French forces retreated from Zaragoza.

Through late August and September, Spain celebrated victory: Zaragoza was liberated, the *rey intruso* (intruder king) expelled, and Fernando (though still in France) restored—all thanks to the grace of God.[22] Madrid began preparations for the proclamation of Fernando VII to take place on August 24, five months after his first entry as king. Tadeo Bravo de Rivera, a deputy from Lima whose portrait Goya had painted in 1806, turned again to the artist to design the central composition of five to decorate the façade of his house in front of the church of Saint Martin.[23] Known only through a contemporary description, Goya's design portrayed a female allegory of Fidelity holding a portrait of Fernando VII; behind her, "male and female Peruvian Indians" represented the loyalty of the New World to the king. Two years later Bravo, by then a municipal official in Madrid under Joseph Bonaparte, commissioned Goya to create a portrait of the French king, to which Goya responded with a similar composition of a portrait held by allegorical figures.[24]

With Fernando VII restored in absentia, Goya returned to painting the royal portrait, and on September 10 proposed to the academy that it be an equestrian portrait, "so that the Academy would have a good painting, not just a painting of circumstance." Five days later the academicians accepted his proposal, assuring that necessary adjustments would be made if the painting did not fit in the space for which it was commissioned.[25] Eager to reestablish routine, the academicians announced an upcoming exhibition of works by students and professors to be open to the public from September 30 to October 8, to which Goya submitted three portraits. Within three weeks of the academicians' acceptance of his proposal for an equestrian portrait, he wrote on October 2 to the secretary of the academy, José Luis Munárriz, that it was finished and had only to dry. His fellow academician, José Folch, would deliver the work, for José de Palafox had summoned Goya to Zaragoza to "examine the ruins of that city, with the goal of painting the glory of them

from life, something from which I cannot excuse myself, because the glory of my Patria matters so much to me." He left that same week, after donating twenty-one *varas* of linen for the benefit of the Aragonese patriots.[26] By the time Folch delivered Goya's portrait on November 6, however, early euphoria in Madrid was waning and unease growing, as the return of Napoleon's forces appeared increasingly inevitable. Almost four years, and the devastation of Spain, intervened before the portrait of Fernando VII was exhibited at the academy.

Goya probably arrived in Zaragoza in time for the October 12 celebration of the Virgin of El Pilar, which assumed special meaning as a celebration of the town's expulsion of the French, credited to Her protection. Ceremonies began shortly after dawn, and a mid-morning Mass was celebrated in El Pilar, candlelit for the occasion. At four in the afternoon, the procession began along illuminated streets, augmented by a cannonade, the music of the royal grenadiers, and one hundred horsemen. More music and three hundred torchbearers accompanied the rosary that evening, with Ave Marias in the Santa Capilla in El Pilar continuing into the night.[27] As festivities gave way to daily life, Goya was undoubtedly shocked by the transformation of his hometown, described by another visitor:

> Marks of destruction everywhere met the eye. In some parts whole streets had been levelled with the ground, and still lay in one indiscriminate heap of ruin. It was difficult indeed to find anywhere a house that had not been struck by a cannon shot. But in the principal street, the Cozo [sic], those houses which had escaped entire destruction were completely covered with shot-marks, both of musketry and cannon.... The last remaining tower of the magnificent Church and Convent of Sta. Engracia fell when I was at Saragossa, and standing not far from the spot....[28]

In preparation for a second attack, residents built barricades defended by artillery on all streets leading to El Coso, sealed windows and doors, loopholed walls and façades, and brought into the city provisions from surrounding villages.[29] By mid-November the presence in Spain not only of French troops but of Napoleon himself confirmed expectations. Defensive positions outside the walls of Zaragoza included six thousand men at Monte Terrero, where eight years earlier Jovellanos had admired Goya's three altarpieces. Marshal Moncey launched his attack on December 21.[30]

No evidence survives of any works created during Goya's brief and disheartening stay. Lady Holland reported secondhand that French officers had

slashed drawings of Zaragoza by Goya in Palafox's residence; another report published twenty-three years later stated that Goya painted two sketches of the principal ruins but overpainted them to avoid incrimination and was later unable to remove the overpaint. Neither of these accounts can be verified, and it is improbable that Goya, who knew his materials well enough to critique the work of royal conservators, would overpaint his works in an irreversible manner.[31] Goya presumably left Zaragoza before Marshal Moncey's forces appeared outside the city in late November, and traveled away from the advancing enemy, southwestward from Zaragoza. He reportedly took refuge in his natal village of Fuendetodos, where his brother Tomás still lived, his household including the infant child of his niece—a small ray of light in difficult times.[32] In all likelihood, the sixty-two-year-old deaf artist did not travel to Zaragoza unaccompanied, lending credence to the nineteenth-century account that Luis Gil Ranz, mentioned in 1803 as Goya's assistant, traveled with him.[33] The account is embellished, for it states that Gil accompanied Goya at the order of the king, Fernando VII, who was in France. It also includes the picturesque detail that both Goya and Gil were taken for spies because of the assistant's use of sign language, which forced them to flee and take refuge in Gil's birthplace of Renales (Guadalajara).[34]

Napoleon, determined not to repeat mistakes of the previous summer, crossed the Bidasoa River into Spain on November 4 and arrived at Vitoria the next day, with his best commanders and 250,000 troops. As Moncey's troops appeared on the plains outside Zaragoza on November 30, Napoleon's forces overpowered the 12,000 Spanish troops at the mountain pass of Somosierra and opened the road to Madrid. Two days later they were on the heights north of the city. Napoleon arrived in the village of Chamartín and installed himself in the residence of the duke of Infantado, who had fled that same day to establish contact with the Spanish army; Joseph Bonaparte took up residence at El Pardo. After bombarding the city, French forces entered the Buen Retiro, and on December 4 the city capitulated. The French targeted revenge on specific points of strong resistance, near the present-day locations of the national library and the Palace Hotel.[35]

The *Diario* again announced a new order to the "Inhabitants of Madrid," urging them on December 6 to return to their peaceful ways and surrender their arms. The terms of capitulation proposed by the Spanish forces and concessions made by the French were published next day; there followed orders for residents to repave and clean the areas corresponding to their houses (December 8) and leave the city only with official permission (December 12). On December 23 a list of enemies of the crowns of both France and Spain was published, with names familiar to Goya: the duke and duchess of Osuna,

the marquis of Santa Cruz, the count and countess of Fernán Núñez, and Pedro de Ceballos, who after briefly serving Joseph Bonaparte fled to join the Spanish government in exile. Napoleon had previously made concessions to the Spanish government in drafting the Bayonne constitution, but his mood was no longer conciliatory. With the decrees of Chamartín, he reduced the number of convents and monasteries and dissolved the ministries that had served the old regime. December 24 brought news of the suppression of the Inquisition.[36]

The previous day all male heads of households were notified of their obligation to swear allegiance and obedience to the king, Joseph, to the constitution, and to the new laws. They were to go to their parish church to take the oath following Mass, which would begin punctually at ten in the morning; bells would begin tolling a half hour earlier and would continue to toll as in all major celebrations.[37] Goya, still residing on the Calle de Valverde, and his son Javier, whose residence is listed as 9, Calle de la Zarza, were among more than twenty thousand heads of households who on December 23 attended their parish churches to swear allegiance. Moratín (living near Goya at 6, Calle de Fuencarral), Maella, and Meléndez Valdés also took the oath and would soon find positions within the government of Joseph Bonaparte.[38]

In the Shadow of a New Regime

1809–1810

G OYA did not linger in Madrid after taking the oath to support Joseph Bonaparte. His absence from a special general session of the Royal Academy on February 27, 1809, has long been known,[1] but a list of twenty-one court painters and four honorary painters (who held the title without remuneration) in the Madrid palace archive offers further evidence. At the end of the list—presumably a roll taking of artists available to work for the new king—a notation dated February 13, 1809, reads: "It must be known whether these subjects are alive and are in Madrid." To the left of each name their status is noted: *En Madrid* (in Madrid), *Ausente* (Absent), or *Falleció* (Deceased): "Dⁿ Francᵒ Goya" is one of six painters noted as *Ausente*.[2] Where was he? Testimony of Goya's wartime activities given in 1814 stated that his only absence from Madrid during the war was an undated journey to Piedrahita (a town in Ávila to the west of Arenas de San Pedro, where Goya had once painted for the *infante* don Luis), made to avoid service to the French king. According to the witness, Goya traveled "in the hope of going from there to a free country, and he did not do so because of the pleas of his children and because of the notification given by order of the Minister of Police, of the embargo and sequestration of the property of the entire family, if within the fixed time he did not return to this city."[3] Although many have speculated that Goya's journey took place sometime during or after 1811,[4] the documentation of Goya's absence from Madrid in 1809, as well as the political situation during the early months of Joseph's regime, justify an earlier date for his attempted flight.

Joseph returned to Madrid on January 22, his kingdom under threat. English forces under John Moore entered Spain from the northwest, and Spanish forces under the marquis de la Romana confronted the French armies on their southward advance. If Goya traveled west from Madrid to Piedrahita

shortly after Joseph's return in early 1809, it was with the hope, stated in the 1814 testimony, of reaching territory under Spanish or English control. He did not reach his goal. As the French advanced, an appointed commissioner was ordered to see that all inhabitants of occupied territories returned to their homes and resumed their work; by May a decree was published ordering all clergy and public employees who had left their homes after November 1, 1808, to return to them within twenty days. Those that did not comply would lose their employment and their property, the threat mentioned in the 1814 testimony as the motive for Goya's return.[5] Wherever he was in February 1809, Goya surely learned of the fall of Zaragoza on February 18, and the tragic end of the second siege. His last surviving brother-in-law, Manuel Bayeu, who had been forced to leave his monastery in Huesca when it was abandoned the previous year, probably died in Zaragoza, a possible victim of wounds or of the devastating epidemic that accompanied the second siege.[6]

Goya penned a curiously ill-timed letter following his return to Madrid, writing to the secretary of the academy on May 5 in reference to the "notice from Your Sire dated November 8, by which I was informed of the determination of the Academy concerning me, for the painting that I had executed by your order."[7] His inquiry about the delay of payment for his equestrian portrait of Fernando VII received a prompt reply: the treasury had suspended all payments to the academy, professors had not received payment since the previous August, and the academy had to sell some of its property to meet the salaries of the workers dependent upon this income.[8]

The new regime's interest in Goya went beyond his possible service as an artist. One of Joseph's concerns was to fulfill the promise made in the constitution of Bayonne to rein in Spain's national debt, which approached 6,500,000,000 *reales* by 1808.[9] On February 17 Mariano Luis de Urquijo (the onetime secretary of state to Carlos IV, who now held the same role under Joseph Bonaparte) signed an order imposing a new contribution on the inhabitants of Madrid, officially referred to as an *empréstito*, or loan, assessed on the basis of their profession and personal wealth. The lists of assessments appeared in the *Diario de Madrid* from late February to mid-March 1809, and on March 2 Goya was included among the court painters and, like Maella, was assessed the highest amount of 3,200 *reales*. (Sculptors, including Juan Adán, paid 3,800 *reales*; architects, including Juan de Villanueva, owed 7,200 *reales*.) Five days later Goya's name appeared again under the category of "Pudientes y Hacendadas" (the rich or powerful and propertied) with a second assessment of 8,000 *reales*.[10]

The victory in July of Arthur Wellesley, the future Duke of Wellington, at Talavera and the advance of the Spanish army of the left forced Joseph

Bonaparte to leave Madrid to counter the English advance. The tide turned as Wellesley, whose first priority was the defense of Portugal, was recalled to serve as foreign secretary and returned to England in November. With the arrival of one hundred thirty-eight thousand French reinforcements, among them a corps of the *grande armée*, a division of German infantry, and a force of mounted police trained specifically to fight Spanish guerrillas, the plight of Spain's warworn forces became increasingly dire.[11]

Shortly after he returned to Madrid, Joseph's thoughts turned to matters of art. With the suppression of religious orders on August 20, thousands of works of art became the property of the government, which collected them in repositories including the monasteries of San Francisco el Grande and El Rosario in Madrid. On December 20, 1809, the king decreed the establishment of a museum in Madrid to preserve Spain's patrimony and enhance the standing of its national school:

> Wishing, in order to benefit the fine arts, to place the many paintings, which sequestered from the view of connoisseurs were until now found enclosed in cloisters; so that these examples of the most perfect Old Masters serve as primary models and guide our understanding; that the merit of the celebrated Spanish painters, little known by neighboring nations, shine; obtaining for them at the same time the immortal glory the names of Velázquez, Ribera, Murillo, Rivalta [*sic*], Navarrete, Juan San Vicente and others deserve; ...
>
> A museum of painting will be established in Madrid that will encompass collections of the diverse schools, and to this end will be taken from all public establishments, and even from our palaces, the paintings that are necessary to accomplish the collections we have decreed.

The second article announced "a general collection of celebrated painters of the Spanish school," to serve as a "monument to the glory of Spanish artists" that would be offered to the emperor for exhibition at the Musée Napoléon in Paris.[12] Left unpublished was Joseph's decision to select one hundred paintings to be given as "national compensation" to individuals yet to be named; beneficiaries included Marshall Soult and the general Horace-François-Bastien Sebastiani, who had fought with Joseph the previous summer. This was the second documented gift of paintings to Sebastiani, who had received works from the palace of Buenavista the previous September; these were appraised by Goya on October 20 at a total value of 116,000 *reales*,[13] the first documentation of the artist's yearlong involvement with the court of the intruder king.

Even after Joseph left Madrid in January 1810 to lead his armies in Andalucía, his plans for Spain's artistic treasures continued to evolve. He commissioned his artistic adviser Frédéric Quilliet to compile a list of paintings destined for Paris, which in early March made its way through the necessary channels to Napoleon. Accused in July of the illicit exportation of works of art, Quilliet was removed from his position but continued to play a role in the selection of paintings for the Musée Napoléon behind the scenes; in September the conservator Manuel Napoli was tasked with assembling the paintings, only to find that several were missing. Both Napoli and Goya were ordered to develop a list of works for the national museum in late August, whose location, announced on August 22, would be the Buenavista palace.

When in September Joseph finally reviewed the list of paintings to be sent to Paris, he took umbrage at the number of works from the royal collection, and particularly from his private cabinets. He ordered a change of course, and the development of a new list, with Quilliet no longer involved. Two days later Miot de Melito, superintendent of the royal household, recommended to Joseph's minister, Manuel Romero, that Goya be appointed with Napoli; Romero responded on September 25 by adding Maella to the group. On September 26 Goya, Napoli, and Maella received orders to complete the list with the utmost diligence; they submitted it on October 25, and plans were made for the works to be inspected. Upon receiving an order to appear at San Francisco el Grande at noon on November 10, 1810, in order to review the paintings, Goya requested clarification, for he had orders to be at the palace at the same time. When asked in confidence by Miot de Melito to review the selection made by Goya, Maella, and Napoli, the disgraced Quilliet remarked of its authors: "one in his seventies, having no taste, the other deaf, neither of them having any idea of what is requested of them." Two years passed before the paintings left Madrid, but no further documentation of Goya's involvement has come to light.[14]

Although Goya worked for the Bonaparte regime, he never held any official or salaried position at Joseph's court, unlike Maella, who was recommended on April 7, 1809, by the count of Montehermoso to Miot de Melito and appointed first court painter on April 11, with a salary of 2,000 *reales* per month.[15] Goya was nevertheless active under the new regime. Joseph's reorganization of the municipal government led to the appointment of a new council with Tadeo Bravo de Rivero, whose residence had only a year earlier boasted an allegorical design by Goya celebrating Fernando VII, among its members. Bravo, "knowledgeable about the noble art of painting," was charged on December 23, 1809, with commissioning an artist of his choice to paint a half-length portrait of the king for the chapter room of the city hall,

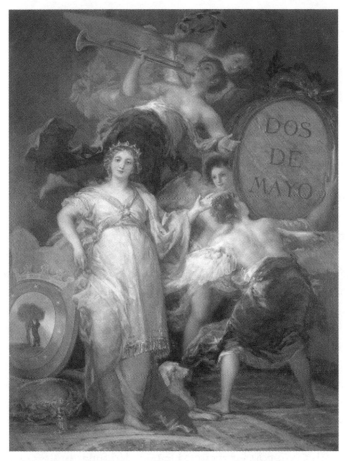

24. *The Allegory of Madrid*, 1810. Oil on canvas, 102 ⅜ × 76 ¾ in. (260 × 195 cm). Museo de Historia de Madrid.

one of several portraits commissioned during the early months of 1810 as the iconography for the new regime took form.[16] Goya accepted the commission, for which he would be paid 15,000 *reales,* and by February 27, 1810, had delivered a response that far exceeded the request for a half-length portrait.[17]

In painting the work today titled *The Allegory of Madrid* (fig. 24), Goya probably recalled the design he had created for the façade of Bravo's house in August 1808, in which the portrait of Fernando VII was presented amid allegorical figures; because Joseph was in Andalucía, Goya based his portrait on an engraving.[18] As interesting as the work itself are the alterations made to it over the next three decades, documenting the political changes of Spain. Following Joseph's departure from Madrid in August 1812, the portrait was overpainted with the word "Constitution," a reference to the constitution

promulgated by the Spanish government in exile in Cádiz in March 1812; when Joseph returned to Madrid, Goya was ordered on December 30, 1812, to return the work to its original state, and assigned the task to Felipe Abas, to whom he paid 80 *reales* to remove the overpainting. Following Joseph's final departure from Madrid in March 1813, Dionisio Gómez earned 60 *reales* in June to again paint the word "Constitution" over the portrait; this was removed when Fernando VII returned to power in 1814 and his portrait added (possibly by Goya). From 1823 to 1826, the *Allegory* remained in the studio of Fernando's preferred artist, Vicente López, who repainted the royal portrait; in 1841 the words seen today, "Dos de Mayo," were painted in, a reference to the by then legendary uprising of May 1808.[19]

Joseph and his court departed from Madrid on January 8, 1810, traveling through Bailén (site of the famous Spanish victory in summer 1808) and Córdoba to arrive by January 30 in Carmona, a short distance from Seville.[20] Negotiations between his ministers and officials in Seville, combined with the threat of approaching troops, led to a peaceful surrender of the city on February 1; the Spanish government in exile and Spanish nobles, among them the widowed duchess of Osuna, had left Seville during the night of January 23–24 with Cádiz as their destination. A delegation, minus the archbishop Luis María de Borbón y Vallabriga, who had also left with the Spanish government, offered a royal welcome that surpassed that for the visit of Carlos IV fourteen years earlier.[21] The Alcázar, Seville's fortress palace, became the seat of the Napoleonic government in Spain as Joseph sought reconciliation, offered amnesty to opponents, and ensured employment to functionaries who took an oath to support his regime. He provided funds to the academies of sciences and fine arts in Seville (something yet to be done in Madrid), and ordered the continuation of excavations at the Roman city of Itálica and the founding of a museum of Sevillian art within the Alcázar.[22] In Madrid the capitulation of Seville was celebrated on February 14 with artillery salvos in the Retiro in the morning and evening, a Te Deum at late morning (accompanied by another salvo), and a full-dress military parade of all troops in the Retiro in early afternoon.[23] It was one day that Goya might have been thankful for his deafness, as he put the finishing touches on his allegorical portrait.

War divided the fortunes of Goya's friends, acquaintances, and patrons. Meléndez Valdés became a judge in the royal council and accompanied Joseph Bonaparte to Andalucía; Francisco de Cabarrús served as minister of finance until his sudden death in April 1810 after he arrived in Seville; and Moratín served as royal librarian.[24] The *Diario* brought news of others, including Ceán, appointed to the Council of the Royal Order of Spain as head of ecclesiastic affairs, and Luis María de Borbón, now considered an enemy

of the people. Goya might have noticed in October 1810 that rooms furnished in good taste in a house once owned by the duchess of Osuna near the Puerta de la Vega were available for rent.[25]

—

Wartime Madrid was a city of contrasts. On March 25, 1810, ministers, diplomats, councillors of state, municipal officials, personnel of the royal household, and others of the "first order" attended a dinner in honor of the absent king, then in Andalucía, and queen, who remained in Paris throughout her husband's reign in Spain. Music played and toasts made to the royal family and imperial armies in Spain, followed by a dance attended by 890 people, again, of the "first order." The guests enjoyed ices and drinks at eleven in the evening and a buffet at one in the morning, "served with great order" in a tent raised for the occasion; the dance continued until seven in the morning with many "Vivas!" for the king. "The brilliance, attendance, and order of this event" reportedly surpassed anything ever witnessed in Madrid.[26] When Joseph returned to the capital in mid-May, the populace was relieved, having heard rumors that he was going to establish his capital in Seville.[27]

Life in Madrid assumed a veneer of normalcy. Theaters were open and plays advertised in the daily newspaper, and entertainments offered in private homes included projections of the planetary system and phases of the moon, an automaton dancing on a tightrope, acrobats, shadow puppets and phantasmagoria with skeletons, ghosts, and portraits of famous men.[28] With warm weather, chairs were again available on the Paseo del Prado and could be rented for 8 maravedís; fines were imposed for their damage or theft and for improper behavior.[29] A bullfight on Sunday, June 24, opened the season with ten bulls and tickets at the same prices as always.[30] The new regime worked to ensure that Madrid provided a clean and safe backdrop for these amusements, renewing regulations first imposed by Carlos III for the sweeping and cleaning of sidewalks and for the disposal of waste.[31] On a grander scale, Joseph sought to improve the city by widening its streets, creating new open spaces, and demanding the demolition of convents and churches, including the parish church of San Martín, where Goya had been married. The proposed renovation of the immediate vicinity of the royal palace was realized only after Joseph's reign with the creation of the Plaza del Oriente and the Plaza de la Armería.[32]

If many entertainments demanded an entrance fee, the grisly spectacles of executions were open to all. Under Joseph, criminals were put to death by the garrote, a method of strangulation deemed more humane than hanging; the condemned were presented with signs around their necks to explain

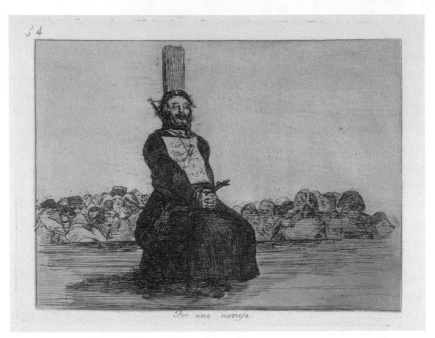

25. *Por una navaja* (*Because of a knife*), *The Disasters of War*, pl. 34, etched 1811, published ca. 1863. Etching, drypoint, burin, and burnisher, 6⅛ × 8 1/16 in. (15.5 × 20.5 cm). The Metropolitan Museum of Art, New York, Purchase, Rogers Fund and Jacob H. Schiff Bequest, 1922.

their crimes; if available, their weapon was also displayed. In July 1810 five men were executed in this manner on three separate occasions, reported in the *Diario* with detailed descriptions of the individual's background and crime.[33] Two etchings (ca. 1811–1812) of the accused on daises, with placards and knives hanging around their necks, suggest that Goya attended (fig. 25). The *Diario* did not report on the war front, but the proclamations it published, to be posted on the door of the principal church in every village and read during Mass on three consecutive Sundays, invited Madrid readers to wonder if villagers in fact followed orders by ringing church bells at the first sighting of guerrilla fighters, or by taking up arms against them (one firearm for every five men was allotted for this purpose). The families of *guerillas* or soldiers in the Spanish army could only inspire sympathy among covert patriots in the capital, for relatives were imprisoned if the fighters did not accept amnesty by a given date.[34]

The economic crisis continued, but those who had made "loans" to the government were repaid with credits (*cédulas de crédito*) with which they could purchase confiscated property (now advertised as *bienes nacionales*, or national

properties) or earn an annual dividend of 4 percent.[35] Listed in the *Diario*, the creditors included Meléndez Valdés and Bernardo de Iriarte for 3,218 and 1,714 *reales*, respectively, and "Josef de Goya" credited with 27,313 *reales*, a significant sum beyond his 11,200 *reales* contribution to the government, which possibly took into account the 15,000 *reales*, due him for *The Allegory of Madrid*. Like all other creditors, Goya waited for his certificate of credit; not until December 13 did the *Diario* carry the notice that this could be retrieved at the commission's office beginning the following day.[36] Given his interest in real estate, he may have perused the confiscated properties that one could purchase in exchange for the credits, listed regularly in the *Diario*: we wonder what his reaction was in noticing among them the site of his early artistic triumph, "the monastery building that was the Charterhouse of Aula Dei, two leagues from Zaragoza, with mills, cellars, and staff."[37] On June 15, 1810, the marquis of Almenara, minister of the interior and protector of the royal academies, visited the Royal Academy of Fine Arts to receive the directors and academicians: Goya was among the twenty-two professors who attended this special session (*junta extraordinaria*). Following a short speech by Bernardo de Iriarte, Almenara spoke in favor of the autonomy of the academy and of financial support for the institution and promised to seek an audience with the king for the academicians. Not until September 1811 did the academy receive monthly financial support of 6,000 *reales*; eighteen months would pass before classes resumed on December 2, 1811.[38]

———

Goya was known to French patrons, for Alexandre Laborde, who first visited Spain with Lucien Bonaparte in 1800, had introduced him in his *Itinéraire descriptif de l'Espagne* (*Descriptive Itinerary of Spain*, Paris, 1808): "born in Zaragoza, whose light and facile brush renders the customs and games of the diverse parts of the Spanish monarchy pleasurably and truthfully, is also successful in portraiture."[39] French sitters sought him out, and at some point between May and September 1810, Goya painted Nicolas Philippe Guye (fig. 26), a distinguished military officer who entered Joseph's service in Naples and followed him to Spain, to become a knight of the Royal Order. Guye had returned to Madrid after serving as governor of Seville from March to May and soon sat for Goya, as confirmed by an inscription once visible on the verso of the portrait (today covered by relining): "Sᵒʳ Dⁿ Nicolas Guye, Marquis of Rios-Milanos, General aide-de-camp to His Catholic Majesty, Member of the Legion of Honor of the French Empire.... Given to Vincent Guye, his brother. In Madrid, October 1, 1810. Painted by Goya." Goya also painted Vincent's son, Victor, wearing what might be the costume of a page, in a portrait

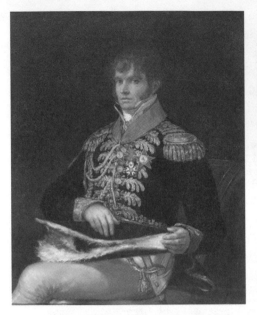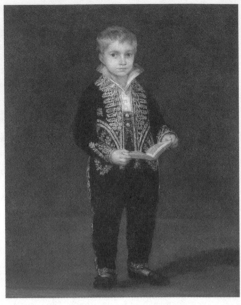

26. General Nicolas Philippe Guye, 1810. Oil on canvas, 41 ¾ × 33 ⅜ in. (106.1 × 84.77 cm). Virginia Museum of Fine Arts, Richmond. Gift of John Lee Pratt.

27. Victor Guye, 1810. Oil on canvas, 40 ¾ × 33 ¼ in. (103.5 × 84.5 cm). National Gallery of Art, Washington, DC, Gift of William Nelson Cromwell. Image Courtesy the National Gallery of Art, Washington, DC.

that also bears an inscription no longer visible: "This portrait of my son was painted by Goya as a pendant to that of my brother, the general. Vᵗ Guye" (fig. 27).[40] At odds with the exquisitely painted decorations of both sitters' uniforms is the subtle melancholy of their expressions: the uncle's gaze is tired, his lips slightly parted; his unsmiling nephew interrupts his reading to look at us, apprehensively. Denied the toys or pets that Goya so often allowed his young sitters, Victor betrays a gravity beyond his years.[41]

Goya's portraits of significant figures associated with Joseph's government, his appointment to select paintings to fulfill Joseph's museological aspirations, and his attendance at the Royal Academy session where the new minister of the interior was presented confirm the artist's involvement with the regime during the first two years of French occupation. Some might have considered him a French sympathizer, or *afrancesado*, but this term had several nuances, encompassing not only those who fully supported the new regime but also government functionaries and small business owners who sought to protect their livelihood.[42] If Goya colluded, he did so because of his profession, not his ideals.

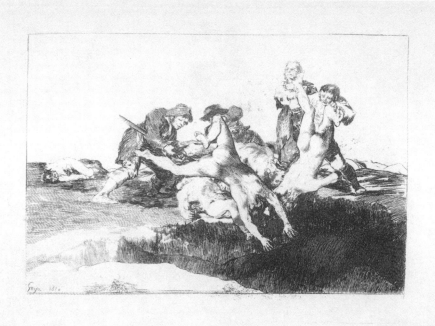

28. Caridad (Charity), working proof, 1810. Etching, drypoint, and burin, 6 $^{7}/_{16}$ × 9 $^{1}/_{8}$ in. (16.3 × 23.2 cm). The Metropolitan Museum of Art, Harris Brisbane Dick Fund, 1932.

Following a hiatus of more than a decade, Goya returned to printmaking. Three copper plates, bearing his etched signature and the date 1810, show corpses piled in a landscape before the outlines of a walled city, wounded figures in uniform assisted by their compatriots, and peasants throwing naked bodies into a common grave, observed by a figure standing in the background with crossed arms, a self-portrait of Goya (fig. 28). Despite the gruesome nature of these subjects, the figures are precisely, even delicately, rendered. Working proofs show that Goya lavished great care on the bodies tossed into a mass grave, enhancing their muscular and lifeless volumes and darkening the shadows of the pit to be their final resting place.[43] Ultimately, the three plates dated 1810 would be among eighty etchings published thirty-five years after his death, when they were christened *Los Desastres de la Guerra* (*The Disasters of War*).

Goya possibly witnessed people fleeing as the enemy approached as he traveled from Zaragoza, or from Madrid in early 1809, but given his presence in Madrid after May, he did not witness atrocities or scenes of the battlefield; rather than reportage, his imagery of "caprice and invention" recalls that of

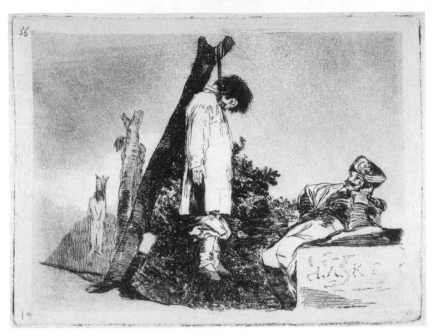

29. Tampoco (Not in this case, either), working proof, ca. 1811–1812. Etching, burnished aquatint, drypoint, burin, and burnisher, 6 × 8 ⅟₁₆ in. (15.3 × 20.5 cm). The Metropolitan Museum of Art, Purchase, Derald H. and Janet Ruttenberg, Dr. and Mrs. Goodwin M. Breinin, Arthur Ross Foundation, and Peter H. B. Freylinghuysen Gifts, and The Elisha Whittelsey Collection, The Elisha Whittelsey Fund, 1987.

the small paintings (*caprichos*) depicting natural catastrophes, murder, and military assaults he had created since the 1790s. As in those paintings on tinplate and canvas, Goya's masterful technique intervenes to temper atrocity, distinguishing these etchings from the mid-nineteenth-century photographs to which they have been compared. Changes in Goya's materials betray the impact of a continuing war: as copper became increasingly scarce, he worked with plates of varying sizes and uneven quality, sometimes marred by pits and scratches that serve as a lasting testimony of war's hardship, and of Goya's creativity under duress. During the three years that he worked on the scenes of war and famine, his perspective shifted from a bird's-eye view to close in on imagined confrontations between enraged adversaries and the aftermath of extreme cruelty (fig. 29). A French officer observes a man hanging from a tree with pants draped at his feet, suggesting that castration was part of the torture preceding his death. Did General Guye come to Goya's mind as he etched the expressionless soldier who contemplates the corpse, possibly pondering the senseless death wrought by war?

We will never know if Goya thought these etchings would find a market, or if they were private, cathartic expressions that he realized could not be published. In this author's opinion, the answer is both: he began to etch wartime *caprichos*, technically perfected through several working proofs, with an eye to a market, but soon was compelled to express the unprecedented suffering of war on any copper plate—no matter its size or condition—that he could find. *Invención* drove him. But even in his silent, darkest sleep of reason he could not imagine the tragedy of the prolonged conflict and its violent political aftermath to which, even after two centuries, these etchings bear witness.

On the Home Front

1811–1812

T HE *Gaceta de Madrid* published a list of the new members of Joseph's
Royal Order of Spain on March 19, 1811, which included "Goya (D. Fran-
cisco), painter"; Mariano Maella, "our first court painter"; Mariano Sepúlveda,
"engraver"; and Juan de Villanueva, "honorary intendant and first architect of
our royal household."[1] Goya's identification simply as "painter," unlike those
of Maella and Villanueva, confirmed that he was not an employee of the royal
household. He and Josefa wrote their will on June 3, 1811, possibly in response
to the ever-worsening situation in Madrid. Famine spread throughout the
peninsula and reached the capital by August, as poor harvests and pillaging
armies made it impossible for markets to supply the city. By December Madrid
struggled to meet the needs of indigents, many of whom sought refuge from
their native, war-torn villages, and the mayor (*corregidor*), Manuel García de
la Prada, addressed the issue of the "pobres necesitados" (poor in need), who
"present themselves on the streets of Madrid, in the porticos of churches, in
the stairs and doorways of many private houses," by ordering those alien to
Madrid to return to their villages and others to be licensed. Even with a li-
cense, they were not to beg at the theater, at the bullfight, or in the doorways
of churches under penalty of arrest (which the vagrants may well have con-
sidered an improvement to life in the streets). This mandate presumably went
unheeded, for its intended audience did not read the *Diario* and was beyond
obeying any regulations that lessened their chances for alms.[2] Yet the implica-
tion of refugees as an eyesore or nuisance, barred from spaces of worship and
entertainment frequented by those more privileged, underscores the disparity
between the destitute and the more fortunate in wartime Madrid.

The total of registered indigents reached 7,000 in December, with a pre-
diction that once registration was complete, it would exceed 10,000. Three

thousand of these, including the aged, widows, orphans, and married couples with children, were deemed to be in the most dire need, but even with the utmost economy the city could provide only 2,200 people a single daily meal, of soup one day, of bread the next. The city appealed to those more fortunate,[3] but the situation worsened through the winter and into the spring. In April the French police reported hospitals "full of the sick, and the populace exhausted by the hunger and misery that reign. In spite of this, spirits are high, and one hears seditious talk."[4] By July an estimated 20,000 people had perished from famine; modern estimates suggest the number approached 26,000, not including infants and young children (who were not counted); probably among the dead were many of the 1,072 infants left that year at the orphanage, a record number.[5] According to parish records, death rates doubled, tripled, even quadrupled: the number of 2,237 deaths in 1812 in the parish of Saint Martin (compared with 434 in 1811 and 690 in 1813) included Josefa Bayeu, who died on June 20, 1812, a possible victim of the disease that inevitably spread in a city ravaged by poverty and starvation. She was buried to the north of the city in the cemetery of the Fuencarral gate.[6]

As witness to the widespread suffering brought to Madrid by famine, Goya etched his most heart-wrenching images of the war. The very material of these images, created on small copper plates often pitted or scratched and of varying sizes, attests to wartime shortages. No longer did he bother with multiple working proofs for these scenes, which remain sadly relevant in the twenty-first century, as he captured the suffering, as well as the generosity and nobility, of indigents weakened by hunger, dying, or dead. Women futilely attempt to comfort emaciated children made inconsolable by hunger; an impoverished woman shares her gruel; men carry off corpses to carts for the dead that became a common sight in the city (fig. 30). Cognizant of his own fortunes, Goya captured the stark inequities of wartime Madrid: a well-dressed young woman averts her gaze from a beggar as she walks to meet a French soldier; a man in a stylish redingote cruelly mimics the gesture of a seemingly blind beggar, whose skeletal body is covered only by a thin, unbelted tunic.

———

As Goya etched scenes of war and famine in Madrid, in Cádiz, the seat of the Spanish government in exile, *Los Caprichos* were offered for sale. They were available at the office of the newspaper, the *Semanario patriótico*, or in a bookshop on the Plazuela of San Agustín, and their advertisement provides the only known commentary on *Los Caprichos* published during Goya's lifetime:

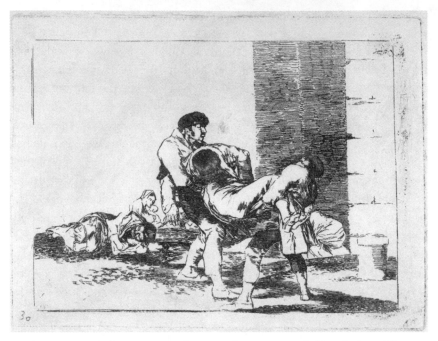

30. Al Cementerio (To the cemetery), working proof, ca. 1811–1812. Etching, lavis, and drypoint, 6 ⅟₁₆ × 8 ⅟₁₆ in. (15.4 × 20.5 cm). The Metropolitan Museum of Art, Harry Brisbane Dick Fund, 1953.

Great profit can be derived from this precious collection of prints. Those who are beginning to be interested in the fine arts will find in it a rich primer of drawings from which they can select life studies difficult of execution and very many subjects *de capricho.* . . . Painters and engravers will find a complete compendium of their professions in the infinite variety of heads, the novelty of composition, the propriety of dress, the peculiarities of physiognomy, profound expression of the passions and the understanding of anatomy. . . .

Poets and writers will see in every satire a fertile source of ideas capable of inspiring them to endless moral reflections. . . .

And finally, what is most valuable, we shall all find printed in these satires our own vices in all their ugliness and our errors ridiculed as they should be, so that we may learn to curb the former and avoid the fatal consequences of the latter, which is the not inconsiderable profit to be derived from this true comedy of human life.[7]

Even though liberated from the censorship of the old regime, the writer considered the etchings as works of art and made no mention of specific satires

of individuals such as Godoy, which modern scholars have considered intrinsic to their meaning.

Almost a year later, the government in Cádiz promulgated the "Political Constitution of the Spanish Monarchy" on March 19, 1812, establishing a monarchy that delegated to the legislative assembly of the Cortes the power to establish the political direction of the nation. It also guaranteed freedom of speech, government-sponsored primary education, and "Universal" suffrage to men twenty-five years or older; Catholicism became the national religion and the practice of other religions was prohibited; the rights of prisoners were not to be violated, and torture was outlawed. That same spring Arthur Wellesley, now Viscount of Wellington following his victory at Talavera three years earlier, saw opportunity in Spain as Napoleon focused his attention and resources on his Russian campaign. On July 22 at the battle of Salamanca, Wellington's forces dealt the French Army of Portugal a major defeat with twelve thousand casualties (the battle is known in Spanish as the battle of Arapiles, after two buttes that were tactically critical). Rather than pursue the Army of Portugal, Wellington left Valladolid on August 6 and with his Anglo-Portuguese army marched on Madrid. Four days later Joseph Bonaparte, his troops and household, two thousand wagons, and around fifteen thousand supporters formed a mass exodus from the capital, traveling southwest through Aranjuez and Albacete to Valencia, still under French control. Bernardo de Iriarte, Juan Meléndez, and Moratín were among the convoy. Not until August 12 did news of Wellington's victory at Salamanca reach Marshal Soult, commander of Andalucía; that same day, Wellington entered Madrid.[8]

Preparations were soon under way at the Royal Academy to install Goya's equestrian portrait of Fernando VII in the assembly chamber (salón de juntas), for which it had been commissioned over four years earlier. On August 28 the concierge of the academy, Francisco Durán, wrote a short note to Goya: "Señor Don Francisco, my Master. I ask Your Honor to do me the favor of telling me what compensation I should give to the son of the late Don Jacinto [Gómez], for having nailed the Portrait on the stretcher. And pardoning this impertinence, order what you will of your most affectionate, Francisco Durán." Although the portrait to which Durán referred was that of Fernando VII, Goya referred to another in his response, written on the same sheet of paper:

Yesterday his Most Excellent Señor Wellington, duke of Ciudad Rodrigo, was here. Putting his portrait on public exhibition in the Royal Academy was discussed, about which he expressed great pleasure;

I mention it to you so that you can relay the message to Señor Don Pedro Franco [the vice-protector] and it can be determined which room is most appropriate: It is a gift to His Excellency and to the public.

I don't have time for anything. Please pardon your most affectionate

Francisco Goya

It seems that you can give two duros to the son of don Jacinto.[9]

The portrait mentioned was the equestrian portrait of Wellington (fig. 31), then nearing completion, if not finished, when Wellington visited Goya's studio. This was not Goya's first meeting with the British hero, since Wellington had sat previously for his bust-length portrait. James McGrigor, the chief of his medical staff, witnessed one session with a Spanish painter, presumably Goya since no other Spanish artists are known to have painted Wellington: "When, upon my arrival at Madrid I waited on Lord Wellington, he received me in the kindest and warmest manner. He was sitting to a Spanish painter for his portrait." The portraitist was in the room as McGrigor reported on provisions he had made, without orders, for the wounded at Salamanca, infuriating Wellington: "His lordship was in a passion, and the Spanish artist, ignorant of the English language, looked aghast, and at a loss to know what I had done to enrage his lordship." Assuming the painter was Goya, his reaction to the sudden outburst was due not to language, but to deafness: might he have thought that his actions had somehow offended his august subject?[10]

Prior to painting the equestrian portrait, Goya drew Wellington in red chalk as the probable preliminary for a bust-length portrait in oil; a second drawing in black pencil records the state of the oil portrait as it left Goya's studio before changes were made to Wellington's medals.[11] This portrait was presumably approved before Goya undertook the large equestrian portrait, which he might not have completed by late August had he not painted over another male figure on horseback. Wellington's figure is slightly larger than that previously painted, so that underlying Wellington's face is a large, curved hat decorated by a cockade, worn by a smiling rider.[12] Both Godoy and Joseph Bonaparte have been proposed as candidates for the phantom figure, but the round face revealed by X-ray supports his identification as Joseph, who, having lived with Goya's equestrian portraits of Carlos IV and María Luisa in the royal palace, had sufficient justification to commission the artist to create his own image, in full control of his steed. (Assuming the rider is Joseph, he offered a symbolic slight to the brother who had continually undermined him as king of Spain, choosing for his own portrait a canvas larger

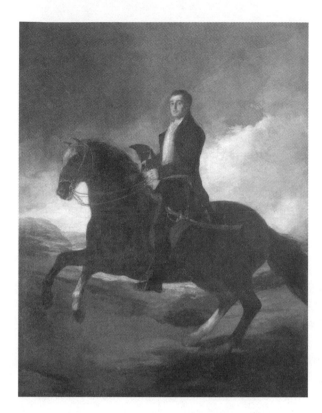

31. Equestrian Portrait of the 1st Duke of Wellington, 1812. Oil on canvas, 115 ¾ × 94 ⅞ in. (294 × 241 cm). Wellington Museum, Apsley House, London.

than that used by David for *Napoleon Crossing the Alps,* which remained in the royal palace until Joseph took it with him upon his final departure from Spain.[13]) As Goya painted Wellington over Joseph, he also destroyed incriminating evidence of his service to the French regime.

The *Diario de Madrid* announced on September 1 that from "tomorrow, Wednesday until Friday, September 11...the rooms on the main floor of the royal house of the academy of the three noble arts will be open to the public...in one of them will be on view the equestrian portrait of the *generalísimo* lord Wellington, duke of Ciudad Rodrigo, that has just been finished by the first painter of the king and director of the academy, D. Francisco Goya." Left unmentioned were paintings by Antonio Carnicero, Zacarías González Velázquez, and Francisco Lacoma, also on view.[14] Goya was not the only member of his family to profess his enthusiasm for the restored government. The new constitution mandated the formation of militias in each province, a reserve force available for duty "when circumstances required it."[15] Lists of recruits in Madrid published in October include in the second battalion, fifth company of riflemen, Lieutenant Francisco Javier de Goya.[16]

If events of late summer distracted Goya and Javier from the settlement of Josefa's estate, Goya initiated the process on October 24, presenting the will to the notary Antonio López de Salazar, who copied it into the record.[17] Father and son requested and received permission to undertake the required appraisal and submit it for approval, and appraisers were named the following day. José García—of whom nothing is known—was to appraise furnishings and linens but also assessed Goya's library, to which he assigned a lump sum of 1,500 *reales*, leaving no further details of its contents. Felipe Abas, who had come to Madrid to study with Goya following early training in the Zaragoza Academy of San Luis, and in December 1812 would remove the overpainting covering the portrait of Joseph Bonaparte in the *Allegory of Madrid*, appraised the paintings. Antonio Martínez, identified as a specialist in diamonds, appraised these, as well as the gold and silver. The appointments of a student to appraise his teacher's paintings, of an expert in diamonds to appraise gold and silver, and of an appraiser of linens to assess a library suggests a somewhat casual and implicitly pro forma process. Within a day the furnishings and linens were valued at 11,264 *reales*; the following day the gold, diamonds, and silver were valued at 52,060 *reales* and the paintings and prints at 11,939 *reales*—a figure very possibly dictated by the teacher to his student. The house was valued at its original cost plus improvements (126,000 *reales*) with specie on-site totaling 156,465 *reales*—three times Goya's royal salary and presumably his wartime stash.

Father and son requested a division of the inventoried property without the intervention of a judge. Diamonds were shared between them, as was the cash (most of it going to Goya). Goya, who was to remain in the house, received most of the furnishings (including a telescope) and kept the silver, composed mainly of decorative or serving pieces. Javier took new linens, possibly including decorated pillows, three bedspreads of fine English cotton, table and bed linens, and a few other furnishings. But most important, Javier inherited the paintings (most of them by Goya) and prints by other masters. Two years later he requested a copy of the division of property and marked the paintings that were his property with his initial "X" and the inventory number—corrected in the 1814 version.[18]

The number of paintings in Goya's home in 1812 confirms that the artist created works without commission, presumably keeping them in his house for occasional sale. These included the six scenes of the capture of Maragato and others unidentified today: twelve paintings of the horrors of war and individual paintings of Saints Anthony, John, and Peter and an Immaculate Conception. Also listed were two paintings of young women on a balcony and another identified as *Time*, generally accepted as a painting of two old

women oblivious to Father Time, about to sweep them away.[19] A portrait of the bullfighter Pedro Romero, another of "Alva" (pl. 12), two paintings of unknown subjects by Tiepolo (whether these were by the father or by one of his sons is unclear), ten prints by Rembrandt, a collection of Piranesi, and a "head by Correggio" were also listed. There is no mention of Goya's own drawings and prints, eventually left in Javier's care upon Goya's departure from Madrid in 1824, or of a printing press of any kind, confirming that he made his prints at another location.

In September 1812, the duchess of Osuna wrote from Cádiz to her treasurer Miguel de la Herrán Terán. After mentioning her straitened circumstances and debts, she ordered a payment to Agustín Esteve and his student, and also asked Herrán to come to terms with Goya about prices, writing that if she paid 50 *doblones* to him for the portrait of Urrutia (ca. 1798), why was she to pay double that for the portrait of her late husband?[20] Goya's commissions for the duke and duchess prior to 1799 are well documented, but this portrait is not among them; absent from the 1812 inventory of Goya's studio, it had presumably been delivered to the duchess prior to her forced departure from Madrid in 1808. Might it be that of the duke today in the Frick Collection, New York? In support of this conjecture, the jewel-like tones, freedom of execution, and palette of that portrait bear little similarity to traits of portraits of the 1790s, and we might speculate that the duchess commissioned the portrait after the duke's passing in January 1807. In this case, her departure from Madrid preempted payment for it, but in 1812 newly open communications allowed Goya to inquire about a bill overdue—an action well in keeping with the artist's character.

Even as Madrid celebrated Wellington and proclaimed the Constitution of 1812, the war had yet to be won. Soult's late summer retreat from Seville offered French forces the opportunity to regroup, and Wellington left Madrid in early September to defend northern territories. On November 2, 1812, Joseph Bonaparte made his third and final entry into the capital.

The Spoils of War

1813–1814

JOSEPH Bonaparte left Madrid for the last time on March 17, 1813, five years after the uprising at Aranjuez that ended the reign of Carlos IV and María Luisa. The following day one hundred cannons saluted King Fernando VII, and illuminations of the streets and theaters, a masked ball, a bullfight with young bulls, and fireworks delighted the "immense" crowd.[1] Joseph's final defeat occurred on June 21 at Vitoria, where his Spanish career had begun five years earlier. According to one account, a British officer forced open the door of his carriage as the former king escaped through the other and rode away on a waiting horse, leaving the men of the 14th Light Dragoons of the Light Division the solid silver dishes and toilet articles that he carried with him.[2] Of greater historical import were the contents of an imperial (a large trunk fitted to the roof of the carriage), reported by Wellington in a letter to his brother:

> The baggage of King Joseph after the battle of Vitoria fell into my hands, after having been plundered by the soldiers; and I found among it an Imperial containing prints, drawings, and pictures.
>
> From the cursory view which I took of them the latter did not appear to me to be anything remarkable. There are certainly not among them any of the fine pictures which I saw in Madrid, by Raphael and others; and I thought more of the prints and drawings, all of the Italian school. . . . I sent them to England, and having desired that they should be put to rights, and those cleaned which required it, I have found that there are among them much finer pictures than I conceived there were; and as, if the King's palaces have been robbed of pictures, it is not improbable that some of his may be among them, and I am desirous of restoring them to His Majesty.[3]

Wellington received no reply to his first offer to return the paintings; when the issue was again raised two years later, Fernando VII declined and offered him the spoils as a gift. Among the eighty-one paintings from Vitoria that hang today in the Wellington Museum in Apsley House, fifty-seven can be firmly traced to the Spanish royal collection, including *The Agony in the Garden* by Correggio, a *Holy Family* by Mengs, several scenes by David Teniers, and two portraits and two genre scenes—*Two Young Men Eating at a Humble Table* and *The Waterseller of Seville*—by Velázquez.

As some point, Goya numbered his etchings of war and famine, possibly as a preliminary for publication. Following this numbering of scenes still untitled, the series opened with the image of a garroted man (fig. 25), immediately recognizable to the inhabitants of Madrid as an emblem of the French occupation. Scenes of cruelty, starvation, and sacrifice followed in a sequence of unrelenting tragedy. If publication was Goya's objective, he probably realized that there was no appetite for these images amid the celebratory subjects of prints that dominated the market after Joseph's departure from Madrid: cards with the portrait of Fernando VII beneath a pavilion supported by Spain and America, scenes of the Second of May 1808 "represented in four prints . . . drawn and engraved by the best professors in Spain," equestrian portraits of the leaders of the Spanish resistance, and a collection of twelve plates portraying the principal plays (*suertes*) of the bullfight.[4] Goya put his numbered plates aside.

Thirteen months intervened between Joseph's departure from Madrid and Fernando's return from France, during which the Constitution of 1812 became law under the interim government led by Luis María de Borbón. This interlude of open debate provides the context for a suite of twenty-three etchings, christened a few years later by Ceán as *caprichos enfáticos* (emphatic caprices), in which Goya criticized institutions both secular and religious and immortalized the disorientation, suffering, and predatory passions unleashed by years of war and political turmoil.[5] Lacking the numbers that Goya added to his earlier scenes of war and famine and etched on unblemished, uniformly sized copper plates, they were created after Joseph's expulsion, when quality materials were again available. During the interregnum, the press enjoyed a freedom unprecedented in Spain and reported on issues debated by the *liberales*, who supported the constitution, and the royalist *serviles*, who opposed it. Rhetoric was charged as the *liberales* identified clerics, lawyers, and the titled as an "astute multitude of rapacious politicians [who have] declared war against all liberal ideas"; the *serviles* in turn decried the weakness of a constitution built on sand, that "will fall to the ground when least expected."[6] By autumn 1813 these entrenched positions were sufficiently

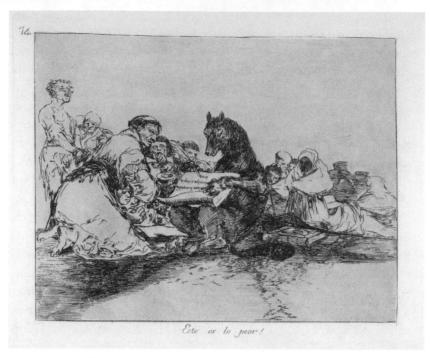

32. *Esto es lo peor!* (*This is the worst!*), etched ca. 1813–1814, published 1863. Etching and burnisher, 6 15/16 × 8 1/2 in. (17.6 × 21.6 cm). The Metropolitan Museum of Art, Purchase, Rogers Fund and Jacob H. Schiff Bequest, 1922.

familiar to become the subject of satirical verse, and of a new three-act play, *The Serviles and the Liberales, or the War of Papers.*[7] If ongoing discussions of politics and parties throughout the heady spring and summer of 1813 inspired Goya to imagine a sequel to *Los Caprichos*, Fernando's return in May 1814 put an end to his project. *The caprichos enfáticos* were stored and the specific context that gave meaning to their imagery largely lost by the time of their inclusion within the first edition of *Los Desastres de la Guerra* in 1863.

One of the *caprichos enfáticos, Esto es lo peor!* (fig. 32), refers directly to the new freedom of the press. A monk bows to a wolf who sits writing before a motley crowd of men, including a figure in rags standing on the left, his hands bound. The wolf has written, "Misera humanidad la culpa es tuya—Casti" (Wretched humanity the blame is yours—Casti), a reference to the Italian author Giambattista Casti, whose 1802 poem *Gli animali parlanti* (*The Talking Animals*) was advertised in Spanish translation in July and August 1813.[8] The subject of the first two cantos, published in Spanish, was well suited to current concerns, as a cast of animals debated the form their government should take; Casti's scheming fox may have inspired Goya's wolf-scribe, who blithely

records the misery of man.[9] *Liberales* championed Casti's poem as testimony of the unjust censorship of the Inquisition, which in 1805 had proscribed it for its injury to "supreme powers, to the high pontiffs and especially against monarchic states," according to the author of a commentary published on August 28, 1813. He posed the sardonic question, "What crime could be more nefarious for the Inquisition than that a writer attack tyranny, and persecute and destroy it wherever it is met?"[10] As the poem gained renewed relevance in 1813, so did the anticlerical satires, allegories of power abused, and complacent onlookers of the *caprichos enfáticos*.

The figures behind the wolf-scribe introduce an element to become increasingly familiar in Goya's postwar imagery: the crowd that passively bears witness to, and is thus complicit with, cruelty, ignorance, and oppression; a crowd energized by bullfights, superstition, and mindless entertainments. It watches as peasants torture French soldiers, sympathizers, or a pathetic plucked bird (sometimes interpreted as the Napoleonic eagle). It stands passively awaiting the outcome as a cleric balances on a tightrope and a single figure in the crowd below shouts, "The rope is breaking!" It awaits the judgment of a gnome with batwing ears, who writes new laws, and looks on as a monk and an owl pay homage to a cat. A procession of anonymous figures serpentines through the landscape, its figures variously dressed in eighteenth-century frock coats, Carthusian robes, and capes, all linked by the rope at their necks to form a chain whose end is not visible. Their leader is a blind man with darkened eyes, probing what lies ahead with extended hand.[11] As protagonists and witnesses, Goya's crowds undermine Enlightenment faith in the agency of the individual. They also reflect his heightened awareness of the anonymous destitute, who prior to war and famines existed largely beyond his purview. On September 3, 1813, a certain Josef María Vizcaino wrote of their plight in the *Diario de Madrid*: of soldiers reduced to penury; of homeless in the streets and squares of Madrid; of abandoned children and youth. He urged the government to bring to justice those pretend patriots who had benefited from the intruder regime and to turn from political debates of *liberales* and *serviles* to the recuperation of Spanish society.[12] That writer might have seen Goya as one such false patriot, but Goya survived unscathed.

As Madrid awaited the return of its king, on February 24, 1814, Goya expressed to the interim government his desire to commemorate the Spanish struggle against Napoleon. The only record of his request is the response from the minister Juan Álvarez Guerra, dated March 9, who cited Goya's "ardent desires to perpetuate with his brush the most notable and heroic actions or scenes of our glorious insurrection against the tyrant of Europe." In light of the artist's claim of penury and "in consideration of the great importance

of such a praiseworthy project, and the well-known aptitude of said professor to carry it out," Guerra requested that the treasury cover the expenses of his "canvases, equipment and paints," in addition to providing a monthly stipend of 1,500 *reales*.[13] This order was long considered the origin of the famous pendants of the *Second* and *Third of May 1808*, but as will be seen, recent evidence suggests a very different history for those paintings. An alternative identification of Goya's project in March and April 1814 is with two smaller works on panel, which entered the royal collection that same year, illustrating scenes of patriotic resistance: the making of gunpowder and the making of shot in sierra de Tardienta, about fifty kilometers north of Zaragoza, under the guerilla leader José Mallén.[14] In them, Goya rendered in oil the precision of detail that he had honed in his etchings of war and famine, as seen in "the factory of gunpowder established by D. Josef Mallén in the sierra of Tardienta in Aragón in the years 1811, 12, 13," a subject identified by an early label on the work (pl. 25). On the left, men grind the mixture of saltpeter, sulfur, and charcoal, to be crated by the man at center, overseen by another who directs the boxes to be carried off to the right. One month after Goya made his request, the *cortes* decreed a commemoration of the victims and events of May 2, 1808. The bodies of the patriots who had faced firing squads buried near the Paseo del Prado were to be exhumed, a monument raised to mark the "Campo de la Lealtad" (today, the Plaza de la Lealtad), and an inscribed marker was to be placed at the cemetery of the Príncipe Pío. The Royal Academy offered a prize for the best painting of "one of the most principal scenes of those witnessed by the people of Madrid on the glorious day of the Second of May 1808" to hang in the chamber of the *cortes*.[15]

———

Fernando, el Deseado ("the Desired One"), crossed the Fluviá River into northeastern Spain on March 24, 1814, six years after his entry as king into Madrid. The *cortes* had ordered that he return directly to Madrid to take an oath to support the constitution prior to assuming the throne, but he chose instead to travel to Zaragoza, where he was acclaimed by enthusiastic supporters, before continuing to Valencia, where he arrived on April 16. He consulted not only with his advisers but also with Henry Wellesley, the British ambassador to Spain and brother of the Duke of Wellington: all opposed the Cádiz constitution.[16] In Valencia, sixty-nine conservative deputies of the *cortes* presented Fernando with a petition against the constitution—a document known as the "Manifesto of the Persians" because of its opening phrase: "It was customary among the ancient Persians."[17] When a delegation of the regency government in Madrid arrived, access to the king was refused. From

Valencia on May 4, Fernando VII decreed that the laws enacted by the *cortes* of Cádiz were "null and of no value or effect."[18] Royal forces entered Madrid unopposed during the night of May 10–11. The constitution was outlawed and its supporters persecuted and imprisoned; according to a contemporary published account, the actors Bernardo Gil (the widower of the beautiful Antonia Zárate) and Isidoro Máiquez were among those detained; Luis María de Borbón as well as his sister the countess of Chinchón were held in Toledo to await royal judgment. At ten in the morning on May 11, the Madrid populace celebrated the new order by destroying the stone plaque in the Plaza Constitucional (Constitution Square) and burning a statue described only as a figure holding a copy of the constitution in its hand.[19] The Council of Castile and the secretarial positions of the reign of Carlos IV were restored.[20]

Goya's response to the return of Fernando was to write to the academy on May 27 to remind its members of the payment due for his equestrian portrait of the king; in a meeting of June 9 it was noted that Goya's petition would be kept in mind when funds became available.[21] The artist soon accepted a commission to paint the half-length portrait of Fernando VII in royal robe and holding a scepter for the government (*diputación*) of Navarra, for which he was paid 2,000 *reales* on July 12. Documents relating to the commission for a portrait of the queen two years later suggest that Goya's portrait fell short of expectations, for he was not considered a second time.[22]

Goya was among the twenty-five professors who convened on July 25 for a royal visit to the academy by Fernando VII, his brother Carlos María Isidro, and his uncle don Antonio. We might imagine the deaf Goya focusing his attention on their faces, noting how they had aged since he painted them fourteen years earlier in individual preparatory portraits for *The Family of Carlos IV*, or perhaps taking advantage of the occasion to focus on the king, memorizing his features for future portraits; for after his return, Fernando VII did not again sit for Goya. Following the appointments of Carlos María and don Antonio as honorary academicians, councillors, and members of the Royal Academy, the king charged the academicians with the preparation of the Buenavista palace to house a gallery of paintings and other objects of artistic interest.[23] The concept for a public museum, championed by Joseph Bonaparte, would finally be realized by one of the most reviled monarchs in modern Spanish history. Once the challenges of renovating the Buenavista palace proved insurmountable, the Royal Museum of the Prado opened in 1819 in a building designed by Juan de Villanueva as a natural history museum during the reign of Carlos III, where it remains, much expanded, today.

As the royal family visited the academy, carpenters in the palace were building two frames for "large paintings alluding to the day of the 2 of May

1808." No other artist is known to have painted this subject, and the dimensions of the frames support their intended use for Goya's paintings. He would have worked on the paintings through the summer and possibly into the fall; the invoices from the metalsmith and carpenter are dated July, by which point the carpenter had delivered frames to Andrés del Peral, whose invoice for gilding the frames is dated to October.[24] Although these works have today achieved iconic status, their early history long proved elusive. Without accounts of contemporary reaction to them, or documents of any commission, scholars linked their origin to Goya's late February petition to the interim regency to immortalize events of the recent war. Their identification as royal commissions explains not only the absence of public reaction but also how they entered the royal collection, from which they were transferred to the Museo del Prado by 1834. Probably because of their gruesome and potentially transgressive subject of a mob uprising, they were valued at only 8,000 *reales* each, one tenth of the value assigned to *The Family of Carlos IV*.[25] Translating imagined atrocity into the exacting medium of etching in *Los Desastres de la Guerra*, Goya had perfected minute details of combat, writ large in the *Second* and *Third of May 1808* (pls. 23 and 24): the precise stances of struggling opponents, the tense grip of a dagger, the reactions of those for whom death is imminent, and the weight of corpses in the left foreground that threaten to bleed into the viewer's space. Revenge takes center stage in the *Second of May 1808* as a man attacks the Mamluk falling from his mount. The patriot's vicious aggression is unwarranted, for his victim is already dead; but with dagger raised, he aims nevertheless to castrate the Mamluk, to the wide-eyed horror of the rider behind.

As Goya painted, the restored government ordered an investigation into the activities of all employees during the French occupation, a process known as *purificación*. Each employee would be assigned to one of four categories: those who refused to serve the "usurper" retained their salaries and were eligible for advancement; those who retained their previous positions were allowed to continue in them; those who advanced under the intruder king, signaling that they worked because they chose to rather than because of necessity, lost their salaries, benefits, and honors; and finally, those who not only served and prospered but encouraged others to do so or persecuted loyal Spaniards lost their positions and honors and would be considered for further punishment.[26] These categories pertained only to possible *afrancesados* rather than to the *liberales*, considered a greater threat to the regime and deserving more severe punishment.[27]

On November 4 Goya testified, "In spite of his age, poor health, and many obligations, not only did he not solicit, but he resisted the many offers and pro-

posals that were made to him, preferring to sell his most prized possessions at a loss rather than serve said government."²⁸ On November 16, Antonio Bailo, a book dealer, spoke on Goya's behalf, stating that he had known and dealt with Goya for many years, and especially during the recent occupation of Madrid, when Goya "made no solicitation to said intruder government, nor had a salary nor a pension from it, in fact, to the contrary, don Francisco Goya conducted himself with great patriotism in favor of the just cause of the Nation, as is public and well-known, and in his declarations, that this witness heard, he proclaimed his hatred for said Government."²⁹ Two days later the director general of the postal system, Fernando de la Serna, stated that Goya had lived in his house and studio working on paintings and engravings, "abandoning most of the people with whom he previously dealt, not only because of his deafness, but still much more for the hatred that he professed for the enemies...that grew with the invasion of the Kingdom of Aragon and ruin of Zaragoza, his patria: Whose horror he wished to perpetuate with his brushes." Serna alone referred to Goya's absence from Madrid and journey as far as Piedrahita, made with the intent of establishing himself in a free country, a hope abandoned because of the pleas of his family and the threat of the ministry of police to embargo and sequester the belongings of the entire family.³⁰

As employees awaited the outcome of the "purification" process to have their salaries restored, Goya was paid 16,666 *reales* (one-third of his annual salary of 50,000) on October 12, 1814,³¹ compensation justified by his work on the *Second* and *Third of May 1808*, then nearing completion or possibly finished. From Zaragoza, the corporation of the Canal de Aragón requested two full-length portraits of the king and his first majordomo, the duke of San Carlos, a commission approved by the monarch on September 20, for which Goya was paid 19,000 *reales* the following June. His full-length portrait of the duke (pl. 26) is a flattering tribute to the man who on April 14, 1815, signed the declaration clearing the artist and his son of any collusion with the French regime and assigning them to the first category: the artist underplays the duke's short stature and nearsightedness by emphasizing his honors, including the Order of the Golden Fleece and the Order of Carlos III, and posing him with his baton of command.³² Installed today to the right of Goya's portrait of the king, the duke stands on a palatial carpet in perpetuity, as the perfect courtier, with hat removed, elegantly uniformed, and turning toward his monarch to present the petition in his hand.

José de Palafox, the commander who six years earlier requested Goya to record the destruction of the first siege of Zaragoza, was captured during the second siege and had spent the war imprisoned in the castle of Vincennes; in 1813 he returned to Spain and the following year was appointed Capitan

General of Aragón. He turned to Goya to paint his portrait.[33] Writing to the sitter in December, Goya proclaimed the finished portrait the best work to leave his hands, despite difficulties caused by the postwar "shortage of pigments, and adulterated oils." Palafox's reply to Goya's statement that the portrait could be delivered by the New Year was only an unenthusiastic notation on the same letter: "He can send it when he likes."[34] If Goya received this message, he chose to ignore it, writing to Palafox on January 4, 1815, with more specifics and mentioning in addition to the portrait a second "tabla" (painting on panel), today unidentified. After opening with an obsequious homage to the sitter, Goya turned to the business of getting the works out of his studio, provided dimensions for two crates, asked whether he was to find someone to ship it or deliver it to someone chosen by Palafox, and detailed how the canvas was to be stretched. Only at this point did he raise a thorny unaddressed issue: "The painting will be first among my works in posterity, and if I had other resources, it would be my pleasure to give it to Your Excellency, but I find it necessary to ask Your Excellency for 100 doblones that will provide me some succor."[35] The 1812 inventory of Goya's possessions, the restoration of his salary as first court painter, and the commission for two full-length portraits from the Canal de Aragón suggest that he did not in fact need such help, although he may have worried whether or not his salary would continue to be paid, given that by August 1815 the monarchy's finances were in critical straits that impacted "the army, the navy, the employees in other branches, the widows, in short: all the creditors of the treasury claim with good reason the payment due them."[36] But Goya had no intention of giving anything away. Palafox, in turn, noted on the January letter that he would "commission someone to come to terms with Goya." Only in 1831 was an accord reached when Palafox purchased the portrait from Javier.[37]

To appreciate Goya's good fortune following Fernando's return, we might consider the fates of two of his acquaintances. As a result of the *purificación*, Maella was assigned to the third category and dismissed from his position as first court painter. There was charity: in light of his long service and age, he was granted an annual stipend of 12,000 *reales* until his death in Madrid in May 1819.[38] Maella's student, Vicente López, assumed his position as first court painter and soon became the king's preferred portraitist. Moratín, to be reunited with Goya in Bordeaux a decade later, left Madrid with the convoy of Joseph's supporters on August 10, 1813, when he was graciously offered a seat in the carriage of the Madrid mayor, Manuel García de la Prada, and his wife, the actress María García. Others returned to Madrid with Joseph, but Moratín chose to remain in Valencia, and with the evacuation of French forces on July 3, 1813, traveled northward to the coastal town

of Peñíscola. With Fernando's return, Moratín was certain that he could undergo the "purification" process and remain in Spain, but upon returning to Valencia in May 1814 encountered a hostile commander who imprisoned him before transferring him to a boat destined first for Barcelona and ultimately for France. The general in Barcelona was more sympathetic and wrote to the court on Moratín's behalf. His possessions were nevertheless confiscated by July 30 and remained sequestered following the testimony of twenty witnesses in Madrid and Valencia. Ordered to live in a small village more than 550 kilometers from Madrid, he was, in his own words, "persecuted without knowing by whom, accused of I don't know what, and punished as a result of my justification."[39]

Another investigation suggests that Goya in fact enjoyed special privileges. The paired paintings of a woman, naked and clothed (figs. 20 and 21), were confiscated from Godoy's collection and transferred in December 1813 to a warehouse in central Madrid; a year later they were moved to buildings owned by the Inquisition. In early January 1815, the caretaker, Francisco de Garivay, was ordered to find information about the owner of the paintings and about "the painters who have occupied themselves with the creation of works so indecent and prejudicial to the common good." Garivay responded on January 7 that the paintings of "a nude woman on a bed" and of a "woman dressed as a maja" (the first use of this term to describe the subject) were by Goya, who on March 16 was ordered to appear before the Inquisitional court.[40] No testimony or further record survives. Did Goya even appear at court? His age, deafness, and position as first court painter perhaps played in his favor; so, too, did friends and patrons in high places.

Portraits of a New Order

1815–1816

B Y 1815 Goya had become part of the historical record, with his frescoes in San Antonio de la Florida and his early altarpiece in San Francisco el Grande mentioned in a guidebook to Madrid published that year.[1] With the passing or exile of his sitters, his portraits entered the Royal Academy: *La Tirana* was donated by her cousin Teresa Ramos; the architect Juan de Villanueva bequeathed his portrait; the still unpaid equestrian portrait of Fernando VII remained; and *Godoy at the Battle of the Oranges* was transferred from Godoy's own collection in 1816. (*The Naked Maja* and *The Clothed Maja* were transferred to the academy only in 1836; *The Clothed Maja* was exhibited four years later, while her naked counterpart remained in storage until the late nineteenth century.) Having outlived many of his contemporaries, Goya sometimes had to correct the record. Upon receiving word that the academicians intended to keep the equestrian portrait of Fernando VII as his reception piece (that is, the work required of all members upon their acceptance by the academy), he replied on October 10, 1816: "When I had the honor of admission to the Royal Academy as one of its members, I presented and donated a Christ painted by my hand, which work was afterwards taken by the clerics of San Francisco el Grande by order of his Most Excellent Señor Count of Floridablanca. I had no part or participation in this decision, but from reports, that painting remains in said convent, although damaged." A response dated October 18 written on Goya's letter requested an investigation in the academy archive, and ten days later a second note recorded the decision to pay Goya in installments as circumstances permitted, at the discretion of the vice-protector.[2] In fact, that account was not settled until the year following Goya's death, when Javier accepted 2,000 *reales* for the portrait and gifted to the academy a self-portrait of his father. That self-portrait, painted on panel and today in the Royal Academy museum, was one of two versions painted

in 1815; the other, on canvas, is in the Museo del Prado (pl. 27). Goya studies himself on a diagonal, as if he were leaning back from his easel to look in a mirror; a white collar emerging from his red velvet robe sets off his careworn face. With only Goya's head and shoulders visible, this is an intensely intimate work, with nothing to distract from our interception of Goya's self-scrutiny. An inscription scratched into the surface and revealed by recent cleaning reads: "Fr. Goya [Pintor?] / Aragonés / Por el mismo / 1815" (Fr. Goya [Painter?] / Aragonese / Painted by himself / 1815).

Hoping to meet Goya, the Swedish envoy to Madrid, the count Gustaf de la Gardie, visited his studio on July 2, 1815, with the "Chevalier Hebia," possibly the lawyer José Hevia y Noriega, who by the following year was an attorney for the supreme royal council.[3] Meeting at ten in the morning, they first called on a young painter, Mr. Possa, who would serve as a translator "with the almost deaf Goya." De la Gardie recounted:

> He accompanied us to Goya, who was not at home, but we were nevertheless able to see his studio as well as his collection of paintings, nearly all of them by his own hand. His particular style has the greatest possible similarity to that of our skillful and lamented Desprez. The imagination equally lively, the execution equally bold and peculiar—several paintings were done without using a brush, only with his fingers or the spattle. His caricatures are outstanding—La Marquise d'Arizza of the greatest likeness. He is busy with a large painting ordered by the Philippine Company and representing the King, after His arrival here, honoring the company's meeting with His presence. Goya, almost deaf, is threatened by blindness as well, which however does not affect his satirical vein. He is living in straitened circumstances, but this too is caused by his curious state of mind and caprices, because one day he suddenly got the idea of writing a letter giving away his whole fortune, which was considerable, to his son and daughter-in-law, the latter of whom, it is said, behaves badly toward her father-in-law, often denying him even the modest minimum that he needs and craves for a living.[4]

The artist to whom de la Gardie compared Goya is the French-born Louis-Jean Desprez (1743–1804), who studied architecture in Rome prior to his appointment in 1784 as court painter to the Swedish king, Gustav III. A talented draftsman, Desprez created a small number of etchings of which the best known is the man-eating Chimera, which might have inspired de la Gardie to compare him with the creator of Los Caprichos. Given that the count did

not meet Goya, he based his assessment of the artist's personal situation on hearsay: no corroboration of his statement that blindness threatened Goya is known, and the publication of the etchings of the *Tauromaquia* the following year argues against it. The 1812 division of property to settle Josefa's will, according to which Javier received the paintings in Goya's studio, might have given the Swedish envoy the impression that Goya had signed over his possessions to Javier and Gumersinda.

But what of the caricature of the "Marquise d'Arrizza" praised by the count? The marquise owed her title to her second husband and cousin, the marquis of Ariza, who served as *sumiller de corps* to both Carlos IV and the restored Fernando VII; by her first marriage with Jacobo Felipe Fitz-James Stuart zu Stolberg-Gedem, she had two sons, one of whom became the fourteenth duke of Alba following the duchess of Alba's death in 1802. Of the marquise, the duchess of Abrantes (the younger daughter of the duchess of Osuna) recalled that "in her youth she had been very beautiful, and at the time I knew her, she still retained her fine figure and graceful deportment."[5] By the time de la Gardie visited Goya's studio, the marquise was forty-three years old and would die in Florence three years later.[6] We can only guess which work inspired the count's comment: an old woman looking at her reflection in *Los Caprichos* or possibly one of the old women about to be swept away by Father Time in a painting listed in the 1812 inventory?

Most important, de la Gardie's account documents one of Goya's most fascinating and least-known canvases, the "large painting ordered by the Philippine Company, and representing the King, after His arrival here, honoring the Company's meeting with His presence" (pl. 28). The work commemorates the king's attendance at a meeting of shareholders on the morning of Thursday, March 30, 1815; apart from the royal presence, it seems to have been a routine affair at which a 3 percent dividend to shareholders was approved.[7] Five days later, royal permission was given to commission a painting of the event, seen by de la Gardie in Goya's studio in early July.

It is, indeed, a "big painting," one of the largest ever painted by Goya, measuring slightly under eleven feet high by fifteen feet wide, almost two feet taller and three wider than the *Second* and *Third of May 1808*. The appearance of Fernando VII at the meeting surprised those in attendance: the king arrived accompanied by only one official, took the president's seat, and stayed to listen to most of the report on the state of the company, read by the secretary at the far right of the directors' table. Goya depicts this portion of the meeting, before the king left the room after one-and-a-half hours, interrupting the reading; he briefly toured the offices, offered his hand to be kissed, and departed, after which the reading and the business meeting

continued.[8] In perhaps the first realistic representation of an audience en-during an extended presentation, Goya captures the blank expressions of the king and directors as the reading continues; stockholders, relegated to the sidelines, fidget and shift in their seats. Morning light enters from the large window on the right to play across the foreground carpet, subtly illuminat-ing a visual path to Fernando VII, seated at the center of the directors' table and at the painting's perspectival vanishing point.

A modern-day viewer might infer a political commentary, reading the king's diminutive scale as a slight, an interpretation corroborated by the ca-sual postures of the shareholders, who chat and gaze into the distance. But the corporate nature of the commission and the painting's intended place-ment in the assembly room of the company building in Madrid argue to the contrary, as does the work's artistic pedigree. Its scale and realism suggest that Goya's objective was to immortalize the meeting by re-creating it, plac-ing the viewer as onlooker, respectfully distanced from the king; possibly, the painting was intended as an illusionistic extension of the room in which it would be installed. The light entering from the large window on the right pays tribute to the illumination in Velázquez's *Las Meninas*, as does the place-ment of Fernando VII, positioned to recall the mirror reflection of the king and queen on the rear wall of Velázquez's work. In both paintings, the im-portance of the monarch stands in reverse proportion to his scale on the can-vas. Who might have seen Goya's painting in situ, prior to the dissolution of the company in 1829?[9] Probably many more than those who attended busi-ness meetings, for on July 29 this "hermosa sala de juntas" (beautiful assem-bly room) was made available to a public school for girls from the Santa Cruz *barrio* (neighborhood) for the examinations of their students. On that date, a portrait of the king hung in the room.[10]

Goya also painted individual portraits of three directors who on March 30 sat at the table with the king: Miguel de Lardizábal, secretary of the Indies; Ignacio Olmuryan y Rourera, vice president of the company; and José Luis Munárriz, who resigned from his position as secretary of the Royal Acad-emy upon his election at this meeting as director of the Company of the Philippines.[11] But a seat at the table was by no means permanent under Fer-nando VII, who according to one nineteenth-century writer went through "six complete sets" of secretaries by 1820.[12] Lardizábal was among the casu-alties. In June 1815 he was the sole minister to have his engraved portrait in-cluded with those of Fernando VII, his uncle, and his brother in a book about the revolution of Spain against Napoleon; Lardizábal had served his king well in arranging the marriage of royal nieces in Brazil to Fernando and his brother Carlos. In September 1815 the ministry of the Indies was disbanded by royal

order, and Lardizábal deposed.[13] Goya's inscription proves the motto on the sitter's coat of arms, ironically granted previously by Fernando VII: "Flucti-bus Reipublicae expulsus / Pintado por Goya 1815" (Tossed out by the waves of government / Painted by Goya 1815). Cast about once again, Lardizábal was also demoted in Goya's painting, removed from his seat at the directors' table to a position on the far left of the canvas, observing the meeting from the doorway.[14]

Goya's responses to commissions from corporations and provincial gov-ernments in need of portraits of Fernando VII range in quality from the ex-quisite portraits of the king and the duke of San Carlos for the company of the Canal of Aragón to an invention of Fernando VII standing before a mili-tary encampment (even though he had never assumed any military role).[15] In 1816 Goya painted two portraits of the children of his patron of thirty years, the duchess of Osuna. That of her youngest daughter, whose husband inher-ited the title of the duke of Abrantes that same year, might surprise those ac-customed to the palette of earlier paintings, for a mantilla has been replaced by a crown of roses; a black dress by a powder-blue empire gown, set off by a yellow shawl; and a fan or letter by a sheet of music, held with elegantly poised fingers. Euterpe, the muse of music, is clearly alluded to, recalling the portrait of the duchess's sister, the marquise of Santa Cruz, painted by Goya a decade earlier in a white empire gown, reclining on a divan, lyre in hand.[16] Goya's last commission from the Osuna family was a full-length por-trait of the tenth duke of Osuna. Fashionably dressed, wearing riding boots with spurs and holding a crop, he has dismounted from the horse held by a page in the background and stands absorbed in the letter he reads (fig. 33). A sagging jowl and tired expression age the thirty-one-year-old, like so many others, a victim of the political turmoil of the preceding decade. An associate in his father's business in 1805, he witnessed its demise following the duke's death, a prologue to the greater trouble to follow. He pledged allegiance to Fernando VII in 1808 and accompanied him to Bayonne before returning to Spain, where, with his mother and family, he followed the government in exile to Cádiz and supported the Constitution of 1812. Having returned to Madrid in 1813, he went the following spring to Zaragoza to welcome the re-turning Fernando VII, but their relationship was an uneasy one: in June 1816 the duke followed the court to Aranjuez only to have the king order him to return immediately to Madrid. The French occupation had left the Osuna properties in ruins and the family business subject to litigation settled only in 1834, the year of the duchess's death at eighty-one years of age. The duke's response to Goya's request for payment, written in November for the por-trait Goya had completed the previous August, betrays the duke's financial

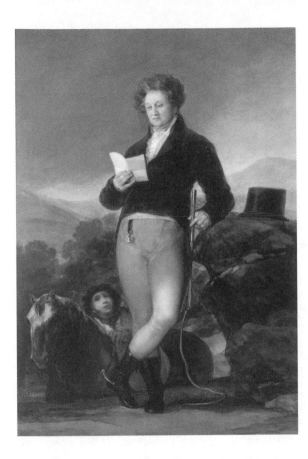

33. The Tenth Duke of Osuna, 1816. Oil on canvas, 79 ½ × 55 ⅛ in. (202 × 140 cm). Musée Bonnat-Helleu, Bayonne.

distress. He explained that his financial matters (*intereses*) had been placed by the king under the control of a government official, to whom Goya wrote on November 22; payment for the portrait was finally issued on March 28, 1817. The duke died three years later at the age of thirty-five.[17]

Writing to the duke, Goya explained his delay by noting that he had been distracted by his work, for which reason he had not "called Your Excellency's attention to the matter until now."[18] He was indeed distracted, for on October 28 he had announced for sale in the *Diario de Madrid* thirty-three etchings of the bullfight, eventually titled the *Tauromaquia*:

> Collection of prints invented and etched by Don Francisco Goya, court painter of his majesty, in which are represented various maneuvers of the bullfight, and plays performed in our bullrings, the series giving an idea of the principles, progress, and current state of these festivals in Spain, which without explanation are clear from the very view of them.

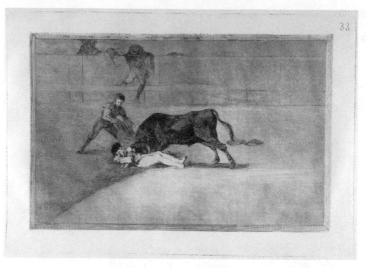

34. La Desgraciada muerte de Pepe Illo en la Plaza de Madrid (*The unlucky death of Pepe Illo in the ring of Madrid*), published 1816. Etching, burnished aquatint, drypoint, and burin, 9 ¹¹⁄₁₆ × 13 ¾ in. (24.6 × 35 cm). The Metropolitan Museum of Art, Rogers Fund, 1921.

Goya's subject was the most accessible of any of his print series, appropriate to the market following Fernando's return, which was dominated by religious images, portraits of the king and royal family, images extolling Spanish resistance to Napoleon, and other subjects, including the bullfight.[19] But if his subject was popular, Goya's intended audience was not, for these are technically exquisite images etched on large plates, created for the connoisseur. The exploitation of aquatint to create light and shade or, in terms of the bullfight, *sol y sombra*, lends to their sophistication, as does his decision to publish them without titles. This should warn against considering them as a simple series of bullfight subjects, comparable to the diagrammatic images of bullfight plays produced by his contemporaries.[20] Goya left his buyers to interpret the thirty-three etchings with subjects spanning centuries, from a man mounted on a horse and dressed in fur, who lances a bull tethered by servants in an open landscape, to a matador pinned to the ground by the bull in a modern-day ring (fig. 34). The interceding plates suggest an historical progression from the fur-clad earliest inhabitants of the Iberian peninsula to Moors to Christian nobles to modern-day bullfighters. But Goya overestimated his audience, and, presumably in response to demand, a page with titles, written by or with the advice of Ceán, was added to the series.[21]

Should we trust titles never intended by Goya? Do they reveal or camouflage his intended meaning? They identify ancient Spaniards fighting bulls

35. James Gillray, *The Spanish Bullfight or the Corsican Matador in Danger*,
July 1808. Hand-colored etching, 10 ¼ × 14 in. (26 × 35.6 cm). Published by
Hanna Humphrey.

on horseback in the country; the eleventh-century nobleman and military
leader "El Cid"; and Spain's first Hapsburg monarch, Carlos I, lancing a bull
in the plaza of Valladolid. What they do not explain is the anomaly of Car-
los's uniform and plumed shako, reminiscent of the uniforms of Napoleonic
soldiers portrayed by Goya a few years earlier in the *Desastres de la Guerra*, or
the diverse crowd armed with lances and other weapons, surrounding a bull
that stands above two fallen figures and seems perplexed by his motley ad-
versaries. Another artist's imagery of the bullfight suggests a subtext for the
Tauromaquia: in 1808 the English caricaturist James Gillray, identified in an
advertisement in the *Diario de Madrid* in October 1808 as the "inventor inglés
del toro español" (English inventor of the Spanish bull), gave form to the bull
as a symbol of Spain in her fight against Napoleon (fig. 35).[22] Gillray's carica-
ture, *The Spanish Bullfight or the Corsican Matador in Danger*, its title translated
as "La fiesta de toros en España ó el matador Corso en peligro," was offered
for sale in November of that year and shows the bull tossing Napoleon in the
"Royal Theater of Europe" as monarchs watch in delight.[23] The identification
of Spain with the bull was embraced by Spaniards and possibly also by Goya,
who in the *Tauromaquia* insinuates a second history, of Spain resilient and tri-
umphant. The bull is taunted by Moors but eventually overthrows them; in
his shako, "Carlos I" (Holy Roman Emperor and the first Hapsburg king of
Spain) invites identification with a more recent unsuccessful intruder.

Recognition of the multiple readings to which these etchings lend themselves justifies Goya's decision not to assign titles and explains the unusually grim concluding image, in which the bull pins his doomed adversary to the ground. For it is grim only if we accept the assigned identification of Pepe Hillo, a matador who met his end in the ring in Madrid on May 11, 1801 (fig. 34). A contemporary manuscript title on a set of the prints in the Boston Public Library refers to this image as *La Muerte de el famoso Pepillo*, tempting further speculation.[24] Pepillo is the diminutive of Pepe, the common nickname for José, or Joseph, all variations used by satirists to mock Joseph Bonaparte. Caricatures of the day offered myriad variations, including *Pepe Botella* (Joe Bottle, because of his love of wine) and, in a print offered for sale as "a capricho most rare" on January 28, 1814, *Pepino* (*Cucumber*), which also identifies Joseph's phallic cucumber mount: "It is neither horse, nor mare, nor donkey that he rides: it is a *pepino*." The caption explains, "Bottles, glasses, cucumbers are the titles, José, with which Spain continues to honor you."[25] Even closer to the *Pepillo* of the Boston manuscript is the broadsheet of *Pepillo Errante*—the Wandering Little Joe, if you will—despised by the French military commander Suchet.[26] The interchangeability of Pepe Hillo, Pepillo, and Pepino justifies a subtext of the final image as the Spanish bull triumphant over Joseph Bonaparte: if Goya could publish neither his scenes of war and famine nor his *caprichos enfáticos*, their spirit persisted in the *Tauromaquia*.

From his arrival in Madrid in 1775 until the outbreak of war in 1808, Goya enjoyed widening circles of patronage, advancement within court circles and beyond, and increasing prestige and wealth. During his recuperation from illness in 1793, he experimented more freely in drawings and paintings, experimentation that from this point forward paralleled his creation of commissioned portraits, as well as allegorical and religious paintings. His illness of 1793 did not impair his career, and the death of Zapater a decade later may have marked a more significant personal turning point. The Peninsular War, however, brought a decisive break from this past. His monarchic patrons fled from Spain, while others, among them the count of Floridablanca, Jovellanos, the duchess of Osuna, and the children of don Luis—the countess of Chinchón and her brother, Luis María—followed the Spanish government into exile, first to Seville and then to Cádiz. Other sitters and past acquaintances—including Francisco de Cabarrús, Leandro Fernández de Moratín, Bernardo de Iriarte, and Juan Meléndez Valdés—assumed positions in the government of the intruder king. By 1816 all of them were deceased, ruined, or living in exile from the court.

Goya endured. And with fewer demands from court and patrons, his caprice and invention flourished.

Part V

Triumphs of Caprice

Disparates

1817–1819

I N 1817 Goya was one of five artists who together contributed six overdoor paintings to decorate the dressing room of Fernando's new queen, Isabel of Braganza. The subjects of the paintings invoked the monarchs' namesakes by portraying the fifteenth-century Spanish rulers Fernando and Isabella and Saint Isabel of Portugal.[1] Painted in a limited, grisaille palette, the works emulated sculptural reliefs, with the exception of Goya's contribution, which gave form to Saint Isabel attending to the sick, with broad brushstrokes of tempera in black, white, and gray. His brash departure may explain why this was his last commission at court.

If Goya spent his days painting a saint for the palace, other pastimes occupied him during Madrid's dark winter evenings. On February 8, 1817, Moratín, now settled in the town of Sarriá outside Barcelona, wrote to the historian and lawyer Juan Antonio Conde, and included a message to those gathered at an inn near Goya's home on the Calle Valverde:

> To the honorable Ceán, to Goya, the Padre Jacinto, to don Santiago and Mr. Valverde, whatever you wish on my behalf. So now, that establishment has become a gambling den of cheats and those ladies the keepers of the barrack's gaming tables? I always knew they had a certain inclination toward the card of clubs and sword; but I never imagined that the disorder would come to this, and that, presided and authorized by doña María Ortiz, a native of Rin de Campos, they would spend entire nights robbing money from one another, and exposing bars of gold that came from Mexico...I don't remember the year...to the luck of a card. Preach to them all against this awful vice.[2]

Moratín's inclusion of Goya among those to whom his feigned outrage was directed implicates the artist as a participant in the debauchery at the inn, owned by don Santiago (Santiago Muñoz) and his wife, María Ortiz. Moratín's correspondent was among their lodgers; also mentioned is their son-in-law Francisco Valverde, who had married Francisca Muñoz in 1816.[3] Letters from Moratín to Francisca ("Paquita") in February and March confirm Goya's friendship with the Muñoz family: after sending her a recently finished portrait drawing under a provisional glazing encased inside a book, Moratín asked that she have a miniature painted, warning her not to entrust it to any "dauber," but to "ask Goya who is the best miniature painter around."[4] A month later Moratín responded to Francisca's surprise at his cap and lost youth, and by way of consolation offered her a portrait of himself at a much younger age, painted by Goya in 1798, that she could have until her death, at which time it was to be returned either to him or to his estate. In closing, he sent regards to Goya, as he would again in a letter of May 31 and in another of June 9, in which Moratín instructed his cousin María: "If I try to explain to you the operation of a camera obscura, I will lose the time spent, you will be left with nothing, and the machine will perish in your hands. The quickest would be for Don Francisco Goya to take the time to explain it to you."[5] With Moratín's departure from Barcelona in late August, his sojourn in Montpellier until the following March, and his stay in Paris with his longtime friend Juan Antonio Melón until 1820, his correspondence with his friends on the Calle Valverde lapsed.

Also mentioned in the February letter is the mutual friend of Moratín and Goya, "the honorable Ceán," an epithet Moratín had used in his January 1797 letter to Jovellanos, previously mentioned. Despite his service to Joseph Bonaparte as overseer of ecclesiastic affairs, Ceán remained in good standing with Fernando VII, to whom he dedicated his treatise *El Arte de ver* (*The Art of Seeing*) in 1827. Having written the first biography of Jovellanos, published in 1814, he immersed himself in writing on art theory, artists, and antiquities, continued to collect prints,[6] and by November 1819 completed a manuscript catalogue of his collection, which included 227 prints by Goya: *Los Caprichos*, the etchings eventually known as the *Desastres de la Guerra*, the *Tauromaquia*, two single etchings—*Flight into Egypt* and another after *Las Meninas*, and sixteen that remain to be identified, possibly proofs of the *Disparates* to be discussed in this chapter.[7] Ceán's collection played a key role in the legacy of Goya's prints, for it included a bound set of working proofs of the scenes of war and famine, as well as the prints that Ceán christened *caprichos enfáticos* (emphatic caprices), today in the British Museum, with each etching captioned in pencil. The manuscript title page, attributed to Ceán, precedes the

36. *Saints Justa and Rufina*, 1817.
Oil on canvas, 121 ⅝ × 69 ⅝ in.
(309 × 177 cm). Cathedral,
Seville, Spain.

etchings: "Fatal consequences of Spain's bloody war with Buonaparte and
other striking caprices in 85 prints. Invented, drawn and engraved by the
original painter, D. Francisco de Goya y Lucientes." In 1850 Ceán's daughter
gifted this volume to the collector Valentín Carderera, who in turn loaned
it to the Royal Academy to serve as a model for the order and engraved cap-
tions of the first edition of *Los Desastres de la Guerra* (1863).[8] Carderera also
owned Ceán's volume of the *Tauromaquia*, given by Goya so that the collec-
tor could draft titles.[9]

 Although Ceán remained in Madrid from 1808 until his death in 1829, his
many years in Seville positioned him to recommend Goya for a major com-
mission for the city's Gothic cathedral: an altarpiece portraying the patron
saints of Seville, Justa and Rufina, standing side by side before a scene of Se-
ville, identified by the tower of La Giralda (fig. 36). On September 13, 1817,
Goya and Javier signed over power of attorney to handle all financial matters
and to collect their salary and pension respectively, a reasonable preliminary

for an extended absence, such as a trip to Seville to inspect the location where the altar would be installed.[10] Ceán's letter to the retired military leader and art collector Tomás Veri suggests the trip was postponed or never taken, for in late September Goya was presumably in Madrid as he worked under Ceán's watchful eye:

> I am now extremely busy in guiding Goya as to the decorum, modesty, devotion, respectability, dignified and simple composition with religious attitudes for a large canvas that the Chapter of the Seville Cathedral commissioned of me for its Holy Church. Since Goya saw with me all the great paintings that are in that beautiful temple, he is working with great respect on one that will be placed on a par with them, and which will determine his merit and reputation: the subject, the martyr saints Justa and Rufina.
>
> . . . I chose that only the two saints be represented, life-size, which with the tender and devoted postures and expressions of the virtues they possessed, inspire devotion and the desire to pray to them, which is the objective to be served by paintings of this type.[11]

We can only wonder if the artist appreciated Ceán's tutelage on "decorum, modesty, devotion [, and] respectability."

Ceán's review of the recently finished altarpiece was printed anonymously in the *Crónica científica y literaria* (*Literary and Scientific Chronicle*) in December 1817, insuring that Goya's work was known beyond Seville.[12] According to the author, Goya had visited Seville three times and seen and examined works in the cathedral by Andalusian artists of the sixteenth and seventeenth centuries. Not wanting to be compared with them, he resisted the commission and relented only at the urging of his friends. This account of Goya's uncharacteristic humility was perhaps Ceán's own invention, given that Goya's signature on the work, "Francisco de Goya y Lucientes. Cesaraugustano [the Latin equivalent to Zaragozan] and first painter of the king, Madrid 1817," proclaimed to all that an Aragonese artist could hold his own among the Andalusian masters. Ceán also described Goya's methodical approach: he read Saint Isidore's account of the saints' martyrdoms; developed studies of expression and gesture to convey their virtue; and learned about the scale, light, and lines of vision at the site where the altar would be installed. Ceán praised the naturalness of the lion at the saints' feet and of the saints' expressions, which he attributed to powers of observation sharpened by deafness: "A total and absolute deafness gave by chance to the unfortunate Goya a gift of great advantage that is usually not acquired except at such a

37. *Después lo veras* (*You'll see later*), ca. 1816–1820. Brush with black and gray wash, 10 ½ × 7 ⅜ in. (26.7 × 18.8 cm). The Metropolitan Museum of Art, Harry Brisbane Dick Fund, 1935.

cost."[13] The painting was installed by January 14 to the acclaim of the cathedral council and everyone who saw it; even Saavedra (the former minister of Carlos IV) judged it as "the best that has been painted in all of Europe." Goya, too, was content with the exceptional payment of 28,000 *reales*.[14]

In drawings, sometimes lightly sketched in pencil before Goya turned to brush-and-ink washes, he continued to explore the limitless subject of the human condition. Captions in Goya's hand add a voice, as words spoken by figures portrayed or as an authorial counterpoint to the image: *You'll See Later* allows us to hear the words of the woman who admonishes a man with wineskin raised, about to take another drink (fig. 37). His dazed expression and unseeing, upward-drifting eyes are proof that he is well beyond hearing or heeding her warnings. Unhindered by the small scale, the painter-draftsman brings the scene to life with a varied application of wash and ink, from the broad passages of medium tones to the darker defining shadows and lines applied with a drier brush, and precisely renders the inebriated man's expression and the fear of the woman, pleading with eyes wide open and raised

38. *Crowd in a Park,* ca. 1812–1820. Brush and iron gall ink, with scraping, 8 ⅛ × 5 ⅝ in. (20.6 × 14.3 cm). The Metropolitan Museum of Art, New York, Harris Brisbane Dick Fund, 1935.

eyebrows. The finished nature of the drawing, its dark black ink border, and penciled caption place it within a group of drawings known as the *Black-Border Album.*

During the last two decades of Goya's life, he freely auditioned not only new subjects but also innovative perspectives. In contrast to the scrutiny of minutiae and individual interaction of *You'll See Later,* he imagined a crowd from a bird's-eye view. Shadows cast by distant figures convey a sunny day in a park enjoyed by the multitude, which spills forth against a raked perspective, from the mid-distance toward the viewer's space (fig. 38). At first glance, we lose sight of the individual, but then discover upon closer inspection that

Goya defined variations within the throng: a woman whispers to her friend, and men and women engage in conversation and flirtation in the foreground, introducing the interactions to be inferred from postures, groupings, and expressions implicit as we follow the figures into the distance. His imagined perspective anticipates that which we today see in aerial images of crowds.

In etchings that defy reduction to logical explanation, invention triumphed. On large plates equal in dimension to those used for the *Tauromaquia*, Goya gave form to an alternative world in prints today known as the *Disparates*: almost two decades after asserting the parity of image and written word in his advertisement for *Los Caprichos*, he destroyed the equivalency, refuted word, and liberated the image. Titles on rare working proofs for some of these etchings open with the word *disparate* (dis—or absence of—parity), commonly translated as "folly," but more precisely connoting irrationality: *ridiculous disparate, cruel disparate, disorderly disparate*. Beyond narrative, these compositions can only be described: women dance, toss dolls in a blanket, and sit on a branch of a tree listening to a gesturing figure wrapped in a striped shawl; a man cowers behind a draped female figure (a statue of the Virgin?) defending himself from a castanet-playing giant, possibly inspired by the processional *gigantones* of Goya's youth. The victim taunted, seen in *Los Caprichos* and in *The Arrest of Christ* painted almost two decades earlier, becomes an unfortunate man mocked, his face melting in misery in anticipation of what is to come as a syringe is prepared for some unspeakable torture (fig. 39). The only humane character in this dark world is a small dog standing near the victim's feet, who, wide-eyed and anxious, barks in a futile attempt to protect his master.

The philosopher Michel Foucault captured the open-ended meaning of these etchings, like dreams both familiar and weird, or, in a word, uncanny:

> The figures of the *Disparates* are born out of nothing: they have no background, in the double sense that they are silhouetted against only the most monotonous darkness, and that nothing can assign them their origin, their limit, their nature. *Los Disparates* are without landscape, without walls, without setting—and this is still a further difference from the *Caprichos*; there is not a star in the night sky of the great human bats we see in the *Way of Flying*.... Faces themselves decompose; this is no longer the madness of the *Caprichos*, which tied on masks truer than the truth of faces; this is a madness *beneath* the mask, a madness that eats away faces, corrodes features; there are no longer eyes or mouths, but glances shot from nowhere and staring at nothing... or screams from black holes.[15]

39. Loyalty, etched 1816–1820, published 1864. Etching and burnished aquatint, 9 ⅝ × 13 ¾ in. (24.3 × 35.2 cm). The Metropolitan Museum of Art, New York, Gift of Mrs. Henry J. Bernheim, 1936.

When Goya etched these plates is not known. The first is generally thought to be an image of men strapped into large wings and flying against a night sky, *Modo de volar* (*Way of flying*), included as the thirty-forth plate in the set of *Tauromaquia* prints given to Ceán, perhaps as a commentary on the vanity of the exploits portrayed in the preceding bullfight prints. Upon his departure from Spain in 1824, Goya left these plates, as well as those of the war and famine scenes, the *caprichos enfáticos*, and the *Tauromaquia*, to Javier. Published by the Royal Academy in Madrid in 1864, these etchings were mistitled *Los Proverbios*, or *Proverbs*, before working proofs bearing the caption "disparate" came to light.

———

Goya's public career as a religious painter, which began almost fifty years earlier with the *Adoration of the Name of God* in El Pilar, and as an academician drew to a close. On May 9, 1819, the Piarist Fathers decided to commission an altarpiece for the church of San Antón of their college in Madrid, portraying the founder of their order, the Aragonese-born Saint Joseph of Calasanz. They commissioned Goya, who may have had a special fondness for the Aragonese saint and as a youth possibly attended the celebration in Zaragoza of

his canonization in 1767. He responded with a moving tribute to a saint devoted to improving the plight of impoverished youth, who late in life became the victim of intrigues within the order he founded. Goya depicts the aged, kneeling saint taking his final communion. Behind him, a reverent audience encompasses the ages of man—old men on the left, mature men at center, and on the left the boys—all of whom represent the beneficiaries of the free, educational institutions founded by Piarists. Goya was paid an advance of 8,000 *reales* in July and the remaining 12,000 *reales* in September, suggesting that he completed the altarpiece in time for the commemoration of the saint's death on August 25.[16]

September 1, 1819, marked the opening of the Royal Academy exhibition, extended a month later by eight days in response to popular demand. Having not exhibited since showing his portrait of Wellington in 1812, Goya participated for a final time, but the accolades he enjoyed two decades earlier were no longer. A November review opened with a description of works by royal members of the academy, as well as royal portraits by the honorary court painter Francisco Lacoma and the first court painter, Vicente López. Mentions of other works followed, preceding the reference to "various portraits by D. Josef Aparicio, D. Francisco Goya, don Luis Cruz y Rios, and the twenty-year-old student, Rafael Tegeo."[17] A note in the academy lists next to Goya's name "portraits," indicating that he exhibited more than one.[18]

Probably among them was Goya's masterful rendering of the academician Juan Antonio Cuervo, signed and dated 1819 (fig. 40). Cuervo entered the academy in 1788, became lieutenant director in 1801, interim director of architecture in 1812, and director two years later. Painting for his peers, Goya defined the gold braid of Cuervo's academic uniform with fluid strokes; brought Cuervo's ruddy face to life with deftly synthesized grays, golden browns, and reds; and used strokes of beige around the eyes to call attention to his alert and intelligent gaze. He signed the portrait "by his friend Goya / the year 1819." Eighty-one years later, when the portrait reappeared in a seminal public exhibition of Goya's work in Madrid, the art historian Narciso Sentenach deemed it "one of the most brilliant examples of the mastery of its artist";[19] the Parisian dealer Paul Durand-Ruel concurred and promptly acquired it. It may have been Goya's friendship with Cuervo that led him the following year to paint Cuervo's nephew, Tiburcio Pérez y Cuervo, like his uncle, an architect and academician (fig. 41). Comparison of the portraits of uncle and nephew illustrates Goya's facility at adapting a style appropriate to the sitter before him. Painting the older, formally posed uncle, Goya worked in a broad range of colors, with a varied, controlled, and—particularly in the face—exquisitely rendered application. In turning to the nephew, posed

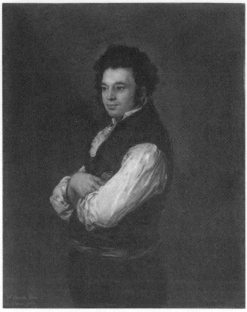

40. Don Juan Antonio Cuervo, 1819. Oil on canvas, 47 ¼ × 34 ¼ in. (120 × 87 cm). The Cleveland Museum of Art, Mr. and Mrs. William H. Marlatt Fund, 1943.90.

41. Tiburcio Pérez y Cuervo, 1820. Oil on canvas, 40 ¼ × 32 in. (102.2 × 81.3 cm). The Metropolitan Museum of Art, Theodore M. Davis Collection, Bequest of Theodore M. Davis, 1915.

casually with shirt sleeves rolled up as he takes a break from his work, Goya chose a limited palette of blacks, greens, grays, and white, and working with larger brushes, applied the paint more freely.

The Real Museo del Prado (Royal Museum of the Prado) opened on November 19, 1819, with three galleries exhibiting 311 works by artists of the Spanish school (galleries of other schools were added over the following decade). The third gallery had only 15 paintings by recently deceased or contemporary artists, including Bayeu, represented by *Christ on the Cross*, and Maella, represented by the *Four Seasons*. Four large canvases honoring the history of Spain dominated the gallery: *The Death of Viriatus, Chief of the Lusitanians* by the neoclassical painter José de Madrazo, thirty-five years junior to Goya; *The Ransom of Prisoners in the Reign of Charles III*, by José de Aparicio, twenty-seven years his junior; and Goya's equestrian portraits of Carlos IV and María Luisa (fig. 19).[20] Goya's most powerful patrons, once despised, now assumed their place in history, having died the previous January, in exile in Italy.

The Artist's Retreat

1820–1823

B Y 1820 Spain's debt had reached unprecedented levels, exacerbated by the loss of her American colonies;[1] the army, navy, and employees of the royal household went unpaid, and widows did not receive their pensions, although there is no evidence that the shortfall affected Goya or his pensioned son. The threat to the monarchy extended far beyond the economy, for since the return to power of Fernando VII in May 1814, liberals in exile in England and France conspired against his regime and assisted in instigating sporadic uprisings in cities beyond the center of power, hoping for a domino effect to topple the regime. Such were the hopes of Lieutenant Colonel Rafael Riego, who addressed the men of his regiment on January 1, 1820, as they prepared to embark for America from the port of Cádiz: "Soldiers, my love for you is great. Because of this, I cannot consent, as your leader, to see you leave your country, in some rotting ships, to take you to wage an unjust war in the new world.... The Constitution, yes, the Constitution, is enough to pacify our brothers in America."[2] Unsuccessful in his attempt to take Cádiz, Riego led his troops to villages throughout Andalucía with little success: by late February he and three hundred followers sought refuge by heading to the Portuguese border. An unexpected uprising in A Coruña on February 21, followed by others in Zaragoza, Barcelona, Pamplona, Murcia, and Cádiz in early March, altered their course; their cause benefited also from the defection of an officer sent in their pursuit by Fernando VII. The Constitution of 1812 was reinstated on March 8 and accepted two days later by the king, who had little choice in the matter. The three years to follow, known as the *trienio liberal*, witnessed efforts to create a constitutional monarchy that laid bare divisions within both the liberal and royalist factions, as well as the difficulties of implementing a constitution in a country that had recently suffered a devastating war to safeguard its traditions and religion.[3] Unaware of the trials ahead, in spring 1820

liberals celebrated the suppression of the Inquisition, the freedom of the press, the reinstatement of constitutional authorities unseated in 1814, and the return to power of Luis María de Borbón as head of a provisional assembly.

As the country confronted crisis, Goya faced his own: a severe illness of late 1819, documented solely by the inscription on a portrait painted early the following year (pl. 29): "Goya gives thanks to his friend Arrieta for the expert care with which he saved his life from an acute and dangerous illness that he suffered at the close of the year 1819 when he was seventy-three years old. He painted it in 1820." Commonly referred to as *Self-Portrait with Dr. Arrieta*, the painting is in fact a portrait of Eugenio García Arrieta in which Goya plays a supporting role. Arrieta was one of two doctors appointed in October 1819 to Madrid's supreme council of health, formed to protect its citizens from a yellow fever epidemic that had broken out in southern Spain and by year's end had spread to Cádiz, but never reached Madrid. Centrally placed, the physician supports Goya and coaxes him to sip his red tincture. The juxtaposition of doctor and patient is a study in contrasts of one man in his prime and another in old age: Arrieta's concentration and focused gaze counter Goya's barely opened eyes and apparent oblivion to his surroundings; Arrieta's vigor contrasts with Goya's inability to sit without his support. Colors reinforce these differences, as the doctor's ruddy complexion, set off by his green coat, counters Goya's ashen pallor and the gray tones of his robe. Goya is present in body only; with eyes unseeing, his mind strays into the shadows, perhaps conjuring the faces that emerge from the shadows behind.

On April 4, 1820, a recuperated Goya attended a session at the Royal Academy to swear allegiance to the king and the constitution, as he had done for Carlos IV, Fernando VII, Joseph Bonaparte, and again for Fernando VII; this is the last time we find Goya listed among the attendees at a session of the Royal Academy.[4] The artist's ease in welcoming regime change became the subject of satire in a letter to the editor published on April 13 in the ultraliberal (or *exaltado*) newspaper, *El Conservador*. Its author, Juan Turbio, wrote to share three proposals. The first was to remove the sign identifying the street of the Inquisition and to rename it the street of the Martyrs of the Inquisition, linking in perpetuity the judges to their victims. His second suggestion was to remove the papers, books, and other furnishings from the two buildings formerly occupied by the Holy Office and open its doors to appease the curiosity of Spaniards and visitors to the city. Turbio's third proposal shifted from institutions to take direct aim at Goya:

As the celebrated don Francisco Goya, the prince of Spanish painters of this century, lives in Madrid, let the city government commission

him to draw or paint that which can be painted or drawn *ad perpe-*
tuam rei memoriam. And by the way, listen to a secret. I know from a
good source that said Goya is so patriotic that he will not fail to accept
this commission; and I add that not only will he fulfill it with his cus-
tomary mastery, but also with the lack of concern for his own bene-
fit with which he has always conducted himself. But this, Mr. Editor,
don't tell it to anyone.

Given the context of the two previous proposals, Turbio's irony is clear: his
critique targeted Goya's willingness to work for, and profit from, the regime
that paid him, and his tongue-in-cheek reference to Goya's lack of self-interest
was understood by liberal readers who presumably shared his perception of
the artist. Goya's own opinion of the events of 1820 is not known, but they
possibly inspired three allegories of the triumph of justice, and a group of
drawings of monks and nuns doffing their robes and habits. Assuming a date
of 1820 for these drawings, they offer the sole unequivocal evidence of Goya's
reaction to the *trienio liberal*.[5]

Commissions, the Royal Academy exhibition, and illness had distracted Goya
from a house he had purchased for 60,000 *reales* in cash on February 27, 1819.
Built over two decades earlier, it sat on a property encompassing more than
twenty-three acres, across the Manzanares River from the royal palace and
situated between roads leading southwest from Madrid to the hermitage of
San Isidro and west to Alcorcón. An adobe *casa de campo*, or country house, it
included a garden with a well, a patio with a second well, land for gardening,
and five white oaks planted by the previous owner. By September 1823, when
Goya transferred the property to his grandson, Mariano, he had expanded the
main house, built a house for the gardeners, and installed a pump in the well.
Ponds, conduits, hedges, and a vineyard were all improvements "on which he
[Goya] has spent considerable sums as is public and well-known."[6] Very possi-
bly, he remained in Madrid as the property was improved, for only on July 15,
1822, did he transfer administration of his houses on the Calle de los Reyes and
on the Calle Valverde to Javier, suggesting that by then he spent more time,
or perhaps even lived, at his country house.[7] Sufficiently lavish to draw public
attention, these improvements show that Goya, who once envied Martín Za-
pater's lands in Zaragoza, enjoyed his retirement as a gentleman landowner.
The house was demolished in 1909, leaving only the paintings that Goya cre-
ated, working in oil directly upon interior plaster walls, which had been trans-
ferred to canvas in the 1870s.[8] The popular rubric for these works, the "black"

paintings, seems to have originated in the mid-twentieth century and is a title best left unused, given the somberness of mind and mood it implies, corroboration of an image of the aged Goya, living isolated in his country house, creating dark visions on its walls. For this, there is no basis in fact.

Alternatively, let us imagine the seventy-four-year-old Goya, recuperated from a life-threatening illness, freed from the obligations of court and patrons, and able to surround himself with creations of his invention, unfettered. By the time he transferred the house to his sole grandson, he had populated the walls on the ground and first floors with a strange cast of characters in fourteen paintings: six larger scenes and four pairs of paintings on either side of doorways on the shorter ends of long rectangular rooms. As with his etchings, Goya left no titles: these were assigned after his death in an inventory by the painter Antonio Brugada, which probably dates to the 1830s. Scenes of a pilgrimage and a witches' Sabbath (pl. 30) dominated the ground floor, with the figures of old men, a young woman, a giant (commonly identified as Saturn) devouring a human, and Judith on either side of its two doorways. Windows dividing the long walls on the upper floor made four large scenes necessary: a procession (identified by some writers as an Inquisitional parade), two fantastic images of figures in flight, and men dueling with cudgels. The smaller scenes around the doorways included two women and a man, men reading, and a small dog, his body mired in paint that threatens to drown him as he looks upwards, seeking help from a master no longer visible. X-rays show landscapes beneath several of these paintings; under the cruel giant identified as Saturn, a lone man dances.[9] Having little in common with Goya's style, these pastoral subjects, appropriate to a country house, were presumably in the house when Goya purchased it. Their presence may even have inspired Goya to take up his brush; only partially in jest might we compare him to a new homeowner today, whose first task is to cover offensive wallpaper or wall colors in her new home. But what exactly was on the walls when in 1823 Goya left the property to his grandson, and whether the images we identify with Goya had fully taken form, are lingering questions.

The experience of viewing whatever Goya originally painted surely had little in common with that of the thousands of visitors to the Museo del Prado today, who view the paintings transferred to canvas, restored, framed, and expertly lit in a single spacious gallery. In Goya's country house, light was minimal, particularly on the lower floor, so that figures emerged from dark distances to be discerned even during the day within shadows, or possibly illuminated by candle or oil lamp. After Goya painted the scenes, he created his gallery by using decorative paper borders (like paper cornices, these were commonly used by the early nineteenth century) to frame the images,

separating them from the patterned wallpaper surrounding. The greater detail of the frames on the ground floor suggests that this may have been the more formal, or possibly the more public, of the two decorated rooms.[10]

Whether consciously or not, Goya conjured earlier works. Creating a decorative sequence of large-scale figural compositions adjusted to the walls of a country residence brought back the format of his early tapestry cartoons, sized to rooms in the palaces of El Pardo and El Escorial. As with those cartoons, the dimensions of compositions for his country house were determined by the space they occupied: larger compositions for the long walls (broken by windows on the upper floor) and smaller pieces above or to either side of the doors. The description of the house as a *casa de campo* in the purchase agreement recalls the Alameda of the duke and duchess of Osuna, for which the duchess had commissioned country scenes fitted to moldings in 1787 and six paintings of witchcraft subjects eleven years later. Goya revisited these subjects, appropriate to retreats beyond city gates that served for relaxation and amusement. A scene of a village procession painted for the Alameda over three decades earlier metamorphosed into eerie pilgrimages; his small painting of a witches' Sabbath for the same patron expanded to cover a wall (pls. 15 and 30). However, while the central he-goat devil is the focus of the Osuna painting, the awestruck and terrified devil worshippers (pl. 30) were the original focus of the composition in Goya's country house, as documented by early photographs. This changed when the painting was cropped, presumably by Salvador Martínez Cubells, who restored the works upon their arrival in the Museo del Prado; about four-and-a-half feet on the right of the canvas were lost, eliminating a view into a distant, dark landscape and shifting the focus from the terror in the faces of the audience to the devil's dark silhouette.[11]

The irrational world of the *Disparates* played out on a grand stage at Goya's country house. In those etchings, two men in masks confront one another; at the country house, they bore cudgels and fought, mired knee-deep in paint; men in sacks who parade forth from darkness in the *Disparates* were transformed into music-making revelers, or monks and nuns processing from the distance to confront the viewer; the small dog who once protected his tormented master was now mired and helpless. The world of Goya's imagination threatens our own as processions advance toward us, as if we are their goal; and even today, the young woman sitting quietly observing, on the right of the *Witches' Sabbath*, becomes our intercessor as we approach. These theatrical traits have led many, including this author, to suggest that Goya painted for an audience, emulating entertainments of magic lanterns and phantasmagoria that had been offered in Madrid since the 1790s. By 1820 señor Mantilla continued to offer a "phantasmagoria machine," in his central

Madrid apartment, possibly first introduced to Madrid by another showman in 1807. The illusions offered included "skeletons, phantoms, portraits of famous men and the tomb of Creus; ending with the amusing silent scene of the Dismembered one."[12] Given such an "amusing" subject, Goya's corpse-devouring maniacal giant was perhaps far less shocking to his contemporaries than it is to modern viewers.

Javier assumed responsibility for the country house in 1830; upon his death twenty-four years later, his son Mariano retained the property. He lost no time in seeking appraisals of the fourteen paintings with subjects that, according to one appraiser, "only their creator could today explain"; the paintings were appraised at values ranging from 120,000 to 220,000 *reales*. With the purchase of the house in 1859, "various deteriorated paintings on the walls" were noted.[13] In his 1867 monograph on Goya, Charles Yriarte claimed that that paintings could not be removed from the walls and were "condemned to death."[14] His naysaying did not deter the Baron Frédéric-Emil d'Erlanger, a French banker of German origin, from purchasing the house in 1873: he paid for the transfer of the paintings from the plaster walls to canvas before exhibiting them at the International Exposition in Paris five years later. Eventually returned to the Spanish government, they entered the collection of the Museo del Prado.[15] It was the restorer Martínez Cubells who in 1874 commissioned Jean Laurent to photograph the works, giving us the sole visual evidence of the original installation, dated to Goya's day on the basis of the early nineteenth-century style of the wallpaper and fictive frames seen in the photographs. Still, assumptions based on the paintings as we see them today remain tentative. Given their deteriorated state in 1859, unknown and possibly untrained hands may have undertaken "improvements" to them even before Laurent photographed them. Comparison of those photographs with what remains shows a more nuanced handling than what we see today, both in the definition of expressions and in the volumes of figures, flattened by the restorer's brush. Goya's subtlety was replaced by a bravura application of paint that came to be inextricable from the modern conception of his genius.

Much remains to be said about these works, but most relevant to the story of Goya's life is the subject of the painting originally to one side of the ground-floor door, a woman who observed all who entered (pl. 31). In his inventory Brugada identified her as "La Leocadia," a reference to Leocadia Weiss, who joined Goya in Bordeaux, where Brugada, a liberal in exile, knew her: writing to Moratín after Goya's death, Leocadia stated that Brugada witnessed Goya's passing.[16] The painting we see today differs significantly from that revealed by X-ray, in which "Leocadia" rests her left elbow on a frame,

standing further back in space, her resting arm foreshortened. Her face was originally rounder, with fuller volumes of cheeks, lips, and nose; her eyebrows higher, and more defined.[17]

Born on December 9, 1788, Leocadia was the daughter of Francisco Zorrilla, whose first wife was Josefa Galarza, a widow with a daughter, Juana Galarza, whose own daughter eventually married Javier Goya. Josefa Galarza died, and Zorrilla married a second time to father Leocadia, who thus had a distant relation, through marriage, to Goya. In 1807 Leocadia married Isidoro Weiss, named for his German-born father, the proprietor of two jewelry stores in Madrid; her dowry of 274,884 *reales* attests to the comfortable situation of her family. The couple had three children: Joaquín, born in 1808; Guillermo, born on January 31, 1811; and Rosario, born on October 2, 1814.[18] If the elder Isidoro hoped to shore up his failing business with the windfall of Leocadia's dowry, he was soon disappointed. By his death in March 1812, the business was in ruins, and within two days of his death his son Isidoro sought a representative for his interests; Leocadia's brother served as a witness.[19] Settlement had yet to be reached over a year later when the *Diario de Madrid* published the order of a judge for all creditors and other parties interested in the Weiss estate to convene at his house at nine in the morning on November 28.[20] Finances were not the only problems plaguing the Weiss-Zorrilla marriage. On September 1, 1811, the younger Isidoro consented to gathering "information from witnesses on the conduct and illicit behavior of his wife, doña Leocadia Zorrilla,"[21] a notice that inspired writers to make the leap identifying Goya as the unnamed object of this illicit behavior.[22] Leocadia and the young Isidoro were reconciled by October 2, 1814, the birth date of Rosario, documented as the daughter of Isidoro Weiss.

Seven years later Rosario provided the first documented connection between Goya and the Weiss family: "At an early age in consequence of the misfortunes experienced by her family, she [Rosario] saw herself placed at the side of the celebrated painter D. Francisco Goya, her relative. That genius, recognizing the great talent and beautiful disposition that she showed from an early age, began to teach her drawing at seven years of age at the same time she learned to write."[23] Rosario thus began her studies with Goya in 1821, as he withdrew from public life in Madrid. Three years later, Rosario, her mother, and brother were united (presumably, reunited) with Goya in Bordeaux. Goya's friends in Bordeaux and Madrid took his relationship with Leocadia in stride, suggesting that the still-married Leocadia, and her children, had already lived with the artist during the constitutional government, beyond city walls, at his country house.

Farewells

1821–June 1824

THE reestablishment of the constitution in 1820 brought the return of many who had left Spain because of their support for either Joseph Bonaparte or the constitution. Moratín was among them and settled in Barcelona with the hope of realizing the publication of the complete works of his father, Nicolás Fernández de Moratín. His close friend Juan Antonio Melón González, with whom he had lodged in Paris, returned to Madrid; their correspondence would prove crucial to our knowledge of Goya in Bordeaux. In March 1821 Moratín wrote to Melón asking him to enlist Ceán to oversee printing the portrait of his father for the complete works; on August 7 Moratín sent him twelve copies of the book with a distribution list that included Ceán; Melón saw that Goya also received a copy.[1] Moratín's contentment in Barcelona was not to last. He mentioned in the letter of August 7 three reported deaths in Barcelona from yellow fever, adding that if more deaths were reported, he would have to uproot once again. After two weeks of deliberation, he departed from Barcelona on August 22, traveled to Girona to await news, and then decided to enter France through the southwestern town of Perpignan; traveling westward, he arrived at Bayonne.[2] There, he wrote to Manuel Silvela y García Aragón, a Spaniard now settled in Bordeaux, to ask if "an honest man will be able to live comfortably in that city for twenty-five duros monthly, subtracting from that sum the cost of a single meal daily, the rent of a room with furniture and help.... You will tell me also if there are around there many Spaniards of the kind that I cannot tolerate."[3]

Silvela had served as a judge on the criminal tribunal during the reign of Joseph Bonaparte,[4] and his defense of Spaniards in that role led to an invitation to remain in Spain following the restoration of Fernando. He chose instead to settle in Bordeaux, where he founded a school for the children of

émigrés from Spain and her colonies; by 1822 he had as many as thirteen students.[5] His response to Moratín's query was apparently both prompt and reassuring, for in mid-October 1821 Moratín wrote to Melón from Bordeaux: "The city you already know, and there is no point in telling you how much I like it. The only bad thing (and even abominable) is it not being as inexpensive as Tarbes or Ortez; but the theaters, walks, the beautiful river, the streets, the shops, the people, and an infinity of things have to cost something."[6] Moratín was soon invited to live with the Silvela family, and in March 1822 the playwright found himself comfortably installed in a large room, with a garden and spacious salons, where he could dally before going to the theater nightly,[7] content not only with his new lodgings but with a new "family" with whom he would spend his last years. Having relocated with the family to new lodgings in August 1823, Moratín was giddy with delight as he described his "magnificent room, with a large parlor, two rooms behind that, and on the side a *cabinet* (that is, a study). . . . I don't want to say anything about the wallpaper, the moldings, the bas-reliefs on the doors and windows, or of the mirrors."[8] As Moratín delighted in bas-reliefs and moldings, supporters of the constitutional government in Spain were fleeing once again, following the triumph of royalist forces in 1823.

———

By 1821 guerrilla warfare was on the rise throughout Spain, as royalist *partidas* formed in opposition to the constitutional government.[9] In Madrid, Javier Goya's name appeared on August 23, 1821, in the *Diario de Madrid,* as one of four men who the previous day volunteered for the infantry of the militia of the constitutional municipal government. Almost a year later, this same militia quelled an uprising by the absolutist royal guard during the night of July 6–7, 1822, an event that led to an increased polarization of political factions. Suspicion that Fernando VII played a role in instigating the uprising led to the replacement of the moderate Martínez de la Rosa by the ultraliberal general Evaristo San Miguel as secretary of state and virtual president of the government (a position that did not exist at the time). Beyond the Pyrenees, the liberal suppression of the royalist coup proved to governments throughout Europe that forces within Spain could not alone reinstate the absolutist monarchy, which European leaders considered paramount, given the influence of the 1820 coup as inspiration for liberal revolutions in Naples and Portugal in 1820 and the following year in the Piedmont.[10] From Bordeaux, Moratín reported to Melón on June 8, 1822, that pro-monarchic forces 1,800 men strong were about to enter Spain through two points, Ollorón and Puigcerdá. But this number was trivial in comparison with the one

hundred thousand French forces ordered into Spain the following January by the French king, Louis XVIII, under the command of his nephew, the duke of Angoulême. Even before these "100,000 sons of Saint Louis" crossed the border into Spain, the constitutional government left Madrid in March 1823 to establish itself in Seville, with Fernando VII in tow. When in mid-June the advance of French troops forced the government's retreat to Cádiz, Fernando VII refused to leave and, in accord with the law of the constitution, was declared incompetent and removed under guard to Cádiz. The royalist camp would tolerate no more.

Crowds in Madrid welcomed the sons of Saint Louis as they entered the city on May 23, 1823, followed two days later by the duke of Angoulême, who promptly appointed a regency government. When the populace of Madrid demanded revenge for the forced transfer of Fernando VII to Cádiz and proposed that any relatives of the liberal deputies who supported these actions be held hostage until the king's release, Angoulême proved a moderating force and opposed those in Madrid who wished to persecute constitutional volunteers.[11] But after a fire in July, thought to have been set by liberals, damaged the church of Santo Spirito in which the duke worshipped, he left Madrid, and also left liberals without a safeguard.[12] On July 24, 1823, the *Gaceta de Madrid* published the order that all volunteers in the constitutional militia (in which Javier had enlisted) could neither be employed in any sector nor retain any honors until the return of the king.[13] To accommodate the growing number of liberals arrested, the newly appointed superintendent of police, Julián Cid, proposed construction of a new jail. An alarmed minister of grace and justice suggested to the minister of the interior that courts be urged to show leniency to the detained, but when Angoulême ordered from the town of Andújar that political prisoners be released, many liberals preferred to remain incarcerated rather than face the wrath of Fernando's supporters on the streets of Madrid.[14]

What impact did these events have on Goya? By the decree of June 27, employees of the royal household hired by the liberal regime were dismissed, employees dismissed by the liberal regime were reinstated, and those who since 1820 had retained positions held prior to the liberal regime were to be investigated. If Goya was among them, no records survive. But the instability that preceded Fernando's return to power in October may explain the visit paid by Goya and Javier to the notary Antonio López de Salazar on September 17, when Goya signed his country house over to his seventeen-year-old grandson Mariano; Javier accepted on the minor's behalf. Although Goya's transfer of the property to Mariano has been interpreted as a sign of his devotion to his grandson, Javier's political involvement and, by September 1823,

the possibility of repercussions against him, might explain Goya's desire to secure the title to the house by transferring ownership to Mariano. Within a week the royalist regency softened the terms for voluntary militiamen, who would be excused if their intent was to maintain public order;[15] no evidence that Javier suffered any consequences has come to light.

Another figure enters Goya's story around this time, a doctor of canon law, José Duaso y Latre. A native of Aragón, he had arrived twenty-two years earlier in Madrid and served both Carlos IV and Fernando VII; on May 30, 1823, he was appointed director of the official *Gaceta de Madrid*. According to a biography written one year after his death in 1849, his "house served as a refuge for various friends and compatriots compromising the liberals, whom he hid or lent protection to as necessary. Among them we can count the celebrated Goya, his compatriot and friend, whom he lodged in his house for three months. With this motive, the celebrated artist proposed to paint him."[16] Even though Duaso's commitment to the absolutist government argues against his possible sympathy to liberals, it has long been accepted that Goya, endangered by the restored king, took refuge with Duaso in early 1824, the date inscribed on Goya's portrait of his alleged host.[17] But his biographer implies that Duaso's protection of liberal refugees occurred shortly after his appointment as director of the *Gaceta* in 1823 or during the interim government appointed by Angoulême, when liberals most feared for their safety; turning to 1824, the writer discusses Duaso's appointment to an advisory council formed to oversee the museum of natural sciences. Let us consider Goya taking refuge with Duaso in late summer 1823, in all likelihood in one of the houses owned and rented by the church of the Buen Suceso, of which Duaso was administrator, described in an 1815 guidebook as including a small "hospital," or hospice, for those in service at the royal palace.[18]

Why did Goya need lodging in Madrid in 1823? The author of the 1843 obituary of Rosario Weiss implied that the return of the royalists led to a separation of Goya and Rosario (and presumably Leocadia): "When in 1823 [*sic*] Goya went to Bordeaux [Rosario] Weiss was put in the care of Don Tiburcio Pérez"[19]—that is, the architect portrayed by Goya three years earlier. Though wrongly given as the date of Goya's departure to France, 1823 may in fact be the date of Goya's separation from Leocadia and her children, assuming they lived together at his country house, for theirs was a situation that returning conservative royalists, now more fervent than ever, would not abide. Their departure from the country house would also justify its transfer to Mariano in September. Having transferred the administration of his houses in Madrid to Javier in 1822, Goya possibly found himself without a residence; his former house on the Calle de Valverde was apparently fully occupied,

given that a year later Javier exercised his proprietary rights and brought a suit to evict the occupant of the main floor, having decided that he did not have sufficient space on the upper floor.[20] The obituary of Rosario says nothing of the whereabouts of her brother Guillermo or her mother; one theory is that Guillermo's participation in a liberal militia for children incriminated both him and his mother,[21] who may have found refuge elsewhere, possibly with her husband.

Goya's involvement with Duaso must somehow be linked to his familiarity with the cleric's nephew, Ramón Satué, orphaned at an early age and educated by his uncle. A supporter of the Spanish government in exile during the Napoleonic occupation, Satué was appointed to a position in 1814 by Fernando VII and remained loyal to the king during the liberal triennial; by 1823, when he sat for Goya, he was magistrate in the court of Madrid and a resident of the Buen Suceso (pl. 32).[22] Goya's portrait of him, inscribed with the date 1823, is a fitting tribute to a man described in his obituary as "handsome, generous, popular, and good-willed,"[23] and leads us to ask if Goya found in Satué an ally within the court of Fernando VII. His portrait of Duaso, dated the following spring, pales in comparison, its deficiencies noted even by Duaso's biographer: "It was a shocking thing, that in spite of his [Goya's] undeniable ability and having begun the portrait as many as four times, he did not manage to capture entirely his appearance."[24]

From Bordeaux, Moratín revived his relationship with Goya, whom he had last mentioned in his correspondence six years earlier. On August 28 he wrote to Melón: "On my part there is no problem that you have given a copy of the *Posthumous Works* to my old friend Goya, and I believe that it would not have bothered the author. You will tell Goya that I greatly appreciate his praises, dictated by friendship; I have always loved him well, and the news you give of his good health pleases me to the greatest extent. Commission him on my behalf to paint, to take great care of his health, and wish that he lives even half of what his works will live."[25] The image of Goya receiving, reading, and commenting on the works of Nicolás Fernández de Moratín as the liberal government met its end calls into question assumptions of the artist persecuted, isolated at his country house, or in hiding with Duaso. Moratín subsequently asked Melón to give his regards to Goya in a letter of October 10, 1823, and again in a letter the following May, shortly before he greeted the artist upon his arrival in Bordeaux.

By spring 1824 Goya's affairs and properties were in order. On February 19, 1824, before a notary of the royal household, he transferred to a certain Gabriel Ramiro the "widest power needed" to administer his financial and legal matters. On May 2 he requested a six-month leave to take the waters in

Plombières (today, Plombières-les-Bains, Vosges, France) to alleviate unspeci-
fied ills; the *sumiller de corps* approved the request on May 28 and royal permis-
sion was communicated to Goya two days later.[26] On June 24 the subprefect
of Bayonne reported to the French minister of the interior: "Don Francisco
Goya, Spanish painter whose passport is enclosed, has received from the town
hall of Bayonne a provisional pass for Paris. He proceeds to that city to con-
sult with doctors and to take the waters that have been prescribed for him."[27]
A second document, signed by the subprefect almost three months later, gives
another motive for Goya's departure from Spain: "I am sending you the pass-
port of Doña Leocadia Zorrilla accompanied by two children, to whom was
given a provisional pass for Bordeaux where she is going to rejoin her hus-
band."[28] But her husband, Isidoro Weiss, remained in Madrid.

Paris

1824

H AD he remained in Madrid, Goya would have faced waning oppor-tunities, as politics and deaths claimed his friends and patrons, and a younger generation of artists came to the fore. France reinvigorated him. He began to draw in crayon, introducing a new freedom of line and form as he represented novelties seen on the streets of Paris and Bordeaux: fig-ures on newfangled roller skates, women in shoulder chairs carried to the theater, and attractions seen at the Bordeaux fair. Adding to a vocabulary of images honed over decades, he imagined isolated madmen lost in their delu-sions, dancing crones, and an aged man and old woman cackling as they ride high on untethered swings. The *majas*, their attendants, and children first in-troduced in his tapestry cartoons reemerged from ink patterns on slivers of ivory; fantasy and memory coalesced in the *Bulls of Bordeaux*. In his portraits, Goya paid tribute to friends and business associates, both French and Span-ish, who aided him during his final years: Leandro Fernández de Moratín, the banker Jacques Galos, and Juan Bautista de Muguiro, the brother-in-law of Javier's sister-in-law, Manuela Goicoechea. Appropriately, he used lithog-raphy for his portrait of Cyprien Charles Marie Nicolas Gaulon, the master lithographer, who published the *Bulls of Bordeaux* in 1825.[1]

Why Bordeaux? Goya may have heard from Melón of Moratín's satisfac-tion with the city, with a cost of living far more manageable than that of Paris, as Goya would later tell his son. There was also a growing community of ex-patriates, as the triumph of conservative forces in 1823 brought emi-grating Spaniards to the city in numbers far greater than those of the pre-vious decade, when Spaniards arriving in Bordeaux spent, on average, only seven months before being resettled elsewhere in France.[2] On August 5, 1823, Moratín reported that Bordeaux was "filling up with Spaniards, both men and women, and little Spanish boys and little Spanish girls. I, thank God,

don't deal with any of them."[3] They continued to arrive: in December, he remarked that the border was "flooded" with Spaniards, and the following February noted that "we are up to our necks in *marqueses*, and one does not go out without seeing a Marquis or a little Marquise."[4]

Another possible influence on Goya's decision to settle in France was the emigration of Javier's now-widowed father-in-law, Martín Miguel de Goicoechea, who arrived in Paris in early summer 1823 accompanied by his daughter Manuela and son-in-law, José Francisco Muguiro. Like most Spanish émigrés, they were known to the French police, who reported on November 11, 1823, that the family had lived in the Hôtel de Castille on the rue de Richelieu for about four months: "The Goicoecheas are known in Paris as estimable people. They receive few people, don't concern themselves at all with political intrigues, and hardly leave their hotel, except to go to the theater or visit other public establishments."[5] During the liberal triennial, the elder Goicoechea served on the chamber of commerce (*comercio de la corte*) and Muguiro was a member of the municipal government, activities that possibly incriminated them in the eyes of the restored government. Another likely motive for their departure was a desire to protect their fortunes and business by escaping the political and economic instability that accompanied the restoration of Fernando VII.

On June 27, 1824, Moratín reported Goya's arrival in Bordeaux to Melón:

Goya in fact arrived, deaf, old, awkward, and weak, and without knowing a word of French, and without a servant (that no one needs more than he), and so content and so desirous to see the world. He was here for three days; two of them he ate with us like a young student; I have insisted that he return by September and not get bogged down in Paris and be surprised by the winter, which would be the end of him. He has a letter so that Arnao sees to his lodging and takes as many precautions with him as are necessary, and there are many, and the most important of them, to my understanding, that he not leave his lodgings except in coach; but I don't know that he will pay any attention to this condition. We'll see if he's alive after the journey. I would greatly regret were anything to happen to him. I enclose a letter from him.[6]

Having not seen Goya for over a decade, Moratín was struck by the changes between the sixty-seven-year-old he had last seen before leaving Madrid in 1813 and the seventy-eight-year-old who arrived at his door. Perhaps for this reason he overstated Goya's fragility, for three days later the artist was en

route to Paris, where he arrived on June 30. We might ask if the letter that Goya gave Moratín to send to Melón was in fact for Leocadia—who, as will be seen, also knew Melón.

Arrived in Paris, Goya found his way to Moratín's longtime friend the lawyer Vicente González Arnao, a scholar and jurist who had served as a prefect of Madrid under Joseph Bonaparte, to whom Moratín sold the manuscript of his plays and poetry, published in Paris in 1825.[7] Arnao had arrived in France in 1814 and worked in Bordeaux for the French government, tracking newly arrived servants of the Bonaparte regime in Spain who were to receive support from the government.[8] Eventually settled in Paris, he put his legal skills to the service of the growing community of Spanish aristocrats and businessmen, many of them invited to salons he held in his house on the rue Faubourg-Montmartre. Arnao found Goya lodging at the Hôtel Favart on the rue Marivaux (across from the Théâtre des Italiens), where the nineteen-year-old businessman Jerónimo Goicoechea, who had arrived in Paris the previous October to join his uncle Martín Miguel, also stayed.[9]

Police surveillance of Spanish émigrés in Paris was routine. The countess of Chinchón arrived in Bayonne on March 21, 1824, accompanied by her sister and brother-in-law, the duke and duchess of San Fernando de Quiroga, with Paris as their destination. There, the police report outlined the countess's background and remarked that her brother's involvement in the constitutional government had influenced the entire family and that the countess's house at 24, rue Chantreine was a gathering place for liberals.[10] The prefect of police also deemed Goya a person of interest in advance of his arrival in Paris and ordered a report on his comings and goings and any preparations for departure, as well as surveillance to see if he "entertains suspicious relations that his employ at the court of Spain would make even more inconvenient." The report of July 15 concluded that Goya was of little interest:

This foreigner arrived in Paris on June 30, and settled at rue Marivaux, no. 5. The surveillance of which he has been the subject has not been able to uncover that he had any regular relations with any of his compatriots; he never receives anyone at his lodgings, and the difficulty he has in speaking and understanding French keeps him often at home, which he leaves only to visit the monuments and stroll in public places. Although he is seventy years old he seems older than his age [in fact he was seventy-eight], and beyond that is extremely deaf.[11]

Goya apparently paid no heed to Moratín's instructions to leave his lodging only in carriage, choosing to play the flâneur, enjoying the sights offered

by the streets of Paris. Only one memory specific to the French capital is documented by a drawing of an aged and infirm figure in a two-wheeled cart drawn by a dog, captioned "I have seen it in Paris."[12] Goicoechea had departed for England with his daughter and son-in-law eleven days before Goya arrived; they returned to Paris sometime after August 15, when they were documented in the northern French city of Valenciennes.[13]

The police report on Goya argues against his attendance at the salon of Arnao, as other authors have suggested, as do his age and deafness.[14] His visits to two other influential émigrés are documented: the duchess of San Fernando de Quiroga, with whom he renewed an acquaintance dating back to his inclusion of her in 1784 as an infant in the arms of a servant in the portrait of the family of don Luis, and Joaquín María Ferrer Cafranga. The well-positioned Arnao possibly introduced Goya to Ferrer, a businessman who made his fortune in the New World before returning to Spain, where he served in the administration of the National Bank of San Carlos and the Philippines Company during the liberal triennial. He was also a member of the *cortes*, which he followed to Cádiz. When in 1823 the king's restoration seemed imminent, Ferrer traveled from Cádiz to Gibraltar and through personal connections secured a passport for France, where he arrived, following a detour to England, in December 1823. The French police considered him a risk, but a major banking house intervened on his behalf with the French minister of foreign affairs, Chateaubriand, who approved Ferrer's sojourn.[15] The French government nevertheless requested information from the Spanish police, who wrote that Ferrer's fortune had been augmented by his purchase of confiscated religious properties under the liberal government, but his self-interest and avarice prevented him from making any sacrifice for his politics. He was not as dangerous as might be feared, circumspect, "with the appearance of calm and sang-froid."[16] Those traits served him well: he returned to politics in Spain, following the death of Fernando VII, and purchased for 1,000,000 *reales* a residence at 13, Calle del Desengaño, not far from where Goya once lived.[17] In a somber portrait, Goya captured Ferrer's reserve: he sits erect against a dark background, with an averted gaze that suggests a preoccupation with his own thoughts.[18] The book he holds is a fitting reference to his publishing ventures, which included an edition of *Don Quixote de la Mancha* in miniature with ten engravings produced in Ferrer's "modern type and engraving shop" (tipografía y calcografía moderna) and printed by Jules Didot in Paris, 1827.

Goicoechea, his eldest daughter Manuela, and her husband returned to Paris and applied for passports for Bordeaux on August 31; Goya requested his the following day, and Jerónimo Goicoecha, Goya's companion at the Hôtel

Favart, followed them to Bordeaux in October.[19] Writers often imagine that Goya attended the Salon of 1824, today best remembered for Delacroix's tribute to the Greek wars, *The Massacre at Chios*, or Ingres's *Vow of Louis XVI*. But when the salon opened on August 25, Goya, recently reunited with family, was preparing for his return trip, having found himself without money and taking up the offer of "friends" who advanced him the cost of the journey.[20] If he had ventured to the Salon during its first week, the crowds and myriad paintings of French history and mythological and religious figures covering every wall, unmediated by art historical selection of iconic works, would surely have overwhelmed him.

If we are to imagine encounters, a more interesting meeting would be that of Goya and a young admirer, the twenty-six-year-old Eugène Delacroix. A friend of Louis and Félix Guillemardet, the sons of the ambassador to Spain whose portrait Goya had painted in 1798, Delacroix knew the portrait, and possibly through the Guillemardet family discovered *Los Caprichos*. He recorded in his journal on March 19, 1824, that he "saw the Goyas, in my studio," and mentioned on April 7 that he was working on caricatures in the manner of Goya.[21] Over thirty years later Delacroix assisted Laurent Matheron in writing the first book-length biography and catalogue of Goya by asking Louis Guillemardet to allow a young artist working with Matheron to see the portrait of Guillemardet and one other in his collection.[22] Matheron's book, published in 1858, was dedicated to Delacroix.

The goal of a biography is to study a life, rather than focus on an artist's work, but there is always hope that lives examined will shed new light on the oeuvre. Looking at 1824 brings disappointment, for still we are without any clues to one of Goya's most intriguing female portraits, signed "Goya, 1824," in which the artist seems to channel simultaneously both Ingres and Manet (pl. 33). The assignment of the name "María Martínez de Puga," presumably a relative of Dionisio Antonio de Puga, a witness to Goya's assignment of power of attorney in February 1824, is tenuous at best.[23] The sitter is a young woman of means: her watch and chain recall those worn by the well-to-do Mrs. Ferrer in a portrait pendant to that of her husband, to which the young woman adds a necklace and earrings.[24] Having sketched in her head and face, Goya defined her black dress with broad strokes of black, applied with an unprecedented freedom, adding touches of lead white to define folds and highlights. He freely applied the same lead white, mixed with gray, to suggest a handkerchief, easing the transition between the sitter's dark dress and white-gloved hand. Returning to her face, Goya brought into

play the colors seen throughout the portrait, as he had done five years earlier in painting Juan Antonio Cuervo. The handling is more subdued than that of her dress, as he defined her black brows and brown eyes, and enlivened her young face with touches of pink verging on orange, repeated in small strokes amid her brown curls and headband. Perhaps at this point he brushed in the abstract background, before returning with a very stiff brush or pliable reed to brush in highlights along her neckline frill. Not content, he scratched out darker tones at the base of the sitter's neck, before adding her earrings, necklace, and watch.

Given the stark contrast between this portrait and the somber effigy of Duaso y Latre painted during Goya's last five months in Madrid, it is inconceivable to this author that Goya painted it prior to his departure from Spain. The work announces a creative liberation analogous to that of the crayon drawings and experimental miniatures he undertook during his first year in Bordeaux. Perhaps a young wife or daughter of a well-to-do member of the Spanish expatriate community, she sat for a rejuvenated Goya in Paris or possibly in his new home.

Unsettled in Bordeaux
September 1824–June 1825

Moratín returned to Bordeaux from a stay in the country in September 1824 to find Goya with the "Señora and the children," in a good, furnished room, situated in the center of town at 24 (today, 38), cours de Tourny.[1] This is the earliest known reference to Leocadia Weiss as Goya's domestic partner, who with her children Guillermo and Rosario had entered France six days earlier, ostensibly to join her husband.[2] In Madrid, her legal husband remained burdened by creditors and increasing poverty, to end only with his death in October 1850; his death certificate described him as married to Leocadia Zorilla and stated that he died with neither a will nor funds to pay for his interment: he was buried in a charity grave.[3] Moratín's reference to Leocadia as "la señora," implies that he knew of her, and his passing reference to her cohabitation with Goya leaves no doubt that the relationship was also known to Goya's friends.

Moratín also mentioned that Goya wanted to paint his portrait, "and from that you can infer how pretty I am, when such skilled brushes aspire to multiply copies of me."[4] A tribute of friendship, the portrait shows the writer casually attired in a brown dressing gown and dark blue pants, his contemplative and intelligent face set off by a white collar as he looks up from his papers, one bearing the signature "Goya" (fig. 42).[5] His dress suggests that Goya painted him at home; radiography reveals several changes were made, perhaps trying the patience of the sitter, who wrote to Melón on September 30: "Another day when I have more time I will write to you; but this Goya is a becoming a bother, and doesn't leave me for a moment."[6]

Moratín's comment on October 23, "Goya is here with his Doña Leocadia; I don't see the greatest harmony between them," suggests that the situation of the newly expatriated couple had its tensions, but these did not lessen Goya's delight in the eleven-year-old Rosario Weiss, evidenced in a letter to

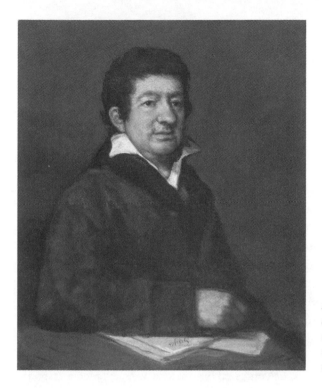

42. Leandro Fernández de Moratín, 1824. Oil on canvas, 23 ⅝ × 19 ½ in. (60 × 49.5 cm). Museo de Bellas Artes, Bilbao.

Ferrer written five days later. Following opening courtesies, he turned to his main motive for writing:

> This celebrated child wants to learn to paint in miniature, and I also wish this, since she is perhaps the greatest phenomenon in the world doing what she does at her age; she is endowed with very appreciable qualities as you will see if you favor me by contributing to it; I would like to send her to Paris for some time but I would want for you to have her as if she were my daughter, offering you compensation with my works or my wealth; I send you a small sample of the things that she does that have astounded all the professors in Madrid as I hope will be the case there; show it to all the professors and particularly the Incomparable Monsieur Martin and if it wouldn't fatten the letter I could send you many more.[7]

No response from Ferrer is known, and Rosario remained in Bordeaux.

Fall was time for the Bordeaux fair. Dating back to the Middle Ages, it had once brought merchants from throughout France to the city to sell fabrics, laces, buckles, and other accessories; jewelry, hardware, spices, foodstuffs,

and wine. The French revolution brought the fair's decline and by the time Goya visited, the event had moved from the stock exchange to its outdoor square and nearby quay, with jugglers and acrobats, tightrope walkers, and wild animals as its main attractions. A trio of dwarfs caught Goya's eye and inspired three drawings (or conceivably a single drawing with three figures), known only from his letter of late November to the duchess of San Fernando de Quiroga: "I take the liberty of sending to Your Excellency these commissioned three, to whom I give the special charge of assuring you how grateful I am for the memory you keep of me, and how much I wish to please and serve you. They are three dwarfs who appeared in the Fair of Bordeaux two months ago, and it seemed opportune for me to try to capture their faces and small figures. He with the little pants measures 18 pulgadas, of the other two (who are man and wife) she measures 21 pulgadas and the husband 20. I will celebrate that they carry out their commission, according to the wishes of the invalid who sends them." Goya also explained to the duchess his hurried departure from Paris three months earlier, writing, "I had a few extra hours, and asked that they bring to the house of Your Excellency a card of farewell. Had this not happened, I would not have overlooked the honor of offering myself at the feet of Your Excellency and the duke." Comfortable in his relationship with the duchess, he confessed his concern as he awaited a response to his request for an extension to his six-month leave, sent to Madrid two days earlier: "Here I am, without knowing what I should do with myself. I have asked for an extension of my leave to be able to spend the winter before the warmth of my hearth, and I don't know if His Majesty will be so kind as to concede it to me."[8]

Feeling his years, or perhaps coming to terms with a new life as he found himself removed from his homeland, old and deaf among strangers, and with more time to think, Goya became anxious. What was he to do if the king refused his request for an extension of his leave? By December 24, 1824, three mail deliveries from Madrid had come and gone, with no word from Javier. Goya fretted: perhaps his son disapproved of a recent investment, but how could he best ensure his own financial security? His concerns coalesced in a letter addressed to Javier in the house on the Calle Valverde. Eager for news, Goya wrote that he visited Goicoechea every day and was told repeatedly that there was nothing to report. He defended his investment in a rent-producing property, reminding Javier that monthly rents were the surest income available. And, who knows? He might, like Titian, live to be ninety-nine years old with nothing else to support him (in fact, Titian died before he reached ninety). He also introduced the businessman who served as his financial adviser, Jacques Galos, who knew that the rental property was to pass to Goya's

heirs. He continued: "I also wonder if they were to deny the extension (that would not matter as long as they don't take my salary) because this would put me on the road when the weather is at its worst. This I already told you in another letter, that although I like this town, it is not enough to abandon one's Patria."[9] Goya apparently never interpreted Javier's silence as a reflection of his or his wife's disapproval of his relationship with a woman of the same age as his daughter-in-law, possibly perceived as a threat to their inheritance.

In requesting the extension of his leave, Goya wrote that the doctors counseled him to take waters at Bagnères the following spring (moving his place of treatment from the distant Vosges to the nearby Pyrenees). No record survives that Goya ever took waters in any location, but his extension was nevertheless granted on January 13, 1825, and a reply written three days later.[10] Javier remained unresponsive, and Goya's complaints continued, leading Moratín to write to Melón the following April: "Goya says that no one from his house writes to him; that he doesn't know to what the silence can be attributed; that he is concerned and would like you to find out and tell him what is behind it all. He also asks why you do not write to him as you should some time?"[11]

As teacher to Rosario, Goya remained true to his opposition to academic methods voiced three decades earlier, and developed his own pedagogic method by drawing "for her on quarto-sized sheets of paper little figures, groups, and caricatures of things that would most call her attention, and she imitated them with extraordinary delight, working only with a pen."[12] It may have been Rosario's interest in miniature, mentioned by Goya to Ferrer, that led Goya to experiment with the format, yielding the results he described to Ferrer almost a year later: "It is true that last winter I painted on ivory and I have a collection of about forty essays, but it is original miniature that I have never seen because it is not made from dots and there are things that look more like the brushes of Velázquez than those of Mengs."[13] Three decades earlier Goya asked Zapater for his opinion of a miniature painted by Esteve, whom Goya had encouraged to paint in the medium;[14] six years later he insisted that only the imprisoned miniature painter Guillermo Ducker could do justice to his royal portraits. His own miniature portraits of Javier and his new in-laws (pls. 21 and 22) attest to his talent in the medium, and very possibly he painted other miniatures that have not survived. His interest in miniature now reawakened, Goya purchased ivory to be shaved into delicate and translucent pieces, ranging in size from about two and one-eighth inches square to about three and one-half inches square, and set to work.

If Goya's desire to teach Rosario explains his return to miniature, his realization that the detail attained in his own earlier miniatures far exceeded

the ability of his student may have inspired him to develop a new technique, described in nineteenth-century sources and confirmed by a modern re-creation.[15] Rather than building up figures through stippling (the "dots" to which Goya refers in his letter to Ferrer), he prepared the ivory surface with a binder, possibly egg white or gum arabic, and then covered it with carbon black mixed with a little water or egg yolk. Water dropped on the still-damp carbon black formed an irregular spot of white that inspired the image to come; remaining black could be wiped or scraped away, and details added with small strokes of color. The pattern left by the water on the surface sug-gested his subjects, one of them a young woman leaning on a parapet, with an old woman, traditionally identified as the legendary Spanish procuress, the Celestina, standing behind (pl. 34). The juxtaposition of youth and old age recalls the portrait of Dr. Arrieta with Goya, as the lively young woman gazes with interest to her right, smiling, and the old woman, with eyes un-defined and perhaps blind, remains oblivious. Held up to light, the translu-cence of the ivory suggests the freshness of the young woman's complexion, set off by a black veil that shadows her eyes beneath a white mantilla, both defined by delicate strokes of watercolor. In contrast, the old woman shows the ravages of age: receding hairline, unseeing eyes, sunburned cheek, tooth-less grimace, and shadows of her sagging jaw. Comparison of this miniature with Goya's 1824 portrait of an unidentified woman (pl. 33) illustrates how his miniature technique inverted that of his paintings on canvas.[16] He began the oil portrait by sketching an outline, then building up the figure with veils or denser layers of paint to culminate in two points: the subtle tonalities of her face and hair and the vigorous strokes implying her handkerchief. The back-ground was thinly brushed in. In contrast, his miniature illustrates a sub-tractive technique, as the thickest pigment defines the background, parts of which are removed, and the figures lifted out of the darkness. Deft applica-tion of colored pigments and scraping, seen on the young woman's bodice, the parapet, and within the area that separates the lovely young thing from her aged companion complete the figures.

Goya's late miniatures draw not only on his career as a painter but also on his experience as a printmaker, in which he also envisioned finished images as he worked by subtraction. Two etchings in *Los Caprichos* are created fully in aquatint, with no etched line.[17] In them, he conceived the image in tonal reverse: a form that prints as white (showing the paper support) would have to be "stopped out" on the plate at the outset (that is, covered with an acid-resistant ground prior to exposing the plate to the etching acid); in a painting however, a white highlight would be a final touch and layer of paint. After one exposure to the acid, Goya stopped out middle tones to prevent deeper

etching; he would do this for each tone until the darkest blacks were etched most deeply. In a rare print of a seated giant, he again worked from dark to light, covering the plate with aquatint that would print as solid black, and then defining forms with a burnisher, which flattens the reticulated surface of aquatint so it holds less ink and prints as a lighter tone or absence of tone. Goya's artistry coalesces in these miniatures. He soon left his student far behind, or perhaps simply marveling at her teacher, as he painted in reverse, on a scale that belies the achievement of these astoundingly beautiful works, most succinctly described by a collector as "itty bitty big pictures."

———

Surprised by the cold in Bordeaux, Goya asked Melón to purchase and send shawls from Madrid, using a grudging Moratín as an intermediary.[18] In addition to creating miniatures, Goya drew, and lacking the inspiration of summer streets and autumn fairs, he imagined madmen and monks, flying dogs and bulls, and also revisited subjects previously drawn or etched: old men and aged women, couples happy or not, human or with wings, flying in the air. But neither his work nor his new family life calmed him:

> Goya, with his seventy-nine Easters and his chronic complaints, neither knows what he hopes, nor what he wants; I tell him to keep quiet until his leave runs out. He likes the city, the country, the food, the independence, the tranquility he enjoys. Since he has been here, he has none of the ills that bothered him there; and notwithstanding, at times it gets into his head that he has much to do in Madrid, and if they allowed him, he would leave on his pack mule, with his cap and cloak, his walnut stirrups, his wineskin and saddlebags.[19]

A serious illness eclipsed his fretting. Two doctors in Bordeaux provided details of the diagnosis in a report dated May 29, 1825, and sent to Madrid: paralysis of bladder, resulting from a hardening that had also affected his senses of sight and hearing, brought him near death. The prognosis was grim given the patient's advanced age and a "voluminous" perineal tumor that made his condition "as dangerous as it is uncomfortable." In support of a forthcoming request for an extension of his leave, the doctors added that the patient was "absolutely incapable of any exercise at this time."[20] Their fatalistic tone recalls that of Zapater's words to Sebastián Martínez concerning the illness Goya suffered thirty-two years earlier: "The nature of his illness is one of the most feared, and makes me think with melancholy about his recuperation."[21] In 1825 as in 1793, Goya beat the odds.

"Only my will abounds"

July 1825–1826

W ITHIN a month of the doctors' dire prognosis of Goya's condition, Moratín reported to Melón: "Goya escaped for now the miserly Acheron: he is very full of himself and paints with a new vehemence, never wanting to correct anything that he paints."[1] Moratín mentioned Goya only once more that summer, to say that he was doing well.[2] Martín Miguel de Goicoechea died on the last day of June, aged seventy years old, and was buried two days later in the cemetery of the Carthusian monastery. Of note are the two witnesses named in the death certificate: the first, already familiar to us, is the thirty-eight-year-old José Francisco Muguiro, the husband of Manuela Goicoechea, who had lived with Martín Miguel, and to whom Javier would assign Goya's power of attorney in August 1826.[3] The second is Muguiro's brother, Juan Bautista, a businessman residing at 24, rue Esprit-des-Lois, who joined the circle of friends and relatives assisting Goya during his final years, to become the subject of Goya's last portrait.[4] From Madrid, Javier applied for an extension of his father's leave, and in early July Goya received word that he had been granted a full year.[5] Perhaps feeling more settled, he and his household relocated in October to "a very comfortable house, with northern and southern light, and a little garden: freestanding and new, where he is well." His new address, 10, rue Croix Blanche, was in the neighborhood of the church of Saint-Seurin, with modest houses, each with a garden, built on a former vineyard. Of the "family," Moratín wrote that "Doña Leocadia, with her customary intrepidity, rants at times, and at others amuses herself. La Mariquita [Rosario] speaks French like a wood lark, sews, plays and entertains herself with some other children of her age," while Goya was again in good form, telling Moratín in early October that "he has fought bulls in his time, and that with the sword in hand, fears no one."[6] Bullfighting was on his

mind, as he turned to the creation of four large lithographs published later that year, known today as the *Bulls of Bordeaux*.

Developed by Alois Senefelder in 1796, the lithographic process spread quickly through Europe. After studying in Munich with Senefelder, José María Cardano founded Madrid's first lithographic establishment in 1819, the date usually given to lithographs printed there after drawings by Goya.[7] All of these were transfer lithographs, meaning that Goya drew images on paper that were transferred to the lithographic stone to be printed. Upon arriving in France, Goya discovered lithography to be far more established and widespread. We can only wonder whether he saw the lithographs executed between 1818 and 1822 by Théodore Géricault, the French contemporary who most invites comparison with Goya: Géricault's quest for the heroism in the everyday, in soldiers wounded in the Napoleonic campaigns, noble and powerful horses, and boxers, seems driven by a spirit akin to that which compelled Goya to draw victims of the war and powerful animals, often struggling against human adversaries.[8] Goya also met Cyprien Gaulon, who in 1818 had founded a lithographic press in Bordeaux, which five years later published the *Album Bordelais ou Caprices* by Gustave de Galarde. In spite of its Goyesque title, the album's subject matter was pleasant, if prosaic, and ranged from views of the elegant Château de Haut-Brion to another of Bordeaux from La Bastide across the Garonne River; from portraits of artists and actors to those of Guillaume Dequet, a seller of ropes and cords who had recently lost his wife, and another of the late sieur Bienassé, the city rat catcher.[9]

In contrast to etching, an in-cut, or intaglio, method in which engraved or etched lines hold ink, lithography is a planographic medium, printed from a flat surface, traditionally limestone; a medium more direct than etching, it allows the artist to draw on the stone with a lithographic crayon (a special ink, or tusche, can also be used). The stone is then dampened before printing, but the greasy crayon repels water and instead holds the viscous lithographic ink applied to it; a sheet of paper laid on the stone absorbs the ink under the pressure of a lithographic press, printing the artist's drawing, in reverse, on the paper. Having turned to crayon as a medium for his drawings after arriving in France, Goya made several smaller lithographs portraying a woman reading to two children, duels, dancers, bulls, and young women with their Celestina; known only thorough rare proofs, these experiments were in all likelihood created before his lithographic tour de force, *The Bulls of Bordeaux*.[10] An account reported by Matheron states that Goya placed the lithographic stone on his easel, as he would a canvas, and "handled

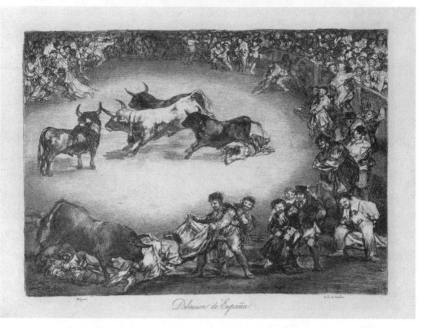

43. *Dibersión de España* (*Spanish entertainment*), from the *Bulls of Bordeaux*, 1825. Crayon lithograph and scraper, 11 ¹⁵⁄₁₆ × 16 ⁵⁄₁₆ in. (30.3 × 41.5 cm). The Metropolitan Museum of Art, New York, Rogers Fund, 1920.

his crayons as if they were brushes, never sharpening them. He usually covered the entire surface with a gray, uniform tone and brought out highlights with a scraper: here a head, a figure, there a horse, a bull; he worked standing, moving backward and forward to judge the effects. Using crayon, he reinforced shadows, accents, and defined figures."[11] As he had done in painting miniatures, Goya worked "in reverse," not only left to right (since the image would be reversed when printed) but also beginning with a tonal ground, lifting out highlights, then, with crayon rather than brush, adding accents and definition.

In *Dibersión de España* (*Spanish entertainment*, fig. 43), Goya wiped out gray tones to suggest the sun shining on the four young bulls (*novillos*), who react to the ebullience of the villagers surrounding. Lithography captured the charged gestures of Goya's hand, offering a directness and freedom unmatched by any other print technique: quick and precise strokes define each figure, highlights are scraped away and the crayon again picked up to reinforce forms, expressions, and shadows. The variety of marks and scrapes that define these amateur toreros offers a visual metaphor for the noisy and boisterous village bullring, where rowdy amateurs goad the bull and one another.

With the other three lithographs of the *Bulls of Bordeaux*, *Dibersión de España* presents memory embellished by invention. The series marks a turning point in the medium recognized by other artists: the posthumous sale of the collection of Eugène Delacroix lists two prints titled *Dibersión de España* (as well as six *Caprichos*, the rare etching of a garroted man, a Spanish dance, and a portrait of a man—Cyprien Gaulon).[12] Gaulon registered the edition of 100 for each print with the Prefecture of Gironde as they were published: one on November 17, 1825; a second on November 29; and two on December 23.[13]

With two of the bullfight lithographs published, Goya took advantage of a friend's travel to Paris to send *Dibersión de España* to Ferrer so that he could show it also to Cardano (the founder of the Madrid lithographic establishment, who was apparently in Paris). In search of an outlet for his new work, Goya offered to send as many prints as they wanted, for he had "three others of the same dimensions and subject of bulls," if they thought the print worthy of distribution.[14] Ferrer declined the offer in a letter of December 13, known only by Goya's response of December 20:

> I am aware of and convinced of what you say of the prints of bulls, but since I thought more that they would be seen by those connoisseurs who abound in that court, as well as the number of people who would have seen them without counting the number of Spaniards, I thought it would be easy, giving them to a print dealer without mentioning my name, which could have been done at little cost. What you say about los caprichos is not possible, because I gave the plates to the King more than twenty years ago along with the other things I have engraved that are in the calcografía of His Majesty, and with all that I was accused by the Inquisition, nor would I copy them because I have better things at present that would sell to greater advantage.[15]

At this point in the letter, Goya turned to the miniatures on ivory he painted the previous winter, with a technique more like that of Velázquez than that of Mengs. A notation on the letter confirms that Ferrer received it on December 24 and did not reply, perhaps disappointed that *Los Caprichos* were not available: Ferrer's request for those etchings may have been inspired by the publication the previous January of *Caricatures espagnoles / Ni plus ni moins, par Goya* (*Spanish caricatures / Neither more nor less, by Goya*), ten lithographic reproductions of etchings from *Los Caprichos*.[16] Goya's reference to the Inquisition has often been cited as evidence that his donation of the plates for *Los Caprichos* in 1803 was not of his choice, but the documented exchange of the plates for a pension for Javier argues otherwise. Moreover, Goya wrote that

he ceded the plates to the king, "y con todo eso" (and with all that) he was accused by the Inquisition, implying that his troubles with the Inquisition occurred after, and despite, his donation of the plates: one possibility is that the Inquisition raised the issue of *Los Caprichos* to incriminate Goya further after discovering his authorship of the *Naked* and *Clothed Majas*.

Goya's works and letters, and the accounts of his friends during his years in Bordeaux, attest to a miraculously undiminished passion for life. But in the final paragraph of this last known letter to Ferrer, Goya confessed his resolute determination in the face of advancing age: "You may thank me a lot me for my bad writing, because neither sight, nor pulse, nor pen nor inkstand, everything is lacking and only my will abounds."[17]

—

The sole portrait firmly dated to 1826 attests to that resilient will (pl. 35). Its inscription, "D.n. Santiago Galos / painted by Goya / at 80 years of age / in 1826," dates it to between Goya's birthday on March 30 and the end of the year. The artist's financial adviser and intermediary, Jacques (Santiago) Galos, who was born to a peasant family in Arance, about two hundred kilometers south of Bordeaux, established himself in business in Pau and lived also in Pamplona, Spain, before going to Bordeaux in 1804. With wealth earned from trade with America, he became a leading merchant in the city, one of the founders of the savings bank in 1819, and a director of the bank of Bordeaux two years later.[18] Goya had first mentioned "Monsieur Galos" as an adviser, with Martín Miguel de Goicoechea, for his investment in a rental property; he also mentioned that "don Martín" told him that Galos would keep the paperwork in order to collect the rent on Goya's behalf.[19] Seated before Goya, the debonaire Galos looked into the distance as the artist outlined his figure before painting the strong features of his handsome face: heavy brows, the shadow of a beard, and a square jaw emphasized by a black line, still visible. The dark blue of his double-breasted coat complements the cool blue-gray tones, broadly brushed to suggest a waistcoat, that transition to the white of his cravat. Goya then returned to the face, adding red tones to enliven the sitter's cheeks, nose, ear, and mouth and balance the cool tones of his clothes and background. The sitter was evidently pleased, for the portrait provided a model for the marble relief on his grave.

A name often associated with Goya's Bordeaux years is that of the painter Antonio Brugada, a student at the Royal Academy in Madrid who joined the national militia in 1820, left Spain in 1823, and settled in Bordeaux.[20] He presumably met Goya, his senior by fifty-eight years, and according to Leocadia was present when the artist died. Brugada returned to Spain in the mid-1830s,

his earliest opportunity to record the paintings in Goya's country house; when liberals came to power 1841, he attained an unsalaried (honorary) position as painter of seascapes at the Spanish court and membership in the Royal Academy. An important source for Goya's biographer Laurent Matheron, Brugada probably provided the descriptions cited of Goya's miniature and lithographic techniques. Yet his account of Goya giving up his brushes for rags or knives, painting impetuously on whatever he found—wood, paper, or cardboard—and repainting the work the following day, has an air of romantic fabrication.[21] Without further collaboration of the close friendship with Goya described by Matheron, we might ask if the much younger Brugada varnished his own reputation by exaggerating his friendship with the late master. One final name appears in relation to Goya's last years: Braulio Poc, an Aragonese producer of chocolate, who relocated to Bordeaux in 1823.[22] Described in 1842, his establishment in Bordeaux provided a meeting place for many "illustrious" Spanish exiles, offering good paintings and a good library.[23] Lacking further evidence, we can only imagine the aging Goya as a client of Poc, enjoying a cup of the Aragonese chocolate to which Zapater had introduced him over four decades earlier.

———

Bordeaux, May 7, 1826: The news I have to tell you from here is of little importance. One is Goya's trip, that he will undertake within three or four days, arranged as he always arranges his travels; he is going alone, and displeased with the French. If he is lucky enough that nothing pains him on the way, you can welcome him when he arrives; and if he doesn't arrive, don't be surprised, because the least little ill can leave him stiff in the corner of an inn.[24]

Goya's petition of May 30 to Fernando VII justifies his determination to return to court:

Francisco Goya. Court Painter of Your Majesty at your Royal Feet humbly states:

That I am eighty years old; that I have served your August Parents and Grandfather for fifty-three years, after Mengs made me return from Rome; that at my age, my aches, and the doctors obliged me to go to France to regain my broken health; that I have achieved this in part; and although the experts assured me that they would cure the headaches that I suffer, I have preferred, at the end of my leave, to

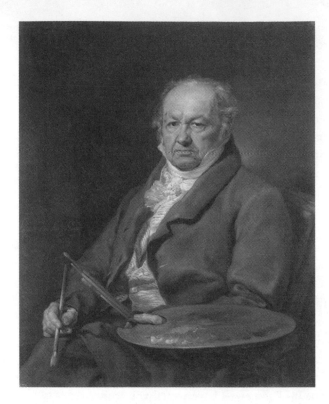

44. Vicente López Portaña, *The Painter Francisco de Goya*, 1826. Oil on canvas, 37 × 30 ¾ in. (94 × 78 cm). Museo del Prado, Madrid.

come to place myself at Your Feet, as your faithful servant, to entreat you to grant me my retirement, with the honorarium I enjoy or that which pleases Your Majesty, to return to take advantage of the climate, the food, and the baths that have alleviated me, if the goodness of Your Majesty concede me this grace.

That the heavens bless Your Majesty as I ask them, in Madrid, on the 30th of May 1826.[25]

The *sumiller de corps* presented Goya's petition to the king on June 4, and on June 17 Goya was granted retirement with full salary and permission to return to France.[26] Before leaving Madrid he sat for Vicente López, by then director of the Royal Museum of the Prado, where his portrait of Goya was soon installed (fig. 44). Goya remained defiant as he studied both López and the viewer, as if wishing to discover their secrets so that he, with brush in hand, might capture them. His scrutiny and palette define both his personality and profession, and his elegant dress—a plush coat, a vest of white silk striped in red, cravat, and jabot—proclaims him a man of standing. His palette becomes

45. *Feria en Bordeaux (Fair in Bordeaux)*, 1826. Black chalk, 7 9/16 × 5 15/16 in.
(19.2 × 15 cm). The Morgan Library & Museum. 1999.20. Gift of Gertrude
Weyhe Dennis in honor of Felice Stampfle on the occasion of the 75th
anniversary of the Morgan Library and the 50th anniversary of the
Association of Fellows.

López's, with the grays, greens, whites, reds, tans, browns, and black used in
painting this portrait, which he signed, "López to his Friend Goya."

Goya returned to Bordeaux by July 15 and delivered to Moratín a publi-
cation on prisoners, from (and presumably by) Melón; from this point until
year's end, Moratín mentioned Goya only once, writing on November 15 that
"Goya is well and his family; they will write to you and in the meantime
send regards."[27] The artist ambled at the Bordeaux fair that had inspired his
drawings of dwarfs two years earlier, where, in addition to performers with
snakes, two attractions, recorded by the chronicler Pierre Bernadeu on Oc-
tober 29, 1826, caught his eye: "Two opposing phenomena are featured at

the fair of this city: the first a female giant measuring six and one-half feet, and very well-proportioned; the second a man who is nothing but skin and bones and weighs only 42 livres. He is called the living skeleton. These two spectacles shock each in their own way, by the pleasing plumpness and by the sad emaciation."[28] Bernadeu's passing mention of the giant's proportions and "pleasing plumpness" leaves no doubt that the men and boys at the fair saw the giant first as a woman, a detail not lost on Goya (fig. 45). Towering over her audience, she wears a fashionable dress adorned by bows and ruffled trim and a bonnet that accentuates her already impressive height, but her fashion sense is lost on the ogling men and boys surrounding. Goya places her hips and pelvis at the eye level of her audience (clearly an invented distortion, un-less the top-hatted man in her audience is only slightly taller than four feet): they cannot resist studying this part of her anatomy and imagining what lies under her skirts—a curiosity emphasized by Goya, who even provides round eyeglasses for one of the boys. For the giant such prurience is part of the job; she looks away, raises her eyes to sky, wondering at the folly of men and wishing her day would soon be over.

The Last Year

1827–April 1828

THE winter of 1827 was cold in Bordeaux, bringing snow and ice that kept Moratín from seeing Goya, although he had heard that new blankets from Madrid had arrived in the Goya household. Writing to Melón on January 28, he expressed surprise that his friend had not heard from Leocadia, although Goya's silence was to be expected given his difficulty in writing letters.[1] The final reference to Goya in Moratín's correspondence is found in a letter of late spring, when Moratín reported to Melón that "Goya is well; he keeps himself busy with his sketches [*borradores*], he takes walks, he eats his midday meal and takes his siesta: it seems that now there is peace in the house."[2] The artist also painted a portrait inscribed (possibly by another hand): "Dn. Juan de Muguiro by / his friend Goya at / 81 years of age in Bordeaux / May 1827," showing the businessman before his worktable, raising his eyes from the letter he reads.[3] On July 2 Muguiro applied for a visa to return to Spain, and Goya possibly decided to accompany him, for although there is no documentation of Goya's departure from Bordeaux, on September 20 he reentered France from Spain at Bayonne.[4]

A letter written that summer from Madrid conveys Goya's contentment with his life in Bordeaux:

Madrid, August 13

My dearest friend, I have just finished reading your precious letter through all its content and it has made me so happy that although I tell you that it has made me all better I do not exaggerate. A million thanks.

This morning Dn. J. Aⁿᵒ. Melón came by and he told me he would write to you today that the business of Wellington is done and that

the subject is now in London. There is no way to repay the affectionate concern he has taken in your matters and mine, and being as busy as he is, with writings on the progress of our nation, that leave him time for nothing else.

I am indebted for all that you tell me about the carriage [*birlocho*] and far more about the friendships with neighbors and of the friendship that my Rosario has made with Madame, her companion at the game board of damas, to whom I send through you my respects and on my knees a thousand thanks. I repeat that you should address the envelope to this house so that I have more time to write without going out. The news from Granada I knew already from Porcel and others.

I am very curious to know more about the matters concerning Silvela and Moratín: I am going to send him [Melón] this so that he includes it with his [letter] as we agreed this morning. A thousand kisses, and a thousand things from your most affectionate Goya [signed].[5]

References to "my Rosario" in the third paragraph confirm that the "dearest friend" addressed is Leocadia, and given that the letter was written from Madrid on August 13, it must date to 1827, since the previous year Goya had returned to Bordeaux by July 15. The many subjects mentioned, and his closing, attest to shared affection, daily routines, and acquaintances. Melón again appears as a benefactor of both Goya and Leocadia, but we are at a loss to know Leocadia's concerns involving Wellington and "the subject" in London, as well as what news arrived from Granada. Goya was delighted with news of the friendships of neighbors, and especially Rosario's new opponent in *damas*, a game resembling draughts; his mention of the affairs of Moratín and Silvela refers to their decision, reported by Moratín in a letter to Manuel García de la Prada on July 31, to move to Paris.[6] Moratín arrived in the French capital on September 28; presumably he had the opportunity to bid farewell to Goya, recently returned from Madrid, before leaving Bordeaux; he died in Paris the following year, nine weeks and three days after Goya.[7] Melón left Madrid and traveled to London before returning to Paris in early November,[8] leaving Goya without a benefactor in Madrid.

Three letters from Goya to his son Javier document his hopes and anxieties during his final months. On January 17, 1828, he wrote:

Dear Javier. I am crazy with joy because of your last letter with the news of Gibraltar of your travelers. I missed the mail, and you will

receive this a little late, but it doesn't matter as long as they come here to pass a couple of years, and you when you can, I will be very content, without thinking of coming to see you.

I suspect as is necessary, that you all will be with me all the time you are in Bordeaux, coming and going from Paris at least that is what I am thinking I am already preparing everything for your reception and stay. It is essential that you tell me in time when they leave Barcelona and of everything and that you take care in doing everything and don't forget anything, you already know that what we have with Galos is all yours....

There is nothing better for me than when I receive a letter from you.

Jubilant at the thought of a visit from his son, daughter-in-law, and grandson, Goya began making plans, urging Javier to keep him informed. In closing he sent regards to the engraver Rafael Esteve.[9]

Goya's pleasure was not to last, for on March 12 he responded to a letter of March 3 from Javier. Diplomatically appreciative of his son's sensitivity to the desires of his family, Goya wanted also for them to go to Paris, but to have a long stay in Bordeaux, "because this is a better town and better for what Marianito needs; and then, what do they have to do there? And you must come also, and you will spend less; and the coming and going can be to your advantage, I will cover costs here and in Paris because you already know what Marianito has with Galos...."[10]

He also reported that he had seen Galos and learned that he had only 3,000 *francs* left to pay from his salary (equivalent to 12,500 *francs d'or* annually) to ensure an annual pension for Mariano of 12,000 *reales*.[11] On March 26 Goya, delighted with Javier's decision to come to Bordeaux to spend more time with him during the coming summer, eagerly awaited the arrival of his daughter-in-law and grandson. He mentioned that the pension for Mariano was now only 979 *francs* short and could be made up if Javier would send him two more installments. He closed the letter: "I am much better and I hope to remain as I was before the episode; I owe my improvement to Molina [a neighbor], who had been telling me to take the herb valerian as a powder, and I am very content with my recuperation to receive my beloved visitors; a Dios / Francisco de Goya."[12] A short, undated note to Javier followed, expressing his delight in the arrival of his guests on March 28, mentioning that he was "slightly indisposed" and in bed.[13]

On April 1 Goya, Mariano, Gumersinda, and Leocadia dined together at midday. The meal, according to Leocadia, made Goya unwell and he awoke

early the following morning, unable to speak; he recovered, but was partially paralyzed. According to Leocadia, "He remained in this state for thirteen days; he recognized everyone; until three hours before his death he saw his hand, but as if stupefied; he wanted to make a will, he was saying, in our favor, but his daughter-in-law responded that he already had one." Goya died at two in the morning on April 16, 1828; according to the doctor, he had not suffered.[14] That same day, Mariano sought out the Spanish consul in Bordeaux, who arrived at Goya's last residence, the third floor of a building at 39, rue Fossés de l'Intendance. Mariano and Gumersinda received him and took him to the room where Goya lay; having known the artist in life, the consul confirmed his identity. He questioned Mariano and his mother about the inheritance, papers, and other matters, and they answered that Goya had left nothing, that he lived with Leocadia, who owned the furniture in the room. They signed this testimony, witnessed by José Pío de Molina and a certain Bernardo de Amati; the documents make no mention of Brugada's presence, mentioned by Leocadia. Pío de Molina, identified as a wealthy owner at Goya's address, also witnessed Goya's death certificate, as did Romualdo Yañez, a merchant residing at 36, rue de Tourny.

A single contemporary report of Goya's funeral has come to light. In a letter of April 20, 1828, Sophie Bonheur, mother of the painter Rosa, remarked on the poverty in which Goya spent his last years in contrast with his funeral: "The Spaniards excel in this: it was magnificent. But it is very unfortunate that it was only in death that anyone gave him any thought."[15] His Latin epitaph can be translated:

> Here lies
> Francisco de Goya y Lucientes
> The most skilled Spanish painter
> Renowned for the great reputation of his name
> The light of his life having run its course
> He died on the 16th of April
> Anno Domini
> MDCCCXXVIII[16]

Javier arrived, thinking he would find his father alive. He came to see Leocadia three times, took the silverware, the chiming clock, and pistols, and left her with a 1,000 *franc* note, the linens, the clothing, and the furniture. Although the apartment was paid to the end of the month, Molina advised her to leave, and she was looking for lodging when she wrote to Moratín on April 28; Javier, Mariano, and Gumersinda left that same day to return to

Madrid; Molina had already gone to Madrid to see if there was any provision for Leocadia in Goya's will. The "poor Rosario" sent her regards.[17] Moratín responded on May 7, fearing that Molina would find no mention of Leocadia in the will, and continued, "For this reason, I urged him to do that paper, written and signed by his hand (that a notary would have authorized afterwards) and you, in a moment of anger tore it to pieces." Leocadia presumably thought that whatever Goya provided for her was not enough, but her temper was her undoing. By way of consolation, Moratín reminded her that she has a son (Guillermo, never mentioned in correspondence until now), whose duty it was to support his mother and sister.[18] He also mentioned that Melón, briefly in Paris, had left for Flanders.

That news of Melón inspired Leocadia's reply, sent from her new residence at 65, rue du Palais Galien. A certain "Mister Hoogen," once the secretary to Lord Wellington when he was ambassador to Paris, married the nanny of Wellington's children and settled in Flanders. Leocadia asked if Melón might be able to locate him and make an inquiry on her behalf, for being of German origin, Hoogen had often enjoyed the hospitality of the Weiss household in Madrid and the company of Leocadia's German father-in-law. Upon his departure from Madrid, he had promised to write, and offered help if ever the family were in need. And then, another mystery: "My refinement doesn't allow me to remind him of a letter that I delivered to him when he was in Santander." (As previously noted, these mentions of Mr. Hoogen have suggested to some scholars that he was the cause of Isidoro's first complaint about the behavior of his wife in 1811,[19] and the reference to Wellington in Goya's August 1827 letter to Leocadia implies a broader familiarity with other members of his entourage.) Leocadia reported that Guillermo wanted to leave Bordeaux because he earned little, but in her opinion he was learning things and in the best shop, facing the public garden; Rosarito was sad, no longer being able to take piano lessons, for the piano had been rented.

Over a year later, Leocadia made an appeal to Juan Bautista de Muguiro, reminding him that he often urged her to give him an oil painting, *La Lechera*, or *The Milkmaid of Bordeaux* (fig. 46), and had asked her to name a price. At the time, she responded that only necessity would make her part with it, and promised to contact him if that day ever came. The day had arrived, and "to Rosario's great sadness" she now wrote to offer Muguiro the painting, mentioning that Goya told her she should not part with it for less than an ounce of gold.[20] Muguiro apparently agreed, for in 1945 his descendants gave the painting to the Museo del Prado. This letter was long seen as proof of Goya's authorship of the work, until arguments were advanced that it was possibly painted by Rosario or by Rosario working with Goya.[21] The painting's palette

46. Goya and Rosario Weiss (?), *The Milkmaid of Bordeaux,* ca. 1825–1827. Oil on canvas, 29 ⅛ × 26 ¾ in. (74 × 68 cm). Museo del Prado, Madrid.

and style have, to be sure, little to do with Goya's other Bordeaux paintings: neither the woman's figure nor the volumes of the brimming milk jug in the lower left corner are worthy of a mature painter. The canvas is reused, and X-rays revealed various sketches beneath its surface, most notably, a head in profile of a turbaned man, which over time has become visible on the left side of the canvas and now appears to stare at the pensive maiden. With the other sketches, the head of the phantom voyeur suggests the hand of a less accomplished artist, presumably Rosario: a profile, it is far easier for a beginner than a three-quarter or frontal depiction of a face, as is the profile of the maid herself. The milkmaid also resembles seated maidens who appear in Rosario's drawings of about 1828.[22] Goya's delight in Rosario, his pride in her talent, and her future success working in oil as a copyist support the hypothesis of *The Milkmaid of Bordeaux* as a teaching piece, done in collaboration and highly valued by Goya and Rosario for this reason. We may never know the full story behind the painting, but Muguiro, a close friend, probably did.

PART V. TRIUMPHS OF CAPRICE

Rosario

1828–1843

R OSARIO continued her studies in Bordeaux and perfected her technique by copying master drawings under Pierre Lacour, who in 1814 had succeeded his father as curator of the city art gallery and director of the free school of drawing.[1] Leocadia meanwhile sought a patron for her daughter and reported her progress in the same letter in which she offered to Muguiro *The Milkmaid of Bordeaux*: an intermediary had presented Rosario's case to the duchess of San Fernando de Quiroga, who responded that "she held her master [Goya] in high esteem, and would do what she could for his disciple."[2] Leocadia hoped that once the duchess returned to Madrid she would remember Rosario and asked Muguiro to do what he could to promote her cause.

During the fall of 1830, Leocadia's son Guillermo enlisted in an army of liberal exiles who, inspired by the July revolution earlier that year, were determined to overthrow Fernando VII. Under the command of General Espoz y Mina, the army crossed into Spain but was stopped at Vera de Bidasoa and chased back to the border; with France now ruled by Louis Philippe, Guillermo was imprisoned in a military camp in Bergerac until the following year, when Leocadia petitioned for his release due to a medical condition. As Fernando VII lay ill in 1832, the declaration of an amnesty allowed Spanish exiles to return to Spain (and the French government to terminate their subsidies). Having collected her last subsidy on December 31, 1832, Leocadia and her children obtained their passports from the Spanish consul and left for Bayonne the following July. In Spain, the travelers were stopped by customs officers in Miranda (today, Miranda de Ebro), and the drawings among their possessions, by Rosario, by Goya, or by both, were confiscated because the artist and his pupil had used French paper.[3]

In Madrid, Rosario worked as a copyist to support herself and her mother. A British connection again emerged when the envoy and minister

plenipotentiary in Madrid, George William Frederick Villiers (to become the fourth Count of Clarendon in 1838), commissioned copies in pencil of the *Mona Lisa* and *Lucrecia Fede* by Andrea del Sarto (presumably drawn after a workshop copy of the *Mona Lisa* and a *Portrait of a Woman* by del Sarto, both in the Museo del Prado); working in oil, she copied a *Sleeping Christ Child* after Zurbarán, among other works. In the Museo del Prado, she copied the portrait of Goya by Vicente López (the copy is today in the Museum of the Royal Academy); in the academy she copied Goya's portrait of the actress La Tirana, as well "La Charra" by Mengs, presumably the portrait of the marquesa de Llano.[4] In service to the duchess of San Fernando de Quiroga, she painted a small replica of the portrait by Rafael Tegeo of the duchess and her husband (both the original and the copy are today in Museo del Prado), as well as two paintings identified as sketches by Velázquez for his equestrian portraits of the count-duke of Olivares and Philip IV.[5]

Rosario's aptitude for copying may have been her downfall. According to her obituary, the duchess purchased her copies after Velázquez, "without allowing her to continue copying any of the many good paintings she owned."[6] In May 1836 the queen-regent María Cristina granted Rosario's petition for permission to copy, one by one, paintings in the Prado, as her studies demanded; but in early October, Rosario again requested that her access be restored. On October 14 the duke of Híjar, director of the museum, responded that although taking down paintings had caused damage and was absolutely prohibited from this point forward, an exception could be made for Rosario because of her nearsightedness and her sex, which prevented her from climbing the scaffolding used by male artists. María Cristina then ordered that no paintings be removed from the walls, but that scaffolding be built to allow women to maintain decency as they copied. Nothing happened. Almost a year later, on September 14, 1837, Rosario requested that six paintings be taken down from the walls for her to copy, given that her financial situation was "worsening from day to day . . . until losing hope of subsistence without this support." On September 27 her request was denied.[7]

The observation made by the author of her obituary in reference to three copies of paintings in the Royal Academy might explain why both the duchess of San Fernando de Quiroga, and subsequently the queen-regent, denied Rosario permission to copy: "She executed these three paintings with such exactness in the brushwork and color that they were almost taken for the originals."[8] Forced by circumstance, Rosario found another outlet for her talent: "A well-reputed restorer of paintings, a great connoisseur of painting technique, offered her old canvases, from which she made excellent copies, that, covered with a varnish that gave them the appearance of old works, passed

for originals in the eyes of the most knowledgeable artists. This talent, that by itself suffices as proof of the extraordinary merit of Weiss, served to maintain her subsistence, and she had to stop practicing it within a short period of time because of the death of the restorer."[9] The restorer in question has been identified as Serafín García de la Huerta, a court conservator, First Conservator of the Museo del Prado, and an unscrupulous art dealer.[10] Serafín, as he was known to his contemporaries, sought to take advantage of the boom market for Spanish paintings in the 1830s, due in part to the government confiscation in 1836 of monastic properties by the liberal finance minister Juan Álvarez Mendizábal. Formerly cloistered works now flooded the market. The most famous buyer was the French king Louis Philippe, whose emissary to Spain, Baron Taylor, purchased works for the "galerie espagnole," which opened in the Louvre in January 1838. Javier Goya sold him eight paintings for 15,500 *reales*, including the large genre scenes *The Old Women* and *The Letter*, *Majas on a Balcony*, *The Duchess of Alba* (1797), and *The Forge*.[11]

Taking inventory in 1840 of Serafín's collection, following his death the previous year, José Bueno, a student of Vicente López, restorer in the Museo del Prado, and academician, listed seven works by Goya: young women dressed as *majas*; a priest giving communion; a small full-length portrait of the duchess of Alba; portraits of Margaret of Austria and Isabel de Borbón (both copies of the equestrian portraits of Velázquez); a woman in a mantilla and *basquiña*; and the first Mass of a new mother.[12] Given that Goya's 1795 portrait of the duchess remained in the Alba family, the portrait of the duchess of Alba listed was in all likelihood a replica of the 1797 portrait that had been sold by Javier to the emissaries of the French king. The painting of young women dressed as *majas*, too generally described to identify, possibly replicated *Majas on the Balcony,* also sold by Javier to the same buyers. Were the paintings in Serafín's gallery in fact by Goya, or were they copies? More specifically, were they copies of works sold to Louis Philippe, made before they left Spain with an intent to deceive? Deception was easy in a prephotographic age, with the originals in Paris. A final speculation: Given Rosario's recognized talent, did she play a role?

Rosario's slide from the role of copyist to forger did not prevent her from participating in sessions of the Liceo Artístico y Literario (Artistic and Literary Lyceum) in 1837, 1840, and 1841, where she also exhibited paintings in 1837, 1838, and 1839. In a short discussion of women artists in 1838, she was singled out for her "ability in pencil drawing for which she should be considered a professor." She also participated in exhibitions at the Royal Academy: in 1834 she exhibited copies of a Virgin and Child by Murillo and of López's portrait of Goya (which the academy acquired); in September 1836 she exhibited

copies after Velázquez's equestrian portraits and of an "unknown reclining woman," possibly the *Clothed Maja*, which had been transferred to the academy the previous April. In April 1838 the Royal Academy invited her to submit a painting of a "life-size, half-length Contemplative Virgin" as a reception piece; she exhibited this two years later, with her copy of López's portrait, to become an academician. The following year she exhibited a copy of an "old" portrait (*retrato antiguo*), a scene of sacred history, and an angel.[13]

With the abdication and exile of María Cristina in 1840, the liberal regency of General Baldomero Espartero came to power in March 1841, and Agustín Argüelles was appointed tutor of the future queen. Possibly encouraged by her brother's liberal connections, Rosario petitioned Argüelles to consider her for the position of drawing instructor to the future queen; the appointment was granted on January 18, 1842, with a salary of 8,000 *reales*.[14] She requested a leave from Madrid in June, justified by a physician's report that she suffered from a "general nervous affliction, resulting in partial convulsions, pain in her limbs, continual heart palpitations, as well as urinary incontinences from which she has long suffered."[15] Another report added that her symptoms had worsened since an illness two years earlier. Granted a leave of two months to take the waters in Barcelona, and a subsequent extension, Rosario returned to her position on December 6, 1842. She died on July 31, 1843. On January 7, 1844, the *Gaceta de Madrid* reported the acts of beneficence of Queen Isabel II on her accession to the throne. Included among them, she "granted a pension of 4 *reales* daily to Doña Leocadia Weiss, mother of she who was her drawing instructor, and other decorous retirements to some of her teachers, thus giving proof of her thanks to those who broadened her sphere of knowledge during her childhood."[16] It was a small consolation for Leocadia, who died thirteen years later on August 7, 1856.

———

And what of Goya's cherished son Javier? Within three weeks of returning to Madrid in May 1828, he replied to a letter from Vicente López, delighted to learn that the *infante* don Sebastián, the grandson of the *infante* don Gabriel, was interested in acquiring sketches by Goya. Two recently painted series, as well as that of Maragato, were available. Javier also offered a miniature by his father, which he would have presented to the *infante* upon his arrival, had he not been overwhelmed by his "irreparable loss." López responded the same day, and Javier gave the bearer of the letter "the six sketches of the Bulls and the six of Maragato," as well as a painting of "the Mass." He also shared an anecdote about this work, writing that the Viennese ambassador Kaunitz once tried to buy it, but his father would not part with it for less

than 3,000 *duros*. In an undated note, López considered the Maragato paintings "not his best works"and interpreted Javier's response as a desire to keep the Mass and the bullfight paintings. He recommended that don Sebastián's secretary negotiate with the seller, with a postscript: "I repeat that if my advice is not followed, Your Highness will not be able to get what you want of this."[17] From this point forward, Javier was the main contact for buyers interested in Goya's paintings.

The 1840 inventory of the studio of Serafín García de la Huerta confirms the market for Goya's portraits and genre scenes, as well as copies of them. In addition to the paintings attributed to Goya, the inventory included a copy by Leonardo Alenza of Goya's portrait of the actor Isidoro Máiquez and "imitations" of Goya by the same artist, representing an Inquisition scene and a Holy Week procession; two paired portraits of a man and a woman, both unfinished "in the style of Goya" were also listed.[18] With originals inaccessible in private or royal collections, the definition of a "Goya" was vague at best. Although it is unlikely that Javier, who had never fulfilled the obligation to study art mentioned by Cayetano in accepting the donation of *Los Caprichos* in 1803, copied his father's works, he may have made them available to others, for a fee.[19] Here the story of Goya ends and the saga of "Goya" after Goya, yet to be written, begins.[20]

NOTES

ABBREVIATIONS

AGP Archivo General del Palacio, Madrid
AHN Archivo Histórico Nacional, Madrid
BNE Biblioteca Nacional de España
RABASF Real Academia de Bellas Artes de San Fernando
RAH Real Academia de la Historia

INTRODUCTION

1. I draw on the well-known concept of public/private life in relation to the eighteenth-century capital, proposed by Sennett, *Fall of Public Man*, 16–19.

2. The 119 letters in the collection of the Museo del Prado are available with commentary on the *Goya en el Prado* website/ *Documentos/Cartas a Martín Zapater*. For the remaining letters, see Águeda and de Salas, *Cartas*.

3. Sennett, *Fall of Public Man*, 91; Spacks, *Privacy*, 8, 24.

4. Hamilton, *Biography*, 15.

I. EARLY YEARS

1. Matheron, *Goya*, chap. 2. Matheron's inspiration was the account by Vasari of Giotto's discovery by Cimabue.

2. Blasco Martínez, *Zaragoza*, 41–42. The Calle de la Morería Cerrada was replaced by the present-day Calle Valenzuela.

3. González Miranda, "Familia de Pedro de Goya."

4. García de Paso and Rincón, "Datos biográficos," 97.

5. Ansón Navarro, *Goya y Aragón*, 12–13.

6. Pardo Canalís, "Dato para la biografía familiar," 104.

7. Canellas López, *Diplomatario*, 399.

8. Ansón Navarro, *Goya y Aragón*, 33, 172nn124–26; Ona González, *Goya y su familia*, 41–42. In between these two loans, with a total value of 150 in the local currency of *libras jaquesas*, Joseph and his brother-in-law, Miguel de Lucientes, borrowed another 54 *libras jaquesas* from a certain Juan Antonio Burgués. The Aragonese *libra* (pound) was the equivalent of 18.823 *reales de vellón*; 204 *libras* would equal 371 *reales de vellón*. For conversion, see Gómez Zorraquino, *Goicoechea*, 11.

9. López Ortega, "Expediente matrimonial," 67, doc. 7.

10. These parish census records are fundamental to our knowledge of the Goya family residences in Zaragoza. See Ona González, *Goya y su familia*, 32–131.

11. Calvo Ruata, *Manuel Bayeu*, 16.

12. Other residents of the Goya y Lucientes household recorded in the annual parish census included Florentia Lucientes (presumably a relation) in 1754 and 1755 and María Romero and Francisco Rey in 1757.

13. Boloquí Larraya, *Escultura zaragozana*, 1:171.

14. Canellas López, *Diplomatario*, 516–18; *Noticia de los cuadros*, 67–68.

15. Ansón Navarro, *Luzán Martínez*, 17, 56, 147, doc. 37.

16. Ceán Bermúdez, *Diccionario*, 3:56.

17. Boloquí Larraya, *Escultura zaragozana*, 1:399–444; López Ortega, "Expediente matrimonial," 67, doc. 7.

18. Ansón Navarro, *Bayeu*, 24.

19. AGP, caja 835/46, cited by Arnaiz, *Primera obra*, 6.

20. Aramburu de la Cruz, *Zaragoza*, 286–388.

21. Letter dated November 1, 1759, cited in Spinosa and Knight, *Carlos III*, 42–43. Author's translation of the Spanish translation.

22. Spinosa and Knight, *Carlos III*, 43.

23. Aramburu de la Cruz, *Zaragoza*, 390.

2. FIRST TRIALS

1. The new palace replaced the Alcázar that had been destroyed by a Christmas Eve fire in 1734.

2. The bedroom, with its paintings and tapestries, was reconstructed in the 2016–2017 exhibition, *Carlos III: Majestad y ornato en los escenarios del rey ilustrado*. See Patrimonio Nacional, *Carlos III*, 93–153.

3. Roettgen, *Mengs*, 1:501.

4. Ona González, *Goya y su familia*, 56.

5. Ceán Bermúdez, *Diccionario*, 1:99.

6. A *real vellón* was the basic Spanish currency and refers to a *real* made of an alloy of copper and silver equal to 34 *maravedís*. See "Valor de las monedas antiguas y Corrientes de Oro, Plata y Vellón de España," *Kalendario manual y guía de forasteros en Madrid* (1775): 123–24. Variations of the *real* were many, including "El real de á 8" equal to 16 *reales vellón* or a *real de plata* (silver) equal to 2 *reales vellón*. When the list was again published in the *Kalendario* (1784): 171–72, values had changed: the *real de á 8* was now worth 20 *reales de vellón* but that of silver was still valued at 2 *reales*. An analysis of Goya's earnings in *reales de vellón* in relation to the eighteenth-century pound was made by Glendinning, *Critics*, 302–4. He also offers the following comparative figures, drawn from contemporary sources: the standard pay for an agricultural worker was 6 *reales*; in January 1785, two Spanish pounds of bread cost .82 *reales*; a pound of veal cost 2 *reales*; a pound of beef 1.88 *reales*.

7. Ona González, *Goya y su familia*, 52–53, 66–67. On the marriage of Rita Goya, see 317.

8. Chaparro, "Memoria y presente," 86.

9. For works captioned or titled by Goya, or by his friend, Ceán Bermúdez, those Spanish titles will be used, followed by an English translation. If the title was assigned posthumously, it is given in English, with a Spanish translation for better-known titles.

10. Chaparro, "Memoria y presente," 88.

11. Ansón Navarro, *Goya y Aragón*, 30.

12. *Revista de Aragón* 31 (April 1928): n.p., cited by Rodríguez Torres, *Saturno*, 51.

13. Ona González, *Goya y su familia*, 69.

14. RABASF, *Historia y alegoría*, 91–98.

15. López, "El Expediente," 66, doc. 2.

16. Sánchez Cantón, "Primer viaje."

17. Arnaiz, *Primera obra*, 9–12.

18. Ferro placed second in the third-class painting competition in 1760 and first in the second-class competition in June 1763; see Morales y Marín, *Ferro*, 37–40.

19. Ansón Navarro, *Bayeu*, 36.

20. *Noticia de los cuadros*, 68.

21. Aramburu de la Cruz, *Historia*, title page.

22. Ponz, *Viaje*, 1305.

23. Aramburu de la Cruz, *Historia*, 364–66; Herranz Estoduto, *Orígenes*, 49–50. See *Tauromaquia* plates 18 and 19, depicting Martincho, and plate 22, depicting the female fighter La Pajuelera in the ring of Zaragoza.

24. Aramburu de la Cruz, *Historia*, 379.

25. *Kalendario manual y guía de forasteros en Madrid*, 1766, p. 101; 1767, p. 106; 1769, p. 94; 1771, p. 102.

26. Fernández Doctor, *El Hospital*, 257.

27. Fernández Doctor, *El Hospital*, 248–50.

28. Fernández Doctor, *El Hospital*, 269, 279.

29. Fernández Doctor, *El Hospital*, 272.

30. Aramburu de la Cruz, *Historia*, 238.

31. Aramburu de la Cruz, *Historia*, 198.

32. RABASF, *Historia y alegoría*, 101.

33. Maríana, R. P., Juan de, *Historia de España*, BAE (Madrid: Atlas, 1950), vol. 1, book 13, chap. 16, p. 393.

34. RABASF, *Distribución . . . 1766*, 34, 36, 38, 40; RABASF, *Libros de actas, 1766*. 364 v— 367 v/.

35. Museo Goya, *Goya y Zaragoza*, 102–5.

36. Ona González, *Goya y su familia*, 75–78; Ansón Navarro, "Datos socioeconómicos," 626.

37. According to testimony preceding Goya's marriage in 1773, the artist had lived until that date in Zaragoza before traveling to Rome, where he would remain for two years. See López Ortega, "Expediente matrimonial," 67, doc. 7.

3. ITALY

1. The sketchbook, in the collection of the Museo del Prado, is available on the *Goya en el Prado* website, www.goyaenel prado.es. See also Wilson-Bareau and Mena Marqués, *Truth and Fantasy*, 91–93.

2. Barbieri, *Direzzione*, map no. 2.

3. Scotto, *Itinerario*, 315–16.

4. Roettgen, *Mengs*, 2:279.

5. Matilla Tascón, "Documentos," 232.

6. Museo de la RABASF, Madrid.

7. Cánovas del Castillo, "Artistas españoles," 163, 180. Eraso's early years in the studio of Francisco Bayeu are mentioned in a letter by Francisco's younger brother, Manuel, to Zapater dated April 3, 1779; see Calvo Ruata, *Cartas*, 95.

8. López Ortega "Expediente matrimonial," 67, doc. 6. For a more detailed analysis of the circumstances surrounding this document, see Gallego, "Capitulaciones matrimoniales." On Adán and Eraso, see Calvo Ruata, "Goya y los artistas de Zaragoza," in Museo Goya, *Goya y Zaragoza*, 47–70.

9. Navarrete Prieto, "Goya en San Nicolás," 293–94; and Arnaiz, "Giaquinto Source." Gallego discusses artists' lodging in Rome in "Roma, teatro," 45.

10. Gallego, "Algunas noticias," 101, 105–9.

11. Gallego, "Roma, teatro," 47–48.

12. García Sánchez and Cruz Alcañiz, "Piazza Barberini," 665–68.

13. Cánovas del Castillo, "Artistas españoles," 186.

14. Goya reported that he traveled to Rome at his own expense in requesting an appointment as court painter on July 24, 1779; see Sambricio, *Tapices*, doc. 56. The motive for his visit was noted in López Ortega, "Expediente matrimonial," 67, doc. 7.

15. Letter from Preciado de la Vega to Manuel de Roda, December 9, 1779, cited by García Sánchez and Cruz Alcañiz, "Piazza Barberini," 670.

16. Cited by Mac Donald, "British Artists," 78.

17. Cortonese, *Descrizione*, 330; for the French Academy and the locations of the antiquities mentioned, see pp. 109, 239, and 499. On the Accademia del Nudo, see Pietrangeli, "Accademia del Nudo," 123–28; on the Capitoline Museum, see Paul, "Capitoline Museum," 1–20.

18. Matilla et al., *Dibujos*, 171–78.

19. Gallego, "Muchos originales," 194.

20. *Diario ordinario*, no. 8164 (May 26, 1770): 21. Mayor, "Hannibal," 296.

21. The letter was first published by Copertini, "Note sul Goya," 11, and is reproduced in Sureda, *Goya e Italia*, 1:127.

22. López Ortega, "Expediente matrimonial," 67.

23. *Diario ordinario*, no. 8288 (August 3, 1771): 12–13.

24. Gallego, "Algunas noticias," 110.

25. Mena Marqués, "Goya: El Viaje interior," in Fundación Amigos del Museo del Prado, *Siglo de las luces*, 360.

26. Gallego, "Algunas noticias," 111–13.

4. TRIUMPHS OF A NATIVE SON

1. Beroquí, "Biografía de Goya," 99.

2. Gallego and Domingo, *Los Bocetos* 72, doc. 16.

3. Torra et al., *Regina Martirum*, 98.

4. Unless otherwise noted, the source for documents pertaining to El Pilar cited here is Torra et al., *Regina Martirum*, 138–44; author's translation.

5. Gallego and Domingo, *Los Bocetos*, 46.

6. Museo Goya, *Goya y Zaragoza*, 120–25. The sketch was acquired by the Ibercaja collection in 2003 after passing through several owners; significantly, the first was Juan Martín de Goicoechea, a wealthy businessman, protector of the arts, and, eventually, friend of Goya.

7. Ona González, *Goya y su familia*, 93.

8. Ona González, *Goya y su familia*, 76, 91.

9. Ona González, *Goya y su familia*, 91.

10. Ona González, *Goya y su familia*, 94.

11. Cited by Calvo Ruata, "Goya y los artistas de Zaragoza," Apéndice documental, in Museo Goya, *Goya y Zaragoza*, 70.

12. Torra et al., *Regina Martirum*, 140, doc. 11.

13. Ansón Navarro, *Bayeu*, 56.

14. AGP, Expediente personal, Bayeu: caja 12365/1.

15. López Ortega, "Expediente matrimonial," 65, doc. 1.

16. Torra et al., *Regina Martirum*, 141, doc. 15. Assuming the cost of Bayeu's work is in *escudos de vellón*, his price would equal 40,000 *reales de vellón*. (A silver *escudo* would translate to an unlikely sum, almost four times greater.) See "Valor de las Monedas antiguas y corrientes de Oro, Plata y Vellón de España," in the *Kalendario manual y guía de forasteros en Madrid* (1775): 124.

17. Torra et al., *Regina Martirum*, 142, doc. 16.

18. Torra et al., *Regina Martirum*, 142–43, doc. 17.

19. Dated June 3, 1773. See Matilla Tascón, "Documentos," 203. My translation of the value in *doblones* to *reales* assumes that the *doblón sencillo* is the *doblón* of least value listed in the *Kalendario* (1775): 123.

20. López Ortega, "Expediente matrimonial," 65, doc. 5.

21. The testimony is dated June 30, 1773; see López Ortega, "Expediente matrimonial," 67, doc. 7.

22. López Ortega, "Expediente matrimonial," 65, doc. 1.

23. Ponz, *Viaje*, 1327.

24. Ona González, *Goya y su familia*, 91, 251–52.

25. By the early nineteenth century, the Aula Dei was the twelfth-largest landholder in Zaragoza. See Peiró, *Regadío*, 45.

26. On Martínez's work at Aula Dei, see Boloquí Larraya, *Escultura zaragozana*, 1:123, 380–83; 2:141–53.

27. Cited by Gonzalo M. Borrás Gualis, "Goya antes del viaje a Madrid (1746–1774)," in Fundación Amigos del Museo del Prado, *Siglo de las luces*, 334.

28. "Cuaderno italiano," p. 51, *Goya en el Prado* website/*Dibujos*.

29. "Cuaderno italiano" pp. 80–83, *Goya en el Prado* website/*Dibujos*.

30. "Cuaderno italiano," pp. 85–86, 90–91, *Goya en el Prado* website/*Dibujos*. These were presumably *veintenos*, or *escudos* valued at 20 *reales*: *Kalendario* (1775): 123.

31. The only other works firmly attributed to Tomás Goya as "master gilder" are four angels and their brackets by Agustín Vidal Laban (ca. 1719–ca. 1774), in the church of San Lorenzo in Magallón, fifty-nine kilometers from modern-day Zaragoza. For gilding these Tomás was paid 75 *libras* (1,410 *reales vellón*) in 1768. See Boloquí Larraya, *Escultura zaragozana*, 1:229.

32. Boloquí Larraya, *Escultura zaragozana*, 1:449; Borrás Gualis, "Las Pinturas murales de Goya en la cartuja de Aula Dei," in Sureda, *Goya e Italia*, 126; Calvo Ruata, "El Factor Bayeu," figs. 91–100.

33. "Cuaderno italiano," p. 47, *Goya en el Prado* website/*Dibujos*.

34. Cruz, *Gentlemen, Bourgeois*, 24.

35. Following Goya's disagreement

with the building committee at El Pilar in 1781, Mariano remained in Zaragoza and by 1787 was a student of Manuel Eraso in the academy of drawing. See Ansón Navarro, *Academicismo*, 209.

36. Ona González, *Goya y su familia*, 59–61.

37. Ansón Navarro, "Revisión crítica," 250.

38. Calvo Ruata, *Manuel Bayeu*, 33–4.

5. SETTINGS FOR THE COURT OF CARLOS III

1. Baretti, *Journey*, 2:255–56.

2. Baretti, *Journey*, 2:258–59.

3. Sabatini was ordered to select painters for the tapestry factory on August 30, 1776; see Sambricio, *Tapices*, doc. 20.

4. Luis Cervera Vera, "Normas para las mejoras urbanas en el Madrid de Carlos III y algunas disposiciones precedentes," in Madrid, *Carlos III*, 246–63.

5. Proclamations outlawing wide-brimmed hats and capes had been made in 1716, 1719, 1723, 1729, 1737, 1740, and 1745; see Dufour, *Lumières*, 24.

6. Gutierrez de los Ríos, *Vida de Carlos III*, 168–69; Mª Victoria López-Cordon Cortezo, "Servir y seguir al rey," in Comunidad de Madrid, *Corte para el rey*, 68.

7. For the history of this establishment, whose inhabitants were ultimately moved to Madrid sometime around 1800, see Soubeyroux, "Paupérisme," 611–28.

8. Dufour, *Lumières*, 27, 29.

9. "La Descrizione del viaggio di Giovanni Battista Malaspina fatto nell'anno 1785 ed 1786," Archivo di Stato di Firenze, Fondo Malaspina num. 187, p. 111; cited by José del Corral, "Viajes y viajeros en el Madrid de Carlos III," in Madrid, *Carlos III*, 190.

10. Reese, "Hipódromos," 1–47.

11. Swinburne, *Travels*, 361.

12. Swinburne, *Travels*, 327–31.

13. Swinburne, *Travels*, 402.

14. Swinburne, *Travels*, 399.

15. On the tapestry cartoons, see Tomlinson, *Tapestry Cartoons*; Bayeu's document is discussed on p. 18.

6. "OF MY INVENTION"

1. In 1804 Manuel Godoy, then resident in the palace, purchased numbers 4, 5, and 6 on the Calle del Reloj and renovated them to accommodate support services for the residence; see Blasco Castiñeyra, *Palacio*, 61–62. See by the same author, "Tradición y reforma en los alrededores del Palacio Real Nuevo: Un Palacio para los Secretarios de Estado en el Madrid de Carlos III," in Madrid, *Carlos III*, 497–500.

2. Calvo Ruata, *Manuel Bayeu*, 19, 22.

3. Calvo Ruata, *Cartas*, 8–10, 21–22. Unless otherwise cited, this is the source for all correspondence by Manuel Bayeu mentioned here; author's translation.

4. Manuel Bayeu to Zapater, February 15, 1775, Calvo Ruata, *Cartas*, 25.

5. Held, *Genrebilder*, 101–2.

6. Letter dated March 1, 1775, Torra et al., *Regina Martirum*, 144–45, doc. 22.

7. For images, see *Goya en el Prado* website/*Cartones para tapices/Comedor de los príncipes de Asturias en San Lorenzo de El Escorial, 1775*.

8. Sambricio, *Tapices*, doc. 8.

9. Sambricio, *Tapices*, docs. 6–10.

10. Payment dated August 5, 1775. Matilla Tascón, "Documentos," 222.

11. Sambricio, *Tapices*, docs. 12, 13.

12. Museo Goya, *Goya y Zaragoza*, provides an introduction to early devotional paintings attributed to Goya.

13. Sayre et al., *Changing Image*, 7–9.

14. Torra et al., *Regina Martirum*, 146, doc. 24.

15. Mano, *Maella*, 323.

16. Sambricio, *Tapices*, doc. 16.

17. Sambricio, *Tapices*, doc. 17.

18. Sambricio, *Tapices*, doc. 19.

19. Mengs's other students were Francisco Agustín, Ventura Salesa, Carlos Espinosa, and Francisco Xavier Ramos. See Jordán de Urríes, "Últimos discípulos." Manuel Napoli reappears in Goya's circles following his return to Madrid in 1800 and subsequent appointment as conservator of the royal collections.

20. The transcription translated here, as well as the bibliography on the document, is available on the *Goya en el Prado* website/*Dibujos*/*Cuaderno italiano* 169–70.

21. Invoice dated October 30, 1776, Sambricio, *Tapices*, doc. 22. Illustrations of *The Picnic* (*La Merienda*) and all the tapestry cartoons discussed here are available on the *Goya en el Prado* website/*Pinturas*/*Cartones para tapices*.

22. Goya to Zapater, January 22, 1777, *Goya en el Prado* website/*Documentos*.

23. Goya to Zapater, December 1778, see Águeda and de Salas, *Cartas*, 69.

24. Sambricio, *Tapices*, doc. 17.

25. Bueno Paz, "Datos documentales," 59; Goya to Zapater, January 22, 1777, *Goya en el Prado* website/*Documentos*.

26. Manuel Bayeu to Zapater, February 4, 1777, Calvo Ruata, *Cartas*, 44–46.

27. Manuel Bayeu to Zapater, February 26, 1777, Calvo Ruata, *Cartas*, 48.

28. Goya to Zapater, April 16, 1777, *Goya en el Prado* website/*Documentos*. This identification of "Maríano," now generally accepted, was made by Ansón Navarro, "Revisión crítica," 249. Ponzano's name recurs in the parish census of the Goya household in Zaragoza in 1781, when he presumably assisted Goya at El Pilar. A recent argument for an alternative identification is made by Matilla and Mena Marqués, *Dibujos*, 200, justified according to the authors by Ponzano's age, fourteen or fifteen years old, which they consider young for an apprenticeship. In fact, this was an appropriate age for such as position, perhaps facilitated by the relationship of Ponzano's father with Joseph Goya discussed above.

29. Goya to Zapater, April 16, 1777, *Goya en el Prado* website/*Documentos*.

30. For images, see *Goya en el Prado* website/*Pinturas*/*Cartones para tapices*/*Comedor de los Príncipes de Asturias en el Palacio del Pardo, 1776–78*.

31. The series of engravings was advertised in the *Gaceta de Madrid*, on September 2, 1777. On these cartoons, see Tomlinson, *Tapestry Cartoons*, 41–64.

32. Sambricio, *Tapices*, doc. 33.

7. GOYA MEETS VELÁZQUEZ

1. Ponz, *Viaje*, 479, 555–56.

2. Ponz, *Viaje*, 569–70.

3. Ponz, *Viaje*, 574.

4. The letter suggests either that Goya's family had again relocated or, possibly, that Goya had a studio at the address. See Goya to Zapater, October 7, 1778, *Goya en el Prado* website/*Documentos*.

5. *Gaceta de Madrid* (July 28, 1778): 300, and (January 22, 1778): 640. For an introduction to the series, see Vega, "Prints after Velázquez."

6. Glendinning, "Nineteenth-Century Editions," 394–95.

7. Santiago Páez et al., *Ydioma Universal*, 129, cat. 93.

8. Sayre et al., *Changing Image*, 20.

9. Franco Rubio, *La Vida cotidiana*, 111–12.

10. Ponz, *Viaje*, 666.

11. Velázquez, *España de Carlos III*, 176.

12. José María Vallejo García-Hevia, "José Moñino y Redondo, Count of Floridablanca," in RAH, *Diccionario*.

13. Rose de Viejo, "Proyecto dieciochesco malogrado," 173. See also Rose Wagner, "Manuel Godoy," 1:249.

14. Canellas López, *Diplomatario*, 516–18; Beroquí, "Biografía de Goya."

15. Goya's request is dated October 26, 1778; Vandergoten's memo is undated. See Sambricio, *Tapices*, docs. 48, 49.

16. At his death, Sabatini's collection included three small paintings by Goya, suggested by their sizes to be sketches for tapestry cartoons, representing "various subjects" and "amusements" in the countryside. See Glendinning, "Spanish Inventory References," 108.

17. Goya to Zapater, December 1778, Águeda and de Salas, *Cartas*, 69.

18. Manuel Bayeu to Zapater, December 8, 1778, Calvo Ruata, *Cartas*, 77.

19. Goya to Zapater, January 9, 1779, Águeda and de Salas, *Cartas*, 72.

20. Goya to Zapater, January 9, 1779, Águeda and de Salas, *Cartas*, 72.

21. Sambricio, *Tapices*, doc. 56.

22. Sambricio, *Tapices*, doc. 17.

23. AGP, caja 12365/1.

24. Carlos Sambricio, "Vivienda y crecimiento urbano en el Madrid de Carlos III," in Madrid, *Carlos III,* 409. The building permit for numbers 1, 2, and 3 on the Calle Desengaño was issued to Juan del Riego Pica. The first notice of this address was published by Lasso de la Vega, "Goya en Madrid," 13–14.

25. Goya's advertisement offering a reward for the box appeared in the *Diario de Madrid,* June 17, 1793, and is discussed by Cerón, "Snuff Box."

26. Franco Rubio, *La Vida cotidiana,* 130. According to Gómez Zorraquino, *Goicoechea,* a *peso* was the equivalent of 8 silver *reales*; according to the *Kalendario Manual y guia de forasteros,* in 1775 and 1784, the silver *real* was worth 2 *reales vellón*. Thus, a *peso* was the equivalent of 16 *reales vellón,* giving a value of 80,000 *reales vellón* to Goya's 5,000 *peso* investment.

27. Sambricio, *Tapices*, doc. 72.

28. Morales y Marín, *Bayeu,* 236–37, doc. 86.

29. The honorific *Vuestra Merced,* found in the correspondence of Goya and Bayeu, is here translated as "Your Grace" in favor of the more literal translation, "Your Mercy." In contrast to the term's English usage, in Spanish it does not connote royal or aristocratic rank.

30. Morales y Marín, *Bayeu,* 237, doc. 87.

31. Morales y Marín, *Bayeu,* 237–8, doc. 90.

32. Morales y Marín, *Bayeu,* 238, doc. 93.

33. Goya to Zapater, May 10, 1780, *Goya en el Prado* website/*Documentos.*

34. Morales y Marín, *Bayeu,* 239, doc. 98.

35. RABASF, *Secretaria general: Académicos. Francisco Goya,* leg. 1-41-5, doc. 1. On the painting, see *Goya en el Prado* website/ *Pintura religiosa.*

36. RABASF, *Libros de actas, 1780,* 151r.

37. Goya to Zapater, May 24, 1780, *Goya en el Prado* website/*Documentos.*

8. THE ZARAGOZA AFFAIR

1. Morales y Marín, *Bayeu,* 240, docs. 103, 104, 106; the unpublished letter explaining the nature of the hay is in the Museo del Prado, ODB 021.

2. Águeda and de Salas, *Cartas,* 81–83.

3. Ona González, *Goya y su familia,* 109–10.

4. Torra et al., *Regina Martirum,* 151, doc. 47; 152, doc. 48.

5. Francho is a nickname for Francisco Bayeu; see Calvo Ruata, *Cartas,* 118.

6. Torra et al., *Regina Martirum,* 152, doc. 49.

7. Torra et al., *Regina Martirum,* 152, doc. 50.

8. Torra et al., *Regina Martirum,* 152, doc. 51.

9. The minutes of the committee meetings, Allué's letter to Goya, and the artist's response were first published by Muñoz y Manzano, *Goya,* appendix I, 163–73. The most complete compendium of documents pertaining to the El Pilar commission remains Torra et al., *Regina Martirum,* 138–64; cited here: letter of March 11, 1781, 152–53, doc. 52.

10. Allué to Francisco Bayeu, March 12, 1781, Torra et al., *Regina Martirum,* 153, doc. 53.

11. Goya to the building committee, March 17, 1781, Torra et al., *Regina Martirum,* 153–55, doc. 54.

12. Goya to the building committee, March 27, 1781, Torra et al., *Regina Martirum,* 155–56, doc. 58.

13. Goya to Zapater, January 21, 1778, *Goya en el Prado* website/*Documentos.*

14. Torra et al., *Regina Martirum,* 158, doc. 61.

15. José Ipas to Goya, March 31, 1781, Torra et al., *Regina Martirum,* 159, doc. 62.

16. Félix Salcedo to Goya, March 30, 1781, Torra et al., *Regina Martirum,* 156–57, doc. 60.

17. Minutes of the building committee meetings, May 28, 1781, Torra et al., *Regina*

Martirum, 160, doc. 66. For the payment, see docs. 67 and 68.

18. Juan Martín de Goicoechea to Zapater, June 6, 1781, Museo del Prado, Madrid, ODZ 012.

19. Gassier and Wilson, *Life and Complete Work*, 51.

20. Goya to Joaquina Alduy, July 6, 1781, *Goya en el Prado* website/*Documentos*.

21. Goya to Zapater, July 14, 1781, Águeda and de Salas, *Cartas*, 94.

9. FLORIDABLANCA

1. Goya to Zapater, December 1, 1781, *Goya en el Prado* website/*Documentos*.

2. Boloquí Larraya, *Escultura zaragozana*, 1:171.

3. Goya to Zapater, March 27, 1798, offers the last mention of support for his family: a payment of six *reales* to his sister Rita and another of 2,000 *reales* to his brother Tomás; see *Goya en el Prado* website/*Documentos*.

4. In an undated letter to Zapater, assigned on the basis of its content to March 1783, Goya suggests bringing his mother, as well as Camilo and Rita, to Madrid, after discussing the idea with Josefa; see *Goya en el Prado* website/*Documentos*.

5. Ona González, *Goya y su familia*, 117.

6. Ponz, *Viaje*, 440.

7. Goya to Zapater, July 25, 1781, Águeda and de Salas, *Cartas*, 95.

8. Manuel Bayeu to Zapater, August 4, 1781, Calvo Ruata, *Cartas*, 124–26.

9. Manuel Bayeu to Zapater, August 11, 1781, Calvo Ruata, *Cartas*, 132.

10. Manuel Bayeu to Zapater, August 25, 1781, Calvo Ruata, *Cartas*, 133–35. The author points out that "Belmúdez" may well be "Bermúdez" given that the letters *l* and *r* were often interchanged in writing of the era; see Calvo Ruata, "Goya y los Bayeu," 393.

11. Goya to Zapater, August 29, 1781, *Goya en el Prado* website/*Documentos*.

12. Goya to Floridablanca, September 22, 1781, Canellas López, *Diplomatario*, 238.

13. Goya to Zapater, October 6 and November 13, 1781, *Goya en el Prado* website/*Documentos*.

14. Goya to Zapater, January 11, 1783, Águeda and de Salas, *Cartas*, 134.

15. Goya to Zapater, October 6, 1781, *Goya en el Prado* website/*Documentos*.

16. Matilla Tascón, "Archivo de Protocolos," 18.

17. Goya to Zapater, September 1781, *Goya en el Prado* website/*Documentos*.

18. Goya to Zapater, after October 6, 1781, *Goya en el Prado* website/*Documentos*.

19. Bueno Paz, "Datos documentales," 61; *Goya en el Prado* website/*Dibujos*/*Cuaderno italiano*, 112–13.

20. Goya to Zapater, between May 28 and July 30, 1785; and August 5, 1789, *Goya en el Prado* website/*Documentos*.

21. Pérez Moreda, *Las Crisis*, 336, 354–56.

22. The idea of family debts beginning with his last visit to Zaragoza suggests that Goya returned to the city following his father's death. Goya to Zapater, November 23, 1782, *Goya en el Prado* website/*Documentos*.

23. Muñoz y Manzano, *Goya*, 181.

24. Goya to Zapater, January 11, 1783, Águeda and de Salas, *Cartas*, 134.

25. Goya to Zapater, January 11, 1783, Águeda and de Salas, *Cartas*, 134.

26. Ceán Bermudez, *Memorias*, 137–38, cited by Álvarez-Valdés y Valdés, *Jovellanos*, 112. For Jovellanos's early career in Madrid, see Álvarez-Valdés y Valdés, *Jovellanos*, 101–12.

27. RABASF, *Distribución...1832*, 51.

28. RABASF, *Libros de actas, 1781*, 191v.

29. Jovellanos, *Elogio*, 45.

30. For Jovellanos's letter, see *Obras completas at* www.jovellanos2011.es. See also Clissón Aldama, *Ceán Bermúdez*, 50–52, 56; a chronology of Ceán's life is offered in Santiago Páez, *Ceán Bermúdez*, 23–38. For an English language introduction to Cabarrús, see Cruz, *Gentlemen, Bourgeois*, 176–94.

31. Goya to Zapater, January 22, 1783, *Goya en el Prado* website/*Documentos*.

32. Goya to Zapater, undated letter usually assigned on the basis of content to February 1783, *Goya en el Prado* website/*Documentos*.

33. Loupès, *Espagne de 1780 à 1802*, 227.

34. Arnaiz and Montero, "Goya y el Infante," 44–46.

35. Goya to Zapater, undated, Águeda and de Salas, *Cartas*, 146.

36. Arnaiz and Montero, "Goya y el Infante," 48.

37. Wilson-Bareau and Mena Marqués, *Truth and Fantasy*, 132–33; Matilla and Mena Marqués, *Dibujos*, vol. 1, cat. 32, 325–28.

38. Álvarez García, "Goya, Ramón Bayeu," 178–82.

39. Lasso de la Vega, "Colegio de Calatrava."

40. Goya to Zapater, April 26, 1783, *Goya en el Prado* website/*Documentos*.

41. Goya did not know the original of the Batoni portrait (Art Institute of Chicago), given its early provenance in a Roman collection, but possibly had access to a copy.

42. Identification of this figure as Vicente Bermúdez (Bray, *Portraits*, 37) does not justify the compass as attribute.

43. Goya to Zapater, July 9, 1783, *Goya en el Prado* website/*Documentos*. The Royal Library, relocated in 1775 to the space in the Casa de la Panadería on the Plaza Mayor, had a staff of four according to the *Kalendario y guía de forasteros* (Madrid: Imprenta Real, 1783), 87: the senior librarian, don Juan de Santander, and three others—Miguel Casiri, Tomás Sánchez, and Rafaél Casalbon.

10. DON LUIS

1. Peña Lázaro, "Don Luis de Borbón," 39.

2. Ponz, *Viaje*, 534.

3. Dalrymple, *Travels*, 42.

4. Peña Lázaro, "Don Luis de Borbón," 40.

5. The exclusion of women from the Spanish throne and the ruling that heirs to the throne had to be born in Spain was determined by the *cortes* under Felipe V in May 1713. See Giménez López, "Tránsito del siglo XVIII al XIX," 32.

6. Peña Lázaro, "Don Luis de Borbón," 37–46.

7. It has been suggested that Marcos del Campo, recently married to María Josefa Matea Bayeu, provided Goya's introduction to don Luis through his brother, Francisco, who served María Teresa de Vallabriga. However, a letter from Camilo Goya to Martín Zapater, discussed below, leaves no doubt that Francisco Bayeu was envious of Goya's success with the *infante*, making it likely that if Marcos had any influence in the decision, he would have promoted Francisco or Ramón Bayeu rather than Goya.

8. Goya to Zapater, September 23, 1783, *Goya en el Prado* website/*Documentos*. The value of a *duro* at 20 *reales* is made in a document of 1795 generously provided by Gudrun Maurer.

9. A town honored by the Bourbon monarchs for its loyalty during the war of the Spanish succession, Chinchón, today best known for the production of *anís* (anisette liqueur), was the property of don Luis, purchased from his brother Philip in 1761.

10. González Santos, "Jovellanos por Goya," is the essential study on this painting, today on extended loan to the Museo de Bellas Artes de Asturias, Oviedo, from the Museo Nacional de Escultura, Valladolid. The identification of the underlying portrait as that of María Teresa de Vallabriga was proposed by the conservator, Clara Gonález Fanjul, and was published in *20 Minutos: Asturias* (January 17, 2013).

11. Camilo Goya to Zapater, October 18, 1783, Canellas López, *Diplomatario*, 430.

12. Goya to Zapater, January 14, 1784, *Goya en el Prado* website/*Documentos*.

13. Goya to Zapater, March 3, 1784, *Goya en el Prado* website/*Documentos*.

14. Peña Lázaro, "Don Luis de Borbón," 50.

15. Arnaiz and Montero, "Goya y el Infante," 46.

16. Sambricio, *Tapices*, doc. 78; Mano, *Maella*, 269–73.

17. Goya to Zapater, January 7, 1784, Águeda and de Salas, *Cartas*, 161–63.

18. On the *Westmoreland* and the fate of its treasures, see Sánchez Jáuregui and Wilcox, *English Prize*.

19. Sánchez Jáuregui and Wilcox, *English Prize*, 186–87, 276–77, 334, 345.

20. Both portraits are today in the Museo del Prado, Madrid, P000048 and P000049. See Suárez Huerta, "Portrait of George Legge."

21. Blasco Castiñeyra, *Palacio*, 34, 46.

22. Goya to Zapater, March 3, 1784, *Goya en el Prado* website/*Documentos*.

23. Goya to Zapater, July 2, 1784, *Goya en el Prado* website/*Documentos*.

24. Goya to Zapater, October 13, 1784, *Goya en el Prado* website/*Documentos*.

25. Goya to Zapater, October 13, 1784, *Goya en el Prado* website/*Documentos*.

26. Goya to Zapater, October 25, 1784, Águeda and de Salas, *Cartas*, 180.

27. The portrait (Nationalmuseum, Stockholm) bears an inscription giving the date and origin of the commission.

28. Lasso de la Vega, "Colegio de Calatrava," 7.

29. Canellas López, *Diplomatario*, 431.

30. Goya to Zapater, November 3, 1784, *Goya en el Prado* website/*Documentos*.

31. Cruz, *Gentlemen, Bourgeois*, 114.

32. *Goya en el Prado* website/*Dibujos*/ *Cuaderno italiano*, 64. On Goya's fifteen shares, which he signed over to other individuals in 1788, see García de Valdeavellano, "Apuntes," 61–62.

33. Goya to Zapater, November 3 and 17, 1784, *Goya en el Prado* website/ *Documentos*.

34. *Memorial literario, instructivo y curioso de la Corte de Madrid* (December 1784): 106–12.

35. Goya to Zapater, December 11, 1784, *Goya en el Prado* website/*Documentos*.

36. Goya to Zapater, January 14, 1785, *Goya en el Prado* website/*Documentos*.

37. *Memorial literario, instructivo y*

curioso de la Corte de Madrid (April 1785): 427–29.

38. Muñoz y Manzano, *Goya*, 181.

39. Goya to Zapater, December 11, 1784, *Goya en el Prado* website/*Documentos*.

40. Goya to Zapater, December 4, 1784, *Goya en el Prado* website/*Documentos*.

11. "THE HAPPIEST MAN"

1. Goya to Zapater, February 19, 1785, Águeda and de Salas, *Cartas*, 194.

2. Goya to Zapater, March 25, 1786, *Goya en el Prado* website/*Documentos*.

3. Goya to Zapater, March 30, 1785, *Goya en el Prado* website/*Documentos*. Original punctuation retained.

4. The Cinco Gremios Mayores were the merchant guilds for the sale of cloths of silk, gold, and silver; woolens; linens; spices and drugs; and jewelry and by the last decade of the eighteenth century had a presence beyond Madrid in several Spanish cities and European financial centers. By 1808 this body was the wealthiest financial institution in Spain, with a lending capacity of 50,000,000 *reales* (compared to the national bank's capacity of 3,000,000). See Cruz, *Gentlemen, Bourgeois*, 18–19.

5. "Noticia de las funciones y fiestas…" supplement to the *Gazeta de Madrid* (April 1, 1785).

6. Goya to Zapater, March 30, 1785, *Goya en el Prado* website/*Documentos*.

7. *Memorial literario* (October 1785): 175.

8. Goya to Zapater, dated to July 1786, Águeda and de Salas, *Cartas*, 228.

9. Molas Ribalta, "La Política interior," 126.

10. Matilla, "Retrato de Miguel de Múzquiz"; and Cabarrús, *Elogio*, frontispiece.

11. Gutiérrez de los Ríos, *Vida de Carlos III*, 382–83.

12. Jovellanos, "Noticias biográficas de Lerena," in *Obras completas* at www .jovellanos2011.es.

13. Molas Ribalta, "La Política interior," 129.

14. Goya to Zapater, May 28, 1785, *Goya en el Prado* website/*Documentos*; Alfonso Pérez Sánchez, "Pintura de los siglos XVI al XVIII," 67–91, in Viñuela, *Colección de pintura del Banco de España*, 76–77.

15. RABASF, Sección General, Académicos: Francisco Goya, leg. 1-41-5, doc. 2.

16. RABASF, *Francisco Goya*, leg. 1-41-5, docs. 2–5.

17. RABASF, Archive, *Libros de actas, 1785*, 287r–v, 288r.

18. RABASF, *Francisco Goya*, leg. 1-41-5, doc. 6.

19. Goya to Zapater, November 23, 1782, January 27, 1783, and January 29, 1783, *Goya en el Prado* website/*Documentos*. Águeda and de Salas, *Cartas*, 146. Pirán, mentioned in the letter of November 23, 1782, is Francisco Javier Pirán, who acted as an agent for Zapater in Madrid; see Águeda and de Salas, *Cartas*, 124n6.

20. The portrait is in the National Gallery of Art, Washington DC.

21. Goya to Zapater, August 23, 1786, *Goya en el Prado* website/*Documentos*.

22. For a summary of documented Osuna patronage of Goya, see Gassier and Wilson, *Life and Complete Work*, 383–84.

23. Goya to Zapater, dated between May 28 and July 30, 1785, *Goya en el Prado* website/*Documentos*.

24. Goya to Zapater, August 17, 1785, *Goya en el Prado* website/*Documentos*.

25. "Descripción del Retablo nuevamente construido en la Iglesia de S. Antonio del Prado," *Memorial literario* (February 1786), 215–18. On the painting and its sketch, see Pérez Sánchez and Sayre, *Spirit of Enlightenment*, 16–18.

26. Bédat, *Académicos*, 92–93.

27. Goya to Zapater, March 11, 1786, *Goya en el Prado* website/*Documentos*.

28. Goya to Zapater, March 25, 1786, *Goya en el Prado* website/*Documentos*.

29. Goya to Zapater, June 20, 1786, *Goya en el Prado* website/*Documentos*.

30. Sambricio, *Tapices*, docs. 79, 81.

31. Sambricio, *Tapices*, docs. 82–84, 86.

32. Sambricio, *Tapices*, doc. 88.

33. Sambricio, *Tapices*, doc. 92.

34. AGP, Sec. Administrativa, leg. 38. On the commission for the palace of the secretaries of state, see Martínez Arranz, "Dos pinturas inéditas."

35. Goya to Zapater, July 7, 1786, *Goya en el Prado* website/*Documentos*.

36. Manuel Bayeu to Zapater, September 2, 1786, Calvo Ruata, *Cartas*, 149–50.

37. Cruz, *Gentlemen, Bourgeois*, 110.

38. *Diario curioso, erudito, económico, y comercial* (June 17, 1786), 71.

39. Goya to Zapater, August 1, 1786, Águeda and de Salas, *Cartas*, 231.

40. Goya to Zapater, August 23, 1786, *Goya en el Prado* website/*Documentos*.

41. Goya to Zapater, April 17 and 25, 1787, and May 4, 1787, *Goya en el Prado* website/*Documentos*. For the letter of June 13, see Águeda and de Salas, *Cartas*, 264.

42. Goya to Zapater, May 4, 1787, *Goya en el Prado* website/*Documentos*.

12. "GOD HAS DISTINGUISHED US"

1. Although Goya identified the room as a dining room, it may instead have served as a "conversation room." See Goya to Zapater, September 12, 1786, *Goya en el Prado* website/*Documentos*; and for the carpenter's invoice for stretchers for the full-scale cartoons that identified their destination as the "pieza de conversación," see Sambricio, *Tapices*, doc. 106. Goya paid 384 *reales* for a coach to take him to El Escorial to present the sketches to His Majesty; see Sambricio, *Tapices*, doc. 103.

2. On the series, Tomlinson, *Tapestry Cartoons*, 156–79. For images of the series, see *Goya en el Prado* website/*Pinturas/Cartones para tapices/Comedor, o Sala de Conversación de los príncipes de Asturia en el Palacio de El Pardo*.

3. Pérez Sánchez, "Pintura de los siglos XVI al XVIII," in Viñuela, *Colección de pintura del Banco de España*, 76–79; and Glendinning and Medrano, *Goya y el Banco Nacional*.

4. The portraits of the directors remain in the collection of the Banco de España,

and the portrait of Manuel Osorio is in the Metropolitan Museum of Art. On Goya and the Altamira family, see Salomon, "Altamira Family."

5. Gassier and Wilson, *Life and Complete Work*, 383–84.

6. The invoices are dated April 22 and May 12, 1787; the countess paid 10,000 *reales* as the first installment on June 7 and the remainder in February 1788.

7. On June 18, 1787, the duchess of Osuna contracted Juan Bautista Mulot in Paris with the stipulation that he could not work on any other house in Spain and if he left the Alameda would have to return to France. See AHN, Sec. De Osuna, leg. 514, cited by Carmen Añón Feliú, "Armonía y ornato de la naturaleza en el Madrid de Carlos III," in Madrid, *Carlos III*, 153.

8. Six of the paintings are today in private collections, a seventh painting is today lost; see Museo del Prado, *Goya en las colecciones madrileñas*, 138–47.

9. Goya to Zapater, June 6, 1787, *Goya en el Prado* website/*Documentos*.

10. Sambricio, *Tapices*, doc. 109. One *vara* equals 83.5 cm.

11. Sambricio, *Tapices*, doc. 102; Goya to Zapater, May 12, 1787, Águeda and de Salas, *Cartas*, 259.

12. Herr, *Eighteenth-Century Revolution*, 76.

13. Goya to Zapater, November 14 and 28, 1787, *Goya en el Prado* website/*Documentos*; and Águeda and de Salas, *Cartas*, 270.

14. Rose Wagner, "Manuel Godoy," 1:83–84.

15. Sambricio, *Tapices*, docs. 112, 113.

16. Goya to Zapater, May 31, 1788, *Goya en el Prado* website/*Documentos*. Both I and others have interpreted Goya's words as a reference to the need to finish the sketches. However, Goya's payment for the wooden stretchers for the full-scale cartoons on April 10 suggests that he had already completed and received approval for the five sketches, for which he had ordered canvases in early February. His challenge now, expressed with his words that the task was "so difficult, and with so much to do," was to finish the cartoons, rendering details only implied in the sketches.

17. Goya to Zapater, May 31, 1788, *Goya en el Prado* website/*Documentos*.

18. My observation is based on an examination of *Blind Man's Bluff*, in conservation at the Museo del Prado, on December 9, 2015, and I am indebted to the curatorial staff for making this visit possible. My opinion that the reference in Goya's May letter is to the cartoons rather than to their sketches is not shared by colleagues at the Museo del Prado. The often-repeated assumption that Goya never painted the full-size cartoons is perhaps contradicted in a memorandum from the director of the tapestry factory dated January 18, 1800, in which he suggests completing the tapestries for this series after the paintings by Goya and others that were in his possession. However, he identifies that series with an otherwise unknown commission for the *infante* don Gabriel, rather than for the *infantas*. Sambricio, *Tapices*, doc. 197.

19. Another sketch, different in palette and tone from these, shows inebriated men at a picnic in a dark grove, its subject clearly inappropriate for the bedroom of royal princesses. Although it has been catalogued as one of the sketches executed in 1788, it was probably one of the two "asumptos de campo," or country subjects, added to the sketches when the duke and duchess of Osuna purchased them as specified in the payment order of April 26, 1799. See Gassier and Wilson, *Life and Complete Work*, cat. 274 and 384.

20. For the letter of June 13, 1787, see Águeda and de Salas, *Cartas*, 264; for all others, see *Goya en el Prado* website/*Documentos*.

21. Goya to Zapater, November 28, 1787, Águeda and de Salas, *Cartas*, 270.

22. Goya to Zapater, May 9 and 19, 1787, *Goya en el Prado* website/*Documentos*.

23. Two hundred *reales* for gilding was added to the 2,000 *reales* charged for the portrait of Francisco Javier de Larrumbe (October 5, 1787); gilding was included in the fee of 4,500 *reales* for the portrait of Francisco Cabarrús (April 21, 1788). See Canellas López, *Diplomatario*, 438–39.

24. Goya to Zapater, April 25, 1787, *Goya en el Prado* website/*Documentos*.

25. Goya to Zapater, May 31, 1788, *Goya en el Prado* website/*Documentos*.

26. Goya to Zapater, July 2, 1788, *Goya en el Prado* website/*Documentos*.

27. Goya to Zapater, August 23, 1786 and June 6, 1787, *Goya en el Prado* website/*Documentos*.

28. Goya to Zapater, June 13, 1787, Águeda and de Salas, *Cartas*, 264.

29. My thanks to Dr. Philip Mackowiak for explaining that although the term "tertian fevers" today refers mainly to malaria, it had a more general connotation in Goya's day. Goya to Zapater, August 25, 1787, *Goya en el Prado* website/*Documentos*.

30. Pérez Moreda, *Las Crisis*, 337–39, 346–50.

31. Goya to Zapater, March 19, 1788, *Goya en el Prado* website/*Documentos*.

32. Mena Marqués, *Eighteenth-Century Spanish Painting*, 208.

33. Pérez Moreda, *Las Crisis*, 351–57.

34. Pérez Moreda, *Las Crisis*, 358–59.

35. Goya to Zapater, November 19, 1788, *Goya en el Prado* website/*Documentos*.

36. Jovellanos, "Enfermedad y muerte del rey Carlos III," January 1, 1789; see *Obras completas* at www.jovellanos2011.es.

37. Goya to Zapater, January 7, 1789, Águeda and de Salas, *Cartas*, 289.

38. *Mercurio histórico y político* (January 1789), 63–67.

39. Mano, "Goya versus Bayeu," 135.

40. Mano, "Goya versus Bayeu," 137–38.

41. RABASF, *Libros de actas*, 1789, 96v–97v.

42. Cited by Mano, "Goya versus Bayeu," 139–40.

43. Goya requested reimbursement for these costs in an invoice dated June 30, 1789; see Sambricio, *Tapices*, doc. 125. The royal departure is noted in the *Mercurio histórico y político* (April 1789), 399.

44. For the gilders' invoice dated July 4, 1789, mentioning the "two plain frames, that were taken to the house of Goia, the painter," see Mena Marqués and Mühle Maurer, *Duquesa de Alba*, 247.

45. AGP, Carlos IV (Casa), leg. 91, cited by Mano, "Goya versus Bayeu," 150n67. Vicente Gómez had requested the position on January 9, 1789; see AGP, Expediente Personal de Vicente Gómez, 442/15.

13. A CORONATION UNDER DARKENING SKIES

1. Ponz, *Viaje*, 96.

2. Bourgoing, *Travels*, 1:247–48, 258.

3. Urriagli Serrano, *Colecciones*, 30.

4. From a diary entry of the Venezuelan Francisco de Miranda, cited by Mano, *Maella*, 148.

5. Urriagli Serrano, *Colecciones*, 34–68.

6. Bourgoing, *Travels*, 1:198–200.

7. Mano, *Maella*, 383–87.

8. Sambricio, *Tapices*, doc. 119.

9. On the *casita* at El Pardo, see Sancho et al., *Casita del Príncipe*; on the academias, 14.

10. Gómez's work at the *casita* at El Pardo included a ceiling painted with ivory-colored grotesques, the decoration of the "yellow room," and the "long room," known today as the Pompeian room, for which Gómez designed the ceiling, wall ornamentation, furniture, and textiles. He also painted a ceiling in tempera emulating the logge of the Vatican in the "large cabinet of the fireplace," whose name derived from its carved Italian marble hearth, part of the *Westmoreland* trove. See Sancho et al., *Casita del Príncipe*, 83–85, 92–93.

11. *Mercurio de España* (June 1789): 185.

12. Goya to Zapater, May 2, 1789, Águeda and de Salas, *Cartas*, 291–92.

13. Mano, "Royal Portraits," 86. The order to paint the miniatures followed on May 9.

14. Goya to Zapater, April 25, 1789, *Goya en el Prado* website/*Documentos*. On Tomás Goya and his family after 1790, see Ona González, *Goya y su familia*, 117–26.

15. Goya to Zapater, May 23, 1789, Águeda and de Salas, *Cartas*, 293.

16. Goya to Zapater, June 23, 1789, *Goya en el Prado* website/*Documentos*.

17. Goya's June 30 invoice for materials for the "portraits of his Majesties, that by their order Don Francisco de Goya, as Painter of the Royal Court, is painting" included expenses for two canvases for full-length portraits, a crate and a mule to carry them to Aranjuez and return them to Madrid, and a round trip by coach. The invoice is dated June 30, 1789; see Sambricio, *Tapices*, doc. 125; for the portraits, Museo del Prado P02862 and P03224, see *Goya en el Prado* website/*Pinturas*.

18. Goya received payment of 4,000 *reales* from the tobacco factory on May 11, 1789; see Rodríguez Gordillo, *Retratos*, 23–24. The portraits for the Royal Academy of History, were 30 cm taller than the others, justifying their higher price of 6,000 *reales*; Jovellanos oversaw the commission, and portraits were delivered by September 11, 1789; see Canellas López, *Diplomatario*, 441. The portraits for the mint (Casa de Moneda) were completed by January 5, 1790, for which Goya was paid 4,000 *reales*; on March 3 a payment of 2,000 *reales* was ordered for a copy of Goya's original portrait of the king for the office of Lerena, minister of finance; see Matilla Tascón, "Documentos," 224–25. For Ceán's account of Esteve's participation, see BNE, Madrid, ms. 21.455 (8), fol. 39v, cited and translated in Mano, "Royal Portraits," 88.

19. Entry for August 21, 1789, BNE, ms. 12628.

20. Sambricio, *Tapices*, docs. 122, 123.

21. On the pastels of popular types by Lorenzo Tiepolo, see Patrimonio Nacional, *Carlos III*, 227–37.

22. Fernández-Miranda, *Inventarios*, inventory numbers 21, 27, 54, 55, 59, 60, 109, 539.

23. Juan Martín de Goicoechea was made a knight of the Order of Carlos III; see Ansón Navarro, "Revisión crítica," 274. Goya to Zapater, August 5, 1789, *Goya en el Prado* website/*Documentos*.

24. Goya to Zapater, June 23, 1789, *Goya en el Prado* website/*Documentos*. Given Asensio Martínez's name and profession, he may be the subject of a small portrait of a man standing with a building under construction (Museo Nacional Thyssen Bornemisza, Madrid) inscribed "to Asensí." On the sole basis of this inscription, the sitter is conventionally identified as Asensio Juliá.

25. Goya to Zapater, August 5 and October 21, 1789, *Goya en el Prado* website/*Documentos*. For Zapater's reply to the situation of Goya's nephew, see Canellas López, "Un Borrador," 10.

26. *Mercurio histórico y político de España* (September 1789): 65–71.

27. Moreno and Bonet Correa, *Ornatos públicos*; and Mano, "Goya versus Bayeu," 159.

28. Herr, *Eighteenth-Century Revolution*, 242–43.

29. *Mercurio de España* (January 1790): 13–15.

30. *Mercurio de España* (January 1790): 16–17.

31. Goya to Zapater, February 20, 1790, Águeda and de Salas, *Cartas*, 303.

32. Cruz, *Gentlemen, Bourgeois*, 110.

33. Hoz García, "Reformas de la Hacienda madrileña," 80.

34. Loupès, *Espagne de 1780 à 1802*, 238.

35. Loupès, *Espagne de 1780 à 1802*, 234.

36. Sánchez-Blanco, *Ilustración goyesca*, 28–29.

37. Anonymous, *Correo de Madrid* (December 5, 1789): 2540–41.

14. CHANGING TIMES

1. Sambricio, *Tapices*, docs. 129–35; cited here: doc. 134.

2. Goya to Zapater, April 25, 1789, *Goya en el Prado* website/*Documentos*.

3. Bayeu's portrait of the king was

completed in April 1791; see Mano, "Goya versus Bayeu," 143–44.

4. Morales y Marín, *Bayeu,* 259–61.

5. Mano, *Dibujos,* 1: 326–31.

6. Mano, *Maella,* 532–35; the canvas is today in storage in the Museo del Prado. See Mena Marqués, *Familia de Carlos IV,* 131–32.

7. *Mercurio de España* (June 1790): 147–48.

8. Alcázar Molina, "España en 1792," 102–5.

9. Herr, *Eighteenth-Century Revolution,* 261.

10. Goya's preliminary drawing is in the Museo del Prado. See Salas, "Valdemoro"; and *Goya en el Prado* website, *Dibujos/Varios/Preparatorios de pinturas.*

11. Bermejo, "El Azotado"; and Canellas López, *Diplomatario,* 442–43.

12. Romero Tobar, *Goya en las literaturas,* 176–77.

13. The permission is dated July 17, 1790, Sambricio, *Tapices,* doc. 136.

14. Goya first mentioned Ferrer, whose portrait he had painted, in a letter to Zapater on September 20, 1783; see *Goya en el Prado* website/*Documentos.*

15. Goya to Zapater, August 28, 1790, *Goya en el Prado* website/*Documentos.* In the early 1780s, Antonio Carnicero painted the Albufera; see Museo del Prado, P00640.

16. Canellas López, *Diplomatario,* 443–44.

17. Ansón Navarro, "Revisión crítica," 268–69.

18. The account of the bullfight, by the Zaragoza chronicler Faustino de Casamayor, is cited by G. Demerson, *Meléndez Valdés,* 274. In showing these plays in the *Tauromaquia* (nos. 19 and 24), Goya changed the identity of arena or figure: Maríano Ceballo, alias "el Indio," mounts the bull in the ring in Madrid; and it is Martincho who jumps, shackled, from a table in the Zaragoza ring.

19. Zapater to Joaquín Yoldi, December 4, 1790, Canellas López, *Diplomatario,* 445.

20. Cited by José Enguita Utrilla,

"Goya: Aragón en la Palabra," in Museo Goya, *Goya y Zaragoza,* 89. On October 20, Goya had been elected to the Royal Academy of San Carlos in Valencia; see Canellas López, *Diplomatario,* 301–2.

21. *Diario de Madrid* (October 11, 1790): 1139.

22. Goya to Zapater, November 10, 1790, Águeda and de Salas, *Cartas,* 307. The letter was acquired by the Museo del Prado in 2018 (ODG 124). See Matilla and Mena Marqués, *Dibujos,* 222–26, where the drawing of the heart is interpreted as "burning or inflamed with love." As the authors note, this might replace a written salutation of affection, such as "Querido mío" (My dearest) or "Mío de mi Alma" (Mine of my soul). More simply, it replaces the cross (which over time is more freely drawn so that the vertical line sometimes resembles an *s*) with which Goya often began his letters, including that which followed this letter, dated to mid-November 1790; see *Goya en el Prado* website.

23. Goya to Zapater, (mid-November), *Goya en el Prado* website/*Documentos.*

24. Ansón Navarro, "Revisión crítica," 272. Although Goya's reference to more than one portrait has led to a tentative identification of the second with a half-length portrait of Juan Martín de Goicoechea, it is also possible that other friends or members of Zapater's household sat for him. The portrait of Goicoechea is traditionally dated a year earlier to coincide with the sitter's award of the Order of Carlos III, which he wears in the portrait.

25. Goya to Zapater, (mid-November to early December 1790), *Goya en el Prado* website/*Documentos.*

26. Goya to Zapater, (December 1790), *Goya en el Prado* website/*Documentos.* A recent interpretation of the drawings as a reference to "a physical union, explicit and radiant" that Goya could not give to Zapater because of the distance separating them is, to this author, unconvincing; see Matilla and Mena Marqués, *Dibujos,* 129–232.

27. In addition to the recent reading by Matilla and Mena Marqués, *Dibujos* see Pagés-Rangel, *Dominio público*, 155–96; and Seseña, *Goya y las mujeres*, 59–69.

28. Goya to Zapater, (late December 1790), *Goya en el Prado* website/*Documentos*. On that website, another letter dated to December 1790 is redated at the end of this chapter to fall 1791.

29. AGP, sec. Reinados, Carlos IV, Casa, leg. 50/1, cited and discussed in: Mena Marqués and Mühle Maurer, *Duquesa de Alba*, 173.

30. An inscription stating that the boy is portrayed at the age of two years and eight months, supports a date for the portrait of spring 1791.The portrait entered the Musée du Louvre in 2009.

31. Sambricio, *Tapices*, doc. 139.

32. Matilla Tascón, "Documentos," 225.

33. Sambricio, *Tapices*, doc. 140.

34. Sambricio, *Tapices*, doc. 141.

35. Sambricio, *Tapices*, doc. 143.

36. Goya to Bayeu, June 3, 1790, Sambricio, *Tapices*, doc. 142.

37. Matilla Tascón, "Documentos," 205.

38. No firmly attributed sketch survives; the cartoon of *The Wedding* (*La Boda*) is in the Museo del Prado. For a discussion of this cartoon in relation to contemporaneous debates on the relationship of the sexes, see Tomlinson, "Goya y lo Popular."

39. *Mercurio de España* (January 1791): 69; (March 1791): 213; (August 1791): 330; (December 1791): 339.

40. *Mercurio de España* (September 1791): 63–64.

41. Sambricio, *Tapices*, doc. 149; RABASF *Libros de actas*, 1791, 476v.

42. Goya to Zapater, dated December 1790, here dated to after his return from Zaragoza in fall 1791, *Goya en el Prado* website/*Documentos*. Having written the letter, Goya received eight more popular songs (four *seguidillas* and four *tiranas*) and took a second sheet of paper to ask that Zapater copy but not distribute them; he also discussed two English knives he had purchased for his friend.

43. Salas, "Aportaciones," 410–12.

15. THE BEST OF TIMES, THE WORST OF TIMES

1. Molas Ribalta, "La Política interior," 129–30.

2. Herr, *Eighteenth-Century Revolution*, 265–69.

3. G. Demerson, *Meléndez Valdés*, 283; Ansón Navarro, *Academicismo*, 129–30.

4. On the founding of the Royal Academy of Fine Arts of San Luis in Zaragoza, see Ansón Navarro, *Academicismo*, chap. 6.

5. Ansón Navarro, "Revisión crítica," 277.

6. Goya to Zapater, February 17, 1792, *Goya en el Prado* website/*Documentos*.

7. The correspondence cited is in the Museo del Prado, Departamento de Dibujos y Estampas, ODZ 013–023.

8. Morales y Marin, *Bayeu*, 261, doc. 200.

9. Ansón Navarro, *Academicismo*, 135.

10. Péman Medina, "Colección artística," 59.

11. Péman Medina, "Estampas y libros," 304.

12. Cruz Valdovinos, "Inquisidores e ilustrados."

13. *Mercurio de España* (March 1792): 262; for Ponz's description of Martinez's collection, see Ponz, *Viaje*, 1587–88.

14. Kenyon Cox, "Workmanship," MMA *Bulletin* 12, no. 7 (July 1917): 150, cited by Ives and Stein, *Goya*, 39.

15. Goya to Zapater, (between February 21 and March 14, 1792), *Goya en el Prado* website/*Documentos*.

16. *Diario de Madrid* (January 25, 1792): 97–98.

17. *Diario de Madrid* (March 21, 1792): 349–50.

18. Goya to Zapater, (between March 7 and 14, 1792), *Goya en el Prado* website/ *Documentos*.

19. On the series, see Tomlinson, *Tapestry Cartoons*, 187–210. The purchase of canvases prior to June 30, 1792, was included in invoices published by Sambricio, *Tapices*, docs. 153–56. Stretched canvases delivered after this date and specifically cited

in the invoice as "for overdoors" were in-
cluded in the receipts dated December 31,
1793; see Núñez Vernis, "Seis documen-
tos," 38–40.

20. Jordán de Urríes, "Coleccionismo
de Bernardo Iriarte," 261–62.

21. Musée des Beaux-Arts, Strasbourg,
France.

22. Maurer, "Leyenda persistente,"
76–7. Sepúlveda offered very brief summa-
ries of the reports read at the October 28
meeting in his diary; see BNE, ms. 12628
entry, October 28, 180–81.

23. Goya's report was first published
by Held, "Akademiekritik," in Spanish
with commentary in German. For discus-
sion of the curricular reform of the 1790s,
see Tomlinson, Twilight of Enlightenment,
38–45.

24. BNE, ms. 12628, 180–81.

25. Sambricio, Tapices, doc. 158.

26. Baticle, "À la découverte," 111.

27. Sambricio, Tapices, doc. 157.

28. Maurer, "Leyenda persistente," 76.

29. Diario de Madrid (April 15, 1792):
451–52. On the diagnosis of Goya's illness
as lead poisoning, see Rodríguez y Torres,
Saturno.

30. Morales y Marín, Bayeu, 261, doc.
199.

31. Sambricio, Tapices, docs. 155, 173.

32. Sambricio, Tapices, doc. 160. The
request remained with Zapater's corre-
spondence, implying that either it was not
delivered to the palace or that Martínez
provided Zapater a copy, in which case,
the original has not come to light; see
Maurer, "Leyenda persistente," 77–78.

33. The letter was long misdated to
January; the history and repercussions of
the misdating of this letter are discussed
by Maurer, "Leyenda persistente," 74–77.

34. Sambricio, Tapices, doc. 162; see
Maurer, "Leyenda persistente," 78.

35. Sambricio, Tapices, doc. 161; the let-
ter is today in the Museo del Prado, ODZ
059.

36. Sambricio, Tapices, doc. 161.

37. Rodríguez Torres, Saturno,
30–34, discusses the relation of Goya's

symptoms to the Disertación médica sobre
el cólico de Madrid inserta en las Memorias
de la Real Academia Médica de Madrid y pu-
blicada separadamente de orden de la misma
en beneficio común (Madrid: Imprenta
Real, 1796).

38. Martínez to Zapater, March 29,
1793; see Sambricio, Tapices, doc. 161. The
doctors who saw Goya in Cádiz are named
in Martínez's letter to Zapater of March
19, 1793 (Sambricio, Tapices, doc. 160) as
Dr. Labrera and Dr. Francisco Canivell,
a navy surgeon and surgeon of the court
of Carlos IV; see Rodríguez Torres, Sat-
urno, 64.

39. Vallés Valera, "Goya, su sordera,
su tiempo," 127; Ravin and Ravin, "What
Ailed Goya?"

40. Hertzano, Tomlinson, and Macko-
wiak, "Goya's Lost Hearing," 40.

41. Maurer, "Leyenda persistente," 76,
79; RABASF, Libros de actas, 1793, 249r.

42. Blasco Castiñeyra, Palacio, 57.

43. Herr, Eighteenth-Century Revolution,
307–10.

44. Maurer, "Leyenda persistente."
For Goya's advertisement in the Diario de
Madrid on June 17, 1793, see Cerón, "Snuff
Box."

16. "THERE ARE NO RULES
IN PAINTING"

1. Goya attended no meetings from
July 1793 through 1808. See Bédat, Académi-
cos, 114–59.

2. RABASF, Archive, leg. 1–21/9, pub-
lished by Buendía and Peña, "Goya,
Académico," 307–8.

3. Cruz Valdovinos, "La Decoración
de la Capilla Alta: Encargo, iconografía,
y análisis formal," in Cruz Valdovinos,
Santa Cueva de Cádiz, 43.

4. RABASF, Archive, leg. 41; Canellas
López, Diplomatario, 323–24.

5. RABASF, Distribución, 1796, 8.

6. RABASF, Libros de actas, 1794, 279r.

7. Goya to Iriarte, January 4, 1794,
British Library, ms. Egerton, 585, fol. 74,
author's translation. For an image and al-
ternative translation of the document,

see Gassier and Wilson, *Life and Complete Work*, 108.

8. Goya to Iriarte, January 7, 1794, British Library, ms. Egerton, 585, fol. 75; see Gassier and Wilson, *Life and Complete Work*, 382.

9. Goya to Iriarte, January 9, 1794; British Library, ms. Egerton, 585, fol. 76; see Gassier and Wilson, *Life and Complete Work*, 382.

10. Mor de la Fuente, *Serafina*, 181–82. This novel is a second revision of the author's very popular *El Cariño perfecto u Alfonso y Serafina* published in 1798; see García Garrosa, "Tres versiones."

11. Espinosa Ibarra, "Testimonio."

12. BNE, mss./14515/28 (dated 1740) and mss. 14515/24 (undated). Both are available on the library's *Biblioteca digital hispánica.*

13. Wilson-Bareau and Mena Marqués, *Truth and Fantasy*, 189–203.

14. Wilson-Bareau and Mena Marqués, *Truth and Fantasy*, 356–57, identify the Chopinot paintings with those shown in January 1794 to the Royal Academy, which were in all likelihood painted, like *Yard with Lunatics*, on tinplate. Given that the Chopinot inventory identifies the support as panel, it is likely that the Chopinot paintings are not those seen by the academicians in 1794.

15. Glendinning, "Spanish Inventory References," 100, 109. Including works created over a decade or longer, the Romana group has survived intact; see Mena Marqués, *Tiempos de guerra*, 233–37.

16. Wilson-Bareau and Mena Marqués, *Truth and Fantasy*, 212–25.

17. Sambricio, *Tapices*, doc. 177; Núñez Vernis, "Seis documentos," doc. 3.

18. Mena Marqués and Mühle Maurer, *Duquesa de Alba*, 176.

19. Sambricio, *Tapices*, doc. 179.

20. The portrait of La Tirana is in a private collection in Madrid; the portrait of Larriátegui is in the Indianapolis Museum of Art.

21. On the full-length "La Tirana," see Águeda, *"La Tirana."* On the portrait of

Larriátegui, see Kasl and Stratton, *Enlightenment*, 246–47.

22. Rose, "Retrato de General Ricardos," 118. The painting is in the Museo del Prado, Madrid.

23. Herr, *Eighteenth-Century Revolution*, 322, discusses Aranda's exile but does not note the coincidence with Ricardos's death.

24. *Mercurio de España* (April 1794): 421. On the countess, see Martín-Valdepeñas Yagüe, "Retrato," 75–76.

25. Mena Marqués and Mühle Maurer, *Duquesa de Alba*, 179.

26. Goya to Zapater, February 15 and May 21, 1794, *Goya en el Prado* website/*Documentos*. Goya invested 84,000 *reales* in the Real Fondo Vitalicio on May 26, 1794; see Sánchez Cantón, "Como vivía Goya," 100.

27. Goya to Zapater, April 23, 1794, *Goya en el Prado* website/*Documentos*. For the program of the bullfight on Monday, April 28, 1794, see *Diario de Madrid* (April 29, 1794): 482–83.

28. Goya to Zapater, mid-June 1794, *Goya en el Prado* website/*Documentos*.

29. Goya to Zapater, undated, *Goya en el Prado* website. The letter has long been dated to 1794, its content interpreted as a reference to Zapater's bedroom and related to his purchase of a new bed.

30. References to Bayeu's leave from court (from mid-July to late August 1794) and to Godoy as duke of Alcudia (to change a year later) corroborates the date of August 1794; see *Goya en el Prado* website/*Documentos*.

31. On the duchess of Alba as inspiration for contemporary poets, see Mena Marqués and Mühle Maurer, *Duquesa de Alba*, 27–47.

32. Letter of March 21, 1800, published by Pereyra, *Cartas confidenciales*, 271–72.

33. The portrait is in the Museo de Bellas Artes de Bilbao.

34. Zapater y Gómez, *Goya*, 3–4, 48.

35. Rent was paid for Goya's lodging at La Granja on September 26; see Mena

Marqués and Mühle Maurer, *Duquesa de Alba*, 253, doc. 7. One of the sketches is today in a private collection; another is thought to underlie the small painting *La Garrochista* in the Museo del Prado. The full-size portrait, once thought to underlie the equestrian portrait of the Duke of Wellington (Wellington Museum, Apsley House) is thought to be lost. See Rose de Viejo, La Parra López, and Giménez López, *Imagen*, 134–37.

36. For Bayeu's letter to Zapater mentioning Goya's presence at the bullfight, see Morales y Marín, *Bayeu*, 262, doc. 208; for a report on Romero's performance, see *Diario de Madrid* (September 2, 1794): 1000–1002.

37. Maurer, "Goya, sordo," discusses this letter in context; for the letter see p. 94.

38. Symmons et al., *Printing the Unprintable*, 53–54.

39. José Manuel Matilla, "De los reyes abajo todo el mundo me conoce," in Fundación Amigos del Museo del Prado, *Siglo las luces*, 395–96; *Diario de Madrid* (January 7, 1795): 25.

40. "Glosa," *Diario de Madrid* (January 14, 1794): 58.

41. "Letrilla," *Diario de Madrid* (April 10, 1793): 414.

42. "Glosa," *Diario de Madrid* (January 14, 1794): 58.

43. *Diario de Madrid* (August 14, 1795): 961.

44. Soubeyroux, "Paupérisme," 2:710–11.

45. *Diario de Madrid* (December 5, 1795): 2073.

46. *Diario de Madrid* (January 5, 1791): 19.

47. *Diario de Madrid* (May 11, 1793): 549.

48. *Diario de Madrid* (April 15, 1795): 443. *Petimetre* refers to a simple-minded man concerned mainly with appearance and fashion and derives from the French *petit maître*; *petimetra* is his female counterpart.

49. *Diario de Madrid* (July 4, 1796): 749.

50. See the *Diario de Madrid* (March 7, 1792): 284, three prints of animals in fashionable dress; (February 18, 1794): 199, harlequin figures; (February 23, 1793): 215, Rita Luna; (July 14 1792): 840, and (March 9, 1795): 283, dance positions; (October 2, 1792): 1157, four plays of the bullfight; and (September 17, 1793): 1068, death of Marat.

51. On the dating of the *sueños* drawings and their possible relation to drawings categorized as album "B," see Vega, "El Sueño dibujado."

52. Carderera, "François Goya," 223.

53. Mayor, "Goya's Creativeness," 106.

54. For an introduction in English to this early group of drawings, see Wilson-Bareau, *Drawings from His Private Albums*, 37–46.

55. Sambricio, *Tapices*, docs. 109, 112, 116, 124, 137.

56. Mena Marqués and Mühle Maurer, *Duquesa de Alba*, 250.

17. GOYA AND THE DUCHESS

1. The duke of la Roca and marquis of Sofraga (San Diego Museum of Art) and portraits of the widowed marquise of Villafranca and her son the duke of Alba (Museo del Prado, Madrid) are all dated to 1795. On the full-length portrait of Godoy, detected beneath the portrait of the countess of Chinchón, see Mena Marqués and Mühle Maurer, *Duquesa de Alba*, 102–3.

2. Mena Marqués and Mühle Maurer, *Duquesa de Alba*, 126. The palace was destroyed during the Spanish Civil War.

3. Hervás y Panduro, *Escuela española*, 2:28.

4. The copy by Esteve (private collection, Madrid) is illustrated in Mena Marqués and Mühle Maurer, *Duquesa de Alba*, 110; Goya's half-length portrait of the duke of Alba is in The Art Institute of Chicago.

5. Mena Marqués and Mühle Maurer, *Duquesa de Alba*, 117.

6. BNE (B/1270a) and the Museo del Prado (D-4183).

7. The identification of the older woman with Rafaela Luisa Velázquez,

or "La Beata," was made by Ezquerra del Bayo, *Duquesa de Alba*, 180. The painting of the duchess and "La Beata" is in the Museo del Prado; that with Luisito Berganza is in a private collection.

8. Bray, *Portraits*, 86, citing Mena Marqués and Mühle Maurer, *Duquesa de Alba*, 18.

9. Morales y Marín, *Bayeu*, docs. 209–15, pp. 262–64.

10. Morales y Marín, *Bayeu*, doc. 211, pp. 263–64.

11. Morales y Marín, *Bayeu*, docs. 216, 219, pp. 264, 293.

12. RABASF, *Libros de actas, 1795*, 20v, 21r. For Goya's solicitation, see Canellas López, *Diplomatario*, 321.

13. The self-portrait of Bayeu that served Goya as a model is today in the Museo de la Real Academia de Bellas Artes de San Fernando in Madrid; the date of 1796 given by Feliciana suggests that Goya completed the portrait following its exhibition at the academy. See Lafuente Ferrari, *Antecedentes*, 65n2. Goya's portrait of Bayeu is in the Museo del Prado.

14. The document, British Library, ms. Egerton, 586, fol. 73, was first published by Loga, *Francisco de Goya*, 166–67n191. "Sr. Llaguno" refers to Eugenio de Llaguno Amirola, secretary of grace and justice, elected honorary academician of the RABASF on January 5, 1794 (the same meeting at which Goya's paintings of "caprice and invention" were presented).

15. The king wasted no time in reallocating part of the salary freed by Bayeu's death: Jacinto Gómez, a court painter without salary since 1793, was granted a salary of 15,000 *reales* on August 12; Joseph Beratón, previously paid 10,000, received a 5,000-*reales* raise on August 8; and the miniature portraitist Francisca Meléndez—niece of the better-known still-life painter Luis Meléndez—benefitted from an increase from 6,000 to 10,000 *reales*, a salary

equal to that of the miniature painter Ximenez de Cisneros. See Canellas López, *Diplomatario*, 462; and Tomlinson, *Twilight of Enlightenment*, appendix 2.

16. *Mercurio de España* (September 1795): 66.

17. Herr, *Eighteenth-Century Revolution*, 335n66.

18. Herr, *Eighteenth-Century Revolution*, 325–26.

19. *Mercurio de España* (December 1794): 491.

20. Cited by Kendrick, *Malaspina*, 123. See also Mena Marqués and Mühle Maurer, *Duquesa de Alba*, 189–91 and 196–201.

21. Kendrick, *Malaspina*, 123–27.

22. Kendrick, *Malaspina*, 142.

23. Jovellanos, *Obras completas* at www.jovellanos2011.es.

24. Ezquerra del Bayo, *Duquesa de Alba*, 185; Mena Marqués and Mühle Maurer, *Duquesa de Alba*, 202, citing the document in AHP, prot. 19520, fols. 52 and ss.

25. *Mercurio de España* (January 1796): 63.

26. Mena Marqués and Mühle Maurer, *Duquesa de Alba*, 254.

27. Maurer, "Leyenda persistente," 78, fig. 3.

28. Jovellanos refers to the letters in diary entries of May 6 and June 8, 1796; see *Obras completas* at www.jovellanos 2011.es.

29. Salas, "Autorretrato de Goya," 320.

30. Escrivano Montoya, *Elogio fúnebre*, 42.

31. Cited by Mena Marqués and Mühle Maurer, *Duquesa de Alba*, 89. The changes to the portrait ordered by the duchess, which included altering the powdered hair with curls and eliminating the medals, leave no doubt that the portrait is that of the duke today in The Art Institute of Chicago.

32. Ceán Bermúdez, *Diccionario*, 5:68–69. The sculpture, today in the Museo de

Bellas Artes in Seville, was in the Monastery of Saint Jerome of Buenavista.

33. The mentions of Goya in Moratín's diaries were first discussed by Jeannine Baticle, "L'Activité." See also Andioc and Andioc, *Diario*, passim, and Andioc, *Epistolario*, 213–14, for his acknowledgment of Godoy's letter of August 9 offering him the appointment; pp. 217–28 for his letter to Jovellanos; and p. 130 for evidence of Moratín's meeting Godoy in 1792.

34. The reference of this drawing to the Cádiz arsenal was first noted by Gassier, *Drawings*, 94 (illus.), 131. It is today in the Musée du Louvre.

35. Conde de Maule, *Viage de España, Francia é Italia* (1812–1813), cited in Mena Marqués and Mühle Maurer, *Duquesa de Alba*, 207.

36. On dating of the rings, see Mena Marqués and Mühle Maurer, *Duquesa de Alba*, 157. The observation that the rings were not painted by Goya was borne out by a comparison with the rings worn by María Luisa, also in a black mantilla (Patrimonio Nacional) when the two portraits were exceptionally in the same room at the exhibition "Goya: The Portraits" in the National Gallery, London, October 7, 2015–January 10, 2016.

37. *Le Temps*, February 4, 1838, cited by Baticle and Marinas, *La Galerie espagnole*, 89.

18. DREAMING, ENLIGHTENED

1. Canellas López, *Diplomatario*, 323–24; Sánchez Cantón, "Goya en la Academia," 16–17.

2. Anonymous, "Sueño," *Diario de Madrid* (October 28, 1793): 1231–32.

3. See *Goya en el Prado* website/*Dibujos/Varios/Espejo mágico*; and René Andioc, "Goya y los Temperamentos," in *Goya: Letra y figuras*, 273–310.

4. Anonymous, "El Sueño," *Diario de Madrid* (May 23, 1794): 578.

5. Rée, *I See a Voice*, 43.

6. "Madrid" album, or album "B,"

numbered pages 56 and 57. See Gassier, *Drawings*, 88–89 (illus.), 130.

7. Today in the Museo del Prado, the *Sueño* drawings are illustrated and discussed on the *Goya en el Prado* website/*Dibujos/Preparatorio series de grabados/Sueños*.

8. Canellas López, *Diplomatario*, 323.

9. Glendinning, "Incunables," 305–6.

10. Entry for March 12, 1806, Andioc and Andioc, *Diarios*, 337.

11. G. Demerson, *Meléndez Valdés*, 326–35.

12. Baticle, "L'Activité," 111–12.

13. Museo de Bellas Arts de Bilbao.

14. Rodríguez Torres, "Retratos de Amigos," 7, at museodebilbao.com.

15. See chapter 12; and G. Demerson, "Quelques documents," 258–60.

16. Goicoechea to Zapater, May 16, 1797, Museo del Prado, ODZ 027.

17. Musée des Beaux-Arts, Strasbourg.

18. Ponz, *Viaje*, 500.

19. Jordán de Urríes, "Iriarte," 266.

20. RABASF, *Libros de actas*, 1797, 88v; Jordán de Urríes, "Iriarte," 266.

21. For the letters and references cited, see Jovellanos, *Obras completas* at www.jovellanos2011.es.

22. Saavedra y Sangronis, *Memorias inéditas*, 75.

23. November 22, 1797, Jovellanos, *Obras completas* at www.jovellanos2011.es.

24. Herr, *Rural Change*, 84.

25. Ringrose, "Spanish Miracle," 122–28; Barbier and Klein, "Public Finances," 328, 333.

26. Herr, *Rural Change*, 84.

27. Goya to Zapater, (between December 12 and 15, 1797), *Goya en el Prado* website/*Documentos*. The identity of most who signed the letter is discussed in Matilla and Mena Marqués, *Dibujos*, 246 54. In the absence of further research, the revised date proposed for the letter (Easter Sunday, April 18, 1802) remains tentative.

28. Matilla, Mena Marqués et al., *Dibujos*, 1, 254.

19. *SUBIR Y BAJAR*

1. For contemporary commentaries on each of *Los Caprichos*, see Blas and Matilla, *Libro*; cited here: 294.

2. Cited by G. Demerson, *Meléndez Valdés*, 346.

3. Contemporary manuscripts identify the subject of *Capricho 32, Por que fue sensible*, as the wife of Castillo; see Blas and Matilla, *Libro*, 192. See also Glendinning, "Goya on Women."

4. Meléndez Valdés, *Discursos forenses*, 1–199.

5. Jovellanos notes letters to Goya in his diary on February 7, 1794, on September 16, 1795, and on May 5, 1796; see *Obras completas* at www.jovellanos2011.es. The "long friendship" has been assumed most recently by Bray, *Portraits*, 96.

6. Goya to Zapater, March 27, 1798, *Goya en el Prado* website/*Documentos*. The letter is dated March 27 with no year given, but Goya's mention that the "minister" was a friend of Saavedra (the minister of finance, Francisco de Saavedra) establishes this as 1798 and the minister as Jovellanos. In the second paragraph, Goya asks Zapater to give 6 *reales* to his sister (proof that Rita is still living) and to get a receipt if Zapater gives his brother Tomás 2,000 *reales*.

7. *Gaceta de Madrid* (March 30, 1798): 286–87; *Mercurio de España* (March 1798): 256–57.

8. Baticle, *Goya*, 245.

9. Herr, *Eighteenth-Century Revolution*, 399–400.

10. Sambricio, *Tapices*, docs. 181–90. In June 1798 Goya submitted receipts for expenses from January 1, 1796, to March 31, 1797; see Núñez Vernis, "Seis documentos," 42–44.

11. Herr, *Rural Change*, 87; *Gaceta de Madrid* (June 5, 1798): 452.

12. González Santos, "Jovellanos por Goya," 45–56.

13. Bray, *Portraits*, 97.

14. Santiago Páez et al., *Ydioma Universal*, 94–97.

15. Cited in Santiago Páez et al., *Ydioma Universal*, 59 and n. 64.

16. Goya's recommendation is dated April 9, 1795; see Yebes, *Condesa-Duquesa de Benavente*, 46–47.

17. On the portrait and Urrutia's career, see the entry on the *Goya en el Prado* website.

18. Gassier and Wilson, *Life and Complete Work*, 383.

19. For images and a discussion of this series, see Wilson-Bareau and Mena Marqués, *Truth and Fantasy*, 212–22. In-depth analyses of two of the images are offered by Tal in "'Enlightened View'" and "Demonic Possession."

20. *Diario de Madrid* (August 17, 1798): 919–20.

21. *Diario de Madrid* (September 1, 1798): 982.

22. Rehfues, *Espagne*, 1:123.

23. Urriagli Serrano, *Colecciones*, 485–90.

24. Andioc and Andioc, *Diario*, 202–3.

25. The order is dated June 15, 1798; see Sambricio, *Tapices*, doc. 191.

26. For a discussion in English of the project and its sketches, see Wilson-Bareau and Mena Marqués, *Truth and Fantasy*, 232–37.

27. Borrás Gualis, *Frescos*, 32–33.

28. *Mercurio de España* (August 1798): 372–73.

29. G. Demerson, *Meléndez Valdés*, 353, 363–66. On Caballero, see José Manuel Cuenca Toribio, "José Antonio Caballero y Campo Herrera," in RAH, *Diccionario*.

30. Andioc and Andioc, *Diario*, 207.

20. "THE KING AND QUEEN ARE CRAZY ABOUT YOUR FRIEND"

1. RABASF, *Libros de actas*, 1799, IIIr.

2. Goya's mention of a commission from Lorenzana in a letter to Zapater of July 2, 1788, is thought to refer to this commission. For the letter, see *Goya en el Prado* website/*Documentos*. The *Expolio*

measures 285 × 276 cm; Goya's *Arrest of Christ* measures 300 × 200 cm.

3. On the evolution of Goya's etching technique, see Tomlinson, *Graphic Evolutions*, 11–24.

4. *Diario de Madrid* 37 (February 6, 1799): 149–50.

5. *Gaceta de Madrid* 15 (February 19, 1799): 132.

6. Cayetano Soler to the king's treasurer, October 6, 1803, Canellas López, *Diplomatario*, 477.

7. Gassier and Wilson, *Life and Complete Work*, 384.

8. Yebes, *Condesa-Duquesa de Benavente*, 152–88.

9. Herr, *Rural Change*, 101.

10. Romero Peña, "Mariano Luis de Urquijo," 58–59.

11. Two letters from Mor to Zapater attest to their friendship, the first dated May 23, 1797, and the second datable to April 2, 1798, given the author's report that the printing of *Serafina*—the first of three editions of his successful novel of customs—"has come out beautifully and without error." The two letters are in the Museo del Prado, ODZ 64, 65. Mor's novel was a runaway success, set in Zaragoza, published in 1798 as *El Cariño perfecto* or *Alonso y Serafina* and revised and expanded in 1802 and again in 1807 with the title *La Serafina*. See García Garrosa, "Tres versiones."

12. The portrait of Guillemardet is in the Musée du Louvre, Paris.

13. The identification of paintings exhibited by Goya is known from manuscript lists in the archive of the Real Academia de Bellas Artes de San Fernando, leg. 55–2/1. For the comments of the Danish ambassador, Herman de Schubart, see Schubart, *Lettres*, 403. Given the history between Guillemardet and Urquijo, it is highly unlikely that Urquijo introduced Goya to the French ambassador, as suggested by Bray, *Portraits*, 107.

14. For a discussion in English of these portraits and their sources in the queen's correspondence, see Tomlinson, *Twilight of Enlightenment*, 82–84.

15. For a summary in English of the correspondence referring to Marcial, see Rodríguez Torres, *Retrato de Palafox*, 144–48.

16. Sambricio, *Tapices*, doc. 194.

17. Zapater y Gómez, *Goya*, 53–54.

18. The redating of the letter discussed in chapter 18, note 27 would make it the penultimate.

19. For the equestrian portrait of Carlos IV, see *Goya en el Prado* website/ *Pinturas/Retratos*.

20. See Rodríguez Torres, *Retrato de Palafox*, 131, cited here: English translation by Jonathan Snyder, 130.

21. Valgoma y Díaz-Varela, "Goya, pescador," 221.

22. The royal portraits may have been those engraved by Esteve in 1799; although thought to have been engraved for the annual almanac, no versions of the publication including the engravings are known; see BNE, Grabados, IH/1712/50. See also Valgoma y Díaz-Varela, "Goya, pescador," 222–23.

23. Sambricio, *Tapices*, doc. 196.

24. *Mercurio de España* (November 1799): 258–59.

25. Grandmaison, *Ambassade française*, 183.

26. Lipschutz, *Spanish Painting*, 10.

27. Grandmaison, *Ambassade française*, 185–90.

28. *Diario de Madrid* (December 15, 1799): 1514; and (January 1, 1800): 1.

29. *Diario de Madrid* (December 12, 1799): 1503.

30. *Mercurio de España* (December 1799): 448–49.

21. THE FRENCH CONNECTION

1. On the circulation of the *Mercurio*, see the article on the *Hemeroteca digital* of the BNE; on the quarantine of Andalucía, see *Mercurio de España* (October 1800): 166–70.

2. Jordán de Urríes, "Retrato equestre," 503–5.

3. The version commissioned by Carlos IV is that today in the Musée National, Malmaison.

4. Azara to Bernardo de Iriarte, July 21, 1802, cited by Jordán de Urríes, "Retrato equestre," 511.

5. Dispatch from Alquier to Talleyrand, October 18, 1800, cited by Grandmaison, *Ambassade française*, 196–97.

6. Jordán de Urríes and Sánchez Gaspar, "Gabinete de platino," 136–39; Gastinel-Coural, "Cabinet de platine."

7. Jordán de Urríes, *Real Casa*, 110–15; Urriagli Serranó, *Colecciones*, 128–29; Rose Wagner, "Manuel Godoy," 1:130.

8. Sambricio, *Tapices*, docs. 197, 198, 201–7.

9. AHN, sec. *Hacienda*, legs. 3752 and 3580, cited by Emilio La Parra López, "El Mejor servidor del rey: Manuel Godoy (1767–1851)," in Rose de Viejo, La Parra López, and Giménez López, *Imagen*, 84 n70. Inscribed and dated 1801, the portrait of Noriega is today in the National Gallery of Art, Washington, DC.

10. *Diario de Madrid* (May 18, 1800): 595.

11. Matilla Tascón, "Archivo de Protocolos," 17.

12. Maurer, "Nuevos documentos," 94, 97nn14–15.

13. Herr, *Rural Change*, 101.

14. The surviving studies are in the Museo del Prado. For the correspondence pertaining to these paintings, see Pereyra, *Cartas*, 233, 235–37, 284–85, 304, 310.

15. On June 9 María Luisa wrote Godoy that Goya had finished all of the sketches except for those of her and the king; Goya would begin hers the following day. First published by Pereyra, *Cartas*; excerpts from the letters between the queen and Godoy relevant to the *Family of Carlos IV* are cited by Canellas López, *Diplomatario*, 475–76. Goya's invoice of materials for reimbursement includes the dates of materials purchased; see Sambricio, *Tapices*, doc. 215.

16. These expenses are included in Goya's invoice of July 23, covering expenses for the "stay at the Royal Residence of Aranjuez to paint the ten portraits of their Majesties and the Royal Family"; see Sambricio, *Tapices*, 213; see Mena Marqués, *Familia de Carlos IV*, 132.

17. Andioc and Andioc, *Diario*, 242. Although the original stretcher was subsequently replaced, X-rays of the canvas show the imprint of that original support. See Carmen Garrido, "Como se pintó el retrato de la familia," in Mena Marqués, *Familia de Carlos IV*, 296.

18. Carmen Garrido, "Como se pintó el retrato de la familia," in Mena Marqués, *Familia de Carlos IV*, 302.

19. Jordán de Urríes, "Retrato equestre," 512.

20. Pardo Canalís, "Visita," 301, 304.

21. Pardo Canalís, "Visita," 301–2.

22. Tomlinson, "Burn it, Hide it."

23. Rose Wagner, "Manuel Godoy," 1:293.

22. ABSENCES

1. Miguel Ángel Ochoa Brun, "Ceballos y Guerra de la Vega, Pedro Félix de," RAH, *Diccionario*.

2. Rose Wagner, "Manuel Godoy," 1: 187.

3. Canellas López, *Diplomatario*, 331–32. The mention of "Seneca" suggests that among them was *The Death of Seneca*, today in the Museo del Prado and attributed to the studio of Peter Paul Rubens.

4. Ceballos's request was dated July 26, 1801, and Goya's response July 29. See Gallego, "Carta inédita," 172–74.

5. García Sánchez, "Manuel Napoli," 30.

6. AGP, Manuel Napoli y Maurino, expediente personal, caja 733, no. 28. Dated only 12/1808 and written on paper with the stamped date of 1808.

7. Canellas López, *Diplomatario*, 332; Emilio Soler Pascual, "Fernando Brambila," in RAH, *Diccionario*.

8. Two versions, both by Goya, of

the portrait of Luis María as cardinal are known, one in the Museo del Prado, the other in the Museo de Sao Paolo Assis Chateaubriand; see the entry on the *Goya en el Prado* website. The portrait of the third and youngest child of the *infante* Don Luis, María Luisa (Galleria degli Uffizi, Florence) was also painted ca. 1800–1801; see Tomlinson, Stepanek, and Ilchman, *Order and Disorder*, 187, 193.

9. Maurer, "Nuevos documentos," 92–97.

10. Enrique Giménez López, "El Contexto histórico: Manuel Godoy y la España de Carlos IV," in Rose de Viejo, La Parra López, and Giménez López, *Imagen*, 48.

11. Paid on January 10, 1802, Goya's invoice of early July is the last known document of portraits of Carlos IV and María Luisa by his hand and the last known reimbursement for his supplies. Sambricio, *Tapices*, doc. 218.

12. Mena Marqués, *Familia de Carlos IV*, 114–15.

13. María Luisa to Godoy, January 13, 1803, in Rose de Viejo, "Manuel Godoy," 1:472, doc. 19.

14. Rose Wagner, "Goya's Allegories." The author dated these works to 1801–1802 (p. 39). "Science" was in poor condition by the mid-nineteenth century; the three other paintings, today in the Museo del Prado, have been dated on the *Goya en el Prado* website to 1801–1806.

15. Tomlinson, *Twilight of Enlightenment*, 102–3, 115–27.

16. Rose de Viejo, "Alberto Foraster," 82. For Goya's undated letter to José Joaquín de Castaños, see Canellas López, *Diplomatario*, 361.

17. Saavedra de Sangronis, *Memorias inéditas*, 224.

18. *Diario de Madrid* (March 7, 1800): 158.

19. Gil-Díez Usandizaga, "Sebastián Martínez," 202.

20. Jovellanos, *Obras completas* at www.jovellanos2011.es. Jovellanos wrongly identified the subject of the main altarpiece,

which in fact shows Saint Isidore appearing to King Fernando III of Castile.

21. Two of the sketches are in the Fundación Lázaro Galdiano, Madrid; the third is in the Museo de Bellas Artes, Buenos Aires. See Cano Cuesta, *Lázaro Galdiano*, 96–107.

22. Jordán de Urríes, "Iriarte," 269 and 278n75.

23. Baticle, "L'Activité," 113.

24. P. Demerson, *Condesa de Montijo*, 360.

25. Letters of June 30, July 7, and August 2 (or 9?): P. Demerson, *Condesa de Montijo*, 359–61.

26. Mena Marqués and Mühle Maurer, *Duquesa de Alba*, 160–61, fig. 83.

27. Rose Wagner, "Manuel Godoy," 1: 467–68.

28. The notice of Zapater's death as well as a draft of his will were published by Baticle, *Goya*, 509n8. In 1868 the son of Francisco Zapater published a biography based on the correspondence of Goya and Martín Zapater.

23. SOCIETY HIGH AND LOW

1. The 1785 map by Tomás López lists two "calles de los Reyes": *alta* (upper), near the Salesas Reales; and *baja* (lower), in the older sections of town, near what is today the Centro Reina Sofía. It should not be confused with the present-day street of the same name.

2. Matilla Tascón, "Archivo de Protocolos," 18.

3. Document dated June 15, cited by Sánchez Cantón, "Como vivía Goya," 76. The advertisement mentioning the paintings by Corrado appeared in the *Diario de Madrid* (June 5, 1803): 627.

4. Sánchez Cantón, "Como vivía Goya," 76–77.

5. Canellas López, *Diplomatario*, 476–77; AGP, Expediente Personal, Jacinto Gómez Pastor, caja 439, 10. I have here used the value of the "common or new silver ducado" at 16 *reales* and 17 *maravedís* in calculating the salaries in *reales de*

vellón; see "Valor de la monedas antiguas y corrientes de Oro, Plata, y Vellón de España," *Kalendario manual y guía de forasteros* (1800): 209–10.

6. Canellas López, *Diplomatario*, 360.

7. Cayetano Soler to the royal treasurer, October 6, 1803: Canellas López, *Diplomatario*, 477.

8. The first recorded printing of the *Caprichos* by the Calcografía dates to the 1830s. See Glendinning, "Nineteenth-Century Editions," 397.

9. Goya to Cayetano Soler, October 9, 1803, *Goya en el Prado* website/*Documentos/Cartas a otros destinarios*.

10. A copy of the order, from a private collection, was on view in the exhibition *Museo del Prado, 1819–2019* in January 2019.

11. *Diario de Madrid* (January 11, 1803): 41.

12. *Diario de Madrid* (February 19, 1803): 197; (March 28, 1803): 345.

13. *Diario de Madrid* (April 6, 1803): 381–82.

14. The *Burial* and the *Procession* are in the Museum of the Royal Academy of Fine Arts of San Fernando, Madrid; the "black" paintings are in the Museo del Prado.

15. Pérez Moreda, *Crisis de mortalidad*, 377–87.

16. Seoane, "Correspondencia epistolar," 58, translated by the author. The passage was previously cited and translated by Glendinning, *Critics*, 42–43.

17. On Queraltó, see Luna and Moreno de la Heras, *Goya*, 391; on the Fernán Núñez portraits, see Mena Marqués, *Tiempos de guerra*, 198–201.

18. For the marquise of Villafranca, see the entry on the *Goya en el Prado* website; on the marquis of San Adrian, see Mena Marqués, *Tiempos de guerra*, 202–3. The far less appealing portrait of the marquise of Santiago is discussed by Sayre, "Marquesa de Santiago."

19. Rose de Viejo, "Alberto Foraster," discusses the portrait, as well as the sitter's relationship to Godoy. For the Garcini

portraits, see the entry on the Metropolitan Museum website.

20. On the Azara portrait, today in the Museo Goya Colección Ibercaja, Zaragoza, see the entry on the museum website.

21. On the portraits of Vargas Ponce and the Barruso mother and daughter, see Mena Marqués, *Tiempos de guerra*, 208–11. Little is known of Francisca Vicenta Chollet y Caballero; the portrait is in the Norton Simon Museum, Pasadena.

22. See the entry on the *Goya en el Prado* website.

23. The portrait is in the Alte Pinakothek, Munich.

24. The portrait is in the Brooklyn Museum of Art. See Trapier, *Goya and His Sitters*, 30–31.

25. See the *Diario de Madrid* (April 21, 1790): 445; (May 27, 1792): 625; (May 24, 1793): 600; (March 15, 1797): 305; (May 19, 1797), 573; (April 7, 1798): 387; (October 14, 1799): 1264; (September 4, 1802): 1000; (May 4, 1804): 506; (October 11, 1811): 419. See also Cotarelo y Mori, *Máiquez*, 70, 141, 202, 247.

24. A MONARCHY AT TWILIGHT

1. RABASF, *Libros de actas*, 1804, fol. 118.

2. RABASF, Secretaría General: Préstamos de exposiciones de 1793–1851, leg. 1-55-2, in Navarrete Martínez, *Academia*, 466–72.

3. Of these exhibited works only two, the portraits of the marquise of Villafranca (Madrid, Museo del Prado) and of Isidoro Máiquez (Art Institute of Chicago) are known and firmly identified. See Gassier and Wilson, *Life and Complete Work*, cat. nos. 817, 854. Although to this author the manuscript name identified by Navarrete is not clearly legible, reading it as "Mauguiro" suggests the name of the husband of Manuela Goicoechea, Muguiro, the sister-in-law of Goya's son, Javier.

4. Sánchez Cantón, "Como vivía Goya," 77–79, 99–101.

5. On Javier's pension, see Sambricio, *Tapices*, doc. 220; for the wedding certificate, see Canellas López, *Diplomatario*, 478.

6. Sánchez Cantón, "Como vivía Goya," 101; Canellas López, *Diplomatario*, 480.

7. Illustrated in Wilson-Bareau and Mena Marqués, *Truth and Fantasy*, 268–69. See also Mena Marqués, *Tiempos de guerra*, 212–14.

8. The full-length portraits of Javier and Gumersinda are in a private collection. The *Bookseller's Wife* is in the National Gallery of Art, Washington, DC; the *Woman with a Fan* is in the Musée du Louvre, Paris; *Mariano Goya* is in a private collection; and the portraits of Javier's mother and father-in-law are in the Abelló Collection, Madrid. The portrait of Juan Bautista de Muguiro is in the Museo del Prado.

9. A summary of the issue of dating Goya's drawings in English was offered by this author in Tomlinson, "Recent Publications," 83–84. The Museo del Prado is currently developing a new catalogue of Goya's drawings in which their chronology will be reconsidered.

10. Glendinning, "Spanish Inventory References," 100, 108.

11. In the Art Institute of Chicago.

12. *Diario de Madrid* (July 8, 1806): 53; (July 17, 1806): 76; (July 19, 1806): 83. Other prints of the events, which do not fit the description of those advertised, are reproduced by Wilson-Bareau and Mena Marqués, *Truth and Fantasy*, 293. I have not located the pamphlet cited by the authors as the source for Goya's narrative.

13. *Memorial literario* (August 30, 1806): 283–85; cited here: 284–85.

14. Rose Wagner, "Manuel Godoy," 1:483, doc. 66.

15. Letter dated August 8, 1806; Rose Wagner, "Manuel Godoy," 1:227.

16. Rose Wagner, "Manuel Godoy," 1:227.

17. The emblem is known only through engravings; a fragment of the painting showing students of the Pestalozzi Institute is in the Meadows Museum, Dallas; see Tomlinson, *Twilight of Enlightenment*, 110–15.

18. Carrasco Martínez, "Entre Francia e Inglaterra," 118–20.

19. The report of that battle in the Spanish press mentioned only the death of Horatio Nelson and damage to the English fleet, overlooking the fourteen thousand casualties within the Franco-Spanish navy, including five thousand Spaniards. No reference was made to a navy that had long been in decline, with no funds to outfit ships or build new ones and with few trained and experienced to operate them. *Mercurio de España* (November 30, 1805): 258; Esdaile, *Peninsular War*, 23.

20. Emilio La Parra López, "El Mejor servidor del rey," in Rose de Viejo, La Parra López, and Giménez López, *Imagen*, 91.

21. Emilio La Parra López, "Cronología," in Rose de Viejo, La Parra López, and Giménez López, *Imagen*, 25.

22. Grandmaison, *Espagne et Napoléon*, 460–62.

23. Carrasco Martínez, "Entre Francia e Inglaterra," 122.

24. Roberts, *Napoleon*, 474 78.

25. Grandmaison, *Espagne et Napoléon*, 464.

26. Esdaile, *Peninsular War*, 24–25, 30.

25. THE OLD ORDER FALLS

1. Unless otherwise cited, this summary of events in 1808 is based on Esdaile, *Peninsular War*, chap. 1.

2. *Diario de Madrid* (March 18, 1808): 349.

3. Rose, "Celebrada caída."

4. Rose Wagner, "Manuel Godoy," 1:353.

5. On the dispersal of Godoy's art collection, see Rose Wagner, "Manuel Godoy," 1:348–419, esp. 348–62.

6. La Parra López, "Cronología,"

in Rose de Viejo, La Parra López, and Giménez López, *Imagen*, 15–33.

7. *Diario de Madrid* (March 21, 1808): 361; (March 22, 1808): 365; (March 24, 1808): 373.

8. Esdaile, *Peninsular War*, 55.

9. Esdaile, *Fighting Napoleon*, 68.

10. Sambricio, *Tapices*, doc. 230.

11. Canellas López, *Diplomatario*, 361–62, 480–82.

12. Piquero López and González Amezúa del Pino, *Goyas de la Academia*, 28–29.

13. Comte de las Cases, *Mémorial de Sainte Hélène*, edited by G. Walter (Paris, 1956), I: 780–81, cited and excerpted by Esdaile, *Peninsular War*, 35.

14. Diaz Torrejón, *José Napoleón I*, 12–13.

15. AHN, Consejo de Castilla, Sala de Alcaldes y Cortes, 1808, 2, fols. 538, 541.

16. José Manuel de la Mano, "Goya intruso: Arte y política en el reinado de José I," in Mena Marqués, *Tiempos de guerra*, 56, 64.

17. Evidence that these works were commissioned by the returning king in 1814 will be presented in chapter 28.

18. *Diario de Madrid* (May 4, 1808): 537–38.

19. *Diario de Madrid* (May 19, 1808): 37–38. For the May 8 order to Talleyrand, see Grandmaison, *Espagne et Napoléon*, 486–87.

20. S. Blaze, *Mémoires d'un apothécaire sur le Guerre d'Espagne* (Paris, 1828), I: 55, cited by Esdaile, *Peninsular War*, 73.

21. Joseph to Napoleon, July 24, 1808, cited by Glover, *Legacy of Glory*, 43–44.

22. *Diario de Madrid* (September 11, 1808): 189–93.

23. José Manuel de la Mano, "Goya intruso," in Mena Marqués *Tiempos de guerra*, 64. The portrait of Bravo is in the Brooklyn Museum of Art.

24. The description of the work appeared in the *Gazeta de Mexico* (November 30, 1808): 923–24; "Don Antonio Juliá" (presumably, Asensio Juliá) executed Goya's

design. On Goya's portrait of Joseph, today known as the *Allegory of Madrid*, see chapter 26.

25. "Junta Particular de 15 de septiembre de 1808," in the Libro de Juntas, Academia de San Fernando, 127/3, fol. 298, cited in Piquero López and González Amezúa del Pino, *Goyas de la Academia*, 28.

26. Canellas López, *Diplomatario*, 362; Goya's donation is listed in the *Diario de Madrid* (October 4, 1808): 312; a second donation of two shirts, four bandages, and *hila* (thread) from Josefa Bayeu y Goya, possibly made during her husband's absence, appears in the *Diario de Madrid* (November 24, 1808): 583.

27. Serrano Montalvo, "Vida municipal," 138–39.

28. Oman, "Charles Vaughan," I:245.

29. Lovett, *Napoleon*, I: 264. On the first and second sieges of Zaragoza, see pp. 234–84.

30. Lovett, *Napoleon*, I: 244, 266–67.

31. Agustín Alcaide Ibieca, *Suplemento a la historia de los dos sitios que pusieron á Zaragoza en los años de 1808 y 1809 las tropas de Napoleon* (Madrid, 1831), 51, cited by Ona González, *Goya y su familia*, 129. The account of Lady Holland was, to this author's knowledge, first cited by Sayre et al., *Changing Image*, 127. Lady Holland recounted what she was told by "Doyle," presumably the British general William Doyle, who had visited Zaragoza twice following the first siege (see Lovett, *Napoleon*, I: 257–58); thus the account is at least third hand.

32. Ona González, *Goya y su familia*, 129–30.

33. Lafuente Ferrari, *Antecedentes*, 154–55.

34. Ossorio y Bernard, *Galería biográfica*, 286.

35. Rose de Viejo, "Alberto Foraster," 87.

36. *Diario de Madrid* (December 6, 1808): 617–18; (December 7, 1808): 623–24; (December 8, 1808): 627; (December 9, 1808):

632; (December 23, 1808): 688; (December 24, 1808): 691. Fuentes Aragonés, *El Fin*, 19–20.

37. *Diario de Madrid* (December 23, 1808): 690.

38. G. Demerson, "Les Registres d'habitants," 204.

26. IN THE SHADOW
OF A NEW REGIME

1. García Sánchez, "La Real Academia de San Fernando," 123.

2. AGP, sec. administrativa, Carlos III, Pintores de Cámara, leg. 3879.

3. The testimony by D. Fernando de la Serna was part of an investigation launched in 1814 into the activities of all court employees during Joseph's reign; see Sambricio, *Tapices*, doc. 238.

4. Baticle, *Goya*, 347, and Tobajas, *Papeles*, 198–99 also argue for a date of early 1809 for Goya's trip to Piedrahita.

5. AHN, Estado, leg. 3.092, cited in Artola, *Los Afrancesados*, 120–21.

6. Calvo Ruata, *Manuel Bayeu*, 41.

7. Canellas López, *Diplomatario*, 363.

8. The response is dated to the following day, May 6. Canellas López, *Diplomatario*, 483.

9. Esdaile, *Peninsular War*, 228–29.

10. *Diario de Madrid* (March 2, 1809): 249, and (March 7, 1809): 265.

11. Esdaile, *Peninsular War*, 216–18.

12. *Gaceta de Madrid* (December 21, 1809): 1554–56; *Diario de Madrid* (December 22, 1809): 693–94.

13. AGP, "Gobierno intruso," caja 104, published by Mano, "Goya, intruso," in Mena Marqués, *Tiempos de guerra*, 66.

14. This summary of the maneuvers surrounding the selection of paintings for the Musée Napoléon is based on Mano, "Goya, intruso," in Mena Marqués, *Tiempos de guerra*, 67–74; for Qulliet's comments on Goya and Maella, see p. 74. In English, see Tinterow and Lacambre, *Manet/Velázquez*, esp. 18–27, 93–113; and Lipschutz, *Spanish Painting*, appendix 3:

266–326, with the list of works selected by Maella, Napoli, and Goya, 316–17.

15. Morales y Marín, *Maella*, 315–16.

16. Maella and Augustín Esteve also contributed works. Mano, "Goya, intruso," in Mena Marqués, *Tiempos de guerra*, 74–75.

17. Gaya Nuño, "'Alegoría.'"

18. Mano, "Goya, intruso," in Mena Marqués, *Tiempos de guerra*, 72.

19. Gaya Nuño, "'Alegoría.'"

20. On Joseph's itinerary through the south of Spain, see Díaz Torrejón, *José Napoleón*; cited here: 21, 32.

21. Díaz Torrejón, *José Napoleón*, 91–99.

22. Díaz Torrejón, *José Napoleón*, 100–106, 117–18. The creation of the museum in the Alcázar was reported in the *Diario de Madrid* (March 2, 1810): 252.

23. *Diario de Madrid* (February 14, 1810): 180.

24. Diaz Torrejón, *José Napoleón*, 324–25.

25. *Diario de Madrid* (October 19, 1810): 484.

26. *Diario de Madrid* (April 11, 1810): 402–3.

27. Díaz Torrejón, *José Napoleón*, 346–47.

28. *Diario de Madrid* (February 18, 1810): 195; (March 23, 1810): 327; (April 8, 1810): 391.

29. *Diario de Madrid* (June 27, 1810): 715.

30. *Diario de Madrid* (June 23, 1810): 700.

31. *Diario de Madrid* (April 29, 1810): 473–74.

32. Ruiz Palomeque, "Paisaje urbano."

33. *Diario de Madrid* (July 3, 1810): 31–32; (July 18, 1810): 103; (July 25, 1810): 139.

34. *Diario de Madrid* (Feburary 24, 1810): 217–18.

35. Esdaile, *Peninsular War*, 228–29.

36. *Diario de Madrid* (June 25, 1810): 706–7; (June 27, 1810). /13; (December 13, 1810): 734.

37. *Diario de Madrid* (July 23, 1810): 131.

38. Navarrete Martínez, *Academia*, 227–29.

39. Laborde, *Itinéraire descriptif*, 5:326.

40. See the entry on the portrait of both Guye and his nephew in Mena Marqués, *Tiempos de guerra*, 266–68.

41. The Spanish officials of Joseph's court painted by Goya include Manuel Romero, who served first as Joseph's minister of the interior and after December 1809 as minister of justice (The Art Institute of Chicago); Manuel Silvela, judge of the royal family and court (Museo del Prado); and Juan Antonio Llorente, state councillor commissioned by Joseph to write the history of the recently abolished Inquisition (Museo de Arte, São Paulo).

42. Artola, *Los Afrancesados*, 53–54.

43. Sayre et al., *Changing Image*, 165–69.

27. ON THE HOME FRONT

1. *Gaceta de Madrid* (March 19, 1811): 310–12. The notice reappeared in the *Diario de Madrid* during the week of March 25; Goya is mentioned on March 26, 1811: 342.

2. *Diario de Madrid* (December 8, 1811): 649–51.

3. *Diario de Madrid* (December 23, 1811): 711–12.

4. Cited by Bozal Fernández, *Miradas*, 208.

5. Pérez Moreda, "Población madrileña," 403–4.

6. For records on deaths in Madrid parishes, see Carbajo Isla, *Población*, 322; for the death certificate of Josefa Bayeu, see Sambricio, *Tapices*, doc. 224.

7. The article appeared in the *Semanario patriótico* on March 27, 1811; translated by E. Harris, "Contemporary Review," 42–43.

8. On Wellington's 1812 campaign, see Esdaile, *Peninsular War*, 369–427.

9. This letter is reproduced in Cano Cuesta, *Lázaro Galdiano*, 294. On Durán, see Gies, "Sentencias y buenas máximas," 452.

10. McGrigor's visit was first cited by Braham, "Duke of Wellington," 79n3. See McGrigor, *Scalpel and the Sword*, 201–2.

11. The red chalk drawing is in the British Museum; the half-length portrait is in the National Gallery, London; and a second drawing in black pencil is in the Kunsthalle, Hamburg. See Hoffman-Samland et al., *Spanish Gesture*, 208–9.

12. Braham, "Duke of Wellington."

13. The equestrian portrait of Wellington measures 294 x 241 cm in comparison with that of Napoleon, measuring 262 × 224 cm.

14. *Diario de Madrid* (September 1, 1812): 253; *Lista de las obras presentadas al público en la Academia desde el dia 2 hasta el 11 de septiembre de 1812 55–2/1*, cited by Navarrete Martínez, *Academia*, 302.

15. *Constitución política de la monarquía española*. Promulgada en Cádiz a 19 de marzo de 1812, section VIII, chap. 2, art. 362–65.

16. *Diario de Madrid* (October 3, 1812): 396.

17. The inventory and division of property was first published and discussed by Sánchez Cantón, "Como vivía Goya," 79–91. It was subsequently discovered that the document published by Sánchez Cantón was in fact an 1814 transcription; see Cruz Valdovinos, "Partición," 133–41.

18. Cruz Valdovinos, "Partición," 140. The original 1812 version is reproduced and discussed by Juliet Wilson-Bareau, "'Aprende a ver': Hacia un mejor entendimiento del inventario de 1812 y de la obra de Goya," in Mena Marqués, *Tiempos de guerra*, 37–42.

19. Palais des Beaux-Arts, Lille, *Regard libre*, 233–41.

20. AHN, Sec. Nobleza, C. 512, D. 10 *Correspondencia entre la condesa duquesa desde Cádiz y Miguel de la Herrán Terán desde Madrid*, cited by Pérez Hernández, "Reconstrucción," 10.

28. THE SPOILS OF WAR

1. *Diario de Madrid* (March 21, 1813): 321.

2. McGrigor, *Scalpel and the Sword*, 228.

3. Letter of March 16, 1814, to Sir Henry Wellesley, cited by Kauffman, *Catalogue*, 11–12.

4. *Diario de Madrid* (June 2, 1813): 614; (June 11, 1813): 649; (June 19, 1813): 682; (July 13, 1813): 55.

5. Tomlinson and Howe, *Goya's War*, 85–109.

6. *Diario de Madrid* (April 3, 1813): 374–75.

7. *Diario de Madrid* (October 29, 1813): 520–21; (November 11, 1813): 582. For many, concern with restoring a country devastated by war was more urgent than political debate. By early June procedures were outlined to sequester the property and possessions of the French occupiers and to restore to the nation property or papers that had strayed during the war. Laws governing the weight and composition of bread were reinstated. See *Diario de Madrid* (June 3, 1813): 615–18.

8. For the sale announcements, see *Diario de Madrid* (July 15, 1863): 67; (August 19, 1813): 223; (August 28, 1813): 266.

9. These similarities were noted by Glendinning, "A Solution," 187. A small pen-and-ink portrait of Casti, perhaps a preliminary for a frontispiece to the author's work, bears an apocryphal signature, "Goya," a tenuous link between the artist and the author. See Cano Cuesta, *Lázaro Galdiano*, 348–49.

10. *Diario de Madrid* (August 28, 1813): 266.

11. Plates 28, 29, 76, 77, 71, and 70 of *Los Desastres de la Guerra* as published in 1863.

12. *Diario de Madrid* (September 3, 1813): 289–90.

13. Sambricio, *Tapices*, doc. 225.

14. See the entry on these works by Gudrun Maurer in Mena Marqués, *Tiempos de guerra*, 272–74.

15. *Colección de los decretos*, 144.

16. Varela Suanzes-Carpegna, *Monarquía doceañista*, 194–95.

17. Fuentes Aragonés, *El Fin*, 34.

18. Varela Suanzes-Carpegna, *Monarquía doceañista*, 197.

19. Anonymous, *Entrada de su Magestad en Madrid* (n.d.), BNE, VE 1412–19.

20. On Fernando's return to Spain in English, see Esdaile, *Peninsular War*, 482–503; in Spanish the overview offered by Fuentes Aragonés, *El Fin*, 35–50 is recommended.

21. RABASF, Archive, *Sección General Académicos: Francisco Goya*, leg. 1-41-5; Navarrete Martinez, *La Academia*, 366n170.

22. Castro Alava, "Diputación de Navarra," 39.

23. Navarrete Martínez, *Academia*, 232.

24. Mena Marqués, *Tiempos de guerra*, 360.

25. On the history of the *Second* and *Third of May 1808*, see *Goya en el Prado* website/*Pinturas/Asuntos históricos*.

26. Sambricio, *Tapices*, doc. 228.

27. Varela Suanzes-Carpegna, *Monarquía doceañista*, 201.

28. Sambricio, *Tapices*, doc. 230.

29. Sambricio, *Tapices*, doc. 236.

30. Sambricio, *Tapices*, doc. 238.

31. AGP, Goya, Expediente Personal 476, doc. 40–150; Sambricio, *Tapices*, doc. 278.

32. Sambricio, *Tapices*, doc. 248.

33. Museo del Prado, Madrid.

34. Goya to José Palafox y Melci, December 14, 1814, in Canellas López, *Diplomatario*, 371–72.

35. Goya to Palafox, January 4, 1815, in Canellas López, *Diplomatario*, 374.

36. A report to Fernando VII of August 22, 1815, documents the financial crisis; see AHN, Sec. *Estado*, leg. 196, reproduced in Fuentes Aragonés, *El Fin*, 293.

37. See the entry at *Goya en el Prado* website/*Pinturas/Retratos*, as well as Javier's letter to Palafox, dated December 13, 1831, in which Javier tells Palafox that he cannot give him the portrait without remuneration; see Canellas López, *Diplomatario*, 520.

38. On Maella's "purification," see Morales y Marin, *Maella*, 318–19.

39. Andioc, *Epistolario*, 302. The account is based on this edition of Moratín's correspondence, see pp. 280–81, 291, 296–98, 301–2.

40. Tomlinson, *Twilight of Enlightenment*, 126.

29. PORTRAITS OF A NEW ORDER

1. *Paseo por Madrid,* 39, 36.

2. Goya's letter is dated October 10, 1816; see Canellas López, *Diplomatario,* 376–77; his painting of the Crucifixion is today in the Museo del Prado.

3. *Kalendario manual y guia de forasteros en Madrid* (1816): 74. Years later in 1829, Hevia y Noriega, by then a minister of the royal council, served as an executor of the estate of Ceán Bermúdez; see Clisson Adama, *Ceán Bermúdez,* 99.

4. The entry was published and translated by Bjurström, "De la Gardie," 81.

5. Junot Abrantes, *Memoirs,* 128.

6. See Espinosa Martín, *Miniaturas,* 44–45, 148.

7. *Diario de Madrid* (March 28, 1815): 330, and (April 12, 1815): 390. See Baticle, "Goya et la *Junte,*" 108–9.

8. I am indebted to Luis Martín-Estudillo for bringing to my attention the account of the meeting published in the *Gaceta de Madrid.* His insightful analysis of the painting is the subject of a forthcoming article.

9. The history of the painting between 1829 and 1881, when it was acquired by the painter and businessman Marcel Briguiboul in Madrid as a portrait of the *cinco gremios* (five guilds) is not known; Baticle, "Goya et la *Junte,*" 107. Briguiboul's son donated his father's collection to the town of Castres in 1894.

10. *Diario de Madrid* (August 2, 1815): 139–40.

11. The portrait of Lardizábal is in the National Gallery, Prague; that of Olmuryan y Rourera, in the Nelson-Atkins Museum of Art, Kansas City; and that of Munárriz is in the Museum of the Real Academia de Bellas Artes de San Fernando.

12. Mesonero Romanos, as cited by Fuentes Aragonés, *El Fin,* 37.

13. Elena Legorburu Faus, "Miguel de Lardizábal y Uribe," in RAH, *Diccionario.* The book, *Historia razonada de la gloriosa revolucion de España contra el tirano Napoleon,* was advertised in the *Diario de Madrid* (May 19, 1815): 553.

14. Baticle, "Goya et la *Junte,*" 109–10.

15. Given in 1869 by the School of Roadway Engineers to the Museo de la Trinidad, whose collection would soon be merged with that of the Museo del Prado, the portrait was possibly a commission from that same institution, founded by Carlos IV in 1802. See the entry for the portrait on the *Goya en el Prado* website.

16. See entries for both the *Duchess of Abrantes* and the *Marquesa de Santa Cruz* on the *Goya en el Prado* website/Pinturas/Retratos. Goya was paid 4,000 *reales* on April 30, 1816; see Gassier and Wilson, *Life and Complete Work,* 384.

17. Mena Marqués, *Tiempos de guerra,* 458–61; for the documentation, see Canellas López, *Diplomatario,* 377–78 and 494; and Gassier and Wilson, *Life and Complete Work,* 384.

18. Canellas López, *Diplomatario,* 377.

19. Carrete Parrondo, "Goya," 222, provides a more precise count: 37 percent religious images, 25 percent portraits of the king and the royal family, 14 percent subjects relating to the war against Napoleon, and 24 percent various subjects, encompassing the bullfight (4 percent).

20. Compare, for example, the etchings of the bullfight published by Antonio Carnicero in 1790.

21. For a discussion of Ceán Bermudez's authorship of the titles, see Sayre et al., *Changing Image,* 200.

22. *Diario de Madrid* (October 27, 1808): 437.

23. *Diario de Madrid* (November 18, 1808): 548.

24. On the manuscript titles on the individual etchings of this set, see Sayre et al., *Changing Image,* 204–7. Sayre identified the Boston titles as Goya's own; this author does not accept this attribution.

25. Bozal Fernández, *Miradas,* 257.

26. Camp, *Invasión napoleónica,* 48.

30. DISPARATES

1. The dating of the series to early 1817 is based on a reference by José Aparicio, one of the artists involved, in a document

of April 20, 1817, in which he explained his delay in finishing a work commissioned the previous year "for having used the time to paint the chiaroscuro painting that was ordered of him for the royal palace." Cited by Junquera, "Lienzo inédito," 189.

2. Conde, the recipient of this letter, married Moratín's first cousin, María Fernández de Moratín. See Andioc, *Epistolario*, 358, 252.

3. Andioc, *Epistolario*, 255, 323.

4. Letter dated February 18, 1817, Andioc, *Epistolario*, 360.

5. Letter dated March 22, 1817, Andioc, *Epistolario*, 361. Manuel García de la Prada, executor of Moratín's estate, oversaw the transfer of the portrait to the Royal Academy in December 1828.

6. Clissón Aldama, *Ceán Bermúdez*, 98; the author provides an overview and discussion of his writings: 113–316.

7. Santiago Páez and Wilson-Bareau, *Idioma Universal*, 57.

8. T. Harris, *Engravings*, 1: 140.

9. T. Harris, *Engravings*, 1: 173–74. Also in Ceán's volume, today in the British Museum, were two etchings not included in the 1863 edition and three small etchings of prisoners.

10. Canellas López, *Diplomatario*, 378.

11. Ceán Bermúdez to Tomás Veri, September 27, 1817; Canellas López, *Diplomatario*, 495.

12. Anon. [Ceán Bermúdez], "Bellas Artes." The essay was also published as a separate pamphlet; see Anon. [Ceán Bermúdez], *Análisis*.

13. Anon. [Ceán Bermúdez], "Bellas Artes," 2–3.

14. Ceán Bermúdez to Tomás Veri, January 14, 1818, Cotoner et al., *Cuadros notables*, 118–19.

15. Foucault, *Madness and Civilization*, 280–81.

16. See the entry on the painting in Mena Marqués, *Tiempos de guerra*, 503–4; and Tomlinson, Stepanek, and Ilchman, *Order and Disorder*, 328–31.

17. *Mercurio de España* (November 1819): 256–59.

18. *Resumen del desarrollo de la exposición una vez concluida a comienzos de octubre. Algunas obras de la presentadas [. . . 1819]* (55–2/1), in Navarrete Martínez, *Academia*, 472, no. 61.

19. Narcisco Sentenach, cited by Vega, *Goya 1900*, 298.

20. Eusebi, *Catálogo de los cuadros*, 20–21.

31. THE ARTIST'S RETREAT

1. Fuentes Aragonés, *El Fin*, 44–78.

2. Cited in Fuentes Aragonés, *El Fin*, 47.

3. Varela Suanzes-Carpegna, *Monarquía doceañista*, 244.

4. RABASF, *Libros de actas*, 1820, 24r.

5. *Goya en el Prado* website *Dibujos/Álbumes/Album C*, 117–18, 122–31.

6. Sánchez Cantón, "Como vivía Goya," 107–9.

7. Archivo Histórico de Protocolos de Madrid, doc. 22.886, fol. 59, cited by Matilla Tascón, "Archivo de Protocolos," 20.

8. For an introduction to these paintings, see *Goya en el Prado* website/*Pinturas/Pinturas negras*.

9. Garrido, "Algunas consideraciones," 22.

10. Torrecillas Fernández, "Pinturas de la Quinta del Sordo."

11. The photographs are reproduced in Torrecillas Fernández, "Pinturas de la Quinta del Sordo," 59–66.

12. *Diario de Madrid* (January 30, 1820): 142. The earliest detailed exploration of the paintings as theatrical entertainment was offered by Muller, *Goya's "Black" Paintings*, 215–33. She discusses the internationally known phantasmagoria of Etienne Gaspar Robertson, which came to Madrid in 1821, as well as the unusually long run of Mantilla's phantasmagoria, advertised in 1819, 1820, and 1822. See also Varey, "Robertson's Phantasmagoria," *Theatre Notebook*, vols. 9 and 11.

13. Lasso de la Vega, "Goya en Madrid," 20.

14. Yriarte, *Goya*, 91–96, 285–87.

15. On the history of the paintings, see Glendinning, "Strange Translation," 466.

16. Canellas López, *Diplomatario*, 512.

17. Garrido, "Algunas consideraciones," 6–7. For the X-ray image, see the entry for the painting on the *Goya en el Prado* website.

18. Sánchez Díez, *Dibujos*; Cruz Valdovinos, "Partición," 143–44.

19. Cruz Valdovinos, "Partición," 145.

20. *Diario de Madrid* (October 21, 1813): 490.

21. Cruz Valdovinos, "Partición," 143.

22. Cruz Valdovinos, "Partición," 148–49, suggests another man was responsible for Isidoro's complaint, mentioned by Leocadia herself after Goya's death, when, destitute, she sought the assistance of a certain Mr. Hoogen, "secretary of Lord Wellington when this man was ambassador in Paris," who, being German, like Leocadia's father-in-law, had been well treated in the Weiss household. Leocadia's mention that Hoogen shared a language with the elder Weiss proves that his relationship with the family began prior to the patriarch's death in 1812 and so aligns the relationship with the date of Isidoro's complaint against his wife.

23. Rascón, "Necrología," 4. The accuracy of this account, confirmed by other sources, is accepted by scholars. The date of 1815 is given in the biography of Goya on the Museo del Prado website; for authors who share this opinion, see Sánchez Díez, *Dibujos*, 37–38.

32. FAREWELLS

1. Andioc, *Epistolario*. On Melón, see Argimiro Calama y Rosellón, "Juan Antonio Melón González," in RAH, *Diccionario*.

2. Andioc, *Epistolario*, 447–52.

3. This final reference is to the supporters of Fernando VII, or *serviles*; Andioc, *Epistolario*, 457.

4. Jerónimo Herrera Navarro, "Manuel Silvela y García Aragón," in RAH, *Diccionario*; and for an English-language introduction to Silvela, see Brown and Galassi, *Last Works*, 112–17.

5. Andioc, *Epistolario*, 491–92.

6. Andioc, *Epistolario*, 461.

7. Moratín to Melón, March 2, 1822, Andioc, *Epistolario*, 486.

8. Moratín to Melón, August 5, 1823, Andioc, *Epistolario*, 557.

9. Fuentes Aragonés, *El Fin*, 53–54.

10. Fuentes Aragonés, *El Fin*, 67.

11. Sarrailh, *Contre-révolution*, 76.

12. Sarrailh, *Contre-révolution*, 64–65, 107.

13. *Gaceta de Madrid* (July 24, 1823): 163.

14. Sarrailh, *Contre-révolution*, 70, 107–8, 117.

15. Sarrailh, *Contre-révolution*, 131.

16. Fuente, *Biografía*, 11–12; on Goya's portrait, see Brown and Galassi, *Last Works*, 94–96.

17. On Duaso, see Pardo Canalís, "Bosquejo histórico"; and Luis Blanco Domingo, "José Duaso y Latre," in RAH, *Diccionario*.

18. *Paseo por Madrid*, 33. *Hospital* might be translated as "hospital," but also as a "hostel" for temporary lodging.

19. Rascón, "Necrología," 4.

20. AGP, Juridica, "Actos seguidos contra la mujer y herederos de Pedro José de Marcopeta, por varios acreedores (1824–1832), caja 25893, Expediente 6. Javier's suit is undated, although a note on the document bears the date August 4, 1824. It is one of several cases brought against Pedro José de Marcopeta, his wife, and heirs, by his creditors. Marcopeta is identified as a *gentilhombre de boca* of the royal household, in which role he would attend the king at meals, at chapel, and at other public appearances.

21. Álvarez Lopera, "Carrera," 310.

22. *Kalendario manual y guía de forasteros en Madrid* (1823): 71. According to Pardo Canalís, "Bosquejo histórico," 271, Satué rented lodgings at the Buen Suceso from August 27, 1822, to September 27, 1823, and again from October 18, 1823, until his death at the age of fifty-nine on December 21, 1824.

23. Pardo Canalís, "Bosquejo histórico," 271–72; for Satué's obituary, note 28.

24. Fuente, *Biografía*, 12.

25. Andioc, *Epistolario*, 563.

26. AGP, Goya, Expediente Personal 476, docs. 76–81.

27. Canellas López, *Diplomatario*, 496.

28. The permission is dated September 14, 1824; see Núñez de Arenas, "Manojo de noticias," 256–57.

33. PARIS

1. On Gaulon, see Brown and Galassi, *Last Works*, 164–65.

2. López, "Espagnols à Bordeaux," 1.

3. Moratín to Melón, August 5, 1823, Andioc, *Epistolario*, 558.

4. Moratín to Melón, December 14, 1823, and Moratín to Melón, February 5, 1824, Andioc, *Epistolario*, 578, 580.

5. Núñez de Arenas, "Manojo de noticias," 241.

6. Andioc, *Epistolario*, 586.

7. Eduardo Torres Corrominas, "Vicente González Arnao," in RAH, *Diccionario*; Andioc, "Sobre Moratín y Goya," 34–35.

8. López, "Espagnols à Bordeaux," 8–9.

9. Moratín to Melón, July 8, 1824, Andioc, *Epistolario*, 587–88.

10. Rúspoli, "Condesa de Chichón," 149.

11. Canellas López, *Diplomatario*, 498.

12. Gassier, *Drawings*, 524, 564–65.

13. Núñez de Arenas, "Manojo de noticias," 242.

14. Rúspoli, "Condesa de Chinchón," 150.

15. José Ramón Urquijo Goitia, "Juan Tomás Joaquín María Ferrer Cafranga," in RAH, *Diccionario*.

16. Núñez de Arenas, "Manojo de noticias," 239.

17. Cruz, *Gentlemen, Bourgeois*, 134.

18. Brown and Galassi, *Last Works*, cat. 8, 101–2.

19. Núñez de Arenas, "Manojo de noticias," 242.

20. Goya to the duchess of San Fernando, November 30, 1824, Canellas López, *Diplomatario*, 387.

21. Delacroix, *Journal*, 1:128–24. On Delacroix's studies after Goya, see Fayos-Pérez, "Delacroix after Goya's *Caprichos*."

22. Joubin, *Correspondance*, Supplément: 199–200. The "other" portrait owned by the Guillemardet family was a small likeness of a woman in Spanish costume, donated with the portrait of Guillemardet to the Musée du Louvre in 1865.

23. The question of the sitter's identity is discussed in Brown and Galassi, *Last Works*, 97–98.

24. Brown and Galassi, *Last Works*, 103–5.

34. UNSETTLED IN BORDEAUX

1. Moratín to Melón, September 20, 1824, Andioc, *Epistolario*, 394.

2. Núñez de Arenas, "Manojo de noticias," 256–57.

3. Cruz Valdovinos, "Partición," 147–48.

4. Andioc, *Epistolario*, 594.

5. Today much darkened, the colors of his robe and pants were revealed through pigment analysis. On this and on the X-ray images of the work, see Rodríguez Torres, "Retratos de amigos," 11, 15 at museobilbao .com.

6. Moratín to Melón, September 30, 1824, Andioc, *Epistolario*, 596.

7. Goya to Ferrer, October 28, 1824, Canellas López, *Diplomatario*, 386. Goya's correspondence with Ferrer in 1824 and 1825 is translated in Sayre, "Bordeaux Miniatures," 112–14.

8. Goya to the duchess of San Fernando de Quiroga, November 30, 1824; Canellas López, *Diplomatario*, 387–88. A *pulgada* is 1/12 of a *pie*, or 1/36 of a *vara*, 83.5 cm or about 33 inches.

9. Goya to Javier, December 24, 1824, Canellas López, *Diplomatario*, 388.

10. AGP, Goya: Expediente personal, 97–108; Canellas López, *Diplomatario*, 386–87, 499.

11. Moratín to Melón, dated to April 1825, Andioc, *Epistolario*, 620.

12. Rascón, *Necrología*, 4.

13. Goya to Ferrer, December 20, 1825, *Goya en el Prado* website/*Documentos*.

14. Goya to Zapater, April 23, 1794, *Goya en el Prado* website/*Documentos*.

15. Sayre, "Bordeaux Miniatures,"

97–98. My thanks to Barbara Duval and her students for repeating the experiment described by Sayre, but introducing gum arabic as a possible binder.

16. Sayre, "Bordeaux Miniatures," 93.

17. *Los Caprichos* plates 32, *Por que fue sensible*, and 39, *Asta su abuelo*.

18. Moratín to Melón, March 10, 1825, Andioc, *Epistolario*, 611.

19. Moratín to Melón, April 14, 1825, Andioc, *Epistolario*, 619.

20. AGP, Goya: Expediente personal, 476, 40-119-20; see also Canellas López, *Diplomatario*, 501.

21. Zapater to Martínez, March 19, 1793, Sambricio, *Tapices*, doc. 159 (dated January 19, 1793). On the dating of this letter, see Maurer, "Leyenda persistente," 74–75.

35. "ONLY MY WILL ABOUNDS"

1. Moratín to Melón, June 28, 1825, Andioc, *Epistolario*, 630.

2. Moratín to Melón, July 17, 1825, Andioc, *Epistolario*, 633.

3. Matilla Tascón, "Archivo de Protocolos," 20.

4. Núñez de Arenas, "Manojo de noticias," 253.

5. Sambricio, *Tapices*, docs. 263–68.

6. Moratín to Melón, October 30 and October 7, 1825, Andioc, *Epistolario*, 647, 646.

7. On Cardano, see Jesusa Vega González, "José María Cardano y Bauzá," in RAH, *Diccionario*.

8. Janis Tomlinson, "En busca del héroe: Goya y Géricault (1814–1824)," in Mena Marqués, *Tiempos de guerra*, 38–97.

9. T. Harris, *Engravings*, 2:424.

10. T. Harris, *Engravings*, 2:421–23, cat. nos. 276–81. I am indebted to the staff of the Interlibrary Loan office at the University of Delaware Library for obtaining a digital imprint of the *Album Bordelais*.

11. Matheron, *Goya*, chap. 11.

12. Lipschutz, *Spanish Painting*, 262.

13. T. Harris, *Engravings*, 1:150.

14. Goya to Joaquín María Ferrer, December 6, 1825, Canellas López, *Diplomatario*, 389.

15. Goya to Joaquín María Ferrer, December 20, 1825, *Goya en el Prado* website / *Documentos*.

16. The collection was published by Motte. Núñez de Arenas, "Manojo de noticias," 271.

17. Goya to Joaquín María Ferrer, December 20, 1825, *Goya en el Prado* website / *Documentos*.

18. Courteault, "Á propos du Séjour," 8–9.

19. Canellas López, *Diplomatario*, 387.

20. Natalia Fraguas Fernández, "Antonio de Brugada Vila," in RAH, *Diccionario*.

21. Matheron, *Goya*, chap. 11.

22. Núñez de Arenas, "Manojo de noticias," 249.

23. *El Constitucional: Periódico político, literario, y comercial* (March 22, 1842): 1.

24. Moratín to Melón, May 7, 1826, Andioc, *Epistolario*, 663.

25. Sambricio, *Tapices*, doc. 269.

26. Sambricio, *Tapices*, docs. 270–74.

27. Moratín to Melón, July 15, 1826, and Moratín to Melón, November 15, 1826, Andioc, *Epistolario*, 667–68n3, 672.

28. Pierre Bernadau, *Extraits des Tablettes* (March 1787–April 1852), https://bernadau.wordpress.com (accessed October 13, 2018). For Goya's drawing of the giant woman, see Brown and Galassi, *Last Works*, 191–94; for the "living skeleton," see Ilatoveskaya, "Drawings," 68–69.

36. THE LAST YEAR

1. Moratín to Melón, January 28, 1827, Andioc, *Epistolario*, 677.

2. Moratín to Melón, dated to May–June 1827, Andioc, *Epistolario*, 679.

3. *Goya en el Prado* website / *Retratos*.

4. Baticle, *Goya*, 471.

5. Young, "Unpublished Letter," 558. Young's translation is here revised by the author.

6. Moratín to Manuel García de la Prada, July 31, 1827, Andioc, *Epistolario*, 683.

7. Moratín to Manuel García de la Prada, October 4, 1827, Andioc, *Epistolario*, 692.

8. Andioc, *Epistolario*, 696, no. 2. The letter attests to Melón's presence in Paris by November 1827.

9. Goya to Javier Goya, January 17, 1828, *Goya en el Prado* website/*Documentos/Cartas a otros destinatarios*.

10. Canellas López, *Diplomatario*, 393–94.

11. Brown and Galassi, *Last Works*, 25.

12. Goya to Javier Goya, March 26, 1828, Canellas López, *Diplomatario*, 394.

13. Goya to Javier, early April 1828, Canellas López, *Diplomatario*, 395.

14. These details of Goya's last weeks are based on a letter from Leocadia to Moratín, April 28, 1828, Canellas López, *Diplomatario*, 512.

15. Cited in Ribemont and Garcia, *Hommages*, 26.

16. Canellas López, *Diplomatario*, 512.

17. Canellas López, *Diplomatario*, 512–13.

18. Moratín to Leocadia, from Paris, May 7, 1828; see Reuter, "Goya no se olvidó de Leocadia."

19. Sánchez Díez, *Dibujos*, 34.

20. Leocadia to Juan Muguiro, December 9, 1829, Canellas López, *Diplomatario*, 515. Stamps on the letter show it was mailed on January 13, 1830, and received in Madrid on January 19; see Wilson-Bareau, "Lechera de Burdeos," 352.

21. Wilson-Bareau, "Lechera de Burdeos," 349–67.

22. Sánchez Díez, *Dibujos*, cat. nos. 34–36.

EPILOGUE: ROSARIO

1. On Rosario, see Rascón, *Necrología*; Sánchez Díez, *Dibujos*; and Álvarez Lopera, "Carrera." On Rosario and Lacour, see Ribemont and Garcia, *Hommages*, 26–27.

2. Leocadia to Muguiro, December 9, 1829, Canellas López, *Diplomatario*, 515.

3. Sánchez Díez, *Dibujos*, 55–58.

4. Rascón, *Necrología*, 4, enumerates the copies painted by Rosario for a secretary of the embassy; Álvarez Lopera,

"Carrera," 313–14, presents evidence that identifies Villiers as her patron. On Clarendon's collection, see Glendinning, "Goya and England," 11.

5. On the portraits of the duke and duchess, see Barón, *De Goya a Sorolla*, 98–99.

6. Rascón, "Necrología," 4.

7. Sánchez Díez, *Dibujos*, 60–64.

8. Rascón, "Necrología," 4; and Álvarez Lopera, "Carrera," 314–15.

9. Rascón, "Necrología," 4.

10. Álvarez Lopera, "Carrera," 316–17.

11. *The Old Women* and *The Letter* are in the Musée des Beaux-Arts, Lille; *Majas on a Balcony* is in a private collection; the 1797 portrait of the duchess of Alba is in the Hispanic Society of America; and *The Forge* is in the Frick Collection, New York. See Baticle and Marinas, *La Galerie espagnole*, 82–90, 271–73.

12. See numbers 184, 732, 784, 812, 813, 859, and 1018 of the inventory: Lasso de la Vega, "D. Serafín García de la Huerta."

13. On Weiss's participation in Royal Academy exhibitions, see Navarrete Martínez, *Academia*, 113, 308, 462, 473, 486, 488.

14. Sánchez Díez, *Dibujos*, 80–81.

15. Cited by Álvarez Lopera, "Carrera," 323.

16. Cited by Álvarez Lopera, "Carrera," 324.

17. Wilson-Bareau, "X Numbers," 160–61, 172–74. Cited here: "Note by Vicente López, undated," 174.

18. See inventory numbers 58, 737, 738, 1003, and 1004: Lasso de la Vega, "D. Serafín García de la Huerta."

19. The hypothesis that Javier copied his father's works was proposed by Wilson-Bareau, "X Numbers," 167.

20. For an introduction to some of the questions surrounding Goya in the nineteenth century, see Wilson-Bareau, "X Numbers"; and Tomlinson, "Evolving Concepts."

BIBLIOGRAPHY

Note: The bibliography is not intended to serve as a general bibliography on the artist. It is composed of works cited or which informed this biography; the absence of many interpretive studies of Goya's work should not be seen as a judgment on their quality.

Three digital sources have been essential to my research. The first is the *Goya en el Prado* website (www.goyaenelprado.es), which provides a full catalogue and high-quality images of all of the works in the collection of the Museo del Prado, Madrid. These include 119 letters from Goya to his friend Martín Zapater, digitally reproduced, with full transcription (in Spanish).

The periodicals of Goya's day cited here are accessible on the *Hemeroteca digital* of the Biblioteca Nacional de España (www.bne.es) The *Diccionario Biográfico electrónico* of the Real Academia de la Historia provides introductions to the historical figures of Goya's day (www.dbe.rah.es).

Translations are by the author, unless otherwise noted.

Águeda, Mercedes. *"La Tirana" de Francisco Goya*. Madrid: El Viso, 2001.

Águeda, Mercedes, and Xavier de Salas, eds. *Cartas a Martín Zapater*. Madrid: Istmo, 2003.

Alcázar Molina, Cayetano. "España en 1792: Floridablanca, su derrumbamiento del gobierno y sus procesos de responsabilidad política." *Revista de estudios políticos* 71 (September–October 1953): 92–138.

Álvarez García, Andrés. "Goya, Ramón Bayeu, y José del Castillo en los retablos de las Iglesias parroquiales de la Puebla del Híjar, Vinaceite y Urrea de Gaén (Teruel)." *Archivo Español de Arte* 75, no. 298 (2002): 167–89.

Álvarez Lopera, José. "La Carrera de Rosario Weiss en España: A la búsqueda de un perfil," in *La Mujer en el arte español, Actas, VIII Jornadas de Arte*, 309–24. Madrid: C.S.I.C, 1997.

Álvarez-Valdés y Valdés, Manuel. *Jovellanos: Vida y pensamiento*. Oviedo: Ediciones Nobel, 2012.

Andioc, René. *Goya: Letra y figuras*. Collection de la Casa de Velázquez, vol. 103. Madrid: Casa de Velázquez, 2008.

Andioc, René, ed. *Epistolario de Leandro Fernández de Moratín*. Madrid: Editorial Castalia, 1973.

Andioc, René. "Sobre Moratín y Goya," in *Goya y Moratín (en Burdeos)*, 9–36. Bilbao: Museo de Bellas Artes, 1998.

Andioc, René, and Mireille Andioc, eds. *Leandro Fernández de Moratín: Diario (May 1780–March 1808)*. Madrid: Editorial Castalia, 1967.

Anon. [Ceán Bermúdez, Juan Antonio]. *Análisis de un cuadro que pintó Don*

Francisco Goya para la Catedral de Sevilla.
Madrid: Imprenta Real y Mayor, 1817.

Anon. [Ceán Bermúdez, Juan Antonio].
"Bellas Artes." *Crónica científica y literaria* (December 9, 1817): 1–3.

Ansón Navarro, Arturo. *Academicismo y enseñanza de las bellas artes en Zaragoza durante el siglo XVIII: Precedentes, fundación y organización de la Real Academia de Bellas Artes de San Luis.* Zaragoza: Gobierno de Aragón, Departamento de Cultura y Educación/Real Academia de Bellas Artes de San Luis, 1993.

Ansón Navarro, Arturo. *Los Bayeu: Una Familia de artistas de la Ilustración.* Zaragoza: Caja Inmaculada, 2012.

Ansón Navarro, Arturo. "Datos socioeconómicos sobre los pintores Zaragozanos del siglo XVIII y sus talleres." *Estado actual de los estudios sobre Aragón* 2 (1981): 625–38.

Ansón Navarro, Arturo. *Goya y Aragón: Familia, amistades, y encargos artísticos.* Zaragoza: Caja de Ahorros de la Inmaculada de Aragón, 1995.

Ansón Navarro, Arturo. *El Pintor y profesor José Luzán Martínez (1710–1785).* Zaragoza: Caja de Ahorros de la Inmaculada de Aragón, 1986.

Ansón Navarro, Arturo. "Revisión crítica de la cartas escritas por Goya a su amigo Martín Zapater." *Boletín del Museo e Instituto Camón Aznar* 59–60 (1995): 247–91.

Aramburu de la Cruz, Manuel Vicente. *Historia Chronológica de la Santa Angélica y Apostólica Capilla de Nuestra Señora del Pilar... Relación Panegyrica de las solemnes fiestas, que ha celebrado la misma Augusta, Imperial Ciudad.* Zaragoza: Imprenta del Rey, 1766.

Aramburu de la Cruz, Manuel Vicente. *Zaragoza festiva en los fieles aplausos de el ingreso, y mansión en ella de el Rey Nuestro Señor Don Carlos III.* Zaragoza: Imprenta de el Rey Nuestro Señor, 1760.

Arnaiz, José Manuel. "Another Giaquinto Source for Goya." *The Burlington Magazine* 126, no. 978 (September 1984): 561–63.

Arnaiz, José Manuel. *La Primera obra documentada de Francisco de Goya.* Madrid: Editorial Alpuerto, 1992.

Arnaiz, José Manuel, and Ángel Montero. "Goya y el Infante Don Luis." *Antiquaria* 27 (March 1986): 44–55.

Artola, Miguel. *Los Afrancesados.* Madrid: Ediciones Turner, 1984.

Barbier, Jacques A., and Herbert S. Klein. "Revolutionary Wars and Public Finances: The Madrid Treasury, 1784–1807." *Journal of Economic History* 41 no. 2 (June 1981): 315–39.

Barbieri, Carlo. *Direzzione pe' viaggiatori in Italia colla notizia di tutte le poste, e loro prezzi.* Bologna: Giovanni Battista Sassi, 1773.

Baretti, Giuseppe Marco Antonio. *A Journey from London to Genoa, through England, Portugal, Spain, and France.* London: T. Davis and L. Davis, 1770.

Barón, Javier. *El retrato español en el Prado: De Goya a Sorolla.* Madrid: Museo Nacional del Prado, 2008.

Baticle, Jeanine. "À la découverte de la biographie véridique de Goya: État de la question," in *Goya: Un Regard libre.* Paris: Réunion des Musées Nationaux, 1998. Exhibition catalogue.

Baticle, Jeanine. "L'Activité de Goya entre 1796 et 1806 vue à travers le 'Diario' de Moratín." *Revue de l'Art* 13 (1971): 111–13.

Baticle, Jeanine. *Goya.* Paris: Fayard, 1992.

Baticle, Jeanine. "Goya et la *Junte des Philippines.*" *Revue du Louvre* 34 (1984): 107–16.

Baticle, Jeanine, and Cristina Marinas, *La Galerie espagnole de Louis Philippe au Louvre, 1838–1848.* Paris: Réunion des Musées Nationaux, 1981.

Bédat, Claude. *Los Académicos y las Juntas 1752–1808.* Madrid: Real Academia de Bellas Artes de San Fernando, 1982.

Bermejo, Ildefonso Antonio. "El Azotado." *La Ilustración Española y Americana* 25 (1886): 7.

Beroquí, Pedro. "Una Biografía de Goya escrita por su hijo." *Archivo Español de Arte* 3 (1929): 99–100.

Bjurström, Per. "Jacob Gustaf De la Gardie och Goya." *Meddelander fron National-museum* (1962): 77–81.

Blas, Javier, and José Manuel Matilla. *El Libro de Los Caprichos.* Madrid: Museo del Prado, 1999.

Blasco Castiñeyra, Selina. *El Palacio de Godoy.* Madrid: Centro de Estudios Constitucionales, 1996.

Blasco Martínez, Rosa María. *Zaragoza en el siglo XVIII (1700–1770).* Zaragoza: Librería General, 1977.

Boloquí Larraya, Belén. *Escultura zaragozana en la época de los Ramírez, 1710–1780.* 2 vols. Madrid: Ministerio de Cultura, 1984.

Borrás Gualis, Gonzálo M. *Goya: Los Frescos de San Antonio de la Florida.* Barcelona: Electa, 2000.

Bourgoing, Jean-François. *Travels in Spain.* 3 vols. London: Printed for G.G.J. and J. Robinson, 1789.

Bozal Fernández, Valeriano, and BNE/Biblioteca Nacional de España, *Miradas sobre la Guerra de la Independencia.* Madrid: Biblioteca Nacional, 2008. Exhibition catalogue.

Braham, Allan. "Goya's Equestrian Portrait of the Duke of Wellington." *The Burlington Magazine* 108, no. 765 (February 1966): 618–21.

Bray, Javier. *Goya: The Portraits.* London: National Gallery, 2015. Exhibition catalogue.

Brown, Jonathan, and Susan Grace Galassi. *Goya's Last Works.* New Haven, CT: Yale University Press, 2006. Exhibition catalogue.

Buendía, Rogelio, and Rosario Peña. "Goya, Académico," in *IV Jornadas de Arte. El Arte en tiempo de Carlos III,* 302–10. Madrid: Ediciones Alpuerto, 1989.

Bueno Paz, José. "Datos documentales sobre los hijos de Goya." *Arte Español* (1947): 57–63.

Cabarrús, Francisco de. *Elogio del Excelentísimo Señor Conde de Gausa.* Madrid: Viuda de Ibarra, 1786.

Calvo Ruata, José Ignacio. *Cartas de Fray Manuel Bayeu a Martín Zapater.* Zaragoza: Instituto Fernando el Católico/Museo del Prado, 1996.

Calvo Ruata, José Ignacio. "El Factor Bayeu en la formación de Goya." *Artigrama* 25 (2010): 21–51.

Calvo Ruata, José Ignacio. *Fray Manuel Bayeu: Cartujo, pintor y testigo de su tiempo.* Huesca: Diputación Provincial de Huesca, 2018.

Calvo Ruata, José Ignacio. "Goya y los Bayeu a través de las cartas de Fray Manuel Bayeu." *Artigrama* 10 (1993): 373–402.

Calvo Ruata, José Ignacio. "Vida y obra del pintor Fra Manuel Bayeu." PhD diss., Universidad de Zaragoza, 1998.

Camp, Federico. *La Invasión napoleónica.* Barcelona: Ayma, 1943.

Canellas López, Angel, comp. *Francisco de Goya: Diplomatario.* Zaragoza: Institución Fernando el Católico, 1981.

Canellas López, Ángel. "Goya y un borrador de cartas a Martín Zapater." *Boletín del Museo e Instituto Camón Aznar* 31–32 (1988): 7–14.

Cano Cuesta, Marina. *Goya en la Fundación Lázaro Galdiano.* Madrid: Fundación Lázaro Galdiano, 1999.

Cánovas del Castillo, Soledad. "Artistas españoles en la Academia de San Luca de Roma, 1740–1808." *Academia: Boletín de la Real Academia de Bellas Artes de San Fernando* 68 (1989): 155–209.

Carbajo Isla, María F. *La Población de la Villa de Madrid.* Madrid: Siglo XXI de España, 1987.

Carderera, Valentín. "François Goya: Sa vie, ses dessins, and ses eaux-fortes," *Gazette des Beaux-Arts* 7 (1860): 215–27.

Carrasco Martínez, Antonio. "Entre Francia e Inglaterra: La Política mediterránea de Carlos IV," in *1802: España entre dos siglos,* 105–124. Mahon: Museo de Menorca, 2002.

Carrete Parrondo, Juan. "Goya. *Disparates.* Serviles o liberales?," in *La Represión absoluta y el exilio,* edited by Marieta Cantons Casenave and Alberto Ramos Santana, 217–39. Cádiz: Editorial UCA, 2015.

Castro Alava, José Ramón. "El Goya de la Diputación de Navarra." *Principe de Viana* 3 (1942): 37–39.

Ceán Bermúdez, Juan Agustín. *Diccionario histórico de los más ilustres profesores de las Bellas Artes en España.* 6 vols. Madrid: Imp. Viuda de Ibarra, 1800.

Ceán Bermúdez, Juan Agustín. *Memorias para le vida del Excmo. Sr. Don Gaspar Melchor de Jovellanos y noticias analíticas de sus obras.* Madrid: Imprenta que fue de Fuentenebro, 1814.

Centro de Estudios Históricos. *El Arte en tiempo de Carlos III.* Madrid: Editorial Alpuerto, 1989.

Cerón, M. "Goya's Lost Snuff Box." *The Burlington Magazine* 152, no. 1291 (2010): 675–77.

Chaparro, Francisco J. R. "Memoria y presente en Goya: El Auto de fe de Orosia Moreno en 1760 y el Albúm C." *Dieciocho* 41 (Spring 2018): 79–106.

Clissón Aldama, José. *Juan Agustín Ceán Bermúdez: Escritor y crítico de Bellas Artes.* Oviedo: I.D.E.A., 1982.

Colección de los decretos y órdenes que han expedido las Cortes ordinarias desde 25 de setiembre de 1813, día de su instalación, hasta 11 de mayo de 1814, en que fueron disueltas. Madrid: Imprenta Nacional, 1821.

Comunidad de Madrid. *Una Corte para el rey: Carlos III y los sitios reales.* Madrid: Comunidad de Madrid, 2016.

Copertini, Giovanni. "Note sul Goya," in *Annuario per l'Anno Scolastico 1928–9 del R. Liceo Gimnasio Gian Domenico Romagnosi.* Parma: Officina Grafica Fresching, 1928.

Cortonese, Ridolfino Venuti. *Accurata e succinta descrizione topografica e istorica di Roma Moderna.* 2 vols. Rome: Carlo Barbiellini, 1766.

Cotarelo y Mori, Emilio. *Isidoro Maíquez y el teatro de su tiempo.* 1902. Reprint, Madrid: Association of Directores de Escena de España, 2009.

Cotoner y Verí Allende-Salazar y Fortuny, Marqués de Ariany y de la Cenia; Antonio Ayerbe; and Tomás de Verí y Togores. *Cuadros notables de Mallorca: Principales colecciones de pinturas que existen en la isla de Mallorca. Colección de Don Tomás de Veri.* Madrid: V. H. Sanz Calleja, 1920.

Courteault, Paul. "Á propos du Séjour de Goya à Bordeaux." *Revue Philomathique de Bordeaux et du Sud-Ouest* (1908): 3–11.

Cruz, Jesús. *Gentlemen, Bourgeois, and Revolutionaries: Political Change and Cultural Persistence among Spanish Dominant Groups, 1750–1850.* Cambridge: Cambridge University Press, 1996.

Cruz Valdovinos, José Manuel. "Inquisidores e ilustrados: Las Pinturas y estampas 'indecentes' de Sebastián Martínez," in Centro de Estudios Históricos, *El Arte en tiempo de Carlos III,* 311–20. Madrid: Editorial Alpuerta, S.A., 1989.

Cruz Valdovinos, José Manuel. "La Partición de bienes entre Francisco y Javier Goya a la muerte de Josefa Bayeu y otras cuestiones," in *Goya: Nuevas Visiones: Homenaje a Enrique Lafuente Ferrari,* edited by Isabel García de la Rasilla and Francisco Calvo Serraller, 133–53. Madrid: Amigos del Museo del Prado, 1987.

Cruz Valdovinos, José Manuel. *Monumentos restaurados: La Santa Cueva de Cádiz.* Madrid: Fundación Caja Madrid, 2001.

Dalrymple, William. *Travels through Spain and Portugal in 1774 with a Short Account of the Spanish Expedition against Algiers in 1775.* London: J. Almon, 1777.

Delacroix, Eugène. *Journal, 1822–1857.* 2 vols. Paris: José Corti, 2009.

Demerson, Georges. *Don Juan Meléndez Valdés y su tiempo.* Madrid: Taurus, 1971.

Demerson, Georges. "Juan Meléndez Valdés: Quelques documents inédits pour completer sa biographie." *Bulletin Hispanique* (1953): 252–95.

Demerson, Georges. "Les Registres d'habitants de Madrid sous Joseph." *Bulletin Hispanique* 59, no. 2 (1957): 199–205.

Demerson, Paula. *María Francisca de Sales*

Portocarrero (Condesa de Montijo): Una Figura de la ilustración. Madrid: Editora Nacional, 1975.

Diaz Torrejón, Francisco Luis. José Napoleón I en el sur de España: Un Viaje regio por Andalucía (enero–mayo 1810). Córdoba: Publicaciones obra Social y Cultura CajaSur, 2008.

Dufour, Gérard. Lumières et ilustración en Espagne. Paris: Ellipses, 2006.

Encisco Recio, Luis Miguel. Actas del Congreso Internacional: El Dos de Mayo. Madrid: Consorcio para la Organización de Madrid Capital de Europa, 1992.

Escrivano Montoya, Josef. Elogio fúnebre del Excelentísimo Señor Don Josef Alvarez de Toledo, Gonzága y Caracciolo, etc. Duque de Alba. Madrid: Viuda e Hijo de Marín, 1796.

Esdaile, Charles J. Fighting Napoleon: Guerillas, Bandits and Adventurers in Spain, 1808–1814. New Haven, CT: Yale University Press, 2004.

Esdaile, Charles J. The Peninsular War: A New History. London: Penguin, 2003.

Espinosa Ibarra, Julian. "Un Testimonio de la influencia de la psiquiatría española de la ilustración en la obra de Pinel: El Informe de José Iberti acerca de la asistencia en el manicomio de Zaragoza (1791)." Asclepio 16 (1964): 179–82.

Espinosa Martín, Carmen. Las Miniaturas en el Museo del Prado: Catálogo razonado. Madrid: Museo del Prado, 2011.

Eusebi, Luis. Catálogo de los cuadros de la escuela española que existen en el Real Museo del Prado. Madrid: Imprenta Real, 1819.

Ezquerra del Bayo, Joaquín. La Duquesa de Alba y Goya. Madrid: Aguilar, 1958.

Fayos-Pérez, Paula. "Delacroix after Goya's Caprichos: A New Sheet of Drawings." The Burlington Magazine 161 (June 2019): 474–81.

Fernández Doctor, Asunción. El Hospital de Ntra. Sra. De Gracia de Zaragoza en el siglo XVIII. Zaragoza: Institución Fernando el Católico, 1987.

Fernández-Miranda y Lozana, Fernando.

Inventarios reales: Carlos III, 1789. Vol. 1. Madrid: Patrimonio Nacional, 1991.

Foucault, Michel. Madness and Civilization: A History of Insanity in the Age of Reason. Translated by Richard Howard. New York: Vintage, 1973.

Franco Rubio, Gloria A. La Vida cotidiana en tiempos de Carlos III. Madrid: Ediciones Libertarias, 2001.

Fuente, Vicente de la. Biografía del Doctor Don José Duaso y Latre. Madrid: Imprenta de Arcos, 1850.

Fuentes Aragonés, Juan Francisco. El Fin del antiguo regimen (1808–1868): Política y sociedad. Madrid: Editorial Síntesis, 2007.

Fundación Amigos del Museo del Prado. El Arte del siglo de las luces. Madrid: Galaxia Gutenberg, 2010.

Gallego, Julián. "Una Carta inédita de Goya sobre la restauración de pinturas." Academia: Boletín de la Real Academia de Bellas Artes de San Fernando 76 (1993): 169–79.

Gallego, Julián, and Tomás Domingo. Los Bocetos y las pinturas murales del Pilar. Zaragoza: Caja de Ahorros de la Inmaculada, 1987.

Gallego, Raquel. "Algunas noticias sobre tres contactos en Italia de Francisco de Goya: Timoteo Martínez, Bartolomeo Puigvert y Luis Martínez de Beltrán." Acta/Artis Estudis d'Art Modern 3 (2015): 99–115.

Gallego, Raquel. "Muchos originales del Bernini y de Langarde: Sul possibile apprendistato di Francisco de Goya y Lucientes presso Ca'Farsetti a Venezia." Arte Veneta 69 (2014): 190–96.

Gallego, Raquel. "Roma, teatro de las naciones: El Artista y la ciudad (1750–1780)." Acta/Artis: Estudis d'Art Modern 4/5 (2016/2017): 41–53.

Gallego, Raquel. "Sobre las capitulaciones matrimoniales de Francisco de Goya y la prisa del Aragonés en abandonar a Roma." Archivo Español de Arte 87, no. 346 (2014): 109–18.

García de Paso, Alfonso, and Wifredo

Rincón García. "Datos biográficos de Francisco de Goya y su familia en Zaragoza." *Boletín del Museo e Instituto Camón Aznar* 5 (1981): 93–104.

García de la Rasilla, Isabel, and Francisco Calvo Serraller, eds. *Goya: Nuevas Visiones: Homenaje a Enrique Lafuente Ferrari*. Madrid: Amigos del Museo del Prado, 1987.

García Garrosa, María Jesús. "De *El Cariño perfecto* (1798) a *La Serafina* (1802 y 1807): Las Tres versiones de una novela de José Mor de Fuentes." *Revista de Literatura* 71 (2009): 461–96.

García Sánchez, Jorge. "Manuel Napoli, un retaurador italiana al servicio de José Bonaparte." *Reales Sitios* 44, no. 172 (2007): 28–49.

García Sánchez, Jorge. "La Real Academia de San Fernando en una época de crisis, 1808–1814." *Hispana Nova* 7 (2007): 115–38.

García Sánchez, Jorge, and Cándido de la Cruz Alcañiz. "Piazza Barberini: A Spanish Artists' District in Eighteenth-Century Rome." *The Burlington Magazine* 152, no. 1291 (October 2010): 665–70.

García de Valdeavellano, Luis. "Apuntes para la biografía Goyesca: Las Relaciones de Goya con el Banco de San Carlos." *Boletín de la Sociedad Española de Excursiones* 36 (April 1928): 56–65.

Garrido, María del Carmen. "Algunas consideraciones sobre la técnica de las pinturas Negras de Goya." *Boletín del Museo del Prado* 5, no. 13 (1984): 4–40.

Gassier, Pierre. *The Drawings of Goya: The Complete Albums*. Translated by Robert Allen and James Emmons. London: Thames and Hudson, 1973.

Gassier, Pierre, and Juliet Wilson. *The Life and Complete Work of Francisco Goya*. New York: Renal in association with William Morrow, 1971.

Gastinel-Coural, Chantal. "Le Cabinet de platine de la Casa del Labrador à Aranjuez: Documents inédits." *Bulletin de la Société de l'Art français* (1993): 181–205.

Gaya Nuño, Juan Antonio. "La 'Alegoría de la Villa de Madrid' de Goya." *Villa de Madrid* 7 (1969): n.p.

Gies, David T. "'Sentencias y buenas máximas'": Francisco Durán, dramaturgo y poeta ilustrado," in *El siglo que llaman ilustrado: Homenaje a Francisco Aguilar Piñal*, 451–57. Madrid: C.S.I.C., 1996.

Gil-Díez Usandizaga, Ignacio. "Sebastián Martínez, el amigo de Goya." *BROCAR* 38 (2014): 197–209.

Giménez López, Enrique. "El Tránsito del siglo XVIII al XIX en España," in *1802: España entre dos siglos y la devolución de Menorca*, 29–42. Mahon: Museo de Mallorca, 2002.

Glendinning, Nigel. "Goya and England in the Nineteenth Century." *The Burlington Magazine* 106, no. 730 (1964): 4–14.

Glendinning, Nigel. *Goya and His Critics*. London: Yale University Press, 1977.

Glendinning, Nigel. "Goya on Women in the *Caprichos*: The Case of Castillo's Wife." *Apollo* 107 (February 1978): 130–34.

Glendinning, Nigel, ed. "Incunables goyescos: Antonio Rodríguez-Moñino." *Bulletin of Hispanic Studies* 63 (1981): 293–312.

Glendinning, Nigel. "Nineteenth-Century Editions of Goya's Etchings: New Details of Their Sales Statistics." *Print Quarterly* 6 (December 1989): 394–403.

Glendinning, Nigel. "A Solution to the Enigma of Goya's 'Emphatic Caprices,' Nos. 56–80 of *The Desastres de la Guerra*." *Apollo* 107 (March 1978): 186–91.

Glendinning, Nigel. "Spanish Inventory References to Paintings by Goya, 1800–1850: Originals, Copies, and Valuations." *The Burlington Magazine* 136, no. 1091 (February 1994): 100–110.

Glendinning, Nigel. "The Strange Translation of Goya's 'Black Paintings'." *The Burlington Magazine* 117, no. 868 (June 1975): 465–79.

Glendinning, Nigel, and José Miguel Medrano. *Goya y el Banco Nacional de San Carlos*. Madrid: Banco de España, 2005.

Glover, Michael. *Legacy of Glory: The*

Bonaparte Kingdom of Spain, 1808–1813. New York: Charles Scribner's Sons, 1971.

Gómez Zorraquino, José Ignacio. *Los Goicoechea y su interés por la tierra y el agua.* Colección "Temas de Historia Aragonesa," no. 14. Zaragoza: Diputación General de Aragón, 1989.

González Miranda, Marina. "La Familia de Pedro de Goya según sus propias anotaciones manuscritas." *Seminario de arte aragonés* 27–28 (1978): 5–12.

González Santos, Javier. "Jovellanos por Goya: Precisiones históricas e iconográficas sobre dos conocidos retratos." *Boletín del Museo del Prado* 13 (1992): 45–56.

Grandmaison, Geoffroy de. *L'Ambassade française en Espagne pendant la révolution, 1789–1804.* Paris: E. Plon, Nourret, 1892.

Grandmaison, Geoffroy de. *L'Espagne et Napoléon, 1804–1809.* 2nd ed. Paris: Librairie Plon, 1908.

Gutiérrez de los Ríos y Rohan, Carlos, José Chabot, Conde de Fernán Núñez. *Vida de Carlos III.* Madrid: M. Aguilar, 1944.

Hamilton, Nigel. *Biography: A Brief History.* Cambridge, MA: Harvard University Press, 2007.

Harris, Enriqueta, "A Contemporary Review of Goya's *Caprichos.*" *The Burlington Magazine* 106, no. 730 (January 1964): 40–43.

Harris, Tomás. *Goya: Engravings and Lithographs.* 2 vols. 1963. Reprint, San Francisco: Alan Wofsy Fine Arts, 1983.

Held, Jutta. *Die Genrebilder der Madrider Teppichmanufaktur und die Anfänge Goyas.* Berlin: Mann Verlag, 1971.

Held, Jutta. "Goya's Akademiekritik." *Münchner Jahrbuch für Bildende Kunst* 17 (1966): 214–24.

Herr, Richard. *The Eighteenth-Century Revolution in Spain.* Princeton, NJ: Princeton University Press, 1973.

Herr, Richard. *Rural Change and Royal Finances in Spain at the End of the Old Regime.* Berkeley: University of California Press, 1989.

Herranz Estoduto, Alfonso. *Origenes de la Plaza de Toros de Zaragoza: Datos para su historia (1764–1818).* Zaragoza: Diputación Provincial e Institución "Fernando el Católico," 1978.

Hertzano, Ronna P., Janis A. Tomlinson, and Philip A. Mackowiak. "Goya's Lost Hearing: A Twenty-First-Century Perspective on Its Cause, Effect, and Possible Treatment." *American Journal of the Medical Sciences* 357, no. 4 (2019): 275–79.

Hervás y Panduro, Lorenzo. *Escuela española de sordomudos, ó Arte para enseñarles á escribir y hablar el idioma español.* Madrid: Imprenta Real, 1795.

Hoffman-Samland, Jens, et al. *The Spanish Gesture: Drawings from Murillo to Goya in the Hamburger Kunsthalle.* Hamburg: Hamburger Kunsthalle, 2014. Exhibition catalogue.

Hoz García, Carlos de la. "Las Reformas de la Hacienda madrileña en la época de Carlos III," in *Carlos III, Madrid, y la Ilustración,* 77–102. Madrid: Siglo Veintiuno, 1988.

Ilatoveskaya, Tatiana. "Drawings by Francisco de Goya from the Gerstenberg-Scharf Collection," in *Master Drawings Re-discovered: Treasures from Prewar German Collections,* 15–101. New York: Abrams, 1996.

Ives, Colta, and Allison Stein. *Goya in the Metropolitan Museum of Art.* New York: MMA, 1996. Exhibition catalogue.

Jordán de Urríes y de la Colina, Javier. "El Coleccionismo de Bernardo Iriarte." *Goya* 319–20 (2007): 259–80.

Jordán de Urríes y de la Colina, Javier. *La Real Casa del Labrador de Aranjuez.* Madrid: Patrimonio Nacional, 2009.

Jordán de Urríes y de la Colina, Javier. "El Retrato equestre de Bonaparte en el gran San Bernardo de David comprador por Carlos IV." *Archivo Español de Arte* 64, no. 256 (1991): 503–11.

Jordán de Urríes y de la Colina, Javier. "Los Últimos discípulos españoles de Mengs (Ramos, Agustín, Salesa, Napoli

y Espinosa)," in *Congreso International Pintura Española Siglo XVIII*, 435–50. Marbella, Spain: Museo del Grabado Español Contemporáneo, 1998.

Jordán de Urríes y de la Colina, Javier, and José Luis Sánchez Gaspar. "El Gabinete de platino de la Real Casa del Labrador in Aranjuez," in *Charles Percier e Pierre Fontaine: Dal soggiorno romano alla traformazione di Parigi*, 133–43. Milan: Silvano Editore, 2014.

Joubin, André, ed. *Correspondance générale de Eugène Delacroix*. 4 vols. Paris: Librairie Plon, 1938.

Jovellanos, Gaspar Melchor de. *Elogio de las Bellas Artes*. Introduction by Javier Portús Pérez. Madrid: Casimiro Libros, 2014.

Jovellanos, Gaspar Melchor de. *Obras Completas*. 2011 *Jovellanos Bicentenario* Jovellanos2011.es/Obras completas.

Junot Abrantes, Laure. *Memoirs of the Duchess of Abrantes (Madame Junot)*. London: Richard Bentley, 1832.

Junquera, Paulina. "Un Lienzo inédito de Goya en el Palacio de Oriente." *Archivo Español de Arte* 33 (1959): 185–92.

Kasl, Ronda, and Suzanne Stratton, eds. *Painting in Spain in the Age of Enlightenment: Goya and His Contemporaries*. Seattle: University of Washington Press, 1997. Exhibition catalogue.

Kauffman, C. M. *Catalogue of Paintings in the Wellington Museum*. Revised by Susan Jenkins. London: English Heritage and Paul Holbertson, 2009.

Kendrick, John. *Alejandro Malaspina: Portrait of a Visionary*. Montreal: McGill-Queen's University Press, 1999.

Laborde, Alexandre. *Itinéraire descriptif de l'Espagne, et tableau élémentaire des differentes branches de l'administration et de l'industrie de ce royaume*. 5 vols. Paris: H. Nicolle, 1808.

Lafuente Ferrari, Enrique. *Antecedentes, coincidencias e influencias del arte de Goya*. Madrid: Sociedad Española de Amigos del Arte, 1947.

Lasso de la Vega y López de Tejada, Miguel, el Marqués del Saltillo. "Colecciones madrileñas de pinturas: La de D. Serafín García de la Huerta (1840)." *Arte Español* 18 (1951):170–210.

Lasso de la Vega y López de Tejada, Miguel, el Marqués del Saltillo. "Goya en Madrid: Su familia y alegados," in *Miscelánea madrileña, histórica y artística*, first series, 11–42. Madrid: Imprenta y Editorial Mestre, 1952.

Lasso de la Vega y López de Tejada, Miguel, el Marqués del Saltillo. "Las Pinturas de Goya en el Colegio de Calatrava de Salamanca (1780–1790)." *Seminario de Arte Aragonés* 6 (1954): 5–9.

Lipschutz, Ilse Hempel. *Spanish Painting and the French Romantics*. Cambridge, MA: Harvard University Press, 1972.

Loga, Valerian von. *Francisco de Goya*. Berlin: G. Grote'sche Verlagsbuchhandlung, 1921.

López, François. "Les Espagnoles à Bordeaux de 1808 à 1823," in *Images des Espagnols en Aquitaine*, 1–11. Bordeaux: Presses Universitaires de Bordeaux, 1988.

López Ortega, Jesús. "El Expediente matrimonial de Francisco de Goya." *Boletín del Museo del Prado* 26 (2008): 62–68.

Lozano López, Juan Carlos. "Problemática del Goya joven (1746–75). *Artigrama* 25 (2010): 67–78.

Loupès, Philippe. *L'Espagne de 1780 à 1802*. Paris: Sedes, 1982.

Lovett, Gabriel H. *Napoleon and the Birth of Modern Spain*. 2 vols. New York: New York University Press, 1965.

Luna, Juan J., and Margarita Moreno de la Heras. *Goya: 250 Aniversario*. Madrid: Museo del Prado, 1996.

Mac Donald, M. F. "British Artists at the Accademia del Nudo in Rome," in *Academies of Art: Between Renaissance and Romanticism*. Leids Kunsthistorisch Jaarboek 5–6 (1986–1987): 77–94. The Hague: SDU Uitgeverij, 1989.

Madrid, Ayuntamiento. *Carlos III, Alcalde de Madrid*. Madrid: Ayuntamiento, 1988.

Lasso de la Vega y López de Tejada,

Mano, José Manuel de la. "Goya versus Bayeu: De la Proclamación a la Exaltación de Carlos IV," in *Francisco Bayeu y sus discípulos*, 132–60. Zaragoza: Cajalón, 2007.

Mano, José Manuel de la. *Mariano Salvador Maella Dibujos: Catálogo razonado.* 2 vols. Santander: Fundación Botín, 2011.

Mano, José Manuel de la. *Mariano Salvador Maella: Poder e Imagen en la España de la Ilustración.* Madrid: Fundación Arte Hispánico, 2011.

Mano, José Manuel de la. "Towards Goya's Royal Portraits: The Evolution of the Official Iconography of Charles IV and María Luisa of Parma through Their Court Painters," in *Royal Splendor in the Enlightenment: Carlos IV of Spain, Patron and Collector*, 79–97. Dallas: Meadows Museum and the Patrimonio Nacional, 2010. Exhibition catalogue.

Martín-Valdepeñas Yagüe, Elisa. "El Retrato de la condesa de Truillas de Agustín Esteve y Marqués (1797)." *Archivo Español de Arte* 91, no. 361 (2018): 70–78.

Martínez Arranz, Raúl. "Dos pinturas inéditas de José del Castillo para le decoración del palacio de los secretarios de estados en las colecciones del Instituto Valencia de Don Juan." *Archivo Español de Arte* 90, no. 357 (2017): 83–90.

Matheron, Laurent. *Goya.* Paris: Schulz et Thuillé, 1858.

Matilla, José Manuel. "Retrato de Miguel de Múzquiz, conde de Gausa," in *No Solo Goya*, exhibition catalogue, 109–10. www.museodelprado.es.

Matilla, José Manuel, Manuela B. Mena Marqués, et al. *Francisco de Goya (1746–1828): Dibujos Catálogo Razonado.* Vol. 1. Madrid: Fundación Botín-Museo Nacional del Prado, 2018.

Matilla Tascón, Antonio. "Documentos del Archivo del Ministerio de Hacienda relativos a pintores de cámara y de las fábricas de tapices y porcelana. Siglo XVIII." *Revista de Archivos, Bibliotecas y Museos* 68 (1960): 199–270.

Matilla Tascón, Antonio. "Goya en el Archivo de Protocolos de Madrid." *Villa de Madrid* 58 (1978): 17–20.

Maurer, Gudrun. "Goya, sordo, y la 'máquina eléctrica.'" *Boletín del Museo del Prado* 30 (2012): 94–97.

Maurer, Gudrun. "Una Leyenda persistente: El Viaje de Goya a Andalucía en 1793." *Boletín del Museo del Prado* 28 (2010): 74–81.

Maurer, Gudrun. "Nuevos documentos sobre Josefa Bayeu y Pedro Gómez, moledor de colores y el entorno de Goya en 1801." *Boletín del Museo del Prado* 35 (2017): 92–97.

Mayor, A. Hyatt. "Goya's Creativeness." *The Metropolitan Museum of Art Bulletin* 5 (December 1946): 105–109.

Mayor, A. Hyatt. "Hannibal Crossing the Alps." *The Burlington Magazine* 97 (1955): 295–96.

McGrigor, James. *The Scalpel and the Sword: The Autobiography of the Father of Army Medicine.* Edited by Mary McGrigor. Dalkeith: Scottish Cultural Press, 2000.

Meléndez Valdés, Juan. *Discursos forenses de D. Juan Meléndez Valdés.* Madrid: Imprenta Real, 1821.

Mena Marqués, Manuela B. *Goya: La Familia de Carlos IV.* Madrid: Museo Nacional del Prado, 2002.

Mena Marqués, Manuela B. *Goya and Eighteenth-Century Spanish Painting.* Madrid: Museo del Prado, 2000.

Mena Marqués, Manuela B. *Goya en tiempos de guerra.* Madrid: Museo del Prado, 2008. Exhibition catalogue.

Mena Marqués, Manuela B., and Gudrun Mühle Maurer. *La Duquesa de Alba, "musa" de Goya: El Mito y la historia.* Madrid: Museo Nacional del Prado, 2006.

Molas Ribalta, Pedro. "La Política interior del Conde de Floridablanca," in Fundación Caja Murcia, Real Academia de Bellas Artes de San Fernando, *Floridablanca, 1728–1808: La Utopía reformadora*, 123–33. Murcia: Region de Murcia, 2008. Exhibition catalogue.

Mor de la Fuente, José. *La Serafina.* Madrid: Repuellés, 1807.

Morales y Marín, José Luis. *Francisco Bayeu: Vida y Obra*. Zaragoza: Moncayo, 1995.

Morales y Marín, José Luis. *Gregorio Ferro (1742–1812)*. A Coruña: Fundación Pedro Barrié de la Maza, 1999.

Morales y Marín, José Luis. *Mariano Maella: Vida y obra*. Zaragoza: Moncayo, 1996.

Moreno, José, and Antonio Bonet Correa. *Los Ornatos públicos de Madrid en la coronación de Carlos IV*. Barcelona: Editorial Gili, 1983.

Muller, Priscilla. *Goya's "Black" Paintings: Truth and Reason in Light and Liberty*. New York: Hispanic Society of America, 1984.

Muñoz y Manzano, Cipriano, Conde de la Viñaza. *Goya: Su tiempo, su vida, sus obras*. Madrid: Manuel G. Hernández, 1887.

Museo de Bellas Artes de Bilbao. *Goya y Moratín (en Burdeos)*. Bilbao: Museo de Bellas Artes, 1998.

Museo del Prado. *Goya en las colecciones madrileñas*. Madrid: Museo del Prado, 1983. Exhibition catalogue.

Museo Goya. *Goya y Zaragoza, 1746–1775: Sus raíces aragonesas*. Zaragoza: Ibercaja Obra Social/Gobierno de Aragón-Fundación Goya en Aragón, 2014. Exhibition catalogue.

Navarrete Martínez, Esperanza. *La Academia de Bellas Artes de San Fernando y la pintura en la primera mitad del siglo XIX*. Madrid: Fundación Universitaria Española, 1999.

Navarrete Prieto, Benito. "Francisco de Goya en San Nicolás de los Lorenenses de Roma 1770." *Archivo Español de Arte* 75, no. 299 (2002): 293–96.

Noticia de los cuadros que se hallan colocados en la Galería del Museo del Rey Nuestro Señor, sitio en el Prado de esta Corte. Madrid: Hija de Francisco Martínez Dávila, 1828.

Núñez de Arenas, M. "Manojo de noticias: La Suerte de Goya en Francia." *Bulletin Hispanique* 52 (1950): 229–73.

Núñez Vernis, Bertha. "Seis documentos inéditos relacionados con don Francisco de Goya." *Boletín del Museo e Instituto "Camón Aznar"* 47 (1992): 33–46.

Oman, Charles. "Diary of Charles Vaughan in Spain, 1808," in *Publicaciones del Congreso Histórico Internacional de la guerra de la independencia y su época (1807–1815)*, vol. 1, 241–56. Zaragoza: E. Casañal, 1909.

Ona González, José Luis. *Goya y su familia en Zaragoza: Nuevas noticias biográficas*. Zaragoza: Institución Fernando el Católico, 1997.

Ossorio y Bernard, Manuel. *Galería biográfica de artistas españoles del siglo XIX*. Madrid: Ramón Moreno, 1883–1884.

Pagés-Rangel, Roxana. *Del dominio público: Itinerarios de la carta privada*. Amsterdam: Rodopi, 1997.

Palais des Beaux-Arts, Lille. *Goya: Un Regard libre*. Paris: Éditions de la Réunion des Musées Nationaux, 1998.

Pardo Canalís, Enrique. "Bosquejo histórico de Don José Duaso y Latre." *Anales del Instituto de Estudio Madrileños* 3 (1968): 253–80.

Pardo Canalís, Enrique. "Un Dato para la biografía familiar de Goya." *Seminario de arte aragonés* 5 (1953): 104–5.

Pardo Canalís, Enrique. "La Iglesia Zaragozana de San Fernando y las pinturas de Goya." *Goya* 84 (1968): 360–63.

Pardo Canalís, Enrique. "Una Visita de la galería del Principe de la Paz." *Goya* 148–50 (1979): 300–311.

Paseo por Madrid ó Guía de Forastero en la Corte. Madrid: Imprenta de Repullés, January 1815.

Patrimonio Nacional. *Carlos III: Majestad y ornato en los escenarios del rey ilustrado*. Madrid: Patrimonio Nacional, 2016. Exhibition catalogue.

Paul, Carole. "Capitoline Museum, Rome: Civic Identity and Personal Cultivation," in *The First Modern Museums of Art: The Birth of an Institution in Eighteenth- and Early Nineteenth-Century Europe*, 1–20. Edited by Carole Paul.

Los Angeles: The J. Paul Getty Museum, 2012.

Peiró, Antonio. *Regadío, transformaciones económicas, y capitalismo (La tierra en Zaragoza 1766–1849)*. Zaragoza: Diputación General de Aragón, 1988.

Péman Medina, María. "La Colección artística de Don Sebastián Martínez, el amigo de Goya, en Cádiz." *Archivo Español de Arte* 51, no. 201 (1978): 53–62.

Péman Medina, María. "Estampas y libros que vió Goya en casa de Sebastián Martinez." *Archivo Español de Arte* 65, no. 259–60 (1992): 303–20.

Peña Lázaro, Rosario. "Don Luis de Borbón y Teresa de Vallabriga," in *Goya y el Infante Don Luis de Borbón: Homenaje a la "infanta" Doña María Teresa de Vallabriga*, 37–63. Zaragoza: Patio de la Infanta, 1996. Exhibition catalogue.

Pereyra, Carlos, ed. *Cartas confidenciales de la Reina María Luisa y de Don Manuel Godoy*. Madrid: M. Aguilar, n.d.

Pérez Hernández, Mª Isabel. "Reconstrucción del emplazamiento de los cuadros realizados por Francisco de Goya para la Casa de campo de la Alameda de la condesa duquesa de Benavente." *AXA* (October 2012): 2–53. www.uax.es.

Pérez Moreda, Vicente. *Las Crisis de mortalidad en la España interior (siglos XIV–XIX)*. Madrid: Siglo Veintiuno Editores, 1980.

Pérez Moreda, Vicente. "La Población madrileña," in *Actas del Congreso Internacional: El Dos de Mayo y sus Precedentes*, 397–408. Edited by Luis Miguel Enciso Recio. Madrid: Capital Europea de Cultura, 1992.

Pérez Sánchez, Alfonso, and Eleanor A. Sayre. *Goya: The Spirit of Enlightenment*. Boston: Museum of Fine Arts, 1989.

Pietrangeli, Carlo. "'L'Accademia del Nudo' in Campidoglio." *Strenna dei Romanisti* 20 (1959): 123–28.

Piquero López, María Ángeles Blanca, and Mercedes González Amezúa del Pino. *Los Goyas de la Academia*. Madrid: Real Academia de Bellas Artes de San Fernando, 2002.

Ponz, Antonio. *Viaje de España*. Madrid: Aguilar, 1947.

Rascón, J. A. de. "Necrología: Doña Rosario Weiss." *La Gaceta de Madrid* (September 3, 1843): 3–4.

Ravin, James G., and Tracy B. Ravin. "What Ailed Goya?" *History of Ophthalmology* 44, no. 2 (October 1999): 163–70.

RABASF. *Distribución de los premios concedidos por el Rey Nuestro Señor*. Madrid: Ibarra, 1832.

RABASF. *Distribución de los premios concedidos por el Rey Nuestro Señor a los discípulos de las nobles artes, hecho por la Real Academia de San Fernando en la Junta General de 3 de agosto de 1766*. Madrid: Imprenta de Eliseo Sánchez, 1766.

RABASF. *Distribución de los premios concedidos por el Rey Nuestro Señor a los discípulos de las tres nobles artes*. Madrid: Viuda de Ibarra, 1796.

RABASF. *Historia y alegoría: Los Concursos de la Real Academia de Bellas Artes de San Fernando (1753–1808)*. Madrid: RABASF, 1994.

RABASF. *Renovación, crisis, continuismo: La Real Academia de San Fernando en 1792*. Madrid: RABASF, 1992.

RABASF, Archive. *Libros de actas de las sesiones particulares, ordinarias, generales, extraordinarias, públicas y solemnes, 1752/1984*. Alicante: Biblioteca Virtual Miguel de Cervantes, 2007.

RABASF, Archive. Secretaria general: Académicos. Francisco Goya, legajo 1-41-5.

RAH/Real Academia de la Historia, *Diccionario Biográfico electrónico*. www.dbe .rah.es.

Rée, Jonathan. *I See a Voice: A Philosophical History of Language, Deafness, and the Senses*, London: Harper Collins, 1999.

Reese, Thomas F. "Hipódromos, carros, fuentes paseantes y la diversión pública en la España del siglo XVIII: Un Programa agrario y la antigüedad clásica para el salón del Prado," in *El Arte en*

tiempo de Carlos III, 1–47. Madrid: Editorial Alpuerto, 1989.

Rehfues, J. F. *L'Espagne en Mil Huit Cent Huit*. 2 vols. in 1. Paris: Truettel et Würtz, 1811.

Reuter, Anna. "Goya no se olvidó de Leocadia: Una Carta inédita de Moratín." *Boletín del Museo del Prado* 26 (2008): 69–72.

Ribemont, Francis, and Françoise Garcia. *Goya: Hommages*. Bordeaux: Musée des Beaux-Arts de Bordeaux, 1998.

Ringrose, David D. *Spain, Europe, and the "Spanish Miracle," 1700–1900*. Cambridge: Cambridge University Press, 1996.

Roberts, Andrew. *Napoleon: A Life*. New York: Viking, 2014.

Rodríguez Gordillo, José M. *Goya: Retratos para la Real Fábrica de Tabacos de Sevilla*. Madrid: Tabapress, 1985.

Rodríguez Torres, María Teresa. "Francisco de Goya: Retratos de Amigos, Zapater and Moratín." *Boletín. Museo de Bellas Artes de Bilbao* 2 (2007): 145–79. PDF version at museobilbao.com.

Rodríguez Torres, María Teresa. *Goya, Saturno y el saturnismo*. Madrid: Rodríguez Torres, 1992.

Rodríguez Torres, María Teresa. *Un Retrato de Palafox en La Familia de Carlos IV*. Translated by Rachel Stein. Madrid: 2008.

Roettgen, Steffi. *Anton Raphael Mengs, 1728–1779*. 2 vols. Munich: Hirmer, 1999–2003.

Romero Peña, Aleix. "Mariano Luis de Urquijo: Biografía de un ilustrado." *Sancho el Sabio* 34 (2011): 55–78.

Romero Tobar, Leonardo. *Goya en las literaturas*. Madrid: Marcial Pons, Ediciones de Historia, S.A., 2016.

Rose, Isadora. "'La Celebrada caída de nuestro coloso': Destrucciones espontáneas de retratos de Manuel Godoy por el populacho." *Academia* 47 (1978): 199–226.

Rose, Isadora. "Sobre el retrato de General Ricardos que pinto Goya." *Academia* 50 (1980): 115–23.

Rose de Viejo, Isadora. "Goya's Allegories and the Sphinxes: 'Commerce,' 'Agriculture,' 'Industry,' and 'Science' in situ." *The Burlington Magazine* 126, no. 970 (January 1984): 34–39.

Rose de Viejo, Isadora. "More on Goya's Portrait of Alberto Foraster." *The Burlington Magazine* 145, no. 1119 (February 2003): 82–87.

Rose de Viejo, Isadora. "Un Proyecto dieciochesco malogrado: El Plan de reproducir en grabados los cuadros principales existentes en las colecciones reales." *Academia* 53 (1981): 171–81.

Rose de Viejo, Isadora, Emilio La Parra López, and Enrique Giménez López. *La Imagen de Godoy*. Badajoz: Junta de Extremadura, 2001.

Rose Wagner, Isadora Joan. "Manuel Godoy: Patrón de las artes y coleccionista." 2 vols. PhD diss., Universidad Complutense, Madrid, 1983.

Ruiz Palomeque, María Eulalia. "El Paisaje urbano desaparecido en Madrid entre 1808 y 1813." *Actas del Congreso Internacional: El Dos de Mayo y sus Precedentes*, 375–96. Edited by Luis Miguel Enciso Recio. Madrid: Capital Europea de la Cultura, 1992.

Rúspoli, Enrique. "La Condesa de Chichón." *Boletín de la Real Academia de la Historia* 1 (2000): 129–52.

Saavedra y Sangronis, Francisco. *Memorias inéditas de un ministro ilustrado*. Edited by Manuel Moreno Alonso. Seville: Editorial Castillejo, 1992.

Salas, Xavier de. "Aportaciones a la genealogía de D. Francisco Goya." *Boletín de la Real Academia de la Historia* 174 (1977): 405–15.

Salas, Xavier de. "El Goya de Valdemoro." *Archivo Español de Arte* 37, no. 148 (1964): 281–93.

Salas, Xavier de. "Sobre un autorretrato de Goya y dos cartas inéditas del pintor." *Archivo Español de Arte* 27 (1964): 317–20.

Salomon, Xavier. "Goya and the Altamira Family." *The Metropolitan Museum of Art Bulletin* 71, no. 4 (Spring 2014): 27–42.

Sambricio, Valentín de. *Tapices de Goya.* Madrid: Patrimonio Nacional, 1946.

Sánchez-Blanco, Francisco. *La Ilustración goyesca: La Cultura en España durante el reinado de Carlos IV (1788–1808).* Madrid: CSIC, 2007.

Sánchez Cantón, F. J. "Como vivía Goya." *Archivo Español de Arte* 19 (1946): 73–109.

Sánchez Cantón, F. J. "Goya en la Academia," 11–23, in *Real Academia de Bellas Artes: Primer Centenario de Goya— Discursos.* Madrid: J. Sánchez de Ocaña, 1928.

Sánchez Cantón, Francisco Javier. "El Primer viaje de Goya a Madrid." *Archivo Español de Arte e Arqueología* 5 (1929): 193–94.

Sánchez Díez, Carlos. *Dibujos de Rosario Weiss (1814–1843): Catálogo razonado.* Madrid: Centro de Estudios Europa Hispánica, 2018.

Sánchez Jáuregui, María Dolores, and Scott Wilcox. *The English Prize: The Capture of the Westmoreland, an Episode of the Grand Tour.* New Haven, CT: Yale University Press, 2012. Exhibition catalogue.

Sancho, José Luis, et al. *La Casita del Príncipe en El Pardo.* Madrid: Patrimonio Nacional, 2008.

Santiago Páez, Elena María. *Ceán Bermúdez: Historiador del arte y coleccionista ilustrado.* Madrid: Biblioteca Nacional de España, 2016.

Santiago Páez, Elena María, and Juliet Wilson-Bareau. *Ydioma Universal: Goya en la Biblioteca Nacional.* Madrid: Biblioteca Nacional, 1996. Exhibition catalogue.

Sarrailh, Jean. *La Contre-révolution sous la Régence de Madrid (mai–octobre 1823).* Bordeaux: Feret et Fils, 1930.

Sayre, Eleanor A., et al. *The Changing Image: Prints by Francisco Goya.* Boston: Museum of Fine Arts, 1974. Exhibition catalogue.

Sayre, Eleanor A. "Goya's Bordeaux Miniatures." *Bulletin: Museum of Fine Arts, Boston* 64 (1966): 84–123.

Sayre, Eleanor A. "The Portrait of the Marquesa de Santiago and Ceán's Criticism of Goya." *J. Paul Getty Museum Journal* 13 (1985): 147–50.

Schubart, Hermann. *Lettres d'un diplomate danois en Espagne.* Edited by Emil Gigas. Paris: Revue Hispanique, 1902.

Schulz, Andrew. "Goya's Portraits of the Duchess of Osuna: Fashioning Identity in Enlightenment Spain," in *Women, Art, and Politics of Identity in Eighteenth-Century Europe,* 263–83. Edited by Melissa Hyde and Jennifer Milam. Burlington, VT: Ashgate, 2003.

Scotto, Francesco. *Itinerario d'Italia.* Rome: Stamperia del Bernabò, 1748.

Seoane, Marquis of. "Correspondencia epistolar entre D. José Vargas y Ponce y D. Juan Agustín Ceán Bermúdez, durante los años de 1803 a 1805, existente en los Archivos de la Dirección de Hidrografía y de la Real Academia de la Historia." *Boletín de la Real Academia de la Historia* 47 (1905): 5–60.

Sennett, Richard. *The Fall of Public Man.* 1974. Reprint, New York: W. W. Norton, 1992.

Serrano Montalvo, Antonio. "La Vida municipal Zargozana en el otoño de 1808." *Cuadernos de Historia Jerónimo Zurita* 3 (1954): 123–52.

Seseña, Natacha. *Goya y las mujeres.* Madrid: Taurus, 2004.

Soubeyroux, Jacques. "Paupérisme et rapport sociaux à Madrid au XVIIIème siècle." 2 vols. PhD diss., Université de Montpellier, 1976.

Spacks, Patricia Meyer. *Privacy: Concealing the Eighteenth-Century Self.* Chicago: University of Chicago Press, 2003.

Spinosa, Nicola, and Carlo Knight. *Carlos III: Entre Nápoles y España.* Madrid: Real Academia de Bellas Artes de San Fernando, 2009. Exhibition catalogue.

Suárez Huerta, Ana María. "A Portrait of George Legge by Batoni." *The Burlington Magazine* 148 (April 2006): 252–56.

Sureda, Joan, ed. *Goya e Italia.* Zaragoza: Museo de Zaragoza, 2008. Exhibition catalogue.

Swinburne, Henry. *Travels through Spain in the Years 1775 and 1776*. London: For P. Elmsly, in the Strand, 1779.

Symmons, Sarah, et al. *Printing the Unprintable*. Essex, UK: University of Essex, 1999. Exhibition catalogue.

Tal, Guy. "An 'Enlightened View' of Melancholy and Delusionary Experience in Goya's *Spell*." *Zeitschrift für Kunstgeschichte* 75 (2012): 33–50.

Tal, Guy. "Demonic Possession in the Enlightenment: Goya's *Flying Witches*." *Magic, Ritual, and Witchcraft* (Winter 2016): 176–207.

Tinterow, Gary, and Geneviève Lacambre. *Manet/Velázquez: The French Taste for Spanish Painting*. New York: Metropolitan Museum of Art, 2003. Exhibition catalogue.

Tobajas, Marcelino. *Papeles del vivir de Goya y de su España*. Madrid: Publicaciones EME, 1984.

Tomlinson, Janis A. "Burn It, Hide It, Flaunt It: Goya's *Majas* and the Censorial Mind." *Art Journal* 50, no. 4 (Winter 1991): 59–64.

Tomlinson, Janis A. "Evolving Concepts: Spain, Painting, and Authentic Goya in Nineteenth-Century France." *Metropolitan Museum of Art Bulletin* 31 (1996): 189–200.

Tomlinson, Janis A. *Francisco Goya: The Tapestry Cartoons and Early Career at the Court of Madrid*. Cambridge: Cambridge University Press, 1989.

Tomlinson, Janis A. *Goya in the Twilight of Enlightenment*. New Haven, CT: Yale University Press, 1992.

Tomlinson, Janis A. "Goya y lo Popular Revisited: On the Iconography of *The Wedding*." *Pantheon* 42 (1984): 23–29.

Tomlinson, Janis A. *Graphic Evolutions: The Print Series of Francisco Goya*. New York: Columbia University Press, 1989.

Tomlinson, Janis A. "Recent Publications on Goya's Prints and Drawings," *Master Drawings* 42 (Spring 2004): 80–84.

Tomlinson, Janis A., and Kathleen Howe. *Goya's War: Los Desastres de la Guerra*.

Claremont, CA: Pomona College Museum of Art, 2013. Exhibition catalogue.

Tomlinson, Janis A., Stephanie Loeb Stepanek, and Frederick Ilchman. *Goya: Order and Disorder*. Boston: MFA Publications, 2014. Exhibition catalogue.

Torra, Eduardo, Federico Torralba, Carlos Barboza and Teresa García, and Tomás Domingo. *Regina Martirum: Goya*. Zaragoza: Banco Zaragozano, 1982.

Torrecillas Fernández, María Carmen. "Las Pinturas de la Quinta del Sordo fotografiadas por J. Laurent." *Boletín del Museo del Prado* 13, no. 31 (1992): 87–96.

Trapier, Elizabeth du Gué. *Goya and His Sitters: A Study of His Style as a Portraitist*. New York: Hispanic Society of America, 1964.

Urriagli Serrano, Diana. *Las Colecciones de pinturas de Carlos IV en España*. Madrid: Fundación Universitaria Española, 2012.

Valgoma y Díaz-Varela, Dalmiro de la. "Goya, pescador fluvial y abogado del miniaturista Ducker." *Goya* 148–50 (1979): 221–24.

Vallés Valera, H. "Goya, su sordera, su tiempo." *Acta Otorrinolaringolica Español* 56 (2005): 122–31.

Varela Suanzes-Carpegna, Joaquín. *La Monarquía doceañista (1810–1837): Avatares, encomios y denuestos de una extraña forma de gobierno*. Madrid: Marcial Pons, 2013.

Varey, J. E. "Robertson's Phantasmagoria in Madrid, 1821 (Part 1)." *Theatre Notebook* 9 (1955): 89–95.

Varey, J. E. "Robertson's Phantasmagoria in Madrid, 1821 (Part 2)." *Theatre Notebook* 11 (1957): 82–91.

Vega, Jesusa. *Goya 1900: Catálogo ilustrado*. Madrid: Ministerio de Educación, Cultura y Deporte, 2002.

Vega, Jesusa. "Goya's Prints after Velázquez." *Print Quarterly* 12 (1995): 145–63.

Vega, Jesusa. "El Sueño dibujado," in *Realidad y sueño en los viajes de Goya* in *Actas de las I Jornadas de arte en Fuendetodos*, 41–67. Zaragoza: Diputación de Zaragoza, 1996.

Velázquez, María Carmen. *La España de Carlos III de 1764 a 1776 según los embajadores austríacos*. México: Universidad Nacional Autónoma de México, 1963.

Viñuela, J. M. *Colección de pintura del Banco de España*. Madrid: Banco de España, 1988.

Wilson-Bareau, Juliet, *Goya: Drawings from His Private Albums*. London: Hayward Gallery in association with Lund Humphries, 2001. Exhibition catalogue.

Wilson-Bareau, Juliet. "Goya and the X Numbers: The 1812 Inventory and Early Acquisitions of 'Goya' Pictures." *The Metropolitan Museum Journal* 31 (1996): 159–74.

Wilson-Bareau, Juliet. "La Lechera de Burdeos," in Fundación de Amigos del Prado, *Goya*, 349–67. Madrid: Galaxia Gutenberg/Círculo de Lectores, 2002.

Wilson-Bareau, Juliet, and Manuel Mena Marqués. *Goya: Truth and Fantasy*. New Haven: Yale University Press, 1994. Exhibition catalogue.

Yebes, Condesa de. *La Condesa-Duquesa de Benavente: Una Vida en cartas*. Madrid: Espasa Calpe, S.A., 1955.

Young, Eric. "An Unpublished Letter from Goya's Old Age." *The Burlington Magazine* 114, no. 833 (August 1972): 558–59.

Yriarte, Charles. *Goya: Sa biographie, la fresques, les toiles, les tapisseries, les eaux-fortes et la catalogue de l'oeuvre*. Paris: Plon, 1867.

Zapater y Gómez, Francisco. *Goya: Noticias biográficas*. Zaragoza: Imprenta de la Perseverancia, 1868.

INDEX

Ferrer, Mariano, 109
Ferrer Cafranga, Joaquín María, 291, 294–95, 297, 303
Ferro, Gregorio, 11, 65, 67, 80, 83, 143, 205
The Fight at the New Inn (Goya), 43
Flight into Egypt (Goya), 39, 266
Floridablanca, count of (José Moñino y Redondo): Goya and, 47–48, 64, 68, 70–71, 73, 76, 82–84, 262; Jovellanos and, 67; political career of, 47, 76–77, 82–83, 94–95, 103, 104, 108, 114, 117–19; Ponz and, 65, 77, 80, 118–19; portraits of, 70–71; Royal Academy and, 86, 95–96; San Francisco el Grande and, 64, 65, 67
Folch Costa, José Antonio, 205, 219–20
Folch de Cardona, Francisco, 107–8
Fontainebleau, Treaty of (1807), 213
Fontana, Filippo, 168
Foraster, Alberto, 202–3
The Forge (Goya), 317
The Forge of Vulcan (Velázquez), 45, 102
Foucault, Michel, 271
Four Seasons (Maella), 274
Francisco de Saavedra (Goya), 163–64, Pl.14
Frayle, Francisco, 10, 11
Frayle, Manuela, 25
Frayle, Mariano, 25
French language, 91
Fuendetodos, 3–4, 99, 221

Gaceta de Madrid (newspaper): announcements and advertisements in, 47; Carlos IV and, 114; on constitutional militia, 284; Duaso y Latre and, 285; Goya's announcements and advertisements in, 45, 173, 326n31; on Isabel II, 318; on members of Joseph's royal order of Spain, 236
Gainsborough, Thomas, 141–42
Galarza, Josefa, 281
Galarza, Juana, 206, 281
Galeria de mujeres fuertes (*Gallery of Strong Women*) (Le Moyne), 137
Galos, Jacques, 288, 296–97, 304, 311
García de la Huerta, Serafín, 317, 319
García de la Prada, Manuel, 236, 252, 310, 353n2
Garcini, Ignacio, 202–3
Garcini, Josefa Castilla Portugal de, 202–3
Gardie, Gustaf de la, 255–56

garrote, 229–30, *230*
Gaspar Melchor de Jovellanos (Goya), 163–64, Pl.13
Gaulon, Cyprien Charles Marie Nicolas, 288, 301, 303
Gazeta de Mexico (newspaper), 348n24
General Nicolas Philippe Guye (Goya), 231–32, *232*
Genoa, 17–18, 20, 23
Géricault, Théodore, 301
Giaquinto, Corrado, 6, 9, 19, 42, 198
Gibraltar, 52
Gil, Bernardo, 203, 249
Gil Ranz, Luis, 199, 205, 221
Gil y Zárate, Antonio, 203
Gillray, James, 261, *261*
Ginés, José, 168
Giordano, Luca, 47
Girodet, Anne-Louis, 181–82
Giusti, P. P., 47
Glendinning, Nigel, 322n6
Godoy at the Battle of the Oranges (Goya), 254
Godoy y Álvarez de Faria, Manuel: as collector and patron of the arts, 196, 253, 325n1; Fernández de Moratín and, 148; Goya and, 133, 135–37, 143–44, 182, 183, 193–94, 215, 240; Goya's *caprichos* and, 161; Goya's portraits of, 141, 185–86, 191–92, *192*; life and family of, 158–59, 185–86; Peninsular War and, 213–14, 216, 218; political career of, 114, 124–25, 143–46, 155, 158–59, 163, 173–74, 181, 191, 195, 208–9; Velázquez and, 166
Goicoecha, Jerónimo, 291–92
Goicoechea, Juan Martín de: Aranda and, 117–18; Goya and, 54, 56, 58–59, 66, 81, 93, 102, 156, 176, 324n6; San Francisco el Grande and, 64–65
Goicoechea, Martín Miguel de: death of, 300; Goya and, 296, 304; life and family of, 206, 207, 289, 291–92
Goicoechea y Galarza, Gumersinda, 206–7, 311–13
Goicoechea y Galarza, Manuela, 207, 289, 291–92, 300
Gómez, Dionisio, 228
Gómez, Pastor-Jacinto, 101, 199, 340n15
Gómez, Pedro, 163, 191
Gómez, Vicente, 96, 97, 98
Gómez Marañón, Ángel, 188

IMAGE CREDITS